John Berger
Selected Essays

John Berger
Selected Essays

Edited by Geoff Dyer

Pantheon Books, New York

Library of Congress Cataloging-in-Publication Data
Berger, John.
[Selections. 2002]
Selected essays / John Berger; edited by Geoff Dyer.
p. cm.
ISBN 0-375-42156-4
I. Dyer, Geoff. II. Title

PR6052.E564 A6 2002 824'.914—dc21 2001036673

www.pantheonbooks.com

Printed in the United States of America
First American Edition
9 8 7 6 5 4 3 2 1

Contents

The Booker Prize Speech

From *About Looking* (1980)

From *The White Bird* (1985) (US title *The Sense of Sight*)

Editor's Introduction

John Berger's achievements as a writer are both widely recognised and – because of their diversity – difficult to grasp. Even admirers tend to know him in only one or two of his many incarnations. The questions 'Which is his best book?' or 'Which book should I read first?' are unanswerable. It is the entire body of work that is remarkable; no single volume represents Berger adequately. However, the occasion of his seventy-fifth birthday, in November 2001, provided a timely opportunity to try to come up with just such a book.

Throughout his working life Berger has written essays. Far from being adjuncts to the main body of work, these essays are absolutely central to it. Many of the ideas in the ground-breaking book and TV series *Ways of Seeing* – ideas which have since become part of our received cultural knowledge – were presented first and, in some ways, more sensitively, in essays for *New Society*. Polemical, meditative, radical, always original ('The moment at which a piece of music begins provides a clue to the nature of all art'), Berger's essays are, of course, extremely wide-ranging. It is not just that he has written on photographers, artists, thinkers and peasants, on zoos, museums and cities he has travelled to; these diverse concerns are often combined in the course of a single essay. Taken together, however, this signature variegation emphasises the continuities that have underpinned more than forty years of tireless intellectual inquiry and fierce political engagement. Viewed chronologically they do not simply show how his views have changed or how his thought has evolved; they add up to a kind of vicarious autobiography and a history of our time as refracted through the prism of art.

More than any other writer of the post-war period, it is Berger who has explored and expanded the possibilities of the essay. Essays by the usually cited contemporary masters of the form such as Gore Vidal or John Updike are marked by apparently effortless eloquence. In Berger's case,

by contrast, we come close to witnessing thought as an act of almost physical labour. Partly this is due to his refusal to separate the two concerns that have dominated his life and work: the enduring mystery of great art and the lived experience of the oppressed (the two come together most clearly in his essay on Joyce's *Ulysses*). Partly it is due to a determination to present complex ideas in the plainest possible language. This has not been without its ironic consequences. In 1980 Berger recommended John Barrell's *The Dark Side of the Landscape* to 'all those interested in how class ideology produces cultural codes'. He concluded that, together with T. J. Clarke, Barrell lent hope to the idea 'that an internationally relevant English school of radical art history studies may be in the making'. The prophecy was no sooner uttered than it was fulfilled and betrayed. The 'radical art history' that Berger had done so much to usher in quickly barricaded itself in the cultural-studies departments of polytechnics and universities where second-rate Eagletons discoursed away in the confident belief that no one with any sense was likely to be paying attention. Nietzsche was right: 'Those who know that they are profound strive for clarity; those who would like to seem profound . . . strive for obscurity.'

Berger was one of the first British writers to absorb the influence of Europeans such as Roland Barthes and Walter Benjamin whose work helped lay the foundations for media studies and so forth. The fact that he has lived abroad since the early sixties reinforces the notion of Berger as a European rather than English writer, one who has more in common with Sartre or Camus than with Kingsley Amis. Fair enough, but it is also possible to trace a highly selective, specifically English line of descent. Richard Holmes's description of Shelley applies just as readily to Berger:

> a writer in the most comprehensive sense: poet, essayist, dramatist, pamphleteer, translator, reviewer and correspondent. He was moreover a writer who moved everywhere with a sense of ulterior motive, a sense of greater design, an acute feeling for the historical moment and an overwhelming consciousness of his duty as an *artist* in the immense and fiery process of social change of which he knew himself to be a part.

Holmes goes on to observe that 'the encroaching condition of exile plays a highly significant part in his story'. Then there is D. H. Lawrence, another nomadic self-exile with a similarly unruly output. It is no surprise that for a man of Berger's generation Lawrence was a vitally important figure – especially, as Berger once remarked, because of 'his hatred of England'. More relevant in this context are Lawrence's essays, their polemical intermingling of autobiography and art – never more evident than in his 'Introduction to These Paintings' –

generating surges of wild illumination. Finally there is George Orwell, another writer in the 'comprehensive sense' intended by Holmes. Orwell felt that historical circumstances – the unavoidable awareness 'of the enormous injustice and misery of the world' – had led him away from 'a purely aesthetic attitude' to life and literature and forced him 'into becoming a sort of pamphleteer'. The 'invasion of literature by politics' may have been inevitable but Orwell was somewhat grudging about having to forgo the single-minded literary devotion of Henry James in favour of the manifold obligations of pamphleteering (though his distinction as a writer depends precisely on this abandonment). For Berger, there was no tension or regret on this score. Responding to his critics in a letter to the *New Statesman* (4 April 1953) he insisted that 'far from my dragging politics into art, art has dragged me into politics'. In a poem published nine years later in *Labour Monthly*, he declared:

> Men go backwards or forwards.
> There are two directions
> But not two sides.

Differences aside (and there are, of course, many), what unites Shelley, Lawrence, Orwell and Berger – not a tradition but a trajectory – is the way that they arranged their lives in such a way as to seek out the experiences appropriate to their respective gifts. Each embodies what Nietzsche considered 'something very rare but a thing to take delight in: a man with a finely constituted intellect who has the character, the inclinations and *also the experiences* appropriate to such an intellect'.

In Berger's case the dilemma famously and falsely encapsulated by Yeats – perfection of the man or the work – is resolved in a fashion similar to that suggested by Camus. 'The problem,' Camus confided in his notebooks, 'is to acquire that knowledge of life (or rather to have lived) which goes beyond the mere ability to write. So that in the last analysis the great artist is first and foremost a man who has lived greatly (it being understood that in this case living also implies thinking about life – that living is in fact precisely this subtle relationship between experience and our awareness of it).' In keeping with this tentative credo, Berger's essays are all the time testing his life, probing and assessing it. Particularly in the later works his writing is, if you like, a measure of how far he has gone beyond the mere ability to write.

Although Berger claims that 'all that interests me about my past life are the common moments', many of the essays depend on an interrogation of the contingency of his own experience – an undertaking that brings us close to the characteristic preoccupations of many novelists. Much of Berger's fiction up to and including the Booker-winning *G* is

discursive, analytical, essayistic; his essays, on the other hand, are often marked by the kind of narrative drive associated with fiction. In a 1984 interview he said that 'even when I was writing on art, it was really a way of telling stories' (an impulse that finds eventual expression in the trilogy *Into Their Labours* and *To the Wedding*). Not surprisingly, then, the picture of the storyteller in the essay 'A Story for Aesop' is also a reflected self-portrait. 'He observes, watches, recognises, listens to what surrounds him and is exterior to him, and at the same time he ponders within, ceaselessly arranging what he has perceived, trying to find a sense which goes beyond the five senses with which he was born.'

This sense of exploration is crucial to Berger's conception of writing. His essays are journeys, fuelled by a self-replenishing supply of ideas. For Salman Rushdie, in a review reprinted in *Imaginary Homelands*, these ideas are the most distinctive and important feature of Berger's output. Entirely reasonable, an observation like this needs to be seen in the context of the widespread idea that writers do not need ideas, are even hindered by them. At the end of an essay in which Auden is berated for being 'easily infatuated' by ideas, for constantly 'indulging his weakness for notions', Craig Raine comes straight out and – echoing a favourite bleat of John Carey's – declares: 'We need ideas, but not in our art.' This belief – and it is hard not to think of Oxford as its heartland – is a serious blot on the English literary landscape. It means we have tended to rely on exotic foreign imports (Borges, Calvino, Kundera and, most recently, W. G. Sebald) to do the idea stuff for us, thereby – the parallel with football is irresistible – impoverishing the development of the domestic game. The corollary of this is that someone like Bruce Chatwin who had a few (half-baked) ideas is radically overvalued, almost as a compensatory reflex. Berger, meanwhile, has come to be regarded as a kind of honorary European. (Nothing wrong with that, of course, but, to repeat something I said fifteen years ago in the preface to *Ways of Telling*, it is not enough simply to lobby for Berger's name to be printed more prominently on an existing map of literary reputations; his *example* urges us fundamentally to alter its shape.)

In her teens Rebecca West was drawn to Ibsen who 'corrected the chief flaw in English literature, which is a failure to recognise the dynamism of ideas'. With characteristic vehemence West later decided that Ibsen 'cried out for ideas for the same reason that men cry out for water, because he had not got any', but the general point still stands. 'That ideas are the symbols of real relationships among real forces that make people late for breakfast, that take away their breakfast, that make them beat each other across the breakfast-table, is something which the English do not like to realise.' That the author of 'The Eaters and the Eaten' realises this is evident on every page of this book.

The purpose of which is, quite simply, to make available a compre-

hensive selection of essays from *Permanent Red* (in America, *Toward Reality*), *The Moment of Cubism, The Look of Things, About Looking, The White Bird* (in America, *The Sense of Sight*) and *Keeping a Rendezvous*. A couple of previously uncollected items are also included. Hopefully a balance has been struck between the continuity – emphasised by the inclusion of different essays on the same artists – and variegation noted earlier. Many of Berger's books exist between genres and this volume perhaps hovers between two stools in that it is too slim to merit the subtitle 'Collected Essays', but more substantial than 'Selected' tends to suggest. Hopefully it will serve both as a one-volume edition of his essays and as a kind of *Berger Reader*. It is one answer – mine, not John's – to that question, 'Which book of Berger's should I read first?'

Geoff Dyer, March 2001

From *Permanent Red*

(US title *Toward Reality*)

Preface to the 1979 Edition

This book was first published in 1960. Most of it was written between 1954 and 1959. It seems to me that I have changed a lot since then. As I re-read the book today I have the impression that I was trapped at that time: trapped in having to express all that I felt or thought in art-critical terms. Perhaps an unconscious sense of being trapped helps to explain the puritanism of some of my judgments. In some respects I would be more tolerant today: but on the central issue I would be even more intransigent. I now believe that there is an absolute incompatibility between art and private property, or between art and state property – unless the state is a plebeian democracy. Property must be destroyed before imagination can develop any further. Thus today I would find the function of regular current art criticism – a function which, whatever the critic's opinions, serves to uphold the art market – impossible to accept. And thus today I am more tolerant of those artists who are reduced to being largely destructive.

Yet it is not only I who have changed. The future perspective of the world has changed fundamentally. In the early 1950s when I began writing art criticism there were two poles, and only two, to which any political thought and action inevitably led. The polarization was between Moscow and Washington. Many people struggled to escape this polarization but, objectively speaking, it was impossible, because it was not a consequence of *opinions* but of a crucial world-struggle. Only when the USSR achieved (or was recognized to have achieved) parity in nuclear arms with the USA could this struggle cease to be the primary political factor. The achieving of this parity just preceded the Twentieth Congress of the CPSU and the Polish and Hungarian uprisings, to be followed later by the first obvious divergences between the USSR and China and by the victory of the Cuban Revolution. Revolutionary examples and possibilities have since multiplied. The raison d'être of polarized dogmatism has collapsed.

I have always been outspokenly critical of the Stalinist cultural policy of the USSR, but during the 1950s my criticism was more restrained than now. Why? Ever since I was a student, I have been aware of the injustice, hypocrisy, cruelty, wastefulness and alienation of our bourgeois society as reflected and expressed in the field of art. And my aim has been to help, in however small a way, to destroy this society. It exists to frustrate the best man. I know this profoundly and am immune to the apologetics of liberals. Liberalism is always for the alternative *ruling* class: never for the exploited class. But one cannot aim to destroy without taking account of the state of existing forces. In the early 1950s the USSR represented, despite all its deformations, a great part of the force of the socialist challenge to capitalism. It no longer does.

A third change, although trivial, is perhaps worth mentioning. It concerns my conditions of work. Most of this book was first written as articles for the *New Statesman*. They were written, as I have explained, at the height of the Cold War during a period of rigid conformism. I was in my 20s (at a time when to be young was inevitably to be patronized). Consequently every week after I had written my article I had to fight for it line by line, adjective by adjective, against constant editorial cavilling. During the last years of the 1950s I had the support and friendship of Kingsley Martin, but my own attitude towards writing for the paper and being published by it had already been formed by then. It was an attitude of belligerent wariness. Nor were the pressures only from within the paper. The vested interests of the art world exerted their own through the editors. When I reviewed an exhibition of Henry Moore arguing that it revealed a falling-off from his earlier achievements, the British Council actually telephoned the artist to apologize for such a regrettable thing having occurred in London. The art scene has now changed. And on the occasions when I now write about art I am fortunate enough to be able to write quite freely.

Re-reading this book I have the sense of myself being trapped and many of my statements being coded. And yet I have agreed to the book being re-issued as a paperback. Why? The world has changed. Conditions in London have changed. Some of the issues and artists I discuss no longer seem of urgent concern. I have changed. But precisely because of the pressures under which the book was written – professional, political, ideological, personal pressures – it seems to me that I needed at that time to formulate swift but sharp generalizations and to cultivate certain long-term insights in order to transcend the pressures and escape the confines of the genre. Today most of these generalizations and insights strike me as still valid. Furthermore they seem consistent with what I have thought and written since. The short essay on Picasso is in many ways an outline for my later book on Picasso. The recurring theme of the present book is the disastrous relation between art and property and this is the only

theme connected with art on which I would still like to write a whole book.

The title *Permanent Red* was never meant to imply that I would not change. It was to claim that I would never compromise my opposition to bourgeois culture and society. In agreeing to the re-issue of the book I repeat the claim.

John Berger, 1968/1979

Introduction

If you take a long-term historical view, ours is obviously a period of mannerism and decadence. The excessive subjectivity of most of our art and criticism confirms this. The historical and social explanations are not hard to find. It may be unpopular but it is not stupid to condemn works as bourgeois, formalist and escapist.

If, on the other hand, you take a very limited view it is possible to sympathize with almost all artists. If you accept what they themselves are trying to do, you can admire their effort. The work is then no longer proof of the validity of the artist's intentions: his intentions have to prove the validity of his work. If you want to know what it feels like to be X, his paintings will tell you as much as anything else ever will. Accept that it is necessary for him to create a kind of tidal world of flux in which solidity, weight and identity are all sucked away, and then his paintings are certainly impressive.

The limitation of the first approach is that it tends to be over-mechanical. To take a long-term historical view you must stand outside your own time and culture. You must base yourself on the past, in an imaginary future or in the centre of an alternative culture. Your general opinion will probably be right. But you will almost certainly be blind to the processes by which your own period is changing itself. You will tend to see the dramatic break between the culture with which you identify yourself and the culture that surrounds you more clearly than you will see the dialectic leading up to and away from that break. You would, for instance, have seen that Surrealism was decadent but you would have failed to understand how it nourished Eluard who later opposed all decadence. It is an approach that assumes that your own period is finished rather than continuous.

The limitation of the second way of approach is its subjectivity. Intentions count for more than results. You judge the distance travelled

instead of the distance still necessary to travel. You think as though history begins afresh with each individual. Your mind is open – but anything can enter it and so seem positive. You will admit the genius and the fool – and not know which is which.

So what is required is a combination of both approaches. Then you will be fully equipped to recognize that rare transformation which, when it happens, allows an artist's pursuit of his personal needs to become a pursuit of the truth. You will have the historical perspective necessary to evaluate the truth he discovers, and you will have the imaginative appreciation necessary to understand the route he must take to travel towards his discovery. In theory, such a combination would equip the ideal critic. But in fact it is impossible.

The two approaches are mutually opposed. You are demanding that the critic is simultaneously in one place (in X's imagination) and everywhere (in history). You are casting him for the role of God. Which is, of course, the role most critics cast for themselves. Their one concern and one fear is that they will fail to understand the next genius, the latest discovery, the newest trend. Yet they are not God. So they wander about, looking for they know not what, and always believing that they have just found it.

Proper criticism is more modest. First, you must answer the question: What can art serve here and now? Then you criticize according to whether the works in question serve that purpose or not. You must beware of believing that they can always do so directly. You are not simply demanding propaganda. But you need not fall over backwards in order to avoid being proved wrong by those who later take your place. You will make mistakes. You will miss perhaps the genius who finally vindicates himself. But if you answer your initial question with historical logic and justice, you will be helping to bring about the future from which people will be able to judge the art of your own time with ease.

The question I ask is: Does this work help or encourage men to know and claim their social rights? First let me explain what I do not mean by that. When I go into a gallery, I do not assess the works according to how graphically they present, for example, the plight of our old-age pensioners. Painting and sculpture are clearly not the most suitable means for putting pressure on the government to nationalize the land. Nor am I suggesting that the artist, when actually working, can or should be primarily concerned with the justice of a social cause.

> Shut the door of the Pope's chapel,
> Keep those children out.
> There on that scaffolding reclines
> Michael Angelo.
> With no more sound than the mice make

His hand moves to and fro.
Like a long-legged fly upon the stream
His mind moves upon silence.

Yeats understood the necessary preoccupations of the artist.

What I do mean is something less direct and more comprehensive. After we have responded to a work of art, we leave it, carrying away in our consciousness something which we didn't have before. This something amounts to more than our memory of the incident represented, and also more than our memory of the shapes and colours and spaces which the artist has used and arranged. What we take away with us – on the most profound level – is the memory of the artist's way of looking at the world. The representation of a recognizable incident (an incident here can simply mean a tree or a head) offers us the chance of relating the artist's way of looking to our own. The forms he uses are the means by which he expresses his way of looking. The truth of this is confirmed by the fact that we can often recall the experience of a work, having forgotten both its precise subject and its precise formal arrangement.

Yet why should an artist's way of looking at the world have any meaning for us? Why does it give us pleasure? Because, I believe, it increases our awareness of our own potentiality. Not of course our awareness of our potentiality as artists ourselves. But a way of looking at the world implies a certain relationship with the world, and every relationship implies action. The kind of actions implied vary a great deal. A classical Greek sculpture increases our awareness of our own potential physical dignity; a Rembrandt of our potential moral courage; a Matisse of our potential sensual awareness. Yet each of these examples is too personal and too narrow to contain the whole truth of the matter. A work can, to some extent, increase an awareness of different potentialities in different people. The important point is that a valid work of art promises in some way or another the possibility of an increase, an improvement. Nor need the work be optimistic to achieve this; indeed, its subject may be tragic. For it is not the subject that makes the promise, it is the artist's way of viewing his subject. Goya's way of looking at a massacre amounts to the contention that we ought to be able to do without massacres.

Works can be very roughly divided into two categories, each offering, in the way just described, a different kind of promise. There are works which embody a way of looking that promises the mastering of reality – Piero, Mantegna, Poussin, Degas. Each of these suggests in a different way that space, time and movement are understandable and controllable. Life is only as chaotic as men make it or allow it to be. There are other works which embody a way of looking whose promise lies not so much in any suggested mastery, but rather in the fervour of an implied desire for change – El Greco, Rembrandt, Watteau, Delacroix, Van

Gogh. These artists suggest that men in one way or another are larger than their circumstances – and so could change them. The two categories are related, perhaps, to the old distinction between Classic and Romantic, but they are broader because they are not concerned with specific historical vocabularies. (It is obviously absurd to think of El Greco as a romantic in the same sense as Delacroix or Chopin.)

All right, you may now say, I see your point: art is born out of hope – it's a point that's often been made before, but what has it to do with claiming social rights? Here it is essential to remember that the specific meaning of a work of art changes – if it didn't, no work could outlive its period, and no agnostic could appreciate a Bellini. The meaning of the improvement, of the increase promised by a work of art, depends upon who is looking at it when. Or, to put it dialectically, it depends upon what obstacles are impeding human progress at any given time. The rationality of a Poussin first gave hope in the context of absolute monarchism: later it gave hope in the context of free trade and Whig reforms; still later it confirmed Léger's faith in proletarian Socialism.

It is our century, which is pre-eminently the century of men throughout the world claiming the right of equality, it is our own history that makes it inevitable that we can only make sense of art if we judge it by the criterion of whether or not it helps men to claim their social rights. It has nothing to do with the unchanging nature of art – if such a thing exists. It is the lives lived during the last fifty years that have now turned Michelangelo into a revolutionary artist. The hysteria with which many people today deny the present, inevitable social emphasis of art is simply due to the fact that they are denying their own time. They would like to live in a period when they'd be right.

1960

Drawing

For the artist drawing is discovery. And that is not just a slick phrase, it is quite literally true. It is the actual act of drawing that forces the artist to look at the object in front of him, to dissect it in his mind's eye and put it together again; or, if he is drawing from memory, that forces him to dredge his own mind, to discover the content of his own store of past observations. It is a platitude in the teaching of drawing that the heart of the matter lies in the specific process of looking. A line, an area of tone, is not really important because it records what you have seen, but because of what it will lead you on to see. Following up its logic in order to check its accuracy, you find confirmation or denial in the object itself or in your memory of it. Each confirmation or denial brings you closer to the object, until finally you are, as it were, inside it: the contours you have drawn no longer marking the edge of what you have seen, but the edge of what you have become. Perhaps that sounds needlessly metaphysical. Another way of putting it would be to say that each mark you make on the paper is a stepping-stone from which you proceed to the next, until you have crossed your subject as though it were a river, have put it behind you.

This is quite different from the later process of painting a 'finished' canvas or carving a statue. Here you do not pass through your subject, but try to re-create it and house yourself in it. Each brush-mark or chisel-stroke is no longer a stepping-stone, but a stone to be fitted into a planned edifice. A drawing is an autobiographical record of one's discovery of an event – seen, remembered or imagined. A 'finished' work is an attempt to construct an event in itself. It is significant in this respect that only when the artist gained a relatively high standard of individual 'autobiographical' freedom, did drawings, as we now under-stand them, begin to exist. In a hieratic, anonymous tradition they are unnecessary. (I should perhaps point out here that I am talking about

working drawings – although a working drawing need not necessarily be made for a specific project. I do not mean linear designs, illustrations, caricatures, certain portraits or graphic works which may be 'finished' productions in their own right.)

A number of technical factors often enlarge this distinction between a working drawing and a 'finished' work: the longer time needed to paint a canvas or carve a block: the larger scale of the job: the problem of simultaneously managing colour, quality of pigment, tone, texture, grain, and so on – the 'shorthand' of drawing is relatively simple and direct. But nevertheless the fundamental distinction is in the working of the artist's mind. A drawing is essentially a private work, related only to the artist's own needs; a 'finished' statue or canvas is essentially a public, *presented* work – related far more directly to the demands of communication.

It follows from this that there is an equal distinction from the point of view of the spectator. In front of a painting or statue he tends to identify himself with the subject, to interpret the images for their own sake; in front of a drawing he identifies himself with the artist, using the images to gain the conscious experience of seeing as though through the artist's own eyes.

As I looked down at the clean page in my sketchbook I was more conscious of its height than its breadth. The top and bottom edges were the critical ones, for between them I had to reconstruct the way he rose up from the floor, or, thinking in the opposite direction, the way that he was held down to the floor. The energy of the pose was primarily vertical. All the small lateral movements of the arms, the twisted neck, the leg which was not supporting his weight, were related to that vertical force, as the trailing and overhanging branches of a tree are related to the vertical shaft of the trunk. My first lines had to express that; had to make him stand like a skittle, but at the same time had to imply that, unlike a skittle, he was capable of movement, capable of readjusting his balance if the floor tilted, capable for a few seconds of leaping up into the air against the vertical force of gravity. This capability of movement, this irregular and temporary rather than uniform and permanent tension of his body, would have to be expressed in relation to the side edges of the paper, to the variations on either side of the straight line between the pit of his neck and the heel of his weight-bearing leg.

I looked for the variations. His left leg supported his weight and therefore the left, far side of his body was tense, either straight or angular; the near, right side was comparatively relaxed and flowing. Arbitrary lateral lines taken across his body ran from curves to sharp points – as streams flow from hills to sharp, compressed gulleys in the cliff-face. But of course it was not as simple as that. On his near, relaxed side his fist was clenched and the hardness of his knuckles recalled the

hard line of his ribs on the other side – like a cairn on the hills recalling the cliffs.

I now began to see the white surface of the paper, on which I was going to draw, in a different way. From being a clean flat page it became an empty space. Its whiteness became an area of limitless, opaque light, possible to move through but not to see through. I knew that when I drew a line on it – or *through* it – I should have to control the line, not like the driver of a car, on one plane: but like a pilot in the air; movement in all three dimensions being possible.

Yet, when I made a mark, somewhere beneath the near ribs, the nature of the page changed again. The area of opaque light suddenly ceased to be limitless. The whole page was changed by what I had drawn just as the water in a glass tank is changed immediately you put a fish in it. It is then only the fish that you look at. The water merely becomes the condition of its life and the area in which it can swim.

Then, when I crossed the body to mark the outline of the far shoulder, yet another change occurred. It was not simply like putting another fish into the tank. The second line altered the nature of the first. Whereas before the first line had been aimless, now its meaning was fixed and made certain by the second line. Together they held down the edges of the area between them, and the area, straining under the force which had once given the whole page the potentiality of depth, heaved itself up into a suggestion of solid form. The drawing had begun.

The third dimension, the solidity of the chair, the body, the tree, is, at least as far as our senses are concerned, the very proof of our existence. It constitutes the difference between the word and the world. As I looked at the model I marvelled at the simple fact that he *was* solid, that he occupied space, that he was more than the sum total of ten thousand visions of him from ten thousand different viewpoints. In my drawing, which was inevitably a vision from just one point of view, I hoped eventually to imply this limitless number of other facets. But now it was simply a question of building and refining forms until their tensions began to be like those I could see in the model. It would of course be easy by some mistaken over-emphasis to burst the whole thing like a balloon; or it might collapse like too-thin clay on a potter's wheel; or it might become irrevocably misshapen and lose its centre of gravity. Nevertheless, the thing was there. The infinite, opaque possibilities of the blank page had been made particular and lucid. My task now was to coordinate and measure: not to measure by inches as one might measure an ounce of sultanas by counting them, but to measure by rhythm, mass and displacement: to gauge distances and angles as a bird flying through a trellis of branches; to visualize the ground plan like an architect; to feel the pressure of my lines and scribbles towards the uttermost surface of

the paper, as a sailor feels the slackness or tautness of his sail in order to tack close or far from the surface of the wind.

I judged the height of the ear in relation to the eyes, the angles of the crooked triangle of the two nipples and the navel, the lateral lines of the shoulders and hips – sloping towards each other so that they would eventually meet, the relative position of the knuckles of the far hand directly above the toes of the far foot. I looked, however, not only for these linear proportions, the angles and lengths of these imaginary pieces of string stretched from one point to another, but also for the relationships of planes, of receding and advancing surfaces.

Just as looking over the haphazard roofs of an unplanned city you find identical angles of recession in the gables and dormer-windows of quite different houses – so that if you extended any particular plane through all the intermediary ones, it would eventually coincide perfectly with another; in exactly the same way you find extensions of identical planes in different parts of the body. The plane, falling away from the summit of the stomach to the groin, coincided with that which led backwards from the near knee to the sharp, outside edge of the calf. One of the gentle, inside planes, high up on the thigh of the same leg, coincided with a small plane leading away and around the outline of the far pectoral muscle.

And so, as some sort of unity was shaped and the lines accumulated on the paper, I again became aware of the real tensions of the pose. But this time more subtly. It was no longer a question of just realizing the main, vertical stance. I had become involved more intimately with the figure. Even the smaller facts had acquired an urgency and I had to resist the temptation to make every line over-emphatic. I entered into the receding spaces and yielded to the oncoming forms. Also, I was correcting: drawing over and across the earlier lines to reestablish proportions or to find a way of expressing less obvious discoveries. I saw that the line down the centre of the torso, from the pit of the neck, between the nipples, over the navel and between the legs, was like the keel of a boat, that the ribs formed a hull and that the near, relaxed leg dragged on its forward movement like a trailing oar. I saw that the arms hanging either side were like the shafts of a cart, and that the outside curve of the weight-bearing thigh was like the ironed rim of a figure on a crucifix. Yet such images, although I have chosen them carefully, distort what I am trying to describe. I saw and recognized quite ordinary anatomical facts; but I also felt them physically – as if, in a sense, *my* nervous system inhabited *his* body.

A few of the things I recognized I can describe more directly. I noticed how at the foot of the hard, clenched, weight-bearing leg, there was clear space beneath the arch of the instep. I noticed how subtly the straight under-wall of the stomach elided into the attenuated, joining planes of

thigh and hip. I noticed the contrast between the hardness of the elbow and the vulnerable tenderness of the inside of the arm at the same level.

Then, quite soon, the drawing reached its point of crisis. Which is to say that what I had drawn began to interest me as much as what I could still discover. There is a stage in every drawing when this happens. And I call it a point of crisis because at that moment the success or failure of the drawing has really been decided. One now begins to draw according to the demands, the needs, of the drawing. If the drawing is already in some small way true, then these demands will probably correspond to what one might still discover by actual searching. If the drawing is basically false, they will accentuate its wrongness.

I looked at my drawing trying to see what had been distorted; which lines or scribbles of tones had lost their original and necessary emphasis, as others had surrounded them; which spontaneous gestures had evaded a problem, and which had been instinctively right. Yet even this process was only partly conscious. In some places I could clearly see that a passage was clumsy and needed checking; in others, I allowed my pencil to hover around – rather like the stick of a water-diviner. One form would pull, forcing the pencil to make a scribble of tone which could re-emphasize its recession; another would jab the pencil into restressing a line which could bring it further forward.

Now when I looked at the model to check a form, I looked in a different way. I looked, as it were, with more connivance: to find only what I wanted to find.

Then the end. Simultaneously ambition and disillusion. Even as in my mind's eye I saw my drawing and the actual man coincide – so that, for a moment, he was no longer a man posing but an inhabitant of my half-created world, a unique expression of my experience – even as I saw this in my mind's eye, I saw in fact how inadequate, fragmentary, clumsy my small drawing was.

I turned over the page and began another drawing, starting from where the last one had left off. A man standing, his weight rather more on one leg than the other . . .

1953

Jackson Pollock

In a period of cultural disintegration – such as ours in the West today – it is hard to assess the value of an individual talent. Some artists are clearly more gifted than others and people who profoundly understand their particular media ought to be able to distinguish between those who are more and those who are less gifted. Most contemporary criticism is exclusively concerned with making this distinction; on the whole, the critic today accepts the artist's aims (so long as they do not challenge his own function) and concentrates on the flair or lack of it with which they have been pursued. Yet this leaves the major question begging: how far can talent exempt an artist if he does not think beyond or question the decadence of the cultural situation to which he belongs?

Perhaps our obsession with genius, as opposed to talent, is an instinctive reaction to this problem, for the genius is by definition a man who is in some way or another larger than the situation he inherits. For the artist himself the problem is often deeply tragic; this was the question, I believe, which haunted men like Dylan Thomas and John Minton. Possibly it also haunted Jackson Pollock and may partly explain why in the last years of his life he virtually stopped painting.

Pollock was highly talented. Some may be surprised by this. We have seen the consequences of Pollock's now famous innovations – thousands of Tachiste and Action canvases crudely and arbitrarily covered and 'attacked' with paint. We have heard the legend of Pollock's way of working: the canvas on the floor, the paint dripped and flung on to it from tins; the delirium of the artist's voyage into the unknown, etc. We have read the pretentious incantations written around the kind of painting he fathered. How surprising it is then to see that he was, in fact, a most fastidious, sensitive and 'charming' craftsman, with more affinities with an artist like Beardsley than with a raging iconoclast.

His best canvases are large. One stands in front of them and they fill

one's field of vision: great walls of silver, pink, new gold, pale blue nebulae seen through dense skeins of swift dark or light lines. It is true that these pictures are not composed in the Renaissance sense of the term; they have no focal centre for the eye to travel towards or away from. They are designed as continuous surface patterns which are perfectly unified without the use of any obvious repeating motif. Nevertheless their colour, their consistency of gesture, the balance of their tonal weights all testify to a natural painter's talent. The same qualities also reveal that Pollock's method of working allowed him, in relation to what he wanted to do, as much control as, say, the Impressionist method allowed the Impressionists.

Pollock, then, was unusually talented and his paintings can delight the sophisticated eye. If they were turned into textile design or wall-papers they might also delight the unsophisticated eye. (It is only the sophisticated who can enjoy an isolated, single quality removed from any normal context and pursued for its own sake – in this case the quality of abstract decoration.) But can one leave the matter there?

It is impossible. Partly because his influence as a figure standing for something more than this is now too pressing a fact to ignore, and partly because his paintings must also be seen – and were probably intended – as images. What is their content, their meaning? A well-known museum curator, whom I saw in the gallery, said 'They're *so* meaningful.' But this, of course, was an example of the way in which qualitative words are now foolishly and constantly stood on their heads as everybody commandeers the common vocabulary for their unique and personal usage. These pictures are meaningless. But the way in which they are so is significant.

Imagine a man brought up from birth in a white cell so that he has never seen anything except the growth of his own body. And then imagine that suddenly he is given some sticks and bright paints. If he were a man with an innate sense of balance and colour harmony, he would then, I think, cover the white walls of his cell as Pollock has painted his canvases. He would want to express his ideas and feelings about growth, time, energy, death, but he would lack any vocabulary of seen or remembered visual images with which to do so. He would have nothing more than the gestures he could discover through the act of applying his coloured marks to his white walls. These gestures might be passionate and frenzied but to us they could mean no more than the tragic spectacle of a deaf mute trying to talk.

I believe that Pollock imaginatively, subjectively, isolated himself almost to that extent. His paintings are like pictures painted on the inside walls of his mind. And the appeal of his work, especially to other painters, is of the same character. His work amounts to an invitation: Forget all, sever all, inhabit your white cell and – most ironic paradox of all – discover the universal in your self, for in a one-man world you are universal!

The constant problem for the Western artist is to find themes for his art which can connect him with his public. (And by a theme I do not mean a subject as such but the developing significance found in a subject.) At first Pollock was influenced by the Mexicans and by Picasso. He borrowed stylistically from them and was sustained by their fervour, but try as he might he could not take over their themes because they were simply not applicable to his own view of his own social and cultural situation. Finally in desperation he made his theme the impossibility of finding a theme. Having the ability to speak, he acted dumb. (Here a little like James Dean.) Given freedom and contacts, he condemned himself to solitary confinement in the white cell. Possessing memories and countless references to the outside world, he tried to lose them. And having jettisoned everything he could, he tried to preserve only his consciousness of what happened at the moment of the act of painting.

If he had not been talented this would not be clear; instead one would simply dismiss his work as incompetent, bogus, irrelevant. As it is, Jackson Pollock's talent did make his work relevant. Through it one can see the disintegration of our culture, for naturally what I have described was not a fully conscious and deliberate personal policy; it was the consequence of his living by and subscribing to all our profound illusions about such things as the role of the individual, the nature of history, the function of morality.

And perhaps here we have come to something like an answer to my original question. If a talented artist cannot see or think beyond the decadence of the culture to which he belongs, if the situation is as extreme as ours, his talent will only reveal negatively but unusually vividly the nature and extent of that decadence. His talent will reveal, in other words, how it itself has been wasted.

1958

Henry Moore

I believe that Henry Moore himself considers that most 'interpretations' of his work are so much nonsense. He is probably right. Not only because many critics are fools, but because the problem of the meaning of his work haunts him and forces him round in circles so that finally his inability to solve it actually supplies him with his subject matter. On certain occasions Moore has tackled straight subjects – the Madonna and Child, the Dead Warrior, the War Sketch Books. On other occasions he has got lost and confused and so produced works which are objects and not images at all. But most of the time he has to wrestle – even if unconsciously. And so must we, too, but consciously and logically. We can, of course, simply say that Moore has the ability to create forms that somehow please us and then use words like Dignity, Strength, Power – words offered to mysterious gods. But in time these words wear thin, and if Moore's work is to last, its significance must become clearer.

Take his figure for the Unesco building in Paris. A reclining figure is what it is called. Probably feminine. The forms of the body rounded, hollowed out, transported and transformed. If it wasn't for the head on the neck it would be difficult to recognize as a figure at all. Given this clue, however, the forms do become readable. Yet as what? As you walk round the work, the five massive earth-bound forms change their relationship with one another, change their formation as easily and freely as five birds in the sky. And in the pliable imagination suggested by that, you recognize Moore's mastery. Yet mastery for what purpose? A master makes the form of a work seem inevitable. Then this inevitability challenges the inevitability of nature in the name of something. In the name of what does this sculpture challenge? Why do three boulder-like masses fuse together to challenge two legs? The questions nag. You respond to the work. You say to yourself: the meaning of art cannot always be made explicit in words. But imagining yourself a sculptor, you

also sense that no one could go on from where Moore leaves off. And no one has. Why?

The distortions in this work are not emotional in the expressionist sense: they clearly don't reflect the artist's attitude to his subject, if his subject is assumed to be a woman. Nor are they structurally analytical: they reveal nothing about the way a body moves, grows or is controlled. They don't, in other words, take us *beyond* static appearances, propelled forward by either emotion or dynamic knowledge. On the contrary, Moore's distorted forms appear more immutable than any living appearance. They are dead? Not quite. More dead than alive? Yes, but what is more dead than alive? Inorganic matter. And there you have it. Moore's subject here is not a woman: it is the inert material he has in his hands. This work doesn't challenge the reality of the human figure: it challenges the reality of the meaningless mass that it might so easily have been. It is an object striving to become an image: a prophecy of life not yet manifest. And so it seems to me that Moore's work represents effectively and truthfully the modern artist's struggle to achieve vitality, to discover a theme. It poses the problem, it begs for a solution, but it does not offer one. It is art which has voluntarily put its back against the ultimate wall. Which is also why no one can follow Moore. One can't go further back than he has.

1955

Juan Gris

By temperament Gris appears to have been obstinate, cold, mean, but courageous about his health – he died at forty; his great virtues as an artist were his intelligence and clarity, the latter quality being the result, as with Stendhal, of an extreme, disciplined frankness. He was as near to a scientist as any modern painter has been, and thus, because Picasso's and Braque's discovery of Cubism was the discovery of a formula, Gris was the purest and most apt of all the Cubists.

It may seem shocking in our period of hysterical individualism to say that Cubism supplied a formula. Yet this was its unique advantage over all other twentieth-century movements, and is why many second-rate artists who came under its influence were temporarily made first-rate. At its best it was not, of course, a formula for making pictures, although it finally became that; it was a formula for interpreting and understanding reality.

Theoretically, the reality of an object for a Cubist consisted of the sum total of all its possible appearances. Yet in practice this total could never be arrived at, because the number of possible visual appearances (or aspects) was infinite. Consequently, the most the Cubist could do was somehow to suggest the range of, the infinity of possibilities open to, his vision. The real subject of a Cubist painting is not a bottle or a violin; the real subject is always the same, and is the functioning of sight itself. The bottle or the violin is only the point of focus, the stake to which the artist's circling vision is tied. (The Cubists' trick of imitating the surfaces of the objects they were painting – by wood graining, marble patterning, etc. – served to fix this necessary focus in the quickest possible way.) To look at a Cubist painting is like looking at a star. The star exists objectively, as does the subject of the painting. But its shape is the result of our looking at it.

The artist, in other words, became his own subject, not in any subjective or egocentric manner, but as a result of his considering

himself and the functioning of his own senses as an integral part of the Nature he was studying. This was the formula for Cubism and when Cézanne insisted on being faithful to Nature via his *petite sensation* he predicted it. Again, however, I want to emphasize that by formula I mean a new, revolutionary truth, which, once posed, can be generally learned, taught and applied. Why revolutionary? Because, simultaneously with the scientific discoveries of that period (Rutherford, Planck, Einstein) which were just beginning to give man, for the first time in history, the possibility of an adequate control of his environment, the Cubist formula presupposed, also for the first time in history, man living unalienated from Nature. And it is perhaps this which explains why those few Cubist pictures which were created during the years immediately preceding the First World War are the calmest works painted since the French Revolution.

Following the war and its consequences, the prophetic confidence of the Cubists was broken. They had enlarged the vocabulary of painting, but the revolutionary meaning of what they had added was largely forgotten. Only Léger remained consistently faithful to the original spirit of Cubism: Picasso was so spasmodically: whilst Braque and Gris withdrew into decorative idioms – Gris in an architectural spirit, Braque with the spirit of an epicure poet.

It still seems logical to believe, however, that when eventually a modern tradition of art and teaching is established – and this tradition will inevitably be materialist in philosophy and uncommercial in context – it is to Cubism that its exponents will return as a starting point.

1958

Jacques Lipchitz

Critics should always look their hobby-horses in the mouth. Yet despite this warning, the more I think about the art of the last and the next forty years (which is the minimum time-span with which any critic should concern himself) the more I am convinced that the question of Cubism is a – and probably the – fundamental one. Cubist mannerisms are of course widespread, but it is not to these that I refer; stylistic mannerisms are the small-talk of art. It is the Cubist attitude to nature, to the content of art, which has opened up so many real and truly modern possibilities.

The static single viewpoint in painting and sculpture can no longer satisfy the expectations deriving from our new knowledge of history, physical structure, psychology. We now think in terms of processes rather than substances. Many twentieth-century artists have expressed this shift and progress in our knowledge by using unusual, eccentric viewpoints whose significance depends on vibrant comparisons, made outside the picture, with other less eccentric viewpoints. This is the principle behind expressionist distortions and surrealist juxtapositions. Their success depends on – as it were – setting the viewer spinning. Their argument is: a form is not in fact what it appears to be, and therefore if we wilfully deform it we can usefully make people doubt the apparent truth; so let us cast off and trust to the unknown currents. The reduction to absurdity of this attitude is the worship of the accident, as in Action Painting.

The Cubist attitude is totally opposed to this. The Cubists established the principle of using multiple viewpoints *within* the picture and there-fore of controlling the spin and the vibrations of meaning. They were concerned with establishing new knowledge rather than with destroying the old, and so they were concerned with statements, not doubts. They wanted their art to be as self-sufficient as the truth. They aimed to disclose processes, not to ride hell bent down them into ferment. They were not of course scientists. They were artists, and so they connected

one phenomenon with another by an imaginative rather than physical logic. Human consciousness was their arena as well as their tool. But they were almost unique in modern art in that they believed that this consciousness could be considered rationally, not, as all romantics believe, just suffered.

Readers might now reasonably assume that I am talking about the classic Cubist works of 1908 to 1913, and that when I say 'multiple viewpoints' I mean it literally and optically. The true consequences of Cubism, however, are far wider, and nobody illustrates this better than the sculptor Jacques Lipchitz, along with Zadkine among the few possibly great sculptors of our time.

Lipchitz would be the first to admit that he was formed by Cubism. Indeed, from 1913 for about ten years he produced sculpture which looked very like early Cubist paintings: the same scrolly shapes, sharp edges, lack of depth, and even the same subjects. These were the works of his apprenticeship. Mostly they fail as sculpture. The forms have been taken too directly from painting. They look like canvases seen through stereoscopic spectacles. But from the middle twenties Cubism ceased to be a matter of style for him, and became a question of imaginative vision. Some of his new works were open wire-like sculptures; others were massive figures, a little like the sculptural equivalent of Léger's, with surfaces sometimes polished and sometimes very broken-up. All, however, were metaphors in movement.

I fear that that is an obscure phrase but perhaps I can clarify it by an example. There is a large work of a pair of lovers on the ground. The forms are very severely simplified. There are no hands, no feet, no faces. One mass presses down on another. Their four legs have become two simple forms – a little like the front wings of a car. The man's arms connect two shoulders – his own with hers. Their heads, both bent backwards from the chin, form a shape like an open beak, his the top bill and hers the bottom. In profile the whole work looks somewhat like a tortoise – the shell their two bodies – raising itself up on its legs. But its spirit is not in the least zoomorphic. It is cast in bronze and its forms are metallic. Just as much as a tortoise, it also suggests a fulcrum, levers and counter-weights. Its distortions and simplifications have not been governed by the material as in Moore, nor by emotional urges and fears as in Marini; they have been very carefully derived from the objective structural stresses and movements of the subject. Hence the energy of the work. It springs from its own base. Rodin, whom Lipchitz much admires, was also concerned with movement, but for Rodin the movement of a figure was something that happened to it. For Lipchitz, concerned with processes rather than substances, and looking in imagination from multiple viewpoints, movement is the very mode of being for his figures.

Poetically this means that he conjures up allusions to all forms of

movement: to the wind, to animals, to fire, to plants opening, to gestation. His refugees fall like stones from a collapsing building; Prometheus strangles the vulture (an intended symbol for Fascism) as wind strangles a flame. His happy figures are like new boats on the stocks. Orpheus rediscovers his love and they are like two clouds in the sky.

Ideologically it means that he is in a position to make the truthful symbols of our time. Speed is rightly – but not just in the sense of travelling fast – our special concern. We aim to set processes in motion. Only gods are static. And historically it means that Lipchitz has learnt, when he is at his best, the lessons of Cubism: has learnt to control the spin and produce a modern rational art.

1959

Ossip Zadkine

In May 1940 the centre of Rotterdam – including, among other buildings, 25,000 homes – was bombed to rubble. It was the second European city to be a victim of the German policy of extermination bombing. Warsaw was the first.

On the waterfront of the new city there now stands Zadkine's monument to the ordeal of the old city. It is a reminder of which the citizens of Rotterdam are almost unanimously proud. It is a memorial which can shame those Germans capable of admitting shame. It is an inspiration in the struggle for progress and peace. And quite apart from this, it is – in my opinion at least – the best modern war monument in Europe.

You can only see it properly by walking round it on foot. It stands by itself, well away from any road or large building, overlooking the harbour. Although near the centre, this is one of the few quiet, still places in the modern city. You walk round the plain granite block on which the figure, cast in dark bronze, simultaneously stands, dies and advances. The scale is big. Two or three large gulls can perch on the hand that appears to be flattened against the surface of the sky. Between the outstretched arms the clouds move. A ship's siren sounds on the other side of the water, and you think of the largest anchor, but buckled, and trailing not over the sea bed but over those moving clouds. At night it is different. It becomes a silhouette, less symbolic and more human. Shadows, which are half the visual language of sculpture, are obliterated. Only the gesture therefore remains. A man stands, arms raised to hold off an invisible load between him and the stars. Then in the early morning you see again the lime of the gulls and the dead fixed texture of the massively cast bronze in contrast with the bright, crinkling surface of the water. Thus the sculpture changes with the time of day. It is not a passive figure with a corrugated cloak waiting to be benighted, lit up, scorched and snowed upon until it becomes no more than the unmel-

table core of a snowman. Its function and not just its appearance depends upon the hours. It engages time. And the reason for this is that its whole conception as a work of art is based on an awareness of development and change.

But first let me admit that there is one very weak passage in this work: the tree stump by the side of the figure. An upright form is necessary there to support the figure, but both the shape and the associations of a tree stump are quite unsuitable: like a potato by the side of a crystal. However, it is almost possible to ignore this. It is not part of the figure and it is not part of the work's true image.

What is the meaning of this image? Or, rather, what are the meanings? – for it is the fact that this work has simultaneous meanings that allows it to express development and change so well. The figure represents the city. And the first dominant theme is that of the city being ravaged, razed. The hands and the head cry out against the sky from which the man-aimed bombs fall. I say man-aimed because this makes the anguish sharper and fiercer than that of an Old Testament prophet crying out against the wrath of his god, and this extra anguish partly explains, I think, the violence of the distortions in modern tragic works like this. The torso of the man is ripped open and his heart destroyed. The wound is not portrayed in terms of flesh. The man represents a city, and the sculpture is of bronze and so the wound, which in fact is a hole right through the body, is seen in terms of the twisted metal of the burnt-out shell of a building. The legs give at the knees. The whole figure is about to fall.

The second theme is very different. This is also a figure of aspiration and advance. The heart is ripped out, but the arms and hands are not only held high in anguish and a vain attempt to hold off, they also raise and lift. The legs not only give at the knees, they also bend because they are steady. And from every direction as you walk round this figure, the step appears to be forwards. The figure has no back – and so cannot retreat. It advances in every direction (and do not think I am now talking metaphorically; I am being quite literal). On the site of the old city a new one was to be built. One week after the German attack, plans were made to rebuild Rotterdam after the Germans were eventually driven out. And so the curses also become a rallying cry.

How does the work achieve this duality? Not by philosophic dualism, not by separating the spiritual from the physical – as in certain crucifix-ions where the body of Christ is tortured and the expression of his face peaceful and triumphant. This is a work which is uncompromisingly physical and the basis of its double meaning is a material one. First, the statue has an existence and logic of its own. It is not imitative. It is a piece of bronze demonstrating something and it does not disguise the fact that it is a piece of bronze: its forms are metallic in both shape and tension.

This allows it to express the content of one moment – the moment of dying or the moment of resurrection – whilst not being exclusively committed to that moment; it also clearly remains a piece of bronze on the waterfront at Rotterdam in 1960. Thus its formalizations become the equivalent of a historical perspective: they do more than generalize, they allow for change. Yet by itself this is a dangerous principle to work upon because it can lead to that kind of abstraction which 'contains' any meaning because it actually has none. Formalizations governed by the material of the work in question must always be modified and checked by observation of the reality of the subject. And this is the second way in which the basis of the double meaning of this work is a material one. It is not by magic that Zadkine has modelled a figure which simultaneously advances and collapses; it is by learning from the methods of Cubism. He now knows what is constant in all the ways in which a body can move and retain its balance. He can sense the points of physical coincidence between a man falling and a man going forwards. (Who has not mistaken laughter for weeping, a gesture of affection for one of attack?)

And so having established these points and the precise relationship between them – round the wrists, at the pit of the neck, under the shoulders, along the thighs, near the knees – he constructs the form of each limb to suggest, given those fixed points, all its possibilities of movement. The figure becomes like a dance which does not need time to unfold. The dancer's movements have been made simultaneous, but within itself each movement obeys its natural law.

Naturally the way Zadkine actually worked was not as cerebral as I have made it seem; nor is the impact of the sculpture half as involved. It is a popular work, accepted by the citizens of Rotterdam, because its dialectic is a very human one. Unlike most memorials, it is neither gruesome nor patronizing. It does not try to turn defeat into victory, nor does it hide the truth by invoking Honour. It shows that different people can use the words defeat and victory to describe the same thing, whilst the reality which is actually suffered is something continuously developing and changing out of that apparent contradiction. And it shows this in terms of pain and effort. It stands on the edge of the land. And it is as if this figure has crossed the world and come through history to stand on the most advanced point to meet those who will soon arrive.

1959

Fernand Léger

Our productive, scientific abilities have outstripped our ethical and social conscience. That is a platitude and no more than a half truth, but it is nevertheless a way of summing up at least an aspect of the crisis of our time. Nearly all contemporary artists who have faced up to this crisis at all have concentrated on the ensuing conflict of conscience. Léger was unique because he seized upon our technical achievements and by concentrating upon their real nature was led on to discover the spirit, the ethics, the attitude of mind, necessary to control and exploit them to our full advantage. It is because of this – because Léger put the facts of our environment first and through them arrived at his attitude to life – that one can claim that he was so boldly a materialist.

As an artist Léger is often accused of being crude, vulgar, impersonal. He is none of these things. It is his buoyant confidence that makes him seem crude to the diffident. It is his admiration of industrial techniques and therefore of the industrial worker that makes him seem vulgar to the privileged; and his belief in human solidarity that makes him seem impersonal to the isolated. His works themselves refute the charge. Look at them. I always feel absurdly pretentious when trying to write about Léger. His works so clearly affirm themselves. In front of a painting by Picasso or Bonnard, one senses such an urgency of conflict that it seems quite appropriate to discuss and debate and plead for all the issues involved. But in front of a Léger one thinks: There it is. Take it or leave it. Or rather, take it when you want it, and leave it when you don't. Scribble moustaches on his girls if you like. Buy a postcard of it and send it home along with a vulgar one. Lean against it, and prompted by the bicycle in it, discuss where you're going next Sunday. Let the dumb-bells in another remind you that you've stopped doing your early morning exercises. Or stand entranced and reflect afterwards that he has probably learned more from Michelangelo than from any other artist. It doesn't

matter. Look at his bicycles, and his girls in their sports clothes, and his holiday straw hats, and his cows with their comic camouflage dapples, and his steeplejacks and acrobats each knowing what the other takes, and his trees like the sprigs you put into a jam jar, and his machinery as gay as the youth who plans to paint his motor-bike, and his nudes as familiar as wives – what other modern painter doesn't paint a nude as though she were either a piece of studio furniture or a surreptitious mistress? – and his compasses and keys painted as if they were emblems on flags to celebrate their usefulness – does his work seem mechanical and cold?

Léger's greatest works are those which he painted since the war and those in which, dealing with the human figure, he expressed directly the profound humanism of his materialist philosophy. Among these are the studies for his famous large painting of builders working together on scaffolding, and the monumental heads with their striped flags of bright colours superimposed over their contours.

These heads with their strips of bright orange, red and blue, represent the culmination of Léger's art. Léger began with the machine. His cubist pictures were untheoretical. In them he simply used the cube and the cylinder to recreate the energy of machine blocks and pistons. Then he discovered the machine-made object. Unlike most artists, but like the average man of our century, he was not interested in its associations but in how it was made. From this period in his painting he learned how to manage solids – how to manufacture them, how to preserve a surface with paint, how to dazzle with contrasts, how to assemble mass-produced signs with colour. Later, interested by how colour changed the appearance of shapes and vice versa, he began designing abstract murals. Yet, unlike so many others, he always realized that abstract painting meant nothing if separated from architecture. 'It is our duty,' he said, 'to spread light and colour' – and he meant into the mean, grimed city apartments. From this phase he learned to see beyond the single static object: he learned to connect. And with this formal development came a human one. He saw that the machine had made labour collective, that its discipline had created a new class, that it could offer freedom. He suddenly saw machines as tools in the hands of men, no longer as mere objects in themselves. From that moment everything he painted ceased to be a celebration of the mechanical industrial world as it is, and became a celebration of the richer human world to which industrialization would eventually lead. He painted Adam and Eve and made them a French worker and his girl granted Leisure. He painted bicycles as a symbol of the machine available to the working class which could convey them to where they wished. And he painted his monumental heads with their waving flags of colour.

Léger was not one to parade his sensibility as though it were his only virtue. The bright dynamic colours reflect what he learned from the machine. The unblinking confidence of the heads, expressed in their

faces themselves and in the steady unchanging contours which define them, reflect what he learned from those who work machines. The two then combine. These paintings incorporate all the formal discoveries of modern art and yet are classic, suggest order and yet are full of gaiety. The strips of colour run across many different forms yet are so finely modified and placed that they give to each a solidity and definition which is nothing short of miraculous. I have called these works flags. They are emblems for something permanent and are as full of movement as pennants in the wind.

In fact Léger was the only modern European artist to have created an heroic style. Many factors prove this; that his work has a dignity and a sense of scale which in no way relies upon his literal subject; that on one hand it is as formal and architectural as a Corbusier building, and on the other is as simple in meaning as a ballad; that the nudity of his figures is less private than any painted since Michelangelo. He makes his figures nude to emphasize what they have in common. He calls one picture *Les Trois Soeurs*. The heroic artist cannot by definition be interested in idiosyncrasies.

Léger rejected every implication of 'Glamour'. 'Glamour', as it has now come to be understood, stands for everything that separates one person from another, whether it is their 'special' understanding of art or the colour of their lipstick; Léger was only concerned with what we have in common. The current vision of the genius is almost synonymous with that of the mysterious, misunderstood outcast; Léger's vision of the genius was of a man with an imagination so in tune with his time and therefore so easily understandable, that he could become almost anonymous – his works as easy and yet sharp to the eye as popular proverbs to the ear.

He stands beside Picasso. Picasso is the painter of today; his greatness rests on the vitality with which he expresses our present conflicts. Léger is the painter of the future. And by that I do not simply mean that his future as an artist is assured, but that he assures his audience, if they have the courage to accept it, of their future. Yet at the same time Léger was not Utopian. He recognized human vulnerability and allowed for it by the tenderness of gesture and mood of his figures. In a Utopia there might be gaiety and co-operation and happiness but there would be no need for tenderness, for tenderness is the result of understanding human weakness. His *Constructeurs* do not only build together: they also protect one another – as, in practice, men working on high scaffolding must. His portrait of Eluard shows all the doubting that a lyrical poet must undergo. In one of his last canvases, called *Maternité*, the typical bands of bright colour set the drawing flying, as gay as a tricolour, but the daughter's hand touches her mother's cheek with the necessary reassurance that children can give. Such tenderness is not innocent.

1954

30

Pablo Picasso

Because Picasso holds the position he does, every misinterpretation of his work can only increase contemporary misunderstanding of art in general. That is the justification for adding a few more hundred to the millions of words through whose mesh he himself always escapes.

Above all Picasso suffers from being taken too seriously. He recognizes this himself and it is one of the ironical themes of some of his drawings. The indignant take him too seriously because they attach too much importance to the mad prices his works fetch and so assume that he – instead of his hangers-on – is a racketeer. The ostentatiously tolerant take him too seriously because they forgive him his excesses on the ground that, when he wants to be, he is a great draughtsman. In fact this is untrue. His best drawings if compared to those of Géricault, Daumier or Goya appear brilliant but not profound. Picasso's future reputation as a great artist would not, as is so often said, be guaranteed by his realistic works alone. The enthusiastic take him too seriously because they believe that every mark he has made, the date on which he made it and the address he happened to be living at, are of sacred significance. The critical minority in the Communist Party take him too seriously because they consider him capable of being a great socialist artist and assume that his political allegiance is the result of dialectical thinking rather than of a revolutionary instinct.

In front of Picasso's work one pays tribute above all to his personal spirit. The old argument about his political opinions on one hand and his art on the other is quite false. As Picasso himself admits, he has, as an artist, discovered nothing. What makes him great are not his individual works, but his existence, his personality. That may sound obscure and perverse, but less so, I think, if one inquires further into the nature of his personality.

Picasso is essentially an improviser. And if the word improvisation

conjures up, amongst other things, associations of the clown and the mimic – they also apply. Living through a period of colossal confusion in which so many values both human and cultural have disintegrated, Picasso has seized upon the bits, the fragments, the smithereens, and with magnificent defiance and vitality made something of them to amuse us, shock us, but primarily to demonstrate to us by the example of his spirit that within the confusion, out of the debris, new ideas, new values, new ways of looking at the world can and will develop. His achievement is not that he himself has developed these things, but that he has always been irrepressible, has never been at a loss. The romanticism of Toulouse-Lautrec, the classicism of Ingres, the crude energy of Negro sculpture, the heart-searchings of Cézanne towards the truth about structure, the exposures of Freud – all these he has recognized, welcomed, pushed to bizarre conclusions, improvised on, sung through, in order to make us recognize our contemporary environment, in order (and here his role is very much like that of a clown) to make us recognize ourselves in the parody of a distorting mirror.

Obviously, this shorthand view of Picasso oversimplifies, but it does, I think, go some way to explaining other facts about him: the element of caricature in all his work; the extraordinary confidence behind every mark he makes – it is the confidence of the born performer; the failure of all his disciples – if he were a profoundly constructive artist this would not be so; the amazing multiplicity of his styles; the sense that, by comparison with any other great artist, any single work by Picasso seems unfinished; the truth behind many of his enigmatic statements: 'In my opinion, to search means nothing in painting. To find is the thing.' 'To me there is no past or future in art. If a work of art cannot live always in the present it must not be considered at all.' Or, 'When I have found something to express, I have done it without thinking of the past or the future.'

The tragedy of Picasso is that he has worked at a time when a few live by art alone and the vast majority live without art at all. Such a state of affairs is of course tragic for all artists – but not to the same extent. Certain painters – such as Cézanne, Degas, Gris – can work for the sake of research. They work to extend painting's conquest over nature. Picasso is not such an artist; it is significant, for instance, that for over forty years he has scarcely ever worked directly from a model. Other painters – such as Corot, Dufy, Matisse – work to communicate a quintessence of pleasure and are comparatively satisfied if this pleasure is shared even by a few. Again, Picasso is not such an artist. There is a violence in everything he has done which points to a moral, didactic conviction that cannot be satisfied simply by an awareness of pleasure. Picasso is, as Rodin was in a different way, naturally a popular dramatic artist, terribly handicapped by a lack of constant popular themes.

What makes a work by Picasso immediately recognizable? It is not only his familiar formalizations but his unique form of conviction, of utter singlemindedness in any one canvas. Possibly that sounds a vague quality. Yet if one goes into a Romanesque church and sees side by side a twelfth- and an eighteenth-century fresco, it is this quality of singlemindedness which distinguishes them, when all the other obvious differences have been allowed for. The twelfth-century painter, if a local one, was usually clumsy, unoriginal and entirely ignorant of theoretical pictorial princi- ples. The eighteenth-century painter was often sensitive, highly skilful in rendering an unlimited variety of poses and steeped in valid pictorial theory. What then explains the force of the twelfth-century artist's composition, the expressiveness of his drawing, the clarity of his narra- tive, and the comparative feebleness in all these respects of the later work? It is surely the earlier artist's singlemindedness – a singleminded- ness which in terms of religion was impossible in the eighteenth century. Because the earlier artist knew exactly what he wanted to say – and it was something quite simple – it did not occur to him to think of anything else. This reduced observation to a minimum but it gave his work the strength of seeming absolutely inevitable. It is precisely the same quality which distinguishes Picasso's work from that of his contemporaries and disciples; or, on a quite different level, it is the same quality that one finds in the humorous drawings of Edward Lear.

Look at the drawing of the hands and feet in *Guernica*. They are based on no more penetrating observation than those in the work of an efficient cartoonist. They represent no more than the *idea* of hands and feet. But – and this is why *Guernica* can still strike our hearts until we are forced to make resolutions – the ideas of hands, feet, a horse's head, a naked electric light bulb, a mother and ravaged child, are all equally, heartrendingly and entirely dominated by the *idea* of the painting: the idea of horror at human brutality.

I believe that in almost every work of Picasso's a single idea has dominated in this way and so created a similar sense of inevitability. If the idea is, for example, that of sexual beauty, it demands more subtle forms: the girl's back will be made to twist very sensitively: but the principle remains the same and rests on the same ability of the artist to forgo all questioning and to yield completely to his one purpose. Forms become like letters in an alphabet whose significance solely depends upon the word they spell. And that brings us back to the tragedy of Picasso. Obviously in the case of an artist such as I have described, his development within himself and his impact on others depend exclusively on his ideas, on his themes. Picasso could not have painted *Guernica* had it only been a personal nightmare. And equally, if the picture which now exists had always been called *Nightmare* and we knew nothing of its connection with Spain, it would not move us as it does. All aesthetes will

object to that. But *Guernica* has deservedly become the one legendary painting of this century, and although works of art can perpetuate legends, they do not create them. If they could Picasso's problem would have been solved, for his tragedy is that most of his life he has failed to find themes to do himself justice. He has produced *Guernica, War* and *Peace*, some miraculous Cubist studies, some beautiful lyrical drawings, but in hundreds of works he has, as a result of his singlemindedness, sacrificed everything to ideas which are not worthy of the sacrifice. Many of his paintings are jokes, either bitter or gay; but they are the jokes of a man who does not know what else to do except laugh, who improvises with fragments because he can find nothing else to build upon.

It would be foolish to imagine that Picasso could have developed differently. His genius is wilful and instinctive. He had to take what was at hand and the unity of popular feeling essential to sustain the themes of a dramatic artist such as he is, has often been lacking or beyond his horizon. He then faced the choice of either abandoning his energy or expending it on something trivial and so creating parodies.

I am sure he is aware of this. He is obsessed by the question of whether art, which as we understand it today is so conscious an affair, can ever be born of happiness and abundance instead of lack and loss. The immortal incomplete artist beside the mortal complete man – this is one of his recurring themes. The sculptor chisels instead of enjoying his model. The poet-lovers search for images in one another's eyes instead of each other. A woman's head is drawn in a dozen different ways, is almost endlessly improvised upon, because no single representation can do her living justice. And then at other times, and particularly in the second half of his life, Picasso reverses his comment and comparison, and contrasts the artist's always new, fresh imagination with his ageing body. The old man and the young girl, Beauty and the Beast, Beauty and the Minotaur: the theme of the self-same artist and man being unable to accept each other's roles.

Yet finally why is it so impossible to end without saluting him? Because by his dedication to his great themes, by his constant extremism, by the audacity of his jokes, by his simplicity (which is usually taken for incomprehensibility), by his very method of working, he has proved that all the paraphernalia, all the formulae of art are expendable for the sake of the spirit. If we now take him too seriously we destroy his example by re-establishing all the paraphernalia he has liberated us from.

1954/1955

Henri Matisse

Matisse's greatness has been recognized but not altogether understood. In an ideological climate of anguish and nostalgia an artist who frankly and supremely celebrated Pleasure, and whose works are an assurance that the best things in life are immediate and free, is likely to be thought not quite serious enough. And indeed, in Matisse's obituaries the word 'charming' appeared too frequently. 'I want people who feel worried, exhausted, overworked, to get a feeling of repose when looking at my painting.' That was Matisse's intention. And now, looking back over his long life's work, one can see that it represents a steady development towards his declared aim, his works of the last fifteen or twenty years coming nearest to his ideal.

Matisse's achievement rests on his use – or in the context of contemporary Western art one could say his invention – of pure colour. The phrase, however, must be defined. Pure colour as Matisse understood it had nothing to do with abstract colour. He repeatedly declared that colour 'must serve expression'. What he wanted to express was 'the nearly religious feeling' he had towards sensuous life – towards the blessings of sunlight, flowers, women, fruit, sleep.

When colour is incorporated into a regular pattern – as in a Persian rug – it is a subsidiary element: the logic of the pattern must come first. When colour is used in painting it usually serves either as a decorative embellishment of the forms – as, say, in Botticelli – or as a force charging them with extra emotion – as in Van Gogh. In Matisse's later works colour becomes the entirely dominant factor. His colours seem neither to embellish nor charge the forms, but to uplift and carry them on the very surface of the canvas. His reds, blacks, golds, ceruleans, flow over the canvas with the strength and yet utter placidity of water above a weir, the forms carried along on their current.

Obviously such a process implies some distortion. But the distortion is

far more of people's preconceived ideas about art than of nature. The numerous drawings that Matisse always made before he arrived at his final colour-solution are evidence of the pains he took to preserve the essential character of his subject whilst at the same time making it 'buoyant' enough to sail on the tide of his colour scheme. Certainly the effect of these paintings is what he hoped. Their subjects invite, one embarks, and then the flow of their colour-areas holds one in such sure equilibrium that one has a sense of perpetual motion – a sense of movement with all friction removed.

Nobody who has not painted himself can fully appreciate what lies behind Matisse's mastery of colour. It is comparatively easy to achieve a certain unity in a picture either by allowing one colour to dominate or by muting all the colours. Matisse did neither. He clashed his colours together like cymbals and the effect was like a lullaby.

Perhaps the best way of defining Matisse's genius is to compare him with some of his contemporaries who were also concerned with colour. Bonnard's colours dissolve, making his subjects unattainable, nostalgic. Matisse's colours could hardly be more present, more blatant, and yet achieve a peace which is without a trace of nostalgia. Braque has cultivated his sensibility until it has become precious. Matisse broadened his sensibility until it was as wide as his colour range, and said that he wanted his art to be 'something like a good armchair'. Dufy shared Matisse's sense of enjoyment and his colours were as gay as the fêtes he painted; but Matisse's colours, no less bright, go beyond gaiety to affirm contentment. The only man who possibly equals Matisse as a colourist is Léger. But their aims are so different that they can hardly be compared. Léger is essentially an epic, civic artist; Matisse essentially a lyrical and personal one.

I said that Matisse's paintings and designs of the last fifteen years were his greatest. Obviously he produced fine individual works before he was seventy. Yet not I think till then had he the complete control of his art that he needed. It was, as he himself said, a question of 'organizing the brain'. Like most colourists he was an intuitive painter, but he realized that it was necessary to select rigorously from his many 'instincts' to make them objective in order to be able to build upon them rationally. In terms of the picture this control makes the all-important difference between recording a sensation and re-constructing an emotion. The Fauves, whom Matisse led, recorded sensations. Their paintings were (and are) fresh and stimulating, but they depended upon and evoke a forced intoxication. When Matisse painted red flashes against ultramarine and magenta stripes to describe the movement of goldfish in a bowl, he communicated a pleasurable shock; one is brought up short by the climax but no solution follows. It was for this reason, I think, that Matisse finally abandoned Fauvism and returned to a more disciplined form of

painting. Between 1914 and 1918 he produced paintings – mostly interiors – which are magnificently resonant in colour, but in which the colours seem *assembled* rather than dynamic – like the furnishings in a room. Then for the next ten years he painted his famous Odalisques. In these the colour is freer and more pervasive, but, being based on a heightening of the actual local colour of each object, it has a slightly exotic effect. This period, however, led him to his final great phase: the phase in which he was able to combine the energy of his early Fauve days with a quite objective visual wisdom.

It is of course true that Matisse's standards of imagination and taste belonged to the world of the French *haute bourgeoisie.* No other class in the modern world enjoyed the kind of seclusion, fine taste and luxury that are expressed in Matisse's work. It was Matisse's narrowness (I can think of no modern artist with less interest in either history or psychology) that saved him from the negative and destructive attitudes of the class-life to which his art belonged. It was his narrowness that allowed him to enjoy this milieu without being corrupted by it, or becoming critical of it. He retained throughout his whole career something of Veronese's naive sense of wonder that life could be so rich and luxurious. He thought and saw only in terms of silks, fabulous furnishings, the shuttered sunlight of the Côte d'Azur, women with nothing to do but lie on grass or rug for the delight of men's calm eyes, flower-beds, private aquaria, jewellery, couturiers and perfect fruit, as though such joys and achievements, unspoilt by mention of the price, were still the desire, the ambition of the entire world. But from such a vision he distilled experiences of sensuous pleasure, which, disassociated from their circumstances, have something of the universal about them.

1954

Oskar Kokoschka

Kokoschka's genius is difficult to define. On the one hand, it is sensible to compare him with Rubens – not necessarily in stature, but temperamentally, because he has the same kind of scale as a painter. Like Rubens, he has painted panoramic landscapes which the light visits like an archangel at an Annunciation. Like Rubens, he glories in exotic animals and fruits, seeing them as symbols of various kinds of human power. Like Rubens, he paints human flesh as though it were a garden and each brushmark a blossom. And, like Rubens too, he is immensely confident, never failing through diffidence, but sometimes through abundance becoming chaos. Yet on the other hand, Kokoschka is a man of the twentieth century. He has not created a new language or a new form of art. What he has done is to speak with great authority in an unforgettable tone of voice – always remembering that for an artist his tone of voice is inseparable from what he has to say:

> All life is a risk, but that is no reason for panic. In the normal course of things it ends in death; only in the Académie Française are immortals to be found. But to anyone who is clear about the risks of life and learns to confront them with open eyes, the inscrutable, humanized in art form, becomes comprehensible and thus loses its terror.

Kokoschka is usually labelled an Expressionist. This is misleading, because since he is often considered as a German painter, it means that he is bracketed with other German expressionists, whereas his aim, unlike theirs, was to reduce, not to parade, panic. It is also usually said that his early work is stronger than his later work, but this judgment springs from the same misconception: that he is essentially an artist of conflict and pain. In fact, his constant theme is something quite different – energy. In his earlier works, up to about 1920, he was concerned,

mostly in portraits, with what is roughly called nervous energy. The spirits of his sitters crackle like lightning, and their hands, with their out-stretched fingers, often look like trees that have just been struck. Later he was concerned, in his large panoramic views, with the energy of cities – with what might be called historical energy. Still later he turned to ancient legends to find themes which embodied the energy of the cycle of life itself.

But of course the word energy is too vague and too abstract to define the character of Kokoschka's achievement and searching. It makes it easy to understand why he has turned to baroque artists for help, but it does not explain why his voice has such authority, why he is so surely a modern artist.

Energy means for him movement and development. In his portraits one has the sense that the sitter has been painted, unawares, whilst on a journey, not necessarily a physical journey, but a journey of thoughts and decisions, which is going to change – which indeed at that very moment is changing – his life. In our century of crisis these are, in this sense, the most precarious portraits painted, and in that precariousness we recog-nize ourselves. How often in his panoramic landscapes he includes a river or, as an important not an incidental element in the picture, birds in the sky; and these again suggest voyaging, movement, time passing. In his recent large triptychs his concern with development, with conse-quences, is even more obvious, for here he has painted consecutive incidents from a story – the story of Prometheus or the story of the Greeks defending Thermopylae.

Kokoschka did not of course arbitrarily select this constant theme. It has arisen from his experience. As a mid-European born in 1886, he has seen much. And he has never been a passive spectator or a remote studio man. He has prophesied and committed himself. He is acutely aware of the way our European societies alienate man from man (and incidentally believes abstract art to be a symptom of this alienation):

> That technical civilization, in which we have all collaborated, has been throughout two world wars nothing but an attempt to escape disaster by means of an intensified production for the mere sake of produc-tion, and the effort is shown to be all the more senseless as the numbers of the homeless, the desperate and the starving roaming over the untilled fields of the world increase.

Consequently he has searched for a way forward, a way of release. The emotion behind most of his work is liberating. The figures, the animals, the cities in his canvases are set free: the skies around them are like those endlessly imagined by a prisoner. His richness and abundance is not luxurious as in true baroque art, rather it represents a kind of innocence.

Not that he is a Utopian artist. His aim is simply to make us see what we are capable of, to warn us against accepting the idea that all circumstances are final.

His weakness as a painter is that he is sometimes formlessly effusive. This may be the result of the fact that he blames technology itself for our predicament, so that his positive alternative becomes an unselective all-embracing humanism. If he were more aware of the economic and social basis of history, his hopes might be sharper and less generalized. Nevertheless we can only honour. He has confronted our situation with open eyes and has never retreated into cynicism, nihilism or morbid subjectivity: his genius has remained expectant. Having borne witness to great suffering, he still, at the age of over seventy, believes with Blake that 'Exuberance is Beauty'.

1952

The Clarity of the Renaissance

It's depressing. The rain's set in. It's wet but we can't grumble. It's grey and dull. Each of these comments describes the same day from a different point of view: the subjective, the practical, the moralistic and the visual. All true painters naturally see and feel in a way that is a hundred times more acutely visual and tangible than the last, or indeed any comment, can illustrate. But what they see and feel is – normally – the same as everybody else. To say this is, I realize, platitudinous. But how often it is forgotten. Indeed, has it ever been consistently taken for granted since the sixteenth century?

I spent the other day in the National Gallery looking mainly at the Flemish and Italian Renaissance works. What is it that makes these so fundamentally different from nearly all the works – and especially our own – that have followed them? The question may seem naive. Social and stylistic historians, economists, chemists and psychologists have spent their lives defining and explaining this and many other differences between individual artists, periods and whole cultures. Such research is invaluable. But its complexity often hides from us two simple, very obvious facts. The first is that it is our own culture, not foreign ones, which can teach us the keenest lessons: the culture of individualist humanism which began in Italy in the thirteenth century. And the second fact is that, at least in painting, a fundamental break occurred in this culture two and a half centuries after it began. After the sixteenth century artists were more psychologically profound (Rembrandt), more successfully ambitious (Rubens), more evocative (Claude); but they also lost an ease and a visual directness which precluded all pretension; they lost what Berenson has called 'tactile values'. After 1600 the great artists, pushed by lonely compulsion, stretch and extend the range of painting, break down its frontiers. Watteau breaks out towards music, Goya towards the stage, Picasso towards pantomime. A few, such as Chardin,

Corot, Cézanne, did accept the strictest limitations. But before 1550 every artist did. One of the most important results of this difference is that in the great later forays only genius could triumph: before, even a small talent could give profound pleasure.

I am not advocating a new Pre-Raphaelite movement, nor am I making any qualitative judgment – in the broadest human sense – of the art of the last three and a half centuries. But now when so many artists tend – either in terms of technique or subjective experience – to throw themselves vainly against the frontiers of painting in the hope that they will be able to cut their own unique individual passes, now when the legitimate territory of painting is hardly definable, I think it is useful to observe the limitations within which some of the greatest painters of our culture were content to remain.

When one goes into the Renaissance galleries, it is as if one suddenly realized that in all the others one had been suffering from a blurred short-sightedness. And this is not because many of the paintings have been finely cleaned, nor because chiaroscuro was a later convention. It is because every Flemish and Italian Renaissance artist believed that it was his subject itself – not his way of painting it – which had to express the emotions and ideas he intended. This distinction may seem slight but it is critical. Even a highly mannered artist like Tura convinces us that every woman he painted as a madonna actually had doubly sensitive, double-jointed fingers. But a Goya portrait convinces us of Goya's own insight before it convinces us of his sitter's anatomy; because we recognize that Goya's interpretation is convincing, we are convinced by his subject. In front of Renaissance works the exact opposite occurs. After Michelangelo the artist lets us follow him; before, he leads us to the image he has made. It is this difference – the difference between the picture being a starting-off point and a destination – that explains the clarity, the visual definitiveness, the tactile values of Renaissance art. The Renaissance painter limited himself to an exclusive concern with what the spectator could see, as opposed to what he might infer. Compare Titian's *presented* Venus of Urbino of 1538 with his elusive Shepherd and Nymph of thirty years later.

This attitude had several important results. It forbade any attempt at literal naturalism because the only appeal of naturalism is the inference that it's 'just life like': it obviously isn't, in fact, like life because the picture is only a static image. It prevented all merely subjective suggestibility. It forced the artist, as far as his knowledge allowed him, to deal simultaneously with all the visual aspects of his subject – colour, light, mass, line, movement, structure, and not, as has increasingly happened since, to concentrate only on one aspect and to infer the others. It allowed him to combine more richly than any later artists have done realism and decoration, observation and formalization. The idea that

they are incompatible is only based on today's assumption that their inferences are incompatible; visually an embroidered surface or drapery, *invented* as the most beautiful mobile architecture ever, can combine with realistic anatomical analysis as naturally as the courtly and physical combine in Shakespeare.

But, above all, the Renaissance artist's attitude made him use to its maximum the most expressive visual form in the world – the human body. Later the nude became an idea – Arcadia or Bohemia. But during the Renaissance every eyelid, breast, wrist, baby's foot, nostril, was a double celebration of fact: the fact of the miraculous structure of the human body and the fact that only through the senses of this body can we apprehend the rest of the visible, tangible world.

This lack of ambiguity is the Renaissance, and its superb combination of sensuousness and nobility stemmed from a confidence which cannot be artificially re-created. But when we eventually achieve a confident society again, its art may well have more to do with the Renaissance than with any of the moral or political artistic theories of the nineteenth century. Meanwhile, it is a salutary reminder for us even today that, as Berenson has said so often and so wisely, the vitality of European art lies in its 'tactile values and movement' which are the result of the observation of the 'corporeal significance of objects'.

1955

The Calculations of Piero

After reading Brecht's *Galileo* I was thinking about the scientist's social predicament. And it struck me then how different the artist's predicament is. The scientist can either reveal or hide the facts which, supporting his new hypothesis, take him nearer to the truth. If he has to fight, he can fight with his back to the evidence. But for the artist the truth is variable. He deals only with the particular version, the particular way of looking that he has selected. The artist has nothing to put his back against – except his own decisions.

It is this arbitrary and personal element in art which makes it so difficult for us to be certain that we are accurately following the artist's own calculations or fully understanding the sequence of his reasoning. Before most works of art, as with trees, we can see and assess only a section of the whole: the roots are invisible. Today this mysterious element is exploited and abused. Many contemporary works are almost entirely subterranean. And so it is refreshing and encouraging to look at the work of the man who probably hid less than any other artist ever: Piero della Francesca.

Berenson praises 'the ineloquence' of Piero's paintings:

> In the long run, the most satisfactory creations are those which, like Piero's and Cézanne's, remain ineloquent, mute, with no urgent communication to make, and no thought of rousing us with look or gesture.

This ineloquence is true so far as Piero's protagonists are concerned. But in inverse ratio to how little his paintings say in terms of drama, they say volumes about the working of his own mind. I don't mean they reveal his psychology. They reveal the processes of his conscious thought. They are open lessons in the logic of creating order. And possibly the inverse ratio

exists because, just as the aim of the machine is economy of effort, the aim of systematic thought is economy of thought. Anyway it remains true that before a Piero you can be quite sure that any correspondence or coincidence which you discover is deliberate. Everything has been calculated. Interpretations have changed, and will change again. But the elements of the painting have been fixed for good and with comprehensive forethought.

If you study all Piero's major works, their internal evidence will lead you to this conclusion. But there is also external evidence. We know that Piero worked exceptionally slowly. We know he was a mathematician as well as a painter, and that at the end of his life, when he was too blind to paint, he published two mathematical treatises. We can also compare his works to those of his assistants: the works of the latter are equally undemonstrative, but this, instead of making them portentous, makes them lifeless. Life in Piero's art is born of his unique power of calculation.

This may at first sound coldly cerebral. However, let us look further – at the *Resurrection* in Piero's home town of San Sepolcro. When the door of the small, rather scruffy municipal hall is first opened and you see this fresco between two fictitious, painted pillars, opening out in front of you, your instinct is somehow to freeze. Your hush has nothing to do with any ostentatious reverence before art or Christ. It is because looking between the pillars you become aware of time and space being locked in a perfect equilibrium. You stay still for the same reason as you do when you are watching a tight-rope walker – the equilibrium is that fine. Yet how? Why? Would a diagram of the structure of a crystal affect you in the same way? No. There is more here than abstract harmony. The images convincingly represent men, trees, hills, helmets, stones. And one knows that such things grow, develop and have a life of their own, just as one knows that the acrobat can fall. Consequently, when here their forms are made to exist in perfect correspondence, you can only feel that all that has previously occurred to them has occurred in preparation for this presented moment. Such a painting makes the present the apex of the whole past. Just as the very basic theme of poetry is that of time passing, the very basic theme of painting is that of the moment made permanent.

This is one of the reasons why Piero's calculations were not so cold, why – when we notice how the left soldier's helmet echoes the hill behind him, how the same irregular shield-shape occurs about ten times throughout the painting (count them), or how Christ's staff marks in ground plan the point of the angle formed by the two lines of trees – why we are not merely fascinated but profoundly moved. Yet it is not the only reason. Piero's patient and silent calculations went much further than the pure harmonies of design.

Look, for instance, at the overall composition of this work. Its centre, though not of course its true centre, is Christ's hand, holding his robe as he rises up. The hand furrows the material with emphatic force. This is no casual gesture. It appears to be central to Christ's whole upward movement out of the tomb. The hand, resting on the knee, also rests on the brow of the first line of hills behind, and the folds of the robe flow down like streams. Downwards. Look now at the soldiers so mundanely, so convincingly asleep. Only the one on the extreme right appears somewhat awkward. His legs, his arm between them, his curved back are understandable. Yet how can he rest like that just on one arm? This apparent awkwardness gives a clue. He looks as though he were lying in an invisible hammock. Strung from where? Suddenly go back to the hand, and now see that all four soldiers lie in an invisible net, trawled by that hand. The emphatic grip makes perfect sense. The four heavy sleeping soldiers are the catch the resurrecting Christ has brought with him from the underworld, from Death. As I said, Piero went far beyond the pure harmonies of design.

There is in all his work an aim behind his calculations. This aim could be summed up in the same way as Henri Poincaré once described the aim of mathematics:

> Mathematics is the art of giving the same name to different things. . . .
> When language has been well chosen one is astonished to find that all
> demonstrations made for a known object apply immediately to many
> new objects.

Piero's language is visual, not mathematical. It is well chosen because it is based on the selection of superb drawing. Nevertheless, when he connects, by means of composition, a foot with the base of a tree, a foreshortened face with a foreshortened hill, or sleep with death, he does so in order to emphasize their common factors – or, more accurately still, to emphasize the extent to which they are subject to the same physical laws. His special concern with space and perspective is dependent on this aim. The necessity of existing in space is the first common factor. And this is why perspective had so deep a *content* for Piero. For nearly all his contemporaries it remained a technique of painting.

His 'ineloquence', as already hinted, is also connected with the same aim. He paints everything in the same way so that the common laws which govern them may be more easily seen. The correspondences in Piero's works are endless. He did not have to invent them, he only had to find them. Cloth to flesh, hair to foliage, a finger to a leg, a tent to a womb, men to women, dress to architecture, folds to water – but somehow the list misses the point. Piero is not dealing in metaphors

– although the poet in this respect is not so far removed from the scientist: he is dealing in common causes. He explains the world. All the past has led to this moment. And the laws of this convergence are the true content of his art.

Or so it seems. But in fact how could this be possible? A painting is not a treatise. The logic of its measuring is different. Science in the second half of the fifteenth century lacked many concepts and much information which we now find necessary. So how is it that Piero remained convincing, whilst his contemporary astronomers have not?

Look again at Piero's faces, the ones that watch us. Nothing corresponds to their eyes. Their eyes are separate and unique. It is as though everything around them, the landscape, their own faces, the nose between them, the hair above them, belonged to the explicable, indeed the already explained world: and as though these eyes were looking from the outside through two slits on to this world. And there is our last clue – in the unwavering, speculative eyes of Piero's watchers. What in fact he is painting is a state of mind. He paints what the world would be like if we could fully explain it, if we could be entirely at one with it. He is the supreme painter of *knowledge*. As acquired through the methods of science, or – and this makes more sense than seems likely – as acquired through happiness. During the centuries when science was considered the antithesis of art, and art the antithesis of well-being, Piero was ignored. Today we need him again.

1959

Poussin's Order

At Dulwich Art Gallery there are six Poussin canvases, and I recommend the reader to go there and study them under ideal conditions – it is quiet, the rooms are small and well-lit and one can think without being disturbed. And strange as it may seem, here – not in the endless volumes put out by the Museums of Modern Art – is the clue to all the best works created since Cézanne.

Take a picture like the *Nurture of Jupiter*. Are we still interested in a child god being suckled by a goat, in bees that made special honey for him and in Cretan nymphs? Hardly. Was even Poussin as interested as is often thought? A nymph, the Virgin Mary, a spectator of David's triumph over Goliath – each has the same face. So why are we moved? By the purely formal design? If that were so, we would be moved in the same way by, say, a Byzantine mosaic. Clearly we are not. No. In fact, it is here that we come to the first discovery: that in Poussin – and actually, though less obviously, in all art which survives its period – there is something between form and content arbitrarily divided: there is the way of looking at the world, the artist's method of selection, which the work in its entirety expresses and which is more profound than either its subject matter or its formal organization.

Poussin offers us the world as an impossibly honest trader. Everything on show is declared and defined without the slightest ambiguity. One can see on what every foot stands, what every finger touches. Compare his large tree with the trees in Claude next door. Claude's are far truer to the confusion of appearances as they normally strike us. In the Poussin the leaves are as defined as those of a book. Yet this clarity is not a question of fussy accuracy. On the contrary Poussin painted broadly and simply – the surface of his painted flesh like that of water running shallowly and imperceptibly over a perfectly smooth pebble. His clarity is the result of order. Nothing in his figure paintings (his late landscapes are different)

has been snatched from chaos or temporarily rescued from mystery. The wind blows in the right direction to furl the striding nymph's golden dress so that it becomes a precise extension and variation on her own movement. The reeds break, and point like arrows to the focal centre of the scene. The sitting nymph's foot forms a perfect ten-toed fan with the foot of the child.

Yet why, then, is the picture not completely artificial? For two reasons. First, because Poussin's intensely sensuous vision of the human body forced him – as true sensuousness, as opposed to vicarious eroticism, must always do – to recognize the nature of physical human energy. His figures move with the same inevitability as water finds its own level, and consequently they transcend their rhetorical gestures. A man, after all, lifts his arm to stop a bus in the same way as he might wave to greet the spirit of a poet on Parnassus. And in this painting the kneeling foster-father could be wringing out a wet towel just as well as holding the head of the goat between his legs. Secondly, because the scene, given its arrangement, is still *visually* true. For example, the deep velvet blue of the sitting nymph's robe, the pale aquamarine dress of the nymph on the rocks and then the sudden porcelain blue of the sky behind the hills – these blues, in a cereal-coloured landscape, clash, welcome, correspond and set up distances between themselves just as blues can do on Boat Race day.

And so we think: this is not another world, nor is it even a stage fantasy. Here the aspect of a shoulder or a breast is like the voice of an actress delivering Racine's words: we have seen and heard them in different situations. This is simply the world ordered beyond any previous imagining.

Which brings us to the crux of the matter and the second discovery. Poussin's sense of order added up to something more than an impeccable sense of composition – as we now use the term. Compare the studio works or the copies at Dulwich with the artist's own works. On the canvas they are sometimes just as well arranged or composed. But only on the canvas. The shapes and colours and lines are ordered. But not the scene itself. In front of a Poussin one feels that he brought order to the slice of life he was painting before he even picked up a brush: that he posed his whole subject, as he might have posed a single model: that his power to organize didn't just derive from the act of painting, but from his whole attitude to life itself. It is by this that we are elated. A Poussin is not simply evidence that a master can control his medium: it is evidence that a man has believed that man can control his fate. We have the same sense of elation in front of Renaissance artists like Piero, Mantegna, and to some extent Raphael, who was Poussin's own star. But because Poussin was working a century later and painting had become very much more complex, Poussin's expression of order was wider in scope. In front of a

Piero we see, as it were, the blueprint of an ordered world; in front of a Poussin we see velvet, metal, flesh and the time of day all far more tangibly under control.

And now how can one explain this historically? I suspect the full explanation will upset a good many apple-carts, for clearly Poussin was simultaneously both a very reactionary and a very revolutionary artist. He was reactionary because for his subjects and for his examples – classical sculpture and the works of the mid-Renaissance – he looked backwards, and also because probably his sense of order derived from, and was sustained by, the absolutism of the France of Louis XIII and XIV. One has only to compare him to his contemporaries, such as Rembrandt, Velázquez or Galileo, to see how far he stood apart from the new subjects, the new problems and the progressive possibilities of his time.

He was a revolutionary artist, not only because his work was supremely rational – and consequently was to inspire the revolutionary classicism of David – but even more profoundly, because his determination to demonstrate the possibility of man controlling his fate and environment made his art the solitary link, in this respect, between the two periods when such a control could generally be believed in: the Renaissance and our own century. Between Poussin and Cézanne there were many works of genius, but none of them suggest an order imposed upon nature before the act of painting. Which is why Cézanne knew he had to go back to Poussin in order to continue from where Poussin had stopped.

Poussin's system of order was static – however much energy his figures may imply. Look at *The Triumph of David*. If, as a result of the implied movement of the triumphal procession, we reckon with new consequences and changed circumstances, the whole unity of the picture falls to bits. What happens when the procession moves on and the head of Goliath no longer coincides with the robes of the spectator behind, and the folds of those robes no longer echo the victorious arm of David? For this reason Poussin could not deal with the constantly moving dynamic forces of nature, as expressed in full, open landscapes; he then had to let in mystery, the unknowable. His struggle, with inadequate means, to avoid doing this is very moving. In *A Roman Road* he tries desperately to keep everything under control: he emphasizes the straight edge of the man-made road, he makes as much as he can of the calculated angles of the church roof, he disposes the small figures in their telling, clear poses, but the evening light making shadow chase shadow, the sun going down behind the hills, the awaited night – these are too much for him. For Poussin there was chaos beyond the town walls, beyond the circle of learning – as there was bound to be until it was realized that human consciousness had as material a basis as nature itself.

And it was from this point that Cézanne continued. Cézanne's incredible struggle was to find some system of order which could

embrace the whole of nature and its constant changes. Against his wishes this struggle forced him to abandon the order of the static viewpoint, to admit that human consciousness was subject to the same dialectical laws as nature. And the Cubists continued from where he stopped, rejecting the Renaissance because they were aiming at the same end with quite different means. Even today the process is incomplete, the solution only partial. But for those who will take the next step forward, Poussin, straddling the two periods in our culture when men sought order in life before they sought it in art, will remain an inspirer.

1959

Watteau as the Painter of His Time

Historical generalizations – and particularly Marxist ones – can danger-
ously over-simplify. Yet unless one takes into account the fact that the
eighteenth century ended with the French Revolution, it is impossible to
understand how Watteau was so incomparably greater than all his
followers.

The eighteenth century in France saw the complete transformation
of power from the aristocracy to the middle class. The struggle and
contradictions behind this transformation were reflected in the art of
the period – but reflected in a highly complicated way. By the begin-
ning of the century, following the death of Louis XIV, the doctrine of
absolute monarchism was dead and with it declined the solemn,
monumental, impersonal classicism of Poussin, Le Brun, Racine. There
followed the transitional rococo art of Watteau, Fragonard, Boucher,
whose public was the aristocracy now freed – fatally – from royal
obligations and restraint, and the affected élite of the rising middle
class. It was a transitional art because it preserved much of the
artificiality of the previous classicism but introduced more movement
(Watteau was greatly influenced by Rubens) and substituted casual
Dalliance and Elegance for imperial Power and Dignity. In reaction to
its hedonism, but continuing its tendency towards movement, charac-
terization and informality, there arose the middle-class art of such
painters as Chardin and Greuze: an art based on the virtues of
domesticity, industry and personal responsibility. Finally under David
there was the return to Classicism as the only sufficiently heroic style for
the revolution itself. But this classicism was very different from that of
the seventeenth century: it was far more concerned psychologically with
the individual and contained much of the realistic observation of the
preceding genre-painters.

Such is the bare outline of development. How did this affect

Watteau? No historical analysis explains genius; it can only help to explain the way genius develops. If one compares Watteau's fêtes-galantes with similar works by Pater, Fragonard or Robert, their greater depth of meaning and observation becomes immediately obvious. The hands of a figure in a Fragonard are merely elegant gestures terminating the movement of an arm; in a Watteau the hands of each figure, however small, have their own energy as they restlessly finger the strings of a guitar or bodice. Faces in the work of the other painters are automatic, like the made-up faces of a chorus; in a Watteau, however silken the dalliance and finery, beady eyes look out from faces expressing all the desperation of an unrealized boredom with pleasure – an echo almost of voices in Chekhov. Watteau's followers painted the stage of 'manners' as seen from the auditorium; he himself painted the performance from the wings whence one can occasionally see a performer querying his role. In his fragment of a *Girl's Head* one is suddenly made to realize the disturbing (or encouraging) fact that no make-up can ever disguise the expression of the eyes. Or compare Watteau's nudes with those of Robert or Boucher. For Boucher nudity was a commercial aphrodisiac; for Watteau it was a moment – evanescent as everything else – of intimacy.

And so one comes to the now accepted view of Watteau's art. 'The content of Watteau's work, if we may dare state it in a word, is mortality – that fatal sense of life's transience about which his every picture whispers but never speaks openly,' as Mr Gordon Washburn has put it. Watteau's own temperament and his suffering from tuberculosis obviously contributed to his vision. But what made his expression of such an attitude to life larger than his personal feelings and bigger than the subjects he represented was that he expressed so surely the reality of his time. He revealed in feeling the true transitional nature of the style he worked in. He remained (and was born) outside the social order he painted, but the ambivalence of the mood of his work was a perfect expression of the nature and destiny of that order. It was to be said later, 'Under Louis XIV no one dared open his mouth, under Louis XV everyone whispered, now everyone speaks out loud and in a perfectly free-and-easy way.' The whispering in Watteau's paintings (which both quotations refer to) is partly a nostalgia for a past order, partly a premonition of the instability of the present; partly an unknown hope for the future. The courtiers assemble for the embarkation for Cythera but the poignancy of the occasion is due to the implication that when they get there it will not be the legendary place they expect – the guillotines will be falling. The paradox is that whenever an artist achieves such a true expression of his time as Watteau did, he transcends it and comments on a permanent aspect of life itself: in Watteau's case on the brevity of it. The difference between Watteau and his followers (Fragonard's landscapes are in a

separate category) is that they were unable to see beyond the consoling pretence of the charades they painted – and incidentally were therefore very much more popular with their public.

1954

The Honesty of Goya

Goya's genius as a graphic artist was that of a commentator. I do not mean that his work was straightforward reportage, far from it; but that he was much more interested in events than states of mind. Each work appears unique not on account of its style but on account of the incident upon which it comments. At the same time, these incidents lead from one to another so that their effect is culminative – almost like that of film shots.

Indeed, another way of describing Goya's vision would be to say that it was essentially theatrical. Not in the derogatory sense of the word, but because he was constantly concerned with the way action might be used to epitomize a character or a situation. The way he composed was theatrical. His works always imply an encounter. His figures are not gathered round a natural centre so much as assembled from the wings. And the impact of his work is also dramatic. One doesn't analyse the processes of vision that lie behind an etching by Goya; one submits to its climax.

Goya's method of drawing remains an enigma. It is almost impossible to say *how* he drew: where he began a drawing, what method he had of analysing form, what system he worked out for using tone. His work offers no clues to answer these questions because he was only interested in *what* he drew. His gifts, technical and imaginative, were prodigious. His control of a brush is comparable to Hokusai's. His power of visualizing his subject was so precise that often scarcely a line is altered between preparatory sketch and finished plate. Every drawing he made is undeniably stamped with his personality. But despite all this, Goya's drawings are in a sense as impersonal, as automatic, as lacking in temperament as footprints – the whole interest of which lies not in the prints themselves but in what they reveal of the incident that caused them.

What was the nature of Goya's commentary? For despite the variety of the incidents portrayed, there is a constant underlying theme. His theme was the consequences of Man's neglect – sometimes mounting to

hysterical hatred – of his most precious faculty, Reason. But Reason in the eighteenth-century materialistic sense: Reason as a discipline yielding Pleasure derived from the Senses. In Goya's work the flesh is a battleground between ignorance, uncontrolled passion, superstition on the one hand and dignity, grace and pleasure on the other. The unique power of his work is due to the fact that he was so *sensuously* involved in the terror and horror of the betrayal of Reason.

In all Goya's works – except perhaps the very earliest – there is a strong sensual and sexual ambivalence. His exposure of physical corruption in his Royal portraits is well known. But the implication of corruption is equally there in his portrait of Dona Isabel. His Maja undressed, beautiful as she is, is *terrifyingly* naked. One admires the delicacy of the flowers embroidered on the stocking of a pretty courtesan in one drawing, and then suddenly, immediately, one foresees in the next the mummer-headed monster that, as a result of the passion aroused by her delicacy, she will bear as a son. A monk undresses in a brothel and Goya draws him, hating him, not in any way because he himself is a puritan, but because he senses that the same impulses that are behind this incident will lead in the Disasters of War to soldiers castrating a peasant and raping his wife. The huge brutal heads he put on hunchback bodies, the animals he dressed up in official robes of office, the way he gave to the cross-hatched tone on a human body the filthy implication of fur, the rage with which he drew witches – all these were protests against the abuse of human possibilities. And what makes Goya's protests so desperately relevant for us, after Buchenwald and Hiroshima, is that he knew that when corruption goes far enough, when the human possibilities are denied with sufficient ruthlessness, both ravager and victim are made bestial.

Then there is the argument about whether Goya was an objective or subjective artist; whether he was haunted by his own imaginings, or by what he saw of the decadence of the Spanish Court, the ruthlessness of the Inquisition and the horror of the Peninsular War. In fact, this argument is falsely posed. Obviously Goya sometimes used his own conflicts and fears as the starting point for his work, but he did so because he consciously saw himself as being typical of his time. The intention of his work was highly objective and social. His theme was what man was capable of doing to man. Most of his subjects involve action between figures. But even when the figures are single – a girl in prison, an habitual lecher, a beggar who was once 'somebody' – the implication, often actually stated in the title, is 'Look what has been done to them.'

I know that certain other modern writers take a different view. Malraux, for instance, says that Goya's is 'the age-old religious accent of useless suffering rediscovered, perhaps for the first time, by a man who believed himself to be indifferent to God'. Then he goes on to say that Goya paints 'the absurdity of being human' and is 'the greatest inter-

preter of anguish the West has ever known'. The trouble with this view, based on hindsight, is that it induces a feeling of subjection much stronger than that in Goya's own work: only one more shiver is needed to turn it into a feeling of meaningless defeat. If a prophet of disaster is proved right by later events (and Goya was not only recording the Peninsular War, he was also prophesying) then that prophecy does not increase the disaster; to a very slight extent it lessens it, for it demonstrates that man can foresee consequences, which, after all, is the first step towards controlling causes.

The despair of an artist is often misunderstood. It is never total. It excepts his own work. In his own work, however low his opinion of it may be, there is the hope of reprieve. If there were not, he could never summon up the abnormal energy and concentration needed to create it. And an artist's work constitutes his relationship with his fellow men. Thus for the spectator the despair expressed by a work can be deceiving. The spectator should always allow his comprehension of that despair to be qualified by *his* relationship with his fellow men: just as the artist does implicitly by the very act of creation. Malraux, in my opinion – and in this he is typical of a large number of disillusioned intellectuals – does not allow this qualification to take place; or if he does, his attitude to his fellow men is so hopeless that the weight of the despair is in no way lifted.

One of the most interesting confirmations that Goya's work was outward-facing and objective is his use of light. In his works it is not, as with all those who romantically frighten themselves, the dark that holds horror and terror. It is the light that discloses them. Goya lived and observed through something near enough to total war to know that night is security and that it is the dawn that one fears. The light in his work is merciless for the simple reason that it shows up cruelty. Some of his drawings of the carnage of the Disasters are like film shots of a flare-lit target after a bombing operation; the light floods the gaps in the same way.

Finally and in view of all this one tries to assess Goya. There are artists such as Leonardo or even Delacroix who are more analytically interesting than Goya. Rembrandt was more profoundly compassionate in his understanding. But no artist has ever achieved greater honesty than Goya: honesty in the full sense of the word meaning facing the facts *and* preserving one's ideals. With the most patient craft Goya could etch the appearance of the dead and the tortured, but underneath the print he scrawled impatiently, desperately, angrily, 'Why?' 'Bitter to be present', 'This is why you have been born', 'What more can be done?' 'This is worse'. The inestimable importance of Goya for us now is that his honesty compelled him to face and to judge the issues that still face us.

1954

The Dilemma of the Romantics

The term Romanticism has recently been taken to cover almost all the art produced in Europe between about 1770 and 1860. Ingres and Gainsborough, David and Turner, Pushkin and Stendhal. Thus the pitched battles of the last century between Romanticism and Classicism are not taken at their face value, but rather it is suggested that the differences between the two schools were less important than what they both had in common with the rest of the art of their time.

What was this common element? To take a century of violent agitation and revolt and then to try to define the general, overall nature of its art, is to deny the very character of such a period. The significance of the outcome of any revolution can only be understood in relation to the specific circumstances pertaining. There is nothing less revolutionary than generalizing about revolution. However, a stupid question usually gets stupid answers. Some try to define Romantic art by its subject matter. But then Piero di Cosimo is a Romantic artist along with George Morland! Others suggest that Romanticism is an irrational force present in all art, but that sometimes it predominates more than at other times over the opposite force of order and reason. Yet this would make a great deal of Gothic art romantic! Another observes that it must all have had something to do with the English weather.

No, if one must answer the question – and as I've said, no answer is going to get us all that far – one must do so historically. The period in question falls between the growing points of two revolutions, the French and the Russian. Rousseau published *Le Contrat Social* in 1762. Marx published *Capital* in 1867. No two other single facts could reveal more. Romanticism was a revolutionary movement that rallied round a promise which was bound to be broken: the promise of the success of revolutions deriving their philosophy from the concept of the natural man. Romanticism represented and acted out the full predicament of those who

created the goddess of Liberty, put a flag in her hands and followed her only to find that she led them into an ambush: the ambush of reality. It is this predicament which explains the two faces of Romanticism: its exploratory adventurousness and its morbid self-indulgence. For pure romantics the two most unromantic things in the world were firstly to accept life as it was, and secondly to succeed in changing it.

In the visual arts the two faces reveal themselves in a sense of new dimensions on the one hand, and in an oppressive claustrophobia on the other. They are Constable's clouds formed by land and water we can't see, and there is the typical romantic painting of a man being buried alive in his coffin. There is Géricault looking calmly and openly at the inmates of an asylum, and there are the German Romantic painters in the Mediterranean painting the hills and sky such a legendary blue that the whole scene looks as though it could be smashed like a saucer. There is Stubbs scientifically comparing animals and looking into the eyes of a tiger, and there is James Ward reducing Gordale Scar to a rock of ages just cleft for him. There is a new awareness of the size and power of the forces in the world – an awareness which invested the word *Nature* with a completely new meaning, and there is the breathlessness of the new superstitions that protected men from the enormity of what they were discovering: above all the superstition that a feeling in the heart was somehow comparable with a storm in the sky.

Naturally the focal centres of Romantic art varied a great deal according to time and place. In England the provocation was the Industrial Revolution and the new light (literal and metaphorical) that it threw on landscape; in France the predominant stimulus was the new mode of military heroism established by Napoleon; in Germany it was the mounting compulsion to establish a national identity. Naturally, too, the political predicament I've described often presented itself in indirect forms. More Romantic artists were directly influenced by the literary cult of the past when life was thought to have been 'simpler' and more 'natural', than they were by, say, Chartism. Newtonian science was also relevant to Romanticism. The Romantics accepted the way science had freed thought from religion, but at the same time were intuitively in protest against its closed mechanistic system, the inhumanity of which seemed to be demonstrated in practice by the horrors of the economic system. The complexities of the situation are immense. Certain artists of the time, precisely because they were not affected by the Romantic predicament, should not be classed as Romantics even though they borrowed from the Romantic vocabulary: *e.g.* Goya and Daumier.

Yet, despite the complexities, this historical definition is the only one that will make any general sense at all. It is confirmed by the fact that after 1860 when the predicament was no longer real because the knowledge and experience with which to overcome it were available,

Romanticism degenerated into effete aestheticism. And it is confirmed most strikingly by the work which represents Romanticism at its height: Delacroix's *Massacre at Chios*.

The sub-title of the picture is *A Greek Family Awaiting Death or Slavery*. It is an acknowledged masterpiece and contains brilliant passages of painting. Its political gesture was important and also undoubtedly sincere. But it remains a gesture. It has nothing to do with any true imaginative understanding of either death or slavery. It is a voluptuous charade. The woman tied to the horse is a languorous sex-offering, the rope round her arm like an exotic snake playing with her. The couple in the centre might be lying in a harem. Indeed all the figures (with the possible exception of the old woman) are exotic. They belong to art dreams and literary legends, and have only been placed in an actual context for the sake of being 'ennobled' further by also belonging to an historical tragedy.

Delacroix records how he talked to a traveller just back from Greece and says that on one occasion this man 'was so much impressed by the head of a Turk who appeared on the battlements that he prevented a soldier from shooting at him.' Elsewhere Delacroix raves about a painting by Gros and says, 'You can see the flash of the sabre as it plunges into the enemy's throats.' Such was the romantic view of war: you could stop or start it like a film. It was a sincere view, but it was a compromisingly privileged view. And between the privilege and the reality lay the predicament.

1959

Millet and Labour

Millet's holy humble peasants have been used to illustrate many moral lessons and have comforted many uneasy consciences: the consciences of those who have borne everything 'with fortitude', but who suspect themselves of perhaps having accepted too much too passively: also, the consciences of those who, living off the labour of others, have nevertheless always believed that in an indescribable sort of way (and God help those who describe it too explicitly) the labourer has a nobility which they themselves lack. And, above all, Millet's pictures have been quoted to persuade the confined to count the blessings in their cells; they have been used as a kind of pictorial label round the great clerical bottle of Bromide prescribed to quieten every social fever and irritation. This is a more important part of the history of Millet's art than the fact that highbrow fashion has ignored him for the last thirty or forty years. Otherwise what is important is that such artists as Degas, Monet, Van Gogh, Sickert, all accepted as a matter of course that he was a great draughtsman. In fact, Michelangelo, Poussin, Fragonard, Daumier, Degas, can all be cited in discussing his work – though it is only necessary to do so in order to convince the 'art-loving' public, misled by its textbooks, that Millet was not just a kind of John the Baptist forerunner of the Pre-Raphaelites or of Watts. But when that has been said, it is the moral issue which is *the* issue that Millet raises.

Millet was a moralist in the only way that a great artist can be: by the power of his identification with his subjects. He chose to paint peasants because he was one, and because – under a somewhat similar influence to the unpolitical realists today – he instinctively hated the false elegance of the beau monde. His genius was the result of the fact that, choosing to paint physical labour, he had the passionate, highly sensuous and sexual temperament that could lead him to intense physical identification. Sir Kenneth Clark makes much of the point that at the age of thirty-five he

gave up painting nudes which were – but only in the mythology they employed – a little like eighteenth-century boudoir art. Yet there was no inhibited puritanism behind this decision. Millet objected to Boucher because 'he did not paint nude women, but only little creatures un-dressed'.

As for the nature of Millet's power of identification, this is clearly revealed in one of his remarks about a drawing by Michelangelo.

> When I saw that drawing of his in which he depicts a man in a fainting fit – I felt like the subject of it, as though I were racked with pain. I suffered with the body, with the limbs, that I saw suffer.

In the same way he strode forward with *The Sower*, felt the weight of the hand on a lap even when it was obscured in shadow (see his etching of a *Mother Feeding her Child*), embraced with the harvesters the trusses of hay, straightened his back with the hoers, clenched his leg to steady the log with the wood-cutters, leant his weight against the tree trunk with the shepherdess, sprawled at midday on the ground with the exhausted. This was the extent of his moral teaching. When he was accused of being a socialist, he denied it – although he continued to work in the same way and suffer the same accusation – because socialism seemed to him to have nothing to do with the truth he had experienced and expressed: the truth of the peasant driven by the seasons: the truth so dominating that it made it absolutely impossible for him to conceive of any other life for a peasant.

It is fatal for an artist's moral sense to be in advance of his experience of reality. (Hogarth's wasn't; Greuze's was.) Millet, without a trace of sentimentality, told the truth as he knew it: the passive acceptance of the couple in *The Angelus* was a small part of the truth. And the sentimentality and false morality afterwards foisted upon this picture will prove – perhaps already has proved – to be temporary. In the history of nine-teenth- and twentieth-century art the same story is repeated again and again. The artist, isolated, knows that his maximum moral responsibility is to struggle to tell the truth; his struggle is on the near side, not the far, of drawing moral conclusions. The public, or certain sections of it, then draw moral conclusions to disguise the truth: the artist's work is called immoral – Balzac, Zola: or is requisitioned for false preaching – Millet, Dostoevsky: or, if neither of these subterfuges work, it is dismissed as being naive – Shelley, Brecht.

1956

The Politics of Courbet

Because Courbet was a declared and incorruptible Socialist (he was of course imprisoned for the part he played in the Commune and at the end of his life was driven into exile in Switzerland), reactionary critics have pretended that his politics were nothing to do with his art – they couldn't deny his art itself if only because of his important influence on later artists such as Manet and Cézanne; progressive critics, on the other hand, have tended to assume that his art is great as an automatic result of his political loyalty. So it is pertinent to ask exactly how his socialism was implied in his paintings, how his attitude to life was reflected in the innovations of his art.

First, though, it is necessary to clean off some of the mud that has stuck. Because Courbet was uncompromising in his convictions, because his work and his way of life 'vulgarly' proved that art was as relevant to the back-parlour, the workshop, the cell, as to the drawing-room, because his paintings never offered the slightest possibility of escape from the world as it was, he was officially rejected in his lifetime and has since been only grudgingly admitted. He has been accused of being bombastic. Look at his self-portrait in prison. He sits by the window quietly smoking his pipe, the invitation of the sunlight in the courtyard outside the only comment on his confinement. Or look at his copy of the Rembrandt self-portrait. He had the humility to impose that discipline on himself at the age of fifty. He has been accused of coarseness. Look at a Normandy seascape, in which the receding air between the empty sea and the low clouds holds firmly but with an extraordinary finesse all the mystery implied by the apparent fact and the actual illusion of an horizon. He has been charged with sentimentality. Look at his painting of the great hooked trout; its truth to the essential facts forces one to feel the weight of the fish, the power with which, struggling, his tail would slap the rocks, the cunning necessary to play him, the deliberation necessary to gaff him – he would be too large to net. Occasionally, of course, such criticisms are fair, yet no artist only paints masterpieces, and

the work, say, of Constable (whom Courbet in his independent contribution to landscape painting somewhat resembled), Corot or Delacroix is just as unequal, but is far less frequently singled out for prejudiced attack.

But to return to the main problem: Courbet believed in the independence of the artist – he was the first painter to hold a one-man show. Yet to him this meant independence from art for art's sake, from the prevailing Romantic view that the artist or his work were more important than the existence of the subject painted, and from the opposing Classic view that the inspiration of all art was absolute and timeless. He realized that the artist's independence could only be productive if it meant his freedom to identify himself with his living subject, to feel that *he* belonged to *it*, never vice versa. For the painter as such that is the meaning of Materialism. Courbet expressed it in words – this indestructible relationship between human aspiration and actual fact – when he wrote, '*Savoir pour pouvoir – telle fut ma pensée.*' But Courbet's acknowledgment, with all the force of his imagination, of the actuality of the objects he painted, never deteriorated into naturalism: a thoughtless superficial goggling at appearances – a tripper's view of a beauty spot, for instance. One does not just feel that every scene he painted *looked* like that but that it was *known* like that. His country landscapes were revolutionary in so far as they presented real places without suggesting any romantic antithesis with the city, but within them – not imposed upon them – one can also discover a sense of potential Arcadia: a local recognition that for playing children and courting couples such ordinary scenes might gather familiar magic. A magnificent nude in front of a window and landscape is an uncompromising portrayal of a woman undressed – subject to many of the same laws as the trout: but, at the same time, the picture evokes the shock of the unexpected loneliness of nudity: the personal shock that inspires lovers, expressed in another way in Giorgione's *Tempest.* His portraits (the masterpieces of Jules Vallès, Van Wisselingh, The Hunter) are particular people; one can imagine how they will alter; one can imagine their clothes worn, ill-fitting, by somebody else; yet they share a common dignity because all are seen with the knowledge of the same man's affection. The light plays on them kindly because all light is welcome that reveals the form of one's friends.

A parallel principle applies to Courbet's drawing and grasp of structure. The basic form is always established first, all modulations and outcrops of texture are then seen as organic variations – just as eccentricities of character are seen by a friend, as opposed to a stranger, as part of the whole man.

To sum up in one sentence, one might say that Courbet's socialism was expressed in his work by its quality of uninhibited Fraternity.

1953

Gauguin's Crime

Gauguin's life – poverty, disease, loneliness, disillusion, guilt – was wholly tragic. The legend of the stockbroker who chucked up his family and job, or that of the Genius sublimely above Responsibility, are inadequate both to the facts and to the suffering involved. Gauguin was a criminal. It may seem perverse to call a great artist that – and one must remember that his ruthlessness always extended to his own treatment of himself – but it is the only way, I think, of beginning to understand him.

Gauguin's self-portraits, after he left his family in Copenhagen and became an outcast, are very revealing, especially if one remembers the innocence of Van Gogh's. The large lumbering body, the big hooked nose, the dark eyes whose expression is defensive and gives nothing away, the whole face – like one carved forcefully but with a blunt knife out of crude wood – are seen bitterly, cynically, as though the image Gauguin saw in the mirror reminded him of how a convict might strike a prison visitor, or how a man might appear, brought up from a dark cell for interrogation.

His crime was his decision in 1883 to become a professional, dedicated painter. It amounted to a crime partly because of the social attitude forced upon the imaginative artist at that time, and partly because of Gauguin's own temperament. All the great works of the late nineteenth century were produced in the belief that the individual could only risk himself creatively *against* society. This by itself turned the artist into an outcast. One half of Gauguin's character accepted this role so uncompromisingly that he was *treated* as a criminal: the other half, longing for acceptance and respect, made him *feel* a criminal. He instinctively understood both processes. 'A terrible epoch,' he wrote, 'is being prepared in Europe for the coming generation: the reign of gold. Everything is rotten, both men and the arts. You must understand that two natures dwell within me: the Indian and the Sensitive Man.'

Although Gauguin claimed descent from the Peruvian Indians, the Indian also had a symbolic meaning for him: he was the Free Man, the Independent Hunter, the Pure Primitive of uncorrupted appetite. The sensitive man was the exact opposite: the man of Esteem, cultivated, articulate Taste, Affection and Family Feeling. The two combine, the independence of the Indian and the guilt of the Sensitive Man, in such twisted agonized remarks as: 'Yes, I'm a great criminal all right. But what does it matter? Michelangelo also. And I'm not Michelangelo.'

All through his life until his attempted suicide six years before his death, this conflict continued. His letters from Panama, Brittany, Tahiti, the Marquesas, read like those of a man on the run, always planning to get over the border to security and comfort and a normal full life.

> You are without confidence in the future, but I have that confidence because I want to have it. Without that I should have long since thrown up the sponge. To hope is almost to live. I must live to do my duty to the end, and I can only do so by forcing my illusions, by creating hopes out of dreams. When day after day, I eat my dry bread with a glass of water, I make myself believe it is a beefsteak.

And at the end he wrote: 'You have known for a long time what it is I wish to establish: the right to dare everything.' *Dare* not *Do.* In that difference of motive the conflict emerges again. One only talks of risking what one values.

It was not until after the death of his favourite daughter and his attempt at poisoning himself that Gauguin seems to have given up hope, or, more accurately, to have accepted his own terrible sentence on himself of deportation. His physical sufferings increased even further, but in his mind he achieved a certain reconciliation and calm.

Now, none of this would be worth pointing out and one could at least leave Gauguin his privacy, if it did not give us an important clue to understanding his art. Given the ideas of his time, Gauguin's painting was a very direct expression of his personality.

The Sensitive Man, robbed of security and sensibility, needed to dream. This might have led Gauguin to pure fantasy, symbolism, esoteric religious art – all of which he touched but never developed because the Indian in him required tangible trophies, required that 'the dream' should have weight and body to it. Hence his travels: to Brittany (where the dream had to be forced a little) and to the South Seas where dream and actuality were fused: the scene simultaneously exotic and stark.

The Sensitive Man inspired the mood and often the titles of the paintings: *Alone, Nevermore, Where Do We Come From, What Are We, Whither Do We Go?* The Indian bound with contours as strong as leather the simple tangible forms. Neither was concerned with superficial illusions:

both wanted to strip their subjects to what they thought was the heart of the matter: one to the essential mystery, the other to the instinctive body.

Consider the masterpiece *Nevermore*. Like all Gauguin's most original and mature works, it is, in one sense, clumsily painted. This clumsiness, however, is absolutely necessary to express the constant tension within the picture between the evocative and the real; between the hieratic gesture of a carved statue (or the stylized movement of a dancer) and the spontaneous pose of a Tahitian girl lying in wait on a couch: between flat decoration and solid structure: between allegorical and local colour. As in all Gauguin's later works, there is a marked distinction between the figure and its surroundings. The girl's body is modelled and physically convincing, the background is two-dimensional and schematic. As one thinks about this one suddenly realizes the explanation. The painting is the most accurate interpretation of what the girl herself might have felt as she lay there, intensely aware on the one hand of the reality of her own body, and, on the other hand, of the intangible comfort and threat of the dimensionless images projected around her from her own mind.

I believe that, sometimes very directly and sometimes less so, this duality of interpretation explains a great deal in Gauguin's greatest and most mysterious works. In his art he finally achieved his aim: to become a primitive and at the same time to remain finely articulate: to be simultaneously the Indian and the Sensitive Man. His work represents a single-handed attempt to build from primitive material an alternative civilization to the one he inherited. It is not altogether surprising that the latter considered the activity a criminal one.

1955

From *The Moment of Cubism*

The Moment of Cubism

This essay is dedicated to Barbara Niven who prompted it in an ABC teashop off the Gray's Inn Road a long time ago.

> Certains hommes sont des collines
> Qui s'élèvent entre les hommes
> Et voient au loin tout l'avenir
> Mieux que s'il était présent
> Plus net que s'il était passé.
>
> Apollinaire

> The things that Picasso and I
> said to one another during those years will never be said again,
> and even if they were,
> no one would understand them any more.
> It was like
> being roped together on a mountain.
>
> Georges Braque

> There are happy moments,
> but no happy periods in history.
>
> Arnold Hauser

> The work of art is therefore
> only a halt in the becoming
> and not a frozen aim on its own.
>
> El Lissitzky

I find it hard to believe that the most extreme Cubist works were painted over fifty years ago. It is true that I would not expect them to have been painted today. They are both too optimistic and too revolutionary for that. Perhaps in a way I am surprised that they have been painted at all. It would seem more likely that they were yet to be painted.

Do I make things unnecessarily complicated? Would it not be more helpful to say simply: the few great Cubist works were painted between 1907 and 1914? And perhaps to qualify this by adding that a few more, by Juan Gris, were painted a little later?

And anyway is it not nonsense to think of Cubism having not yet taken place when we are surrounded in daily life by the apparent effects of

Cubism? All modern design, architecture and town planning seems inconceivable without the initial example of Cubism.

Nevertheless I must insist on the sensation I have in front of the works themselves: the sensation that the works and I, as I look at them, are caught, pinned down, in an enclave of time, waiting to be released and to continue a journey that began in 1907.

Cubism was a style of painting which evolved very quickly, and whose various stages can be fairly specifically defined.[1] Yet there were also Cubist poets, Cubist sculptors, and later on so-called Cubist designers and architects. Certain original stylistic features of Cubism can be found in the pioneer works of other movements: Suprematism, Constructivism, Futurism, Vorticism, the de Stijl movement.

The question thus arises: can Cubism be adequately defined as a style? It seems unlikely. Nor can it be defined as a policy. There was never any Cubist manifesto. The opinions and outlook of Picasso, Braque, Léger or Juan Gris were clearly very different even during the few years when their paintings had many features in common. Is it not enough that the category of Cubism includes those works that are now generally agreed to be within it? This is enough for dealers, collectors, and cataloguers who go by the name of art historians. But it is not, I believe, enough for you or me.

Even those whom the stylistic category satisfies are wont to say that Cubism constituted a revolutionary change in the history of art. Later we shall analyse this change in detail. The concept of painting as it had existed since the Renaissance was overthrown. The idea of art holding up a mirror to nature became a nostalgic one: a means of diminishing instead of interpreting reality.

If the word 'revolution' is used seriously and not merely as an epithet for this season's novelties, it implies a process. No revolution is simply the result of personal originality. The maximum that such originality can achieve is madness: madness is revolutionary freedom confined to the self.

Cubism cannot be explained in terms of the genius of its exponents. And this is emphasized by the fact that most of them became less profound artists when they ceased to be Cubists. Even Braque and Picasso never surpassed the works of their Cubist period: and a great deal of their later work was inferior.

The story of how Cubism happened in terms of painting and of the leading protagonists has been told many times. The protagonists themselves found it extremely difficult – both at the time and afterwards – to explain the meaning of what they were doing.

To the Cubists, Cubism was spontaneous. To us it is part of history. But a curiously unfinished part. Cubism should be considered not as a

stylistic category but as a moment (even if a moment lasting six or seven years) experienced by a certain number of people. A strangely placed moment.

It was a moment in which the promises of the future were more substantial than the present. With the important exception of the avant-garde artists during a few years after 1917 in Moscow, the confidence of the Cubists has never since been equalled among artists.

D. H. Kahnweiler, who was a friend of the Cubists and their dealer, has written:

> I lived those seven crucial years from 1907 to 1914 with my painter friends . . . what occurred at that time in the plastic arts will be understood only if one bears in mind that a new epoch was being born, in which man (all mankind in fact) was undergoing a transformation more radical than any other known within historical times.[2]

What was the nature of this transformation? I have outlined elsewhere (in *The Success and Failure of Picasso*) the relation between Cubism and the economic, technological and scientific developments of the period. There seems little point in repeating this here: rather, I would like to try to push a little further our definition of the philosophic meaning of these developments and their coincidence.

An interlocking world system of imperialism; opposed to it, a socialist international; the founding of modern physics, physiology and sociology; the increasing use of electricity, the invention of radio and the cinema; the beginnings of mass production; the publishing of mass-circulation newspapers; the new structural possibilities offered by the availability of steel and aluminium; the rapid development of chemical industries and the production of synthetic materials; the appearance of the motor-car and the aeroplane: what did all this mean?

The question may seem so vast that it leads to despair. Yet there are rare historical moments to which such a question can perhaps be applied. These are moments of convergence, when numerous developments enter a period of similar qualitative change, before diverging into a multiplicity of new terms. Few of those who live through such a moment can grasp the full significance of the qualitative change taking place; but everybody is aware of the times changing: the future, instead of offering continuity, appears to advance towards them.

This was surely the case in Europe from about 1900 to 1914 – although one must remember, when studying the evidence, that the reaction of many people to their own awareness of change is to pretend to ignore it.

Apollinaire, who was the greatest and most representative poet of the Cubist movement, repeatedly refers to the future in his poetry.

Where my youth fell
You see the flame of the future
You must know that I speak today
To tell the whole world
That the art of prophecy is born at last.

The developments which converged at the beginning of the twentieth century in Europe changed the meaning of both time and space. All, in different ways, some inhuman and others full of promise, offered a liberation from the immediate, from the rigid distinction between absence and presence. The concept of the field, first put forward by Faraday when wrestling with the problem – as defined in traditional terms – of 'action at a distance', entered now, unacknowledged, into all modes of planning and calculation and even into many modes of feeling. There was a startling extension through time and space of human power and knowledge. For the first time the world, as a totality, ceased to be an abstraction and became *realizable*.

If Apollinaire was the greatest Cubist poet, Blaise Cendrars was the first. His poem 'Les Pâques à New York' (1912) had a profound influence on Apollinaire and demonstrated to him how radically one could break with tradition. The three major poems of Cendrars at this time were all concerned with travelling – but travelling in a new sense across a *realizable* globe. In 'Le Panama ou Les Aventures de Mes Sept Oncles' he writes:

Poetry dates from today
 The milky way round my neck
 The two hemispheres on my eyes
 At full speed
 There are no more breakdowns
If I had the time to save a little money I'd
 be flying in the air show
I have reserved my seat in the first train through
 the tunnel under the Channel
I am the first pilot to cross the Atlantic solo
900 millions

The 900 millions probably refers to the then estimated population of the world.

It is important to see how philosophically far-reaching were the consequences of this change and why it can be termed qualitative. It was not merely a question of faster transport, quicker messages, a more complex scientific vocabulary, larger accumulations of capital, wider markets, international organizations, etc. The process of the secularization of the world was at last complete. Arguments against the existence of

God had achieved little. But now man was able to extend *himself* indefinitely beyond the immediate: he took over the territory in space and time where God had been presumed to exist.

'Zone', the poem that Apollinaire wrote under the immediate influence of Cendrars, contains the following lines:

> Christ pupil of the eye
> Twentieth pupil of the centuries knows how
> This century changed into a bird ascends like Jesus
> Devils in pits raise their heads to watch it
> They say it's imitating Simon Magus of Judea
> If it can fly, we'll call it the fly one
> Angels swing past its trapeze
> Icarus Enoch Elias Apollonius of Tyana
> Hover round the first aeroplane
> Dispersing at times to let through the priests
> As they bear the Holy Eucharist
> Forever ascending and raising the Host . . .[3]

The second consequence concerned the relation of the self to the secularized world. There was no longer any essential discontinuity between the individual and the general. The invisible and the multiple no longer intervened between each individual and the world. It was becoming more and more difficult to think in terms of having been *placed* in the world. A man was part of the world and indivisible from it. In an entirely original sense, which remains at the basis of modern consciousness, a man *was* the world which he inherited.

Again, Apollinaire expresses this:

> I have known since then the bouquet of the world
> I am drunk from having drunk the universe whole.

All the previous spiritual problems of religion and morality would now be increasingly concentrated in a man's choice of attitude to the existing state of the world considered as his own existing state.

It is now only against the world, within his own consciousness, that he can measure his stature. He is enhanced or diminished according to how he acts towards the enhancement or diminishment of the world. His self apart from the world, his self wrenched from its global context – the sum of all existing social contexts – is a mere biological accident. The secularization of the world exacts its price as well as offering the privilege of a choice, clearer than any other in history.

Apollinaire:

> I am everywhere or rather I start to be everywhere
> It is I who am starting this thing of the centuries
> to come.

As soon as more than one man says this, or feels it, or aspires towards feeling it – and one must remember that the notion and the feeling are the consequence of numerous material developments impinging upon millions of lives – as soon as this happens, the unity of the world has been proposed.

The term 'unity of the world' can acquire a dangerously utopian aura. But only if it is thought to be politically applicable to the world as it is. A *sine qua non* for the unity of the world is the end of exploitation. The evasion of this fact is what renders the term utopian.

Meanwhile the term has other significations. In many respects (the Declaration of Human Rights, military strategy, communications, etc.) the world since 1900 has been treated as a single unit. The unity of the world has received *de facto* recognition.

Today we know that the world should be unified, just as we know that all men should have equal rights. Insofar as a man denies this or acquiesces in its denial, he denies the unity of his own self. Hence the profound psychological sickness of the imperialist countries, hence the corruption implicit in so much of their learning – when knowledge is used to deny knowledge.

At the moment of Cubism, no denials were necessary. It was a moment of prophecy, but prophecy as the basis of a transformation that had actually begun.

Apollinaire:

> Already I hear the shrill sound of the friend's voice to come
> Who walks with you in Europe
> Whilst never leaving America . . .

I do not wish to suggest a general period of ebullient optimism. It was a period of poverty, exploitation, fear and desperation. The majority could only be concerned with the means of their survival, and millions did not survive. But for those who asked questions, there were new positive answers whose authenticity seemed to be guaranteed by the existence of new forces.

The socialist movements in Europe (with the exception of that in Germany and sections of the trade-union movement in the United States) were convinced that they were on the eve of revolution and that the revolution would spread to become a world revolution. This belief was shared even by those who disagreed about the political means necessary – by syndicalists, parliamentarians, communists and anarchists.

A particular kind of suffering was coming to an end: the suffering of

hopelessness and defeat. People now believed, if not for themselves then for the future, in victory. The belief was often strongest where the conditions were worst. Everyone who was exploited or downtrodden and who had the strength left to ask about the purpose of his miserable life was able to hear in answer the echo of declarations like that of Lucheni, the Italian anarchist who stabbed the Empress of Austria in 1898: 'The hour is not far distant when a new sun will shine upon all men alike'; or like that of Kalyaev in 1905 who, on being sentenced to death for the assassination of the Governor-General of Moscow, told the court 'to learn to look the advancing revolution straight in the eye'.

An end was in sight. The limitless, which until now had always reminded men of the unattainability of their hopes, became suddenly an encouragement. The world became a starting point.

The small circle of Cubist painters and writers were not directly involved in politics. They did not think in political terms. Yet they were concerned with a revolutionary transformation of the world. How was this possible? Again we find the answer in the historical timing of the Cubist movement. It was not then essential for a man's intellectual integrity to make a political choice. Many developments, as they converged to undergo an equivalent qualitative change, appeared to promise a transformed world. The promise was an overall one.

'All is possible,' wrote André Salmon, another Cubist poet, 'everything is realizable everywhere and with everything.'

Imperialism had begun the process of unifying the world. Mass production promised eventually a world of plenty. Mass-circulation newspapers promised informed democracy. The aeroplane promised to make the dream of Icarus real. The terrible contradictions born of the convergence were not yet clear. They became evident in 1914 and they were first politically polarized by the Russian Revolution of 1917. El Lissitzky, one of the great innovators of Russian revolutionary art until this art was suppressed, implies in a biographical note how the moment of political choice came from the conditions of the Cubist moment:

The Film of El's Life till 1926[4]
BIRTH: My generation was born
a few dozen years
before the Great October Revolution.
ANCESTORS: A few centuries ago our ancestors had the luck
to make the great voyages of discovery.
WE: We, the grandchildren of Columbus,
are creating the epoch of the most glorious inventions.
They have made our globe very small,
but have
expanded our space

and intensified our time.

SENSATIONS: My life is accompanied
by unprecedented sensations.
Barely five years old I had the rubber leads
of Edison's phonograph stuck in my ears.
Eight years,
and I was chasing after the first electric tram in Smolensk,
the diabolical force
which drove the peasant horses out of the town.

COMPRESSION OF MATTER: The steam engine rocked my
 cradle.
In the meantime it has gone the way of all ichthyosauruses.
Machines are ceasing
to have fat bellies full of intestines.
Already we have the compressed skulls
of dynamos with their electric brains.
Matter and mind
are directly transmitted through crankshafts
and thus made to work.
Gravity and inertia are being overcome.

1918: In 1918 in Moscow before my eyes
the short-circuit sparked
which split the world in
half.
This stroke drove our present apart
like a wedge
between yesterday and tomorrow.
My work
too
forms part of driving the wedge
further
in.
One belongs here or there:
there is no middle.

The Cubist movement ended in France in 1914. With the war a new kind of suffering was born. Men were forced to face for the first time the full horror – not of hell, or damnation, or a lost battle, or famine, or plague – but the full horror of what stood in the way of their own progress. And they were forced to face this in terms of their own responsibility, not in terms of a simple confrontation as between clearly defined enemies.

The scale of the waste and the irrationality and the degree to which men could be persuaded and forced to deny their own interests led to the belief that there were incomprehensible and blind forces at work.

But since these forces could no longer be accommodated by religion, and since there was no ritual by which they could be approached or appeased, each man had to live with them *within himself*, as best he could. Within him they destroyed his will and confidence.

On the last page of *All Quiet on the Western Front* the hero thinks:

> I am very quiet. Let the months and years come, they can take nothing from me, they can take nothing more. I am so alone, and so without hope that I can confront them without fear. The life that has borne me through these years is still in my hands and my eyes. Whether I have subdued it, I know not. But so long as it is there it will seek its own way out, heedless of the will that is within me.[5]

The new kind of suffering which was born in 1914 and has persisted in Western Europe until the present day is an inverted suffering. Men fought within themselves about the meaning of events, identity, hope. This was the negative possibility implicit in the new relation of the self to the world. The life they experienced became a chaos within them. They became lost within themselves.

Instead of apprehending (in however simple and direct a way) the processes which were rendering their own destinies identical with the world's, they submitted to the new condition passively. That is to say the world, which was nevertheless indivisibly part of them, reverted *in their minds* to being the old world which was separate from them and opposed them: it was as though they had been forced to devour God, heaven and hell and live for ever with the fragments inside themselves. It was indeed a new and terrible form of suffering and it coincided with the widespread, deliberate use of false ideological propaganda as a weapon. Such propaganda preserves within people outdated structures of feeling and thinking whilst forcing new experiences upon them. It transforms them into puppets – whilst most of the strain brought about by the transformation remains politically harmless as inevitably *incoherent* frustration. The only purpose of such propaganda is to make people deny and then abandon the selves which otherwise their own experience would create.

In 'La Jolie Rousse', Apollinaire's last long poem (he died in 1918), his vision of the future, after his experience of the war, has become a source of suffering as much as of hope. How can he reconcile what he has seen with what he once foresaw? From now on there can be no unpolitical prophecies.

> We are not your enemies
> We want to take over vast strange territories
> Where the flowering mystery waits to be picked
> Where there are fires and colours never yet seen

A thousand imponderable apparitions
Which must be given reality
We wish to explore the vast domain of goodness
 where everything is silent
And time can be pursued or brought back
Pity us who fight continually on the frontiers
Of the infinite and the future
Pity for our mistakes pity for our sins.

The violence of summer is here
My youth like the spring is dead
Now, O sun, is the time of scorching Reason
Laugh then laugh at me
Men from everywhere and more particularly here
For there are so many things I dare not tell you
So many things you will not let me say
Have pity on me.

We can now begin to understand the central paradox of Cubism. The spirit of Cubism was objective. Hence its calm and its comparative anonymity as between artists. Hence also the accuracy of its technical prophecies. I live in a satellite city that has been built during the last five years. The character of the pattern of what I now see out of the window as I write can be traced directly back to the Cubist pictures of 1911 and 1912. Yet the Cubist spirit seems to us today to be curiously distant and disengaged.

This is because the Cubists took no account of politics *as we have since experienced them.* In common with even their experienced political contemporaries, they did not imagine and did not foresee the extent, depth and duration of the suffering which would be involved in the political struggle to realize what had so clearly become possible and what has since become imperative.

The Cubists imagined the world transformed, but not the process of transformation.

Cubism changed the nature of the relationship between the painted image and reality, and by so doing it expressed a new relationship between man and reality.

Many writers have pointed out that Cubism marked a break in the history of art comparable to that of the Renaissance in relation to medieval art. That is not to say that Cubism can be equated with the Renaissance. The confidence of the Renaissance lasted for about sixty years (approximately from 1420 to 1480): that of Cubism lasted for about six years. However, the Renaissance remains a point of departure for appreciating Cubism.

In the early Renaissance the aim of art was to imitate nature. Alberti formulated this view: 'The function of the painter is to render with lines and colours, on a given panel or wall, the visible surface of any body, so that at a certain distance and from a certain position it appears in relief and just like the body itself.'[6]

It was not, of course, as simple as that. There were the mathematical problems of linear perspective which Alberti himself solved. There was the question of choice – that is to say the question of the artist doing justice to nature by choosing to represent what was typical of nature at her best.

Yet the artist's relation to nature was comparable to that of the scientist. Like the scientist, the artist applied reason and method to the study of the world. He observed and ordered his findings. The parallelism of the two disciplines is later demonstrated by the example of Leonardo.

Although often employed far less accurately during the following centuries, the metaphorical model for the function of painting at this time was *the mirror*. Alberti cites Narcissus when he sees himself reflected in the water as the first painter. The mirror renders the appearances of nature and simultaneously delivers them into the hands of man.

It is extremely hard to reconstruct the attitudes of the past. In the light of more recent developments and the questions raised by them, we tend to iron out the ambiguities which may have existed before the questions were formed. In the early Renaissance, for example, the humanist view and a medieval Christian view could still be easily combined. Man became the equal of God, but both retained their traditional positions. Arnold Hauser writes of the early Renaissance: 'The seat of God was the centre round which the heavenly spheres revolved, the earth was the centre of the material universe, and man himself a self-contained microcosm round which, as it were, revolved the whole of nature, just as the celestial bodies revolved round that fixed star, the earth.'[7]

Thus man could observe nature around him on every side and be enhanced both by what he observed and by his own ability to observe. He had no need to consider that he was essentially part of that nature. *Man was the eye for which reality had been made visual*: the ideal eye, the eye of the viewing point of Renaissance perspective. The human greatness of his eye lay in its ability to reflect and contain, like a mirror, what was.

The Copernican revolution, Protestantism, the Counter-Reformation destroyed the Renaissance position. With this destruction modern subjectivity was born. The artist becomes primarily concerned with creation. His own genius takes the place of nature as the marvel. It is the gift of his genius, his 'spirit', his 'grace' which makes him god-like. At the same time the equality between man and god is totally destroyed. Mystery enters art to emphasize the inequality. A century after Alberti's claim that

art and science are parallel activities, Michelangelo speaks – no longer of imitating nature – but of imitating Christ: 'In order to imitate in some degree the venerable image of Our Lord, it is not enough to be a painter, a great and skilful master; I believe that one must further be of blameless life, even if possible a saint, that the Holy Spirit may inspire one's understanding.'[8]

It would take us too far from our field even to attempt to trace the history of art from Michelangelo onwards – Mannerism, the Baroque, seventeenth- and eighteenth-century classicism. What is relevant to our purpose is that, from Michelangelo until the French Revolution, the metaphorical model for the function of painting becomes the *theatre stage*. It may seem unlikely that the same model works for a visionary like El Greco, a Stoic like Poussin (who actually worked from stage models he built himself) and a middle-class moralist like Chardin. Yet all the artists of these two centuries shared certain assumptions. For them all the power of art lay in its *artificiality*. That is to say they were concerned with constructing comprehensive examples of some truth such as could not be met with in such an ecstatic, pointed, sublime or meaningful way in life itself.

Painting became a schematic art. The painter's task was no longer to represent or imitate what existed: it was to summarize experience. Nature is now what man has to redeem himself from. The artist becomes responsible not simply for the means of conveying a truth, but also for the truth itself. Painting ceases to be a branch of natural science and becomes a branch of the moral sciences.

In the theatre the spectator faces events from whose consequences he is immune; he may be affected emotionally and morally but he is physically removed, protected, separate, from what is happening before his eyes. What is happening is artificial. It is *he* who now represents nature – not the work of art. And if, at the same time, it is from himself that he must redeem himself, this represents the contradiction of the Cartesian division which prophetically or actually so dominated these two centuries.

Rousseau, Kant and the French Revolution – or rather, all the developments which lay behind the thought of the philosophers and the actions of the Revolution – made it impossible to go on believing in constructed order as against natural chaos. The metaphorical model changed again, and once more it applies over a long period despite dramatic changes of style. The new model is that of the *personal account*. Nature no longer confirms or enhances the artist as he investigates it. Nor is he any longer concerned with creating 'artificial' examples, for these depend upon the common recognition of certain moral values. He is now alone, surrounded by nature, from which his own experience separates him.

Nature is what he sees *through* his experience. There is thus in all nineteenth-century art – from the 'pathetic fallacy' of the Romantics to the 'optics' of the Impressionists – considerable confusion about where the artist's experience stops and nature begins. The artist's personal account is his attempt to make his experience as real as nature, which he can never reach, by communicating it to others. The considerable suffering of most nineteenth-century artists arose out of this contradiction: because they were alienated from nature, they needed to present *themselves* as nature to others.

Speech, as the recounting of experience and the means of making it real, preoccupied the Romantics. Hence their constant comparisons between paintings and poetry. Géricault, whose 'Raft of the Medusa' was the first painting of a contemporary event consciously based on eye-witness accounts, wrote in 1821: 'How I should like to be able to show our cleverest painters several portraits, which are such close resemblances to nature, whose easy pose leaves nothing to be desired, and of which one can really say that all they lack is the power of speech.'[9]

In 1850 Delacroix wrote: 'I have told myself a hundred times that painting – that is to say, the material thing called painting – was no more than the pretext, the bridge between the mind of the painter and that of the spectator.'[10]

For Corot experience was a far less flamboyant and more modest affair than for the Romantics. But nevertheless he still emphasized how essential the personal and the relative are to art. In 1856 he wrote: 'Reality is one part of art: feeling completes it . . . before any site and any object, abandon yourself to your first impression. If you have really been touched, you will convey to others the sincerity of your emotion.'[11]

Zola, who was one of the first defenders of the Impressionists, defined a work of art as 'a corner of nature seen through a temperament'. The definition applies to the whole of the nineteenth century and is another way of describing the same metaphorical model.

Monet was the most theoretical of the Impressionists and the most anxious to break through the century's barrier of subjectivity. For him (at least theoretically) the role of his temperament was reduced to that of the process of perception. He speaks of a 'close fusion' with nature. But the result of this fusion, however harmonious, is a sense of powerlessness – which suggests that, bereft of his subjectivity, he has nothing to put in its place. Nature is no longer a field for study, it has become an overwhelming force. One way or another the confrontation between the artist and nature in the nineteenth century is an unequal one. Either the heart of man or the grandeur of nature dominates. Monet wrote:

I have painted for half a century, and will soon have passed my sixty-ninth year, but, far from decreasing, my sensitivity has sharpened with

age. As long as constant contact with the outside world can sustain the ardour of my curiosity, and my hand remains the quick and faithful servant of my perception, I have nothing to fear from old age. I have no other wish than a close fusion with nature, and I desire no other fate than (according to Goethe) to have worked and lived in harmony with her rules. Beside her grandeur, her power and her immorality, the human creature seems but a miserable atom.

I am well aware of the schematic nature of this brief survey. Is not Delacroix in some senses a transitional figure between the eighteenth and nineteenth centuries? And was not Raphael another transitional figure who confounds such simple categories? The scheme, however, is true enough to help us appreciate the nature of the change which Cubism represented.

The metaphorical model of Cubism is the *diagram*: the diagram being a visible, symbolic representation of invisible processes, forces, structures. A diagram need not eschew certain aspects of appearances: but these too will be treated symbolically as *signs*, not as imitations or re-creations.

The model of the *diagram* differs from that of the *mirror* in that it suggests a concern with what is not self-evident. It differs from the model of the *theatre stage* in that it does not have to concentrate upon climaxes but can reveal the continuous. It differs from the model of the *personal account* in that it aims at a general truth.

The Renaissance artist imitated nature. The Mannerist and Classic artist reconstructed examples from nature in order to transcend nature. The nineteenth-century artist experienced nature. The Cubist realized that his awareness of nature was part of nature.

Heisenberg speaks as a modern physicist. 'Natural science does not simply describe and explain nature; it is part of the interplay between nature and ourselves: it describes nature as exposed to our method of questioning.'[12] Similarly, the frontal facing of nature became inadequate in art.

How did the Cubists express their imitation of the new relation existing between man and nature?

1 By their use of space

Cubism broke the illusionist three-dimensional space which had existed in painting since the Renaissance. It did not destroy it. Nor did it muffle it – as Gauguin and the Pont-Aven school had done. It broke its continuity. There is space in a Cubist painting in that one form can be inferred to be behind another. But the relation between any two

forms does not, as it does in illusionist space, establish the rule for all the spatial relationships between all the forms portrayed in the picture. This is possible without a nightmarish deformation of space, because the two-dimensional surface of the picture is always there as arbiter and resolver of different claims. The picture surface acts in a Cubist painting as the constant which allows us to appreciate the variables. Before and after every sortie of our imagination into the problematic spaces and through the interconnections of a Cubist painting, we find our gaze resettled on the picture surface, aware once more of two-dimensional shapes on a two-dimensional board or canvas.

This makes it impossible to *confront* the objects or forms in a Cubist work. Not only because of the multiplicity of viewpoints – so that, say, a view of a table from below is combined with a view of the table from above and from the side – but also because the forms portrayed never present themselves as a totality. The totality is the surface of the picture, *which is now the origin and sum of all that one sees.* The viewing point of Renaissance perspective, fixed and outside the picture, but to which everything within the picture was drawn, has become a field of vision which is the picture itself.

It took Picasso and Braque three years to arrive at this extraordinary transformation. In most of their pictures from 1907 to 1910 there are still compromises with Renaissance space. The effect of this is to deform the subject. The figure or landscape becomes the construction, instead of the construction being the picture acting as an expression of the relation between viewer and subject.[13]

After 1910 all references to appearances are made as signs on the picture surface. A circle for a top of a bottle, a lozenge for an eye, letters for a newspaper, a volute for the head of a violin, etc. Collage was an extension of the same principle. Part of the actual or imitation surface of an object was stuck on to the surface of the picture as a sign referring to, but not imitating, its appearance. A little later painting borrowed from this experience of collage, so that, say, a pair of lips or a bunch of grapes might be referred to by a drawing which 'pretended' to be on a piece of white paper stuck on to the picture surface.

2 By their treatment of form

It was this which gave the Cubists their name. They were said to paint everything in *cubes.* Afterwards this was connected with Cézanne's re-mark: 'Treat nature by the cylinder, by the sphere, the cone, everything in proper perspective.' And from then on the misunderstanding has continued – encouraged, let it be said, by a lot of confused assertions by some of the lesser Cubists themselves.

The misunderstanding is that the Cubist wanted to simplify – for the sake of simplification. In some of the Picassos and Braques of 1908 it may look as though this is the case. Before finding their new vision, they had to jettison traditional complexities. But their aim was to arrive at a far more complex image of reality than had ever been attempted in painting before.

To appreciate this we must abandon a habit of centuries: the habit of looking at every object or body as though it were complete in itself, its completeness making it separate. The Cubists were concerned with the interaction between objects.

They reduced forms to a combination of cubes, cones, cylinders – or, later, to arrangements of flatly articulated facets or planes with sharp edges – so that the elements of any one form were interchangeable with another, whether a hill, a woman, a violin, a carafe, a table or a hand. Thus, as against the Cubist discontinuity of space, they created a continuity of structure. Yet when we talk of the Cubist discontinuity of space, it is only to distinguish it from the convention of linear Renaissance perspective.

Space is part of the continuity of the events within it. It is in itself an event, comparable with other events. It is not a mere container. And this is what the few Cubist masterpieces show us. The space between objects is part of the same structure as the objects themselves. The forms are simply reversed so that, say, the top of a head is a convex element and the adjacent space which it does not fill is a concave element.

The Cubists created the possibility of art revealing processes instead of static entities. The content of their art consists of various modes of interaction: the interaction between different aspects of the same event, between empty space and filled space, between structure and movement, between the seer and the thing seen.

Rather than ask of a Cubist picture: Is it true? or: Is it sincere? one should ask: Does it continue?

Today it is easy to see that, since Cubism, painting has become more and more diagrammatic, even when there has been no direct Cubist influence – as, say, in Surrealism. Eddie Wolfram in an article about Francis Bacon has written: 'Painting today functions directly as a conceptual activity in philosophical terms and the art object acts only as a cypher reference to tangible reality.'[14]

This was part of the Cubist prophecy. But only part. Byzantine art might equally well be accommodated within Wolfram's definition. To understand the full Cubist prophecy we must examine the content of their art.

A Cubist painting like Picasso's 'Bottle and Glasses' of 1911 is two-dimensional insofar as one's eye comes back again and again to the

surface of the picture. We start from the surface, we follow a sequence of forms which leads into the picture, and then suddenly we arrive back at the surface again and deposit our newly acquired knowledge upon it, before making another foray. This is why I called the Cubist picture-surface the origin and sum of all that we can see in the picture. There is nothing decorative about such two-dimensionality, nor is it merely an area offering possibilities of juxtaposition for dissociated images – as in the case of much recent neo-Dadaist or pop art. We begin with the surface, but since everything in the picture refers back to the surface we begin with the conclusion. We then search – not for an explanation, as we do if presented with an image with a single, predominant meaning (a man laughing, a mountain, a reclining nude), but for some under-standing of the configuration of events whose interaction is the conclusion from which we began. When we 'deposit our newly acquired knowledge upon the picture surface', what we in fact do is find the sign for what we have just discovered: a sign which was always there but which previously we could not read.

To make the point clearer it is worth comparing a Cubist picture with any work in the Renaissance tradition. Let us say Pollaiuolo's 'Martyrdom of St Sebastian'. In front of the Pollaiuolo the spectator completes the picture. It is the spectator who draws the conclusions and infers all except the aesthetic relations between the pieces of evidence offered – the archers, the martyr, the plain laid out behind, etc. It is he who through his reading of what is portrayed seals its unity of meaning. The work is presented to him. One has the feeling almost that St Sebastian was martyred so that he should be able to explain this picture. The complexity of the forms and the scale of the space depicted enhance the sense of achievement, of grasp.

In a Cubist picture, the conclusion and the connections are given. They are what the picture is made of. They are its content. The spectator has to find his place *within* this content whilst the complexity of the forms and the 'discontinuity' of the space remind him that his view from that place is bound to be only partial.

Such content and its functioning was prophetic because it coincided with the new scientific view of nature which rejected simple causality and the single permanent all-seeing viewpoint.

Heisenberg writes:

One may say that the human ability to understand may be in a certain sense unlimited. But the existing scientific concepts cover always only a very limited part of reality, and the other part that has not yet been understood is infinite. Whenever we proceed from the known to the unknown we may hope to understand, but we may have to learn at the same time a new meaning of the word understanding.[15]

Such a notion implies a change in the methodology of research and invention. W. Grey Walter, the physiologist, writes:

> Classical physiology, as we have seen, tolerated only one single unknown quantity in its equations – in any experiment there could be only one thing at a time under investigation . . . We cannot extract one independent variable in the classical manner; we have to deal with the interaction of many unknowns and variables, all the time . . . In practice, this implies that not one but many – as many as possible – observations must be made at once and compared with one another, and that whenever possible a simple known variable should be used to modify the several complex unknowns so that their tendencies and interdependence can be assessed.[16]

The best Cubist works of 1910, 1911 and 1912 were sustained and precise models for the method of searching and testing described above. That is to say, they force the senses and imagination of the spectator to calculate, omit, doubt and conclude according to a pattern which closely resembles the one involved in scientific observation. The difference is a question of appeal. Because the act of looking at a picture is far less concentrated, the picture can appeal to wider and more various areas of the spectator's previous experience. Art is concerned with memory: experiment is concerned with predictions.

Outside the modern laboratory, the need to adapt oneself constantly to presented totalities – rather than making inventories or supplying a transcendental meaning as in front of the Pollaiuolo – is a feature of modern experience which affects everybody through the mass media and modern communication systems.

Marshall McLuhan is a manic exaggerator, but he has seen certain truths clearly:

> In the electric age, when our central nervous system is technologically extended to involve us in the whole of mankind and to incorporate the whole of mankind in us, we necessarily participate, in depth, in the consequences of our every action . . . The aspiration of our time for wholeness, empathy and depth of awareness is a natural adjunct of electric technology. The age of mechanical industry that preceded us found vehement assertion of private outlook the natural mode of expression . . . The mark of our time is its revolution against imposed patterns. We are suddenly eager to have things and people declare their beings totally.[17]

The Cubists were the first artists to attempt to paint totalities rather than agglomerations.

* * *

I must emphasize again that the Cubists were not aware of all that we are now reading into their art. Picasso and Braque and Léger kept silent because they knew that they might be doing more than they knew. The lesser Cubists tended to believe that their break with tradition had freed them from the bondage of appearances so that they might deal with some kind of spiritual essence. The idea that their art coincided with the implications of certain new scientific and technological developments was entertained but never fully worked out. There is no evidence at all that they recognized as such the qualitative change which had taken place in the world. It is for these reasons that I have constantly referred to their *intimation* of a transformed world: it amounted to no more than that.

One cannot explain the exact dates of the maximum Cubist achievement. Why 1910 to 1912 rather than 1905 to 1907? Nor is it possible to explain *exactly* why certain artists, at exactly the same time, arrived at a very different view of the world – artists ranging from Bonnard to Duchamp or de Chirico. To do so we would need to know an *impossible* amount about each separate individual development. (In that impossibility – which is an absolute one – lies our freedom from determinism.)

We have to work with partial explanations. With the advantage of sixty years' hindsight, the correlations I have tried to establish between Cubism and the rest of history seem to me to be undeniable. The precise route of the connections remains unknown. They do not inform us about the intentions of the artists: they do not explain exactly why Cubism took place in the manner it did; but they do help to disclose the widest possible continuing meaning of Cubism.

Two more reservations. Because Cubism represented so fundamental a revolution in the history of art, I have had to discuss it as though it were pure theory. Only in this way could I make its revolutionary content clear. But naturally it was not pure theory. It was nothing like so neat, consistent or reduced. There are Cubist paintings full of anomalies and marvellous gratuitous tenderness and confused excitement. We see the beginning in the light of the conclusions it suggested. But it was only a beginning, and a beginning cut short.

For all their insight into the inadequacy of appearances and of the frontal view of nature, the Cubists used such appearances as their means of reference to nature. In the maelstrom of their new constructions, their liaison with the events which provoked them is shown by way of a simple, almost naïve reference to a pipe stuck in the 'sitter's' mouth, a bunch of grapes, a fruit dish or the title of a daily newspaper. Even in some of the most 'hermetic' paintings – for example Braque's 'Le Portugais' – you can find naturalistic allusions to details of the subject's appearance, such as the buttons on the musician's jacket, buried intact within the con-

struction. There are only a very few works – for instance Picasso's 'Le Modèle' of 1912 – where such allusions have been totally dispensed with.

The difficulties were probably both intellectual and sentimental. The naturalistic allusions seemed necessary in order to offer a measure for judging the transformation. Perhaps also the Cubists were reluctant to part with appearances because they suspected that in art they could never be the same again. The details are smuggled in and hidden as mementoes.

The second reservation concerns the social content of Cubism – or, rather, its lack of it. One cannot expect of a Cubist painting the same kind of social content as one finds in a Brueghel or a Courbet. The mass media and the arrival of new publics have profoundly changed the social role of the fine arts. It remains true, however, that the Cubists – during the moment of Cubism – were unconcerned about the personalized human and social implications of what they were doing. This, I think, is because they had to simplify. The problem before them was so complex that their manner of stating it and their trying to solve it absorbed all their attention. As innovators they wanted to make their experiments in the simplest possible conditions; consequently, they took as subjects whatever was at hand and made least demands. The content of these works is the relation between the seer and the seen. This relation is only possible given the fact that the seer inherits a precise historical, economic and social situation. Otherwise they become meaningless. They do not illustrate a human or social situation, they posit it.

I spoke of the continuing meaning of Cubism. To some degree this meaning has changed and will change again according to the needs of the present. The bearings we read with the aid of Cubism vary according to our position. What is the reading now?

It is being more and more urgently claimed that 'the modern tradition' begins with Jarry, Duchamp and the Dadaists. This confers legitimacy upon the recent developments of neo-Dadaism, auto-destructive art, happenings, etc. The claim implies that what separates the characteristic art of the twentieth century from the art of all previous centuries is its acceptance of unreason, its social desperation, its extreme subjectivity and its forced dependence upon existential experience.

Hans Arp, one of the original Dadaist spokesmen, wrote: 'The Renaissance taught men the haughty exaltation of their reason. Modern times, with their science and technology, turned men towards megalomania. The confusion of our epoch results from this overestimation of reason.'

And elsewhere: 'The law of chance, which embraces all other laws and is as unfathomable to us as the depths from which all life arises, can only be comprehended by complete surrender to the Unconscious.'[18]

Arp's statements are repeated today with a slightly modified vocabu-

lary by all contemporary apologists of outrageous art. (I use the word 'outrageous' descriptively and not in a pejorative sense.)

During the intervening years, the Surrealists, Picasso, de Chirico, Miró, Klee, Dubuffet, the Abstract Expressionists and many others can be drafted into the same tradition: the tradition whose aim is to cheat the world of its hollow triumphs, and disclose its pain.

The example of Cubism forces us to recognize that this is a one-sided interpretation of history. Outrageous art has many earlier precedents. In periods of doubt and transition the majority of artists have always tended to be preoccupied with the fantastic, the uncontrollable and the horrific. The greater extremism of contemporary artists is the result of their having no fixed social role; to some degree they can create their own. But there are precedents for the spirit of it in the history of other activities: heretical religions, alchemy, witchcraft, etc.

The real break with tradition, or the real reformation of that tradition, occurred with Cubism itself. The modern tradition, based on a qualitatively different relationship being established between man and the world, began, not in despair, but in affirmation.

The proof that this was the objective role of Cubism lies in the fact that, however much its spirit was rejected, it supplied to all later movements the primary means of their own liberation. That is to say, it re-created the syntax of art so that it could accommodate modern experience. The proposition that a work of art is a new object and not simply the expression of its subject, the structuring of a picture to admit the coexistence of different modes of space and time, the inclusion in a work of art of extraneous objects, the dislocation of forms to reveal movement or change, the combining of hitherto separate and distinct media, the diagrammatic use of appearances – these were the revolutionary innovations of Cubism.

It would be foolish to underestimate the achievements of post-Cubist art. Nevertheless it is fair to say that in general the art of the post-Cubist period has been anxious and highly subjective. What the evidence of Cubism should prevent us doing is concluding from this that anxiety and extreme subjectivity constitute the nature of modern art. They constitute the nature of art in a period of extreme ideological confusion and inverted political frustration.

During the first decade of this century a transformed world became theoretically possible and the necessary forces of change could already be recognized as existing. Cubism was the art which reflected the possibility of this transformed world and the confidence it inspired. Thus, in a certain sense, it was the most modern art – as it was also the most philosophically complex – which has yet existed.

The vision of the Cubist moment still coincides with what is technologically possible. Yet three-quarters of the world remain undernour-

ished and the foreseeable growth of the world's population is outstripping the production of food. Meanwhile millions of the privileged are the prisoners of their own sense of increasing powerlessness.

The political struggle will be gigantic in its range and duration. The transformed world will not arrive as the Cubists imagined it. It will be born of a longer and more terrible history. We cannot see the end of the present period of political inversion, famine and exploitation. But the moment of Cubism reminds us that, if we are to be representative of our century – and not merely its passive creatures – the aim of achieving that end must constantly inform our consciousness and decisions.

The moment at which a piece of music begins provides a clue to the nature of all art. The incongruity of that moment, compared to the uncounted, unperceived silence which preceded it, is the secret of art. What is the meaning of that incongruity and the shock which accompanies it? It is to be found in the distinction between the actual and the desirable. All art is an attempt to define and make *unnatural* this distinction.

For a long time it was thought that art was the imitation and celebration of nature. The confusion arose because the concept of nature itself was a projection of the desired. Now that we have cleansed our view of nature, we see that art is an expression of our sense of the inadequacy of the given – which we are not obliged to accept with gratitude. Art mediates between our good fortune and our disappointment. Sometimes it mounts to a pitch of horror. Sometimes it gives permanent value and meaning to the ephemeral. Sometimes it describes the desired.

Thus art, however free or anarchic its mode of expression, is always a plea for greater control and an example, within the artificial limits of a 'medium', of the advantages of such control. Theories about the artist's inspiration are all projections back on to the artist of the effect which his work has upon us. The only inspiration which exists is the intimation of our own potential. Inspiration is the mirror image of history: by means of it we can see our past, while turning our back upon it. And it is precisely this which happens at the instant when a piece of music begins. We suddenly become aware of the previous silence at the same moment as our attention is concentrated upon following sequences and resolutions which will contain the desired.

The Cubist moment was such a beginning, defining desires which are still unmet.

1969

The Historical Function of the Museum

The art museum curators of the world (with perhaps three or four exceptions) are simply not with us. Inside their museums they live in little châteaux or, if their interests are contemporary, in Guggenheim fortresses. We, the public, have our hours of admission and are accepted as a diurnal necessity: but no curator dreams of considering that his work actually begins with us.

Curators worry about heating, the colours of their walls, hanging arrangements, the provenances of their works, and visitors of honour. Those concerned with contemporary art worry about whether they are striking the right balance between discretion and valour.

Individuals vary, but as a professional group their character is patronizing, snobbish and lazy. These qualities are, I believe, the result of a continuous fantasy in which to a greater or lesser degree they all indulge. The fantasy weaves round the notion that they have been asked to accept as a *grave civic responsibility* the prestige accruing from the ownership of the works under their roof.

The works under their protection are thought of, primarily, as property – and therefore have to be owned. Most curators may believe that it is better for works of art to be owned by the state or city than by private collectors. But owned they must be. And so somebody must stand in an honorary owning relation to them. The idea that works of art, before they are property, are expressions of human experience and a means to knowledge is utterly distasteful to them because it threatens – not their position – but what they have constructed for themselves on the basis of their position.

Since the 'museum world' forms a large sector of the 'art world' which has recently acquired very considerable commercial and even diplomatic power, what I am saying is bound to be attacked as jaundiced. Nevertheless it is my considered opinion after years of treating with museum

directors throughout Europe and in both the socialist and capitalist countries. Leningrad in this respect is the same as Rome or Berlin.

It would be quite wrong to suggest that what curators now do is useless. They conserve – in the full sense of the word – what is already there; and some of them acquire new works intelligently. It is not useless but it is inadequate. And it is inadequate because it is outdated. Their view of art as a self-evident source of pleasure appealing to a well-formed Taste, their view of Appreciation being ultimately based on Connoisseurship – that is to say the ability to compare product with product within a very narrow range – all this derives from the eighteenth century. Their sense of heavy civic responsibility – transformed, as we have seen, into honorary prestige – their view of the public as a passive mass to whom works of art, embodying spiritual value, should be made available, this belongs to the nineteenth-century tradition of public works and benevolence. Anybody who is not an expert entering the average museum today is made to feel like a cultural pauper receiving charity, whilst the phenomenal sales of fifth-rate art books reflect the consequent belief in Self-Help.

The influence of the twentieth century on the thinking of museum curators has been confined to décor or to technical innovations for facilitating the passing of the public through their domain. In a book published a few years ago and written by an important curator in France it is suggested that the museum of the future will be mechanized: the visitors will sit still in little viewing boxes and the canvases will appear before them on a kind of vertical escalator. 'In this way, in one hour and a half, a thousand visitors will be able to see a thousand paintings without leaving their seats.' Frank Lloyd Wright's conception of the Guggenheim Museum in New York as a machine for having seen pictures in is only a more sophisticated example of the same attitude.

What then constitutes a truly modern attitude? Naturally every museum poses a different problem. A solution which might suit a provincial city would be absurd for the National Gallery. For the moment we can only discuss general principles.

First it is necessary to make an imaginative effort which runs contrary to the whole contemporary trend of the art world: it is necessary to see works of art freed from all the mystique which is attached to them as property objects. It then becomes possible to see them as testimony to the process of their own making instead of as products; to see them in terms of action instead of finished achievement. The question: what went into the making of this? supersedes the collector's question of: what is this?

It is worth noticing that this change of emphasis has already deeply affected art. From Action Painting onwards artists have become more and more concerned with revealing a process rather than coming to a

conclusion. Harold Rosenberg, who was the spokesman for the American innovators, has put it quite simply: 'Action painting . . . indicated a new motive for painting in the twentieth century: that of serving as a means for the artist's recreation of himself and as an evidence to the spectator of the kind of activities involved in this adventure.'

The new emphasis is the result of a revolution in our mode of general thinking and interpreting. Process has swept away all fixed states; the supreme human attribute is no longer knowledge as such, but the self-conscious awareness of process. The more original artists of the last twenty-five years have felt the shock of this revolution more keenly than most other people; but because they have also felt isolated in an indifferent society (success when it eventually came in no way qualified this indifference), they have been able to find no content for their new art except their own loneliness. Hence the narrowness of interest of their art; but hence also the relevance of its intimation.

In practical terms this means that in the modern museum, works of art of any period need to be shown within the context of various processes: the technical process of the artist's means, the biographical process of his life, and, above all, the historical process which he may reflect, influence, prophesy or be annulled by. This context will need to be established by the sequence in which paintings are hung and, whenever necessary, by texts on the wall. Photographs of paintings which are elsewhere will need to be hung next to real paintings. In the case of water-colours and drawings, facsimiles will need to be mixed with originals. Inferior works will need to be presented and explained as such. The Connoisseur's categories of nation and period will frequently need to be broken: a Boucher nude might be hung next to a Courbet. All decors will need to be neutral and mobile. The châtelain will lose his red velours South Room.

I might continue the list of other possible practical consequences but I can already hear the protests. Puritan, didactic propaganda! The philistine enslavement of art to historicism! With these and a thousand other cries and guffaws the sanctity of art as property will be defended: and the present curators will save themselves the humiliation of trying to think about their subject as a whole.

If the application of ideas to the understanding of art implies propaganda, that is indeed what I am proposing. On the other hand, I am certainly not suggesting that a museum should arrange its work along the line of a single permanent argument. Each group of works might be treated in a different way. No argument should be permanent, and even within one grouping of works there would be the possibility – by hanging pictures along screen-walls which intersect at the key work – of presenting a number of different arguments simultaneously. In the great collections works not being temporarily used as part of an argument

would be hung as now, for reference and for the pleasure of those who already know them, without comment.

In the case of all but the great metropolitan museums, the approach I am suggesting would transform them utterly. Their reputation would no longer depend upon the small number of unrivalled masterpieces they can claim. Second- and third-rate works could, by their context, be made significant and moving. Imagine a Greuze child study put beside a formal official baroque portrait by one of his contemporaries. Inferior and boring works would suddenly acquire a positive function – for they would illuminate the problems which another work had resolved. If museums collaborated with one another, every museum could have a fabulous collection of facsimile water-colours and drawings to suit its arguments or studies. Photographs could 'borrow' for many comparative purposes works from any collection in the world. In brief, the museum, instead of being a depository of so many unique sights or treasures, would become a living school with the very special advantage of dealing in visual images, which, given a simple framework of historical and psychological knowledge, can convey experience far more deeply to people than most literary and scientific expositions.

I have not the slightest doubt that museums will eventually serve the kind of function I am suggesting. I am certain about this, not only because museums will finally be forced to recognize their century and here is an obvious solution to many of their already existing problems, but also because of the only possible future function of the art we have inherited.

The purely aesthetic appeal and justification of art is based on less than a half-truth. Art must also serve an extra-artistic purpose. A great work often outlives its original purpose. But it does so because a later period is able to discern, within the profundity of the experience it contains, another purpose. For example: Villon wrote to introduce himself as he was to God. We read him today as perhaps the first poet of the 'free' man alone in Christian Europe.

We can no longer 'use' most paintings today as they were intended to be used: for religious worship, for celebrating the wealth of the wealthy, for immediate political enlightenment, for proving the romantic sublime, etc. Nevertheless painting is especially well-suited to developing the very faculty of understanding which has rendered its earlier uses obsolete: that is to say to developing our historical and evolutionary self-consciousness.

In front of a work from the past, by means of our aesthetic response as well as by imaginative intelligence, we become able to recognize the choices which reality allowed an artist four thousand, four hundred or forty years ago. This recognition need never be academic. We are given (as we are not in literature) the sensuous data through which the

alternatives of his choice must have presented themselves to him. It is as though we can benefit from our sensations and responses to the form and content of his work, being interpreted by his mind, conditioned by his period, as well as by our own mind. An extraordinary dialectic working across time! An extraordinary aid to realizing how we have historically arrived at becoming ourselves!

1966

The Changing View of Man in the Portrait

It seems to me unlikely that any important portraits will ever be painted again. Portraits, that is to say, in the sense of portraiture as we now understand it. I can imagine multi-medium memento-sets devoted to the character of particular individuals. But these will have nothing to do with the works now in the National Portrait Gallery.

I see no reason to lament the passing of the portrait – the talent once involved in portrait painting can be used in some other way to serve a more urgent, modern function. It is, however, worth while inquiring why the painted portrait has become outdated; it may help us to understand more clearly our historical situation.

The beginning of the decline of the painted portrait coincided roughly speaking with the rise of photography, and so the earliest answer to our question – which was already being asked towards the end of the nineteenth century – was that the photographer had taken the place of the portrait painter. Photography was more accurate, quicker and far cheaper; it offered the opportunity of portraiture to the whole of society: previously such an opportunity had been the privilege of a very small *élite*.

To counter the clear logic of this argument, painters and their patrons invented a number of mysterious, metaphysical qualities with which to prove that what the painted portrait offered was incomparable. Only a man, not a machine (the camera), could interpret the soul of a sitter. An artist dealt with the sitter's destiny: the camera with mere light and shade. An artist judged: a photographer recorded. Etcetera, etcetera.

All this was doubly untrue. First, it denies the interpretative role of the photographer, which is considerable. Secondly, it claims for painted portraits a psychological insight which ninety-nine per cent of them totally lack. If one is considering portraiture as a genre, it is no good thinking of a few extraordinary pictures but rather of the endless portraits of the local nobility and dignitaries in countless provincial

museums and town halls. Even the average Renaissance portrait – although suggesting considerable presence – has very little psychological content. We are surprised by ancient Roman or Egyptian portraits, not because of their *insight*, but because they show us very vividly how little the human face has changed. It is a myth that the portrait painter was a revealer of souls. Is there a qualitative difference between the way Velázquez painted a face and the way he painted a bottom? The comparatively few portraits that reveal true psychological penetration (certain Raphaels, Rembrandts, Davids, Goyas) suggest personal, obsessional interests on the part of the artist which simply cannot be accommodated within the *professional* role of the portrait painter. Such pictures have the same kind of intensity as self-portraits. They are in fact works of self-discovery.

Ask yourself the following hypothetical question. Suppose that there is somebody in the second half of the nineteenth century in whom you are interested but of whose face you have never seen a picture. Would you rather find a painting or a photograph of this person? And the question itself posed like that is already highly favourable to painting, since the logical question should be: would you rather find a painting or a whole album of photographs?

Until the invention of photography, the painted (or sculptural) portrait was the only means of recording and presenting the likeness of a person. Photography took over this role from painting and at the same time raised our standards for judging how much an informative likeness should include.

This is not to say that photographs are *in all ways* superior to painted portraits. They are more informative, more psychologically revealing, and in general more accurate. But they are less tensely unified. Unity in a work of art is achieved as a result of the limitations of the medium. Every element has to be transformed in order to have its proper place within these limitations. In photography the transformation is to a considerable extent mechanical. In a painting each transformation is largely the result of a conscious decision by the artist. Thus the unity of a painting is permeated by a far higher degree of intention. The total effect of a painting (as distinct from its truthfulness) is less arbitrary than that of a photograph; its construction is more intensely socialized because it is dependent on a greater number of human decisions. A photographic portrait may be more revealing and more accurate about the likeness and character of the sitter; but it is likely to be less persuasive, less (in the very strict sense of the word) conclusive. For example, if the portraitist's intention is to flatter or idealize, he will be able to do so far more convincingly with a painting than with a photograph.

From this fact we gain an insight into the actual function of portrait painting in its heyday: a function we tend to ignore if we concentrate on

the small number of exceptional 'unprofessional' portraits by Raphael, Rembrandt, David, Goya, etcetera. The function of portrait painting was to underwrite and idealize a chosen social role of the sitter. It was not to present him as 'an individual' but, rather, as an individual monarch, bishop, landowner, merchant and so on. Each role had its accepted qualities and its acceptable limit of discrepancy. (A monarch or a pope could be far more idiosyncratic than a mere gentleman or courtier.) The role was emphasized by pose, gesture, clothes and background. The fact that neither the sitter nor the successful professional painter was much involved with the painting of these parts is not to be entirely explained as a matter of saving time: they were thought of and were meant to be read as the accepted attributes of a given social stereotype.

The hack painters never went much beyond the stereotype; the good professionals (Memlinck, Cranach, Titian, Rubens, Van Dyck, Velázquez, Hals, Philippe de Champaigne) painted individual men, but they were nevertheless men whose character and facial expressions were seen and judged in the exclusive light of an ordained social role. The portrait must fit like a hand-made pair of shoes, but the type of shoe was never in question.

The satisfaction of having one's portrait painted was the satisfaction of being personally recognized and *confirmed in one's position*: it had nothing to do with the modern lonely desire to be recognized 'for what one really is'.

If one were going to mark the moment when the decline of portraiture became inevitable, by citing the work of a particular artist, I would choose the two or three extraordinary portraits of lunatics by Géricault, painted in the first period of romantic disillusion and defiance which followed the defeat of Napoleon and the shoddy triumph of the French bourgeoisie. The paintings were neither morally anecdotal nor symbolic: they were straight portraits, traditionally painted. Yet their sitters had no social role and were presumed to be incapable of fulfilling any. In other pictures Géricault painted severed human heads and limbs as found in the dissecting theatre. His outlook was bitterly critical: to choose to paint dispossessed lunatics was a comment on men of property and power; but it was also an assertion that the essential spirit of man was independent of the role into which society forced him. Géricault found society so negative that, although sane himself, he found the isolation of the mad more meaningful than the social honour accorded to the success-ful. He was the first and, in a sense, the last profoundly anti-social portraitist. The term contains an impossible contradiction.

After Géricault, professional portraiture degenerated into servile and crass personal flattery, cynically undertaken. It was no longer possible to believe in the value of the social roles chosen or allotted. Sincere artists painted a number of 'intimate' portraits of their friends or models

(Corot, Courbet, Degas, Cézanne, Van Gogh), but in these the social role of the sitter is reduced to *that of being painted*. The implied social value is either that of personal friendship (proximity) or that of being seen in such a way (being 'treated') by an original artist. In either case the sitter, somewhat like an arranged still life, becomes subservient to the painter. Finally it is not his personality or his role which impress us but the artist's vision.

Toulouse-Lautrec was the one important latter-day exception to this general tendency. He painted a number of portraits of tarts and cabaret personalities. As we survey them, they survey us. A social reciprocity is established through the painter's mediation. We are presented neither with a disguise – as with official portraiture – nor with mere creatures of the artist's vision. His portraits are the only late nineteenth-century ones which are persuasive and conclusive in the sense that we have defined. They are the only painted portraits in whose social evidence we can believe. They suggest, not the artist's studio, but 'the world of Toulouse-Lautrec': that is to say a specific and complex social milieu. Why was Lautrec such an exception? Because in his eccentric and obverse manner he believed in the social roles of his sitters. He painted the cabaret performers because he admired their performances: he painted the tarts because he recognized the usefulness of their trade.

Increasingly for over a century fewer and fewer people in capitalist society have been able to believe in the social value of the social roles offered. This is the second answer to our original question about the decline of the painted portrait.

The second answer suggests, however, that given a more confident and coherent society, portrait painting might revive. And this seems unlikely. To understand why, we must consider the third answer.

The measures, the scale-change of modern life, have changed the nature of individual identity. Confronted with another person today, we are aware, through this person, of forces operating in directions which were unimaginable before the turn of the century, and which have only become clear relatively recently. It is hard to define this change briefly. An analogy may help.

We hear a lot about the crisis of the modern novel. What this involves, fundamentally, is a change in the mode of narration. It is scarcely any longer possible to tell a straight story sequentially unfolding in time. And this is because we are too aware of what is continually traversing the story line laterally. That is to say, instead of being aware of a point as an infinitely small part of a straight line, we are aware of it as an infinitely small part of an infinite number of lines, as the centre of a star of lines. Such awareness is the result of our constantly having to take into account the simultaneity and extension of events and possibilities.

There are many reasons why this should be so: the range of modern

means of communication: the scale of modern power: the degree of personal political responsibility that must be accepted for events all over the world: the fact that the world has become indivisible: the unevenness of economic development within that world: the scale of the exploitation. All these play a part. Prophecy now involves a geographical rather than historical projection; it is space not time that hides consequences from us. To prophecy today it is only necessary to know men as they are throughout the whole world in all their inequality. Any contemporary narrative which ignores the urgency of this dimension is incomplete and acquires the over-simplified character of a fable.

Something similar but less direct applies to the painted portrait. We can no longer accept that the identity of a man can be adequately established by preserving and fixing what he looks like from a single viewpoint in one place. (One might argue that the same limitation applies to the still photograph, but as we have seen, we are not led to expect a photograph to be as conclusive as a painting.) Our terms of recognition have changed since the heyday of portrait painting. We may still rely on 'likeness' to identify a person, but no longer to explain or place him. To concentrate upon 'likeness' is to isolate falsely. It is to assume that the outermost surface *contains* the man or object: whereas we are highly conscious of the fact that nothing can contain itself.

There are a few Cubist portraits of about 1911 in which Picasso and Braque were obviously conscious of the same fact, but in these 'portraits' it is impossible to identify the sitter and so they cease to be what we call portraits.

It seems that the demands of a modern vision are incompatible with the singularity of viewpoint which is the prerequisite for a static-painted 'likeness'. The incompatibility is connected with a more general crisis concerning the meaning of individuality. Individuality can no longer be contained within the terms of manifest personality traits. In a world of transition and revolution individuality has become a problem of historical and social relations, such as cannot be revealed by the mere characterizations of an already established social stereotype. Every mode of individuality now relates to the whole world.

1967

Art and Property Now

A love of art has been a useful concept to the European ruling classes for over a century and a half. The love was said to be their own. With it they could claim kinship with the civilizations of the past and the possession of those moral virtues associated with 'beauty'. With it they could also dismiss as inartistic and primitive the cultures they were in the process of destroying at home and throughout the world. More recently they have been able to equate their love of art with their love of freedom and to oppose both loves to the alleged or real abuse of art in the socialist countries.

The usefulness of the concept had to be paid for. There were demands that a love of art, which was so apparently a privilege and was so apparently and intimately connected with morality, should be encouraged in all deserving citizens. This demand led to many nineteenth-century movements of cultural philanthropy – of which Western Ministries of Culture are the last, absurd and doomed manifestations.

It would be exaggeration to claim that the cultural facilities concerned with the arts and open to the public at large have yielded no benefits at all. They have contributed to the cultural development of many thousands of individuals. But all these individuals remain exceptions because the fundamental division between the initiated and the uninitiated, the 'loving' and the indifferent, the minority and the majority, has remained as rigid as ever. And it is inevitable that this should be so; for, quite apart from the related economic and educational factors, there is a hopeless contradiction within the philanthropic theory itself. The privileged are not in a position to teach or give to the underprivileged. Their own love of art is a fiction, a pretension. What they have to offer as lovers is not worth taking.

I believe that this is finally true concerning all the arts. But – for reasons which we shall examine in a minute – it is most obvious in the

field of the visual arts. For twenty years I have searched like Diogenes for a true lover of art: if I had found one I would have been forced to abandon as superficial, as an act of bad faith, my own regard for art which is constantly and openly political. I never found one.

Not even among artists? Least of all. Failed artists wait to be loved for themselves. Working artists love their next, as yet nonexistent, project. Most artists alternate between being one and the other.

During the summer, at the Uffizi Palace in Florence, the crowds, packed together, hot, their vision constantly obstructed, submit to a one- or two-hour guided tour in which nothing reveals itself or is revealed. They suffer an ordeal, but their reward is that they are able to claim that they have been to the Uffizi Palace. They have been near enough to the Botticellis to make sure that they are framed bits of wood or canvas which are possessible. They have, in a certain sense, acquired them: or, rather, they have acquired the right to refer to them in a proprietary context. It is as though – in a highly attenuated way – they have been, or they have played at being, the guests of the Medicis. All museums are haunted by the ghosts of the powerful and the wealthy: and on the whole we visit them to walk with the ghosts.

I know a private collector who owns some of the finest Cubist paintings ever painted, who has an encyclopaedic knowledge of the art of the period in which he is interested, who has excellent discrimination and who was or is a personal friend of several important artists. He has no business distractions; his inherited wealth is assured. He would seem to represent the antithesis of the uninformed and unseeing crowds who suffer the ordeal of the Uffizi Palace. He lives with his paintings in a large house with the time and quiet and knowledge to come as close to them as anybody has ever done. Here surely we have found a love of art? No, here we find a manic obsession to prove that everything he has bought is incomparably great and that anybody who in any way questions this is an ignorant scoundrel. So far as the psychological mechanism is concerned, the paintings could as well be conkers.

Walk down a street of private galleries – but it is unnecessary to describe the dealers with their faces like silk purses. Everything they say is said to disguise and hide their proper purpose. If you could fuck works of art as well as buy them, they would be pimps: but, if that were the case, one might assume a kind of love; as it is they dream of money and honour.

Critics? John Russell speaks for the vast majority of his colleagues when – without any sense of incongruity or shame – he explains how one of the excitements of art criticism lies in the opportunity it affords of acquiring an 'adventurous' private collection.

The truth is that a painting or a sculpture is a significant form of property – in a sense in which a story, a song, a poem is not. Its value as

property supplies it with an aura which is the last debased expression of the quality which art objects once possessed when they were used magically. It is around property that we piece together our last tattered religion, and our visual works of art are its ritual objects.

It is for this reason that, during the last decade, with the emergence of the new ideology of the consumer society, the visual arts have acquired a glamour such as they have not enjoyed for centuries. Exhibitions, art books, artists carry an urgent message even when the works themselves remain unintelligible. The message is that the work of art is the ideal (and therefore magical, mysterious, incomprehensible) commodity. It is dreamed of as the *spiritualized* possession. Nobody dreams or thinks of music, the theatre, the cinema or literature in the same way.

The extremism of most recent visual art is a consequence of the same situation. The artist welcomes the prestige and liberty accorded him; but insofar as he has an imaginative vision he profoundly resents his work being treated as a commodity. (The argument that there is nothing new in this situation, because works of art have been bought and sold for centuries, cannot be taken very seriously: the concept of private property has been stripped of its ideological disguise only very slowly.) Abstract Expressionism, *L'Art Brut,* Pop Art, Auto-Destructive art, Neo-Dada – these and other movements, despite profound differences of spirit and style, have all tried to exceed the limits within which a work of art can remain a desirable and valuable possession. All have questioned what makes a work of art art. But the significance of this questioning has been widely misunderstood – sometimes by the artists themselves. It does not refer to the process of creating art: it refers to the now blatantly revealed role of art as property.

I have never believed and still do not that Francis Bacon is a tragic artist. The violence he records is not the violence of the world: nor is it even the violence such as an artist might subjectively feel within himself; it is violence done to the idea that a painting might be desirable. The 'tragedy' is the tragedy of the easel painting, which cannot escape the triviality of becoming a desirable possession. And all the protesting art of recent years has been defeated in the same way. Hence its oppressiveness. It cannot liberate itself. The more violent, the more extreme, the rawer it becomes, the more appeal it acquires as an unusual and rare possession.

Marcel Duchamp, much admired today by the young because he was the first to question what makes a work of art art, and who already in 1915 bought a ready-made snow-shovel from a hardware store and did no more than give it a title (several editions of it are now in museums) – Duchamp himself recently admitted defeat as an iconoclast when he said: 'Today there is no shocking. The only thing shocking is no shocking.'

I do not mean it metaphorically when I say that soon a dealer will mount an exhibition of shit and collectors will buy it. Not, as is repeatedly said, because the public is gullible or because the art world is crazy, but because the passion to own has become so distorted and exacerbated that it now exists as an absolute need, abstracted from reality.

A certain number of artists have understood this situation, instead of merely reacting to it, and have tried to produce art which by its very nature resists the corruption of the property nexus: I refer to kinetic art and certain allied branches of Op art and Constructivism.

Twelve years ago Vasarely wrote:

> We cannot leave the pleasure to be got out of art in the hands of an *élite* of connoisseurs for ever. The new art forms are open to all. The art of tomorrow will be for all or it will not exist . . . In the past the idea of plastic art was tied to an artisan attitude and to the myth of the unique product: today the idea of plastic art suggests possibilities of re-creation, multiplication, expansion.[1]

That is to say the work of art can now be produced industrially and need have no scarcity value. It does not even have a fixed and proper state in which it can be preserved: it is constantly open to change and alteration. Like a toy, it wears out.

Such art differs qualitatively from all art that preceded it and that still surrounds it because its value resides in what it *does*, not in what it *is*. What it does is to encourage or provoke the spectator by the stimulus of its movements to become conscious of, and then to play with the processes of his own visual perception: in doing this it also renews or extends his awareness and interest in what is immediately surrounding both him and the work. The kinds of movement involved can vary; they may be optical or mechanical, planned or haphazard. The only essential is that the work is dependent upon changes whose origins are outside itself. Even if it moves regularly, driven by its own motor, this movement is only to start and set in motion changes which are beyond itself. Its nature is environmental. It is a device, of little intrinsic value, placed for our pleasure to interact between our senses and the space and time that surrounds them.

The promise of such art to date is limited. Its proper application to those environments in which the majority work and live must involve political and economic decisions beyond the control of artists. Meanwhile it has to be sold on the private market.

More profoundly, such art is limited because as yet its content does not admit the stuff of social relations: that is to say it cannot treat of tragedy, struggle, morality, cooperation, hatred, love. It is for this reason that one might categorize it so far (but not to belittle it) as a decorative art.

Nevertheless its essential nature, its mode of production and its refusal

to exploit the individual personality of the artist (which is inevitably unique) allows it to be free of the inversions and to escape the contradictions which cripple the rest of art today. The experiments of these artists will eventually be useful. As artists they have found a way of partly transcending their historical situation.

Does all this mean that the enduring and unique work of art has now served its purpose? Its heyday coincided with that of the bourgeoisie – will they both disappear together? If one takes the long historical view, this seems quite probable. But meanwhile the unevenness of historical development can hide unexpected, even unforeseeable possibilities. In the socialist countries the development of art has been artificially restrained. In much of the third world the autonomous work of art exists only as an export to feed the sick appetite of Europe. It may be that elsewhere the unique work will be given a different social context.

What is certain is that in our European societies as they are now, the unique work of art is doomed: it cannot escape being a ritual object of property, and its content, if not entirely complacent, cannot help but be an oppressive, because hopeless, attempt to deny this role.

1967

Image of Imperialism

On Tuesday, 10 October 1967, a photograph was transmitted to the world to prove that Guevara had been killed the previous Sunday in a clash between two companies of the Bolivian army and a guerrilla force on the north side of the Rio Grande river near a jungle village called Higueras. (Later this village received the proclaimed reward for the capture of Guevara.) The photograph of the corpse was taken in a stable in the small town of Vallegrande. The body was placed on a stretcher and the stretcher was placed on top of a cement trough.

During the preceding two years 'Che' Guevara had become legendary. Nobody knew for certain where he was. There was no incontestable evidence of anyone having seen him. But his presence was constantly assumed and invoked. At the head of his last statement – sent from a guerrilla base 'somewhere in the world' to the Tricontinental Solidarity Organization in Havana – he quoted a line from the nineteenth-century revolutionary poet José Martf: 'Now is the time of the furnaces, and only light should be seen.' It was as though in his own declared light Guevara had become invisible and ubiquitous.

Now he is dead. The chances of his survival were in inverse ratio to the force of the legend. The legend had to be nailed. 'If,' said *The New York Times*, 'Ernesto Che Guevara was really killed in Bolivia, as now seems probable, a myth as well as a man has been laid to rest.'

We do not know the circumstances of his death. One can gain some idea of the mentality of those into whose hands he fell by their treatment of his body after his death. First they hid it. Then they displayed it. Then they buried it in an anonymous grave in an unknown place. Then they disinterred it. Then they burnt it. But before burning it, they cut off the fingers for later identification. This might suggest that they had serious doubts whether it was really Guevara whom they had killed. Equally it can suggest that they had no doubts but feared the corpse. I tend to believe the latter.

The purpose of the radio photograph of 10 October was to put an end to a legend. Yet on many who saw it its effect may have been very different. What is its meaning? What, precisely and unmysteriously, does this photograph mean now? I can but cautiously analyse it as regards myself.

There is a resemblance between the photograph and Rembrandt's painting of *The Anatomy Lesson of Professor Tulp*. The immaculately dressed Bolivian colonel with a handkerchief to his nose has taken the professor's place. The two figures on his left stare at the cadaver with the same intense but impersonal interest as the two nearest doctors on the professor's left. It is true that there are more figures in the Rembrandt – as there were certainly more men, unphotographed, in the stable at Vallegrande. But the placing of the corpse in relation to the figures above it, and in the corpse the sense of global stillness – these are very similar.

Nor should this be surprising, for the function of the two pictures is similar: both are concerned with showing a corpse being formally and objectively examined. More than that, both are concerned with *making an example of the dead*: one for the advancement of medicine, the other as a political warning. Thousands of photographs are taken of the dead and the massacred. But the occasions are seldom formal ones of demonstration. Doctor Tulp is demonstrating the ligaments of the arm, and what he says applies to the normal arm of every man. The colonel with the handkerchief is demonstrating the final fate – as decreed by 'divine providence' – of a notorious guerrilla leader, and what he says is meant to apply to every guerrillero on the continent.

I was also reminded of another image: Mantegna's painting of the dead Christ, now in the Brera at Milan. The body is seen from the same height, but from the feet instead of from the side. The hands are in identical positions, the fingers curving in the same gesture. The drapery over the lower part of the body is creased and formed in the same manner as the blood-sodden, unbuttoned, olive-green trousers on Guevara. The head is raised at the same angle. The mouth is slack of expression in the same way. Christ's eyes have been shut, for there are two mourners beside him. Guevara's eyes are open, for there are no mourners: only the colonel with the handkerchief, a U.S. intelligence agent, a number of Bolivian soldiers and the journalists. Once again, the similarity need not surprise. There are not so many ways of laying out the criminal dead.

Yet this time the similarity was more than gestural or functional. The emotions with which I came upon that photograph on the front page of the evening paper were very close to what, with the help of historical imagination, I had previously assumed the reaction of a contemporary believer might have been to Mantegna's painting. The power of a

photograph is comparatively short-lived. When I look at the photograph now, I can only reconstruct my first incoherent emotions. Guevara was no Christ. If I see the Mantegna again in Milan, I shall see in it the body of Guevara. But this is only because in certain rare cases the tragedy of a man's death completes and exemplifies the meaning of his whole life. I am acutely aware of that about Guevara, and certain painters were once aware of it about Christ. That is the degree of emotional correspondence.

The mistake of many commentators on Guevara's death has been to suppose that he represented only military skill or a certain revolutionary strategy. Thus they talk of a setback or a defeat. I am in no position to assess the loss which Guevara's death may mean to the revolutionary movement of South America. But it is certain that Guevara represented and will represent more than the details of his plans. He represented a decision, a conclusion.

Guevara found the condition of the world as it is intolerable. It had only recently become so. Previously, the conditions under which two thirds of the people of the world lived were approximately the same as now. The degree of exploitation and enslavement was as great. The suffering involved was as intense and as widespread. The waste was as colossal. But it was not intolerable because the full measure of the truth about these conditions was unknown – even by those who suffered it. Truths are not constantly evident in the circumstances to which they refer. They are born – sometimes late. This truth was born with the struggles and wars of national liberation. In the light of the new-born truth, the significance of imperialism changed. Its demands were seen to be different. Previously it had demanded cheap raw materials, exploited labour and a controlled world market. Today it demands a mankind that counts for nothing.

Guevara envisaged his own death in the revolutionary fight against this imperialism.

> Wherever death may surprise us, let it be welcome, provided that this, our battle-cry, may have reached some receptive ear and another hand may be extended to wield our weapons and other men be ready to intone the funeral dirge with the staccato chant of the machine-gun and new battle-cries of war and victory.[1]

His envisaged death offered him the measure of how intolerable his life would be if he accepted the intolerable condition of the world as it is. His envisaged death offered him the measure of the necessity of changing the world. It was by the licence granted by his envisaged death that he was able to live with the necessary pride that becomes a man.

At the news of Guevara's death, I heard someone say: 'He was the

world symbol of the possibilities of one man.' Why is this true? Because he recognized what was intolerable for man and acted accordingly.

The measure by which Guevara had lived suddenly became a unit which filled the world and obliterated his life. His envisaged death became actual. The photograph is about this actuality. The possibilities have gone. Instead there is blood, the smell of formol, the untended wounds on the unwashed body, flies, the shambling trousers: the small private details of the body rendered in dying as public and impersonal and broken as a razed city.

Guevara died surrounded by his enemies. What they did to him while he was alive was probably consistent with what they did to him after he was dead. In his extremity he had nothing to support him but his own previous decisions. Thus the cycle was closed. It would be the vulgarest impertinence to claim any knowledge of his experience during that instant or that eternity. His lifeless body, as seen in the photograph, is the only report we have. But we are entitled to deduce the logic of what happens when the cycle closes. Truth flows in the obverse direction. His envisaged death is no more the measure of the necessity for changing the intolerable condition of the world. Aware now of his actual death, he finds in his life the measure of his justification, and the world-as-his-experience becomes tolerable to him.

The foreseeing of this final logic is part of what enables a man or a people to fight against overwhelming odds. It is part of the secret of the moral factor which counts as three to one against weapon power.

The photograph shows an instant: that instant at which Guevara's body, artificially preserved, has become a mere object of demonstration. In this lies its initial horror. But what is it intended to demonstrate? Such horror? No. It is to demonstrate at the instant of horror, the identity of Guevara and, allegedly, the absurdity of revolution. Yet by virtue of this very purpose, the instant is transcended. The life of Guevara and the idea or fact of revolution immediately invoke processes which preceded that instant and which continue now. Hypothetically, the only way in which the purpose of those who arranged for and authorized the photograph could have been achieved would have been to preserve artificially at that instant the whole state of the world as it was: to stop life. Only in such a way could the content of Guevara's living example have been denied. As it is, either the photograph means nothing because the spectator has no inkling of what is involved, or else its meaning denies or qualifies its demonstration.

I have compared it with two paintings because paintings, before the invention of photography, are the only visual evidence we have of how people saw what they saw. But in its effect it is profoundly different from a painting. A painting, or a successful one at least, comes to terms with the processes invoked by its subject matter. It even suggests an attitude

towards those processes. We can regard a painting as almost complete in itself.

In face of this photograph we must either dismiss it or complete its meaning for ourselves. It is an image which, as much as any mute image ever can, calls for decision.

October 1967

Prompted by another recent newspaper photograph, I continue to consider the death of 'Che' Guevara.

Until the end of the eighteenth century, for a man to envisage his death as the possibly direct consequence of his choice of a certain course of action is the measure of his *loyalty* as a servant. This is true whatever the social station or privilege of the man. Inserted between himself and his own meaning there is always a power to which his only possible relationship is one of service or servitude. The power may be considered abstractly as Fate. More usually it is personified in God, King or the Master.

Thus the choice which the man makes (the choice whose foreseen consequence may be his own death) is curiously incomplete. It is a choice submitted to a superior power for acknowledgement. The man himself can only judge *sub judice*: finally it is he who will be judged. In exchange for this limited responsibility he receives benefits. The benefits can range from a master's recognition of his courage to eternal bliss in heaven. But in all cases the ultimate decision and the ultimate benefit are located as exterior to his own self and life. Consequently death, which would seem to be so definitive an *end*, is for him a *means*, a treatment to which he submits for the sake of some aftermath. Death is like the eye of a needle through which he is threaded. Such is the mode of his heroism.

The French Revolution changed the nature of heroism. (Let it be clear that I do not refer to specific courages: the endurance of pain or torture, the will to attack under fire, the speed and lightness of movement and decision in battle, the spontaneity of mutual aid under danger – these courages must be largely defined by physical experience and have perhaps changed very little. I refer only to the choice which may precede these other courages.) The French Revolution brings the King to judgement and condemns him.

Saint-Just, aged twenty-five, in his first speech to the Convention argues that monarchy is crime, because the king usurps the sovereignty of the people.

It is impossible to reign innocently: the madness of it is too clear. Every king is a rebel and a usurper.[2]

It is true that Saint-Just serves – in his own mind – the General Will of the people, but he has freely chosen to do so because he believes that the People, if allowed to be true to their own nature, embody Reason and that their Republic represents Virtue.

In the world there are three kinds of infamy with which Republican virtue can reach no compromise: the first are kings: the second is the serving of kings: the third is the laying down of arms whilst there still exists anywhere a master and a slave.[3]

It is now less likely that a man envisages his own death as the measure of his loyalty as a servant to a master. His envisaged death is likely to be the measure of his love of Freedom: a proof of the principle of his own liberty.

Twenty months after his first speech Saint-Just spends the night preceding his own execution writing at his desk. He makes no active attempt to save himself. He has already written:

Circumstances are only difficult for those who draw back from the grave . . . I despise the dust of which I am composed, the dust which is speaking to you: any one can pursue and put an end to this dust. But I defy anybody to snatch from me what I have given myself, an independent life in the sky of the centuries.[4]

'What I have given to myself'. The ultimate decision is now located within the self. But not categorically and entirely; there is a certain ambiguity. God no longer exists, but Rousseau's Supreme Being is there to confuse the issue by way of a metaphor. The metaphor allows one to believe that the self will share in the historical judgement of one's own life. 'An independent life in the sky' of historical judgement. There is still the ghost of a pre-existent order.

Even when Saint-Just is declaring the opposite – in his defiant last speech of defence for Robespierre and himself – the ambiguity remains:

Fame is an empty noise. Let us put our ears to the centuries that have gone: we no longer hear anything; those who, at another time, shall walk among our urns, shall hear no more. The good – that is what we must pursue, whatever the price, preferring the title of a dead hero to that of a living coward.[5]

But in life, as opposed to the theatre, the dead hero never hears himself so called. The political stage of a revolution often has a theatrical, because exemplary, tendency. The world watches to learn.

> Tyrants everywhere looked upon us because we were judging one of theirs; today when, by a happier destiny, you are deliberating on the liberty of the world, the people of the earth who are the truly great of the earth will, in their turn, watch you. (Saint-Just to the Convention on the Constitution.)[6]

Yet, notwithstanding the truth of this, there is, philosophically, a sense in which Saint-Just dies triumphantly trapped within his 'stage' role. (To say this in no way detracts from his courage.)

Since the French Revolution, the bourgeois age. Amongst those few who envisage their own death (and not their own fortunes) as the direct consequence of their principled decisions, such marginal ambiguity disappears.

The confrontation between the living man and the world as he finds it becomes total. There is nothing exterior to it, not even a principle. A man's envisaged death is the measure of his refusal to accept what confronts him. There is nothing beyond that refusal.

The Russian anarchist Voinarovsky, who was killed throwing a bomb at Admiral Dubassov, wrote: 'Without a single muscle on my face twitching, without saying a word, I shall climb on the scaffold – and this will not be an act of violence perpetrated on myself, it will be the perfectly natural result of all that I have lived through.'[7]

He envisages his own death on the scaffold – and a number of Russian terrorists at that time died exactly as he describes – as though it were the peaceful death of an old man. Why is he able to do this? Psychological explanations are not enough. It is because he finds the world of Russia, which is comprehensive enough to seem like the whole world, intolerable. Not intolerable to him personally, as a suicide finds the world, but intolerable *per se*. His foreseen death 'will be the perfectly natural result' of all that he has lived through in his attempt to change the world, because the foreseeing of anything less would have meant that he found the 'intolerable' tolerable.

In many ways the situation (but not the political theory) of the Russian anarchists at the turn of the century prefigures the contemporary situation. A small difference lies in 'the world of Russia' *seeming* like the whole world. There was, strictly speaking, an alternative beyond the borders of Russia. Thus, in order to destroy this alternative and make Russia a world unto itself, many of the anarchists were drawn towards a somewhat mystical patriotism. Today there is no alternative. The world is a single unit, and it has become intolerable.

Was it ever more tolerable? you may ask. Was there ever less suffering, less injustice, less exploitation? There can be no such audits. It is necessary to recognize that the intolerability of the world is, in a certain sense, an historical achievement. The world was not intolerable so long as God existed, so long as there was the ghost of a pre-existent order, so long as large tracts of the world were unknown, so long as one believed in the distinction between the spiritual and the material (it is there that many people still find their justification in finding the world tolerable), so long as one believed in the natural inequality of man.

The photograph shows a South Vietnamese peasant being interrogated by an American soldier. Shoved against her temple is the muzzle of a gun, and, behind it, a hand grasps her hair. The gun, pressed against her, puckers the prematurely old and loose skin of her face.

In wars there have always been massacres. Interrogation under threat or torture has been practised for centuries. Yet the meaning to be found – even via a photograph – in this woman's life (and by now her probable death) is new.

It will include every personal particular, visible or imaginable: the way her hair is parted, her bruised cheek, her slightly swollen lower lip, her name and all the different significations it has acquired according to who is addressing her, memories of her own childhood, the individual quality of her hatred of her interrogator, the gifts she was born with, every detail of the circumstances under which she has so far escaped death, the intonation she gives to the name of each person she loves, the diagnosis of whatever medical weakness she may have and their social and economic causes, everything that she opposes in her subtle mind to the muzzle of the gun jammed against her temple. But it will also include global truths: no violence has been so intense, so widespread or has continued for so long as that inflicted by the imperialist countries upon the majority of the world: the war in Vietnam is being waged to destroy the example of a united people who resisted this violence and proclaimed their independence: the fact that the Vietnamese are proving themselves invincible against the greatest imperialist power on earth is a proof of the extraordinary resources of a nation of thirty-two million: elsewhere in the world the resources (such resources include not only materials and labour but the possibilities of each life lived) of our 2,000 millions are being squandered and abused.

It is said that exploitation must end in the world. It is known that exploitation increases, extends, prospers and becomes ever more ruthless in defence of its right to exploit.

Let us be clear: it is not the war in Vietnam that is intolerable: Vietnam confirms the intolerability of the present condition of the world. This condition is such that the example of the Vietnamese people offers hope.

Guevara recognized this and acted accordingly. The world is not intolerable until the possibility of transforming it exists but is denied. The social forces historically capable of bringing about the transformation are – at least in general terms – defined. Guevara chose to identify himself with these forces. In doing so he was not submitting to so-called 'laws' of history but to the historical nature of his own existence.

His envisaged death is no longer the measure of a servant's loyalty, nor the inevitable end of an heroic tragedy. The eye of death's needle has been closed – there is nothing to thread through it, not even a future (unknown) historical judgement. Provided that he makes no transcendental appeal and provided that he acts out of the maximum possible consciousness of what is knowable to him, his envisaged death has become the measure of the parity which can now exist between the self and the world: it is the measure of his total commitment and his total independence.

It is reasonable to suppose that after a man such as Guevara has made his decision, there are moments when he is aware of this freedom which is qualitatively different from any freedom previously experienced.

This should be remembered as well as the pain, the sacrifice and the prodigious effort involved. In a letter to his parents when he left Cuba, Guevara wrote:

> Now a will-power that I have polished with an artist's attention will support my feeble legs and tired-out lungs. I will make it.[8]

December 1967

Nude in a Fur Coat

Rubens

The interest in drawing or painting nude or semi-nude figures is profoundly sexual: likewise the appreciation of the finished product. The assertion that all plastic art has a sexual basis is liable to confuse the issue. The interest I am talking about is direct and in most cases quite conscious. Titian knew perfectly well why he enjoyed painting nymphs: just as the homosexual painters of the Renaissance knew why they were interested in the subject of St Sebastian: the subject which allowed them to paint a young, nude man in ecstasy.

It is this which makes it possible to compare Rubens's painting of his wife with a fur round her shoulders with a typical but prettier than average photograph from *Beauties of the Month*. Both painting and photograph were intended to appeal to the viewer's imaginative sexual pleasure in a woman's body.

There are important differences. A wife from the Flemish *haute bourgeoisie* of the seventeenth century was a very different person from a free-roaming young woman in London today: physically different and aspiring to a different physical ideal.

There are also differences of purpose. One picture was made largely for the artist's personal satisfaction; the other largely for an impersonal market. Nevertheless the comparison is possible because of their common appeal and because our sexual imagination, unless distressingly inhibited, should be able to transcend the historical changes of taste involved. I want to make the comparison, not in order to prove the obvious – which is that the photograph here is rather less than a work of art – but because I believe the comparison may throw some light on the problem of sexual imagery.

There are surprisingly few paintings in European art of entirely disclosed nude women. The foci of sexual interest – the sexual parts themselves and the breasts – are usually disguised or underemphasized. Inconsequential draperies fall between women's legs; or their hands,

while drawing attention to their sex, hide it. Until comparatively recently, women were invariably painted without pubic hair. Similarly, although breasts were more openly displayed, their nipples were modestly diminished in size and emphasis.

To explain this in terms of moral injunctions would be to project a late-nineteenth-century puritanism backwards into the past. To explain it in terms of aesthetics might be historically more accurate. A Renaissance painter would probably have justified his practice in terms of what seemed and did not seem beautiful. Yet aesthetics are a consequence rather than a cause. And although the producers of *Beauties of the Month* and other such booklets can hardly be accused of aestheticism, they obey the same rule. The models (except in one or two other series from abroad) are shaved: the ratio of half-disguised or half-dressed figures to naked ones is about four to one. Is this simply the result of the very indirect influence of pictorial convention?

It is a truism that figures undressing are more provocative than naked ones. Clearly the viewer's expectations are an important factor: imagine a strip club where the girls begin naked and end up fully clothed. (Only poets and lovers would perhaps attend, remembering the experience of lying in bed and watching her dress.) Yet why should it be the preliminary expectations that appeal most? Why is the ensuing nakedness an anti-climax by comparison?

To answer this question we must turn to the sexual function of nakedness in reality, rather than on a stage or in a picture. Clothes encumber contact and movement. But it would seem that nakedness has a positive visual value in its own right: we want to *see* her naked: she delivers to us the sight of herself and we seize upon it – often quite regardless of whether we are seeing her for the first time or the hundredth. What does this sight of her mean to us, how does it, at that instant of total disclosure, affect our desire?

I may be wrong, and professional psychologists may correct me, but it seems to me that her nakedness acts as a confirmation and provokes a very strong sense of relieved happiness. She is a woman like any other: we are overwhelmed by the marvellous simplicity of the familiar mechanism.

We did not, of course, consciously expect her to be otherwise: unconscious homosexual, sado-masochistic or other desires may have led us to suppress more fantastic expectations: but our 'relief' can be explained without recourse to the unconscious.

We did not expect her to be otherwise, but the urgency and complexity of our feelings bred a sense of uniqueness which the sight of her, *as she is*, then dispels. She is more like any other woman than she is different. In this lies the warm and friendly – as opposed to cold and impersonal – anonymity of nakedness.

The relief of being reminded that women have sexual characteristics

in common can obviously be explained by an Oedipus relationship to the mother: it is the relief of being reminded that all women are really like the first one. But what concerns me more now is the attempt to define that element of banality in the instant of total disclosure: an element that exists only because we need it.

Up to that instant she is more or less mysterious. The etiquettes of modesty are not only puritan or sentimental: they recognize the loss of mystery as real. And the explanation is largely a visual one. The focus of interest shifts from her eyes, her mouth, her shoulders, her hands – all of which are capable of such subtleties of expression that her personality, perceived through them, remains manifold – it shifts from these to her sexual parts, whose formation suggests an utterly compelling but single process. She is reduced or elevated – whichever you prefer – to her primary category: she is *female.* Our relief is the relief of finding a reality to whose exigencies all our earlier fantasies must now yield.

I said that we needed the banality which we find in the first instant of disclosure. And I have explained how – crudely speaking – it brings us back to reality. But it does more than that. This reality, by promising the familiar, proverbial mechanism of sex, offers at the same time the opportunity of mutual subjective identification: the opportunity of what I term in my essay on Picasso the 'shared subjectivity of sex'.[1]

Thus it is from the instant of disclosure onwards that we and she can become mysterious as a single unit. Her loss of mystery occurs simultaneously with the offering of the means for creating a shared mystery. The sequence is: subjective – objective – subjective to the power of two.

How much has this to do with seeing? Could not the same process take place in the dark? It could; but this only substitutes a rather narrowly ranged sense of touch for the far freer and comprehensive sense of sight. Indeed, the sense of sight is so free – that is to say so susceptible to the imagination it feeds – that the process I have described, although normally occurring as part of an overt sexual relationship, can also take place metaphorically.

When I was drawing a lot from models and teaching Life Drawing, the first sight of the model just undressed always had an equivalent effect on me. Prior to that moment she was the creature of her own temperament. Suddenly she became proverbial. Later as one drew her, relying alternately upon analysis and empathy, her particular idiosyncratic existence and one's own imagination became – for the duration of the drawing – inseparable.

We can now understand the difficulty of presenting an image of emphatic and total nakedness. The image will tend to strike us as banal. And, taken out of context and sequence, this banality, instead of serving as a bridge between two intense imaginative states, will tend merely to emphasize itself.

Let us now return to the comparison of the two pictures. Neither of the two models is entirely naked. Yet our conclusions are relevant; for having analysed nakedness at its most extreme as a factor of sexual experience, we can now see how any degree of nakedness is part of a process which naturally continues past the point of total disclosure. Some may object that this is only a needlessly complicated way of saying: if you see her undressed, you want to fuck her. But crass over-simplification about such matters is an evasion.

Both pictures are intended to imply development in time.

We are meant to presume that the next thing the girl in the photograph will do is to take her panties off. She wears them for our benefit rather than for her own. Rubens's wife is in the act of turning, her fur about to slip off her shoulders. Clearly she cannot remain as she is for more than a second. In a superficial sense her image is more instantaneous than the photograph's.

But, in a more profound sense, the painting 'contains' time and its experience. It is easy to imagine that a moment before the woman pulled the fur round her shoulders, she was entirely naked. The consecutive stages up to and away from the moment of total disclosure have been transcended. She can belong to any or all of them simultaneously. This is not the case with the girl in the photograph. Everything about her – her expression, her pose, her relationship with the viewer and the nature of the medium as used here – makes it certain that she can only be about to undress further.

Something similar happens in terms of form. In the photograph she confronts us as a matter of fact. Our own or anybody else's possible pleasure in this fact is a totally separate issue. It is not that we are disinterested, but that the image offered us is disinterested. It is as though we saw her through the *eyes* of a eunuch while our sexual interest remained normal. Hence her so peculiar tangibility. She is there and yet she is not there: this contradiction being the result, not of the naturalism of the picture, but of its total lack of subjectivity. One might describe this lack – projecting it back onto her – by saying that her body looks as though it is numb.

In the Rubens the woman's body, far from looking numb, looks extremely susceptible and vulnerable: which, by the same conversion as we have just made, means that she confronts us as experience.

Why do we have such an impression? There are superficial literary reasons: her dishevelled hair, the expression of her eyes revealing how sex liberates into temporary timelessness, the extreme paleness of her skin. But the profound reason is a formal and visual one. Her appearance has been literally broken by the painter's subjectivity. Beneath the fur that she holds across herself, the upper part of her body and her legs can never meet. There is a displacement sideways of about nine inches:

her thighs, in order to join on to her hips, are at least nine inches too far to the left.

I doubt whether Rubens planned this: just as I doubt whether most viewers consciously notice it. In itself it is unimportant. What matters is what it permits. It permits the body to become impossibly dynamic. Its coherence is no longer within itself but within the wishes of the viewer. More precisely, it permits the upper and lower halves of the body to rotate separately and in opposite directions round the sexual centre which is hidden: the torso turning to the right, the legs to the left. At the same time this hidden sexual centre is connected by means of the dark fur coat to all the surrounding darkness in the picture, so that she is turning both *around* and *within* the dark which has been made a metaphor for her sex.

Apart from the necessity of transcending the single moment and of admitting subjectivity, there is one further element which is essential for any great sexual image of the nude. This is the element of banality. In one form or another this has to exist because, as we saw, it is what transforms the voyeur into the lover. Different painters – Giorgione in the *Tempesta*, Rembrandt, Watteau, Courbet – have introduced it in different ways: Rubens introduces it here by means of his compulsive painting of the softness of the fat flesh.

1966

The Painter in His Studio

Vermeer

The great revelations all occur before the age of twenty-five. Perhaps because one is so keenly expecting them. Rilke was the first modern European poet I read. Matisse the first draughtsman I understood. My experience of their works is impossible to separate from a girl's bed, London streets in the early hours of the morning, the stair-well we gazed down into, leaning over the balustrade smoking, whilst the model in the life class rested and the German planes flew very high overhead; in the stair-well we watched men and women ascending and descending, each with their own life full of unexpected changes, partings and offers. Certain poems of Rilke's are still charged for me with the pride of that time.

The revelations which come later are more objective. One has the sense of suddenly seeing in a new light. But the light is almost as impersonal as the truth. The images are no longer coloured by the recent sensations of one's own limbs. One becomes simultaneously humbler and more arrogant. One feels a duty and not, as before, just the desire to recognize and be recognized. Everyone over thirty-five starts to explain.

Vermeer's *Painter in His Studio* was a comparatively late revelation. It was the summer a few years ago in the Kunsthistorisches Museum in Vienna. Outside in the public garden the sparrows were bathing in the dust. These sparrows were already making their way into the mind of Corker: the central character of the novel I was writing.

For many years I had walked past Vermeers without looking. The painter Friso ten Holt first persuaded me to look. Then I realized that the only thing Vermeer had in common with the other Dutch interior painters was his subject matter, and this was no more than his starting point. His real concern was different and mysterious.

What was it that he wanted to say in the stillness of his rooms which the

light fills like water a tank? (It is almost possible to imagine that the light flowing in is audible.) What is the meaning of these women at table and window whom the light discloses? Why can we feel so near to them, our eyes taking in every intimate drop of light (as though by observing we were drying slightly moist surfaces), and yet at the same time be so remote from them?

The questions are not purely rhetorical, for Vermeer was one of the most deliberate painters who ever lived. (His extremely small output is related to this.) The meaning of his art, however complex, must have been in large measure conscious.

The explanation usually given is technical. Vermeer used a camera obscura. (A camera obscura works like an old-fashioned plate camera with a head covering for the photographer. But instead of the light falling on a sensitized plate, the artist himself traces the image on paper or canvas.) This is why Vermeer's perspective has a strange remoteness – the foreground objects, although very close, always being seen as if in the middle distance; and this is why his subjects have the odd, cold intimacy of colour photography.

Although this is certainly a partial explanation, it never seemed to me entirely adequate. It begs the question of why Vermeer used his technical means with such a single-minded passion. Lawrence Gowing in his book on Vermeer[1] offers a psychological explanation: that Vermeer could not face reality unprotected, that he always needed an artificial process of mediation. The book interested me when I read it, but I was still not satisfied. There still seemed a philosophical purpose in Vermeer's art which had not yet been fully understood. I did not know what it was.

Meanwhile I merely noticed, as a possible contribution to an unknown answer, his recurring interest in signs, images and writing. In nearly every interior he painted, there is either a map, a sheet of music, a letter, a chart, or a picture whose subject-matter functions like an ideogram. (For instance, behind the woman weighing pearls in a pair of scales is a picture of the Last Judgement.) Was this only the result of convention and contemporary interests? Or was it a more personal, obsessive preoccupation?

I had gone to Vienna to look particularly at the Brueghels and Rubens and also at the Strozzis. Strozzi is a minor painter who fascinates me like a great conversationalist. I find it easy to believe that he was a doctor – this might explain his remarkable psychological insight. I noticed the Vermeer, but saw it as it were out of the corner of my mind. Then, suddenly, it absorbed all my attention. Here was Vermeer's own comment on being a painter, his own confession of purpose. All the other Vermeers I had ever seen might now be tested.

The painting shows a painter painting a young girl standing in the light from an unseen window. It has been interpreted as an allegory in which the young girl represents Clio, the muse of history, holding the

trumpet of fame and the golden record of the world's events. According to this interpretation, she is looking at the emblems of three other muses which are lying on the table: the mask of Comedy, the book of Polyhymnia, the muse of music, and the score of Euterpe, the muse of flute-playing. All commentators are agreed that the painter is Vermeer himself in his own studio in Delft.

The interpretation of the allegory is ingenious, but it seemed to me beside the point. There was a far starker statement waiting to be read. What the girl is looking at on the table are precisely the visual ingredients or elements of her own appearance. There is a face (the mask), another large book, a piece of blue material like that of her own dress, a piece of yellow material the same colour as the binding of her book, a strip of pinkish paper which corresponds to the glimpse we have of her pinkish collar and, woven into the design of the curtain which hangs in front of the table, are the blue leaves from which her laurel wreath is made. True, there is no trumpet on the table, but there is the written music which the trumpet can turn into sound. The point of the confrontation is to demonstrate the difference between the living and the inert: a difference which transcends all the common visual elements. It is as though Vermeer were exclaiming: Breath is all!

And to emphasize how relevant this is to the art of painting, he shows himself carefully making marks on a canvas to represent the laurel leaves of the living girl. The marks he is making are different from the woven leaves on the curtain. The leaves of the curtain are lifeless. The living girl, wearing the same leaves, transforms them; they become, like her, unpredictable. The painter 'fixes' these leaves on his canvas: they become once more inert and two-dimensional but charged now with the painter's awareness of the mystery of his living model.

Vermeer's father was a silk-weaver who probably designed the flowers and figures for the curtains he made. It was perhaps he who first taught Vermeer to draw. If so, Vermeer's ambition to be a painter may well have made him question his father's decorative formulae, so that he became especially aware of the differences between a living form and its formalized representation. Later, his use of the camera obscura must have further increased this awareness. On the one hand, it helped him to be very faithful to living appearances; on the other hand, it emphasized how much art had to depend upon a device. There, outside, was the changing tangible reality! And here, inside the box, was its flat appearance which he traced! This is not to suggest that there is any self-disparagement in Vermeer's art. He was preoccupied, not by his limitations, but by those aspects of reality which by their nature defy visual representation.

Historically this is not surprising. He was born in the year in which Galileo published his Copernican dialogues. He was a contemporary of Pascal, who less than ten years before had written:

This whole visible world is only an imperceptible mark upon the ample bosom of nature. No idea of ours can begin to encompass it. No matter how we extend our conceptions beyond the confines of imaginable space, we can bring forth nothing but atoms, at the cost of the reality of things. It is a sphere whose centre is everywhere and whose circumference is nowhere.[2]

Vermeer was a friend and exact contemporary of the microscopist Leeuwenhoek, who found and described invisible bacteria. For the first time science, rather than religion, was proving the evidence of the eye inadequate.

I began to realize the significance of the maps on Vermeer's walls: the maps are diagrams of the country outside the window which we never see; of his favourite theme of the letter, either just delivered or just being written, and whose message from or to the outside world we cannot know; of the light which always enters obliquely through a window we cannot see through. The fundamental difference between Vermeer and the other Dutch interior painters is that everything in every interior he paints refers to events outside the room. Their spirit is the opposite of the domestic. The function of the closed-in corner of the room is to remind us of the infinite.

Vermeer was the first sceptic in painting, the first to question the adequacy of visual evidence. Because three centuries later this scepticism was transformed into disillusion, and the art of recording immediate appearances was abandoned, it is difficult for us to appreciate how affirmative and calm Vermeer's scepticism was. It was the condition of his approach to reality. He was able to portray with unique precision what constituted one moment because he was so keenly aware, objectively and without a trace of nostalgia, that each succeeding moment is unrepeatable.

The Impressionists were concerned with the momentary, passing effects of light. But they worked on the assumption that these effects, given similar atmospheric conditions, were repeatable. In front of a Monet landscape we become aware of the hour of the day and the season of the year. In front of a Vermeer woman exactly turning her head, reading a letter, pouring milk, trying on a necklace in a mirror, raising a glass, we become aware of the flow of time itself.

That is why the light seems like water.

1966

Et in Arcadia Ego

Poussin

'I have neglected nothing.' Such was Poussin's modest reply when asked to comment on his own unique mastery. It is revealing in two ways. It emphasizes Poussin's methodical, obstinate, highly conscious way of working. He never allowed himself to be in debt to his genius: a fact which has led a lot of stupid and blind people to assume that he had everything except genius, that he achieved what he did simply by obeying all the rules. The remark also emphasizes the outstanding quality of Poussin's finished art. In Poussin's world there are no coincidences, no happy or unhappy accidents. Everything seen is foreseen.

Consider the two earliest battle scenes of Joshua's army, painted when Poussin was thirty. Their turmoil is controlled. They are not seen in terms of the total chaos of the protagonist's view: they are seen in terms of the modified chaos of the safe eye-witness.

Ten years later, in the first whirling *Rape of the Sabines*, everything has been placed in the ordered perspective of history. Everything which is included has been made significant. Thus – though flesh is still flesh – the Romans and the Sabines become gods, incapable of triviality.

Ten years later again – in the late 1640s – Poussin's power becomes complete. He can now go to the centre of the most undramatic incident – a quiet marriage, a baptism, a man walking through a landscape – and so arrange the elements of the scene as to give it a charge, a significance far greater than he gave to the whole of Joshua's army.

Yet with this power to organize, this mastery, came anxiety. How is it that in Poussin, of all artists, you can glimpse the horror and fears that were later to seize and drive Goya onwards? I don't want to exaggerate. You can only just glimpse this. It is no more than a nagging doubt, a cloud no larger than a man's hand on the horizon.

The turning point was about 1648, the year he painted the Dulwich *Roman Road.* He tries desperately to keep everything under control: he

emphasizes the straight edge of the man-made road, he makes as much as he can of the calculated angles of the church roof, he disposes the small figures in their telling, clear poses, but the evening light making shadow chase shadow, the sun going down behind the hills, the awaited night – these are too much for him. Beyond the town walls, beyond the circle of learning, there is a threat.

From 1648 onwards the light suggests the light which precedes a thunderstorm. The sharply defined leaves of the trees seem to cover the eyes of the landscapes, blinding them. It is as though Poussin began to be horrified at the inertia of the earth.

Clouds become a reminder of smoke. There are literally snakes in the grass, and more than one of his figures falls victim to a hidden serpent. The giant Orion stalks across a landscape, himself blind, the dead tree-roots at his feet like frogs. Other giants too appear, questioning the world of reason and proportion. From where do they come? In the foreground of painting after painting there is dark water, as though to suggest that there is an edge, a limit, to what can be ordered, and that around the edge reflections and illusions are seeping.

Much else continues as before: the same marvellously calculated theorems of colour, blue with the gold of white wine, blazon red with copse green; the same appropriateness of gesture to emotion; the same unity of figures and landscape; the same pastoral spaces. I speak only of a hint. But just once this hint is made dreadfully explicit.

There is the terrible contrast in 'The Four Seasons' between the canvases of *Summer* and *Winter*. It is as terrible a contrast as that in the Sistine Chapel between Michelangelo's ceiling and his *Last Judgement* painted twenty-five years later. *Summer*, surely one of the richest paintings in the world, is as life-affirming as the golden loaf of bread suggested by its predominant colour. *Winter*, which also represents *The Deluge*, is ash-coloured and so withered in all its forms that its composition becomes purely linear and gothic – a phenomenon to be found nowhere else in Poussin's work. Clearly these two pictures are far more than a comment on the two seasons. If such a winter ends such a summer, some spectre of haunting futility has been met and not been exorcised. What was this spectre for Poussin, Poussin the man of rule and classic continuity, on whose example all the assured academies have been based?

Was it simply the spectre of his own ageing? When he was in his thirties he borrowed from Veronese and Titian to find the means to express his own intense sexuality. There are muses and goddesses in his early work that look forward towards Renoir. Venus lies in a wood among red and white draperies. When the satyrs pull these off, her body is revealed as a blushing infusion and marriage of the two colours. By the time Poussin was in his fifties syphilis had undercut his faculties. The lines in his late drawings are as wavy as embroidered stitches. In 1665 he wrote: 'I have

nothing to do now except die: that is the only cure for the ills that afflict me.'

Was the spectre the disease in his own body? Partly, I think, but not entirely. Many earlier artists had suffered protracted illnesses, but one does not find in their work the same nagging anxiety. Horror and tragedy – yes. But not this latent disquiet which the confident can even ignore. The self-portrait of 1650 reveals the same thing. The pinched face of a proud, courageous, determined man who would like to know a little less than he does. It is not that he has a guilty secret of his own. The anxiety is not personal *Angst*. It is the price paid for a particular and new kind of opportunity.

The late 1640s were a critical period politically. Charles I was tried and executed. Civil war broke out in France. Nearer Poussin in Rome, there was the plebeian insurrection in Naples, led by Masaniello. The days of absolutism were being numbered. Poussin wrote: 'It is a great pleasure to live in an age when such great things are happening, provided one can tuck oneself away in some quiet corner and watch the Comedy at leisure.' Did the spectre arise out of these events or their shadows? Again, perhaps partly. But I cannot help believing that the most profound historical parallel is less direct.

Descartes was born in 1596, two years after Poussin. The Cartesian division between the soul of the observer and the world around him made the division between mind and matter more final than ever before. Nature becomes the 'dead matter' that can be organized by the natural sciences. The individual soul becomes private. Philosophical reasoning begins on the basis of doubt. In his own field had not Poussin reached the same threshold?

Look at the *Arcadian Shepherds* painted in 1650. The three men decipher an inscription on a tomb they have just come across. The woman bows her head in reflection. Landscape and figures are one. The angle of the mountain above the tomb is the same as that of the elbow of the kneeling shepherd. The boughs grow out of the woman as though she were a dryad. Nothing has been overlooked. Within the arrangement of the three shepherds, there are wheels within wheels. The first circle inscribes the kneeling shepherd – leaving aside the kneeling leg on the ground. The second, larger circle is bounded by the standing shepherd's outstretched arm. The third circle surrounds all four figures. Each circle re-emphasizes the curved shadow of the reader's arm on the tomb: each circle, as it revolves, draws attention to the finger following the inscription. The inscription reads: *Et in Arcadia Ego*.

This phrase was an early seventeenth-century invention. It is first found not in literature but in a painting by Poussin's contemporary Guercino. Unlike a typical medieval inscription – 'Though now food for worms, I was formerly known as a painter' – it is not about the process of

Death, awaiting all; it is about an individual being taken out of his environment, which is indifferent to his departure, which continues as though he had never been there.

In the painting every material form is ordered and put in its proper place. But the centre of the picture is less than a shadow. There is the shepherd who reads, then there is his shadow, and beyond that, inside the tomb, there is nothing. There is only written evidence of a presence, now departed.

I am not suggesting that Poussin deliberately painted a philosophic allegory. I am not even suggesting that he read Descartes. We have no evidence that he did. What I am suggesting is that Poussin reached in his own art a degree of order and control such as the natural sciences were to reach as a result of the Cartesian division; but that, having reached this, he became uneasy about the limitations of this control. He was haunted by the spectre of Time: that Time, crueller than any experienced before, which was rushing into the new gulf cut between mind and matter. That Time which rendered Vermeer – with his very different temperament – calmly sceptical.

It is no coincidence that Cézanne went back to Poussin as a starting point, for Cézanne's art was the first to try to rebridge the gulf.

1960

The Maja Dressed *and* The Maja Undressed

Goya

First, she lies there on the couch in her fancy-dress costume: the costume which is the reason for her being called a Maja. Later, in the same pose, and on the same couch, she is naked.

Ever since the paintings were first hung in the Prado at the beginning of this century, people have asked: who is she? Is she the Duchess of Alba? A few years ago the body of the Duchess of Alba was exhumed and her skeleton measured in the hope that this would prove that it was not she who had posed! But then, if not she, who?

One tends to dismiss the question as part of the trivia of court gossip. But then when one looks at the two paintings there is indeed a mystery implied by them which fascinates. But the question has been wrongly put. It is not a question of *who*? We shall never know, and if we did we would not be much the wiser. It is a question of *why*? If we could answer that we might learn a little more about Goya.

My own explanation is that *nobody* posed for the nude version. Goya constructed the second painting from the first. With the dressed version in front of him, he undressed her in his imagination and put down on the canvas what he imagined. Look at the evidence.

There is the uncanny identity (except for the far leg) of the two poses. This can only have been the result of an *idea*: 'Now I will imagine her clothes are not there.' In actual poses, taken up on different occasions, there would be bound to be greater variation.

More important, there is the drawing of the nude, the way the forms of her body have been visualized. Consider her breasts – so rounded, high and each pointing outwards. No breasts, when a figure is lying, are shaped quite like that. In the dressed version we find the explanation. Bound and corseted, they assume exactly that shape and, supported, they will retain it even when the figure is lying. Goya has taken off the silk to reveal the skin, but has forgotten to reckon with the form changing.

The same is true of her upper arms, especially the near one. In the nude it is grotesquely, if not impossibly, fat – as thick as the thigh just above the knee. Again, in the dressed version we see why. To find the outline of a naked arm Goya has had to guess within the full, pleated shoulders and sleeves of her jacket, and has miscalculated by merely simplifying instead of reassessing the form.

Compared to the dressed version, the far leg in the nude has been slightly turned and brought towards us. If this had not been done, there would have been a space visible between her legs and the whole boat-like form of her body would have been lost. Then, paradoxically, the nude would have looked *less* like the dressed figure. Yet if the leg were really moved in this way, the position of both hips would change too. And what makes the hips, stomach and thighs of the nude seem to float in space – so that we cannot be certain at what angle they are to the bed – is that, although the far leg has been shifted, the form of the near hip and thigh has been taken absolutely directly from the clothed body, as though the silk there was a mist that had suddenly lifted.

Indeed the whole near line of her body as it touches the pillows and sheet, from armpit to toe, is as unconvincing in the nude as it is convincing in the first painting. In the first, the pillows and the couch sometimes yield to the form of the body, sometimes press against it: the line where they meet is like a stitched line – the thread disappearing and reappearing. Yet the line in the nude version is like the frayed edge of a cut-out, with none of this 'give-and-take' which a figure and its surroundings always establish in reality.

The face of the nude jumps forward from the body, not because it has been changed or painted afterwards (as some writers have suggested), but because it has been *seen* instead of conjured up. The more one looks at it, the more one realizes how extraordinarily vague and insubstantial the naked body is. At first its radiance deceives one into thinking that this is the glow of flesh. But is it not really closer to the light of an apparition? Her face is tangible. Her body is not.

Goya was a supremely gifted draughtsman with great powers of invention. He drew figures and animals in action so swift that clearly he must have drawn them without reference to any model. Like Hokusai, he knew what things looked like almost instinctively. His knowledge of appearances was contained in the very movement of his fingers and wrist as he drew. How then is it possible that the lack of a model for this nude should have made his painting unconvincing and artificial?

The answer, I think, has to be found in his motive for painting the two pictures. It is possible that both paintings were commissioned as a new kind of scandalous *trompe l'oeil* – in which in the twinkling of an eye a woman's clothes disappeared. Yet at that stage of his life Goya was not the man to accept commissions on other men's trivial terms. So if these

pictures were commissioned, he must have had his own subjective reasons for complying.

What then was his motive? Was it, as seemed obvious at first, to confess or celebrate a love affair? This would be more credible if we could believe that the nude had really been painted from life. Was it to brag of an affair that had not in fact taken place? This contradicts Goya's character; his art is unusually free from any form of bravado. I suggest that Goya painted the first version as an informal portrait of a friend (or possibly mistress), but that as he did so he became obsessed by the idea that suddenly, as she lay there in her fancy dress looking at him, she might have no clothes on.

Why 'obsessed' by this? Men are always undressing women with their eyes as a quite casual form of make-believe. Could it be that Goya was obsessed because he was afraid of his own sexuality?

There is a constant undercurrent in Goya which connects sex with violence. The witches are born of this. And so, partly, are his protests against the horrors of war. It is generally assumed that he protested because of what he witnessed in the hell of the Peninsular War. This is true. In all conscience he identified himself with the victims. But with despair and horror he also recognized a potential self in the torturers.

The same undercurrent blazes as ruthless pride in the eyes of the women he finds attractive. Across the full, loose mouths of dozens of faces, including his own, it flickers as a taunting provocation. It is there in the charged disgust with which he paints men naked, always equating their nakedness with bestiality – as with the madmen in the madhouse, the Indians practising cannibalism, the priests awhoring. It is present in the so-called 'Black' paintings which record orgies of violence. But most persistently it is evident in the way he painted all flesh.

It is difficult to describe this in words, yet it is what makes nearly every Goya portrait unmistakably his. The flesh has an expression of its own – as features do in portraits by other painters. The expression varies according to the sitter, but it is always a variation on the same demand: the demand for flesh as food for an appetite. Nor is that a rhetorical metaphor. It is almost literally true. Sometimes the flesh has a bloom on it like fruit. Sometimes it is flushed and hungry-looking, ready to devour. Usually – and this is the fulcrum of his intense psychological insight – it suggests both simultaneously: the devourer and the to-be-devoured. All Goya's monstrous fears are summed up in this. His most horrific vision is of Satan eating the bodies of men.

One can even recognize the same agony in the apparently mundane painting of the butcher's table. I know of no other still life in the world which so emphasizes that a piece of meat was recently living, sentient flesh, which so combines the emotive with the literal meaning of the

word 'butchery'. The terror of this picture, painted by a man who has enjoyed meat all his life, is that it is *not* a still life.

If I am right in this, if Goya painted the nude Maja because he was haunted by the fact that he imagined her naked – that is to say imagined her flesh with all its provocation – we can begin to explain why the painting is so artificial. He painted it to exorcise a ghost. Like the bats, dogs and witches, she is another of the monsters released by 'the sleep of reason', but, unlike them, she is beautiful because desirable. Yet to exorcise her as a ghost, to call her by her proper name, he had to identify her as closely as possible with the painting of her dressed. He was not painting a nude. He was painting the apparition of a nude within a dressed woman. This is why he was tied so faithfully to the dressed version and why his usual powers of invention were so unusually inhibited.

I am not suggesting that Goya intended us to interpret the two paintings in this way. He expected them to be taken at their face value: the woman dressed and the woman undressed. What I am suggesting is that the second, nude version was probably an *invention* and that perhaps Goya became imaginatively and emotionally involved in its 'pretence' because he was trying to exorcise his own desires.

Why do these two paintings seem surprisingly modern? We assumed that the painter and model were lovers when we took it for granted that she agreed to pose for the two pictures. But their power, as we now see it, depends upon there being so *little* development between them. The difference is only that she is undressed. This should change everything, but in fact it only changes our way of looking at her. She herself has the same expression, the same pose, the same distance. All the great nudes of the past offer invitations to share their golden age; they are naked in order to seduce and transform us. The Maja is naked but indifferent. It is as though she is not aware of being seen – as though we were peeping at her secretly through a keyhole. Or rather, more accurately, as though she did not know that her clothes had become 'invisible'.

In this, as in much else, Goya was prophetic. He was the first artist to paint the nude as a stranger: to separate sex from intimacy: to substitute an aesthetic of sex for an energy of sex. It is in the nature of energy to break bounds: and it is the function of aesthetics to construct them. Goya, as I have suggested, may have had his own reason for fearing energy. In the second half of the twentieth century the aestheticism of sex helps to keep a consumer society stimulated, competitive and dissatisfied.

1964

133

Mathias Grünewald

The crooked houses, narrow streets and leaning door-frames of Colmar do not look picturesque. They are just old, unchanged and outdated. Apart from the square and the cathedral, there is one other landmark: a tall chimney belching out black smoke from the very centre of the town. This is the boiler of the public bath-house. Private baths are a modern luxury.

Thus, in its own peculiar way, Colmar prepares the visitor for the Grünewald altarpiece. The town hints at a different age, with different expectations of life. Unless the visitor takes this hint, he will get no further than the cliché that Grünewald's *mystic* genius was *timeless.*

The altarpiece, now housed in the town's museum, consists of ten separate panels, of which the most memorable are the Crucifixion, the Resurrection, and the Temptation of St Anthony. The Crucifixion, now one of the most famous ever painted, is always being referred to in discussions on Expressionism, Germanic cruelty and religious ecstasy. Its true significance seems to me to be much more precise. It is one of the very few great paintings concerned with disease, with physical sickness.

The altarpiece was originally commissioned by an Antonite hospice at Isenheim just outside Colmar, and Grünewald worked there from 1510 to 1515. This hospice was famous for its care and treatment of the sick, especially those suffering from the plague and syphilis. In the second half of the fifteenth century the plague was probably as common as influenza is today. In 1466, for example, 60,000 people died of it in Paris alone. Syphilis was also sweeping across Europe on an unprecedented scale. The uncertainty of life as a result of disease was at least as great as the uncertainty experienced by men in the front line in either of the two World Wars.

When a new patient – although the word *patient* is already too modern – when a new *recruit* arrived at Isenheim, he was taken, even before he

was examined or washed, to be shown Grünewald's Crucifixion. Confronted with such evidence of physical suffering he became a little more reconciled and so easier to treat, if not cure.

So much and no more is known from the records. There is also a report that later Grünewald died of the plague himself. But so far as his own attitudes are concerned we have to guess. The longer I looked at the Colmar altarpiece, the more convinced I became that for Grünewald disease represented the actual state of man. Disease was not for him the prelude to death – as modern man tends to fear: it was the condition of life.

All the evidence around him suggested that he lived in an infected world. Like Jeremiah he cried out: Is it nothing to you, all ye that pass by? And the *it* represented all that made disease possible and incurable: the shifting insecurity of the world, the apparent indifference of God, the ignorance. He was obsessed with physical disease because it seemed to him to express the most far-reaching truths he had yet discovered about the healthy.

Church and State, as he knew them, were corrupt and merciless. (He was later a follower of Luther and a supporter of the peasants in the Peasants' War.) All authority, like an epidemic, was arbitrary and terrible. Everything, as the medieval world broke up, decreed that life was cheap.

I am not, of course, suggesting that this Crucifixion is only about disease and not about the New Testament. What I am suggesting is that its images and content have been taken straight from the medieval lazarhouse. Christ's body is a corpse from Isenheim, covered with sores, swollen, infected. The feet are gangrenous, the hands suffer a paralysing cramp. The whole is tallow-coloured.

The Virgin Mary topples like a struck tree against St John's trailing arm. Both of them are as dumb as wood – which is what makes them the most poignant and haunting survivors in the history of art. But, by the same token, it is clear that they were not imagined as figures in a historical religious tragedy. On the contrary, they were minutely observed bereaved at the hospice. And the fact that Grünewald knew that Christ in reality suffered at the hands of men only emphasizes how he saw disease as the epitome of the inhumanity of his world.

It is the same in other panels. The monsters who surround St Anthony represent the traditional sins only in a nominal way. What they really represent is disease, fever, infection. This is a painting of a man on his sick bed. Once consider it in this way, and it becomes obvious. The text at the bottom reads: *Where wert thou, Holy Jesus? Why wast thou not there to heal my wounds?*

In the Resurrection, Christ ascends to heaven, white and pallid as a corpse – whenever Grünewald uses white it has this connotation of the pallor of death, it is never a positive, pure colour. His winding sheet forks

like lightning; and the soldiers, far from sleeping, writhe in convulsions as though poisoned.

Even in the happier scenes the same fatality is implicit. In the Virgin and Child, the swaddling cloth is the same tattered (infected?) rag which serves as loin-cloth for the crucified Christ. In the Annunciation, the angel bursts in upon and dwarfs the Virgin with his promise, to which she reacts as to the news of an incurable illness.

I want now to mention a highly personal and idiosyncratic motivation which Grünewald's work appears to reveal and which perhaps supports this argument of mine, but which I have not seen previously discussed.

In the Temptation of St Anthony, amongst all the grotesque, invented monsters, there is one passage which is painted with scrupulous accuracy. Its very literalness makes it outstanding. It is the passage concerned with the feathers of the mythical sparrow-hawk. It has clearly been painted by a man for whom feathers had a special significance: for whom feathers *in themselves* were as charged as all the apocalyptic details which surround them.

One can also find (in other panels) evidence of a similar special significance for Grünewald attached to feathers. The wing feathers of Gabriel in the Annunciation have no connection whatsoever with the rest of the figure; they are like the severed wings of a bird mysteriously held in space above the angel's shoulders. In the Angels' Concert, there is the inexplicable feathered one – a kind of prophecy of Papageno in *The Magic Flute*. He wears a crown of feathers and is also clothed in them. As he plays, his expression suggests aspiration and longing.

Even where feathers are not introduced directly, Grünewald insists again and again on textures and forms which are feather equivalents: palm trees against the sky like tail feathers, and the plaited palm robe worn by St Paul to keep himself warm: the ribbed, padded tunic of a soldier, each segment of cloth curving like a feather: the spires of a coronet worn by an angel.

It is hard to say nearly 500 years afterwards what exact significance feathers may have had for Grünewald, especially as it was almost certainly an unconscious one. But in general psychological theory, feathers are a symbol of power, of aspiration and the ability to transcend (or escape from) material reality. The feathers of the sparrow-hawk probably emphasize the incomprehensible power of his aggression. The feathered angel in the Angels' Concert may well represent the 'flight' of human imagination.

The point of this observation about the feathers is that it may explain a little more about the great, mysterious figure of Christ in the Crucifixion. The lacerated body is unique: no other painter ever depicted Christ on the cross like this. The literal explanation of the lacerations is that the body has been scourged and scratched by thorns – some of the thorns,

broken, are still in the flesh. The circumstantial explanation is that the lacerations resemble the sores of the sick – in the bottom left-hand corner of the Temptation of St Anthony there is a man suffering from syphilis who is pock-marked in a somewhat similar way.

Yet the uniformity of the marks over the entire body makes both these explanations rather unconvincing. *Surely the overall appearance of Christ's body is more than anything else suggestive of a bird that has had its feathers plucked?* Surely here Grünewald was being obedient to an imaginative compulsion, emotionally charged beyond the possibility of all narrative logic? Surely here he was saying: Christ, like the victims of Isenheim, dies in agony without the slightest comfort of hope because all his spiritual power has been drawn out of him by the degree of his suffering – because he has been stripped naked unto death.

1963

L. S. Lowry

Lowry was born in a Manchester suburb in 1887. He was a vague child. He never passed any exams. He went to art school because nobody was very convinced that he could do anything else. At the age of about thirty he began to paint the industrial scene around him: he began to produce what would now be recognizable Lowrys. He continued for twenty years with scant recognition or success. Then a London dealer saw some of his paintings by chance when he went to a framer's. He inquired about the artist. A London exhibition was arranged – it was now 1938, and Lowry began slowly to acquire a national reputation. At first it was other artists who most appreciated his work. The public gradually followed. From 1945 onwards he began to receive official honours – honorary degrees, Royal Academician, freedom of the City of Salford. None of this has changed him in any way. He still lives on the outskirts of Manchester: modest, eccentric, comic, lonely.

> 'You know, I've never been able to get used to the fact that I'm alive! The whole thing frightens me. It's been like that from my earliest days. It's too big you know – I mean life, sir.'[1]

In 1964 the Hallé Orchestra gave a special concert in honour of Lowry's seventy-fifth birthday: a number of artists, including Henry Moore, Victor Pasmore and Ivon Hitchens, contributed to an honorary exhibition: and Sir Kenneth Clark wrote an appreciation. In it, Clark compares Lowry to Wordsworth's 'Leech Gatherer':

> Our leech gatherer has continued to scrutinise his small black figures in their milky pool of atmosphere, isolating and combining them with a loving sense of their human qualities . . . All those black people walking to and fro are as anonymous, as individual, as purposeless and

as directed as the stream of real people who pass before our eyes in the square of an industrial town.[2]

Edwin Mullins, who wrote the introduction to the catalogue of Lowry's retrospective exhibition at the Tate in 1966, makes the point that Lowry is primarily interested in 'the battle of life'.

It is a battle engaged between undignified pea-brained homunculi who pour out of a mill after a day's work, or congregate round a street fight, pace a railway platform, whoop it up on V.E. Day, watch a regatta or football match, take a pram and an idiotic dog for a walk along the promenade.[3]

These quotations reveal the submerged patronage found in nearly all critical comment on Lowry's work. This tendency to patronize is a form of self-defence: defence not so much against the artist as against the subject-matter of his work. It is hard to reconcile a life devoted to aesthetic expositions with the streets and houses and front doors of those who live in Bury, Rochdale, Burnley or Salford.

Lowry has been compared with Chaplin, Brueghel and the Douanier Rousseau. The curious mood of his work has been analysed, sometimes with considerable subtlety. His technique has been explained and it has been pointed out that technically he is a highly sophisticated artist. Many stories are told about his behaviour and conversation. He is indeed an original, dignified man for whom one can feel deeply.

I might add stories of my own, but there is something more important to say. The extraordinary fact is that nobody, faced with Lowry's pictures whose subject-matter is nearly always social, ever discusses the social or historical meaning of his art. Instead it is treated as though it dealt with the view out of the window of a Pullman train on its non-stop journey to London, where everything is believed to be very different. His subjects, if they have to be considered at all in relation to what actually exists, are considered as local exotica.

I don't want to exaggerate the meaning of Lowry's work or give it a historical load which is too heavy for it. The range of his work is small. It does not belong to the mainstream of twentieth-century art, which is concerned in one way or another with interpreting new relationships between man and nature. It is a spontaneous (as opposed to a consciously self-developing) art. It is static, local and subjectively repetitive. But it is consistent within itself, courageous, obstinate, unique, and the phenomenon of its creation and apprecia-tion *is* significant.

Perhaps I should emphasize here that this significance must be considered separately from, though not necessarily in opposition to,

Lowry's conscious intentions. He says he doesn't know why he paints his pictures. They come to him.

> I started as I often do, with nothing particular in mind; things just happen – they grow from nothing. When I had painted the figure of the woman on the left, walking away, I got stuck. I just couldn't think what to do next. Then a young lady friend of mine came to the rescue. 'Why don't you paint another figure walking towards you,' she suggested. 'Shall I paint the same woman turned around?' I asked. 'Yes,' she said, 'that would be a very good idea.' 'All right,' I replied, 'but what can I call the picture?' 'Why not call it *The Same Woman Coming Back?*' she said. And I did![4]

Even allowing for the simplification Lowry makes in telling this story, it is clear that he works intuitively, without fixed aims. His aim is only to finish the picture. Any wider significance his work may have is the result of a certain coincidence between his own private half-hidden motivations and the nature of the outside world which he uses as raw material and to which he delivers back his finished pictures. On a certain level, he himself is probably aware of this coincidence: it is probably the substance of his conviction that what he has to say as an artist is, in some mysterious way, relevant. But this is very far from implying that he consciously intends the meaning which his pictures acquire.

What is this meaning? I have already suggested that its basis is social. Let us now try to place Lowry's pictures within a context. First, they are very specifically English. They could be about nowhere else. Nowhere else are there comparable industrial landscapes. The light, which is not natural but which was manufactured in the nineteenth century, is unique. Only in the Midlands and North of England do people live – to use Sir Kenneth Clark's euphemism – in such a milky pool.

The character of the figures and crowds is also specially English. The industrial revolution has isolated them and uprooted them. Their home-made ideology, except when they are led and organized by revolution-aries, is a kind of ironic stoicism. Nowhere else do crowds look so simultaneously *civic* and *deprived*. They appear to have as little to lose as a mob: and yet they are not a mob. They know each other, recognize each other, exchange help and jokes – they are not, as is sometimes said, like lost souls in limbo; they are fellow-travellers through a life which is impervious to most of their choices.

All this might seem at first to date Lowry's paintings. One might suppose that they are more to do with the nineteenth century than with today when there are television aerials on the houses, cars in the back streets, hairdressers for mill girls, and a Labour government.

Yet, in order to place Lowry's work within an historical as well as

geographical context, we must distinguish rather carefully between different elements in it. Most of Lowry's paintings are synthetic, insofar as they are constructed from his observation and memory of different incidents and places. Only a few represent specific scenes. If, however, one goes to the mill towns, to the potteries, to Manchester, to Barrow-in-Furness, to Liverpool, one finds countless streets, skylines, doorsteps, bus stops, squares, churches, homes, which look like those depicted by Lowry, and have never been depicted by anybody else. His paintings are no more dated than certain English cities and towns.

If one looks more carefully at the pictures one notices that the figures, even in the most recent ones, are wearing clothes which belong, at the latest, to the 1920s or early 1930s: that is to say to the period when Lowry first determined to paint the area where he had been brought up and where he was going to spend the rest of his life. Similarly, there are very few cars or modern buildings to be seen. He says that he hates change. And his pictures, both in detail, as cited above, and in general spirit, suggest an essential changelessness. (One sees this in a different way in his deserted landscapes and seascapes of endlessly repeating hills or waves.) The bustle of the crowds, the walk to the sea and back, the fight, the accident, the once-yearly excitement of the fair, the ageing of some, the crippling of others, changes nothing. In certain canvases this sense of unchanging time becomes an almost metaphysical sense of eternity.

Thus we can summarize: Lowry's paintings correspond in many respects to existing places: certain details belong to the past: the artist's vision exaggerates a feeling of changelessness: the three elements combine together to create an atmosphere of dramatic obsolescence. Stylistic considerations apart, there is in fact no question of these pictures belonging to the spirit of the nineteenth century. The notion of progress – however it is applied – is foreign to them. Their virtues are stoic: their logic is one of decline.

These paintings are about what has been happening to the British economy since 1918, and their logic implies the collapse still to come. This is what has happened to the 'workshop of the world'. Here is the recurring so-called production crisis: the obsolete industrial plants: the inadequacy of unchanged transport systems and overstrained power supplies: the failure of education to keep pace with technological advance: the ineffectiveness of national planning: the lack of capital investment at home and the disastrous reliance on colonial and neo-colonial overseas investments: the shift of power from industrial capital to international finance capital, the essential agreements within the two-party system blocking every initiative towards political independence and thus economic viability.

The argument is not so far-fetched as it may seem if one pauses to consider the circumstances in which the pictures have been painted.

Lowry has happened to live and work in an area where the truth of our economic decline has been far less disguised than elsewhere. His art is partly subjective, but what he has seen around him has confirmed, and perhaps even helped to sustain and create, his subjective tendencies. In the 1920s, Lancashire was a depressed area. (One tends to forget that before the depression of the 1930s, there were never less than one million unemployed.) What the 1930s were like has been described many times. Yet the relevance of their desolation to Lowry is seldom mentioned. Here Orwell is virtually describing a painting by Lowry:

> I remember a winter afternoon in the dreadful environs of Wigan. All round was the lunar landscape of slag heaps, and to the north, through the passes, as it were, between the mountains of slag, you could see factory chimneys sending out their plumes of smoke. The canal path was a mixture of cinders and frozen mud, criss-crossed by the imprints of innumerable clogs, and all round, as far as the slag heaps in the distance, stretched the 'flashes' – pools of stagnant water that had seeped into the hollows caused by the subsidence of ancient pits. It was horribly cold. The 'flashes' were covered with ice the colour of raw umber, the bargemen were muffled to the eyes in sacks, the lock gates wore tears of ice. It seemed a world from which vegetation had been banished; nothing existed except smoke, shale, ice, mud, ashes, and foul water.[5]

The poverty of the 1930s has passed. But in many parts of the north-west today there is a sense of profound exhaustion. There is nothing Spenglerian about this: it is the result of the scale of what has to be destroyed before anything can be renewed. Town-planners, investors, educationalists know it. I quote from the government's North-West Study, published in 1965:

> Slums, general obsolescence, dereliction and neglect all add up to a formidable problem of environmental renewal extending over a wide area of the region. It is plain that this problem cannot be disposed of in a few years and the question which arises is whether it is feasible to break the back of it in, say, ten to 15 years or whether the turn of another century will find Lancashire still struggling under the grim heritage of the industrial revolution.

In a different way many of the voters know it too. They have always voted Labour, believing in an alternative plan. Today they see Wilson thirty-five years later performing the same role as Ramsay MacDonald and abandoning any possibility of an alternative.

Historians of the future will cite Lowry's work as both expressing and

illustrating the industrial and economic decline of British capitalism since the First World War. But of course he is not simply that, as described in those remote terms. He is an artist concerned with loneliness, with a certain humour – somewhat like Samuel Beckett's: the humour found in the contemplation of time passing without meaning. He is an artist who has uniquely found a way of painting the character of hand-me-down clothes, the sensation of damp rising from the ground, the effect of smog on the texture of the surfaces exposed to it, the strange closing of distance which smoke and mist bring about so that each person carries with him his own small parcel of visibility, which constitutes his world.

'My three most cherished records,' says Lowry, 'are the fact that I've never been abroad, never had a telephone and never owned a motor-car.' He is a man strongly attached to where he found himself. Everything in his work is informed by the character of a specific place and period.

I have tried to define that character. If Lowry were a greater artist, there would be more of himself in his work. (His 'naïvety' is probably an excuse for hiding his own experience.) It would then be far less possible to localize his work, either geographically or historically: emotions are always more general than circumstances. As it is, given his inhibitions as an artist, he intuitively chose correctly. He chose to paint the historic.

1966

Henri de Toulouse-Lautrec

To understand the work of Toulouse-Lautrec two current fallacies have to be demolished.

There are those – however surprising it may seem – who still argue that, despite some unfortunate incidents, Lautrec, the illustrious son of one of the noblest families in France, remains a credit to his background.

The second argument has more respect for the facts and the suffering involved. Even Lautrec's last words on his death-bed at the age of thirty-seven are admitted. They were: *'Le vieux con'* – and they referred to his father. But this argument maintains that his life was transcended by his art. In a sense this is true, but only if one also recognizes that his work was a direct expression of his life. The only miracle is art; but even in art, the facts count.

Lautrec was born with two terrible handicaps: the family around him and the disease in his bones. His father was mad about horses and women. His mother was a martyr to his father's infidelities. It was a family of many châteaux, but also of empty rooms and absences. The ideals it instilled in the young Lautrec were exclusively extrovert ideals of physical prowess.

The disease struck when he was fourteen. It is sometimes thought that his legs stopped growing as the result of two falls. But recent medical opinion strongly suggests that this would have happened anyway and that the fractures were the *result* of an inborn dystrophic disease which was probably in its turn the result of his parents being first cousins.

The disease transformed the boy into a monster. Adolescence, instead of being the process of becoming sexually mature, became the process of becoming sexually obscene. It was not only a question of walking on stunted legs. His body, his organs, his face, his fingers, all coarsened as though swollen with the pressure of frustrated growth. The thickness of his lips made him splutter when speaking. It was as if at the moment of

first recognizing his own sex, he discovered only the final price of debauchery.

He escaped into a Paris milieu of prostitutes, singers, dancers. This was the traditional field for the aristocrat's other 'sport', but to him it offered a kind of peace. Here the absurdity of his ravenous sexual appetite could be temporarily forgotten in the business of satisfying it; here he could avoid (as he would not have been able to do in a circle of artists) all middle-class preoccupations with cause and effect, aims and purpose; here he could easily be allowed to kill himself by trying through sex and drink to achieve a momentary, impossible equality.

His art records this milieu. But his great paintings – nearly all of women by themselves, lying or sitting on beds, dressing, waiting, gazing – amount to far more than a record. They are also intensely moving. Why? Why do these off-duty moments of old, tired prostitutes seem hallowed? There is no appeal to religion or social conscience. There is no spirituality and, in the proper sense of the word, there is no evidence of compassion. Compassion shows what lies behind. Lautrec shows only what is there in front of his eyes.

Can we explain it by claiming that art *is* the pursuit of truth? Hardly, for we then have to ask what we mean by truth: and certainly Lautrec's view of the truth was excessively limited. The truth was only what he could stare at. He was the most banally existential of all the great artists. Yet his work is never banal. The more clinical his observation, the more tender and lyrical the image becomes. Why?

The explanation is to be found in his own condition. The reality of other people's daily lives and bodies was for him something unapproachable. *Thus it was already an ideal – and he painted it as such.* The closer he came to representing a woman as she was, the more ideal she became for him.

Lautrec, his posters apart, was no great innovator. It is the content of his best paintings which is unique. He makes us look at his models as though it were impossible to judge them (not just morally but in any way), as though they were a species never before seen, as though all we could wish to do is to watch them endlessly because they are there. We see a breast or an arm which normally we would consider prematurely worn out, and Lautrec makes us wonder whether it was not naturally and pristinely meant to be like that.

His actual technique of painting and drawing poignantly confirms this. He took from the Impressionists the system of painting with small, separate brushmarks. In the case of the Impressionists themselves, the Pointillists and later painters like Bonnard, these brushmarks form a kind of curtain of colour and light through which the scene appears or from which it emerges. In the case of Van Gogh the brushmarks actually imitate the substance of what is being depicted and become metaphors of paint.

Lautrec's use of the same technique was quite different. Each brush-mark is like a touch on the skin of what is being painted. The form as an idea or generalization is established by vigorously drawn contours, but all its particular, sensuous reality is built up by touch after touch, each qualifying the last. It is as if his models had nine skins, the ninth being paint from the touch of his sable brushes.

His method reveals his attitude. His intelligence instantaneously recognized and intermittently defined his subject – sometimes to the point of caricature. This was the ironic gift of a man watching others hurrying past him. The process of discovering the sensuous individuality of his subject was a very much slower one: a process of imaginatively touching her, of coming as close to her as possible again and again. The tentativeness, the delicacy of each touch had more to do with diffidence than tenderness. The touches are like the timid flicks of a lizard's tongue. The diffidence was the result of Lautrec's certain knowledge that he could never in fact approach as an equal this creature who let him watch her.

The resulting paintings imply an intimacy between seer and seen unparalleled in the history of art: an intimacy which precludes all judgement. This is not because the women were tired prostitutes who did not care who saw them. (They *would* have cared.) It is because of the intensity of Lautrec's need to idealize. As so often, a terrible and extreme case throws light on the universal. Intimacy is in fact always an imaginative construction, and for all of us what distinguishes it from familiarity is our need to idealize. Lautrec's need was greater and from it, para-doxically, he created his uniquely realistic art.

1964

Alberto Giacometti

The week after Giacometti's death *Paris-Match* published a remarkable photograph of him which had been taken nine months earlier. It shows him alone in the rain, crossing the street near his studio in Montparnasse. Although his arms are through the sleeves, his raincoat is hoiked up to cover his head. Invisibly, underneath the raincoat, his shoulders are hunched.

The immediate effect of the photograph, published when it was, depended upon it showing the image of a man curiously casual about his own well-being. A man with crumpled trousers and old shoes, ill-equipped for the rain. A man whose preoccupations took no note of the seasons.

But what makes the photograph remarkable is that it suggests more than that about Giacometti's character. The coat looks as though it has been borrowed. He looks as though underneath the coat he is wearing nothing except his trousers. He has the air of a survivor. But not in the tragic sense. He has become quite used to his position. I am tempted to say 'like a monk', especially since the coat over his head suggests a cowl. But the simile is not accurate enough. He wore his symbolic poverty far more naturally than most monks.

Every artist's work changes when he dies. And finally no one remembers what his work was like when he was alive. Sometimes one can read what his contemporaries had to say about it. The difference of emphasis and interpretation is largely a question of historical development. But the death of the artist is also a dividing line.

It seems to me now that no artist's work could ever have been more changed by his death than Giacometti's. In twenty years no one will understand this change. His work will seem to have reverted to normal – although in fact it will have become something different: it will have become evidence from the past, instead of being, as it has been for the last forty years, a possible preparation for something to come.

The reason Giacometti's death seems to have changed his work so radically is that his work had so much to do with an awareness of death. It is as though his death confirms his work: as though one could now arrange his works in a line leading to his death, which would constitute far more than the interruption or termination of that line – which would, on the contrary, constitute the starting point for reading back along that line, for appreciating his life's work.

You might argue that after all nobody ever believed that Giacometti was immortal. His death could always be deduced. Yet it is the fact which makes the difference. While he was alive, his loneliness, his conviction that everybody was unknowable, was no more than a chosen point of view which implied a comment on the society he was living in. Now by his death he has proved his point. Or – to put it a better way, for he was not a man who was concerned with argument – now his death has proved his point for him.

This may sound extreme, but despite the relative traditionalism of his actual methods, Giacometti was a most extreme artist. The neo-Dadaists and other so-called iconoclasts of today are conventional window-dressers by comparison.

The extreme proposition on which Giacometti based all his mature work was that no reality – and he was concerned with nothing else except the contemplation of reality – could ever be shared. This is why he believed it impossible for a work to be finished. This is why the content of any work is not the nature of the figure or head portrayed but the incomplete history of *his* staring at it. The act of looking was like a form of prayer for him – it became a way of approaching but never being able to grasp an absolute. It was the act of looking which kept him aware of being constantly suspended between being and the truth.

If he had been born in an earlier period, Giacometti would have been a religious artist. As it was, born in a period of profound and widespread alienation, he refused to escape through religion, which would have been an escape into the past. He was obstinately faithful to his own time, which must have seemed to him rather like his own skin: the sack into which he was born. In that sack he simply could not in all honesty overcome his conviction that he had always been and always would be totally alone.

To hold such a view of life requires a certain kind of temperament. It is beyond me to define that temperament precisely. It was visible in Giacometti's face. A kind of endurance lightened by cunning. If man was purely animal and not a social being, all old men would have this expression. One can glimpse something similar in Samuel Beckett's expression. Its antithesis was what you could see in Le Corbusier's face.

But it is by no means only a question of temperament: it is even more a question of the surrounding social reality. Nothing during Giacometti's

lifetime broke through his isolation. Those whom he liked or loved were invited to share it temporarily with him. His basic situation – in the sack into which he was born – remained unchanged. (It is interesting that part of the legend about him tells of how almost nothing changed or was moved in his studio for the forty years he lived there. And during the last twenty years he continually recommenced the same five or six subjects.) Yet the nature of man as an essentially social being – although it is objectively proved by the very existence of language, science, culture – can only be felt subjectively through the experience of the force of change as a result of common action.

Insofar as Giacometti's view could not have been held during any preceding historical period, one can say that it reflects the social fragmentation and manic individualism of the late bourgeois intelligentsia. He was no longer even the artist in retreat. He was the artist who considered society as irrelevant. If it inherited his works it was by default.

But having said all this, the works remain and are unforgettable. His lucidity and total honesty about the consequences of his situation and outlook were such that he could still save and express a truth. It was an austere truth at the final limit of human interest; but his expressing of it transcends the social despair or cynicism which gave rise to it.

Giacometti's proposition that reality is unshareable is true in death. He was not morbidly concerned with the process of death: but he was exclusively concerned with the process of life as seen by a man whose own mortality supplied the only perspective in which he could trust. None of us is in a position to reject this perspective, even though simultaneously we may try to retain others.

I said that his work had been changed by his death. By dying he has emphasized and even clarified the content of his work. But the change – anyway as it seems to me at this moment – is more precise and specific than that.

Imagine one of the portrait heads confronting you as you stand and look. Or one of the nudes standing there to be inspected, hands at her side, touchable only through the thickness of two sacks – hers and yours – so that the question of nakedness does not arise and all talk of nakedness becomes as trivial as the talk of bourgeois women deciding what clothes to wear for a wedding: nakedness is a detail for an occasion that passes.

Imagine one of the sculptures. Thin, irreducible, still and yet not rigid, impossible to dismiss, possible only to inspect, to stare at. If you stare, the figure stares back. This is also true of the most banal portrait. What is different now is how you become conscious of the track of your stare and hers: the narrow corridor of looking between you: perhaps this is like the track of a prayer if such a thing could be visualized. Either side of the corridor nothing counts. There is only one way to reach her – to stand still and stare. That is why she is so thin. All other possibilities and

functions have been stripped away. Her entire reality is reduced to the fact of being seen.

When Giacometti was alive you were standing, as it were, in his place. You put yourself at the beginning of the track of his gaze and the figure reflected this gaze back to you like a mirror. Now that he is dead, or now that you know that he is dead, you take his place rather than put yourself in it. And then it seems that what first moves along the track comes from the figure. It stares, and you intercept the stare. Yet however far back you move along the narrow path, the gaze passes through you.

It appears now that Giacometti made these figures during his lifetime, for himself, as observers of his future absence, his death, his becoming unknowable.

1966

Pierre Bonnard

Since his death in 1947 at the age of eighty, Pierre Bonnard's reputation has grown fairly steadily, and in the last five years or so quite dramatically. Some now claim that he is *the* greatest painter of the century. Twenty years ago he was considered a minor master.

This change in his reputation coincides with a general retreat among certain intellectuals from political realities and confidence. There is very little of the post-1914 world in Bonnard's work. There is very little to disturb – except perhaps the unnatural peacefulness of it all. His art is intimate, contemplative, privileged, secluded. It is an art about cultivating one's own garden.

It is necessary to say this so that the more extreme recent claims for Bonnard can be placed in an historical context. Bonnard was essentially a conservative artist – although an original one. The fact that he is praised as 'a pure painter' underlines this. The purity consisted in his being able to accept the world as he found it. Was Bonnard a greater artist than Brancusi – not to mention Picasso, or Giacometti? Each period assesses all surviving artists according to its own needs. What is more interesting is why Bonnard will undoubtedly survive. The conventional answer, which begs the question, is that he was a great colourist. What was his colour for?

Bonnard painted landscapes, still-lifes, occasional portraits, very occasional mythological pieces, interiors, meals and nudes. The nudes seem to me to be far and away the best pictures.

In all his works after about 1911 Bonnard used colours in a roughly similar way. Before then – with the help of the examples of Renoir, Degas, Gauguin – he was still discovering himself as a colourist; after 1911 he by no means stopped developing, but it was a development along an already established line. The typical mature Bonnard bias of colour – towards marble whites, magenta, pale cadmium yellow, ceramic

blues, terracotta reds, silver greys, stained purple, all unified like reflections on the inside of an oyster – this bias tends in the landscapes to make them look mythical, even faery; in the still-lifes it tends to give the fruit or the glasses or the napkins a silken glamour, as though they were part of a legendary tapestry woven from threads whose colours are too intense, too glossy; but in the nudes the same bias seems only to add conviction. It is the means of seeing the women through Bonnard's eyes. The colours confirm the woman.

Then what does it mean to see a woman through Bonnard's eyes? In a canvas painted in 1899, long before he was painting with typical Bonnard colours, a young woman sprawls across a low bed. One of her legs trails off the bed on to the floor: otherwise, she is lying very flat on her back. It is called *L'Indolente: Femme assoupie sur un lit.*

The title, the pose and the *art-nouveau* shapes of the folds and shadows all suggest a cultivated *fin-de-siècle* form of eroticism very different from the frankness of Bonnard's later works; yet this picture – perhaps just because it doesn't engage us – offers us a clear clue.

Continue to look at the picture and the woman begins to disappear – or at least her presence becomes ambiguous. The shadow down her near side and flank becomes almost indistinguishable from the cast shadow on the bed. The light falling on her stomach and far leg marries them to the golden-lit bed. The shadows which reveal the form of a calf pressed against a thigh, of her sex as it curves down and round to become the separation between her buttocks, of an arm thrown across her breasts – these eddy and flow in exactly the same rhythm as the folds of the sheet and counterpane.

The picture, remaining a fairly conventional one, does not actually belie its title: the woman continues to exist. But it is easy to see how the painting is pulling towards a very different image: the image of the imprint of a woman on an *empty* bed. Yeats:

> . . . the mountain grass
> Cannot but keep the form
> Where the mountain hare has lain.[1]

Alternatively one might describe the same state of affairs in terms of the opposite process: the image of a woman losing her physical limits, overflowing, overlapping every surface until she is no less and no more than the *genius loci* of the whole room.

Before I saw the Bonnard exhibition at the Royal Academy in London in January 1966, I was vaguely aware of this ambiguity in Bonnard's work between presence and absence, and I explained it to myself in terms of his being a predominantly nostalgic artist: as though the picture was all he could ever save of the subject from the sweep of time passing. Now

this seems far too crude an explanation. Nor is there anything nostalgic about *Femme assoupie sur un lit,* painted at the age of thirty-two. We must go further.

The risk of loss in Bonnard's work does not appear to be a factor of distance. The far-away always looks benign. One has only to compare his seascapes with those of Courbet to appreciate the difference. It is proximity which leads to dissolution with Bonnard. Features are lost, not in distance, but, as it were, in the near. Nor is this an optical question of something being too close for the eye to focus. The closeness also has to be measured in emotional terms of tenderness and intimacy. Thus *loss* becomes the wrong word, and nostalgia the wrong category. What happens is that the body which is very near – in every sense of the word – becomes the axis of everything that is seen: everything that is visible relates to it: it acquires a domain to inhabit: but by the same token it has to lose the precision of its own fixed position in time and space.

The process may sound complex, but in fact it is related to the common experience of falling in love. Bonnard's important nudes are the visual expressions of something very close to Stendhal's famous definition of the process of 'crystallization' in love:

A man takes pleasure in adorning with a thousand perfections the woman of whose love he is certain; he recites to himself, with infinite complacency, every item that makes up his happiness. It is like exaggerating the attractions of a superb property that has just fallen into our hands, which is still unknown, but of the possession of which we are assured . . . In the salt mines of Salzburg they throw into the abandoned depths of a mine a branch of a tree stripped of its leaves by winter; two or three months later they draw it out, covered with sparkling crystallizations: the smallest twigs, those which are no larger than the foot of a titmouse, are covered with an infinity of diamonds, shifting and dazzling; it is impossible any longer to recognize the original branch.[2]

Many other painters have of course idealized women whom they have painted. But straightforward idealization becomes in effect indistinguishable from flattery or pure fantasy. It in no way does justice to the energy involved in the psychological state of being in love. What makes Bonnard's contribution unique is the way that he shows in pictorial terms how the image of the beloved emanates *outwards from her* with such dominance that finally her actual physical presence becomes curiously incidental and in itself indefinable. (If it could be defined, it would become banal.)

Bonnard said something similar himself.

By the seduction of the first idea the painter attains to the universal. It is the seduction which determines the choice of the motif and which corresponds exactly to the painting. If this seduction, if the first idea vanishes all that remains . . . is the object which invades and dominates the painter . . .[3]

Everything about the nudes Bonnard painted between the two World Wars confirms this interpretation of their meaning, confirms it visually, not sentimentally. In the bath nudes, in which the woman lying in her bath is seen from above as through a skylight, the surface of the water serves two pictorial functions simultaneously. First it diffuses the image of her whole body, which, whilst remaining recognizable, sexual, female, becomes as varied and changeable and large as a sunset or an aurora borealis; secondly, it seals off the body from us. Only the light from it comes through the water to reflect off the bathroom walls. Thus she is potentially everywhere, except specifically here. She is lost in the near. Meanwhile what structurally pins down these paintings to prevent their presence becoming as ambiguous as hers is the geometric patterning of the surrounding tiles or linoleum or towelling.

In other paintings of standing nudes, the actual surface of the picture serves a similar function to the surface of the water. Now it is as though a large part or almost all of her body had been left unpainted and was simply the brown cardboardy colour of the original canvas. (In fact this is not the case: but it is the deliberate effect achieved by very careful colour and tonal planning.) All the objects around her – curtains, discarded clothes, a basin, a lamp, chairs, her dog – frame her in light and colour as the sea frames an island. In doing so, they break forward towards us, and draw back into depth. But she remains fixed to the surface of the canvas, simultaneously an absence and a presence. Every mark of colour is related to her, and yet she is no more than a shadow against the colours.

In a beautiful painting of 1916–19 she stands upright on tip-toe. It is a very tall painting. A rectangular bar of light falls down the length of her body. Parallel to this bar, just beside it and similar in colour, is a rectangular strip of wall-papered wall. On the wall-paper are pinkish flowers. On the bar of light is her nipple, the shadow of a rib, the slight shade like a petal under her knee. Once again the surface of that bar of light holds her back, makes her less than present: but also once again, she is ubiquitous: the designs on the wall-paper are the flowers of her body.

In the *Grand Nu Bleu* of 1924, she almost fills the canvas as she bends to dry a foot. This time no surface or bar of light imposes on her. But the extremism of the painting of her body itself dissolves her. The painting is, as always, tender: its extremism lies in its rendering of what is near and what is far. The distance between her near raised thigh and the inside of

the far thigh of the leg on which she is standing – the distance of the caress of one hand underneath her – is made by the force of colour to be felt as a landscape distance: just as the degree to which the calf of that standing leg swells towards us is made to seem like the emerging of a near white hill from the blue recession of a plain running to the horizon. Her body is her habitation – the whole world in which she and the painter live; and at the same time it is immeasurable.

It would be easy to quote other examples: paintings with mirrors, paintings with landscapes into which her face flows away like a sound, paintings in which her body is seen like a sleeve turned inside out. All of them establish with all of Bonnard's artfulness and skill as a draughtsman and colourist how her image emanates outwards from her until she is to be found everywhere except within the limits of her physical presence.

And now we come to the harsh paradox which I believe is the pivot of Bonnard's art. Most of his nudes are directly or indirectly of a girl whom he met when she was sixteen and with whom he spent the rest of his life until she died at the age of sixty-two. The girl became a tragically neurasthenic woman: a frightened recluse, beside herself, and with an obsession about constantly washing and bathing. Bonnard remained loyal to her.

Thus the starting point for these nudes was an unhappy woman, obsessed with her toilet, excessively demanding and half 'absent' as a personality. Accepting this as a fact, Bonnard, by the strength of his devotion to her or by his cunning as an artist or perhaps by both, was able to transform the literal into a far deeper and more general truth: the woman who was only half present into the image of the ardently beloved.

It is a classic example of how art is born of conflict. In art, Bonnard said, *il faut mentir.* The trouble with the landscapes and still-lifes and meals – the weakness expressed through their colour – is that in them the surrounding world conflicts are still ignored and the personal tragedy is temporarily put aside. It may sound callous, but it seems probable that his tragedy, by forcing Bonnard to express and marvellously celebrate a common experience, ensured his survival as an artist.

1965

Frans Hals

In my mind's eye I see the story of Frans Hals in theatrical terms.

The first act opens with a banquet that has already been going on for several hours. (In reality these banquets often continued for several days.) It is a banquet for the officers of one of the civic guard companies of Haarlem – let us say the St George's Company of 1627. I chose this one because Hals's painted record of the occasion is the greatest of his civic guard group portraits.

The officers are gay, noisy and emphatic. Their soldierly air has more to do with the absence of women and with their uniforms than with their faces or gestures, which are too bland for campaigning soldiers. And on second thoughts even their uniforms seem curiously unworn. The toasts which they drink to one another are to eternal friendship and trust. May all prosper together!

One of the most animated is Captain Michiel de Wael – downstage wearing a yellow jerkin. The look on his face is the look of a man certain that he is as young as the night and certain that all his companions can see it. It is a look that you can find at a certain moment at most tables in any night-club. But before Hals it had never been recorded. We watch Captain de Wael as the sober always watch a man getting tipsy – coldly and very aware of being an outsider. It is like watching a departure for a journey we haven't the means to make. Twelve years later Hals painted the same man wearing the same chamois jerkin at another banquet. The stare, the look, has become fixed and the eyes wetter. If he can, he now spends the afternoons drinking at club bars. And his throaty voice as he talks and tells stories has a kind of urgency which hints that once, a long way back when he was young, he lived as we have never done.

Hals is at the banquet – though not in the painting. He is a man of nearly fifty, also drinking heavily. He is at the height of his success. He has the reputation of being wilful and alternately lethargic and violent.

(Twenty years ago there was a scandal because they said he beat his wife to death when drunk. Afterwards he married again and had eight children.) He is a man of very considerable intelligence. We have no evidence about his conversation but I am certain that it was quick, epigrammatic, critical. Part of his attraction must have lain in the fact that he behaved as though he actually enjoyed the freedom which his companions believed in in principle. His even greater attraction was in his incomparable ability as a painter. Only he could paint his companions as they wished. Only he could bridge the contradiction in their wish. Each must be painted as a distinct individual and, at the same time, as a spontaneous natural member of the group.

Who are these men? As we sensed, they are not soldiers. The civic guards, although originally formed for active service, have long since become purely ceremonial clubs. These men come from the richest and most powerful merchant families in Haarlem, which is a textile-manufacturing centre.

Haarlem is only eleven miles from Amsterdam and twenty years before Amsterdam had suddenly and spectacularly become the financial capital of the entire world. Speculation concerning grain, precious metals, currencies, slaves, spices and commodities of every kind is being pursued on a scale and with a success that leaves the rest of Europe not only amazed but dependent on Dutch capital.

A new energy has been released and a kind of metaphysic of money is being born. Money acquires its own virtue – and, on its own terms, demonstrates its own tolerance. (Holland is the only state in Europe without religious persecution.) All traditional values are being either superseded or placed within limits and so robbed of their absolutism. The States of Holland have officially declared that the Church has no concern with questions of usury within the world of banking. Dutch arms-merchants consistently sell arms, not only to every contestant in Europe, but also, during the cruellest wars, to their own enemies.

The officers of the St George's Company of the Haarlem Civic Guard belong to the first generation of the modern spirit of Free Enterprise. A little later Hals painted a portrait which seems to me to depict this spirit more vividly than any other painting or photograph I have ever seen. It is of Willem van Heythuyzen.

What distinguishes this portrait from all earlier portraits of wealthy or powerful men is its instability. Nothing is secure in its place. You have the feeling of looking at a man in a ship's cabin during a gale. The table will slide across the floor. The book will fall off the table. The curtain will tumble down.

Furthermore, to emphasize and make a virtue out of this precariousness, the man leans back on his chair to the maximum angle of possible balance, and tenses the switch which he is holding in his hands so as

almost to make it snap. And it is the same with his face and expression. His glance is a momentary one, and around his eyes you see the tiredness which is the consequence of having always, at each moment, to calculate afresh.

At the same time the portrait in no way suggests decay or disintegration. There may be a gale but the ship is sailing fast and confidently. Today van Heythuyzen would doubtless be described by his associates as being 'electric', and there are millions who model themselves – though not necessarily consciously – on the bearing of such men.

Put van Heythuyzen in a swivel chair, without altering his posture, pull the desk up in front of him, change the switch in his hands to a ruler or an aluminium rod, and he becomes a typical modern executive, sparing a few moments of his time to listen to your case.

But to return to the banquet. All the men are now somewhat drunk. The hands that previously balanced a knife, held a glass between two fingers, or squeezed a lemon over the oysters, now fumble a little. At the same time their gestures become more exaggerated – and more and more directed towards us, the imaginary audience. There is nothing like alcohol for making one believe that the self one is presenting is one's true, up to now always hidden, self.

They interrupt each other and talk at cross-purposes. The less they communicate by thought, the more they put their arms round each other. From time to time they sing, content that at last they are acting in unison, for each, half lost in his own fantasy of self-presentation, wishes to prove to himself and to the others only one thing – that he is the truest friend there.

Hals is more often than not a little apart from the group. And he appears to be watching them as we are watching them.

The second act opens on the same set with the same banqueting table, but now Hals sits alone at the end of it. He is in his late sixties or early seventies, but still very much in possession of his faculties. The passing of the intervening years has, however, considerably changed the atmosphere of the scene. It has acquired a curiously mid-nineteenth-century air. Hals is dressed in a black cloak, with a black hat somewhat like a nineteenth-century top hat. The bottle in front of him is black. The only relief to the blackness is his loose white collar and the white page of the book open on the table.

The blackness, however, is not funereal. It has a rakish and defiant quality about it. We think of Baudelaire. We begin to understand why Courbet and Manet admired Hals so much.

The turning point occurred in 1645. For several years before that, Hals had received fewer and fewer commissions. The spontaneity of his portraits which had so pleased his contemporaries became unfashion-

able with the next generation, who already wanted portraits which were more morally reassuring – who demanded in fact the prototypes of that official bourgeois hypocritical portraiture which has gone on ever since.

In 1645 Hals painted a portrait of a man in black looking over the back of a chair. Probably the sitter was a friend. His expression is another one that Hals was the first to record. It is the look of a man who does not believe in the life he witnesses, yet can see no alternative. He has considered, quite impersonally, the possibility that life may be absurd. He is by no means desperate. He is interested. But his intelligence isolates him from the current purpose of men and the supposed purpose of God. A few years later Hals painted a self-portrait displaying a different character but the same expression.

As he sits at the table it is reasonable to suppose that he reflects on his situation. Now that he receives so few commissions, he is in severe financial difficulties. But his financial crisis is secondary in his own mind to his doubts about the meaning of his work.

When he does paint, he does so with even greater mastery than previously. But this mastery has itself become a problem. Nobody before Hals painted portraits of such immediacy. Earlier artists painted portraits of greater dignity and greater sympathy, implying greater permanence. But nobody before seized upon the momentary personality of the sitter as Hals has done. It is with him that the notion of 'the speaking likeness' is born. Everything is sacrificed to the demands of the sitter's immediate presence.

Or almost everything, for the painter needs a defence against the threat of becoming the mere medium through whom the sitter presents himself. In Hals's portraits his brushmarks increasingly acquire a life of their own. By no means all of their energy is absorbed by their descriptive function. We are not only made acutely aware of the subject of the painting, but also of *how* it has been painted. With 'the speaking likeness' of the sitter is also born the notion of the virtuoso performance by the painter, the latter being the artist's protection against the former.

Yet it is a protection that offers little consolation, for the virtuoso performance only satisfies the performer for the duration of the performance. Whilst he is painting, it is as though the rendering of each face or hand by Hals is a colossal gamble for which all the sharp, rapid brushstrokes are the stakes. But when the painting is finished, what remains? The record of a passing personality and the record of a performance which is over. There are no real stakes. There are only careers. And with these – making a virtue of necessity – he has no truck.

Whilst he sits there, people – whose seventeenth-century Dutch costumes by now surprise us – come to the other end of the table and pause there. Some are friends, some are patrons. They ask to be painted. In most cases Hals declines. His lethargic manner is an aid. And

perhaps his age as well. But there is also a certain defiance about his attitude. He makes it clear that, whatever may have happened when he was younger, he no longer shares their illusions.

Occasionally he agrees to paint a portrait. His method of selection seems arbitrary: sometimes it is because the man is a friend: sometimes because the face interests him. (It must be made clear that this second act covers a period of several years.) When a face interests him, we perhaps gather from the conversation that it is because in some way or another the character of the sitter is related to the problem that preoccupies Hals, the problem of what it is that is changing so fundamentally during his lifetime.

It is in this spirit that he paints Descartes, that he paints the new, ineffective professor of theology, that he paints the minister Herman Langelius who 'fought with the help of God's words, as with an iron sword, against atheism', that he paints the twin portraits of Alderman Geraerdts and his wife.

The wife in her canvas is standing, turned to the right and offering a rose in her outstretched hand. On her face is a compliant smile. The husband in his canvas is seated, one hand limply held up to receive the rose. His expression is simultaneously lascivious and appraising. He has no need to make the effort of any pretence. It is as though he is holding out his hand to take a bill of credit that is owing to him.

At the end of the second act a baker claims a debt of 200 florins from Hals. His property and his paintings are seized and he is declared bankrupt.

The third act is set in the old men's almshouse of Haarlem. It is the almshouse whose men and women governors Hals was commissioned to paint in 1664. The two resulting paintings are among the greatest he ever painted.

After he went bankrupt, Hals had to apply for municipal aid. For a long while it was thought that he was actually an inmate of the almshouse – which today is the Frans Hals Museum – but apparently this was not the case. He experienced, however, both extreme poverty and the flavour of official charity.

In the centre of the stage the old men who are inmates sit at the same banqueting table, as featured in the First Act, with bowls of soup before them. Again it strikes us as a nineteenth-century scene – Dickensian. Behind the old men at the table, Hals, facing us, is between two canvases on easels. He is now in his eighties. Throughout the act he peers and paints on both canvases, totally without regard to what is going on elsewhere. He has become thinner as very old men can.

On the left on a raised platform are the men governors whom he is

painting on one canvas; on the right, on a similar platform, are the women governors whom he is painting on the other canvas.

The inmates between each slow spoonful stare fixedly at us or at one of the two groups. Occasionally a quarrel breaks out between a pair of them.

The men governors discuss private and city business. But whenever they sense that they are being stared at, they stop talking and take up the positions in which Hals painted them, each lost in his own fantasy of morality, their hands fluttering like broken wings. Only the drunk with the large tilted hat goes on reminiscing and occasionally proposing a mock banquet toast. Once he tries to engage Hals in conversation.

(I should point out here that this is a theatrical image; in fact the governors and governesses posed singly for these group portraits.)

The women discuss the character of the inmates and offer explanations for their lack of enterprise or moral rectitude. When they sense that they are being stared at, the woman on the extreme right brings down her merciless hand on her thigh and this is a sign for the others to stare back at the old men eating their soup.

The hypocrisy of these women is not that they give while feeling nothing, but that they never admit to the hate now lodged permanently under their black clothes. Each is secretly obsessed with her own hate. She puts out crumbs for it every morning of the endless winter until finally it is tame enough to tap on the glass of her bedroom window and wake her at dawn.

Darkness. Only the two paintings remain – two of the most severe indictments ever painted. They are projected side by side to fill a screen across the whole stage.

Offstage there is the sound of banqueting. Then a voice announces: 'He was eighty-four and he had lost his touch. He could no longer control his hands. The result is crude and, considering what he once was, pathetic.'

1966

Auguste Rodin

'People say I think too much about women,' said Rodin to William Rothenstein. Pause. 'Yet after all, what is there more important to think about?'

The fiftieth anniversary of his death. Tens of thousands of plates of Rodin sculptures have been specially printed this year for anniversary books and magazine features. The anniversary cult is a means of painlessly and superficially informing a 'cultural *élite*' which for consumer-market reasons needs constantly to be enlarged. It is a way of *consuming* – as distinct from understanding – history.

Of the artists of the second half of the nineteenth century who are today treated as masters, Rodin is the only one who was internationally honoured and officially considered illustrious during his working life. He was a traditionalist. 'The idea of progress,' he said, 'is society's worst form of cant.' From a modest *petit-bourgeois* Parisian family, he became a *master* artist. At the height of his career he employed ten other sculptors to carve the marbles for which he was famous. From 1900 onwards his declared annual income was in the region of 200,000 francs: in fact it was probably considerably higher.

A visit to the Hôtel de Biron, the Rodin Museum in Paris, where versions of most of his works are to be seen, is a strange experience. The house is *peopled* by hundreds of figures: it is like a Home or a Workhouse of statues. If you approach a figure and, as it were, question it with your eyes, you may discover much of incidental interest (the detail of a hand, a mouth, the idea implied by the title, etc.). But, with the exception of the studies for the Balzac monument and of the *Walking Man* which, made twenty years earlier, was a kind of prophetic study for the Balzac, there is not a single figure which stands out and claims its own, according to the first principle of free-standing sculpture: that is to say not a single figure which dominates the space around it.

All are prisoners within their contours. The effect on you is cumulative. You become aware of the terrible compression under which these figures exist. An invisible pressure inhibits and reduces every possible thrust outwards into some small surface event for the fingertips. 'Sculpture', Rodin claimed, 'is quite simply the art of depression and protuberance. There is no getting away from that.' Certainly there is no getting away from it in the Hôtel de Biron. It is as though the figures were being forced back into their material: if the same pressure were further increased, the three-dimensional sculptures would become bas-reliefs: if increased yet further the bas-reliefs would become mere imprints on a wall. The *Gates of Hell* are a vast and enormously complex demonstration and expression of this pressure. *Hell* is the force which presses these figures back into the door. *The Thinker*, who overlooks the scene, is clenched against all outgoing contact: he shrinks from the very air that touches him.

During his lifetime Rodin was attacked by philistine critics for 'mutilating' his figures – hacking off arms, decapitating torsos, etc. The attacks were stupid and misdirected, but they were not entirely without foundation. Most of Rodin's figures have been reduced to less than they should be as independent sculptures: they have suffered oppression.

It is the same in his famous nude drawings in which he drew the woman's or dancer's outline without taking his eyes off the model, and afterwards filled it in with a water-colour wash. These drawings, though often striking, are like nothing so much as pressed leaves or flowers.

This failure of his figures (always with the exception of the *Balzac*) to create any spatial tension with their surroundings passed unnoticed by his contemporaries because they were preoccupied with their literary interpretations, which were sharpened by the obvious sexual significance of many of the sculptures. Later it was ignored because the revival of interest in Rodin (which began about fifteen to twenty years ago) concentrated upon the mastery of 'his touch' upon the sculptural surface. He was categorized as a sculptural 'Impressionist'. Nevertheless it is this failure, the existence of this terrible pressure upon Rodin's figures, which supplies the clue to their real (if negative) content.

The figure of the emaciated old woman, *She Who Was Once the Helmet-Maker's Beautiful Wife*, with her flattened breasts and her skin pressed against the bone, represents a paradigmatic choice of subject. Perhaps Rodin was dimly aware of his predisposition.

Often the action of a group or a figure is overtly concerned with some force of compression. Couples clasp each other (*vide The Kiss* where everything is limp except his hand and her arm both pulling inwards). Other couples fall on each other. Figures embrace the earth, swoon to the ground. A fallen caryatid still bears the stone that weighs her down. Women crouch as though pressed, hiding, into a corner.

In many of the marble carvings figures and heads are meant to look as if they have only half emerged from the uncut block of stone: but in fact they look as though they are being compressed into and are merging with the block. If the implied process were to continue, they would not emerge independent and liberated: they would disappear.

Even when the action of the figure apparently belies the pressure being exerted upon it – as with certain of the smaller bronzes of dancers – one feels that the figure is still the malleable creature, unemancipated, of the sculptor's moulding hand. This hand fascinated Rodin. He depicted it holding an incomplete figure and a piece of earth and called it *The Hand of God.*

Rodin explains himself:

> No good sculptor can model a human figure without dwelling on the mystery of life: this individual and that in fleeting variations only reminds him of the immanent type; he is led perpetually from the creature to the creator . . . That is why many of my figures have a hand, a foot, still imprisoned in the marble block; life is everywhere, but rarely indeed does it come to complete expression or the individual to perfect freedom.[1]

Yet if the compression which his figures suffer is to be explained as the expression of some kind of pantheistic fusion with nature, why is its effect so disastrous in sculptural terms?

Rodin was extraordinarily gifted and skilled as a sculptor. Given that his work exhibits a consistent and fundamental weakness, we must examine the structure of his personality rather than that of his opinions.

Rodin's insatiable sexual appetite was well-known during his lifetime, although since his death certain aspects of his life and work (including many hundreds of drawings) have been kept secret. All writers on Rodin's sculpture have noticed its sensuous [*sic*] or sexual character: but many of them treat this sexuality only as an ingredient. It seems to me that it was the prime motivation of his art – and not merely in the Freudian sense of a sublimation.

Isadora Duncan in her autobiography describes how Rodin tried to seduce her. Finally – and to her later regret – she resisted.

> Rodin was short, square, powerful with close-cropped head and plentiful beard . . . Sometimes he murmured the names of his statues, but one felt that names meant little to him. He ran his hands over them and caressed them. I remember thinking that beneath his hands the marble seemed to flow like molten lead. Finally he took a small quantity of clay and pressed it between his palms. He breathed hard as he did so . . . In a few moments he had formed a woman's breast . . .

Then I stopped to explain to him my theories for a new dance, but soon I realised that he was not listening. He gazed at me with lowered lids, his eyes blazing, and then, with the same expression that he had before his works, he came towards me. He ran his hands over my neck, breast, stroked my arms and ran his hands over my hips, my bare legs and feet. He began to knead my whole body as if it were clay, while from him emanated heat that scorched and melted me. My whole desire was to yield to him my entire being . . .[2]

Rodin's success with women appears to have begun when he first began to become successful as a sculptor (aged about forty). It was then that his whole bearing – and his fame – offered a promise that Isadora Duncan describes so well because she describes it obliquely. His promise to women is that he will mould them: they will become clay in his hands: their relation to him will become symbolically comparable to that of his sculptures.

When Pygmalion returned home, he made straight for the statue of the girl he loved, leaned over the couch, and kissed her. She seemed warm: he laid his lips on hers again, and touched her breast with his hands – at his touch the ivory lost its hardness, and grew soft: his fingers made an imprint on the yielding surface, just as wax of Hymettus melts in the sun and, worked by men's fingers, is fashioned into many different shapes, and made fit for use by being used.[3]

What we may term the Pygmalion promise is perhaps a general element in male attraction for many women. When a specific and actual reference to a sculptor and his clay is at hand, its effect simply becomes more intense because it is more consciously recognizable.

What is remarkable in Rodin's case is that he himself appears to have found the Pygmalion promise attractive. I doubt whether his playing with the clay in front of Isadora Duncan was simply a ploy for her seduction: the ambivalence between clay and flesh also appealed to him. This is how he described the Venus de' Medici:

Is it not marvellous? Confess that you did not expect to discover so much detail. Just look at the numberless undulations of the hollow which unites the body and the thigh . . . Notice all the voluptuous curvings of the hip . . . And now, here, the adorable dimples along the loins . . . It is truly flesh . . . You would think it moulded by caresses! You almost expect, when you touch this body, to find it warm.

If I am right, this amounts to a kind of inversion of the original myth and of the sexual archetype suggested by it. The original Pygmalion creates a

statue with whom he falls in love. He prays that she may become alive so that she may be released from the ivory in which he has carved her, so that she may become independent, so that he can meet her *as an equal rather than as her creator*. Rodin, on the contrary, wants to perpetuate an ambivalence between the living and the created. What he is to women, he feels he must be to his sculptures. What he is to his sculptures, he wants to be to women.

Judith Cladel, his devoted biographer, describes Rodin working and making notes from the model.

> He leaned closer to the recumbent figure, and fearing lest the sound of his voice might disturb its loveliness, he whispered: 'Hold your mouth as though you were playing the flute. Again! Again!'
>
> Then he wrote: 'The mouth, the luxurious protruding lips sensuously eloquent . . . Here the perfumed breath comes and goes like bees darting in and out of the hive . . .'
>
> How happy he was during these hours of deep serenity, when he could enjoy the untroubled play of his faculties! A supreme ecstasy, for it had no end:
>
> 'What a joy is my ceaseless study of the human flower!
>
> 'How fortunate that in my profession I am able to love and also to speak of my love!'[4]

We can now begin to understand why his figures are unable to claim or dominate the space around them. They are physically compressed, imprisoned, forced back by the force of Rodin as dominator. Objectively speaking these works are expressions of his own freedom and imagination. But because clay and flesh are so ambivalently and fatally related in his mind, he is forced to treat them as though they were a challenge to his own authority and potency.

This is why he never himself worked in marble but only in clay and left it to his employees to carve in the more intractable medium. This is the only apt interpretation of his remark: 'The first thing God thought of when he created the world was modelling.' This is the most logical explanation of why he found it necessary to keep in his studio at Meudon a kind of mortuary store of modelled hands, legs, feet, heads, arms, which he liked to play with by seeing whether he could add them to newly created bodies.

Why is the *Balzac* an exception? Our previous reasoning already suggests the answer. This is a sculpture of a man of enormous power striding across the world. Rodin considered it his masterpiece. All writers on Rodin are agreed that he also identified himself with Balzac. In one of the nude studies for it the sexual meaning is quite explicit: the right hand grips the erect penis. This is a monument to male potency. Frank

Harris wrote of a later clothed version and what he says might apply to the finished one: 'Under the old monastic robe with its empty sleeves, the man holds himself erect, the hands firmly grasping his virility and the head thrown back.' This work was such a direct confirmation of Rodin's own sexual power that for once he was able to let it dominate him. Or, to put it another way – when he was working on the Balzac, the clay, probably for the only time in his life, seemed to him to be masculine.

The contradiction which flaws so much of Rodin's art and which becomes, as it were, its most profound and yet negative content must have been in many ways a personal one. But it was also typical of an historical situation. Nothing reveals more vividly than Rodin's sculptures, if analysed in sufficient depth, the nature of bourgeois sexual morality in the second half of the nineteenth century.

On the one hand the hypocrisy, the guilt, which tends to make strong sexual desire – even if it can be nominally satisfied – febrile and phantasmagoric; on the other hand the fear of women escaping (as property) and the constant need to control them.

On the one hand Rodin who thinks that women are the most important thing in the world to think about; on the other hand the same man who curtly says: 'In love all that counts is the act.'

1967

From *The Look of Things*

Peter Peri

I knew about Peter Peri from 1947 onwards. At that time he lived in Hampstead and I used to pass his garden where he displayed his sculptures. I was an art student just out of the Army. The sculptures impressed me not so much because of their quality – at that time many other things interested me more than art – but because of their strangeness. They were foreign looking. I remember arguing with my friends about them. They said they were crude and coarse. I defended them because I sensed that they were the work of somebody totally different from us.

Later, between about 1952 and 1958, I came to know Peter Peri quite well and became more interested in his work. But it was always the man who interested me most. By then he had moved from Hampstead and was living in considerable poverty in the old Camden Studios in Camden Town. There are certain aspects of London that I will always associate with him: the soot-black trunks of bare trees in winter, black railings set in concrete, the sky like grey stone, empty streets at dusk with the front doors of mean houses giving straight on to them, a sour grittiness in one's throat and then the cold of his studio and the smallness of his supply of coffee with which nevertheless he was extremely generous. Many of his sculptures were about the same aspects of the city. Thus even inside his studio there was little sense of refuge. The rough bed in the corner was not unlike a street bench – except that it had books on a rough shelf above it. His hands were ingrained with dirt as though he worked day and night in the streets. Only the stove gave off a little warmth, and on top of it, keeping warm, the tiny copper coffee saucepan.

Sometimes I suggested to him that we went to a restaurant for a meal. He nearly always refused. This was partly pride – he was proud to the point of arrogance – and partly perhaps it was good sense: he was used to his extremely meagre diet of soup made from vegetables and black

bread, and he did not want to disorient himself by eating better. He knew that he had to continue to lead a foreign life.

His face. At the same time lugubrious and passionate. Broad, low forehead, enormous nose, thick lips, beard and moustache like an extra article of clothing to keep him warm, insistent eyes. The texture of his skin was coarse and the coarseness was made more evident by never being very clean. It was the face whose features and implied experience one can find in any ghetto – Jewish or otherwise.

The arrogance and the insistence of his eyes often appealed to women. He carried with him in his face a passport to an alternative world. In this world, which physically he had been forced to abandon but which metaphysically he carried with him – as though a microcosm of it was stuffed into a sack on his back – he was virile, wise and masterful.

I often saw him at public political meetings. Sometimes, when I myself was a speaker, I would recognize him in the blur of faces by his black beret. He would ask questions, make interjections, mutter to himself – occasionally walk out. On occasions he and my friends would meet later in the evening and go on discussing the issues at stake. What he had to say or what he could explain was always incomplete. This was not so much a question of language (when he was excited he spoke in an almost incomprehensible English), as a question of his own estimate of us, his audience. He considered that our experience was inadequate. We had not been in Budapest at the time of the Soviet Revolution. We had not seen how Bela Kun had been – perhaps unnecessarily – defeated. We had not been in Berlin in 1920. We did not understand how the possibility of a revolution in Germany had been betrayed. We had not witnessed the creeping advance and then the terrifying triumph of Nazism. We did not even know what it was like for an artist to have to abandon the work of the first thirty years of his life. Perhaps some of us might have been able to imagine all this, but in this field Peri did not believe in imagination. And so he always stopped before he had completed saying what he meant, long before he had disclosed the whole of the microcosm that he carried in his sack.

I asked him many questions. But now I have the feeling that I never asked him enough. Or at least that I never asked him the right questions. Anyway I am not in a position to describe the major historical events which conditioned his life. Furthermore I know nobody in London who is. Perhaps in Budapest there is still a witness left: but most are dead, and of the dead most were killed. I can only speak of my incomplete impression of him. Yet though factually incomplete, this impression is a remarkably total one.

Peter Peri was an exile. Arrogantly, obstinately, sometimes cunningly, he preserved this role. Had he been offered recognition as an artist or as a man of integrity or as a militant antifascist, it is possible that he would

172

have changed. But he was not. Even an artist like Kokoschka, with all his continental reputation and personal following among important people, was ignored and slighted when he arrived in England as a refugee. Peri had far fewer advantages. He arrived with only the distant reputation of being a Constructivist, a militant communist and a penniless Jew. By the time I knew him, he was no longer either of the first two, but had become an eternal exile – because only in this way could he keep faith with what he had learned and with those who had taught him.

Something of the meaning of being such an exile I tried to put into my novel *A Painter of Our Time.*[1] The hero of this novel is a Hungarian of exactly the same generation as Peri. In some respects the character resembles Peri closely. We discussed the novel together at length. He was enthusiastic about the idea of my writing it. What he thought of the finished article I do not know. He probably thought it inadequate. Even if he had thought otherwise, I think it would have been impossible for him to tell me. By that time the habit of suffering inaccessibility, like the habit of eating meagre vegetable soup, had become too strong.

I should perhaps add that the character of James Lavin in this novel is in no sense a *portrait* of Peri. Certain aspects of Lavin derived from another Hungarian émigré, Frederick Antal, the art historian who, more than any other man, taught me how to write about art. Yet other aspects were purely imaginary. What Lavin and Peri share is the depth of their experience of exile.

Peri's work is very uneven. His obstinacy constructed a barrier against criticism, even against comment, and so in certain ways he failed to develop as an artist. He was a bad judge of his own work. He was capable of producing works of the utmost crudity and banality. But he was also capable of producing works vibrant with an idea of humanity. It does not seem to me to be important to catalogue which are which. The viewer should decide this for himself. The best of his works express what he believed in. This might seem to be a small achievement but in fact it is a rare one. Most works which are produced are either cynical or hypo-critical – or so diffuse as to be meaningless.

Peter Peri. His presence is very strong in my mind as I write these words. A man I never knew well enough. A man, if the truth be told, who was always a little suspicious of me. I did my best to help and encourage him, but this did not allay his suspicions. I had not passed the tests which he and his true friends had had to pass in Budapest and Berlin. I was a relatively privileged being in a relatively privileged country. I upheld some of the political opinions which he had abandoned, but I upheld them without ever having to face a fraction of the consequences which he and his friends had experienced and suffered. It was not that he distrusted me: it was simply that he reserved the right to doubt. It was an unspoken doubt that I could only read in his knowing, almost closed

eyes. Perhaps he was right. Yet if I had to face the kind of tests Peter Peri faced, his example would, I think, be a help to me. The effect of his example may have made his doubts a little less necessary.

Peri suffered considerably. Much of this suffering was the direct consequence of his own attitude and actions. What befell him was not entirely arbitrary. He was seldom a passive victim. Some would say that he suffered unnecessarily – because he could have avoided much of his suffering. But Peri lived according to the laws of his own necessity. He believed that to have sound reasons for despising himself would be the worst that could befall him. This belief, which was not an illusion, was the measure of his nobility.

1968

Zadkine

Last night a man who was looking for a flat and asking me about rents told me that Zadkine was dead.

One day when I was particularly depressed Zadkine took us out to dinner to cheer me up. When we were sitting at the table and after we had ordered, he took my arm and said: 'Remember when a man falls over a cliff, he almost certainly smiles before he hits the ground, because that's what his own demon tells him to do.'

I hope it was true for him.

I did not know him very well but I remember him vividly.

A small man with white hair, bright piercing eyes, wearing baggy grey flannel trousers. The first striking thing about him is how he keeps himself clean. Maybe a strange phrase to use – as though he were a cat or a squirrel. Yet the odd thing is that after a while in his company, you begin to realize that, in one way or another, many men don't keep themselves clean. He is a fastidious man; it is this which explains the unusual brightness of his eyes, the way that his crowded studio, full of figureheads, looks somehow like the scrubbed deck of a ship, the fact that under and around the stove there are no ashes or coal-dust, his clean cuffs above his craftsman's hands. But it also explains some of his invisible characteristics: his certainty, the modest manner in which he is happy to live, the care with which he talks of his own 'destiny', the way that he talks of a tree as though it had a biography as distinct and significant as his own.

He talks almost continuously. His stories are about places, friends, adventures, the life he has lived: never, as with the pure egotist, about *his own opinion of himself*. When he talks, he watches what he is telling as

though it were all there in front of his hands, as though it were a fire he was warming himself at.

Some of the stories he has told many times. The story of the first time he was in London, when he was about seventeen. His father had sent him to Sunderland to learn English and in the hope that he would give up the idea of wanting to be an artist. From Sunderland he made his own way to London and arrived there without job or money. At last he was taken on in a woodcarving studio for church furniture.

'Somewhere in an English church there is a lectern, with an eagle holding the bible on the back of its outspread wings. One of those wings I carved. It is a Zadkine – unsigned. The man next to me in the workshop was a real English artisan – such as I'd never met before. He always had a pint of ale on his bench when he was working. And to work he wore glasses – perched on the end of his nose. One day this man said to me: "The trouble with you is that you're too small. No one will ever believe that you can do the job. Why don't you carve a rose to show them?" "What shall I carve it out of?" I asked. He rummaged under his bench and produced a block of apple wood – a lovely piece of wood, old and brown. And so from this I carved a rose with all its petals and several leaves. I carved it so finely that when you shook it, the petals moved. And the old man was right. As soon as the rush job was over, I had to leave that workshop. When I went to others, they looked at me sceptically. I was too young, too small and my English was very approximate. But then I would take the rose out of my pocket, and the rose proved eloquent. I'd get the job.'

We are standing by an early wood-carving of a nude in his studio.

'Sometimes I look at something I've made and I know it is good. Then I touch wood, or rather I touch my right hand.' As he says this, Zadkine touches the back of his small right hand, as though he were touching something infinitely fragile – an autumn leaf for example.

'I used to think that when I died and was buried all my wood carvings would be burnt with me. That was when they called me "the negro sculptor". But now all these carvings are in museums. And when I die, I shall go with some little terracottas in my pocket and a few bronzes strung on my belt – like a pedlar.'

Drinking a white wine of which he is very proud and which he brings to Paris from the country, sitting in a small bedroom off the studio, he reminisces.

'When I was about eight years old, I was at my uncle's in the country. My uncle was a barge-builder. They used to saw whole trees from top to bottom to make planks – saw them by hand. One man at the top end of the saw was high up and looked like an angel. But it was the man at the bottom who interested me. He got covered from head to foot in sawdust. New, resinous sawdust so that he smelt from head to foot of wood – and the sawdust

collected even in his eyebrows. At my uncle's I used to go for walks by myself down by the river. One day I saw a young man towing a barge. On the barge was a young woman. They were shouting at each other in anger. Suddenly I heard the man use the word CUNT. You know how for children the very sound of certain forbidden words can become frightening? I was frightened like that. I remembered hearing the word once before – though God knows where I had learnt that it was forbidden – I was going along the passage between the kitchen and the dining-room and as I passed a door I saw a young man from the village with one of our maids on his knee, his hand was unbuttoning her and he used the same word.

'I started to run away from the river and the shouting couple by the barge towards the forest. Suddenly, as I ran, I slipped and I found myself face down on the earth.

'And it was there, after I had fallen flat on my face as I ran away from the river, that my demon first laid his finger on my sleeve. And so, instead of running on, I found myself saying – I will go back to see why I slipped. I went back and I found that I had slipped on some clay. And again for the second time my demon laid a finger on my sleeve. I bent down and I scooped up a handful of the clay. Then I walked to a fallen tree trunk, sat down on it and began to model a figure, the first in my life. I had forgotten my fear. The little figure was of a man. Later – at my father's house – I discovered that there was also clay in our back garden.'

It is about ten o'clock on a November morning seven years ago. The light in the studio is matter of fact. I have only called to collect or deliver something. It is a time for working rather than talking. Yet he insists that I sit down for a moment.

'I am very much occupied with time,' he says, 'you are young but you will feel it one day. Some days I see a little black spot high up in the corner of the studio and I wonder whether I will have the time to do all that I still have to do – to correct all my sculptures which are not finished. You see that figure there. It is all right up to the head. But the head needs doing again. All the time I am looking at them. In the end, if you're a sculptor, there's very little room left for yourself – your works crowd you out.'

Zadkine's masterpiece remains his monument to the razed and reborn city of Rotterdam. This is how he wrote about it:

It is striving to embrace the inhuman pain inflicted on a city which had no other desire but to live by the grace of God and to grow naturally like a forest . . . It was also intended as a lesson to future generations.

1967

Le Corbusier

It was on market day in the nearest town that I saw the headlines announcing the death of Le Corbusier. There were no buildings bearing the evidence of his life's work in that dusty, provincial and exclusively commercial French town (fruit and vegetables), yet it seemed to bear witness to his death. Perhaps only because the town was an extension of my own heart. But the intimations in my heart could not have been unique; there were others, reading the local newspaper at the café tables, who had also glimpsed with the help of Corbusier the ideal of a town built to the measure of man.

Le Corbusier is dead. A good death, my companions said, a good way to die: quickly in the sea whilst swimming at the age of seventy-eight. His death seems a diminution of the possibilities open to even the smallest village. Whilst he lived, there seemed always to be a hope that the village might be transformed for the better. Paradoxically this hope arose out of the maximum improbability. Le Corbusier, who was the most practical, democratic and visionary architect of our time, was seldom given the opportunity to build in Europe. The few buildings he put up were all prototypes for series which were never constructed. He was the alternative to architecture as it exists. The alternative still remains, of course. But it seems less pressing. His insistence is dead.

We made three journeys to pay our own modest last respects. First we went to look again at the Unité d'Habitation at Marseilles. How is it wearing? they ask. It wears like a good example that hasn't been followed. But the kids still bathe in their pool on the roof, safely, grubbily, between the panorama of the sea and of the mountains, in a setting which, until this century, could only have been imagined as an extravagant one for cherubs in a Baroque ceiling painting. The big lifts for the prams and bicycles work smoothly. The vegetables in the shopping street on the third floor are as cheap as those in the city.

The most important thing about the whole building is so simple that it can easily be taken for granted – which is what Corbusier intended. If you wish, you can condescend towards this building for, despite its size and originality, it suggests nothing which is larger than you – no glory, no prestige, no demagogy and no property-morality. It offers no excuses for living in such a way as to be less than yourself. And this, although it began as a question of spirit, was in practice only possible as a question of proportion.

The next day we went to the eleventh-century Cistercian abbey at Le Thoronet. I have the idea that Corbusier once wrote about it, and anybody who really wants to understand his theory of functionalism – a theory which has been so misunderstood and abused – should certainly visit it. The content of the abbey, as opposed to its form or the immediate purposes for which it was designed, is very similar to that of the Unité d'Habitation. It is very hard indeed to take account of the nine centuries that separate them.

I do not know how to describe, without recourse to drawing, the complex simplicity of the abbey. It is like the human body. During the French Revolution it was sacked and was never re-furnished: yet its nakedness is no more than a logical conclusion to the Cistercian rule which condemned decoration. Children were playing in the cloister, as in the pool on the roof, and running the length of the nave. They were never dwarfed by the structure. The abbey buildings are functional because they were concerned with supplying the means rather than suggesting the end. The end is up to those who inhabit it. The means allow them to realize themselves and so to discover their purpose. This seems as true of the children today as of the monks then. Such architecture offers only tranquillity and human proportion. For myself I find in its discretion everything which I can recognize as spiritual. The power of functionalism does not lie in its utility, but in its moral example: an example of trust, the refusal to exhort.

Our third visit was to the bay where he died. If you follow a scrubby footpath along the side of the railway, eastwards from the station of Roquebrune, you come to a café and hotel built of wood and corrugated roofing. In most respects it is a shack like hundreds of others built over the beaches of the Côte d'Azur – a cross between a houseboat and a gimcrack stage. But this one was built according to the advice of Le Corbusier because *le patron* was an old friend. Some of the proportions and the colour scheme are recognizably his. And on the outside wooden wall, facing the sea, he painted his emblem of the six-foot man who acted as modular and measure for all his architecture.

We sat on the planked terrace and drank coffee. As I watched the sea below, it seemed for one moment that the barely visible waves, looking like ripples, were the last sign of the body that had sunk there a week

before. It seemed for one moment as though the sea might recognize more than the architecture of dyke and breakwater. A pathetic illusion.

Across the bay you can see Monte Carlo. If the light is diffused, the silhouette of the mountains coming down to the sea can look like a Claude Lorrain. If the light is hard, you see the commerce of the architecture on those mountains. Particularly noticeable is a four-star hotel built on the very edge of a precipice. Vulgar and strident as it is, it would never have been built without Corbusier's initial example. And the same applies to a score of other buildings lower down on the slopes. All of them exhort to wealth.

Then I noticed near the modular man the imprint of a hand. A deliberate imprint, forming part of the decoration. It was a few feet from a Coca-Cola advertisement: several hundred feet above the sea: and it faced the buildings that exhorted to wealth. It was probably Le Corbusier's hand. But it could stand for his memorial if it was any man's.

1965

Victor Serge

Victor Serge was born in Belgium in 1890. His parents were Russian émigrés who fled Russia as a result of his father's revolutionary activities.

> On the walls of our humble and makeshift lodgings there were always portraits of men who had been hanged. The conversations of grown-ups dealt with trials, executions, escapes, and Siberian highways, with great ideas incessantly argued over, and with the latest books about these ideas.

Serge left home at fifteen, was quickly disillusioned by the Belgian socialist party, and became an anarchist. In Paris he edited the paper *L'Anarchie* and in 1912 was arrested and sentenced to five years' solitary confinement for being associated with the Bonnot gang who were terrorizing Paris. (One of the recurring features of Serge's life was his 'guilt' by association with those whom he refused to condemn or betray but did not necessarily agree with.)

After his release from prison he went to Barcelona where he became a syndicalist agitator. His one idea following the October revolution was to return to his own country – where he had never yet been – and to work for and defend the revolution. On his way through France he was interned as a suspect Bolshevik. In Petrograd he worked closely with Zinoviev on the founding of the Communist International, and joined the Communist Party. By 1923 he belonged to the Trotskyist left opposition – which at that time was still treated as a loyal opposition. In 1927 he was expelled from the party and afterwards imprisoned and exiled. His life was probably saved by the intercession of certain French writers on his behalf. Deprived of Soviet citizenship, he was allowed to leave the U.S.S.R. In the late thirties, he arrived back in Paris without papers. He broke with the Trotskyists because he considered the Fourth

International sectarian and ineffective. He escaped the Gestapo at the last moment in 1941, by sailing to Mexico. There he died, penniless, in 1947.

Serge wrote about twenty books – books of political comment, history, novels, poems, autobiography. All are related to his own experiences.

Writing, as distinct from agitational journalism, was for Serge a secondary activity, only resorted to when more direct action was impossible. He began writing his serious books in 1928 when his position in the U.S.S.R. was extremely precarious and he was awaiting arrest. He saw writing

> as a means of expressing to men what most of them live inwardly without being able to express, as a means of communion, a testimony to the vast flow of life through us, whose essential aspect we must try to fix for the benefit of those who will come after us.

It was an ambitious view, and it was justified. We, who come after, indeed have the benefit.

I know of no other writer with whom Serge can be very usefully compared. The essence of the man and his books is to be found in his attitude to the truth. There have of course been many scrupulously honest writers. But for Serge the value of the truth extended far beyond the simple (or complex) telling of it.

His *Memoirs*[1] open with the following sentence:

> Even before I emerged from childhood, I seem to have experienced, deeply at heart, that paradoxical feeling which was to dominate me all through the first part of my life: that of living in a world without any possible escape, in which there was nothing for it but to fight for an impossible escape.

The truth for Serge was what he found in his search for the 'impossible'; it was never a mere description of the given as it appears to appear.

> Early on, I learned from the Russian intelligentsia that the only meaning of life is conscious participation in the making of history. . . . It follows that one must range oneself actively against everything that diminishes man, and involve oneself in all struggles which tend to liberate and enlarge him . . . This conviction has brought me, as it has brought others, to a somewhat unusual destiny: but we were, and still are, in line with the development of history, and it is now obvious that, during an entire epoch, millions of individual destinies will follow the paths along which we were the first to travel.

He recognized the forces of history traversing his time and chose to inhabit them, entering into them through both action and imagination. Yet general truths could never obliterate particular ones for him. He never saw anybody as an anonymous agent of historical forces. He could not write even of a passer-by without feeling the tension between the passer-by's inner and outer life. He identified himself imaginatively with everyone he encountered – workers, peasants, judges, crooks, rich lawyers, seamstresses, spies, traitors, heroes. It was methodologically impossible for a stereotype to occur in Serge's writing. The nature of his imagination forbade it.

Such a wide-ranging and ready sympathy combined with his sense of historical destiny might have made Serge a latter-day, inevitably fifth-rate, Tolstoy. (Inevitably because Tolstoy's view of the world was spontaneously possible only for a few decades.) But Serge was not primarily a creative writer. He wrote in order to report on what he had seen as a consequence of his actions. All his life these actions were those of a socialist revolutionary. Unlike Malraux or Koestler in their political novels, Serge was never writing about a phase of his life that was over; writing was never for him a form of renegation. Those with whom he imaginatively identified himself – whether enemies or comrades – were those on whom his life could depend. Thus, just as his imagination precluded stereotypes, his situation precluded any form of sentimental liberalism.

The truth for Serge was something to be undergone. And, if I understand him rightly, in a rather special way. Despite his very considerable intelligence and courage, Serge never proved himself a revolutionary leader. He was always, more or less, among the rank and file. This may have been partly the result of a reluctance to take any final responsibility of command (here his early anarchism corresponded with a temperamental weakness); but it was also the result of a deliberate choice concerning the category of truth he sought. If the role of the proletariat was to be as historic as Marx had declared, it was the truth of *their* experience, between the possible and the impossible, which must be judged crucial, which must define the only proper meaning of social justice.

Birth of Our Power, a novel,[2] refers to the Russian Revolution, and the book is written in the first person plural. The identity of this *we* changes.

We suffocated, about 30 of us, from seven in the morning to 6.30 at night, in the Gambert y Pia print shop.

– this in Barcelona on the eve of an abortive uprising in 1917.

We had a quiet little room with four cots, the walls papered with maps, a table loaded with books. There were always a few of us there, poring

over the endlessly annotated, commented, summarized texts. There Saint-Just, Robespierre, Jacques Roux, Babeuf, Blanqui, Bakunin, were spoken of as if they had just come down to take a stroll under the trees.

– this is a group of revolutionaries thrown together in an internment camp in France in 1918.

The times when it was necessary for us to know how to accept prison, exile, poverty and – the best and strongest of us – death itself are in the past. From now on we must persist obstinately in living and only consent to everything for that.

– these are the defenders of Petrograd in the winter of 1919, starving, without fuel, the White Army closing in, nine miles away. It might be more accurate to say that the identity of Serge's *we* multiplies rather than changes.

His belief that the truth must be actively pursued, his sense of history, his power of imaginative identification, his decision to remain within the mass – this is what equipped Serge to be an exceptional witness of events. His evidence seems to carry the weight of collective experiences which he never renders abstract but which always remain precise and existential. Perhaps no other writer has been so genuine a spokesman for others.

A large part of Serge's testimony has acquired a further value. The supreme event of his life was the Russian Revolution. Everything before 1917 is attendant upon it. The revolution itself, in all its extraordinary diversity of triumphs and desperations, has no precedent. Everything that happens afterwards Serge refers back in one way or another to the opportunities taken and lost between 1917 and 1927. Very few witnesses of that decade survive to give evidence. Of the few who did, most were concerned with self-justification. Serge's testimony has become unique.

His political judgement of events can often be questioned. He tended to criticize rather than to propose. He contributed little to the theory of revolution. But on behalf of thousands of those who made, and lived through, the Russian Revolution, he set down his evidence. The possible conclusions to be drawn from this cannot be compressed into a short essay. Many of them relate to the central question of why the first successful socialist revolution occurred in an industrially backward country. Bolshevism was itself an expression of this fact – as was also the bureaucracy and the autonomous secret police which it created. Years before Stalin's dictatorship and the so-called cult of personality, this bureaucracy tended towards a totalitarianism which inevitably weakened revolutionary morale.

For Serge the first warning came with the Kronstadt uprising of 1921.

Significantly, he recognized that the uprising had to be put down; what shocked him, even more than the unnecessary brutality with which this was done, was the fact that the truth about the revolt was systematically suppressed.

In 1967, the fiftieth anniversary celebrations of the Russian Revolution revealed how grossly Soviet history continues to be falsified. This falsification, which deprives not only Soviet citizens but people all over the world of the benefit of learning from certain crucial mistakes (and achievements) of the revolution, can be said to be a counter-revolutionary act. The official criteria of the U.S.S.R. are no longer those by which all revolutionary activities in the world are forced to be judged. Such is the context in which Serge is likely to be read. His life and its choices demonstrate an exemplary truth to which he was prophetically sensitive and which we should now accept as axiomatic. Institutions can be defended by lies, revolutions never.

1968

Walter Benjamin

Walter Benjamin was born of a bourgeois Jewish family in Berlin in 1892. He studied philosophy and became a kind of literary critic – a kind such as had never quite existed before. Every page, every object which attracted his attention, contained, he believed, a coded testament addressed to the present: coded so that its message should not become a straight highway across the intervening period blocked with the traffic of direct causality, the military convoys of progress and the gigantic pantechnicons of inherited institutionalized ideas.

He was at one and the same time a romantic antiquarian and an aberrant Marxist revolutionary. The structuring of his thought was theological and Talmudic; his aspirations were materialist and dialectical. The resulting tension is typically revealed in such a sentence as: 'The concept of life is given its due only if everything that has a history of its own, and is not merely the setting for history, is credited with life.'

The two friends who probably influenced him most were Gerhard Scholem, a Zionist professor of Jewish mysticism in Jerusalem, and Bertolt Brecht. His lifestyle was that of a financially independent nineteenth-century 'man of letters', yet he was never free of severe financial difficulties. As a writer he was obsessed with giving the objective existence of his subject its full weight (his dream was to compose a book entirely of quotations); yet he was incapable of writing a sentence which does not demand that one accept his own highly idiosyncratic procedure of thought. For example: 'What seems paradoxical about everything that is justly called beautiful is the fact that it appears.'

The contradictions of Walter Benjamin – and I have listed only some of them above – continually interrupted his work and career. He never wrote the full-length book he intended on Paris at the time of the Second Empire, seen architecturally, sociologically, culturally, psychologically, as the quintessential locus of mid-nineteenth-century capitalism. Most of

what he wrote was fragmentary and aphoristic. During his lifetime his work reached a very small public and every 'school' of thought – such as might have encouraged and promoted him – treated him as an unreliable eclectic. He was a man whose originality precluded his reaching whatever was defined by his contemporaries as achievement. He was treated, except by a few personal friends, as a failure. Photographs show the face of a man rendered slow and heavy by the burden of his own existence, a burden made almost overwhelming by the rapid instantaneous brilliance of his scarcely controllable insights.

In 1940 he killed himself for fear of being captured by the Nazis while trying to cross the French frontier into Spain. It is unlikely that he would have been captured. But from a reading of his works it appears likely that suicide may have seemed a natural end for him. He was very conscious of the degree to which a life is given form by its death; and he may have decided to choose that form for himself, bequeathing to life his contradictions still intact.

Fifteen years after Benjamin's death a two-volume edition of his writings was published in Germany and he acquired a posthumous public reputation. In the last five years this reputation has begun to become international and now there are frequent references to him in articles, conversation, criticism and political discussions.

Why is Benjamin more than a literary critic? And why has his work had to wait nearly half a century to begin to find its proper audience? In trying to answer these two questions, we will perhaps recognize more clearly the need in us which Benjamin now answers and which, never at home in his own time, he foresaw.

The antiquarian and the revolutionary can have two things in common: their rejection of the present as given and their awareness that history has allotted them a task. For them both history is vocational. Benjamin's attitude as a critic to the books or poems or films he criticized was that of a thinker who needed a fixed object before him in historic time, in order thereby to measure time (which he was convinced was not homogeneous) and to grasp the import of the specific passage of time which separated him and the work, to redeem, as he would say, that time from meaninglessness.

> Only that historian will have the gift of fanning the spark of hope in the past who is firmly convinced that *even the dead* will not be safe from the enemy (the ruling class) if he wins. And this enemy has not ceased to be victorious.

Benjamin's hypersensitivity to the dimension of time was not, however, limited to the scale of historical generalization or prophecy. He was equally sensitive to the timescale of a life –

A la Recherche du temps perdu is the constant attempt to charge an entire lifetime with the utmost awareness. Proust's method is actualization, not reflexion. He is filled with the insight that none of us has time to live the true dramas of the life that we are destined for. This is what ages us – this and nothing else. The wrinkles and creases on our faces are the registration of the great passions, vices, insights that called on us; but we, the masters, were not home.

– or to the effect of a second. He is writing about the transformation of consciousness brought about by the film:

Our taverns and our metropolitan streets, our offices and furnished rooms, our railroad stations and our factories appeared to have us locked up hopelessly. Then came the film and burst this prison-world asunder by the dynamite of the tenth of a second, so that now, in the midst of its far-flung ruins and debris, we calmly and adventurously go travelling. With the close-up, space expands; with slow motion, movement is extended . . .

I do not wish to give the impression that Benjamin used works of art or literature as convenient illustrations to already formulated arguments. The principle that works of art are not for use but only for judgement, that the critic is an impartial go-between between the utilitarian and the ineffable, this principle, with all its subtler and still current variations, represents no more than a claim by the privileged that their love of passive pleasure must be considered disinterested! Works of art await use. But their real usefulness lies in what they actually are – which may be quite distinct from what they once were – rather than in what it may be convenient to believe they are. In this sense Benjamin used works of art very realistically. The passage of time which so intrigued him did not end at the exterior surface of the work, it entered into it and there led him into its 'after-life'. In this after-life, which begins when the work has reached 'the age of its fame', the separatedness and isolated identity of the individual work is transcended just as was meant to happen to the soul in the traditional Christian heaven. The work enters the totality of what the present consciously inherits from the past, and in entering that totality it changes it. The after-life of Baudelaire's poetry is not only coexistent with Jeanne Duval, Edgar Allen Poe and Constantin Guys but also, for example, with Haussmann's boulevards, the first department stores, Engels's descriptions of the urban proletariat and the birth of the modern drawing-room in the 1830s which Benjamin described as follows:

For the private citizen, for the first time the living-space became distinguished from the place of work. The former constituted itself

as the interior. The counting-house was its complement. The private citizen who in the counting-house took reality into account required of the interior that it should maintain him in his illusions. This necessity was all the more pressing since he had no intention of adding social preoccupations to his business ones. In the creation of his private environment he suppressed them both. From this sprang the phantasmagorias of the interior. This represented the universe for the private citizen. In it, he assembled the distant in space and in time. His drawing-room was a box in the world theatre.

Perhaps it is now a little clearer why Benjamin was more than a literary critic. But one more point needs to be made. His attitude to works of art was never a mechanically social-historical one. He never tried to seek simple causal relations between the social forces of a period and a given work. He did not want to explain the appearance of the work; he wanted to discover the place that its existence needed to occupy in our knowledge. He did not wish to encourage a love of literature; he wanted the art of the past to realize itself in the choices men make today in deciding their own historical role.

Why is it only now that Benjamin begins to be appreciated as a thinker, and why is his influence likely to increase still further in the 1970s? The awakened interest in Benjamin coincides with Marxism's current re-examination of itself; this re-examination is occurring all over the world, even where it is treated as a crime against the state.

Many developments have led to the need for re-examinations: the extent and degree of the pauperization and violence which imperialism and neo-colonialism inflict upon an ever-increasing majority in the world; the virtual depoliticization of the people of the Soviet Union: the re-emergence of the question of revolutionary *democracy* as primary; the achievements of China's *peasant* revolution; the fact that the proletarians of consumer societies are now less likely to arrive at revolutionary consciousness through the pursuit of their directly economic self-interests than through a wider and more generalized sense of pointless deprivation and frustration; the realization that socialism, let alone communism, cannot be fully achieved in one country so long as capitalism exists as a global system, and so on.

What the re-examinations will entail, both in terms of theory and political practice, cannot be foreseen in advance or from outside the specific territories involved. But we can begin to define the interregnum – the period of re-examination – in relation to what actually preceded it, whilst leaving sensibly aside the claims and counter-claims concerning what Marx himself really meant.

The interregnum is anti-deterministic, both as regards the present being determined by the past and the future by the present. It is sceptical

of so-called historical laws, as it is also sceptical of any supra-historical value, implied by the notion of overall Progress or Civilization. It is aware that excessive personal political power always depends for its survival upon appeals to an impersonal destiny: that every true revolutionary act must derive from a personal hope of being able to contest in that act the world as it is. The interregnum exists in an invisible world, where time is short, and where the immorality of the conviction that ends justify means lies in the arrogance of the assumption that time is always on one's own side and that, therefore, the present moment – the time of the Now, as Benjamin called it – can be compromised or forgotten or denied.

Benjamin was not a systematic thinker. He achieved no new synthesis. But at a time when most of his contemporaries still accepted logics that hid the facts, he foresaw our interregnum. And it is in this context that thoughts like the following from his *Theses on the Philosophy of History* apply to our present preoccupations:

The true picture of the past flits by. The past can be seized only as an image which flashes up at the instant when it can be recognized and is never seen again. 'The truth will not run away from us': in the historical outlook of historicism these words of Gottfried Keller mark the exact point where historical materialism cuts through historicism. For every image of the past that is not recognized by the present as one of its own concerns threatens to disappear irretrievably.

A historical materialist cannot do without the notion of a present which is not a transition, but in which time stands still and has come to a stop. For this notion defines the present in which he himself is writing history.

Whoever has emerged victorious participates to this day in the triumphal procession in which the present rulers step over those who are lying prostrate. According to traditional practice, the spoils are carried along in the procession. They are called cultural treasures, and a historical materialist views them with cautious detachment. For without exception the cultural treasures he surveys have an origin which he cannot contemplate without horror. They owe their existence not only to the efforts of the great minds and talents who have created them, but also to the anonymous toil of their contemporaries. There is no document of civilization which is not at the same time a document of barbarism.

1970

Drawings by Watteau

Delicacy in art is not necessarily the opposite of strength. A water-colour on silk can have a more powerful effect on the spectator than a ten-foot figure in bronze. Most of Watteau's drawings are so delicate, so tentative, that they almost appear to have been done in secret; as though he were drawing a butterfly that had alighted on a leaf in front of him and was frightened that the movement or noise of his chalk on the paper would scare it away. Yet at the same time they are drawings which reveal an enormous power of observation and feeling.

This contrast gives us a clue to Watteau's temperament and the underlying theme of his art. Although he mostly painted clowns, harlequins, fêtes and what we would now call fancy-dress balls, his theme was tragic: the theme of mortality. He suffered from tuberculosis and probably sensed his own early death at the age of thirty-seven. Possibly he also sensed that the world of aristocratic elegance he was employed to paint was also doomed. The courtiers assemble for *The Embarkation for Cythera* (one of his most famous paintings), but the poignancy of the occasion is due to the implication that when they get there it will not be the legendary place they expect – the guillotines will be falling. (Some critics suggest that the courtiers are *returning* from Cythera; but either way there is a poignant contrast between the legendary and the real.) I do not mean that Watteau actually foresaw the French Revolution or painted prophecies. If he had, his works might be less important today than they are, because the prophecies would now be outdated. The theme of his art was simply change, transcience, the brevity of each moment – poised like the butterfly.

Such a theme could have led him to sentimentality and wispy nostalgia. But it was at this point that his ruthless observation of reality turned him into a great artist. I say ruthless because an artist's observation is not just a question of his using his eyes; it is the result of his

honesty, of his fighting with himself to understand what he sees. Look at his self-portrait. It is a slightly feminine face: the gentle eyes, like the eyes of a woman painted by Rubens, the mouth full for pleasure, the fine ear tuned to hear romantic songs or the romantic echo of the sea in the shell that is the subject of another one of his drawings. But look again further, for behind the delicate skin and the impression of dalliance is the skull. Its implications are only whispered, by the dark accent under the right cheek bone, the shadows round the eyes, the drawing of the ear that emphasizes the temple in front of it. Yet this whisper, like a stage whisper, is all the more striking because it is not a shout. 'But,' you may object, 'every drawing of a head discloses a skull because the form of any head depends upon the skull.' Of course. There is, however, all the difference in the world between a skull as structure and a skull as a presence. Just as eyes can gaze through a mask, thus belying the disguise, so in this drawing bone seems to gaze through the very flesh, as thin in places as silk.

In a drawing of a woman with a mantle over her head Watteau makes the same comment by opposite means. Here instead of contrasting the flesh with the bone beneath it, he contrasts it with the cloth that is over it. How easy it is to imagine this mantle preserved in a museum – and the wearer dead. The contrast between the face and the drapery is like the contrast between the clouds in the sky above and the cliff and buildings beneath, in a landscape drawing. The line of the woman's mouth is as transient as the silhouette of a bird in flight.

On a sketch-book page with two drawings of a child's head on it, there is also a marvellous study of a pair of hands tying a ribbon. And here analysis breaks down. It is impossible to explain why that loosely tied knot in the ribbon can so easily be transformed into a symbol of the loosely tied knot of human life; but such a transformation is not far-fetched and certainly coincides with the mood of the whole page.

I do not want to suggest that Watteau was always consciously concerned with mortality, that he was morbidly concerned with death. Not at all. To his contemporary patrons this aspect of his work was probably invisible. He never enjoyed great success, but he was appreciated for his skill – very serious in, for example, his portrait of a Persian diplomat – his elegance, and for what would then have seemed his romantic languor. And today one can also consider other aspects of his work: for instance, his masterly technique of drawing.

He usually drew with a chalk – either red or black. The softness of this medium enabled him to achieve the gentle, undulating sense of movement that is typical of his drawing. He described as no other artist has done the way silk falls and the way the light falls on the falling silk. His boats ride on the swell of the sea and the light glances along their hulls with the same undulating rhythm. His studies of animals are full of the

fluency of animal movement. Everything has its tidal movement, slow or edging – look at the cats' fur, the children's hair, the convolutions of the shell, the cascade of the mantle, the whirlpool of the three grotesque faces, the gentle river-bend of the nude flowing to the floor, the delta-like folds across the Persian's gown. Everything is in flux. But within this flux, Watteau placed his accents, his marks of certainty that are impervious to every current. These marks make a cheek turn, a thumb articulate with a wrist, a breast press against an arm, an eye fit into its socket, a doorway have depth, or a mantle circle a head. They cut into every drawing, like slits in silk, to reveal the anatomy beneath the sheen.

The mantle will outlast the woman whose head it covers. The line of her mouth is as elusive as a bird. But the blacks either side of her neck make her head solid, precise, turnable, energetic, and thus – alive. It is the dark, accented lines which give the figure or the form life by momentarily checking the flow of the drawing as a whole.

On another level, human consciousness is such a momentary check against the natural rhythm of birth and death. And, in the same way, Watteau's consciousness of mortality, far from being morbid, increases one's awareness of life.

1964

Fernand Léger

Since the middle of the last century all artists of any worth have been forced to consider the future because their works have been misunderstood in the present. The very concept of the avant-garde suggests this. The qualitative meaning that the word *modern* has acquired suggests it too. *Modern Art*, for those who have produced it, has meant not the art of today, as opposed to yesterday: but the art of tomorrow as opposed to the conservative tastes of today. Every important painter since 1848 has had to rely upon his faith in the future. The fact that he has believed that the future will be different and better has been the result of his awareness (sometimes fully conscious and sometimes only dimly sensed) of living in a time of profound social change. *From the middle of the last century socialism has promised the alternative which has kept the future open, which has made the power (and the philistinism) of the ruling classes seem finite.* It would be absurd to suggest that all the great painters of the last century were socialists; but what is certainly true is that all of them made innovations in the hope of serving a richer future.

Fernand Léger (1881–1955) was unique in that he made his vision of this future the theme of his art.

Léger's subjects are cities, machinery, workers at work, cyclists, picnickers, swimmers, women in kitchens, the circus, acrobats, still-lifes – often of functional objects such as keys, umbrellas, pincers – and landscapes. A similar list of Picasso's recurring subjects might be as follows: bull-fights, the minotaur, goddesses, women in armchairs, mandolins, skulls, owls, clowns, goats, fawns, other painters' paintings. In his preoccupations Picasso does not belong to the twentieth century. It is in the use to which he puts his temperament that Picasso is a modern man. The other major painters of the same generation – Braque, Matisse, Chagall, Rouault – have all been concerned with very specialized subjects.

Braque, for instance, with the interior of his studio; Chagall with the Russian memories of his youth. No other painter of his generation except Léger has consistently included in his work the objects and materials with which everybody who now lives in a city is surrounded every day of his life. In the work of what other artist could you find cars, metal frames, templates, girders, electric wires, number plates, road signs, gas stoves, functional furniture, bicycles, tents, keys, locks, cheap cups and saucers?

Léger then is exceptional because his art is full of direct references to modern urban life. But this could not in itself make him an important painter. The function of painting is not that of a pictorial encyclopedia. We must go further and now ask: what do these references add up to? What is Léger's interest in the tools, artefacts and ornaments of the twentieth-century city?

When one studies an artist's life work as a whole, one usually finds that he has an underlying, constant theme, a kind of hidden but *continuous* subject. For example, Géricault's continuous subject was endurance. Rembrandt's continuous subject was the process of ageing. The continuous subject reflects the bias of the artist's imagination; it reveals that area of experience to which his temperament forces him to return again and again, and from which he creates certain standards of interest with which to judge ordinary disparate subjects as they present themselves to him. There is hardly a painting by Rembrandt where the significance of growing older is not in some way emphasized. The continuous subject of Matisse is the balm of leisure. The continuous subject of Picasso is the cycle of creation and destruction. The continuous subject of Léger is mechanization. He cannot paint a landscape without including in it the base of a pylon or some telegraph wires. He cannot paint a tree without placing sawn planks or posts next to it. Whenever he paints a natural object, he juxtaposes it deliberately with a manufactured one – as though the comparison increased the value of each. Only when he paints a woman, naked, is he content to let her remain incomparable.

A number of twentieth-century artists have been interested by machines – although, surprising as it may seem, the majority have not. The Futurists in Italy, Mondrian and the de Stijl group in Holland, the Constructivists in Russia, Wyndham Lewis and the Vorticists in England, artists like Roger de la Fresnaye and Robert Delaunay in France, all constructed for themselves aesthetic theories based on the machine, but not one of them thought of the machine as a means of production, making inevitable revolutionary changes in the relations between men. Instead they saw it as a god, a 'symbol' of modern life, the means with which to satisfy a personal lust for power, a

Frankenstein's monster, or a fascinating enigma. They treated the machine as though it were a new star in the sky, although they disagreed about interpreting its portents. Only Léger was different. Only Léger saw the machine for what it is – a tool: a tool both practically and historically in the hands of men.

This is perhaps the best place to examine the frequently made accusation that Léger sacrifices the human to the mechanical and that his figures are as 'cold' as robots. I have heard this argument in Bond Street – put forward by those who, if they pay their money, expect art to console them for the way the world is going; but I have also heard it in Moscow, put forward by art experts who want to judge Léger by the standards of Repin. The misunderstanding arises because Léger is something so rare in recent European art that we have almost forgotten the existence of the category of art to which he belongs. He is an *epic* painter. That is not to say that he paints illustrations to Homer. It is to say that he sees his constant subject of *mechanization* as a human epic, an unfolding adventure of which man is the hero. If the word was not discredited one could equally say that he was a monumental painter. He is not concerned with individual psychology or with nuances of sensation: he is concerned with action and conquest. Because the standards by which we judge painting have been created since the Renaissance and because in general this has been the period of the bourgeois discovery of the individual, there have been very few epic painters. In an extraordinarily complex way Michelangelo was one, and if one compares Léger with Michelangelo, from whom he learnt a great deal, one sees how 'traditional' Léger suddenly becomes. But the best test of all is to place Léger beside the fifth-century Greek sculptors. Naturally there are enormous differences. But the quality of emotions implied and *the distance at which the artist stands from the personality of his subject* – these are very similar. The figures, for example, in *Les Perroquets* are no 'colder' or more impersonal than the Doryphorus of Polyclitus. It is absurd to apply the same standards to all categories of art, and it betrays an essential vulgarization of taste to do so. The epic artist struggles to find an image for the whole of mankind. The lyric artist struggles to present the world in the image of his own individualized experience. They both face reality, but they stand back to back.

Léger's attitude to mechanization did not stay the same all his life. It changed and developed as his political and historical understanding increased. Very roughly his work can be divided into three periods. I will try briefly to put into words the attitude suggested by each period so as to make it easier to grasp his *general* approach and the consistent direction of his thinking.

In his early work, up to about 1918, he was fascinated (it is worth remembering that he came from a family of Norman farmers) by the basic material of modern industry – steel. He became a Cubist, but for him, unlike most of the other Cubists, the attraction of Cubism was not in its intellectual system but in its use of essentially manufactured *metallic* shapes. The turning, the polishing, the grinding, the cutting of steel, were all processes which fired the young Léger with a sense of modernity and a new kind of beauty. The cleanness and strength of the new material may also have suggested a symbolic contrast with the hypocrisy and corruption of the bourgeois world that plunged with self-congra- tulation and inane confidence into the 1914 war. I am of course simplifying and I don't want to mislead as a result. Léger did not paint pictures of steel. He painted and drew nudes, portraits, soldiers, guns, aeroplanes, trees, a wedding. But in all his work at this time he uses shapes (and often colours) which suggest metal and a new awareness of speed and mechanical strength. All the artists of that period were aware of living on the threshold of a new world. They knew they were heralds. But it was typical of Léger that the new was epitomized for him by a new *material.*

The second period in Léger's work lasted roughly from 1920 to 1930. His interest shifted from basic materials to finished, machine-made pro- ducts. He began to paint still lifes, interiors, street scenes, workshops, all contributing to the same idea: the idea of the mechanized city. In many of the paintings, figures are introduced: women in modern kitchens with children, men with machines. The relationship of the figures to their environment is very important. It is this that prevents anyone suspecting that Léger is only celebrating commodity goods for their own sake. These modern kitchens are not advertisements for paints, linoleum or up-to-date bungalows. They are an attempt to show (but in terms of painting and not lectures) how modern technology and modern means of production can enable men to build the environment they need, *so that nature and the material world can become fully humanized.* In these paintings it is as though Léger is saying: It is no longer necessary to separate man from what he makes, for he now has the power to make all that he needs, so that what he has and what he makes will become an extension of himself. And this was based, in Léger's mind, on the fact that for the first time in history, we have the productive means to create a world of plenty.

The third period lasted roughly from 1930 to Léger's death in 1955. Here the centre of interest moved again; this time from the means of production to productive relations. During these twenty-five years he painted such subjects as cyclists, picnickers, acrobats, swimmers diving,

building-workers. At first these subjects may seem mysteriously irrelevant to what I have just said. But let me explain further. All these subjects involve groups of people, and in every case these people are depicted in such a way that no one can doubt that they are modern workers. One could, more generally, say therefore that in this period Léger's recurring subjects were workers at work and at leisure. They are not of course documentary paintings. Further, they make no direct comment at all on working conditions at the time at which they were painted. Like almost every picture Léger painted, they are affirmative, gay, happy and, by comparison with the works of most of his contemporaries, strangely carefree. You may ask: What is the significance of these paintings? Can they do nothing but smile?

I believe that their significance is really very obvious, and has been so little understood only because most people have not bothered to trace Léger's development even as sketchily as we are doing now. Léger knew that new means of production make new social relations inevitable; he knew that industrialization, which originally only capitalism could implement, had already created a working class which would eventually destroy capitalism and establish socialism. For Léger this process (which one describes in abstract language) became implicit in the very sight of a pair of pliers, an earphone, a reel of unused film. And in the paintings of his last period he was prophetically celebrating the liberation of man from the intolerable contradictions of the late capitalist world. I want to emphasize that this interpretation is not the result of special pleading. It is those who wish to deny it who must close their eyes to the facts. In painting after painting the same theme is stressed. Invariably there is a group of figures, invariably they are connected by easy movement one with another, invariably the meaning of this connection is emphasized by the very tender and gentle gestures of their hands, invariably the modern equipment, the tackle they are using, is shown as a kind of confirmation of the century, and invariably the figures have moved into a new freer environment. The campers are in the country, the divers are in the air, the acrobats are weightless, the building-workers are in the clouds. These are paintings about freedom: that freedom which is the result of the aggregate of human skills when the major contradictions in the relations between men have been removed.

To discuss an artist's style in words and to trace his stylistic development is always a clumsy process. Nevertheless I should like to make a few observations about the way Léger painted because, unless the form of his art is considered, any evaluation of its content becomes one-sided and distorted; also because Léger is a very clear example of how, when an artist is *certain* about what he wants to express, this *certainty* reveals itself as logically in his style as in his themes or content.

I have already referred to Léger's debt to Cubism and his very special (indeed unique) use of the language of the Cubists. Cubism was for him the only way in which he could demonstrate the quality of the new materials and machines which struck him so forcibly. Léger was a man who always preferred to begin with something tangible (I shall refer later to the effect of this on his style). He himself always referred to his subjects as 'objects'. During the Renaissance a number of painters were driven by a scientific passion. I think it would be true to say that Léger was the first artist to express the passion of the technologists. And this began with his seizing on the style of Cubism in order to communicate his excitement about the potentiality of new materials.

In the second period of his work, when his interest shifted to machine-made products, the style in which he painted is a proof of how thoroughly he was aware of what he was saying. He realized (in 1918!) that mass production was bound to create new aesthetic values. It is hard for us now, surrounded by unprecedented commercial vulgarity, not to confuse the new values of mass production with the gimmicks of the salesmen, but they are not of course the same thing. Mass production turns many old aesthetic values into purely snob values. (Every woman now can have a plastic handbag which is in every way as good as a leather one: the qualities of a good leather one become therefore only the attributes of a status symbol.) The qualities of the mass-produced object are bound at first to be contrasted with the qualities of the hand-made object: their 'anonymity' will be contrasted with 'individuality', and their regularity with 'interesting' irregularity. (As pottery has become mass-produced, 'artistic' pottery, in order to emphasize and give a spurious value to its being hand-made, has become wobblier, rougher and more and more irregular.)

Léger made it a cardinal point of his style at this time to celebrate the special aesthetic value of the mass-produced object in the actual way he painted. His colours are flat and hard. His shapes are regular and fixed. There is a minimum of gesture and a minimum of textural interest (texture in painting is the easiest way to evoke 'personality'). As one looks at these paintings one has the illusion that they too could exist in their hundreds of thousands. The whole idea of a painting being a jewel-like and unique private possession is destroyed. On the contrary, a painting, we are reminded, is an image made by a man for other men and can be judged by its efficiency. Such a view of art may be partisan and one-sided, but so is any view of art held by any practising artist. The important point is that in the way he painted these pictures Léger strove to prove the argument which was their content: the argument that modern means of production should be welcomed

(and not regretted as vulgar, soulless or cheap) because they offered men their first chance to create a civilization not exclusive to a minority, not founded on scarcity.

There are three points worth making about the style of Léger's third period. He now has to deal with far more complex and variegated subjects – whole groups of figures, figures in landscapes, etc. It is essential to his purpose that these subjects appear unified: the cloud and the woman's shoulder, the leaf and the bird's wing, the rope and the arm, must all be seen in the same way, must all be thought to exist under the same conditions. Léger now introduced light into his painting to create this unity of condition. By light I do not mean anything mysterious; I mean simply light and shade. Until the third period Léger mostly used flat local colours and the forms were established by line and colour rather than by tone. Now the forms become much more solid and sculptural because light and shade play upon them to reveal their receding and parallel planes, their rises and hollows. But the play of the light and shade does more than this: it also allows the artist to create an overall pattern, regardless of where one object or figure stops and another begins. Light passes into shade and shade into light, alternately, a little like the black and white squares of a chessboard. It is by this device that Léger is able to *equate* a cloud with a limb, a tree with a sprig, a stream with hair; and it is by the same device that he can bind a group of figures together, turning them into one *unit* in the same way as the whole chessboard can be considered one unit rather than each square. In his later work Léger used the element of light (which means nothing without shade) to suggest the essential *wholeness* of experience for which all men long and which they call freedom. The other artist to use light in a similar way was Michelangelo, and even a superficial comparison between the drawings of the two artists will reveal their closeness in this respect. The all-important difference is that for Michelangelo freedom meant lonely individuality and was therefore tragic, whereas for Léger it meant a classless society and was therefore triumphant.

The second point I want to make about Léger's style in his third period concerns the special use to which he discovered he could put colour. This did not happen until about the last ten years of his life. In a sense, it was a development which grew out of the use of light and shade which I have just described. He began to paint bands of colour across the features or figures of his subject. The result was a little like seeing the subject through a flag which, although quite transparent in places, imposed occasional strips or circles of colour on the scene behind. In fact it was not an arbitrary imposition: the colour strips were always designed in precise relation to the

forms behind them. It is as though Léger now wanted to turn his paintings into emblems. He was no longer concerned with his subjects as they existed but with his subjects as they *could* exist. They are, if you like, paintings in the conditional mood. *La Grande Parade* represents what pleasure, entertainments, popular culture could mean. *Les Constructeurs* represents what work could mean. *Les Campeurs* represents what being at home in the world could mean. This might have led Léger to sentimental idealization and utopian dreams. It did not because Léger understood the historical process which has released and will increasingly release human potentiality. These last 'conditional mood' paintings of Léger's were not made to console and lull. They were made to remind men of what they are capable. *He did not deceive us by painting them as though the scenes already existed.* He painted them as hopes. And one of the ways in which he made this clear (he did not employ the same method in all his last pictures) was to use colour to make the pictures *emblematic.* Here I am using the word in its two senses, thinking of an emblem as both a sign and an allegory. In discussions on twentieth-century art, references are often made to *symbols.* It is usually forgotten that symbols must by definition be accessible. In art, a private symbol is a contradiction in terms. Léger's emblems are among the few true symbols created in our time.

The last point I want to make about Léger's later work has nothing to do, like the first two points, with any stylistic innovation, but with a tendency which, although inherent in all Léger's painting, became stronger and more obvious and conscious as time passed: the tendency to visualize everything he wanted to paint *in terms of its being able to be handled.* His world is literally *a substantial* world: the very opposite of the world of the Impressionists. I have already said that Léger allowed no special value to the hand-made as opposed to the machine-made product. But the human hand itself filled him with awe. He made many drawings of hands. One of his favourite juxtapositions was to put a hand in front of, or beside, a face; as though to convey that without the hand all that makes the human eye human would never have occurred. He believed that man could be manager of his world and he recognized the Latin root of the word manager. *Manus.* Hand. He seized upon this truth as a metaphor, in his struggle against all cloudy mystification. Léger's clouds are in fact like pillows, his flowers are like egg-cups, his leaves are like spoons. And for the same reason he frequently introduces ladders and ropes into his pictures. He wanted to construct a world where the link between man's imagination and his ability to fashion and control with his hands was always emphasized. This, I am certain, is the principal explanation of why he simplified and stylized objects and landscapes in the way he did. He wanted to make everything he included in his art tangible and unmysterious: not because he was a

mechanical nineteenth-century rationalist, but because he was so impressed by the greater mystery: the mystery of man's insatiable desire to hold and understand.

This is perhaps the best place to refer to the artists who influenced Léger: the artists who helped him to develop the means with which to express his unusual vision. I have already mentioned Michelangelo: for Léger he was the example of an artist who created an heroic, epic art based exclusively on man. Picasso and Braque, who invented Cubism, were also indispensable examples. Cubism may have meant something different to its inventors (theirs was perhaps a more consciously art-historical approach and was more closely connected with an admiration for African art) but nevertheless Cubism supplied Léger with his twentieth-century visual language. The last important influence was that of the Douanier Rousseau: the naïve Sunday painter who was treated as a joke or, later, thought to be 'delightful', but who believed himself to be a realist.

It would be foolish to exaggerate the realist element in Rousseau if one is using the word realist in its usual sense. Rousseau was quite uninterested in social issues or politics. His realism, as he believed it to be, was in no sense a protest against a specific set of social or ideological lies. But nevertheless there are elements in Rousseau's art which in a long historical perspective can be seen to have extended the possibilities of painting certain aspects of reality, to use them and transform them for his own purpose.

I will try briefly to explain what these elements were – for the connection between Léger and Rousseau is not yet sufficiently recognized. Rousseau can be termed an amateur artist in so far as he was untrained and both his social and financial position precluded him from having any place at all in the official cultural hierarchy of France. Measured by official standards he was not only totally unqualified to be an artist but also pathetically uncultured. All that he inherited was the usual stale deposit of petit-bourgeois clichés. His imagination, his imaginative experience, was always in conflict with his received culture. (If I may add a personal parenthesis, I would suggest that such conflicts have not yet been properly understood or described; which is one of the reasons why I chose such a conflict as the theme of my novel *Corker's Freedom.*[1]) Every picture that Rousseau painted was a testimony to the existence of an alternative, unrecognized, indeed as yet unformulated culture. This gave his work a curious, self-sufficient and uninhibited conviction. (A little similar in this, though in nothing else, to some of the works of William Blake.) Rousseau had no method to rely on if his imagination failed him: he had no art with which to distract attention, if the *idea* he was trying to communicate was weak. The *idea* of any given

picture was all that he had. (One begins to realize the intensity of these ideas by the story of how he became terrified in his little Parisian room when he was painting a tiger in the jungle.) One might say – exaggerating with a paradox – that Rousseau made all the other artists of his time look like mere virtuosos. And it was probably the strength of Rousseau's 'artlessness' which first appealed to Léger, for Léger also was an artist with surprisingly little facility, for whom the *ideas* of his art were also constant and primary, and whose work was designed to testify to the existence of an alternative, unrecognized culture.

There was, then, a moral affinity between Rousseau and Léger. There was also a certain affinity of method. Rousseau's style had very little to do with the Fine Arts as they were then recognized: as little to do with the fine arts as the circus has with the Comédie Française. Rousseau's models were postcards, cheap stage scenery, shop signs, posters, fairground and café decorations. When he paints a goddess, a nude, it has far more to do – iconographically but not of course emotionally – with the booth of any Fat Lady at a fair than with a Venus by Titian. He made an art of visual wonder out of the visual scraps sold to and foisted upon the petty bourgeoisie. It has always seemed over-romantic to me to call such scraps popular art: one might just as well call second-hand clothes popular *couture!* But the important point is that Rousseau showed that it was possible to make works of art using the visual vocabulary of the streets of the Parisian suburbs instead of that of the museums. Rousseau of course used such a vocabulary because he knew no other. Léger chose a similar vocabulary because of what he wanted to say. Rousseau's spirit was nostalgic (he looked back to a time when the world was as innocent as he) and his ambience was that of the nineteenth century. Léger's spirit was prophetic (he looked forward to the time when everyone would understand what he understood) and the atmosphere of his work belongs to this century. But nevertheless as painters they often both use similar visual prototypes. The posed group photograph as taken by any small-town photographer; the placing of simple theatrical props to conjure up a whole scene – Rousseau makes a jungle out of plants in pots, Léger makes a countryside out of a few logs: the clear-cut poster where everything must be defined – so that it can be read from a distance – and mystery must never creep into the method of drawing: flags and banners to make a celebration: brightly coloured prints of uniforms or dresses – in the pictures of Rousseau and Léger all the clothes worn are easily identifiable and there is a suggested pride in the wearing of them which belongs essentially to the city street. There is also a similarity in the way both artists painted the human head itself. Both tend to enlarge and simplify the features, eyes, nose, mouth, and in doing this, because the mass of people think of a head as a face and a face as a sequence of features to be read like signs – 'shifty eyes', 'smiling mouth' – both come

far nearer to the popular imagination of the storyteller, the clown, the singer, the actor, than to the 'ideal proportions' of the 'Fine' artist.

Lastly, one further element in Rousseau's art which seems to have been important for Léger: its happiness. Rousseau's paintings are affirmative and certain: they reject and dispel all doubt and anxiety: they express none of the sense of alienation that haunted Degas, Lautrec, Seurat, Van Gogh, Gauguin, Picasso. The probable reason for this is simple but surprising: Rousseau was so innocent, so idealistic that it was the rest of the world and its standards which struck him as absurd, never his own unlikely vision. His confidence and credulity and good-naturedness survived, not because he was treated well – he was treated appallingly – but because he was able to dismiss the corruption of the world around him as an absurd accident. Léger also wanted to produce an art which was positive and hopeful. His reasoning was very different; it was based on the acceptance and understanding of facts rather than their rejection; but except for Rousseau, there was no other nineteenth- or twentieth-century artist to whom he could look for support and whose fundamental attitude was one of celebration.

In a certain sense Léger's art is extremely easy to appreciate, and all efforts to explain it therefore run the danger of becoming pretentious. There is less obscurity in Léger's work than in that of any of his famous contemporaries. The difficulties are not intrinsic. They arise from our conditioned prejudices.

We inherit the Romantic myth of the genius and therefore find his work 'mechanical' and 'lacking in individuality'. We expect a popular artist to use the style of debased magazine illustration, and therefore find his work 'formalistic'. We expect socialist art to be a protest and so find his work 'lacking in contradiction'. (The contradiction is in fact between what he shows to be possible and what he knew existed.) We expect his work to be 'modern' and therefore fail to see that it is often tender in the simplest manner possible. We are used to thinking of art in an 'intimate' context and therefore find his epic, monumental style 'crude' and 'oversimplified'.

I would like to end with a quotation from Léger himself. Everything I have said is only a clumsy elaboration of this text.

> I am certain that we are not making woolly prophecies: our vision is very like the reality of tomorrow. We must create a society without frenzy, a society that is calm and ordered, that knows how to live naturally within the Beautiful, without protestations or romanticism, quite naturally. We are going towards it; we must bend our efforts towards that goal. It is a religion more universal than the others, made

of tangible, definite, human joys, free from the troubled, disappointment-filled mysticism of the old ideals which are slowly disappearing every day, leaving the ground free for us to construct our religion of the Future.

1963

Thicker than Water (Corot)

Any critic who attacks Corot does so at his own risk. This is not because Corot was a giant. Clearly he wasn't. It is because in one way or another Corot has won his modest way into the hearts of all those who love painting. For the very sentimental, those for whom all art is a Swan Lake, there are the nymphs beneath the birches (silver); for the realists there are his pellucid landscape sketches coming between Constable and the Impressionists; for the romantics there are his nudes in the grass studio; for the classicists there are his Italianate muses in costume; and for the moralists there is the man himself, his humility, his great generosity, his keeping of Daumier after that dangerous seer had gone blind, his support for Millet's widow, his friendliness and helpfulness to all but the pretentious.

In fact I have no wish to attack Corot. To attack such a man is a form of historical hooliganism. What I do want to do is define his art and give his gifts their proper name. What I have to say is not original. But it is too often forgotten.

Corot was initially a weak draughtsman. He got by with making notations. A little mark here connected with a little mark there. He was unable to grasp his subjects. He was like a mouse trying to come to terms with an elephant. In his early Italian landscape sketches, which he painted on the spot and which certain Corot purists claim as his best work, this always seems to me to be very evident. There is also their marvellous tonal accuracy which allows them to cup the air in their hands. But Corot's eye for tone was again an eye for comparison: this tone here with that tone there. It is still a form of piecemeal notation, of matching and pinning. True, the influence of Poussin makes him stop before one sense rather than another, but it does not embolden him to take any liberties for the sake of art with what Nature presents him.

Up to about 1840 you can see the same thing in his figure paintings.

Even in his exquisite portraits of children. I nevertheless say 'exquisite' because the large burly Corot is on his hands and knees, on exactly the same level as his models, putting their small shapes down on to the canvas as tentatively as a small girl might enter a dark room, and such matter-of-fact gentleness is exquisite. But the painting is still frail; frail like a much darned garment. It is still piecemeal mending and stitching.

Then in the middle 1840s, when Corot himself is nearly fifty, he achieves mastery in his craft. To himself the change was perhaps imperceptible. But to us it is clear. It is no longer a question of stitching. He can now cut the material to his own measure. He now sees his figures complete from their very inception. Consequently they have their due weight. Their patient hands really lie in their laps as they dream or read. In his own shy way he can now even afford to be extravagant. He pins distracting, eye-catching decorations upon them, a garland of leaves catching the light, a flutter of loose material by the bodice, an emphasized red stripe in the skirt, and these charming frivolities do not destroy the form or seriousness of the figure as a whole.

In his landscapes he intensifies the atmosphere. His earlier landscapes are topographical in so far as everyone can plan his own route across them. In the landscapes of this period you must follow Corot. You must enter at that moment of delight at which he entered. (This question of Corot's paintings recapturing the *specific* moment of discovery is far more relevant to his relationship with the Impressionists than the mere fact that he painted out of doors; it also relates him to later painters like Bonnard and Sickert.)

Within ten years of acquiring this mastery, Corot became successful. And, instead of using his mastery, instead of making discoveries that could really have extended human awareness (as Géricault had done and Courbet was doing), he relapsed. He started his prodigious production of *salon* nymphs and glades. These were gauze and chiffon work, tacked together with flimsy, loose threads. They had neither the virtue of the darning nor the energy of the cutting period. They were consolations. He wrote:

In the next room there is a pretty girl who comes and goes at my will. She is Folly, my invisible companion, whose youth is eternal and whose fidelity never wearies.

Why was Corot at first so excessively tentative, and then why, when he could have taken huge steps forward, did he draw back? It would be quite unjust to say that he sold out. Despite his great success, he still believed in what he was doing. As a man he still impressed everyone by his purity. And out of his sales, whilst living modestly himself, he financed all his good works and charities.

No, the answer is more subtle and less insulting. Corot remained a petit-bourgeois. Matching, pinning, sewing, he was never quite able to shake off the effect of his father's drapery business and his mother's dress-shop.

In 1846 when Corot was decorated with the Legion of Honour, his father – according to Théophile Sylvestre – at first thought the cross was for himself:

> When he realized that the government had deigned to cast a bene-volent eye on his son, who at fifty was still not earning enough to pay for his colours, he said: 'My son – a man who has been decorated has duties towards society. I hope that you will understand them. Your negligent dress is unsuitable for one who wears the red ribbon in his buttonhole.' A little later he said to his wife: 'I think we ought to give a little more money to Camille.'

Corot was certainly not the epitome of the petit-bourgeois, as was his father. Indeed this is specifically denied by those who knew him. 'His naïve familiarity stops at exactly where that of the jovial commercial traveller would start.' He must have hated his family's way of life. But his reaction to it was to absent himself in dreams, in modest celibacy, in virtue – just as he absents his favourite models in reverie. I am not suggesting he was a prig – if he were, how could he have been a friend of Daumier's? He was a petit-bourgeois only in his refusal to speculate on how the world could be changed. This explains why he was timid without being a coward. Instead of questioning, he set out to make his own peace, to avoid all contradictions. He knew it himself: 'Delacroix is an eagle and I'm only a lark. I sing little songs in my grey clouds.' He reveals it unconsciously when he says: 'Charity is a still more beautiful thing than talent. Besides, one benefits the other. If you have a kind heart, your work will show it.' How comfortably without contradictions that 'Besides' is!

Corot was tentative as an artist for so long because his true but excessive modesty was his answer to his class's hypocritical obsequious-ness. After all he was not really a mouse trying to come to terms with an elephant. As a landscape artist he should have been a man imposing order on nature. He drew back halfway through his career because to have gone on would have meant being involved in revolutionary changes. Impressionism was an art with a totally new basis, and it was Impressionism that stared him in the face – it was his own art that was leading him to it. His devotion to Poussin combined with his determina-tion to be faithful to nature could conceivably even have led him beyond Impressionism to prophesy Cézanne. There are hints in Corot's work of so much that was to come later, but they are the unconscious hints of a

man who preferred not to see what was happening, what was changing around him.

He knew after all what had befallen Daumier, Géricault, Millet, even Delacroix, and he might have guessed what was going to happen to the Impressionists. Nevertheless he could still, in the second half of the nineteenth century, write:

> If painting is a madness, it is a sweet madness which men should not merely forgive but seek out. Seeing my bright looks and my health, I defy anyone to find traces of worry, ambition or remorse, which hollow the faces of so many poor mortals. That is why one should love the art which procures calm, moral contentment and even health for those who know how to balance their lives.

For others of the same class it has been vegetarianism, spiritualism, teetotalism . . .

Corot was a lovable man. At his best he was an artist of minor genius, comparable to, say, Manet. And let me add – with the due modesty that ought to precede such a statement – that Corot has contributed to many people's happiness.

1960

Painting a Landscape

Dedicated to Sven Blomberg

The first thing my eye questions when I wake up is the small square of sky above the fig tree in the top left-hand corner of the window. If it is blue I am satisfied. It is as though its blueness is a sign that I have had enough sleep. When it is grey and opaque I have to reconcile myself to not seeing either of the landscapes on which I am working.

The house belongs to a painter with whom I often stay. I know the district well. Any peasant born in the village knows it a thousand times better. I can compare it to other very different landscapes, both real and painted. This means that I can name its elements more precisely. For me it is unique not because I have always known it, but because I can compare it.

When I am not here I might dream of this landscape. In my dream I would recognize it. I would recognize it, not in terms of previous events, but by its colour, the forms of its hills, its textures and its scale. I would recognize it before I could distinguish between a cherry and an apricot tree. Sometimes perhaps I would recognize it just by virtue of the sky above it – the range of its blues across its immense distance, and the characteristic deployment of the clouds whose shadows pass across the plain. The sharp edges of these shadows reveal what is literally the lie of the land. The shadows of the clouds are like hands large enough to examine the recumbent body.

But all this amounts to only a generalized image. It concerns a district, not a place. The subjects of the paintings are far more particular. As soon as I begin looking at a field, an escarpment or an orchard as though in it there was some code to be deciphered, it becomes unfamiliar. Even the result – that is to say the 'message' transmitted – remains mysterious. I can never be sure what my own painting says. And this is not just because of the problem of finding words to describe formal revelations; it is because the longer you spend with them, the more mysterious all visual images become.

What is this painting of a landscape? It is said that landscape painting has died a natural death. Certainly there are no great modern landscapes comparable to those of the past. But what of those which are not comparable? Which are not even landscapes? For that is the point: the genre has changed beyond recognition. Cubism when it broke painting broke the landscape too. It is unlikely that the specific appearance of a given landscape will ever again be the aim of an important painter. But it can well be his starting point. Landscape painting must now be subsumed under Painting. That is all that natural death means.

I am painting from nature. What I do between times in the studio is only marginal. I am aware as I walk across the rocks or through the oakwoods whose leaves, just unfurled, are pink at their tips, membrane pink, and white-green at their base as the sea can be, with my folding easel and paint box, I am aware of apparently being a nineteenth-century figure. Yet in my head, in my conditioned eye, it also seems that I have the benefit of all experimental twentieth-century art to date. What is in my head – as the result of three generations of artists – would have been beyond the reckoning of Pissarro or Gauguin. Even what I see in a Pissarro would have surprised the old man himself.

As I work I am faithful to what I see in front of me, because only by being faithful, by constantly checking, correcting, analysing what I can see and how it changes as the day progresses, can I discover forms and structures too complex and varied to be invented out of my head or reconstructed from vague memories. The messages are not the kind that can be sent to oneself.

Yet to a third party (the landscape is the second) what is on the canvas is scarcely readable as a landscape. The 'legibility' of the image is something which must be approached with extreme caution. The cult of obscurity is sentimental nonsense. But the kind of clarity which two centuries of art encouraged people to expect, the clarity of maximum resemblance, is irrevocably outdated. This is not the result of a mere change of fashion but a development in our understanding of reality. Objects no longer confront us. Rather, relationships surround us. These can only be illustrated diagrammatically. Even in front of a Rembrandt we are bound to be far more conscious than before of its diagrammatic aspect.

A work of art is not the same thing as a scientific model. But it stands in an equivalent relationship to reality. Once it was useful to think of art as a mirror. It no longer is – because our view of nature has changed. Today to hold a mirror up to nature is only to diminish the world.

The most difficult thing of all, painting on the spot, is to look at your canvas. Your glance constantly moves between the scene itself and the marks on the canvas: but these glances tend to arrive loaded, and return empty. The largest part of the great, heroic self-discipline of Cézanne lay

precisely in this. He was able to look at his painting, in process of being constructed, as patiently and objectively as at the subject which was complete. It sounds very easy: it is as easy as walking on water.

The marks on the canvas must have a life of their own. We must be made aware of their independence. This is why their logic and their needs must be so carefully assessed. Given their independence and their relation to reality – given, that is, the artist's ability to include his own work as part of the reality he is studying – the image will act as a metaphor. The alternative is for it to be either a false statement or a meaningless exclamation: naturalism or primitivism of one kind or another.

The nature of the metaphor depends on innumerable varying factors; but its *raison d'être* is always the same: it is what connects the event and the artist's judgement of it: it is the means of rendering the subject and its meaning visually inseparable. The thing interpreted becomes the interpretation.

This is why the balance of the metaphor is so difficult to sustain. Every work begins as an obvious metaphor. This explains the modern taste for the 'liveliness' of the sketch, as distinct from the finished painting. As the work progresses, the temptation either to efface oneself before nature or else to return to the abstraction of what is already known becomes harder and harder.

The pretension of what I am trying to do from my rock seems overwhelming. The sunlight already claims the canvas by making the colours apparently fade.

The light is so strong that my shadow seems to have more substance than the earth itself. Thus the long dry grass, which the shadow falls on, looks like the straw stuffing of my shadow-body.

In a field near the house I found an old drawing on yellowed paper. On one side was a student's life-drawing, a reclining nude with large very round breasts, emphasized by the clumsiness of the drawing. On the other side were attached eight or nine small white-shelled snails.

Last night the season changed. The spring became early summer. But this did not happen under the usual clear sky and brilliant stars. It was in a mist with distant thunder that the cicadas began to sing, the frogs to croak louder than ever before this year, the nightingales to crack their tinned liquid songs open more and more blatantly. At this moment of precise change – which was also the moment of dusk – the whole landscape lay indeterminate and confused like an adolescent's dream in a mist of spunk. Clarity is rare.

Nevertheless there are moments of painting when it seems that the pretensions are justified. However short-lived, there are moments of triumph, incomparable in my experience to moments achieved in any

other activity. They are usually short-lived because they depend upon a correspondence existing between the totality of relations between the marks on the canvas and those deducible in the landscape: as soon as one more mark is added or an existing mark modified, this correspondence is liable to collapse utterly. The process of painting is the process of trying to re-achieve at a higher level of complexity a previous unity which has been lost. As one leaves the central area of the painting and paints towards the edges of the canvas this becomes more and more difficult. Then one's memory of the original blank white canvas becomes more and more seductive.

During the moments of triumph one has the sensation of having mastered the landscape according to its own rules and simultaneously of having been liberated from the hegemony of all rules. Some might describe the position as god-like. But there is a common experience which it resembles: the experience of every child who imagines that he is able to fly.

The child distinguishes between the fantasy and the fact. But the distinction is of no importance. The metaphor allows him to imagine the familiar world from above, and his own liberation from it. The actual experience of flying would do no more.

The motive for the metaphor is perhaps born of the dreams of childhood whose power continues in later life. The sexual content assumed to exist in dreams about flying is closely connected to the sexual content of landscape.

But the possible relevance of the metaphor involves our modern approach to reality itself. Liberated from its role as a narrative medium, painting, of all the arts, is the closest to philosophy.

Making lustreless marks upon a tiny canvas in front of a landscape that has been cultivated for centuries and in view of the fact that such cultivation has and still demands lives of the hardest labour, I ask myself what is it to be close to philosophy?

Imagine a cubic metre of space: empty it of your conception of that space: what you are then left with is like death.

The other day I saw a lorry carting blocks of stone, white in the sunlight, from the quarries on the other side of the village. On top of the blocks was a wooden box with tools in it. On top of them, carefully placed so that it should not blow away, lay a sprig of cherry blossom. In the rockface is buried the promise of dynamite: in the dynamite the promise of space: in the space grows the promise of a tree: in the core of the tree the promise of blossom. That was the relationship between the spray and the blocks of stone on the lorry.

The white blossom on the trees, seen from above the reddish earth, is slightly stained with viridian. But the white of the canvas between the marks of paint upon it is more vibrant. The blossom, which the slightest

wind may now blow away, is fixed in space: the white canvas is the field of the diagram.

In the evening S and I hang our unfinished paintings on the kitchen wall. They are distorted by the lamplight with its emphatic shadows and its yellow preponderance: nevertheless we can look at them to prove them wrong. We look at them suddenly from moment to moment as though to catch them unawares. A dozen people talk round the kitchen table. Maybe S and I are more silent than usual. I notice that when the woman opposite S is talking to him, he pretends to be attentive but in fact keeps on glancing beyond her at his painting on the wall. He quizzes it. On his face is that expression otherwise peculiar to self-portraits: a quizzical, sceptical look of inquiry.

I too can't prevent my eyes from straying towards my canvas. If I was absolutely convinced that the canvas was finished, I wouldn't give it a glance. It is only its shortcomings that fascinate me. In these I can see the possibilities of a more accurate metaphor: I can feel all that has escaped me. And it is the consequent sense of the near impossibility of the task which allows me to take pleasure in the little that I have temporarily achieved.

1966

Understanding a Photograph

For over a century, photographers and their apologists have argued that photography deserves to be considered a fine art. It is hard to know how far the apologetics have succeeded. Certainly the vast majority of people do not consider photography an art, even whilst they practise, enjoy, use and value it. The argument of apologists (and I myself have been among them) has been a little academic.

It now seems clear that photography deserves to be considered as though it were *not* a fine art. It looks as though photography (whatever kind of activity it may be) is going to outlive painting and sculpture as we have thought of them since the Renaissance. It now seems fortunate that few museums have had sufficient initiative to open photographic departments, for it means that few photographs have been preserved in sacred isolation, it means that the public have not come to think of any photographs as being *beyond* them. (Museums function like homes of the nobility to which the public at certain hours are admitted as visitors. The class nature of the 'nobility' may vary, but as soon as a work is placed in a museum it acquires the *mystery* of a way of life which excludes the mass.)

Let me be clear. Painting and sculpture as we know them are not dying of any stylistic disease, of anything diagnosed by the professionally horrified as cultural decadence; they are dying because, in the world as it is, no work of art can survive and not become a valuable property. And this implies the death of painting and sculpture because property, as once it was not, is now inevitably opposed to all other values. People believe in property, but in essence they only believe in the illusion of protection which property gives. All works of fine art, whatever their content, whatever the sensibility of an individual spectator, must now be reckoned as no more than props for the confidence of the world spirit of conservatism.

By their nature, photographs have little or no property value because

215

they have no rarity value. The very principle of photography is that the resulting image is not unique, but on the contrary infinitely reproducible. Thus, in twentieth-century terms, photographs are records of things seen. Let us consider them no closer to works of art than cardiograms. We shall then be freer of illusions. Our mistake has been to categorize things as art by considering certain phases of the process of creation. But logically this can make all man-made objects art. It is more useful to categorize art by what has become its social function. It functions as property. Accordingly, photographs are mostly outside the category.

Photographs bear witness to a human choice being exercised in a given situation. A photograph is a result of the photographer's decision that it is worth recording that this particular event or this particular object has been seen. If everything that existed were continually being photographed, every photograph would become meaningless. A photograph celebrates neither the event itself nor the faculty of sight in itself. A photograph is already a message about the event it records. The urgency of this message is not entirely dependent on the urgency of the event, but neither can it be entirely independent from it. At its simplest, the message, decoded, means: *I have decided that seeing this is worth recording.*

This is equally true of very memorable photographs and the most banal snapshots. What distinguishes the one from the other is the degree to which the photograph explains the message, the degree to which the photograph makes the photographer's decision transparent and comprehensible. Thus we come to the little-understood paradox of the photograph. The photograph is an automatic record through the mediation of light of a given event: yet it uses the *given* event to *explain* its recording. Photography is the process of rendering observation self-conscious.

We must rid ourselves of a confusion brought about by continually comparing photography with the fine arts. Every handbook on photography talks about composition. The good photograph is the well-composed one. Yet this is true only in so far as we think of photographic images imitating painted ones. Painting is an art of arrangement: therefore it is reasonable to demand that there is some kind of order in what is arranged. Every relation between forms in a painting is to some degree adaptable to the painter's purpose. This is not the case with photography. (Unless we include those absurd studio works in which the photographer arranges every detail of his subject before he takes the picture.) Composition in the profound, formative sense of the word cannot enter into photography.

The formal arrangement of a photograph explains nothing. The events portrayed are in themselves mysterious or explicable according to the spectator's knowledge of them prior to his seeing the photograph.

What then gives the photograph as photograph meaning? What makes its minimal message – *I have decided that seeing this is worth recording* – large and vibrant?

The true content of a photograph is invisible, for it derives from a play, not with form, but with time. One might argue that photography is as close to music as to painting. I have said that a photograph bears witness to a human choice being exercised. This choice is not between photographing *x* and *y*: but between photographing at *x* moment or at *y* moment. The objects recorded in any photograph (from the most effective to the most commonplace) carry approximately the same weight, the same conviction. What varies is the intensity with which we are made aware of the poles of absence and presence. Between these two poles photography finds its proper meaning. (The most popular use of the photograph is as a memento of the absent.)

A photograph, whilst recording what has been seen, always and by its nature refers to what is not seen. It isolates, preserves and presents a moment taken from a continuum. The power of a painting depends upon its internal references. Its reference to the natural world beyond the limits of the painted surface is never direct; it deals in equivalents. Or, to put it another way: painting interprets the world, translating it into its own language. But photography has no language of its own. One learns to read photographs as one learns to read footprints or cardiograms. The language in which photography deals is the language of events. All its references are external to itself. Hence the continuum.

A movie director can manipulate time as a painter can manipulate the confluence of the events he depicts. Not so the still photographer. The only decision he can take is as regards the moment he chooses to isolate. Yet this apparent limitation gives the photograph its unique power. *What it shows invokes what is not shown.* One can look at any photograph to appreciate the truth of this. The immediate relation between what is present and what is absent is particular to each photograph: it may be that of ice to sun, of grief to a tragedy, of a smile to a pleasure, of a body to love, of a winning race-horse to the race it has run.

A photograph is effective when the chosen moment which it records contains a quantum of truth which is generally applicable, which is as revealing about what is absent from the photograph as about what is present in it. The nature of this quantum of truth, and the ways in which it can be discerned, vary greatly. It may be found in an expression, an action, a juxtaposition, a visual ambiguity, a configuration. Nor can this truth ever be independent of the spectator. For the man with a Polyfoto of his girl in his pocket, the quantum of truth in an 'impersonal' photograph must still depend upon the general categories already in the spectator's mind.

All this may seem close to the old principle of art transforming the

particular into the universal. But photography does not deal in constructs. There is no transforming in photography. There is only decision, only focus. The minimal message of a photograph may be less simple than we first thought. Instead of it being: *I have decided that seeing this is worth recording*, we may now decode it as: *The degree to which I believe this is worth looking at can be judged by all that I am willingly not showing because it is contained within it.*

Why complicate in this way an experience which we have many times every day – the experience of looking at a photograph? Because the simplicity with which we usually treat the experience is wasteful and confusing. We think of photographs as works of art, as evidence of a particular truth, as likenesses, as news items. Every photograph is in fact a means of testing, confirming and constructing a total view of reality. Hence the crucial role of photography in ideological struggle. Hence the necessity of our understanding a weapon which we can use and which can be used against us.

1968

The Political Uses of Photo-Montage

John Heartfield, whose real name was Helmut Herzfelde, was born in Berlin in 1891. His father was an unsuccessful poet and anarchist. Threatened with prison for public sacrilege, the father fled from Germany and settled in Austria. Both parents died when Helmut was eight. He was brought up by the peasant mayor of the village on the outskirts of which the Herzfelde family had been living in a forest hut. He had no more than a primary education.

As a youth he got a job in a relative's bookshop and from there worked his way to art school in Munich, where he quickly came to the conclusion that the Fine Arts were an anachronism. He adopted the English name Heartfield in defiance of German wartime patriotism. In 1916 he started with his brother Wieland a dissenting left-wing magazine, and, with George Grosz, invented the technique of photo-montage. (Raoul Hausmann claims to have invented it elsewhere at the same time.) In 1918 Heartfield became a founder member of the German Communist Party. In 1920 he played a leading role in the Berlin Dada Fair. Until 1924 he worked in films and for the theatre. Thereafter he worked as a graphic propagandist for the German communist press and between about 1927 and 1937 became internationally famous for the wit and force of his photo-montage posters and cartoons.

He remained a communist, living after the war in East Berlin, until his death in 1968. During the second half of his life, none of his published work was in any way comparable in originality or passion to the best of his work done in the decade 1927–37. The latter offers a rare example outside the Soviet Union during the revolutionary years of an artist committing his imagination wholly to the service of a mass political struggle.

What are the qualities of this work? What conclusions may we draw from them? First, a general quality.

There is a Heartfield cartoon of Streicher standing on a pavement beside the inert body of a beaten-up Jew. The caption reads: 'A Pan-German'. Streicher stands in his Nazi uniform, hands behind his back, eyes looking straight ahead, with an expression that neither denies nor affirms what has happened at his feet. It is literally and metaphorically beneath his notice. On his jacket are a few slight traces of dirt or blood. They are scarcely enough to incriminate him – in different circumstances they would seem insignificant. All that they do is slightly to soil his tunic.

In Heartfield's best critical works there is a sense of everything having been soiled – even though it is not possible, as it is in the Streicher cartoon, to explain exactly why or how. The greyness, the very tonality of the photographic prints suggests it, as do the folds of the grey clothes, the outlines of the frozen gestures, the half-shadows on the pale faces, the textures of the street walls, of the medical overalls, of the black silk hats. Apart from what they depict, the images themselves are sordid: or, more precisely, they express disgust at their own sordidness.

One finds a comparable physical disgust suggested in nearly all modern political cartoons which have survived their immediate purpose. It does not require a Nazi Germany to provoke such disgust. One sees this quality at its clearest and simplest in the great political portrait caricatures of Daumier. It represents the deepest universal reaction to the stuff of modern politics. And we should understand why.

It is disgust at that particular kind of sordidness which exudes from those who now wield individual political power. This sordidness is not a confirmation of the abstract moral belief that all power corrupts. It is a specific historical and political phenomenon. It could not occur in a theocracy or a secure feudal society. It must await the principle of modern democracy and then the cynical manipulating of that principle. It is endemic in, but by no means exclusive to, latter-day bourgeois politics and advanced capitalism. It is nurtured from the gulf between the aims a politician claims and the actions he has in fact already decided upon.

It is not born of personal deception or hypocrisy as such. Rather, it is born of the manipulator's assurance, of his own indifference to the flagrant contradiction which he himself displays between words and actions, between noble sentiments and routine practice. It resides in his complacent trust in the hidden undemocratic power of the state. Before each public appearance he knows that his words are only for those whom they can persuade, and that with those whom they do not there are other ways of dealing. Note this sordidness when watching the next party political broadcast.

What is the particular quality of Heartfield's best work? It stems from the originality and aptness of his use of photo-montage. In Heartfield's

hands the technique becomes a subtle but vivid means of political education, and more precisely of Marxist education.

With his scissors he cuts out events and objects from the scenes to which they originally belonged. He then arranges them in a new, unexpected, discontinuous scene to make a political point – for example, parliament is being placed in a wooden coffin. But this much might be achieved by a drawing or even a verbal slogan. The peculiar advantage of photo-montage lies in the fact that everything which has been cut out keeps its familiar photographic appearance. We are still looking first at *things* and only afterwards at symbols.

But because these things have been shifted, because the natural continuities within which they normally exist have been broken, and because they have now been arranged to transmit an unexpected message, we are made conscious of the arbitrariness of their continuous normal message. Their ideological covering or disguise, which fits them so well when they are in their proper place that it becomes indistinguishable from their appearances, is abruptly revealed for what it is. Appearances themselves are suddenly showing us how they deceive us.

Two simple examples. (There are many more complex ones.) A photograph of Hitler returning the Nazi salute at a mass meeting (which we do not see). Behind him, and much larger than he is, the faceless figure of a man. This man is discreetly passing a wad of banknotes into Hitler's open hand raised above his head. The message of the cartoon (October 1932) is that Hitler is being supported and financed by the big industrialists. But, more subtly, Hitler's charismatic gesture is being divested of its accepted current meaning.

A cartoon of one month later. Two broken skeletons lying in a crater of mud on the Western Front, photographed from above. Everything has disintegrated except for the nailed boots which are still on their feet, and, although muddy, are in wearable condition. The caption reads: 'And again?' Underneath there is a dialogue between the two dead soldiers about how other men are already lining up to take their place. What is being visually contested here is the power and virility normally accorded by Germans to the sight of jackboots.

Those interested in the future didactic use of photo-montage for social and political comment should, I am sure, experiment further with this ability of the technique to *demystify things*. Heartfield's genius lay in his discovery of this possibility.

Photo-montage is at its weakest when it is purely symbolic, when it uses its own means to further rhetorical mystification. Heartfield's work is not always free from this. The weakness reflects deep political contradictions.

For several years before 1933, communist policy towards the Nazis on the one hand and the German social democrats on the other was both confused and arbitrary. In 1928, after the fall of Bukharin and under

Stalin's pressure, the Comintern decided to designate all social democrats as 'social fascists' – there is a Heartfield cartoon of 1931 in which he shows an S.P.D. leader with the face of a snarling tiger. As a result of this arbitrary scheme of simplified moral clairvoyance being imposed from Moscow on local contradictory facts, any chance of the German communists influencing or collaborating with the 9,000,000 S.P.D. voters who were mostly workers and potential anti-Nazis was forfeited. It is possible that with a different strategy the German working class might have prevented the rise of Hitler.

Heartfield accepted the party line, apparently without any misgivings. But among his words there is a clear distinction between those which demystify and those which exhort with simplified moral rhetoric. Those which demystify treat of the rise of Nazism in Germany – a social-historical phenomenon with which Heartfield was tragically and intimately familiar; those which exhort are concerned with global generalizations which he inherited ready-made from elsewhere.

Again, two examples. A cartoon of 1935 shows a minuscule Goebbels standing on a copy of *Mein Kampf*, putting out his hand in a gesture of dismissal. 'Away with these degenerate subhumans,' he says – a quotation from a speech he made at Nuremberg. Towering above him as giants, making his gesture pathetically absurd, is a line of impassive Red Army soldiers with rifles at the ready. The effect of such a cartoon on all but loyal communists could only have been to confirm the Nazi lie that the U.S.S.R. represented a threat to Germany. In ideological contrasts, as distinct from reality, there is only a paper-thin division between thesis and antithesis; a single reflex can turn black into white.

A poster for the First of May 1937 celebrating the Popular Front in France. An arm holding a red flag and sprigs of cherry blossom; a vague background of clouds (?), sea waves (?), mountains (?). A caption from the *Marseillaise*: '*Liberté, liberté chérie, combats avec tes défenseurs!*' Everything about this poster is as symbolic as it is soon to be demonstrated politically false.

I doubt whether we are in a position to make moral judgements about Heartfield's integrity. We would need to know and to feel the pressures, both from within and without, under which he worked during that decade of increasing menace and terrible betrayals. But, thanks to his example, and that of other artists such as Mayakovsky or Tatlin, there is one issue which we should be able to see more clearly than was possible earlier.

It concerns the principal type of moral leverage applied to committed artists and propagandists in order to persuade them to suppress or distort their own original imaginative impulses. I am not speaking now of intimidation but of moral and political argument. Often such arguments were advanced by the artist himself against his own imagination.

The moral leverage was gained through asking questions concerning utility and effectiveness. Am I being useful enough? Is my work effective enough? These questions were closely connected with the belief that a work of art or a work of propaganda (the distinction is of little importance here) was a *weapon* of political struggle. Works of imagination can exert great political and social influence. Politically revolutionary artists hope to integrate their work into a mass struggle. But the influence of their work cannot be determined, either by the artist or by a political commissar, in advance. And it is here that we can see that to compare a work of imagination with a weapon is to resort to a dangerous and far-fetched metaphor.

The effectiveness of a weapon can be estimated quantitatively. Its performance is isolable and repeatable. One chooses a weapon for a situation. The effectiveness of a work of imagination cannot be estimated quantitatively. Its performance is not isolable or repeatable. It changes with circumstances. It creates its own situation. There is no *foreseeable* quantitative correlation between the quality of a work of imagination and its effectiveness. And this is part of its nature because it is intended to operate within a field of subjective interactions which are interminable and immeasurable. This is not to grant to art an ineffable value; it is only to emphasize that the imagination, when true to its impulse, is continually and inevitably questioning the existing category of usefulness. It is ahead of that part of the social self which asks the question. It must deny itself in order to answer the question in its own terms. By way of this denial revolutionary artists have been persuaded to compromise, and to do so in vain – as I have indicated in the case of John Heartfield.

It is lies that can be qualified as useful or useless; the lie is surrounded by what has not been said and its usefulness or not can be gauged according to what has been hidden. The truth is always first discovered in open space.

1969

The Sight of a Man

Dedicated to Chris Fox

There are reports that many thousands of monumental sculptures have been recently put up in the towns and villages of China. These sculptures depict local groups of workers or peasants achieving some revolutionary feat – often a production record. The sculptural style is so naturalistic as to suggest the figures being cast from life. The apotheosis of the living heroes is as immediate as possible. They can straight away look at themselves in the monument, not as in a mirror, but as from the outside, as others in history may see them.

From here it is impossible to judge the effect of these works on the masses in China. But one can make a number of general comments. The conscious aim behind the policy decision in Peking to produce these monuments is not different in kind – though leading to a cruder practice – from the unformulated aims of nearly all the patrons of European art since the Renaissance. The aim is to isolate and *reproduce* an aspect of reality in order to award it an outside prize, to confer upon it a value which is not intrinsic to it but which derives from an abstract religious or historical schema. Thus, appearances are abstracted from nature and society, through the imitative faculty of art, and used to dress, to clothe a social-moral-historical ideal. When the schema is not abstract and does not have to be imposed on social life, it has no need of the borrowed clothes of appearances.

The distinction between works produced according to an abstract schema and those rare works which extend, as distinct from transposing, the experience of the spectator, is that the latter never remove appearances from the essential and specific body of meaning behind them. (They never flay their subjects.) They deny the validity of any outside prize. One must add, however, that such masterpieces have as yet contributed nothing directly to solving the problems of revolutionary political organization and education. It is impossible to oppose them

directly to the Chinese monuments. These monuments need not be assessed as art but they can be considered as things to be seen. And it is at this point that – somewhat surprisingly – the example of Cézanne may be relevant.

Millions of words have been written in psychological and aesthetic studies about Cézanne yet their conclusions lack the gravity of the works. Everyone is agreed that Cézanne's paintings appear to be different from those of any painter who preceded him; whilst the works of those who came after seem scarcely comparable, for they were produced out of the profound crisis which Cézanne (and probably also Van Gogh) half foresaw and helped to provoke.

What then made Cézanne's painting different? Nothing less than his view of the visible. He questioned and finally rejected the belief, which was axiomatic to the whole Renaissance tradition, that things are seen for what they are, that their visibility belongs to them. According to this tradition, to make a likeness was to reconstitute a truth; even fantastic painters, like Bosch, treated visibility in the same way; their only difference was that they conferred visibility upon imagined constructions. To be visible was to be there, to make visible was to make there. Reality (nature) consisted of an infinite number of sights; the duty of the artist was to bring together and arrange sights. The artist captured appearances and in capturing them preserved a truth. The world offered its visibility to men as a tree offers its reflection to water. The mediation of optics did not alter this fundamental relation. The visible remained the *object* of every man's vision.

Cézanne, intensely introspective yet determinedly objective, propelled forward by continual self-doubt, born at a time when it was possible for a painter to recognize and give equal weight to his *petite sensation* on the one hand and *nature* on the other, Cézanne, who consciously strove towards a new synthesis between art and nature, who wanted to renew the European tradition, in fact destroyed for ever the foundation of that tradition by insisting, more and more radically as his work developed, that visibility is as much an extension of ourselves as it is a quality-in-itself of things. Through Cézanne we recognize that a visible world begins and ends with the life of each man, that millions of these visible worlds correspond in so many respects that from the correspondences we can construct the visible world, but that this world of appearances is inseparable from each one of us: and each one of us constitutes its centre.

What I am saying may become clearer if related to the actual landscapes in which Cézanne found his 'motifs'. I have been to many places to see how they compare to a painter's concentrated vision of them (Courbet's Jura, Van Gogh's southern Holland, Piero's Umbria, Poussin's Rome, etc.); but the experience of visiting and revisiting Cézanne's landscape round Aix is unique.

The houses in which he worked and their atmosphere have changed a lot. The civilization in which he lived, as distinct from the civilization to which we can read his work as a signpost, has disintegrated. His studio is now in a suburb near a supermarket. The Jas de Bouffan with its large garden and avenue of chestnuts has become an island in a sea of autoroute works. The farm at Bellevue is inhabited but overgrown, broken down, by the side of a car dump. Students camp in the Château Noir at weekends.

The natural landscape is largely unchanged: the Mont Sainte-Victoire, the yellowy-red rocks, the characteristic pine trees are there as they are in the paintings. At first everything looks smaller than you expected. However close you get to one of Cézanne's subjects, it still looks further away than in the painting. But after a while, when you have got used to this, when you are no longer concentrating upon the appearance at any given moment of the mountain, or the trees, or the red roof, or the path through the wood, you begin to realize that what Cézanne painted, and what you are already familiar with because of his paintings, is the *genius loci* of each view.

One might suppose the houses where he painted to be haunted today by a social way of life gone for ever (fortunately). But the landscapes are haunted by their own essence. Or so it seems, because you cannot become innocent of the paintings you know. Mont Sainte-Victoire appears primordial, as does the plain beneath it. Wherever you look, you feel that you are face to face with the origin of what is in front of you. You rediscover the famous silence of Cézanne's paintings in the age of what you are looking at. I do not mean, however, the geological origin of the mountain; I mean the origin of the visibility of the landscape before you. Through this landscape – because Cézanne used it over and over again as his raw material – you come to see what seeing means.

Given this, it is not surprising that Cézanne's work had to wait about fifty years for a philosopher – and not an art historian or art critic – to define its general significance. (The particular significance of each work is of course indefinable beyond or outside its own self-definition as painting.) In 1945 the French philosopher Merleau-Ponty published an essay of seventeen pages entitled *Le Doute de Cézanne*.[1] These few concentrated pages have revealed more to me about Cézanne's painting than anything else I have ever read.

Merleau-Ponty quotes some of Cézanne's own remarks. Of the old masters Cézanne said: 'They created pictures: we are attempting a piece of nature.' Of nature he said: 'The artist must conform to this perfect work of art. Everything comes to us from nature; we exist through it; nothing else is worth remembering.' 'Are you speaking of our nature?' asked Bernard. 'It has to do with both,' said Cézanne. 'But aren't nature and art different?' 'I want to make them the same,' replied Cézanne.

At what moment can art and nature converge and become the same? Never by way of representation, for nature cannot by definition be represented; and the representational devices of art depend entirely on artistic convention. The more consistently imitative art is, the more artificial it is. Metaphoric arts are the most natural. But what is a purely visual metaphor? At what moment is green, in equal measure, a perceived concentration of colour and an attribute of grass? It is the same question as above, formulated differently.

The answer is: at the moment of perception; at the moment when the subject of perception can admit no discontinuity between himself and the objects and space before him; at the moment at which he is an irremovable part of the totality of which he is the consciousness. 'The landscape,' said Cézanne, 'thinks itself in me, and I am its consciousness.' 'Colour,' he also said, 'is the place where our brain and the universe meet.'

The Herculean task Cézanne set himself was to prolong this moment for as long as it took him to paint his picture. And paradoxically this is why he worked so slowly and required so many sittings: he never wanted to let the logic of the painting take precedence over the continuity of perception: after each brushstroke he had to re-establish his innocence as perceiver. And since such a task is never entirely possible, he was always dogged by a greater or lesser sense of his own failure.

What he could not realize was that in failing to paint the pictures he wanted, he heightened our awareness of the visible as it had never been heightened before. He bequeathed to us something far more valuable than masterpieces: a new consciousness of a faculty.

In his attempt to prolong this moment, to be faithful to his 'sensation', to treat nature as a work of art, he abandoned the systematic usages of painting – outlines, consistent perspective, local colour, the optical conventions of impressionism, classical composition, etc. – because he reckoned that these were only ways of constructing a substitute for nature *post facto.* The old masters, he said, 'replaced reality by imagination and by the abstraction which accompanies it'. Today we are so accustomed to thinking that the tradition of the old masters was challenged by increasing abstraction and finally by non-figurative art that we fail to see that Cézanne was the most fundamentally iconoclastic of all modern artists.

Since Cézanne's death certain discoveries by psychologists have proved how true he was to his perceptual experience. For example: the perspective we live is neither geometrical nor photographic. When we see a circle in perspective we do not see a perfect ellipse but a form which oscillates round an ellipse without being one. There is something very poignant about Cézanne, shocked in moments of doubt by his own non-conformity, fearing that his whole art was based on a personal deformity of vision, and it later being established that no painter had

ever been as faithful to the actual processes by which we all see. But neither this poignancy nor the piecemeal confirmation by science of some of his innovations is central to the overall significance of his work.

Merleau-Ponty indicates wherein this significance lies:

> He did not want to separate the stable things which we see and the shifting way in which they appear; he wanted to depict matter as it takes on form, the birth of order through spontaneous organization. He makes a basic distinction not between 'the senses' and 'the understanding' but rather between the spontaneous organization of the things we perceive and the human organization of ideas and sciences. We see things; we agree about them; we are anchored in them; and it is with 'nature' as our base that we construct our sciences. Cézanne wanted to paint this primordial world . . . He wished, as he said, to confront the sciences with the nature 'from which they came'.[2]

This nature is not chaotic; it emerges into order because of 'the spontaneous organization of the things we perceive'. If you compare a drawing of a coat on a chair with many paintings of Mont Sainte-Victoire from the side of the Château Noir made during the same period, you have an exaggerated demonstration of this principle. Not surprisingly the means of rendering the forms of both coat and mountain are similar, but, more importantly, the actual configuration of the coat resembles, to a remarkable degree, that of the mountain. It is an exaggerated, even aberrant case, because Cézanne was obsessed by that mountain; but we may presume that when drawing the coat he was as faithful as usual to his own perception.

At a different level of experience Gestalt psychology has established that in the act of seeing we organize. Nevertheless most psychologists tend to preserve the distinct categories, as applied to vision, of objectivity and subjectivity. In another essay called *Eye and Mind*, written fifteen years later in a village beneath Mont Sainte-Victoire, Merleau-Ponty attacks the conservative oversimplification of these categories:

> We must take literally what vision teaches us: namely, that through it we come in contact with the sun and the stars, that we are everywhere all at once, and that even our power to imagine ourselves elsewhere . . . borrows from vision and employs means we owe to it. Vision alone makes us learn that beings that are different, 'exterior', foreign to one another, yet absolutely *together*, are 'simultaneity'; this is a mystery psychologists handle the way a child handles explosives.[3]

The space, the depth in Cézanne's later paintings refuses to close: it remains open to 'simultaneity': it is full of the promise of reciprocity. If

you imagine taking up a position in the space of one of his pictures, the painting offers you the organizational guidelines of what you would see as you looked backwards or sideways to where you presume you are still standing. You look up at Mont Sainte-Victoire but within the terms of the painting, within its own elements, you are aware of the opportunity and the probable configuration presented by what you would see looking down from the mountain.

Cézanne reasserted the value, complexity and unity of what we perceive (nature) as opposed to the counterfeit simplifications and singularity of European representational art. He testified that the visibility of things belongs to each one of us: not in so far as our minds interpret signals received by our eyes: but in so far as the visibility of things *is* our recognition of them: and to recognize is to relate and to order. It is apt that *blind* has come to mean not only unseeing but also directionless.

It seems to me that these conclusions are finally applicable to the Chinese monuments considered as things to be seen.

To honour individual living men by making them the subject matter of naturalistic art is to render them the creatures of another's vision instead of acknowledging them as masters of their own. And this is true whatever the cultural development of the people concerned. If comparable decisions were taken in other fields of social and cultural activity all revolutionary initiative and democracy would eventually disappear. Meanwhile the monuments may encourage production, the importance of which cannot be dismissed.

1970

Revolutionary Undoing

Some fight because they hate what confronts them; others because they have taken the measure of their lives and wish to give meaning to their existence. The latter are likely to struggle more persistently. Max Raphael was a very pure example of the second type.

He was born near the Polish–German border in 1889. He studied philosophy, political economy and the history of art in Berlin and Munich. His first work was published in 1913. He died in New York in 1952. In the intervening forty years he thought and wrote incessantly.

His life was austere. He held no official academic post. He was forced several times to emigrate. He earned very little money. He wrote and noted without cease. As he travelled, small groups of friends and unofficial students collected around him. By the cultural hierarchies he was dismissed as an unintelligible but dangerous Marxist: by the party communists as a Trotskyist. Unlike Spinoza he had no artisanal trade.

In his book, *The Demands of Art*,[1] Raphael quotes a remark of Cézanne's (in the context of a quite different analysis):

> I paint my still lifes, these *natures mortes*, for my coachman who does not want them, I paint them so that children on the knees of their grandfathers may look at them while they eat their soup and chatter. I do not paint them for the pride of the Emperor of Germany or the vanity of the oil merchants of Chicago. I may get ten thousand francs for one of these dirty things, but I'd rather have the wall of a church, a hospital, or a municipal building.

Since 1848 every artist unready to be a mere paid entertainer has tried to resist the bourgeoisization of his finished work, the transformation of the spiritual value of his work into property value. This regardless of his political opinions as such. Cézanne's attempt, like that of all his con-

temporaries, was in vain. The resistance of later artists became more active and more violent – in that the resistance was built into their work. What constructivism, dadaism, surrealism, etc., all shared was their opposition to art-as-property and art-as-a-cultural-alibi-for-existing-society. We know the extremes to which they went: the sacrifices they were prepared to make as creators: and we see that their resistance was as ineffective as Cézanne's.

In the last decade the tactics of resistance have changed. Less frontal confrontation. Instead, infiltration. Irony and philosophic scepticism. The consequences in tachism, pop art, minimal art, neo-dada, etc. But such tactics have been no more successful than earlier ones. Art is still transformed into the property of the property-owning class. In the case of the visual arts the property involved is physical; in the case of the other arts it is moral property.

Art historians with a social or Marxist formation have interpreted the art of the past in terms of class ideology. They have shown that a class, or groups in a class, tended to support and patronize art which to some degree reflected or furthered their own class values and views. It now appears that in the later stages of capitalism this has ceased to be generally true. Art is treated as a commodity whose meaning lies *only* in its rarity value and in its functional value as a stimulant of sensation. It ceases to have implications beyond itself. Works of art become objects whose essential character is like that of diamonds or sun-tan lamps. The determining factor of this development – internationalism of monopoly, powers of mass-media communication, level of alienation in consumer societies – need not concern us here. But the consequence does. *Art can no longer oppose what is.* The faculty of proposing an alternative reality has been reduced to the faculty of designing – more or less well – an object.

Hence the imaginative doubt in all artists worthy of their category. Hence the fact that the militant young begin to use 'art' as a cover for more direct action.

One might argue that artists should continue, regardless of society's immediate treatment of their work: that they should address themselves to the future, as all imaginative artists after 1848 have had to do. But this is to ignore the world-historical moment at which we have arrived. Imperialism, European hegemony, the moralities of capitalist-Christianity and state-communism, the Cartesian dualism of white reasoning, the practice of constructing 'humanist' cultures on a basis of monstrous exploitation – this entire interlocking system is now being challenged: a world struggle is being mounted against it. Those who envisage a different future are obliged to define their position towards this struggle, obliged to choose. Such a choice tends to lead them either to impotent despair or to the conclusion that world liberation is the pre-condition for any new valid cultural achievement. (I simplify and somewhat exaggerate

the positions for the sake of brevity.) Either way their doubts about the value of art are increased. An artist who now addresses the future does not necessarily have his faith in his vision confirmed.

In this present crisis, is it any longer possible to speak of the revolutionary meaning of art? This is the fundamental question. It is the question that Max Raphael begins to answer in *The Demands of Art*.

The book is based on some lectures that Raphael gave in the early 1930s to a modest adult education class in Switzerland under the title 'How should one approach a work of art?' He chose five works and devoted a chapter of extremely thorough and varied analysis to each. The works are: Cézanne's *Mont Sainte-Victoire* of 1904–6 (the one in the Philadelphia Museum), Degas's etching of *Madame X leaving her bath*, Giotto's *Dead Christ* (Padua) compared with his later *Death of Saint Francis* (Florence), a drawing by Rembrandt of *Joseph interpreting Pharaoh's dreams*, and Picasso's *Guernica*. (The chapter on *Guernica* was of course written later.) These are followed by a general chapter on 'The struggle to understand art', and by an appendix of an unfinished but extremely important essay entitled 'Towards an empirical theory of art', written in 1941.

I shall not discuss Raphael's analysis of the five individual works. They are brilliant, long, highly particularized and dense. The most I can do is to attempt a crude outline of his general theory.

A question which Marx posed but could not answer. If art, in the last analysis, is a superstructure of the economic base, why does its power to move us endure long after the base has been transformed? Why, asked Marx, do we still look towards Greek art as an ideal? He began to answer by speaking about the 'charm' of 'young children' (the young Greek civilization) and then broke off the manuscript and was far too occupied ever to return to the question.

'A transitional epoch,' writes Raphael,

> always implies uncertainty: Marx's struggle to understand his own epoch testifies to this. In such a period two attitudes are possible. One is to take advantage of the emergent forces of the new order with a view to undermining it, to affirm it in order to drive it beyond itself: this is the active, militant, revolutionary attitude. The other clings to the past, is retrospective and romantic, bewails or acknowledges the decline, asserts that the will to live is gone – in short, it is the passive attitude. Where economic, social, and political questions were at stake Marx took the first attitude; in questions of art he took neither.

He merely reflected his epoch.

Just as Marx's taste in art – the classical ideal excluding the extraordinary achievements of palaeolithic, Mexican, African art – reflected

the ignorance and prejudice of art appreciation in his period, so his failure to create (though he saw the need to do so) a theory of art larger than that of the superstructure theory was the consequence of the continual, overwhelming primacy of economic power in the society around him.

In view of this lacuna in Marxist theory, Raphael sets out to

> develop a theory of art that I call empirical because it is based on a study of works from all periods and nations. I am convinced that mathematics, which has travelled a long way since Euclid, will some day provide us with the means of formulating the results of such a study in mathematical terms.

And he reminds the sceptical reader that before infinitesimal calculus was discovered even nature could not be studied mathematically.

'Art is an interplay, an equation of three factors – the artist, the world and the means of figuration.' Raphael's understanding of the third factor, the means or process of figuration, is crucial. For it is this process which permits him to consider the finished work of art as possessing a specific reality of its own.

> Even though there is no such thing as a single, uniquely beautiful proportion of the human body or a single scientifically correct method of representing space, or one method only of artistic figuration, whatever form art may assume in the course of history, it is always a synthesis between nature (or history) and the mind, and as such it acquires a certain autonomy vis-à-vis both these elements. This independence seems to be created by man and hence to possess a psychic reality; but in point of fact the process of creation can become an existent only because it is embodied in some concrete material.

The artist chooses his material – stone, glass, pigment, or a mixture of several. He then chooses a way of working it – smoothly, roughly, in order to preserve its own character, in order to destroy or transcend it. These choices are to a large measure historically conditioned. By working his material so that it represents ideas or an object, or both, the artist transforms raw material into 'artistic' material. What is represented is materialized in the worked, raw material; whereas the worked raw material acquires an immaterial character through its representations and the *unnatural* unity which connects and binds these representations together. 'Artistic' material, so defined, a substance half physical and half spiritual, is an ingredient of the material of figuration.

A further ingredient derives from the means of representation. These are colour, line and light and shade. Perceived in nature these qualities

are merely the stuff of sensation – undifferentiated from one another and arbitrarily mixed. The artist, in order to replace contingency by necessity, first separates the qualities and then combines them around a central idea or feeling which determines all their relations.

The two processes which produce the material of figuration (the process of transforming raw material into artistic material and the process of transforming the matter of sensation into means of representation) are continually interrelated. Together they constitute what might be called the matter of art.

Figuration begins with the separate long-drawn-out births of idea and motif and is complete when the two are born and indistinguishable from one another.

The characteristics of the individual idea are:

1. It is simultaneously an idea and a feeling.

2. It contains the contrasts between the particular and the general, the individual and the universal, the original and the banal.

3. It is a progression toward ever deeper meanings.

4. It is the nodal point from which secondary ideas and feelings develop.

'The motif is the sum total of line, colour and light by means of which the conception is realized.' The motif begins to be born apart from but at the same time as the idea because 'only in the act of creation does the content become fully conscious of itself'.

What is the relation between the pictorial (individual) idea and nature?

The pictorial idea separates usable from unusable elements of natural appearances and, conversely, study of natural appearances chooses from among all possible manifestations of the pictorial idea the one that is most adequate. The difficulty of the method comes down to 'proving what one believes' – 'proof' here consisting in this, that the opposed methodological starting points (experience and theory) are unified, brought together in a reality of a special kind, different from either, and that this reality owes its pictorial life to a motif adequate to the conception and developed compositionally.

What are the methods of figuration? I. The structuring of space. 2. The rendering of forms within that space *effective.*

The structuring of space has nothing to do with perspective: its tasks are to dislocate space so that it ceases to be static (the simplest example is that of the forward-coming relaxed leg in standing Greek figures) and to divide space into quanta so that we become conscious of its divisibility

234

and thus cease to be the creatures of *its* continuity (for example, the receding planes parallel to the picture surface in late Cézannes).

> To create pictorial space is to penetrate not only into the depths of the picture but also into the depths of our intellectual system of coordinates (which matches that of the world). Depth of space is depth of essence or else it is nothing but appearance and illusion.

The distinction between actual form and effective form is as follows:

> Actual form is descriptive; effective form is suggestive, i.e. through it the artist, instead of trying to convey the contents and feelings to the viewer by fully describing them, provides him only with as many clues as he needs to produce these contents and feelings within himself. To achieve this the artist must act not upon individual sense organs but upon the whole man, i.e. he must make the viewer live in the work's own mode of reality.

What does figuration, with its special material, achieve?

> Intensity of figuration is not display of the artist's strength; not vitality, which animates the outer world with the personal energies of the creative artist; not logical or emotional consistency, with which a limited problem is thought through or felt through to its ultimate consequences. What it does denote is the degree to which the very essence of art has been realized: the undoing of the world of things, the construction of the world of values, and hence the constitution of a new world. The originality of this constitution provides us with a general criterion by which we can measure intensity of figuration. Originality of constitution is not the urge to be different from others, to produce something entirely new, it is (in the etymological sense) the grasping of the origin, the roots of both ourselves and things.

One must distinguish here between Raphael's 'world of values' and the idealist view of art as a depository of transcendental values. For Raphael the values lie *in the activity* revealed by the work. The function of the work of art is to lead us from the work to the process of creation which it contains. This process is determined by the material of figuration, and it is within this material, which Raphael discloses and analyses with genius, that mathematics may one day be able to discover precise principles. The process is directed towards creating within the work a synthesis of the subjective and objective, of the conditional and the absolute within a totality governed by its own laws of necessity. Thus the world of things is replaced within the work by a hierarchy of values created by the process it contains.

I can give no indication here of the detailed, specific and unabstract way in which Raphael applies his understanding to the five works he studies. I can only state that his eye and sensuous awareness were as developed as his mind. Reading him one has the impression, however difficult the thought, of a man of unusual and stable balance. One can feel the profile of an austere thinker who belonged to the twentieth century because he was a dialectical materialist inheriting the main tradition of European philosophy, but who at the same time was a man whose vital constitution made it impossible for him to ignore the unknown, the as yet tentative, the explosive human potential which will always render man indefinable within any categorical system.

> Since we cannot know ourselves directly, but only through our actions, it remains more than doubtful whether our idea of ourselves accords with our real motives. But we must strive unremittingly to achieve this congruence. For only self-knowledge can lead to self-determination, and false self-determination would ruin our lives and be the most immoral action we could commit.

To return now to our original question: what is the revolutionary meaning of art? Raphael shows that the revolutionary meaning of a work of art has nothing to do with its subject matter in itself, or with the functional use to which the work is put, but is a meaning continually awaiting discovery and release.

> However strong a given historical tendency may be, man can and has the duty to resist it when it runs counter to his creative powers. There is no fate which decrees that we must be victims of technology or that art must be shelved as an anachronism; the 'fate' is merely misuse of technology by the ruling class to suppress the people's power to make its own history. To a certain extent it is up to every individual, by his participation in social and political life, to decide whether art shall or shall not become obsolete. The understanding of art helps raise this decision to its highest level. As a vessel formed by the creative forces which it preserves, the work of art keeps alive and enhances every urge to come to terms with the world.
>
> We have said that art leads us from the work to the process of creation. This reversion, outside the theory of art, will eventually generate universal doubt about the world as given, the natural as well as the social. Instead of accepting things as they are, of taking them for granted, we learn, thanks to art, to measure them by the standard of perfection. The greater the unavoidable gulf between the ideal and the real, the more inescapable is the question. Why is the existing world the way it is? How has the world come to be what it is? *De omnibus*

rebus dubitandum est! Quid certum? 'We must doubt all things! What is certain?' (Descartes). It is the nature of the creative mind to dissolve seemingly solid things and to transform the world as it is into a world in process of becoming and creating. This is how we are liberated from the multiplicity of things and come to realize what it is that all conditional things ultimately possess in common. Thus, instead of being creatures we become part of the power that creates all things.

Raphael did not, could not, make our choices for us. Everyone must resolve for himself the conflicting demands of his historical situation. But even to those who conclude that the practice of art must be temporarily abandoned, Raphael will show as no other writer has ever done the revolutionary meaning of the works inherited from the past – and of the works that will be eventually created in the future. And this he shows without rhetoric, without exhortation, modestly and with reason. His was the greatest mind yet applied to the subject.

1969

Past Seen from a Possible Future

Has anyone ever tried to estimate how many framed oil paintings, dating from the fifteenth century to the nineteenth, there are in existence? During the last fifty years a large number must have been destroyed. How many were there in 1900? The figure itself is not important. But even to guess at it is to realize that what is normally counted as art, and on the evidence of which art historians and experts generalize about the European tradition, is a quantitatively insignificant fraction of what was actually produced.

From the walls of the long gallery, those who never had any reason to doubt their own significance look down in perpetual self-esteem, surrounded by gilded frames. I look down at the courtyard around which the galleries were built. In the centre, a fountain plays sluggishly: the water slowly but continuously overbrimming its bowl. There are weeping willows, benches and a few gesticulating statues. The courtyard is open to the public. In summer it is cooler than the city streets outside: in winter it is protected from the wind.

I have sat on a bench listening to the talk of those who come into the courtyard for a few minutes' break – mostly old people or women with children. I have watched the children playing. I have paced around the courtyard, when nobody was there, thinking about my own life. I have sat there, blind to everything around me, reading a newspaper. As I look down on the courtyard before turning back to the portraits of the nineteenth-century local dignitaries, I notice that the gallery attendant is standing at the next tall window and that he too is gazing down on the animated figures below.

And then suddenly I have a vision of him and me, each alone and stiff in his window, being seen from below. I am seen quite clearly but not in detail for it is forty feet up to the window and the sun is in such a position that it half dazzles the eyes of the seer. I see myself as seen. I

experience a moment of familiar panic. Then I turn back to the framed images.

The banality of nineteenth-century official portraits is, of course, more complete than that of eighteenth-century landscapes or that of seventeenth-century religious pieces. But perhaps not to a degree that matters. European art is idealized by exaggerating the historical differences within its development and by never seeing it as a whole.

The art of any culture will show a wide differential of talent. But I doubt whether anywhere else the difference between the masterpieces and the average is as large as it is in the European tradition of the last five centuries. The difference is not only a question of skill and imagination, but also of morale. The average work – and increasingly after the sixteenth century – was produced cynically: that is to say its content, its message, the values it was nominally upholding, were less meaningful for the producer than the finishing of the commission. Hack work is not the result of clumsiness or provincialism: it is the result of the market making more insistent demands than the job.

Just as art history has concentrated upon a number of remarkable works and barely considered the largest part of the tradition, aesthetic theory has emphasized the disinterestedly spiritual experience to be gained from works of art and largely ignored their massive ideological function. We spiritualize art by calling it art.

The modern historians of Renaissance and post-Renaissance art – Burckhardt, Wölfflin, Riegl, Dvorak – began writing at the moment when the tradition was beginning to disintegrate. Undoubtedly the two facts were linked within a fantastically complicated matrix of other historical developments. Perhaps historians always require an end in order to begin. These historians, however, defined the various phases of the tradition (Renaissance, Mannerist, Baroque, Neo-Classic) so sharply and explained their evolution from one to the other with such skill that they encouraged the notion that the European tradition was one of change without end: the more it broke with or remade its own inheritance, the more it was itself. Tracing a certain continuity in the past they seemed to guarantee one for the future.

Concentration upon the exceptional works of a couple of hundred masters, an emphasis on the spirituality of art, a sense of belonging to a history without end – all these have discouraged us from ever seeing our pictorial tradition as a whole and have led us to imagine that our own experience of looking today at a few works from the past still offers an immediate clue to the function of the vast production of European art. We conclude that it was the destiny of Europe to make art. The formulation may be more sophisticated, but that is the essential assumption. Try now to see the tradition from the far distance.

'We can have no idea,' wrote Nietzsche, 'what sort of things are going

to become history one day. Perhaps the past is still largely undiscovered; it still needs so many retroactive forces for its discovery.'

During the period we are considering, which can be roughly marked out as the period between Van Eyck and Ingres, the framed easel picture, the oil painting, was the primary art product. Wall painting, sculpture, the graphic arts, tapestry, scenic design, and even many aspects of architecture were visualized and judged according to a value system which found its purest expression in the easel picture. For the ruling and middle classes the easel picture became a microcosm of the whole world that was virtually assimilable: its pictorial tradition became the vehicle for all visual ideals.

To what uses did the easel picture pre-eminently lend itself?

It permitted a style of painting which was able to 'imitate' nature or reality more closely than any other. What are usually termed stylistic changes – from classical to mannerist to baroque and so on – never affected the basic 'imitative' faculty; each subsequent phase simply used it in a different manner.

I put inverted commas round 'imitative' because the word may confuse as much as it explains. To say that the European style imitated nature makes sense only when one accepts a particular view of nature: a view which eventually found its most substantial expression in the philosophy of Descartes.

Descartes drew an absolute distinction between mind and matter. The property of mind was self-consciousness. The property of matter was extension in space. The mind was infinitely subtle. The workings of nature, however complicated, were mechanically explicable and, relative to the mind, unmysterious. Nature was predestined for man's use and was *the ideal object of his observation*. And it was precisely this which Renaissance perspective, according to which everything converged on the eye of the beholder, demonstrated. Nature was that conical segment of the visible whose apex was the human eye. Thus imitating nature meant tracing on a two-dimensional surface what that eye saw or might see at a given moment.

European art – I use the term to refer only to the period we are discussing – is no less artificial, no less arbitrary, no closer to total reality than the figurative art of any other culture or period. All traditions of figurative art invoke different experiences to confirm their own principles of figuration. No figurative works of art produced within a tradition appear unrealistic to those brought up within the tradition. And so we must ask a subtler question. What aspect of experience does the European style invoke? Or more exactly, what kind of experience do its means of representation represent? (Ask, too, the same question about Japanese art, or West African.)

In his book on the Florentine painters Berenson writes:

It is only when we can take for granted the existence of the object painted that it can begin to give us pleasure that is genuinely artistic, as separated from the interest we feel in symbols.

He then goes on to explain that the tangibility, the 'tactile value' of the painted object, is what allows us to take its existence for granted. Nothing could be more explicit about the implications of the artistic pleasure to be derived from European art. That which we believe we can put our hands upon truly exists for us; if we cannot, it does not.

European means of representation refer to the experience of taking possession. Just as its perspective gathers all that is extended to render it to the individual eye, so its means of representation render all that is depicted into the hands of the individual owner-spectator. Painting becomes the metaphorical act of appropriation.

The social and economic modes of appropriation changed a great deal during the five centuries. In fifteenth-century painting the reference was often directly to what was depicted in the painting – marble floors, golden pillars, rich textiles, jewels, silverware. By the sixteenth century it was no longer assembled or hoarded riches which the painting rendered up to the spectator-owner but, thanks to the unity that chiaroscuro could give to the most dramatic actions, whole *scenes* complete with their events and protagonists. These scenes were 'own-able' to the degree that the spectator understood that wealth could produce and control action at a distance. In the eighteenth century the tradition divided into two streams. In one, simple middle-class properties were celebrated, in the other the aristocratic right to buy performances and to direct an unending theatre.

I am in front of a typical European nude. She is painted with extreme sensuous emphasis. Yet her sexuality is only superficially manifest in her actions or her own expression; in a comparable figure within other art traditions this would not be so. Why? Because for Europe ownership is primary. The painting's sexuality is manifest not in what it shows but in the owner-spectator's (mine in this case) right to see her naked. Her nakedness is not a function of her sexuality but of the sexuality of those who have access to the picture. In the majority of European nudes there is a close parallel with the passivity which is endemic to prostitution.

It has been said that the European painting is like a window open on to the world. Purely optically this may be the case. But is it not as much like a safe, let into the wall, in which the visible has been deposited?

So far I have considered the methods of painting, the means of representation. Now to consider what the paintings showed, their subject matter. There were special categories of subjects: portraits, landscapes, still life, genre pictures of 'low life'. Each category might well be studied separately within the same general perspective which I have suggested.

241

(Think of the tens of thousands of still-life canvases depicting game shot or bagged: the numerous genre pictures about procuring or accosting: the innumerable uniformed portraits of office.) I want, however, to concentrate on the category which was always considered the noblest and the most central to the tradition – paintings of religious or mythological subjects.

Certain basic Christian subjects occurred in art long before the rise of the easel painting. Yet described in frescoes or sculpture or stained glass their function and their social, as distinct from purely iconographic, meaning was very different. A fresco presents its subject within a given context – say that of a chapel devoted to a particular saint. The subject *applies* to what is structurally around it and to what is likely to happen around it; the spectator, who is also a worshipper, becomes part of that context. The easel picture is without a precise physical or emotional context because it is transportable.

Instead of presenting its subject within a larger whole it offers its subject to whoever owns it. Thus its subject *applies* to the life of its owner. A primitive transitional example of this principle working are the crucifixions or nativities in which those who commissioned the painting, the donors, are actually painted in standing at the foot of the cross or kneeling around the crib. Later, they did not need to be painted in because physical ownership of the painting guaranteed their immanent presence within it.

Yet how did hundreds of somewhat esoteric subjects apply to the lives of those who owned paintings of them? The sources of the subjects were not real events or rituals but texts. To a unique degree European art was a visual art deriving from literature. Familiarity with these texts or at least with their personae was the prerogative of the privileged minority. The majority of such paintings would have been readable as representational images but unreadable as language because they were ignorant of what they signified. In this respect if in no other most of us today are a little like that majority. What exactly happened to St Ursula? we ask. Exactly why did Andromeda find herself chained to the rocks?

This specialized knowledge of the privileged minority supplied them with a system of references by which to express subtly and evocatively the values and ideals of the life lived by their class. (For the last vestiges of this tradition note the moral value still sometimes ascribed to the study of the classics.) Religious and mythological paintings were something more than mere illustration of their separate subjects; together they constituted a system which classified and idealized reality according to the cultural interest of the ruling classes. They supplied a visual etiquette – a series of examples showing how significant moments in life should be envisaged. One needs to remember that, before the photograph or the cinema, painting alone offered recorded evidence of what people or events looked like or should look like.

Paintings applied to the lives of their spectator-owners because they showed how these lives should ideally appear at their heightened moments of religious faith, heroic action, sensuous abandon, contrition, tenderness, anger, courageous death, the dignified exercise of power, etc. They were like garments held out for the spectator-owners to put their arms into and wear. Hence the great attention paid to the verisimilitude of the *texture* of the things portrayed.

The spectator-owners did not identify themselves with the subjects of the paintings. Empathy occurs at a simpler and more spontaneous level of appreciation. The subjects did not even confront the spectator-owners as an exterior force; they were already theirs. Instead, the spectator-owners identified themselves *in* the subject. They saw themselves or their imagined selves covered over by the subject's idealized appearances. They found in them the guise of what they believed to be their own humanity.

The typical religious or mythological painting from the sixteenth century to the nineteenth was extraordinarily vacuous. We only fail to see this because we are deceived by the cultural overlay that art history has given these pictures. In the typical painting the figures are only superficially related to their painted surroundings; they appear detachable from them: their faces are expressionless: their vast bodies are stereotyped and limp – limp even in action. This cannot be explained by the artist's clumsiness or lack of talent; primitive works, even of a low order of imagination, are infinitely more expressive. These paintings are vacuous because it was their function, as established by usage and tradition, to be empty. They needed to be empty. They were not meant to express or inspire; they were meant to clothe the systematic fantasies of their owners.

The easel picture lent itself by its means of representation to a metaphorical appropriation of the material world: by its iconography to the appropriation by a small privileged minority of all 'the human values' of Christianity and the classic world.

I see a rather undistinguished Dutch seventeenth-century self-portrait. Yet the look of the painter has a quality which is not uncommon in self-portraits. A look of probing amazement. A look which shows slight questioning of what it sees.

There have been paintings which have transcended the tradition to which they belong. These paintings pertain to a true humanity. They bear witness to their artists' intuitive awareness that life was larger than the available traditional means of representing it and that its dramas were more urgent than conventional iconography could now allow. The mistake is to confuse these exceptions with the norms of the tradition.

The tradition and its norms are worth studying, for in them we can find evidence such as exists nowhere else of the way that the European

ruling classes saw the world and themselves. We can discover the typology of their fantasies. We can see life rearranged to frame their own image. And occasionally we can glimpse even in works that are not exceptional – usually in landscapes because they relate to experiences of solitude in which the imagination is less confined by social usage – a tentative vision of another kind of freedom, a freedom other than the right to appropriate.

In one sense every culture appropriates or tries to make the actual and possible world its own. In a somewhat different sense all men acquire experience for themselves. What distinguishes post-Renaissance European practice from that of any other culture is its transformation of everything which is acquired into a commodity; consequently, everything becomes exchangeable. Nothing is appropriated for its own sake. Every object and every value is transmutable into another – even into its opposite. In *Capital*, Marx quotes Christopher Columbus writing in 1503: 'By means of gold one can even get souls into Paradise.' Nothing exists in itself. This is the essential spiritual violence of European capitalism.

Ideally the easel picture is framed. The frame emphasizes that within its four edges the picture has established an enclosed, coherent and absolutely rigorous system of its own. The frame marks the frontier of the realm of an autonomous order. The demands of composition and of the picture's illusory but all-pervasive three-dimensional space constitute the rigid laws of this order. Into this order are fitted representations of real figures and objects.

All the imitative skill of the tradition is concentrated upon making these representations look as tangibly real as possible. Yet each part submits to an abstract and artificial order of the whole. (Formalist analyses of paintings and all the classic demonstrations of compositional rules prove the degree of this submission.) The parts look real but in fact they are ciphers. They are ciphers within a comprehensive yet invisible and closed system which nevertheless pretends to be open and natural.

Such is the tyranny exercised by the easel painting, and from it arises the fundamental criterion for judging between the typical and the exceptional within the European tradition. Does what is depicted insist upon the unique value of its original being or has it succumbed to the tyranny of the system?

Today visual images no longer serve as a source of private pleasure and confirmation for the European ruling classes; rather, they have become a vehicle for its power over others through the mass media and publicity. Yet it is false to draw a comparison between these recent commercial developments and the hallowed tradition of European art. Their references may be different: they may serve a different immediate purpose; but their determining principle is the same – a man is what he possesses.

244

Delacroix was, I think, the first painter to suspect some of what the tradition of the easel picture entailed. Later, other artists questioned the tradition and opposed it more violently. Cézanne quietly destroyed it from within. Significantly, the two most sustained and radical attempts to create an alternative tradition occurred in the 1920s in Russia and Mexico, countries where the European model had been arbitrarily imposed on their own indigenous art traditions.

To most young artists today it is axiomatic that the period of the easel picture is finished. In their works they try to establish new categories in terms of media, form and response. Yet the tradition dies hard and still exerts an enormous influence on our view of the past, our ideas about the role of the visual artist and our definition of civilization. Why has it taken so long to die?

Because the so-called Fine Arts, although they have found new materials and new means, have found no new social function to take the place of the easel picture's outdated one. It is beyond the power of artists alone to create a new social function for art. Such a new function will only be born of revolutionary social change. Then it may become possible for artists to work truly concretely and constructively with reality itself, to work with what men are really like rather than with a visual etiquette serving the interests of a privileged minority; then it may be that art will re-establish contact with what European art has always dismissed – with that which cannot be appropriated.

1970

The Nature of Mass Demonstrations

Seventy-three years ago (on 6 May 1898) there was a massive demonstration of workers, men and women, in the centre of Milan. The events which led up to it involve too long a history to treat with here. The demonstration was attacked and broken up by the army under the command of General Beccaris. At noon the cavalry charged the crowd: the unarmed workers tried to make barricades: martial law was declared and for three days the army fought against the unarmed.

The official casualty figures were 100 workers killed and 450 wounded. One policeman was killed accidentally by a soldier. There were no army casualties. (Two years later Umberto I was assassinated because after the massacre he publicly congratulated General Beccaris, the 'butcher of Milan'.)

I have been trying to understand certain aspects of the demonstration in the Corso Venezia on 6 May because of a story I am writing. In the process I came to a few conclusions about demonstrations which may perhaps be more widely applicable.

Mass demonstrations should be distinguished from riots or revolutionary uprisings although, under certain (now rare) circumstances, they may develop into either of the latter. The aims of a riot are usually immediate (the immediacy matching the desperation they express): the seizing of food, the release of prisoners, the destruction of property. The aims of a revolutionary uprising are long-term and comprehensive: they culminate in the taking over of state power. The aims of a demonstration, however, are symbolic: it *demonstrates* a force that is scarcely used.

A large number of people assemble together in an obvious and already announced public place. They are more or less unarmed. (On 6 May 1898, entirely unarmed.) They present themselves as a target to the forces of repression serving the state authority against whose policies they are protesting.

246

Theoretically demonstrations are meant to reveal the strength of popular opinion or feeling: theoretically they are an appeal to the democratic conscience of the state. But this presupposes a conscience which is very unlikely to exist.

If the state authority is open to democratic influence, the demonstration will hardly be necessary; if it is not, it is unlikely to be influenced by an empty show of force containing no real threat. (A demonstration in support of an already established *alternative* state authority – as when Garibaldi entered Naples in 1860 – is a special case and may be immediately effective.)

Demonstrations took place before the principle of democracy was even nominally admitted. The massive early Chartist demonstrations were part of the struggle to obtain such an admission. The crowds who gathered to present their petition to the Czar in St Petersburg in 1905 were appealing – and presenting themselves as a target – to the ruthless power of an absolute monarchy. In the event – as on so many hundreds of other occasions all over Europe – they were shot down.

It would seem that the true function of demonstrations is not to convince the existing state authority to any significant degree. Such an aim is only a convenient rationalization.

The truth is that mass demonstrations are rehearsals for revolution: not strategic or even tactical ones, but rehearsals of revolutionary awareness. The delays between the rehearsals and the real performance may be very long: their quality – the intensity of rehearsed awareness – may, on different occasions, vary considerably: but any demonstration which lacks this element of rehearsal is better described as an officially encouraged public spectacle.

A demonstration, however much spontaneity it may contain, is a *created* event which arbitrarily separates itself from ordinary life. Its value is the result of its artificiality, for therein lie its prophetic, rehearsing possibilities.

A mass demonstration distinguishes itself from other mass crowds because it congregates in public *to create its function,* instead of forming in response to one: in this it differs from any assembly of workers within their place of work – even when strike action is involved – or from any crowd of spectators. It is an assembly which challenges what is given by the mere fact of its coming together.

State authorities usually lie about the number of demonstrators involved. The lie, however, makes little difference. (It would only make a significant difference if demonstrations really were an appeal to the democratic conscience of the state.) The importance of the numbers involved is to be found in the direct experience of those taking part in or sympathetically witnessing the demonstration. For them the numbers cease to be numbers and become the evidence of their senses, the

conclusions of their imagination. The larger the demonstration, the more powerful and immediate (visible, audible, tangible) a metaphor it becomes for their total collective strength.

I say metaphor because the strength thus grasped transcends the potential strength of those present, and certainly their actual strength as deployed in a demonstration. The more people are there, the more forcibly they represent to each other and to themselves those who are absent. In this way a mass demonstration simultaneously *extends* and *gives body* to an abstraction. Those who take part become more positively aware of how they belong to a class. Belonging to that class ceases to imply a common fate, and implies a common opportunity. They begin to recognize that the function of their class need no longer be limited; that it, too, like the demonstration itself, can create its own function.

Revolutionary awareness is rehearsed in another way by the choice and effect of location. Demonstrations are essentially urban in character, and they are usually planned to take place as near as possible to some symbolic centre, either civic or national. Their 'targets' are seldom the strategic ones – railway stations, barracks, radio stations, airports. A mass demonstration can be interpreted as the symbolic capturing of a city or capital. Again, the symbolism or metaphor is for the benefit of the participants.

The demonstration, an irregular event created by the demonstrators, nevertheless takes place near the city centre, intended for very different uses. The demonstrators interrupt the regular life of the streets they march through or of the open spaces they fill. They 'cut off' these areas, and, not yet having the power to occupy them permanently, they transform them into a temporary stage on which they dramatize the power they still lack.

The demonstrators' view of the city surrounding their stage also changes. By demonstrating, they manifest a greater freedom and in-dependence – greater creativity, even although the product is only symbolic – than they can ever achieve individually or collectively when pursuing their regular lives. In their regular pursuits they only modify circumstances; by demonstrating they symbolically oppose their very existence to circumstances.

This creativity may be desperate in origin, and the price to be paid for it high, but it temporarily changes their outlook. They become corpo-rately aware that it is they or those whom they represent who have built the city and who maintain it. They see it through different eyes. They see it as their product, confirming their potential instead of reducing it.

Finally, there is another way in which revolutionary awareness is rehearsed. The demonstrators present themselves as a target to the so-called forces of law and order. Yet the larger the target they present, the stronger they feel. This cannot be explained by the banal principle of

'strength in numbers', any more than by vulgar theories of crowd psychology. The contradiction between their actual vulnerability and their sense of invincibility corresponds to the dilemma which they force upon the state authority.

Either authority must abdicate and allow the crowd to do as it wishes: in which case the symbolic suddenly becomes real, and, even if the crowd's lack of organization and preparedness prevents it from consolidating its victory, the event demonstrates the weakness of authority. Or else authority must constrain and disperse the crowd with violence: in which case the undemocratic character of such authority is publicly displayed. The imposed dilemma is between displayed weakness and displayed authoritarianism. (The officially approved and controlled demonstration does not impose the same dilemma: its symbolism is censored: which is why I term it a mere public spectacle.)

Almost invariably, authority chooses to use force. The extent of its violence depends upon many factors, but scarcely ever upon the scale of the physical threat offered by the demonstrators. This threat is essentially symbolic. But by attacking the demonstration authority ensures that the symbolic event becomes an historical one: an event to be remembered, to be learnt from, to be avenged.

It is in the nature of a demonstration to provoke violence upon itself. Its provocation may also be violent. But in the end it is bound to suffer more than it inflicts. This is a tactical truth and an historical one. The historical role of demonstrations is to show the injustice, cruelty, irrationality of the existing state authority. Demonstrations are protests of innocence.

But the innocence is of two kinds, which can only be treated as though they were one at a symbolic level. For the purposes of political analysis and the planning of revolutionary action, they must be separated. There is an innocence to be defended and an innocence which must finally be lost: an innocence which derives from justice, and an innocence which is the consequence of a lack of experience.

Demonstrations express political ambitions before the political means necessary to realize them have been created. Demonstrations predict the realization of their own ambitions and thus may contribute to that realization, but they cannot themselves achieve them.

The question which revolutionaries must decide in any given historical situation is whether or not further symbolic rehearsals are necessary. The next stage is training in tactics and strategy for the performance itself.

1968

The Booker Prize Speech

Speech on Accepting the Booker Prize
for Fiction at the Café Royal
in London on 23 November 1972

Since you have awarded me this prize, you may like to know, briefly, what it means to me.

The competitiveness of prizes I find distasteful. And in the case of this prize the publication of the shortlist, the deliberately publicised suspense, the speculation of the writers concerned as though they were horses, the whole emphasis on winners and losers is false and out of place in the context of literature.

Nevertheless prizes act as a stimulus – not to writers themselves but to publishers, readers and booksellers. And so the basic cultural value of a prize depends upon what it is a stimulus to. To the conformity of the market and the consensus of average opinion; or to imaginative independence on the part of both reader and writer. If a prize only stimulates conformity, it merely underwrites success as it is conventionally understood. It constitutes no more than another chapter in a success story. If it stimulates imaginative independence, it encourages the will to seek alternatives. Or, to put it very simply, it encourages people to question.

The reason why the novel is so important is that the novel asks questions which no other literary form can ask: questions about the individual working on his own destiny; questions about the uses to which one can put a life – including one's own. And it poses these questions in a very private way. The novelist's voice functions like an inner voice.

Although it may seem somewhat inappropriate on my part, I would like to salute – and to thank – this year's jury for their independence and seriousness in this respect. All four books on their shortlist demonstrate the kind of imaginative non-conformity I'm talking about. That they gave a prize to my book gave me pleasure – because it represented a response, a response from other writers.

G took five years to write. Since then I have been planning the next five years of my life. I have begun a project about the migrant workers of

Europe. I do not know what form the final book will take. Perhaps a novel. Perhaps a book that fits no category. What I do know is that I want some of the voices of the eleven million migrant workers in Europe and of the forty or so million that are their families, mostly left behind in towns and villages but dependent on the wages of the absent workers, to speak through and on the pages of this book. Poverty forces the migrants, year after year, to leave their own places and culture and come to do much of the dirtiest and worst-paid work in the industrialised areas of Europe, where they form the reserve army of labour. What is their view of the world? Of themselves? Of us? Of their own exploitation?

For this project it will be necessary to travel and stay in many places. I will need sometimes to take Turkish friends with me who speak Turkish, or Portuguese friends, or Greek. I want to work again with a photographer, Jean Mohr, with whom I made the book about the country doctor. Even if we live modestly as we ought to and travel in the cheapest way possible, the project of four years will cost about ten thousand pounds. I did not know exactly how we would find this money. I did not have any of it myself. Now the award of the Booker Prize would make it possible to begin.

Yet one does not have to be a novelist seeking very subtle connections to trace the five thousand pounds of this prize back to the economic activities from which they came. Booker McConnell have had extensive trading interests in the Caribbean for over 130 years. The modern poverty of the Caribbean is the direct result of this and similar exploitation. One of the consequences of this Caribbean poverty is that hundreds of thousands of West Indians have been forced to come to Britain as migrant workers. Thus my book about migrant workers would be financed from the profits made directly out of them or their relatives and ancestors.

More than that, however, is involved. The industrial revolution and the inventions and culture which accompanied it and which created modern Europe was initially financed by profits from the slave trade. And the fundamental nature of the relationship between Europe and the rest of the world, between black and white, has not changed. In *G* the statue of the four chained Moors is the most important single image of the book. This is why I have to turn this prize against itself. And I propose to do so by sharing it in a particular way. The half I give away will change the half I keep.

First let me make the logic of my position really clear. It is not a question of guilt or bad conscience. It certainly is not a question of philanthropy. It is not even, first and foremost, a question of politics. It is a question of my continuing development as a writer: the issue is between me and the culture which has formed me.

Before the slave trade began, before the European de-humanised

himself, before he clenched himself on his own violence, there must have been a moment when black and white approached each other with the amazement of potential equals. The moment passed. And henceforth the world was divided between potential slaves and potential slavemasters. And the European carried this mentality back into his own society. It became part of his way of seeing everything.

The novelist is concerned with the interaction between individual and historical destiny. The historical destiny of our time is becoming clear. The oppressed are breaking through the wall of silence which was built into their minds by their oppressors. And in their struggle against exploitation and neo-colonialism – but only through and by virtue of this common struggle – it is possible for the descendants of the slave and the slavemaster to approach each other again with the amazed hope of potential equals.

This is why I intend to share the prize with those West Indians in and from the Caribbean who are fighting to put an end to their exploitation. The London-based Black Panther movement has arisen out of the bones of what Bookers and other companies have created in the Caribbean; I want to share this prize with the Black Panther movement because they resist both as black people and workers the further exploitation of the oppressed. And because, through their Black People's Information Centre, they have links with the struggle in Guyana, the seat of Booker McConnell's wealth, in Trinidad and throughout the Caribbean: the struggle whose aim is to expropriate all such enterprises.

You know as well as I do that the amount of money involved – as soon as one stops thinking of it as a literary prize – is extremely small. I badly need more money for my project about the migrant workers of Europe. The Black Panther movement badly needs money for their newspaper and for their other activities. But the sharing of the prize signifies that our aims are the same. And by that recognition a great deal is clarified. And in the end – as well as in the beginning – clarity is more important than money.

1972

From *About Looking*

Why Look at Animals?

For Gilles Aillaud

The 19th century, in western Europe and North America, saw the beginning of a process, today being completed by 20th-century corporate capitalism, by which every tradition which has previously mediated between man and nature was broken. Before this rupture, animals constituted the first circle of what surrounded man. Perhaps that already suggests too great a distance. They were with man at the centre of his world. Such centrality was of course economic and productive. Whatever the changes in productive means and social organisation, men depended upon animals for food, work, transport, clothing.

Yet to suppose that animals first entered the human imagination as meat or leather or horn is to project a 19th-century attitude backwards across the millennia. Animals first entered the imagination as messengers and promises. For example, the domestication of cattle did not begin as a simple prospect of milk and meat. Cattle had magical functions, sometimes oracular, sometimes sacrificial. And the choice of a given species as magical, tameable *and* alimentary was originally determined by the habits, proximity and 'invitation' of the animal in question.

> White ox good is my mother
> And we the people of my sister,
> The people of Nyariau Bul . . .
> Friend, great ox of the spreading horns,
> which ever bellows amid the herd,
> Ox of the son of Bul Maloa.
> (*The Nuer: a description of the modes of livelihood and political institutions of a Nilotic people,* by Evans-Pritchard.)

Animals are born, are sentient and are mortal. In these things they resemble man. In their superficial anatomy – less in their deep anatomy

– in their habits, in their time, in their physical capacities, they differ from man. They are both like and unlike.

> 'We know what animals do and what beaver and bears and salmon and other creatures need, because once our men were married to them and they acquired this knowledge from their animal wives.' (Hawaiian Indians quoted by Lévi-Strauss in *The Savage Mind.*)

The eyes of an animal when they consider a man are attentive and wary. The same animal may well look at other species in the same way. He does not reserve a special look for man. But by no other species except man will the animal's look be recognised as familiar. Other animals are held by the look. Man becomes aware of himself returning the look.

The animal scrutinises him across a narrow abyss of non-comprehension. This is why the man can surprise the animal. Yet the animal – even if domesticated – can also surprise the man. The man too is looking across a similar, but not identical, abyss of non-comprehension. And this is so wherever he looks. He is always looking across ignorance and fear. And so, when he is *being seen* by the animal, he is being seen as his surroundings are seen by him. His recognition of this is what makes the look of the animal familiar. And yet the animal is distinct, and can never be confused with man. Thus, a power is ascribed to the animal, comparable with human power but never coinciding with it. The animal has secrets which, unlike the secrets of caves, mountains, seas, are specifically addressed to man.

The relation may become clearer by comparing the look of an animal with the look of another man. Between two men the two abysses are, in principle, bridged by language. Even if the encounter is hostile and no words are used (even if the two speak different languages), the *existence* of language allows that at least one of them, if not both mutually, is confirmed by the other. Language allows men to reckon with each other as with themselves. (In the confirmation made possible by language, human ignorance and fear may also be confirmed. Whereas in animals fear is a response to signal, in men it is endemic.)

No animal confirms man, either positively or negatively. The animal can be killed and eaten so that its energy is added to that which the hunter already possesses. The animal can be tamed so that it supplies and works for the peasant. But always its lack of common language, its silence, guarantees its distance, its distinctness, its exclusion, from and of man.

Just because of this distinctness, however, an animal's life, never to be confused with a man's, can be seen to run parallel to his. Only in death do the two parallel lines converge and after death, perhaps, cross over to become parallel again: hence the widespread belief in the transmigration of souls.

With their parallel lives, animals offer man a companionship which is different from any offered by human exchange. Different because it is a companionship offered to the loneliness of man as a species.

Such an unspeaking companionship was felt to be so equal that often one finds the conviction that it was man who lacked the capacity to speak with animals – hence the stories and legends of exceptional beings, like Orpheus, who could talk with animals in their own language.

What were the secrets of the animal's likeness with, and unlikeness from, man? The secrets whose existence man recognised as soon as he intercepted an animal's look.

In one sense the whole of anthropology, concerned with the passage from nature to culture, is an answer to that question. But there is also a general answer. All the secrets were about animals as an *intercession* between man and his origin. Darwin's evolutionary theory, indelibly stamped as it is with the marks of the European 19th century, never-theless belongs to a tradition, almost as old as man himself. Animals interceded between man and their origin because they were both like and unlike man.

Animals came from over the horizon. They belonged *there* and *here.* Likewise they were mortal and immortal. An animal's blood flowed like human blood, but its species was undying and each lion was Lion, each ox was Ox. This – maybe the first existential dualism – was reflected in the treatment of animals. They were subjected *and* worshipped, bred *and* sacrificed.

Today the vestiges of this dualism remain among those who live intimately with, and depend upon, animals. A peasant becomes fond of his pig and is glad to salt away its pork. What is significant, and is so difficult for the urban stranger to understand, is that the two statements in that sentence are connected by an *and* and not by a *but.*

The parallelism of their similar/dissimilar lives allowed animals to provoke some of the first questions and offer answers. The first subject matter for painting was animal. Probably the first paint was animal blood. Prior to that, it is not unreasonable to suppose that the first metaphor was animal. Rousseau, in his *Essay on the Origins of Languages*, maintained that language itself began with metaphor: 'As emotions were the first motives which induced man to speak, his first utterances were tropes (metaphors). Figurative language was the first to be born, proper meanings were the last to be found.'

If the first metaphor was animal, it was because the essential relation between man and animal was metaphoric. Within that relation what the two terms – man and animal – shared in common revealed what differentiated them. And vice versa.

In his book on totemism, Lévi-Strauss comments on Rousseau's reasoning: 'It is because man originally felt himself identical to all those

like him (among which, as Rousseau explicitly says, we must include animals) that he came to acquire the capacity to distinguish *himself* as he distinguishes *them* – ie, to use the diversity of species for conceptual support for social differentiation.'

To accept Rousseau's explanation of the origins of language is, of course, to beg certain questions (what was the minimal social organisation necessary for the break-through of language?). Yet no search for origin can ever be fully satisfied. The intercession of animals in that search was so common precisely because animals remain ambiguous.

All theories of ultimate origin are only ways of better defining what followed. Those who disagree with Rousseau are contesting a view of man, not a historical fact. What we are trying to define, because the experience is almost lost, is the universal use of animal-signs for charting the experience of the world.

Animals were seen in eight out of twelve signs of the zodiac. Among the Greeks, the sign of each of the twelve hours of the day was an animal. (The first a cat, the last a crocodile.) The Hindus envisaged the earth being carried on the back of an elephant and the elephant on a tortoise. For the Nuer of the southern Sudan (see Roy Willis's *Man and Beast*), 'all creatures, including man, originally lived together in fellowship in one camp. Dissension began after Fox persuaded Mongoose to throw a club into Elephant's face. A quarrel ensued and the animals separated; each went its own way and began to live as they now are, and to kill each other. Stomach, which at first lived a life of its own in the bush, entered into man so that now he is always hungry. The sexual organs, which had also been separate, attached themselves to men and women, causing them to desire one another constantly. Elephant taught man how to pound millet so that now he satisfies his hunger only by ceaseless labour. Mouse taught man to beget and women to bear. And Dog brought fire to man.'

The examples are endless. Everywhere animals offered explanations, or, more precisely, lent their name or character to a quality, which like all qualities was, in its essence, mysterious.

What distinguished man from animals was the human capacity for symbolic thought, the capacity which was inseparable from the development of language in which words were not mere signals, but signifiers of something other than themselves. Yet the first symbols were animals. What distinguished men from animals was born of their relationship with them.

The *Iliad* is one of the earliest texts available to us, and in it the use of metaphor still reveals the proximity of man and animal, the proximity from which metaphor itself arose. Homer describes the death of a soldier on the battlefield and then the death of a horse. Both deaths are equally transparent to Homer's eyes, there is no more refraction in one case than the other.

'Meanwhile, Idomeneus struck Erymas on the mouth with his relent-less bronze. The metal point of the spear passed right through the lower part of his skull, under the brain and smashed the white bones. His teeth were shattered; both his eyes were filled with blood; and he spurted blood through his nostrils and his gaping mouth. Then the black cloud of Death descended on him.' That was a man.

Three pages further on, it is a horse who falls: 'Sarpedon, casting second with his shining spear, missed Patroclus but struck his horse Pedasus on the right shoulder. The horse whinnied in the throes of Death, then fell down in the dust and with a great sigh gave up his life.' That was animal.

Book 17 of the *Iliad* opens with Menelaus standing over the corpse of Patroclus to prevent the Trojans stripping it. Here Homer uses animals as metaphoric references, to convey, with irony or admiration, the excessive or superlative qualities of different moments. *Without the example of animals* such moments would have remained indescribable. 'Menelaus bestrode his body like a fretful mother cow standing over the first calf she has brought into the world.'

A Trojan threatens him, and ironically Menelaus shouts out to Zeus: 'Have you ever seen such arrogance? We know the courage of the panther and the lion and the fierce wild-boar, the most high-spirited and self-reliant beast of all, but that, it seems, is nothing to the prowess of these sons of Panthous . . .!'

Menelaus then kills the Trojan who threatened him, and nobody dares approach him. 'He was like a mountain lion who believes in his own strength and pounces on the finest heifer in a grazing herd. He breaks her neck with his powerful jaws, and then he tears her to pieces and devours her blood and entrails, while all around him the herdsmen and their dogs create a din but keep their distance – they are heartily scared of him and nothing would induce them to close in.'

Centuries after Homer, Aristotle, in his *History of Animals*, the first major scientific work on the subject, systematises the comparative rela-tion of man and animal.

In the great majority of animals there are traces of physical qualities and attitudes, which qualities are more markedly differentiated in the case of human beings. For just as we pointed out resemblances in the physical organs, so in a number of animals we observe gentleness and fierceness, mildness or cross-temper, courage or timidity, fear or confidence, high spirits or low cunning, and, with regard to intelli-gence, something akin to sagacity. Some of these qualities in man, as compared with the corresponding qualities in animals, differ only quantitatively: that is to say, man has more or less of this quality, and an animal has more or less of some other; other qualities in man are

represented by analogous and not identical qualities; for example, just as in man we find knowledge, wisdom and sagacity, so in certain animals there exists some other natural potentiality akin to these. The truth of this statement will be the more clearly apprehended if we have regard to the phenomena of childhood: for in children we observe the traces and seeds of what will one day be settled psychological habits, though psychologically a child hardly differs for the time being from an animal . . .

To most modern 'educated' readers, this passage, I think, will seem noble but too anthropomorphic. Gentleness, cross-temper, sagacity, they would argue, are not moral qualities which can be ascribed to animals. And the behaviourists would support this objection.

Until the 19th century, however, anthropomorphism was integral to the relation between man and animal and was an expression of their proximity. Anthropomorphism was the residue of the continuous use of animal metaphor. In the last two centuries, animals have gradually disappeared. Today we live without them. And in this new solitude, anthropomorphism makes us doubly uneasy.

The decisive theoretical break came with Descartes. Descartes internalised, *within man*, the dualism implicit in the human relation to animals. In dividing absolutely body from soul, he bequeathed the body to the laws of physics and mechanics, and, since animals were soulless, the animal was reduced to the model of a machine.

The consequences of Descartes's break followed only slowly. A century later, the great zoologist Buffon, although accepting and using the model of the machine in order to classify animals and their capacities, nevertheless displays a tenderness towards animals which temporarily reinstates them as companions. This tenderness is half envious.

What man has to do in order to transcend the animal, to transcend the mechanical within himself, and what his unique spirituality leads to, is often anguish. And so, by comparison and despite the model of the machine, the animal seems to him to enjoy a kind of innocence. The animal has been emptied of experience and secrets, and this new invented 'innocence' begins to provoke in man a kind of nostalgia. For the first time, animals are placed in a *receding* past. Buffon, writing on the beaver, says this:

To the same degree as man has raised himself above the state of nature, animals have fallen below it: conquered and turned into slaves, or treated as rebels and scattered by force, their societies have faded away, their industry has become unproductive, their tentative arts have disappeared; each species has lost its general qualities, all of them retaining only their distinct capacities, developed in some by example,

imitation, education, and in others, by fear and necessity during the constant watch for survival. What visions and plans can these soulless slaves have, these relics of the past without power?

Only vestiges of their once marvellous industry remain in far deserted places, unknown to man for centuries, where each species freely used its natural capacities and perfected them in peace within a lasting community. The beavers are perhaps the only remaining example, the last monument to that animal intelligence . . .

Although such nostalgia towards animals was an 18th-century invention, countless *productive* inventions were still necessary – the railway, electricity, the conveyor belt, the canning industry, the motor car, chemical fertilisers – before animals could be marginalised.

During the 20th century, the internal combustion engine displaced draught animals in streets and factories. Cities, growing at an ever increasing rate, transformed the surrounding countryside into suburbs where field animals, wild or domesticated, became rare. The commercial exploitation of certain species (bison, tigers, reindeer) has rendered them almost extinct. Such wild life as remains is increasingly confined to national parks and game reserves.

Eventually, Descartes's model was surpassed. In the first stages of the industrial revolution, animals were used as machines. As also were children. Later, in the so-called post-industrial societies, they are treated as raw material. Animals required for food are processed like manufactured commodities.

Another giant [plant], now under development in North Carolina, will cover a total of 150,000 hectares but will employ only 1,000 people, one for every 15 hectares. Grains will be sown, nurtured and harvested by machines, including airplanes. They will be fed to the 50,000 cattle and hogs . . . those animals will never touch the ground. They will be bred, suckled and fed to maturity in specially designed pens. (Susan George's *How the Other Half Dies.*)

This reduction of the animal, which has a theoretical as well as economic history, is part of the same process as that by which men have been reduced to isolated productive and consuming units. Indeed, during this period an approach to animals often prefigured an approach to man. The mechanical view of the animal's work capacity was later applied to that of workers. F. W. Taylor who developed the 'Taylorism' of time-motion studies and 'scientific' management of industry proposed that work must be 'so stupid' and so phlegmatic that he (the worker) 'more nearly resembles in his mental make-up the ox than any other type'. Nearly all modern techniques of social conditioning were first estab-

lished with animal experiments. As were also the methods of so-called intelligence testing. Today behaviourists like Skinner imprison the very concept of man within the limits of what they conclude from their artificial tests with animals.

Is there not one way in which animals, instead of disappearing, continue to multiply? Never have there been so many household pets as are to be found today in the cities of the richest countries. In the United States, it is estimated that there are at least forty million dogs, forty million cats, fifteen million cage birds and ten million other pets.

In the past, families of all classes kept domestic animals because they served a useful purpose – guard dogs, hunting dogs, mice-killing cats, and so on. The practice of keeping animals regardless of their usefulness, the keeping, exactly, of *pets* (in the 16th century the word usually referred to a lamb raised by hand) is a modern innovation, and, on the social scale on which it exists today, is unique. It is part of that universal but personal withdrawal into the private small family unit, decorated or furnished with mementoes from the outside world, which is such a distinguishing feature of consumer societies.

The small family living unit lacks space, earth, other animals, seasons, natural temperatures, and so on. The pet is either sterilised or sexually isolated, extremely limited in its exercise, deprived of almost all other animal contact, and fed with artificial foods. This is the material process which lies behind the truism that pets come to resemble their masters or mistresses. They are creatures of their owner's way of life.

Equally important is the way the average owner regards his pet. (Children are, briefly, somewhat different.) The pet *completes* him, offering responses to aspects of his character which would otherwise remain unconfirmed. He can be to his pet what he is not to anybody or anything else. Furthermore, the pet can be conditioned to react as though it, too, recognises this. The pet offers its owner a mirror to a part that is otherwise never reflected. But, since in this relationship the autonomy of both parties has been lost (the owner has become the-special-man-he-is-only-to-his-pet, and the animal has become dependent on its owner for every physical need), the parallelism of their separate lives has been destroyed.

The cultural marginalisation of animals is, of course, a more complex process than their physical marginalisation. The animals of the mind cannot be so easily dispersed. Sayings, dreams, games, stories, super-stitions, the language itself, recall them. The animals of the mind, instead of being dispersed, have been co-opted into other categories so that the category *animal* has lost its central importance. Mostly they have been co-opted into the *family* and into the *spectacle.*

Those co-opted into the family somewhat resemble pets. But having no physical needs or limitations as pets do, they can be totally transformed

into human puppets. The books and drawings of Beatrix Potter are an early example; all the animal productions of the Disney industry are a more recent and extreme one. In such works the pettiness of current social practices is *universalised* by being projected on to the animal kingdom. The following dialogue between Donald Duck and his nephews is eloquent enough.

> DONALD: Man, what a day! What a perfect day for fishing, boating, dating or picnicking – only I can't do *any* of these things!
> NEPHEW: Why not, Unca Donald? What's holding you back?
> DONALD: The Bread of Life boys! As usual, I'm broke and its eons till payday.
> NEPHEW: You could take a walk Unca Donald – go bird-watching.
> DONALD: (groan!) I may *have to*! But first, I'll wait for the mailman. He may bring something good newswise!
> NEPHEW: Like a cheque from an unknown relative in Moneyville?

Their physical features apart, these animals have been absorbed into the so-called silent majority.

The animals transformed into spectacle have disappeared in another way. In the windows of bookshops at Christmas, a third of the volumes on display are animal picture books. Baby owls or giraffes, the camera fixes them in a domain which, although entirely visible to the camera, will never be entered by the spectator. All animals appear like fish seen through the plate glass of an aquarium. The reasons for this are both technical and ideological: Technically the devices used to obtain ever more arresting images – hidden cameras, telescopic lenses, flashlights, remote controls and so on – combine to produce pictures which carry with them numerous indications of their normal *invisibility*. The images exist thanks only to the existence of a technical clairvoyance.

A recent, very well-produced book of animal photographs (*La Fête Sauvage* by Frédéric Rossif) announces in its preface: 'Each of these pictures lasted in real time less than three hundredths of a second, they are far beyond the capacity of the human eye. What we see here is something never before seen, because it is totally invisible.'

In the accompanying ideology, animals are always the observed. The fact that they can observe us has lost all significance. They are the objects of our ever-extending knowledge. What we know about them is an index of our power, and thus an index of what separates us from them. The more we know, the further away they are.

Yet in the same ideology, as Lukacs points out in *History and Class Consciousness*, nature is also a value concept. A value opposed to the social institutions which strip man of his natural essence and imprison him. 'Nature thereby acquires the meaning of what has grown organically,

what was not created by man, in contrast to the artificial structures of human civilisation. At the same time, it can be understood as that aspect of human inwardness which has remained natural, or at least tends or longs to become natural once more.' According to this view of nature, the life of a wild animal becomes an ideal, an ideal internalised as a feeling surrounding a repressed desire. The image of a wild animal becomes the starting-point of a daydream: a point from which the day-dreamer departs with his back turned.

The degree of confusion involved is illustrated by the following news story: 'London housewife Barbara Carter won a "grant a wish" charity contest, and said she wanted to kiss and cuddle a lion. Wednesday night she was in a hospital in shock and with throat wounds. Mrs Carter, 46, was taken to the lions' compound of the safari park at Bewdley, Wednesday. As she bent forward to stroke the lioness, Suki, it pounced and dragged her to the ground. Wardens later said, "We seem to have made a bad error of judgment. We have always regarded the lioness as perfectly safe." '

The treatment of animals in 19th-century romantic painting was already an acknowledgement of their impending disappearance. The images are of animals *receding* into a wildness that existed only in the imagination. There was, however, one 19th-century artist who was obsessed by the transformation about to take place, and whose work was an uncanny illustration of it. Grandville published his *Public and Private Life of Animals* in instalments between 1840 and 1842.

At first sight, Grandville's animals, dressed up and performing as men and women, appear to belong to the old tradition, whereby a person is portrayed as an animal so as to reveal more clearly an aspect of his or her character. The device was like putting on a mask, but its function was to unmask. The animal represents the apogee of the character trait in question: the lion, absolute courage: the hare, lechery. The animal once lived near the origin of the quality. It was through the animal that the quality first became recognisable. And so the animal lends it his name.

But as one goes on looking at Grandville's engravings, one becomes aware that the shock which they convey derives, in fact, from the opposite movement to that which one first assumed. These animals are not being 'borrowed' to explain people, nothing is being unmasked; on the contrary. These animals have become prisoners of a human/social situation into which they have been press-ganged. The vulture as landlord is more dreadfully rapacious than he is as a bird. The crocodiles at dinner are greedier at the table than they are in the river.

Here animals are not being used as reminders of origin, or as moral metaphors, they are being used *en masse* to 'people' situations. The movement that ends with the banality of Disney began as a disturbing, prophetic dream in the work of Grandville.

The dogs in Grandville's engraving of the dog-pound are in no way canine; they have dogsfaces, but what they are suffering is imprisonment *like men.*

The bear is a good father shows a bear dejectedly pulling a pram like any other human bread-winner. Grandville's first volume ends with the words 'Goodnight then, dear reader. Go home, lock your cage well, sleep tight and have pleasant dreams. Until tomorrow.' Animals and populace are becoming synonymous, which is to say the animals are fading away.

A later Grandville drawing, entitled *The animals entering the steam ark*, is explicit. In the Judaeo-Christian tradition, Noah's Ark was the first ordered assembly of animals and man. The assembly is now over. Grandville shows us the great departure. On a quayside a long queue of different species is filing slowly away, their backs towards us. Their postures suggest all the last-minute doubts of emigrants. In the distance is a ramp by which the first have already entered the 19th-century ark, which is like an American steamboat. The bear. The lion. The donkey. The camel. The cock. The fox. Exeunt.

'About 1867,' according to the *London Zoo Guide*, 'a music hall artist called the Great Vance sang a song called *Walking in the zoo is the OK thing to do*, and the word "zoo" came into everyday use. London Zoo also brought the word "Jumbo" into the English language. Jumbo was an African elephant of mammoth size, who lived at the zoo between 1865 and 1882. Queen Victoria took an interest in him and eventually he ended his days as the star of the famous Barnum circus which travelled through America – his name living on to describe things of giant proportions.'

Public zoos came into existence at the beginning of the period which was to see the disappearance of animals from daily life. The zoo to which people go to meet animals, to observe them, to see them, is, in fact, a monument to the impossibility of such encounters. Modern zoos are an epitaph to a relationship which was as old as man. They are not seen as such because the wrong questions have been addressed to zoos.

When they were founded – the London Zoo in 1828, the Jardin des Plantes in 1793, the Berlin Zoo in 1844 – they brought considerable prestige to the national capitals. The prestige was not so different from that which had accrued to the private royal menageries. These menageries, along with gold plate, architecture, orchestras, players, furnishings, dwarfs, acrobats, uniforms, horses, art and food, had been demonstrations of an emperor's or king's power and wealth. Likewise in the 19th century, public zoos were an endorsement of modern colonial power. The capturing of the animals was a symbolic representation of the conquest of all distant and exotic lands. 'Explorers' proved their patriotism by sending home a tiger or an elephant. The gift of an

exotic animal to the metropolitan zoo became a token in subservient diplomatic relations.

Yet, like every other 19th-century public institution, the zoo, however supportive of the ideology of imperialism, had to claim an independent and civic function. The claim was that it was another kind of museum, whose purpose was to further knowledge and public enlightenment. And so the first questions asked of zoos belonged to natural history; it was then thought possible to study the natural life of animals even in such unnatural conditions. A century later, more sophisticated zoologists such as Konrad Lorenz asked behaviouristic and ethological questions, the claimed purpose of which was to discover more about the springs of human action through the study of animals under experimental conditions.

Meanwhile, millions visited the zoos each year out of a curiosity which was both so large, so vague and so personal that it is hard to express in a single question. Today in France 22 million people visit the 200 zoos each year. A high proportion of the visitors were and are children.

Children in the industrialised world are surrounded by animal imagery: toys, cartoons, pictures, decorations of every sort. No other source of imagery can begin to compete with that of animals. The apparently spontaneous interest that children have in animals might lead one to suppose that this has always been the case. Certainly some of the earliest toys (when toys were unknown to the vast majority of the population) were animal. Equally, children's games, all over the world, include real or pretended animals. Yet it was not until the 19th century that reproductions of animals became a regular part of the decor of middle-class childhoods – and then, in this century, with the advent of vast display and selling systems like Disney's – of all childhoods.

In the preceding centuries, the proportion of toys which were animal was small. And these did not pretend to realism, but were symbolic. The difference was that between a traditional hobby horse and a rocking horse: the first was merely a stick with a rudimentary head which children rode like a broom handle: the second was an elaborate 'reproduction' of a horse, painted realistically, with real reins of leather, a real mane of hair, and designed movement to resemble that of a horse galloping. The rocking horse was a 19th-century invention.

This new demand for verisimilitude in animal toys led to different methods of manufacture. The first stuffed animals were produced, and the most expensive were covered with real animal skin – usually the skin of still-born calves. The same period saw the appearance of soft animals – bears, tigers, rabbits – such as children take to bed with them. Thus the manufacture of realistic animal toys coincides, more or less, with the establishment of public zoos.

The family visit to the zoo is often a more sentimental occasion than a

visit to a fair or a football match. Adults take children to the zoo to show them the originals of their 'reproductions', and also perhaps in the hope of re-finding some of the innocence of that reproduced animal world which they remember from their own childhood.

The animals seldom live up to the adults' memories, whilst to the children they appear, for the most part, unexpectedly lethargic and dull. (As frequent as the calls of animals in a zoo are the cries of children demanding: Where is he? Why doesn't he move? Is he dead?) And so one might summarise the felt, but not necessarily expressed, question of most visitors as: Why are these animals less than I believed?

And this unprofessional, unexpressed question is the one worth answering.

A zoo is a place where as many species and varieties of animal as possible are collected in order that they can be seen, observed, studied. In principle, each cage is a frame round the animal inside it. Visitors visit the zoo to look at animals. They proceed from cage to cage, not unlike visitors in an art gallery who stop in front of one painting, and then move on to the next or the one after next. Yet in the zoo the view is always wrong. Like an image out of focus. One is so accustomed to this that one scarcely notices it any more; or, rather, the apology habitually anticipates the disappointment, so that the latter is not felt. And the apology runs like this: What do you expect? It's not a dead object you have come to look at, it's alive. It's leading its own life. Why should this coincide with its being properly visible? Yet the reasoning of this apology is inadequate. The truth is more startling.

However you look at these animals, even if the animal is up against the bars, less than a foot from you, looking outwards in the public direction, *you are looking at something that has been rendered absolutely marginal;* and all the concentration you can muster will never be enough to centralise it. Why is this?

Within limits, the animals are free, but both they themselves, and their spectators, presume on their close confinement. The visibility through the glass, the spaces between the bars, or the empty air above the moat, are not what they seem – if they were, then everything would be changed. Thus visibility, space, air, have been reduced to tokens.

The decor, accepting these elements as tokens, sometimes reproduces them to create pure illusion – as in the case of painted prairies or painted rock pools at the back of the boxes for small animals. Sometimes it merely adds further tokens to suggest something of the animal's original landscape – the dead branches of a tree for monkeys, artificial rocks for bears, pebbles and shallow water for crocodiles. These added tokens serve two distinct purposes: for the spectator they are like theatre props: for the animal they constitute the bare minimum of an environment in which they can physically exist.

The animals, isolated from each other and without interaction between species, have become utterly dependent upon their keepers. Consequently most of their responses have been changed. What was central to their interest has been replaced by a passive waiting for a series of arbitrary outside interventions. The events they perceive occurring around them have become as illusory in terms of their natural responses as the painted prairies. At the same time this very isolation (usually) guarantees their longevity as specimens and facilitates their taxonomic arrangement.

All this is what makes them marginal. The space which they inhabit is artificial. Hence their tendency to bundle towards the edge of it. (Beyond its edges there may be real space.) In some cages the light is equally artificial. In all cases the environment is illusory. Nothing surrounds them except their own lethargy or hyperactivity. They have nothing to act upon – except, briefly, supplied food and – very occasionally – a supplied mate. (Hence their perennial actions become marginal actions without an object.) Lastly, their dependence and isolation have so conditioned their responses that they treat any event which takes place around them – usually it is in front of them, where the public is – as marginal. (Hence their assumption of an otherwise exclusively human attitude – indifference.)

Zoos, realistic animal toys and the widespread commercial diffusion of animal imagery, all began as animals started to be withdrawn from daily life. One could suppose that such innovations were compensatory. Yet in reality the innovations themselves belonged to the same remorseless movement as was dispersing the animals. The zoos, with their theatrical decor for display, were in fact demonstrations of how animals had been rendered absolutely marginal. The realistic toys increased the demand for the new animal puppet: the urban pet. The reproduction of animals in images – as their biological reproduction in birth becomes a rarer and rarer sight – was competitively forced to make animals ever more exotic and remote.

Everywhere animals disappear. In zoos they constitute the living monument to their own disappearance. And in doing so, they provoked their last metaphor. *The Naked Ape, The Human Zoo*, are titles of world bestsellers. In these books the zoologist, Desmond Morris, proposes that the unnatural behaviour of animals in captivity can help us to understand, accept and overcome the stresses involved in living in consumer societies.

All sites of enforced marginalisation – ghettos, shanty towns, prisons, madhouses, concentration camps – have something in common with zoos. But it is both too easy and too evasive to use the zoo as a symbol. The zoo is a demonstration of the relations between man and animals; nothing else. The marginalisation of animals is today being followed by

the marginalisation and disposal of the only class who, throughout history, has remained familiar with animals and maintained the wisdom which accompanies that familiarity: the middle and small peasant. The basis of this wisdom is an acceptance of the dualism at the very origin of the relation between man and animal. The rejection of this dualism is probably an important factor in opening the way to modern totalitarianism. But I do not wish to go beyond the limits of that unprofessional, unexpressed but fundamental question asked of the zoo.

The zoo cannot but disappoint. The public purpose of zoos is to offer visitors the opportunity of looking at animals. Yet nowhere in a zoo can a stranger encounter the look of an animal. At the most, the animal's gaze flickers and passes on. They look sideways. They look blindly beyond. They scan mechanically. They have been immunised to encounter, because nothing can any more occupy a *central* place in their attention.

Therein lies the ultimate consequence of their marginalisation. That look between animal and man, which may have played a crucial role in the development of human society, and with which, in any case, all men had always lived until less than a century ago, has been extinguished. Looking at each animal, the unaccompanied zoo visitor is alone. As for the crowds, they belong to a species which has at last been isolated.

This historic loss, to which zoos are a monument, is now irredeemable for the culture of capitalism.

1977

The Suit and the Photograph

What did August Sander tell his sitters before he took their pictures? And how did he say it so that they all believed him in the same way?

They each look at the camera with the same expression in their eyes. Insofar as there are differences, these are the results of the sitter's experience and character – the priest has lived a different life from the paper-hanger; but to all of them Sander's camera represents the same thing.

Did he simply say that their photographs were going to be a recorded part of history? And did he refer to history in such a way that their vanity and shyness dropped away, so that they looked into the lens telling themselves, using a strange historical tense: *I looked like this.* We cannot know. We simply have to recognise the uniqueness of his work, which he planned with the overall title of 'Man of the 20th Century'.

His full aim was to find, around Cologne in the area in which he was born in 1876, archetypes to represent every possible type, social class, sub-class, job, vocation, privilège. He hoped to take, in all, 600 portraits. His project was cut short by Hitler's Third Reich.

His son Erich, a socialist and anti-Nazi, was sent to a concentration camp where he died. The father hid his archives in the countryside. What remains today is an extraordinary social and human document. No other photographer, taking portraits of his own countrymen, has ever been so translucently documentary.

Walter Benjamin wrote in 1931 about Sander's work:

> It was not as a scholar, advised by race theorists or social researchers, that the author [Sander] undertook his enormous task, but, in the publisher's words, 'as the result of immediate observation.' It is indeed unprejudiced observation, bold and at the same time delicate, very much in the spirit of Goethe's remark: 'There is a delicate form of the

empirical which identifies itself so intimately with its object that it thereby becomes theory.' Accordingly it is quite proper that an observer like Döblin should light upon precisely the scientific aspects of this opus and point out: 'Just as there is a comparative anatomy which enables one to understand the nature and history of organs, so here the photographer has produced a comparative photography, thereby gaining a scientific standpoint which places him beyond the photographer of detail.' It would be lamentable if economic circumstances prevented the further publication of this extraordinary corpus . . . Sander's work is more than a picture book, it is an atlas of instruction.

In the inquiring spirit of Benjamin's remarks I want to examine Sander's well-known photograph of three young peasants on the road in the evening, going to a dance. There is as much descriptive information in this image as in pages by a descriptive master like Zola. Yet I only want to consider one thing: their suits.

The date is 1914. The three young men belong, at the very most, to the second generation who ever wore such suits in the European country-side. Twenty or 30 years earlier, such clothes did not exist at a price which peasants could afford. Among the young today, formal dark suits have become rare in the villages of at least western Europe. But for most of this century most peasants – and most workers – wore dark three-piece suits on ceremonial occasions, Sundays and fêtes.

When I go to a funeral in the village where I live, the men of my age and older are still wearing them. Of course there have been modifications of fashion: the width of trousers and lapels, the length of jackets change. Yet the physical character of the suit and its message does not change.

Let us first consider its physical character. Or, more precisely, its physical character when worn by village peasants. And to make generalisation more convincing, let us look at a second photograph of a village band.

Sander took this group portrait in 1913, yet it could well have been the band at the dance for which the three with their walking sticks are setting out along the road. Now make an experiment. Block out the faces of the band with a piece of paper, and consider only their clothed bodies.

By no stretch of the imagination can you believe that these bodies belong to the middle or ruling class. They might belong to workers, rather than peasants; but otherwise there is no doubt. Nor is the clue their hands – as it would be if you could touch them. Then why is their class so apparent?

Is it a question of fashion and the quality of the cloth of their suits? In real life such details would be telling. In a small black and white

photograph they are not very evident. Yet the static photograph shows, perhaps more vividly than in life, the fundamental reason why the suits, far from disguising the social class of those who wore them, underlined and emphasised it.

Their suits deform them. Wearing them, they look as though they were physically mis-shapen. A past style in clothes often looks absurd until it is re-incorporated into fashion. Indeed the economic logic of fashion depends on making the old-fashioned look absurd. But here we are not faced primarily with that kind of absurdity; here the clothes look less absurd, less 'abnormal' than the men's bodies which are in them.

The musicians give the impression of being uncoordinated, bandy-legged, barrel-chested, low-arsed, twisted or scalene. The violinist on the right is made to look almost like a dwarf. None of their abnormalities is extreme. They do not provoke pity. They are just sufficient to undermine physical dignity. We look at bodies which appear coarse, clumsy, brute-like. And incorrigibly so.

Now make the experiment the other way round. Cover the bodies of the band and look only at their faces. They are country faces. Nobody could suppose that they are a group of barristers or managing directors. They are five men from a village who like to make music and do so with a certain self-respect. As we look at the faces we can imagine what the bodies would look like. And what we imagine is quite different from what we have just seen. In imagination we see them as their parents might remember them when absent. We accord them the normal dignity they have.

To make the point clearer, let us now consider an image where tailored clothes, instead of deforming, *preserve* the physical identity and therefore the natural authority of those wearing them. I have deliberately chosen a Sander photograph which looks old-fashioned and could easily lend itself to parody: the photograph of four Protestant missionaries in 1931.

Despite the portentousness, it is not even necessary to make the experiment of blocking out the faces. It is clear that here the suits actually confirm and enhance the physical presence of those wearing them. The clothes convey the same message as the faces and as the history of the bodies they hide. Suits, experience, social formation and function coincide.

Look back now at the three on the road to the dance. Their hands look too big, their bodies too thin, their legs too short. (They use their walking sticks as though they were driving cattle.) We can make the same experiment with the faces and the effect is exactly the same as with the band. They can wear only their hats as if they suited them.

Where does this lead us? Simply to the conclusion that peasants can't buy good suits and don't know how to wear them? No, what is at issue

here is a graphic, if small, example (perhaps one of the most graphic which exists) of what Gramsci called class hegemony. Let us look at the contradictions involved more closely.

Most peasants, if not suffering from malnutrition, are physically strong and well-developed. Well-developed because of the very varied hard physical work they do. It would be too simple to make a list of physical characteristics – broad hands through working with them from a very early age, broad shoulders relative to the body through the habit of carrying, and so on. In fact many variations and exceptions also exist. One can, however, speak of a characteristic physical rhythm which most peasants, both women and men, acquire.

This rhythm is directly related to the energy demanded by the amount of work which has to be done in a day, and is reflected in typical physical movements and stance. It is an extended sweeping rhythm. Not necessarily slow. The traditional acts of scything or sawing may exemplify it. The way peasants ride horses makes it distinctive, as also the way they walk, as if testing the earth with each stride. In addition peasants possess a special physical dignity: this is determined by a kind of functionalism, a way of being *fully at home in effort.*

The suit, as we know it today, developed in Europe as a professional ruling-class costume in the last third of the 19th century. Almost anonymous as a uniform, it was the first ruling-class costume to idealise purely *sedentary* power. The power of the administrator and conference table. Essentially the suit was made for the gestures of talking and calculating abstractly. (As distinct, compared to previous upper-class costumes, from the gestures of riding, hunting, dancing, duelling.)

It was the English *gentleman,* with all the apparent restraint which that new stereotype implied, who launched the suit. It was a costume which inhibited vigorous action, and which action ruffled, uncreased and spoilt. 'Horses sweat, men perspire and women glow.' By the turn of the century, and increasingly after the first world war, the suit was massproduced for mass urban and rural markets.

The physical contradiction is obvious. Bodies which are fully at home in effort, bodies which are used to extended sweeping movement: clothes idealising the sedentary, the discrete, the effortless. I would be the last to argue for a return to traditional peasant costumes. Any such return is bound to be escapist, for these costumes were a form of capital handed down through generations, and in the world today, in which every corner is dominated by the market, such a principle is anachronistic.

We can note, however, how traditional peasant working or ceremonial clothes respected the specific character of the bodies they were clothing. They were in general loose, and only tight in places where they were gathered to allow for freer movement. They were the antithesis of

tailored clothes, clothes cut to follow the idealised shape of a more or less stationary body and then to hang from it!

Yet nobody forced peasants to buy suits, and the three on their way to the dance are clearly proud of them. They wear them with a kind of panache. This is exactly why the suit might become a classic and easily taught example of class hegemony.

Villagers – and, in a different way, city workers – were persuaded to choose suits. By publicity. By pictures. By the new mass media. By salesmen. By example. By the sight of new kinds of travellers. And also by political developments of accommodation and state central organisation. For example: in 1900, on the occasion of the great Universal Exhibition, all the mayors of France were, for the first time ever, invited to a banquet in Paris. Most of them were the peasant mayors of village communes. Nearly 30,000 came! And, naturally, for the occasion the vast majority wore suits.

The working classes – but peasants were simpler and more naïve about it than workers – came to accept as *their own* certain standards of the class that ruled over them – in this case standards of chic and sartorial worthiness. At the same time their very acceptance of these standards, their very conforming to these norms which had nothing to do with either their own inheritance or their daily experience, condemned them, within the system of those standards, to being always, and recognisably to the classes above them, second-rate, clumsy, uncouth, defensive. That indeed is to succumb to a cultural hegemony.

Perhaps one can nevertheless propose that when the three arrived and had drunk a beer or two, and had eyed the girls (whose clothes had not yet changed so drastically), they hung up their jackets, took off their ties, and danced, maybe wearing their hats, until the morning and the next day's work.

1979

Photographs of Agony

The news from Vietnam did not make big headlines in the papers this morning. It was simply reported that the American air force is systematically pursuing its policy of bombing the north. Yesterday there were 270 raids.

Behind this report there is an accumulation of other information. The day before yesterday the American air force launched the heaviest raids of this month. So far more bombs have been dropped this month than during any other comparable period. Among the bombs being dropped are the seven-ton superbombs, each of which flattens an area of approximately 8,000 square metres. Along with the large bombs, various kinds of small antipersonnel bombs are being dropped. One kind is full of plastic barbs which, having ripped through the flesh and embedded themselves in the body, cannot be located by x-ray. Another is called the Spider: a small bomb like a grenade with almost invisible 30-centimetre-long antennae, which, if touched, act as detonators. These bombs, distributed over the ground where larger explosions have taken place, are designed to blow up survivors who run to put out the fires already burning, or go to help those already wounded.

There are no pictures from Vietnam in the papers today. But there is a photograph taken by Donald McCullin in Hue in 1968 which could have been printed with the reports this morning. (See *The Destruction Business* by Donald McCullin, London, 1972.) It shows an old man squatting with a child in his arms, both of them are bleeding profusely with the black blood of black-and-white photographs.

In the last year or so, it has become normal for certain mass-circulation newspapers to publish war photographs which earlier would have been suppressed as being too shocking. One might explain this development by arguing that these newspapers have come to realise that a large section of their readers are now aware of the horrors of war and want to

be shown the truth. Alternatively, one might argue that these newspapers believe that their readers have become inured to violent images and so now compete in terms of ever more violent sensationalism.

The first argument is too idealistic and the second too transparently cynical. Newspapers now carry violent war photographs because their effect, except in rare cases, is not what it was once presumed to be. A paper like the *Sunday Times* continues to publish shocking photographs about Vietnam or about Northern Ireland whilst politically supporting the policies responsible for the violence. This is why we have to ask: What effect do such photographs have?

Many people would argue that such photographs remind us shockingly of the reality, the lived reality, behind the abstractions of political theory, casualty statistics or news bulletins. Such photographs, they might go on to say, are printed on the black curtain which is drawn across what we choose to forget or refuse to know. According to them, McCullin serves as an eye we cannot shut. Yet what is it that they make us see?

They bring us up short. The most literal adjective that could be applied to them is *arresting*. We are seized by them. (I am aware that there are people who pass them over, but about them there is nothing to say.) As we look at them, the moment of the other's suffering engulfs us. We are filled with either despair or indignation. Despair takes on some of the other's suffering to no purpose. Indignation demands action. We try to emerge from the moment of the photograph back into our lives. As we do so, the contrast is such that the resumption of our lives appears to be a hopelessly inadequate response to what we have just seen.

McCullin's most typical photographs record sudden moments of agony – a terror, a wounding, a death, a cry of grief. These moments are in reality utterly discontinuous with normal time. It is the knowledge that such moments are probable and the anticipation of them that makes 'time' in the front line unlike all other experiences of time. The camera which isolates a moment of agony isolates no more violently than the experience of that moment isolates itself. The word *trigger*, applied to rifle and camera, reflects a correspondence which does not stop at the purely mechanical. The image seized by the camera is doubly violent and both violences reinforce the same contrast: the contrast between the photographed moment and all others.

As we emerge from the photographed moment back into our lives, we do not realise this; we assume that the discontinuity is our responsibility. The truth is that any response to that photographed moment is bound to be felt as inadequate. Those who are there in the situation being photographed, those who hold the hand of the dying or staunch a wound, are not seeing the moment as we have and their responses are of an altogether different order. It is not possible for anyone to look pensively at such a moment and to emerge stronger. McCullin, whose

'contemplation' is both dangerous and active, writes bitterly underneath a photograph: 'I only use the camera like I use a toothbrush. It does the job.'

The possible contradictions of the war photograph now become apparent. It is generally assumed that its purpose is to awaken concern. The most extreme examples – as in most of McCullin's work – show moments of agony in order to extort the maximum concern. Such moments, whether photographed or not, are discontinuous with all other moments. They exist by themselves. But the reader who has been arrested by the photograph may tend to feel this discontinuity as his own personal moral inadequacy. *And as soon as this happens even his sense of shock is dispersed*: his own moral inadequacy may now shock him as much as the crimes being committed in the war. Either he shrugs off this sense of inadequacy as being only too familiar, or else he thinks of performing a kind of penance – of which the purest example would be to make a contribution to OXFAM or to UNICEF.

In both cases, the issue of the war which has caused that moment is effectively depoliticised. The picture becomes evidence of the general human condition. It accuses nobody and everybody.

Confrontation with a photographed moment of agony can mask a far more extensive and urgent confrontation. Usually the wars which we are shown are being fought directly or indirectly in 'our' name. What we are shown horrifies us. The next step should be for us to confront our own lack of political freedom. In the political systems as they exist, we have no legal opportunity of effectively influencing the conduct of wars waged in our name. To realise this and to act accordingly is the only effective way of responding to what the photograph shows. Yet the double violence of the photographed moment actually works against this realisation. That is why they can be published with impunity.

1972

Paul Strand

There is a widespread assumption that if one is interested in the visual, one's interest must be limited to a technique of somehow *treating* the visual. Thus the visual is divided into categories of special interest: painting, photography, real appearances, dreams and so on. And what is forgotten – like all essential questions in a positivist culture – is the meaning and enigma of visibility itself.

I think of this now because I want to describe what I can see in two books which are in front of me. They are two volumes of a retrospective monograph on the work of Paul Strand. The first photographs date from 1915, when Strand was a sort of pupil of Alfred Stieglitz; the most recent ones were taken in 1968.

The earliest works deal mostly with people and sites in New York. The first of them shows a half-blind beggar woman. One of her eyes is opaque, the other sharp and wary. Round her neck she wears a label with BLIND printed on it. It is an image with a clear social message. But it is something else, too. We shall see later that in all Strand's best photographs of people, he presents us with the visible evidence, not just of their presence, but of their *life*. At one level, such evidence of a life is social comment – Strand has consistently taken a left political position – but, at a different level, such evidence serves to suggest visually the totality of another lived life, from within which we ourselves are no more than a sight. This is why the black letters B-L-I-N-D on a white label do more than spell the word. While the picture remains in front of us, we can never take them as read. The earliest image in the book forces us to reflect on the significance of seeing itself.

The next section of photographs, from the 1920s, includes photographs of machine parts and close-ups of various natural forms – roots, rocks and grasses. Already Strand's technical perfectionism and strong aesthetic interests are apparent. But equally his obstinate, resolute

respect for the thing-in-itself is also apparent. And the result is often disconcerting. Some would say that these photographs fail, for they remain details of what they have been taken from: they never become independent images. Nature, in these photographs, is intransigent to art, and the machine-details mock the stillness of their perfectly rendered images.

From the 1930s onwards, the photographs fall typically into groups associated with journeys that Strand made: to Mexico, New England, France, Italy, the Hebrides, Egypt, Ghana, Rumania. These are the photographs for which Strand has become well-known, and it is on the evidence of these photographs that he should be considered a great photographer. With these black-and-white photographs, with these records which are distributable anywhere, he offers us the sight of a number of places and people in such a way that our view of the world can be qualitatively extended.

The social approach of Strand's photography to reality might be called documentary or neo-realist in so far as its obvious cinematic equivalent is to be found in the prewar films of Flaherty or the immediate postwar Italian films of de Sica or Rossellini. This means that on his travels Strand avoids the picturesque, the panoramic, and tries to find a city in a street, the way of life of a nation in the corner of a kitchen. In one or two pictures of power dams and some 'heroic' portraits he gives way to the romanticism of Soviet socialist realism. But mostly his approach lets him choose ordinary subjects which in their ordinariness are extraordinarily representative.

He has an infallible eye for the quintessential: whether it is to be found on a Mexican doorstep, or in the way that an Italian village schoolgirl in a black pinafore holds her straw hat. Such photographs enter so deeply into the particular that they reveal to us the stream of a culture or a history which is flowing through that particular subject like blood. The images of these photographs, once seen, subsist in our mind until some actual incident, which we witness or live, refers to one of them as though to a more solid reality. But it is not this which makes Strand as a photographer unique.

His method as a photographer is more unusual. One could say that it was the antithesis to Henri Cartier-Bresson's. The photographic moment for Cartier-Bresson is an instant, a fraction of a second, and he stalks that instant as though it were a wild animal. The photographic moment for Strand is a biographical or historic moment, whose duration is ideally measured not by seconds but by its relation to a lifetime. Strand does not pursue an instant, but encourages a moment to arise as one might encourage a story to be told.

In practical terms this means that he decides what he wants before he takes the picture, never plays with the accidental, works slowly, hardly

ever crops a picture, often still uses a plate camera, formally asks people to pose for him. His pictures are all remarkable for their intentionality. His portraits are very frontal. The subject is looking at us; we are looking at the subject; it has been arranged like that. But there is a similar sense of frontality in many of his other pictures of landscapes or objects or buildings. His camera is not free-roving. He chooses where to place it.

Where he has chosen to place it is not where something is about to happen, but where a number of happenings will be related. Thus, without any use of anecdote, he turns his subjects into narrators. The river narrates itself. The field where the horses are grazing recounts itself. The wife tells the story of her marriage. In each case Strand, the photographer, has chosen the place to put his camera as listener.

The approach: neo-realist. The method: deliberate, frontal, formal, with every surface thoroughly scanned. What is the result?

His best photographs are unusually dense – not in the sense of being over-burdened or obscure, but in the sense of being filled with an unusual amount of substance per square inch. And all this substance becomes the stuff of the life of the subject. Take the famous portrait of Mr Bennett from Vermont, New England. His jacket, his shirt, the stubble on his chin, the timber of the house behind, the air around him become in this image the face of his life, of which his actual facial expression is the concentrated spirit. It is the whole photograph, frowning, which surveys us.

A Mexican woman sits against a wall. She has a woollen shawl over her head and shoulders and a broken plaited basket on her lap. Her skirt is patched and the wall behind her very shabby. The only fresh surface in the picture is that of her face. Once again, the surfaces we read with our eyes become the actual chafing texture of her daily life; once again the photograph is a panel of her being. At first sight the image is soberly materialist, but just as her body wears through her clothes and the load in the basket wears away the basket, and passers-by have rubbed off the surface of the wall, so her being as a woman (her own existence for herself) begins, as one goes on looking at the picture, to rub through the materialism of the image.

A young Rumanian peasant and his wife lean against a wooden fence. Above and behind them, diffused in the light, is a field and, above that, a small modern house, totally insignificant as architecture, and the grey silhouette of a nondescript tree beside it. Here it is not the substantiality of surfaces which fills every square inch but a Slav sense of distance, a sense of plains or hills that continue indefinitely. And, once more, it is impossible to separate this quality from the presence of the two figures; it is there in the angle of his hat, the long extended movement of his arms, the flowers embroidered on her waistcoat, the way her hair is tied up; it is there across the width

of their wide faces and mouths. What informs the whole photograph – space – is part of the skin of their lives.

These photographs depend upon Strand's technical skill, his ability to select, his knowledge of the places he visits, his eye, his sense of timing, his use of the camera; but he might have all these talents and still not be capable of producing such pictures. What has finally determined his success in his photographs of people and in his landscapes – which are only extensions of people who happen to be invisible – is his ability to invite the narrative: to present himself to his subject in such a way that the subject is willing to say: *I am as you see me.*

This is more complicated than it may seem. The present tense of the verb *to be* refers only to the present; but nevertheless, with the first person singular in front of it, it absorbs the past which is inseparable from the pronoun. *I am* includes all that has made me so. It is more than a statement of immediate fact: it is already an explanation, a justification, a demand – it is already autobiographical. Strand's photographs suggest his sitters trust him to *see* their life story. And it is for this reason that, although the portraits are formal and posed, there is no need, either on the part of photographer or photograph, for the disguise of a borrowed role.

Photography, because it preserves the appearance of an event or a person, has always been closely associated with the idea of the historical. The ideal of photography, aesthetics apart, is to seize an 'historic' moment. But Paul Strand's relation as a photographer to the historic is a unique one. His photographs convey a unique sense of duration. The *I am* is given its time in which to reflect on the past and to anticipate its future: the exposure time does no violence to the time of the *I am*: on the contrary, one has the strange impression that the exposure time *is* the lifetime.

1972

Uses of Photography

For Susan Sontag

I want to write down some of my responses to Susan Sontag's book *On Photography*. All the quotations I will use are from her text. The thoughts are sometimes my own, but all originate in the experience of reading her book.

The camera was invented by Fox Talbot in 1839. Within a mere 30 years of its invention as a gadget for an elite, photography was being used for police filing, war reporting, military reconnaissance, pornography, encyclopedic documentation, family albums, postcards, anthropological records (often, as with the Indians in the United States, accompanied by genocide), sentimental moralising, inquisitive probing (the wrongly named 'candid camera'), aesthetic effects, news reporting and formal portraiture. The first cheap popular camera was put on the market, a little later, in 1888. The speed with which the possible uses of photography were seized upon is surely an indication of photography's profound, central applicability to industrial capitalism. Marx came of age the year of the camera's invention.

It was not, however, until the 20th century and the period between the two world wars that the photograph became the dominant and most 'natural' way of referring to appearances. It was then that it replaced the world as immediate testimony. It was the period when photography was thought of as being most transparent, offering direct access to the real: the period of the great witnessing masters of the medium like Paul Strand and Walker Evans. It was, in the capitalist countries, the freest moment of photography: it had been liberated from the limitations of fine art, and it had become a public medium which could be used democratically.

Yet the moment was brief. The very 'truthfulness' of the new medium encouraged its deliberate use as a means of propaganda. The Nazis were among the first to use systematic photographic propaganda.

Photographs are perhaps the most mysterious of all the objects that make up and thicken the environment we recognise as modern. Photographs really are experience captured, and the camera is the ideal arm of consciousness in its acquisitive mood.

In the first period of its existence photography offered a new technical opportunity; it was an implement. Now, instead of offering new choices, its usage and its 'reading' were becoming habitual, an unexamined part of modern perception itself. Many developments contributed to this transformation. The new film industry. The invention of the lightweight camera – so that the taking of a photograph ceased to be a ritual and became a 'reflex'. The discovery of photojournalism – whereby the text follows the pictures instead of vice versa. The emergence of advertising as a crucial economic force.

Through photographs, the world becomes a series of unrelated, free-standing particles; and history, past and present, a set of anecdotes and *faits divers*. The camera makes reality atomic, manageable, and opaque. It is a view of the world which denies interconnectedness, continuity, but which confers on each moment the character of a mystery.

The first mass-media magazine was started in the United States in 1936. At least two things were prophetic about the launching of *Life*, the prophecies to be fully realised in the postwar television age. The new picture magazine was financed not by its sales, but by the advertising it carried. A third of its images were devoted to publicity. The second prophecy lay in its title. This is ambiguous. It may mean that the pictures inside are about life. Yet it seems to promise more: that these pictures *are* life. The first photograph in the first number played on this ambiguity. It showed a newborn baby. The caption underneath read: 'Life begins . . .'

What served in place of the photograph, before the camera's invention? The expected answer is the engraving, the drawing, the painting. The more revealing answer might be: memory. What photographs do out there in space was previously done within reflection.

'Proust somewhat misconstrues that photographs are not so much an instrument of memory as an invention of it or a replacement.'

Unlike any other visual image, a photograph is not a rendering, an imitation or an interpretation of its subject, but actually a trace of it. No painting or drawing, however naturalist, *belongs* to its subject in the way that a photograph does.

'A photograph is not only an image (as a painting is an image), an interpretation of the real; it is also a trace, something directly stencilled off the real, like a footprint or a death mask.'

Human visual perception is a far more complex and selective process than that by which a film records. Nevertheless the camera lens and the eye both register images – because of their sensitivity to light – at great speed and in the face of an immediate event. What the camera does, however, and what the eye in itself can never do, is to *fix* the appearance of that event. It removes its appearance from the flow of appearances and it preserves it, not perhaps for ever but for as long as the film exists. The essential character of this preservation is not dependent upon the image being static; unedited film rushes preserve in essentially the same way. The camera saves a set of appearances from the otherwise inevitable supercession of further appearances. It holds them unchanging. And before the invention of the camera nothing could do this, except, in the mind's eye, the faculty of memory.

I am not saying that memory is a kind of film. That is a banal simile. From the comparison film/memory we learn nothing about the latter. What we learn is how strange and unprecedented was the procedure of photography.

Yet, unlike memory, photographs do not in themselves preserve meaning. They offer appearances – with all the credibility and gravity we normally lend to appearances – prised away from their meaning. Meaning is the result of understanding functions. 'And functioning takes place in time, and must be explained in time. Only that which narrates can make us understand.' Photographs in themselves do not narrate. Photographs preserve instant appearances. Habit now protects us against the shock involved in such preservation. Compare the exposure time for a film with the life of the print made, and let us assume that the print only lasts ten years: the ratio for an average modern photograph would be approximately 20,000,000,000: 1. Perhaps that can serve as a reminder of the violence of the fission whereby appearances are separated by the camera from their function.

We must now distinguish between two quite distinct uses of photography. There are photographs which belong to private experience and there are those which are used publicly. The private photograph – the portrait of a mother, a picture of a daughter, a group photo of one's own team – is appreciated and read in a context which is continuous with that from which the camera removed it. (The violence of the removal is sometimes felt as incredulousness: 'Was that really Dad?') Nevertheless such a photograph remains surrounded by the meaning from which it was severed. A mechanical device, the camera has been used as an instrument to contribute to a living memory. The photograph is a memento from a life being lived.

The contemporary public photograph usually presents an event, a seized set of appearances, which has nothing to do with us, its readers, or with the original meaning of the event. It offers information, but

information severed from all lived experience. If the public photograph contributes to a memory, it is to the memory of an unknowable and total stranger. The violence is expressed in that strangeness. It records an instant sight about which this stranger has shouted: Look!

Who is the stranger? One might answer: the photographer. Yet if one considers the entire use-system of photographed images, the answer of 'the photographer' is clearly inadequate. Nor can one reply: those who use the photographs. It is because the photographs carry no certain meaning in themselves, because they are like images in the memory of a total stranger, that they lend themselves to any use.

Daumier's famous cartoon of Nadar in his balloon suggests an answer. Nadar is travelling through the sky above Paris – the wind has blown off his hat – and he is photographing with his camera the city and its people below.

Has the camera replaced the eye of God? The decline of religion corresponds with the rise of the photograph. Has the culture of capitalism telescoped God into photography? The transformation would not be as surprising as it may at first seem.

The faculty of memory led men everywhere to ask whether, just as they themselves could preserve certain events from oblivion, there might not be other eyes noting and recording otherwise unwitnessed events. Such eyes they then accredited to their ancestors, to spirits, to gods or to their single deity. What was seen by this supernatural eye was inseparably linked with the principle of justice. It was possible to escape the justice of men, but not this higher justice from which nothing or little could be hidden.

Memory implies a certain act of redemption. What is remembered has been saved from nothingness. What is forgotten has been abandoned. If all events are seen, instantaneously, outside time, by a supernatural eye, the distinction between remembering and forgetting is transformed into an act of judgment, into the rendering of justice, whereby recognition is close to *being remembered*, and condemnation is close to *being forgotten*. Such a presentiment, extracted from man's long, painful experience of time, is to be found in varying forms in almost every culture and religion, and, very clearly, in Christianity.

At first, the secularisation of the capitalist world during the 19th century elided the judgment of God into the judgment of History in the name of Progress. Democracy and Science became the agents of such a judgment. And for a brief moment, photography, as we have seen, was considered to be an aid to these agents. It is still to this historical moment that photography owes its ethical reputation as Truth.

During the second half of the 20th century the judgment of history has been abandoned by all except the under-privileged and dispossessed. The industrialised, 'developed' world, terrified of the past, blind to the

future, lives within an opportunism which has emptied the principle of justice of all credibility. Such opportunism turns everything – nature, history, suffering, other people, catastrophes, sport, sex, politics – into spectacle. And the implement used to do this – until the act becomes so habitual that the conditioned imagination may do it alone – is the camera.

> Our very sense of situation is now articulated by the camera's inter-ventions. The omnipresence of cameras persuasively suggests that time consists of interesting events, events worth photographing. This, in turn, makes it easy to feel that any event, once underway, and whatever its moral character, should be allowed to complete itself – so that something else can be brought into the world, the photograph.

The spectacle creates an eternal present of immediate expectation: memory ceases to be necessary or desirable. With the loss of memory the continuities of meaning and judgement are also lost to us. The camera relieves us of the burden of memory. It surveys us like God, and it surveys for us. Yet no other god has been so cynical, for the camera records in order to forget.

Susan Sontag locates this god very clearly in history. He is the god of monopoly capitalism.

> A capitalist society requires a culture based on images. It needs to furnish vast amounts of entertainment in order to stimulate buying and anaesthetise the injuries of class, race and sex. And it needs to gather unlimited amounts of information, the better to exploit the natural resources, increase productivity, keep order, make war, give jobs to bureaucrats. The camera's twin capacities, to subjectivise reality and to objectify it, ideally serve these needs and strengthen them. Cameras define reality in the two ways essential to the workings of an advanced industrial society: as a spectacle (for masses) and as an object of surveillance (for rulers). The production of images also furnishes a ruling ideology. Social change is replaced by a change in images.

Her theory of the current use of photographs leads one to ask whether photography might serve a different function. Is there an alternative photographic practice? The question should not be answered naively. Today no alternative professional practice (if one thinks of the profes-sion of photographer) is possible. The system can accommodate any photograph. Yet it may be possible to begin to use photographs accord-ing to a practice addressed to an alternative future. This future is a hope which we need now, if we are to maintain a struggle, a resistance, against the societies and culture of capitalism.

Photographs have often been used as a radical weapon in posters, newspapers, pamphlets, and so on. I do not wish to belittle the value of such agitational publishing. Yet the current systematic public use of photography needs to be challenged, not simply by turning round like a cannon and aiming it at different targets, but by changing its practice. How?

We need to return to the distinction I made between the private and public uses of photography. In the private use of photography, the context of the instant recorded is preserved so that the photograph lives in an ongoing continuity. (If you have a photograph of Peter on your wall, you are not likely to forget what Peter means to you.) The public photograph, by contrast, is torn from its context, and becomes a dead object which, exactly because it is dead, lends itself to any arbitrary use.

In the most famous photographic exhibition ever organised, *The Family of Man* (put together by Edward Steichen in 1955), photographs from all over the world were presented as though they formed a universal family album. Steichen's intuition was absolutely correct: the private use of photographs can be exemplary for their public use. Unfortunately the shortcut he took in treating the existing class-divided world as if it were a family inevitably made the whole exhibition, not necessarily each picture, sentimental and complacent. The truth is that most photographs taken of people are about suffering, and most of that suffering is man-made.

> One's first encounter [writes Susan Sontag] with the photographic inventory of ultimate horror is a kind of revelation, the prototypically modern revelation: a negative epiphany. For me, it was photographs of Bergen-Belsen and Dachau which I came across by chance in a bookstore in Santa Monica in July 1945. Nothing I have seen – in photographs or in real life – ever cut me as sharply, deeply, instantaneously. Indeed, it seems plausible to me to divide my life into two parts, before I saw those photographs (I was twelve) and after, though it was several years before I understood fully what they were about.

Photographs are relics of the past, traces of what has happened. If the living take that past upon themselves, if the past becomes an integral part of the process of people making their own history, then all photographs would re-acquire a living context, they would continue to exist in time, instead of being arrested moments. It is just possible that photography is the prophecy of a human memory yet to be socially and politically achieved. Such a memory would encompass any image of the past, however tragic, however guilty, within its own continuity. The distinction between the private and public uses of photography would be transcended. The Family of Man would exist.

Meanwhile we live today in the world as it is. Yet this possible prophecy of photography indicates the direction in which any alternative use of photography needs to develop. The task of an alternative photography is to incorporate photography into social and political memory, instead of using it as a substitute which encourages the atrophy of any such memory.

The task will determine both the kinds of pictures taken and the way they are used. There can of course be no formulae, no prescribed practice. Yet in recognising how photography has come to be used by capitalism, we can define at least some of the principles of an alternative practice.

For the photographer this means thinking of her or himself not so much as a reporter to the rest of the world but, rather, as a recorder for those involved in the events photographed. The distinction is crucial.

What makes these photographs (see *Russian War Photographs 1941–45*. Text by A.J.P. Taylor, London 1978) so tragic and extraordinary is that, looking at them, one is convinced that they were not taken to please generals, to boost the morale of a civilian public, to glorify heroic soldiers or to shock the world press: they were images addressed to those suffering what they depict. And given this integrity towards and with their subject matter, such photographs later became a memorial, to the 20 million Russians killed in the war, for those who mourn them. The unifying horror of a total people's war made such an attitude on the part of the war photographers (and even the censors) a natural one. Photographers, however, can work with a similar attitude in less extreme circumstances.

The alternative use of photographs which already exist leads us back once more to the phenomenon and faculty of memory. The aim must be to construct a context for a photograph, to construct it with words, to construct it with other photographs, to construct it by its place in an ongoing text of photographs and images. How? Normally photographs are used in a very unilinear way – they are used to illustrate an argument, or to demonstrate a thought which goes like this:

Very frequently also they are used tautologically so that the photograph merely repeats what is being said in words. Memory is not unilinear at all. Memory works radially, that is to say with an enormous number of associations all leading to the same event. The diagram is like this:

$$\setminus\ |\ /$$
$$-\quad-$$
$$/\ |\ \setminus$$

If we want to put a photograph back into the context of experience, social experience, social memory, we have to respect the laws of memory.

We have to situate the printed photograph so that it acquires something of the surprising conclusiveness of that which *was* and *is*.

What Brecht wrote about acting in one of his poems is applicable to such a practice. For *instant* one can read photography, for *acting* the re-creating of context:

> So you should simply make the instant
> Stand out, without in the process hiding
> What you are making it stand out from.
> Give your acting
> That progression of one-thing-after-another,
> that attitude of
> Working up what you have taken on. In this way
> You will show the flow of events and also the course
> Of your work, permitting the spectator
> To experience this Now on many levels, coming from
> Previously and
> Merging into Afterwards, also having much else Now
> Alongside it. He is sitting not only
> In your theatre but also
> In the world.

There are a few great photographs which practically achieve this by themselves. But any photograph may become such a 'Now' if an adequate context is created for it. In general the better the photograph, the fuller the context which can be created.

Such a context replaces the photograph in time – not its own original time for that is impossible – but in narrated time. Narrated time becomes historic time when it is assumed by social memory and social action. The constructed narrated time needs to respect the process of memory which it hopes to stimulate.

There is never a single approach to something remembered. The remembered is not like a terminus at the end of a line. Numerous approaches or stimuli converge upon it and lead to it. Words, comparisons, signs need to create a context for a printed photograph in a comparable way; that is to say, they must mark and leave open diverse approaches. A radial system has to be constructed around the photograph so that it may be seen in terms which are simultaneously personal, political, economic, dramatic, everyday and historic.

1978

The Primitive and the Professional

Art-historically the word *primitive* has been used in three different ways: to designate art (before Raphael) on the borderline between the medieval and modern Renaissance traditions; to label the trophies and 'curiosities' taken from the colonies (Africa, Caribbean, South Pacific) when brought back to the imperial metropolis; and lastly to put in its place the art of men and women from the working classes – proletarian, peasant, petit-bourgeois – who did not leave their class by becoming *professional* artists. According to all three usages of the word, originating in the last century when the confidence of the European ruling class was at its height, the superiority of the main European tradition of secular art, serving that same 'civilised' ruling class, was assured.

Most professional artists begin their training when young. Most primitive artists of the third category come to painting or sculpture in middle or even old age. Their art usually derives from considerable personal experience and, indeed, is often provoked as a result of the profundity or intensity of that experience. Yet artistically their art is seen as naïve, that is inexperienced. It is the significance of this contradiction that we need to understand. Does it actually exist, and if so, what does it mean? To talk of the dedication of the primitive artist, his patience and his application amounting to a kind of skill, does not altogether answer the question.

The primitive is defined as the non-professional. The category of the professional artist, as distinct from the master craftsman, was not clear until the 17th century. (And in some places, especially in Eastern Europe, not until the 19th century.) The distinction between profession and craft is at first difficult to make, yet it is of great importance. The craftsman survives so long as the standards for judging his work are shared by different classes. The professional appears when it is necessary

for the craftsman to leave his class and 'emigrate' to the ruling class, whose standards of judgement are different.

The relationship of the professional artist to the class that ruled or aspired to rule was complicated, various and should not be simplified. His training however – and it was his training which made him a professional – taught him a set of conventional skills. That is to say, he became skilled in using a set of conventions. Conventions of composition, drawing, perspective, chiaroscuro, anatomy, poses, symbolism. And these conventions corresponded so closely to the social experience – or anyway to the social manners – of the class he was serving, that they were not even seen as conventions but were thought of as the only way of recording and preserving eternal truths. Yet to the other social classes such professional painting appeared to be so remote from their own experience, that they saw it as a mere social convention, a mere accoutrement of the class that ruled over them: which is why in moments of revolt, painting and sculpture were often destroyed.

During the 19th century certain artists, for consciously social or political reasons, tried to extend the professional tradition of painting, so that it might express the experience of other classes (for example, Millet, Courbet, Van Gogh). Their personal struggles, their failures, and the opposition they met with, were a measure of the enormity of the undertaking. Perhaps one pedestrian example will give some idea of the extent of the difficulties involved. Consider Ford Madox Brown's well-known painting of *Work* in Manchester Art Gallery. It shows a team of navvies, with passers-by and bystanders, working on a sidewalk. It took the painter ten years to complete, and it is, at one level, extremely accurate. But it looks like a religious scene – the Mounting of the Cross, or the Calling of the Disciples? (One searches for the figure of Christ.) Some would argue that this is because the artist's attitude to his subject was ambivalent. I would argue that the *optic* of all the visual means he was using with such care pre-empted the possibility of depicting manual work, as the main subject of a painting, in any but a mythological or symbolic way.

The crisis provoked by those who tried to extend the area of experience to which painting might be open – and by the end of the century this also included the Impressionists – continued into the 20th century. But its terms were reversed. The tradition was indeed dismantled. Yet, except for the introduction of the Unconscious, the area of experience from which most European artists drew remained surprisingly unchanged. Consequently, most of the serious art of the period dealt either with the experience of various kinds of isolation, or with the narrow experience of painting itself. The latter produced painting about painting, abstract art.

One of the reasons why the potential freedom gained by the disman-

tling of the tradition was not used may be to do with the way painters were still trained. In the academies and art schools they first learnt those very conventions which were being dismantled. This was because no other professional body of knowledge existed to be taught. And this is still, more or less, true today. No other professionalism exists.

Recently, corporate capitalism, having grounds to believe itself triumphant, has begun to adopt abstract art. And the adoption is proving easy. Diagrams of aesthetic power lend themselves to becoming emblems of economic power. In the process almost all lived experience has been eliminated from the image. Thus, the extreme of abstract art demonstrates, as an epilogue, the original problematic of professional art: an art in reality concerned with a selective, very reduced area of experience, which nevertheless claims to be universal.

Something like this overview of traditional art (and the overview is of course only partial, there are other things to be said on other occasions) may help us to answer the questions about primitive art.

The first primitive artists appeared during the second half of the 19th century. They appeared after professional art had first questioned its own conventional purposes. The notorious Salon des Refusés was held in 1863. This exhibition was not of course the reason for their appearance. What helped to make their appearance possible were universal primary education (paper, pencils, ink), the spread of popular journalism, a new geographical mobility due to the railways, the stimulus of clearer class consciousness. Perhaps also the example of the *bohemian* professional artist had its effect. The bohemian chose to live in a way which defied normal class divisions, and his life-style, if not his work, tended to suggest that art could come from any class.

Among the first were the Douanier Rousseau (1844–1910) and the Facteur Cheval (1836–1924). These men, when their art eventually became known, were nevertheless designated by their other work – the Customs-Man-Rousseau, the Postman-Cheval. This makes it clear – as does also the term *Sunday painter* – that their 'art' is an eccentricity. They were treated as cultural 'sports', not because of their class origin, but because they refused, or were ignorant of, the fact that all artistic expression has traditionally to undergo a class transformation. In this way they were quite distinct from *amateurs* – most, but not all, of whom came from the cultured classes; amateurs, by definition, followed, with less rigour, the example of the professionals.

The primitive begins alone; he inherits no practice. Because of this the term *primitive* may appear at first to be justified. He does not use the pictorial grammar of the tradition – hence he is ungrammatical. He has not learnt the technical skills which have evolved with the conventions – hence he is clumsy. When he discovers on his own a solution to a pictorial problem, he often uses it many times – hence he is naïve. But

then one has to ask: why does he refuse the tradition? And the answer is only partly that he was born far away from that tradition. The effort necessary to begin painting or sculpting, in the social context in which he finds himself, is so great that it could well include visiting the museums. But it never does, at least at the beginning. Why? Because he knows already that his own lived experience which is forcing him to make art has no place in that tradition. How does he know this without having visited the museums? He knows it because his whole experience is one of being excluded from the exercise of power in his society, and he realises from the compulsion he now feels that art too has a kind of power. The will of primitives derives from faith in their own experience and a profound scepticism about society as they have found it. This is true even of such an amiable artist as Grandma Moses.

I hope I have now made clearer why the 'clumsiness' of primitive art is the precondition of its eloquence. What it is saying could never be said with any ready-made skills. For what it is saying was never meant, according to the cultural class system, to be said.

1976

Millet and the Peasant

Jean-François Millet died in 1875. After his death and until recently, a number of his paintings, particularly *The Angelus, The Sower* and *The Gleaners*, were among the best-known painted images in the world. I doubt whether even today there is a peasant family in France who do not know all three pictures through engravings, cards, ornaments or plates. *The Sower* became both the trademark for a US bank and a symbol of revolution in Peking and Cuba.

As Millet's popular reputation spread, his 'critical' reputation declined. Originally, however, his work had been admired by Seurat, Pissarro, Cézanne, Van Gogh. Commentators talk today of Millet becoming a posthumous victim of his own popularity. The questions raised by Millet's art are more far-reaching and more disturbing than this suggests. A whole tradition of culture is in question.

In 1862 Millet painted *Winter with Crows*. It is nothing but a sky, a distant copse, and a vast deserted plain of inert earth, on which have been left a wooden plough and a harrow. Crows comb the ground whilst waiting, as they will all winter. A painting of the starkest simplicity. Scarcely a landscape but a portrait in November of a plain. The horizontality of that plain claims everything. To cultivate its soil is a continual struggle to encourage the vertical. This struggle, the painting declares, is back-breaking.

Millet's images were reproduced on such a wide scale because they were unique: no other European painter had treated rural labour as the central theme of his art. His life's work was to introduce a new subject into an old tradition, to force a language to speak of what it had ignored. The language was that of oil painting; the subject was the peasant as individual *subject*.

Some may want to contest this claim by citing Breughel and Courbet. In Breughel, peasants form a large part of the crowd which is mankind: Breughel's subject is a collectivity of which the peasantry as a whole is

only a part; no man has yet been condemned in perpetuity to solitary individuality and all men are equal before the last judgement; social station is secondary.

Courbet may have painted *The Stonebreakers* in 1850 under Millet's influence (Millet's first Salon 'success' was with *The Winnower*, exhibited in 1848). But essentially Courbet's imagination was sensuous, concerned with the sources of sense experience rather than with the subject of them. As an artist of peasant origin, Courbet's achievement was to introduce into painting a new kind of substantiality, perceived according to senses developed by habits different from those of the urban bourgeois. The fish as caught by a fisherman, the dog as chosen by a hunter, the trees and snow as what a familiar path leads through, a funeral as a regular village meeting. What Courbet was weakest at painting was the human eye. In his many portraits, the eyes (as distinct from the lids and eye sockets) are almost interchangeable. He refused any insight inwards. This explains why the peasant *as subject* could not be his theme.

Among Millet's paintings are the following experiences; scything, sheep shearing, splitting wood, potato lifting, digging, shepherding, manuring, pruning. Most of the jobs are seasonal, and so their experience includes the experience of a particular kind of weather. The sky behind the couple in *The Angelus* (1859) is typical of the stillness of early autumn. If a shepherd is out at night with his sheep, hoar frost on their wool is as likely as moonlight. Because Millet was inevitably addressing an urban and privileged public, he chose to depict moments which emphasise the harshness of the peasant experience – often a moment of exhaustion. Job and, once again, season determine the expression of this exhaustion. The man with a hoe leans, looking unseeing up at the sky, straightening his back. The haymakers lie prostrate in the shade. The man in the vineyard sits huddled on the parched earth surrounded by green leaves.

So strong was Millet's ambition to introduce previously unpainted experience that sometimes he set himself an impossible task. A woman dropping seed potatoes into a hole scooped out by her husband (the potatoes in mid-air!) may be filmable, but is scarcely paintable. At other times his originality is impressive. A drawing of cattle with a shepherd dissolving into darkness, the scene absorbing dusk like dunked bread absorbs coffee. A painting of earth and bushes, just discernible by starlight, as blanketed masses.

> The universe sleeps
> And its gigantic ear
> Full of ticks
> That are stars
> Is now laid on its paw –
> (Mayakovsky)

Such experiences had never been painted before – not even by Van de Neer, whose night scenes were still delineated as if they were day scenes. (Millet's love of night and half-light is something to come back to.)

What provoked Millet to choose such new subject matter? It is not enough to say that he painted peasants because he came from a peasant family in Normandy and, when young, had worked on the land. Any more than it is correct to assume that the 'biblical' solemnity of his work was the result of his own religious faith. In fact, he was an agnostic.

In 1847, when he was 33, he painted a small picture entitled *Return from the Fields* which shows three nymphs – seen somewhat in the manner of Fragonard – playing on a barrow of hay. A light rustic idyll for a bedroom or private library. It was one year later that he painted coarsely the taut figure of *The Winnower* in the dark of a barn where dust rises from his basket, like the dust of white brass, a sign of the energy with which his whole body is shaking the grain. And two years later, *The Sower* striding downhill, broadcasting his grain, a figure symbolising the bread of life, whose silhouette and inexorability are reminiscent of the figure of death. What inspired the change in Millet's painting after 1847 was the revolution of 1848.

His view of history was too passive and too pessimistic to allow him any strong political convictions. Yet the years of 1848 to 1851, the hopes they raised and suppressed, established for him, as for many others, the claim of democracy: not so much in a parliamentary sense, as in the sense of the rights of man being universally applicable. The artistic style which accompanied this modern claim was realism: realism because it revealed hidden social conditions, realism because (it was believed) all could recognise what it revealed.

After 1847, Millet devoted the remaining 27 years of his life to revealing the living conditions of the French peasantry. Two thirds of the population were peasants. The revolution of 1789 had freed the peasantry from feudal servitude, but by the middle of the 19th century they had become victims of the 'free exchange' of capital. The annual interest the French peasantry had to pay on mortgages and loans was equal to that paid on the entire annual national debt of Britain, the richest country in the world. Most of the public who went to look at paintings in the Salon were ignorant of the penury which existed in the countryside, and one of Millet's conscious aims was 'to disturb them in their contentment and leisure'.

His choice of subject also involved nostalgia. In a double sense. Like many who leave their village, he was nostalgic about his own village childhood. For 20 years he worked on a canvas showing the road to the hamlet where he was born, finishing it two years before he died. Intensely green, sewn together, the shadows as substantially dark as the lights are substantially light, this landscape is like a garment he once

wore (*The Hameau Cousin*). And there is a pastel of a well in front of a house with geese and chickens and a woman, which made an extraordinary impression on me when I first looked at it. It is drawn realistically and yet I saw it as the site of every fairy story which begins with an old woman's cottage. I saw it as a hundred times familiar, although I knew I had not seen it before: the 'memory' was inexplicably in the drawing itself. Later I discovered in Robert L. Herbert's exemplary catalogue to the 1976 exhibition that this scene was what was visible in front of the house where Millet was born, and that consciously or unconsciously the artist had enlarged the proportions of the well by two thirds so that they coincided with his childhood perception.

Millet's nostalgia, however, was not confined to the personal. It permeated his view of history. He was sceptical of the Progress being proclaimed on every side and saw it, rather, as an eventual threat to human dignity. Yet unlike William Morris and other romantic medievalists, he did not sentimentalise the village. Most of what he knew about peasants was that they were reduced to a brutal existence, especially the men. And, however conservative and negative his overall perspective may have been, he sensed, it seems to me, two things which, at the time, few others foresaw: that the poverty of the city and its suburbs, and that the market created by industrialisation, to which the peasantry was being sacrificed, might one day entail the loss of all sense of history. This is why for Millet the peasant came to stand for man, and why he saw his paintings as having an historic function.

The reactions to his paintings were as complex as Millet's own feelings. Straightaway he was labelled a socialist revolutionary. With enthusiasm by the left. With outraged horror by the centre and right. The latter were able to say about his *painted* peasants what they feared but dared not say about the real ones, who were still working on the land, or the five million who were drifting landless towards the cities: *they look like murderers, they are cretins, they are beasts not men, they are degenerate.* Having said these things, they accused Millet of inventing such figures.

Towards the end of the century, when the economic and social stability of capitalism was more assured, his paintings offered other meanings. Reproduced by the church and commerce, they reached the countryside. The pride with which a class first sees itself recognisably depicted in a permanent art is full of pleasure, even if the art is flawed and the truth harsh. The depiction gives an historic resonance to their lives. A pride which was, before, an obstinate refusal of shame becomes an affirmation.

Meanwhile the original Millets were being bought by old millionaires in America who wanted to re-believe that the best things in life are simple and free.

And so how are we to judge this advent of a new subject into an old art? It is necessary to emphasise how conscious Millet was of the tradition he inherited. He worked slowly from drawings, often returning to the same motif. Having chosen the peasant as subject, his life's effort was to do him justice by investing him with dignity and permanence. And this meant joining him to the tradition of Giorgione, Michelangelo, the Dutch 17th century, Poussin, Chardin.

Look at his art chronologically and you see the peasant emerging, quite literally, from the shadows. The shadows are the corner tradition-ally reserved for genre painting – the scene of low life (tavern, servant's quarters), glimpsed in passing, indulgently even enviously, by the tra-veller on the high road where there is space and light. *The Winnower* is still in the genre corner, but enlarged. *The Sower* is a phantom figure, oddly uncompleted as a painting, striding forward to claim a place. Up to about 1856 Millet produced other genre paintings – shepherd girls in the shade of trees, a woman churning butter, a cooper in his workshop. But already in 1853, in *Going to Work*, the couple leaving home for the day's work on the plain – they are modelled on Masaccio's *Adam and Eve* – have moved to the forefront and become the centre of the world assumed by the painting. And from now on, this is true in all of Millet's major works which include figures. Far from presenting these figures as something marginal seen in passing, he does his utmost to make them central and monumental. And all these paintings – in differing degrees – fail.

They fail because no unity is established between figures and sur-roundings. The monumentality of the figures refuses the painting. And vice versa. As a result the cut-out figures look rigid and theatrical. The moment lasts too long. By contrast, the same figures in equivalent drawings or etchings are alive and belong to the moment of drawing which includes all their surroundings. For example, the etching of *Going to Work*, made ten years after the painting, is a very great work, compar-able with the finest etching by Rembrandt.

What prevented Millet achieving his aim as a painter? There are two conventional fallback answers. Most 19th-century sketches were better than finished works. A doubtful art-historical generalisation. Or: Millet was not a born painter!

I believe that he failed because the language of traditional oil painting could not accommodate the subject he brought with him. One can explain this ideologically. The peasant's interest in the *land* expressed through his actions is incommensurate with scenic landscape. Most (not all) European landscape painting was addressed to a visitor from the city, later called a tourist; the landscape is *his* view, the splendour of it is *his* reward. Its paradigm is one of those painted orientation tables which name the visible landmarks. Imagine a peasant suddenly appearing at

work between the table and the view, and the social/human contradiction becomes obvious.

The history of forms reveals the same incompatibility. There were various iconographic formulae for integrating figures and landscape. Distant figures like notes of colour. Portraits to which the landscape is a background. Mythological figures, goddesses and so on, with which nature interweaves to 'dance to the music of time'. Dramatic figures, whose passions nature reflects and illustrates. The visitor or solitary onlooker who surveys the scene, an *alter ego* for the spectator himself. But there was no formula for representing the close, harsh, patient physicality of a peasant's labour *on*, instead of *in front of*, the land. And to invent one would mean destroying the traditional language for depicting scenic landscape.

In fact, only a few years after Millet's death, this is exactly what Van Gogh tried to do. Millet was his chosen master, both spiritually and artistically. He made dozens of paintings copied closely from engravings from Millet. In these paintings Van Gogh united the working figure with his surroundings by the gestures and energy of his own brush strokes. Such energy was released by his intense sense of empathy with the subject.

But the result was to turn the painting into a personal vision, which was characterised by its 'handwriting'. The witness had become more important than his testimony. The way was open to expressionism and, later, to abstract expressionism, and the final destruction of painting as a language of supposedly objective reference. Thus Millet's failure and setback may be seen as an historic turning point. The claim of universal democracy was inadmissible for oil painting. And the consequent crisis of meaning forced most painting to become autobiographical.

Why not inadmissible, too, for drawing and graphic work? A drawing records a visual experience. An oil painting, because of its uniquely large range of tones, textures and colours, pretends to reproduce the visible. The difference is very great. The virtuoso performance of the oil painting assembles all aspects of the visible to conduct them to a single point: the point of view of the empirical onlooker. And it insists that such a view constitutes visibility itself. Graphic work, with its limited means, is more modest; it only claims a single aspect of visual experience, and therefore is adaptable to different uses.

Millet's increasing use of pastel towards the end of his life, his love of half-light in which visibility itself becomes problematic, his fascination with night scenes, suggest that intuitively he may have tried to resist the demand of the privileged onlooker for the world arranged as his view. It would have been in line with Millet's sympathies, for did not the inadmissibility of the peasant as a subject into the European tradition of painting prefigure exactly the absolute conflict of interests which

exists today between first and third worlds? If this is the case, Millet's life's work shows how nothing can resolve this conflict unless the hierarchy of our social and cultural values is radically altered.

1976

Seker Ahmet and the Forest

The painting measures 138 × 177 centimetres. Fairly large. It was painted towards the end of the last century in Istanbul. The artist, Seker Ahmet Pasa (1841–1907), worked for a period in Paris, where he was strongly influenced by Courbet and the Barbizon school, and returned to Turkey to become one of the two leading painters whose work introduced a European optic into Turkish art. The painting is entitled *Woodcutter in the Forest.*

As soon as I looked at it, it began to interest and haunt me. Not really because it might introduce me to the work of a painter I did not know, but in itself, this canvas. After going back to the museum in Besiktas, several times to look at the picture, I began to understand more fully why it interested me. Why it haunts me I only understood later.

The colours, the paint texture, the tonality of the painting, are very reminiscent of a Rousseau, a Courbet, a Diaz. With half a glance you read it like a pre-impressionist European landscape, another look at a forest. Yet there is a gravity in it which checks you. And then this gravity turns out to be a peculiarity. There is something deeply but subtly strange about the perspective, about the relationship between the woodcutter with his mule and the far edge of the forest in the top right-hand corner. You see that it is the *far* edge, and, at the same time, that third distant tree (a beech?) appears nearer than anything else in the painting. It simultaneously withdraws and approaches.

There are reasons for this. I'm not creating mysteries. There is the size of the beech trunk (supposed to be 100 or 150 yards away) relative to the size of the man. The beech leaves are as large as the leaves on the nearest tree. The light falling on the beech trunk brings it forward, whereas the two other dark trunks are both leaning away from you. Most important of all – because every convincing painting makes a spatial system of its own – there is the strange diagonal line of the edge of the receding brushwood

which begins on this side of the bridge and extends up to the edge of the forest. This line, this edge, 'concurs' with the third dimensional space, and yet stays on the surface of the painting. It creates a spatial ambiguity. Block it out for a moment, and you will see the beech move back somewhat into the distance.

Each of these things is, academically speaking, a mistake. More than that, they contradict for any viewer, academically minded or not, the logic of the language with which everything else is painted. In a work of art such inconsistency is not usually impressive – it leads to a lack of conviction. The more so when it is unintentional. And the rest of Seker Ahmet's work, though it does suggest that he may have been unusually spiritually illuminated, does not suggest that he would ever consciously question the visual language he had learnt so hard in Paris.

So I was faced with two questions. Why was the painting so convincing or, if you wish, about *what* was it so convincing? And the second question: how did Seker Ahmet come to paint it in the way he did?

If the far beech tree between the edge of the forest and the far side of the clearing is nearer than anything else in the painting, then you are looking *into* the forest from its far edge, and from this point of view the woodcutter and his mule are what is farthest away. Yet we also see him *in* the forest, dwarfed by the huge trees, about to cart across the clearing his load of wood. Why does such a double vision have so precise an authority about it?

Its precision is existential. It accords with the experience of forest. The attraction and the terror of the forest is that you see yourself *in* it as Jonah was in the whale's belly. Although it has limits, it is closed around you. Now this experience, which is that of anybody familiar with forests, depends upon your seeing yourself in double vision. You make your way through the forest and, simultaneously, you see yourself, as from the outside, swallowed by the forest. What gives this painting its peculiar authority is its faithfulness to the experience of the figure of the woodcutter.

When I wrote about Millet, I suggested that one of the enormous difficulties he faced was that of painting the peasant working on the land instead of *in front of it.* This was because Millet inherited a language of landscape painting which had been developed to speak about the traveller's view of a landscape. The problem is epitomised by the horizon. The traveller/spectator looks towards the horizon: for the working peasant bent over the land, the horizon is either invisible or is the totally surrounding edge of the sky from which the weather comes. The language of European landscape could not give expression to such an experience.

Later the same year an exhibition of Chinese peasant paintings from the Hu county came to London. Out of nearly 80 paintings showing peasants working out of doors only 16 showed the sky or an horizon. Although the paintings, painted by peasants themselves (under some

supervision), were far more matter-of-fact than traditional Chinese landscape painting, the latter offered them a relativity of perspective which could, at least partly, accommodate the spatial experience of peasants working on the land. Some of the pictures failed, offering only a helicopter overview which incorporated, graphically, the view of an overseer! Others succeeded. For example, something true of the experience of minding goats, the least domesticated of the domesticated animals, who wander everywhere and need continual *surveillance*, is present in Pai Tien-hsueh's gouache.

This is why Seker Ahmet's painting of the forest so interested me. There was already a place prepared in my mind for its surprise.

How did he come to paint it in the way he did? At one level the question is unanswerable and we shall never know. But it is possible to guess at the depth at which his imagination was working to reconcile two opposed ways of seeing. Before the influence of European painting, the Turkish pictorial tradition was one of book illustrations and miniatures. Many of the latter were Persian. The traditional pictorial language was one of signs and embellishment: its space was spiritual not physical. Light was not something which crossed emptiness but was, rather, an emanation.

For Seker Ahmet the decision to change from one language to another must have been far more problematic than might at first appear to us. It was not just a question of observing what he saw in the Louvre, for what was involved was a whole view of the world, man and history. He was not changing a technique, but an ontology. Spatial perspective is closely connected with the question of time. The fully articulated system of European landscape perspective such as one finds in Poussin, Claude Lorraine, Ruysdael, Hobbema, only preceded by a decade or two Vico's invention of modern history. The path which led away and vanished on the horizon was also that of unilinear time.

Thus there is a close parallel between pictorial representations of space and the ways in which stories are told. The novel, as Lukács pointed out in *Theory of the Novel*, was born of a yearning for what now lay beyond the horizon: it was the art-form of a sense of homelessness. With this homelessness came an openness of choice (most novels are primarily about choices) such as man had never experienced before. Earlier narrative forms are more two-dimensional, but not for that reason less real. Instead of choice, there is pressing necessity. Each event is unavoidable as soon as it is present. The only choices are about treating, coming to terms with, *what is there*. One can talk about immediacy, but since all events narrated in this way are immediate, the term changes its meaning. Events come into being like the genie of Aladdin's lamp. They are equally irrefutable, expected and unexpected.

In telling the story of the woodcutter, Seker Ahmet found himself facing the forest like the woodcutter. Neither Courbet in painting nor

Turgenev in literature (I think of those two because they are contemporary and they both loved forests) could possibly have faced it in the same way. They would both have *placed* the forest, relating it to the world which was not the forest. Or to say the same thing differently, they would have seen the forest as a *scene* in which significant things took place: a deer dying or a hunter thinking about love.

Seker Ahmet, on the other hand, faced the forest as a thing taking place in itself, as a presence that was so pressing that he could not, as he had learnt to do in Paris, maintain his distance from it. This, I think, is what caused the disjuncture to open between the two traditions: the disjuncture in which this forest painting has its being.

Yet having answered its questions, why should it go on haunting me? Months later, back in Europe, I began to see why. I was reading Heidegger's 'Conversation on a country path about thinking', in his *Discourse on Thinking*:

> TEACHER: . . . what lets the horizon be what it is, has not yet been encountered at all.
> SCIENTIST: What do you have in mind in this statement?
> TEACHER: We say that we look into the horizon. Therefore the field of vision is something open, but its openness is not due to our looking.
> SCHOLAR: Likewise we do not place the appearance of objects, which the view within a field of vision offers us, into this openness . . .
> SCIENTIST: . . . rather that comes out of this to meet us . . .
>
> SCIENTIST: Then thinking would be coming-into-the-nearness of distance.
> SCHOLAR: That is a daring definition of its nature, which we have chanced upon.
> SCIENTIST: I only brought together that which we have named, but without representing anything to myself.
> TEACHER: Yet you have thought something.
> SCIENTIST: Or, really, waited for something without knowing for what.

The quotations from this conversation belong to the years 1944–45 when Heidegger, in his mid-fifties, was seeking more metaphoric and vernacular ways of conveying the significance of the fundamental philosophical question which he had raised in *Being and Time* (1927). The sense of thought as the 'coming-into-the-nearness of distance' is central to that question. (For those unfamiliar with Heidegger's life's work, I would recommend George Steiner's admirable small paperback in the Fontana Modern Masters series.)

Had Heidegger known this Turkish painting I think he would have been tempted to write about it. His father worked as a carpenter and he was born in the Black Forest. Continually he uses the forest as a symbol of

reality. The task of philosophy is to find the *Weg*, the woodcutter's path, through the forest. The path may lead to the *Lichtung*, the clearing whose very space, open to light and vision, is the most surprising thing about existence, and is the very condition of Being. 'The clearing is the open for everything that is present and absent.'

Heidegger would undoubtedly have given weight to the fact that Seker Ahmet had not been brought up in any school of European reasoning. His own philosophical starting point was that post-Socratic European thought from Plato to Kant had only answered the comparatively easy questions. The fundamental question, opened by surprise at the very fact of being, had been closed. An artist from a different culture might feel the question was still open.

Seker Ahmet's painting is about the 'coming-into-the-nearness of distance'. I can think of no other painting of which this is so explicitly true. (Implicitly the later work of Cézanne is very close to Heidegger's vision, which is perhaps why Merleau-Ponty, a follower of Heidegger, understood him so deeply.) In the 'coming-into-the-nearness of distance' there is a reciprocal movement. Thought approaches the distant; but the distant also approaches thought.

For Heidegger the present, the now, is not a measurable unit of time, but the result of presence, of the existent actively presenting itself. In his attempt to bend language to describe this, he turns the word presence into a verb: *presencing*. Tentatively, Novalis prefigured this when he wrote: 'Perceptibility is a kind of attentiveness.'

The woodcutter and his mule are stepping forward. Yet the painting renders them almost static. They are scarcely moving. What is moving – and this is so surprising that one senses it without at first being able to realise it – is the forest. The forest with its presence is moving in the opposite direction to the woodcutter – ie, forward towards us and leftwards. 'Presence means: the constant abiding that approaches man, reaches him, is extended to him.' It is unimportant here how obscure or meaningful one judges Heidegger's contribution to modern thought to be. In relation to this painting his words become apposite and transparent. They reveal the painting, and they reveal why it is haunting. The painting confirms them.

Such a coincidence between a painting of a local 19th-century Turkish painter who studied in Paris and the thoughts of a German professor whom some consider the most important European philosopher of the 20th century is an example of how, at this stage of world history, there are truths which can only be uncovered or, as Heidegger would say, *unconcealed* in the folds between cultures and epochs.

1979

La Tour and Humanism

There is no doubt that Georges de La Tour existed. He was born in Lorraine in 1593 and he died in 1652. He probably painted most – or all – of the pictures that are now accredited to him, as well as others which have been destroyed. Yet the personality and oeuvre of La Tour are, in a sense, a modern creation.

After his death, his work and name was forgotten or ignored for nearly three centuries. In the 1920s and 1930s, one or two French art historians began to be interested in a few works then thought to be by him, an obscure provincial painter. Their interest may have been aroused because of a certain formal similarity between La Tour and the work of the post-Impressionists. In the winter of 1934, eleven of his paintings were included in an exhibition called *Painters of Reality* held at the Orangerie in Paris. They made an immediate and very great impact. After the war, art historians and curators all over the world began searching for new works and for information until, in 1972, they were able to present, at the same Orangerie, 31 pictures considered to be by the master himself and 20 copies or doubtful works.

The genius of La Tour has been reborn in the 20th century. What is the likely relation between the reborn genius and the original one? The question can never be completely answered, yet I am sceptical of the answers which have been assumed. La Tour was not quite what we are making him out to be.

The distortions are partly the result of recent French history. La Tour was rediscovered in the period of the Popular Front and his example was immediately put to use to further the idea of a popular democratic French tradition of culture. After the war, through a large New York exhibition, La Tour was presented to, and accepted by, the outside world as a symbolic figure representing the victorious popular soul of France. Here is a typical quotation from a book written at the time in French:

One might quote many illustrious names through the centuries. Three will suffice. Poussin, Watteau, Delacroix . . . but besides these great artists, for whom painting is a magic interpretation of the most profound thoughts and the most beautiful dreams, there is another kind of artist, apparently less elevated, but who brings no less honour to France. Indeed one of France's greatest claims is to have produced such artists, who do not exist elsewhere. These artists are profoundly modest. They choose to remain very close to nature, and with subjects which elsewhere are despised, or mocked, or made rhetorical, they say something very simple whose originality is scarcely at first discernible. Yet those who have eyes to see and a heart to feel, will come to recognise the nobility of their aspirations: their search for the truth without prejudice, without compromise, driven on by an emotion of sympathy which unites all men.

And so it has continued. The frontispiece of the catalogue of the 1972 exhibition showed a single candle burning in front of a mirror. It burnt with holiness. Reproductions and Christmas cards of La Tour's work persuade the public of a consumer society that what they really aspire to is simplicity and humanist reverence.

Yet how does this accord with the facts of La Tour's life, or the real nature of his work? The facts are scanty but they are worth considering. La Tour was the son of a baker from a peasant family. He was able to marry – perhaps as a result of his evident promise as a painter – the daughter of a small local aristocrat. He went to live and work in her town, Lunéville, where he was highly successful as a painter, earned a lot of money and became one of the richest local landowners. During the thirty years' war which ravaged the countryside, he owed allegiance first to the Duke of Lorraine and later, after the French victory over the Duke, to the King of France. In the municipal records of the town there is a strong hint that he profiteered out of grain during the war famines. In 1646 the populace, in an appeal addressed to their exiled Duke, complained against the arrogance, wealth and unjust privileges of the painter La Tour. Meanwhile the same populace were forced to pay for each of his major paintings, offered as gifts to the French Governor of Nancy. In 1648, a record shows that La Tour paid ten francs damages to a man whom he had beaten up in unknown circumstances. Two years later another record indicates that he had to pay 7.20 francs for the medical care of a peasant whom he had attacked when he found him trespassing on his land.

The bare outline of his life would suggest that La Tour was ambitious, hard-dealing, violent, fairly unscrupulous and successful. One must, however, beware of making unhistorical moral judgements. Many of the land-owning class in that part of France profiteered out of the thirty

years' war. Nor is a great painter obliged to lead an exemplary moral life. Yet nevertheless between La Tour, the detested richest citizen of Lunéville, and La Tour, the painter of simple peasants, beggars, ascetic saints and Magdalenes renouncing the world, there is a certain contradiction.

Ever since his rebirth, La Tour has been labelled a '*Caravaggiste*'. And it is true that his 'popular' subject matter and his use of light suggest the indirect influence of Caravaggio. The spirit of the two painters' work, however, could scarcely be more opposed.

Here, in fact, the example of Caravaggio may illuminate a little the contradiction to which I referred above. Look at Caravaggio's *Death of the Virgin*. Caravaggio was involved in countless brawls and beatings-up. He even killed a man. He lived in the underworld of Rome. He painted those he lived beside. He painted them with his own emotions, he saw his own excesses in their very condition. That is to say: he is in the situation he paints. He lacked any sense of self-preservation, and this so coincided with those he painted – and what he painted – that he lent his own life to his images. In such a context it is impossible to talk of conventional morality. We either walk past the *Death of the Virgin* or we mourn her. That is how little contradiction there is in Caravaggio. By contrast, La Tour is never *in* the situation he paints. He is distanced from it. The distance is the measure of his self-preservation. And within that space moral questions can legitimately arise.

La Tour's early paintings depict poor peasants (sometimes presented as saints), street musicians, beggars, card sharpers and fortune tellers. A painting of a seated old man, half-blind, mouth gaping, arthritic hands on the wooden hurdy-gurdy resting on his lap, is particularly striking. For three reasons: the pain of confrontation with such implied misery; the formal colour harmony of the painting; and the fact that the man's flesh is painted as though it were a substance no different in kind from the leather of his shoes, the stones at his feet or the cloth of his cloak. This 'rejection' of the flesh is more explicit in two paintings of St Jerome, who kneels, nude, his skin like the paper of the bible open before him, a blood-stained scourge of rope in his hand with which he has been chastising himself. Is the detachment of such images holy, or merely unfeeling? Are they the result of confronting the suffering and despair to be seen on every side at that time in Lorraine, or did they serve to make the sight of such suffering easier to accept? The *sight*, not the *experience*, for, as I have emphasised, these images are seen entirely from the exterior; they are like still-lifes.

The other early pictures of card-players and tricksters can perhaps answer this question. Once more the painting is clean and harmonious. Once again, flesh is painted as though it were an insensate material – wax or wood or pastry – the eyes like bits of fruit. But there is no suffering

now. There are simply two games being played. The game of cards (or the game of palm-reading) and, under cover of this, the game of cheating or robbing the rich young man who is fair game. The paintings reveal no psychological insight. The interest of these paintings is schematic – in every sense of that word. There is the formal scheme of the painting. The scheme of the game – its rules, its symbolic language; and finally the scheme of the cheating of the young man, its planning, its sign-language of gestures and looks, its ineluctability.

La Tour, I believe, saw the whole of life as a scheme over which nobody on earth had any control, a scheme revealed in prophecy and the scriptures. Accordingly, the existence of beggars becomes no more than a sign, St Jerome no more than a moral injunction; people are transformed into ciphers. Yet the total faith of the middle ages has gone. Scientific observation has begun. The individuality of the thinker and artist cannot be brushed aside or undone. Consequently the painter cannot simply submit to a God-given iconography. He must invent. Yet if he accepts such a view of the world (the world as unquestionable scheme) the only way he can invent is by imitating God, modestly and piously, within the small domain of his own art. Accepting the world as scheme, he makes his own harmonious visual schemes out of it. Before the world he is helpless *except as a maker of pictures*. The abstract formality of La Tour was consolation for a moral defeat.

La Tour's later works seem to bear out this interpretation. In 1636 the French governor set fire to the town of Lunéville rather than let it fall into the hands of the Duke's troops. The town blazed all night. An eye-witness testified that you could read in the streets by the light of the flames. A month later the French captured the town and sacked it. These incidents were a turning point in La Tour's life. Many of his paintings must have been destroyed, likewise some of his property. When he re-established himself in the town, be began to produce his night pieces, his candlelight pictures, for which, then as now, he became best known.

Most of these night scenes imply a different level – but not a different type – of religious preoccupation. The candlelight disembodies and derationalises. And the frontier between being and non-being, appearance and illusion, consciousness and dream, becomes vague. When there is more than one figure, it is hard to be sure whether each is real or only the dream projection of the other. Every lit form proposes the possibility that it is no more than an apparition. Did I see it? Or did I dream it? If I shut my eyes, it is dark again. La Tour is exorcising his doubts. (Is it not just possible that the painting of St Peter weeping is a self-portrait?) They are pictures like monologues or prayers. They do not discourse with the world directly. And so the problem of the painted person, seen as a mere cipher in God's scheme or the painter's, is

removed – because what we are presented with is no longer the world, but the night of the artist's soul.

Within these limits, three of the night paintings are masterpieces. The Magdalene with a mirror. Here everything has been eliminated except what the scheme of the painting and the scheme of the message (scripture) requires. We see her head in profile. Her near hand touches the skull on the table before her. Both hand and skull are silhouetted dark, dead, against the light. Her far arm is lit and living. Thus she is divided into two. She looks into a mirror. What we see in the mirror is the skull. The balance is mathematical and dreamlike.

The second is of St Joseph as a carpenter. He bends forward, working. The candlelight burnishes his flesh which is as opaque as wood. The child Jesus holds up the candle. His childish hand, which shields it, is made transparent by the light, and his lit face is like a window at night seen from the outside. Again, the formal painting and the message (the contrast between childhood and age, the opaque and the transparent, experience and innocence) are entirely uninterrupted and perfectly balanced.

The third masterpiece is one I cannot explain. It is the so-called *Woman with a Flea.* She sits half-naked in the candlelight. Her hands are pressed against each other beneath her breasts. Some say that she is squashing a flea between her thumbnails. I read her hands placed there as a gesture of conviction. The spirit of the painting is unlike any other by La Tour which has survived. It almost confirms the usual view of his art. The woman sitting there is neither symbol nor cipher. The candlelight is gentle; there are no apparitions. She is there. The climate of her body fills the picture. Perhaps La Tour was in love with her.

To appreciate these three works is not, however, to encounter 'an emotion of sympathy uniting all men'. The formal aesthetic perfection to which La Tour aspired was his special solution to a religious and social problem about, precisely, the *meaning* of other men: a problem which, in its own terms, he found insoluble.

1972

Francis Bacon and Walt Disney

A blood-stained figure on a bed. A carcase with splints on it. A man on a chair smoking. One walks past his paintings as if through some gigantic institution. A man on a chair turning. A man holding a razor. A man shitting.

What is the meaning of the events we see? The painted figures are all quite indifferent to one another's presence or plight. Are we, as we walk past them, the same? A photograph of Bacon with his sleeves rolled up shows that his forearms closely resemble those of many of the men he paints. A woman crawls along a rail like a child. In 1971, according to the magazine *Connaissance des Arts*, Bacon became the first of the top ten most important living artists. A man sits naked with torn newspaper around his feet. A man stares at a blind cord. A man reclines in a vest on a stained red couch. There are many faces which move, and as they move they give an impression of pain. There has never been painting quite like this. It relates to the world we live in. But how?

To begin with a few facts:

1. Francis Bacon is the only British painter this century to have gained an international influence.

2. His work is remarkably consistent, from the first paintings to the most recent. One is confronted by a fully articulated world-view.

3. Bacon is a painter of extraordinary skill, a master. Nobody who is familiar with the problems of figurative oil-painting can remain unimpressed by his solutions. Such mastery, which is rare, is the result of great dedication and extreme lucidity about the medium.

4. Bacon's work has been unusually well written about. Writers such as David Sylvester, Michel Leiris and Lawrence Gowing have discussed its internal implications with great eloquence. By 'internal' I mean the implications of its own propositions within its own terms.

Bacon's work is centred on the human body. The body is usually

315

distorted, whereas what clothes or surrounds it is relatively undistorted. Compare the raincoat with the torso, the umbrella with the arm, the cigarette stub with the mouth. According to Bacon himself, the distortions undergone by face or body are the consequence of his searching for a way of making the paint 'come across directly on to the nervous system'. Again and again, he refers to the nervous system of painter and spectator. The nervous system for him is independent of the brain. The kind of figurative painting which appeals to the brain, he finds illustrational and boring.

'I've always hoped to put over things as directly and rawly as I possibly can, and perhaps if a thing comes across directly, they feel that it is horrific.'

To arrive at this rawness which speaks directly to the nervous system, Bacon relies heavily on what he calls 'the accident'. 'In my case, I feel that anything I've ever liked at all has been the result of an accident on which I've been able to work.'

The 'accident' occurs in his painting when he makes 'involuntary marks' upon the canvas. His 'instinct' then finds in these marks a way of developing the image. A developed image is one that is both factual and suggestive to the nervous system.

'Isn't it that one wants a thing to be as factual as possible, and yet at the same time as deeply suggestive or deeply unlocking of areas of sensation other than simple illustrating of the object that you set out to do? Isn't that what art is all about?'

For Bacon the 'unlocking' object is always the human body. Other things in his painting (chairs, shoes, blinds, lamp switches, newspapers) are merely illustrated.

'What I want to do is to distort the thing far beyond appearance, but in the distortion to bring it back to a recording of the appearance.'

Interpreted as process, we now see that this means the following. The appearance of a body suffers the accident of involuntary marks being made upon it. Its distorted image then comes across directly on to the nervous system of the viewer (or painter), who rediscovers the appearance of the body through or beneath the marks it bears.

Apart from the inflicted marks of the painting-accident, there are also sometimes *painted marks* on a body or on a mattress. These are, more or less obviously, traces of body fluids – blood, semen, perhaps shit. When they occur, the stains on the canvas are like stains on a surface which has actually touched the body.

The double-meaning of the words which Bacon has always used when talking about his painting (*accident, rawness, marks*), and perhaps even the double-meaning of his own name, seem to be part of the vocabulary of an obsession, an experience which probably dates back to the beginning of his self-consciousness. There are no alternatives offered in Bacon's

world, no ways out. Consciousness of time or change does not exist. Bacon often starts working on a painting from an image taken from a photograph. A photograph records for a moment. In the process of painting, Bacon seeks the accident which will turn that moment into all moments. In life, the moment which ousts all preceding and following moments is most commonly a moment of physical pain. And pain may be the ideal to which Bacon's obsession aspires. Nevertheless, the content of his paintings, the content which constitutes their appeal, has little to do with pain. As often, the obsession is a distraction and the real content lies elsewhere.

Bacon's work is said to be an expression of the anguished loneliness of western man. His figures are isolated in glass cases, in arenas of pure colour, in anonymous rooms, or even just within themselves. Their isolation does not preclude their being watched. (The triptych form, in which each figure is isolated within his own canvas and yet is visible to the others, is symptomatic.) His figures are alone, but they are utterly without privacy. The marks they bear, their wounds, look self-inflicted. But self-inflicted in a highly special sense. Not by an individual but by the species, Man – because, under conditions of such universal solitude, the distinction between individual and species becomes meaningless.

Bacon is the opposite of an apocalyptic painter who envisages the worst is likely. For Bacon, the worst has already happened. The worst that has happened has nothing to do with the blood, the stains, the viscera. The worst is that man has come to be seen as mindless.

The worst had already happened in the *Crucifixion* of 1944. The bandages and the screams are already in place – as also is the aspiration towards ideal pain. But the necks end in mouths. The top half of the face does not exist. The skull is missing.

Later, the worst is evoked more subtly. The anatomy is left intact, and man's inability to reflect is suggested by what happens around him and by his expression – or lack of it. The glass cases, which contain friends or a Pope, are reminiscent of those in which animal behaviour-patterns can be studied. The props, the trapeze chairs, the railings, the cords, are like those with which cages are fitted. Man is an unhappy ape. But if he knows it, he isn't. And so it is necessary to show that man cannot know. Man is an unhappy ape without knowing it. It is not a brain but a perception which separates the two species. This is the axiom on which Bacon's art is based.

During the early 1950s, Bacon appeared to be interested in facial expressions. But not, as he admits, for what they expressed.

In fact, I wanted to paint the scream more than the horror. And I think if I had really thought about what causes somebody to scream – the horror that produces a scream – it would have made the screams that I

317

tried to paint more successful. In fact, they were too abstract. They originally started through my always having been very moved by movements of the mouth and the shape of the mouth and the teeth. I like, you may say, the glitter and colour that comes from the mouth, and I've always hoped in a sense to be able to paint the mouth like Monet painted a sunset.

In the portraits of friends like Isabel Rawsthorne, or in some of the new self-portraits, one is confronted with the expression of an eye, sometimes two eyes. But study these expressions; read them. Not one is self-reflective. The eyes look out from their condition, dumbly, on to what surrounds them. They do not know what has happened to them; and their poignancy lies in their ignorance. Yet what has happened to them? The rest of their faces have been contorted with expressions which are not their own – which, indeed, are not expressions at all (because there is nothing behind them to be expressed), but are events created by accident in collusion with the painter.

Not altogether by accident, however. Likeness remains – and in this Bacon uses all his mastery. Normally, likeness defines character, and character in man is inseparable from mind. Hence the reason why some of these portraits, unprecedented in the history of art, although never tragic, are very haunting. We see character as the empty cast of a consciousness that is absent. Once again, the worst has happened. Living man has become his own mindless spectre.

In the larger figure-compositions, where there is more than one personage, the lack of expression is matched by the total unreceptivity of the other figures. They are all proving to each other, all the time, that they can have no expression. Only grimaces remain.

Bacon's view of the absurd has nothing in common with existentialism, or with the work of an artist like Samuel Beckett. Beckett approaches despair as a result of questioning, as a result of trying to unravel the language of the conventionally given answers. Bacon questions nothing, unravels nothing. He accepts the worst has happened.

His lack of alternatives, within his view of the human condition, is reflected in the lack of any thematic development in his life's work. His progress, during 30 years, is a technical one of getting the worst into sharper focus. He succeeds, but at the same time the reiteration makes the worst less credible. That is his paradox. As you walk through room after room it becomes clear that you can live with the worst, that you can go on painting it again and again, that you can turn it into more and more elegant art, that you can put velvet and gold frames round it, that other people will buy it to hang on the walls of the rooms where they eat. It begins to seem that Bacon may be a charlatan. Yet he is not. And his fidelity to his own obsession

ensures that the paradox of his art yields a consistent truth, though it may not be the truth he intends.

Bacon's art is, in effect, conformist. It is not with Goya or the early Eisenstein that he should be compared, but with Walt Disney. Both men make propositions about the alienated behaviour of our societies; and both, in a different way, persuade the viewer to accept what is. Disney makes alienated behaviour look funny and sentimental and, therefore, acceptable. Bacon interprets such behaviour in terms of the worst possible having already happened, and so proposes that both refusal and hope are pointless. The surprising formal similarities of their work – the way limbs are distorted, the overall shapes of bodies, the relation of figures to background and to one another, the use of neat tailor's clothes, the gesture of hands, the range of colours used – are the result of both men having complementary attitudes to the same crisis.

Disney's world is also charged with vain violence. The ultimate catastrophe is always in the offing. His creatures have both personality and nervous reactions; what they lack (almost) is mind. If, before a cartoon sequence by Disney, one read and believed the caption, *There is nothing else*, the film would strike us as horrifically as a painting by Bacon.

Bacon's paintings do not comment, as is often said, on any actual experience of loneliness, anguish or metaphysical doubt; nor do they comment on social relations, bureaucracy, industrial society or the history of the 20th century. To do any of these things they would have to be concerned with consciousness. What they do is to demonstrate how alienation may provoke a longing for its own absolute form – which is mindlessness. This is the consistent truth demonstrated, rather than expressed, in Bacon's work.

1972

An Article of Faith

The de Stijl movement, which was centred upon a small magazine of the same name, was founded in Holland in 1917 by the critic and painter Theo van Doesburg. The movement ceased when he died in 1931. It was always a small and fairly informal movement. Members left and others joined. Its first years were probably its most originally productive ones. Members then included the painters Mondriaan and Bart van der Leck, the designer Gerrit Rietveld and the architect J. J. P. Oud. Both the magazine and its artists were, during the whole de Stijl period, relatively obscure and unrecognised.

The magazine was called *The Style* (de Stijl) because it was intended to demonstrate a modern style applicable to all problems of two and three dimensional design. Its articles and illustrations were seen as definitions, prototypes and blueprints for what could become man's total urban environment. The group was as opposed to hierarchic distinctions between different disciplines (painting, designing, town planning and so on) as it was to any cultivated individualism in any art.

The individual must lose and re-find himself in the universal. Art, they believed, had become the preliminary model by means of which man could discover how to control and order his whole environment. When that control was established, art might even disappear. Their vision was consciously social, iconoclastic and aesthetically revolutionary.

The fundamental elements of *The Style* were the straight line, the right angle, the cross, the point, rectangular planes, an always convertible plastic space (quite distinct from the natural space of appearances), the three primary colours red, blue and yellow, a white ground and black lines. With these pure and rigorously abstract elements the de Stijl artists strove to represent and construct essential harmony.

The nature of this harmony was understood somewhat differently by different members of the group: for Mondriaan it was a quasi-mystical

universal absolute: for Rietveld or the architect and civil engineer Van Eesteren it was the formal balance and the implied social meaning which they hoped to achieve in a particular work.

Let us consider a typical work, often referred to in the history books. The Red-Blue Chair (a wooden chair with arm-rests) designed by Rietveld.

The chair is made out of only two wooden elements: the board used for back and seat, and the square sections used for legs, frame and arms. There are no joints in the joiner's sense of the term. Wherever two or more sections meet, they are laid one on top of the other and each protrudes beyond the cross-over. The way in which the elements are painted – blue, red or yellow – emphasises the lightness and the intentional *obviousness* of the assembly.

You have the sense that the parts could be quickly re-assembled to make a small table, a bookcase or the model of a city. You are reminded of how children sometimes use coloured bricks for building an entire world. Yet there is little that is childish about this chair. Its mathematical proportions are exactly calculated and its implications attack in a logical manner a whole series of established attitudes and preoccupations.

This chair eloquently opposes values that still persist: the aesthetic of the hand-made, the notion that ownership bestows power and weight, the virtues of permanence and indestructibility, the love of mystery and secrets, the fear that technology threatens culture, the horror of the anonymous, the mystique and the rights of privilege. It opposes all this in the name of its aesthetic, whilst remaining a (not very comfortable) armchair.

It proposes that for man to situate himself in the universe, he no longer requires God, or the example of nature, or rituals of class or state, or love of country: he requires precise vertical and horizontal coordinates. In these alone will he find the essential truth. And this truth will be inseparable from the style in which he lives. 'The aim of nature is man,' wrote Van Doesburg, 'the aim of man is style.'

The chair, hand-made, stands there like a chair waiting to be mass-produced: yet in certain ways it is as haunting as a painting by Van Gogh.

Why should such an austere piece of furniture have acquired – at least temporarily for us – a kind of poignancy?

An era ended in the early 1960s. During that era the idea of a different, transformed future remained a European and North American prerogative. Even when the future was considered negatively (*Brave New World, 1984*) it was conceived of in European terms.

Today, although Europe (east and west) and North America retain the technological means capable of transforming the world, they appear to have lost the political and spiritual initiative for bringing about any transformation. Thus today we can see the prophecies of the early

European artistic avant-gardes in a different light. The continuity between us and them – such as we might have believed in an attenuated form only ten years ago – has now been broken. They are not for us to defend or attack. They are for us to examine so that we may begin to understand the other world-revolutionary possibilities which they and we failed to foresee or reckon with.

Up to 1914, during the first decade of this century, it was clear to all those who were compelled either by necessity or imagination to consider the forces of change at work, that the world was entering a period of uniquely fast transition. In the arts this atmosphere of promise and prophecy found its purest expression in cubism. Kahnweiler, dealer and friend of the cubists, wrote:

> I lived those seven years from 1907 to 1914 with my painter friends . . . what occurred at that time in the plastic arts will be understood only if one bears in mind that a new epoch was being born, in which man (all mankind in fact) was undergoing a transformation more radical than any other known within historical times.

On the political left, the same conviction of promise was expressed in a fundamental belief in internationalism.

There are rare historical moments of convergence when developments in numerous fields enter a period of similar qualitative change before diverging into a multiplicity of new terms. Few of those who live through such a moment can grasp the full significance of what is happening. But all are aware of change: the future, instead of offering continuity, appears to advance towards them.

The ten years before 1914 constituted such a moment. When Apollinaire wrote:

> I am everywhere or rather I start to be everywhere
> It is I who am starting this thing of the centuries to come,

he was not indulging in idle fancy but responding intuitively to the potential of a concrete situation.

Yet nobody at that time, not even Lenin, foresaw how prolonged, confused and terrible the process of transformation was going to be. Above all, nobody realised how far-reaching would be the effects of the coming *inversion* of politics – that is to say the increasing predominance of ideology over politics. It was a time which offered more long-term and perhaps more accurate perspectives than we can hope for today: but, in the light of later events, we can also see it as a time of relative political innocence, albeit justified.

Soon such innocence ceased to be justified. Too much evidence had

to be denied to maintain it: notably the conduct of the First World War (not its mere outbreak) and the widespread popular acquiescence in it. The October revolution may at first have seemed to confirm earlier forms of political innocence but the failure of the revolution to spread throughout the rest of Europe and all the consequences of that failure within the Soviet Union itself should then have put a final end to them. What in fact happened is that most people remained politically innocent at the price of denying experience – and this in itself contributed further to the political-ideological inversion.

By 1917 Mondriaan was claiming that de Stijl was the result of pursuing the logic of cubism further than the cubists had dared to do. To some degree this was true. The de Stijl artists purified cubism and extracted a system from it. (It was by means of this system that cubism began to influence architecture.) But this purification took place at a time when reality was revealing itself as more tragic and far less pure than the cubists of 1911 could ever have imagined.

Dutch neutrality in the war and a national tendency to revert to a belief in Calvinist absolutes obviously played a part in influencing de Stijl theories. But this is not the point I wish to make. (To understand the relation between de Stijl and its Dutch background, one should consult H.L.C. Jaffé's pioneering work, *De Stijl 1917–31*.) The important point is that what were still intuitively real prophecies for the cubists became utopian dreams for the artists of de Stijl. De Stijl utopianism was compounded of a subjective retreat away from reality in the name of invisible universal principles – and the dogmatic assertion that objectivity was all that mattered. The two opposing but interdependent tendencies are illustrated by the following two statements:

> The painters of this group, wrongly called 'abstractionists', do not have a preference for a certain subject, knowing well enough that the painter has his subject within himself: plastic relations. For the true painter, the painter of relations, this fact contains his entire conception of the world. (Van Doesburg)

> We come to see that the principal problem in plastic art is not to avoid representation of objects, but to be as objective as possible. (Mondriaan)

A similar contradiction can now be seen in the aesthetic of the movement. This was confidently based upon values born of the machine and modern technology: values of order, precision and mathematics. Yet the programme of this aesthetic was formulated when a chaotic, untidy, unpredictable and desperate ideological factor was becoming the crucial one in social development.

Let me be quite clear. I am not suggesting that the de Stijl programme should have been more directly political. Indeed the political programmes of the left were soon to suffer from an exactly equivalent contradiction. A subjective retreat from reality leading to the dogmatic stressing of the need for pure objectivity was of the essence of Stalinism. Nor do I wish to suggest that de Stijl artists were personally insincere. I wish to treat them – as they would surely have wished – as a significant part of history. It goes without saying that we can sympathise with the aims of de Stijl. Yet what, for us, now seems missing from de Stijl?

What is missing is an awareness of the importance of subjective experience as a historical factor. Instead, subjectivity is simultaneously indulged in and denied. The equivalent social and political mistake was to trust in economic determinism. It was a mistake which dominated the whole era that has just ended.

Artists, however, reveal more about themselves than most politicians: and often know more about themselves. This is why their testimony is historically so valuable.

The strain of denying subjectivity whilst indulging in it is poignantly evident in the following manifesto of Van Doesburg's:

White! There is the spiritual colour of our times, the clear-cut attitude that directs all our actions. Not grey, not ivory white, but pure white. White! There's the colour of the new age, the colour which signifies the whole epoch: ours, that of the perfectionist, of purity and of certainty. White, just that. Behind us the 'brown' of decay and of academism, the 'blue' of divisionism, the cult of the blue sky, of gods with greenish whiskers and of the spectre. White, pure white.

Is it only imagination that makes us feel now a similar almost unconscious doubt expressed in the Rietveld chair? That chair haunts us not as a chair but as an article of faith . . .

1968

Between Two Colmars

I first went to Colmar to look at the Grünewald Altarpiece in the winter of 1963. I went a second time ten years later. I didn't plan it that way. During the intervening years a great deal had changed. Not at Colmar, but, generally, in the world, and also in my life. The dramatic point of change was exactly half-way through that decade. In 1968, hopes, nurtured more or less underground for years, were born in several places in the world and given their names: and in the same year, these hopes were categorically defeated. This became clearer in retrospect. At the time many of us tried to shield ourselves from the harshness of the truth. For instance, at the beginning of 1969, we still thought in terms of a second 1968 possibly recurring.

This is not the place for an analysis of what changed in the alignment of political forces on a world scale. Enough to say that the road was cleared for what, later, would be called *normalization*. Many thousands of lives were changed too. But this will not be read in the history books. (There was a comparable, although very different, watershed in 1848, and its effects on the life of a generation are recorded, not in the histories, but in Flaubert's *Sentimental Education*.) When I look around at my friends – and particularly those who were (or still are) politically conscious – I see how the long-term direction of their lives was altered or deflected at that moment just as it might have been by a private event: the onset of an illness, an unexpected recovery, a bankruptcy. I imagine that if they looked at me, they would see something similar.

Normalization meant that between the different political systems, which share the control of almost the entire world, anything can be exchanged under the single condition that nothing anywhere is radically changed. The present is assumed to be continuous, the continuity allowing for technological development.

A time of expectant hopes (as before 1968) encourages one to think of

oneself as unflinching. Everything needs to be faced. The only danger seems to be evasion or sentimentality. Harsh truth will aid liberation. This principle becomes so integral to one's thinking that it is accepted without question. One is aware of how it might be otherwise. Hope is a marvellous focusing lens. One's eye becomes fixed to it. And one can examine anything.

The altarpiece, no less than a Greek tragedy or 19th-century novel, was originally planned to encompass the totality of a life and an explanation of the world. It was painted on hinged panels of wood. When these were shut, those before the altar saw the Crucifixion, flanked by St Anthony and St Sebastian. When the panels were opened, they saw a Concert of Angels and a Madonna and Child, flanked by an Annunciation and Resurrection. When the panels were opened once again, they saw the apostles and some church dignitaries flanked by paintings about the life of St Anthony. The altarpiece was commissioned for a hospice at Isenheim by the Antonite order. The hospice was for victims of the plague and syphilis. The altarpiece was used to help victims come to terms with their suffering.

On my first visit to Colmar I saw the Crucifixion as the key to the whole altarpiece and I saw disease as the key to the Crucifixion. 'The longer I look, the more convinced I become that for Grünewald disease represents the actual state of man. Disease is not for him the prelude to death – as modern man tends to fear; it is the condition of life.' This is what I wrote in 1963. I ignored the hinging of the altarpiece. With my lens of hope, I had no need of the painted panels of hope. I saw Christ in the Resurrection 'as pallid with the pallor of death'; I saw the Virgin in the Annunciation responding to the Angel as if 'to the news of an incurable disease'; in the Madonna and Child I seized upon the fact that the swaddling cloth was the tattered (infected) rag which would later serve as loin cloth in the Crucifixion.

This view of the work was not altogether arbitrary. The beginning of the 16th century was felt and experienced in many parts of Europe as a time of damnation. And undoubtedly this experience *is* in the Altarpiece. Yet not exclusively so. But in 1963 I saw only this, only the bleakness. I had no need of anything else.

Ten years later, the gigantic crucified body still dwarfed the mourners in the painting and the onlooker outside it. This time I thought: the European tradition is full of images of torture and pain, most of them sadistic. How is it that this, which is one of the harshest and most pain-filled of all, is an exception? How is it painted?

It is painted inch by inch. No contour, no cavity, no rise within the contours, reveals a moment's flickering of the intensity of depiction. Depiction is pinned to the pain suffered. Since no part of the body escapes pain, the depiction can nowhere slack its precision. The cause of

the pain is irrelevant; all that matters now is the faithfulness of the depiction. This faithfulness came from the empathy of love.

Love bestows innocence. It has nothing to forgive. The person loved is not the same as the person seen crossing the street or washing her face. Nor exactly the same as the person living his (or her) own life and experience, for he (or she) cannot remain innocent.

Who then is the person loved? A mystery, whose identity is confirmed by nobody except the lover. How well Dostoevsky saw this. Love is solitary even though it joins.

The person loved is the being who continues when the person's own actions and egocentricity have been dissolved. Love recognises a person before the act and the *same* person after it. It invests this person with a value which is untranslatable into virtue.

Such love might be epitomised by the love of a mother for her child. Passion is only one mode of love. Yet there are differences. A child is in process of becoming. A child is incomplete. In what he is, at any given moment, he may be remarkably complete. In the passage between moments, however, he becomes dependent, and his incompleteness becomes obvious. The love of the mother connives with the child. She imagines him more complete. Their wishes become mixed, or they alternate. Like legs walking.

The discovery of a loved person, already formed and completed, is the onset of a passion.

One recognises those whom one does not love by their attainments. The attainments one finds important may differ from those which society in general acclaims. Nevertheless we take account of those we do not love according to the way they fill a contour, and to describe this contour we use comparative adjectives. Their overall 'shape' is the sum of their attainments, as described by adjectives.

A person loved is seen in the opposite way. Their contour or shape is not a surface encountered but an horizon which borders. A person loved is recognised not by attainments but by the *verbs* which can satisfy that person. His or her needs may be quite distinct from those of the lover, but they create value: the value of that love.

For Grünewald the verb was *to paint*. To paint the life of Christ.

Empathy, carried to the degree which Grünewald carried it, may reveal an area of truth between the objective and subjective. Doctors and scientists working today on the phenomenology of pain might well study this painting. The distortions of form and proportion – the enlargement of the feet, the barrel-chesting of the torso, the elongation of the arms, the planting out of the fingers – may describe exactly the *felt* anatomy of pain.

I do not want to suggest that I saw more in 1973 than in 1963. I saw differently. That is all. The ten years do not necessarily mark a progress; in many ways they represent defeat.

The altarpiece is housed in a tall gallery with gothic windows near a river by some warehouses. During my second visit I was making notes and occasionally looking up at the Angel's Concert. The gallery was deserted except for the single guardian, an old man rubbing his hands in woollen gloves over a portable oil stove. I looked up and was aware that something had moved or changed. Yet I had heard nothing and the gallery was absolutely silent. Then I saw what had changed. The sun was out. Low in the winter sky, it shone directly through the gothic windows so that on the white wall opposite their pointed arches were printed with sharp edges, in light. I looked from the 'window lights' on the wall to the light in the painted panels – the painted window at the far end of the painted chapel where the Annunciation takes place, the light that pours down the mountainside behind the Madonna, the great circle of light like an aurora borealis round the resurrected Christ. In each case the painted light held its own. It remained light; it did not disintegrate into coloured paint. The sun went in and the white wall lost its animation. The paintings retained their radiance.

The whole altarpiece, I now realised, is about darkness and light. The immense space of sky and plain behind the crucifixion – the plain of Alsace crossed by thousands of refugees fleeing war and famine – is deserted and filled with a darkness that appears final. In 1963 the light in the other panels seemed to me frail and artificial. Or, more accurately, frail and unearthly. (A light dreamt of in the darkness.) In 1973 I thought I saw that the light in these panels accords with the essential experience of light.

Only in rare circumstances is light uniform and constant. (Sometimes at sea; sometimes around high mountains.) Normally light is variegated or shifting. Shadows cross it. Some surfaces reflect more light than others. Light is not, as the moralists would have us believe, the constant polar opposite to darkness. Light flares out of darkness.

Look at the panels of the Madonna and the Angel's Consort. When it is not absolutely regular, light overturns the regular measurement of space. Light re-forms space as we perceive it. At first what is in light has a tendency to look nearer than what is in shadow. The village lights at night appear to bring the village closer. When one examines this phenomenon more closely, it becomes more subtle. Each concentration of light acts as a centre of imaginative attraction, so that in imagination one measures *from* it across the areas in shadow or darkness. And so there are as many articulated spaces as there are concentrations of light. Where one is actually situated establishes the primary space of a ground plan. But far from there a dialogue begins with each place in light, however distant, and each proposes another space and a different spatial articulation. Each place where there is brilliant light prompts one to imagine oneself there. It is as though the

seeing eye sees echoes of itself wherever the light is concentrated. This multiplicity is a kind of joy.

The attraction of the eye to light, the attraction of the organism to light as a source of energy, is basic. The attraction of the imagination to light is more complex because it involves the mind as a whole and therefore it involves comparative experience. We respond to physical modifications of light with distinct but infinitesimal modifications of spirit, high and low, hopeful and fearful. In front of most scenes one's experience of their light is divided in spatial zones of sureness and doubt. Vision advances from light to light like a figure walking on stepping stones.

Put these two observations, made above, together: hope attracts, radiates as a point, to which one wants to be near, from which one wants to measure. Doubt has no centre and is ubiquitous.

Hence the strength and fragility of Grünewald's light.

On the occasion of both my visits to Colmar it was winter, and the town was under the grip of a similar cold, the cold which comes off the plain and carries with it a reminder of hunger. In the same town, under similar physical conditions, I saw differently. It is a commonplace that the significance of a work of art changes as it survives. Usually, however, this knowledge is used to distinguish between 'them' (in the past) and 'us' (now). There is a tendency to picture *them* and their reactions to art as being embedded in history, and at the same time to credit *ourselves* with an over-view, looking across from what we treat as the summit of history. The surviving work of art then seems to confirm our superior position. The aim of its survival was us.

This is illusion. There is no exemption from history. The first time I saw the Grünewald I was anxious to place *it* historically. In terms of medieval religion, the plague, medicine, the Lazar house. Now I have been forced to place myself historically.

In a period of revolutionary expectation, I saw a work of art which had survived as evidence of the past's despair; in a period which has to be endured, I see the same work miraculously offering a narrow pass across despair.

1973

329

Courbet and the Jura

No artist's work is reducible to *the* independent truth; like the artist's life – or yours or mine – the life's work constitutes its own valid or worthless truth. Explanations, analyses, interpretation, are no more than frames or lenses to help the spectator focus his attention more sharply on the work. The only justification for criticism is that it allows us to see more clearly.

Several years ago I wrote that two things needed explaining about Courbet because they remained obscure. First, the true nature of the materiality, the density, the weight of his images. Second, the profound reasons why his work so outraged the bourgeois world of art. The second question has since been brilliantly answered – not, surprisingly, by a French scholar – but by British and American ones: Timothy Clark in his two books, *Image of the People* and *The Absolute Bourgeois*, and Linda Nochlin in her book on *Realism*.

The first question, however, remains unanswered. The theory and programme of Courbet's realism have been socially and historically explained, but how did he practise it with his eyes and hands? What is the meaning of the unique way in which he rendered appearances? When he said: art is 'the most complete expression of an existing thing', what did he understand by *expression?*

The region in which a painter passes his childhood and adolescence often plays an important part in the constitution of his vision. The Thames developed Turner. The cliffs around Le Havre were formative in the case of Monet. Courbet grew up in – and throughout his life painted and often returned to – the valley of the Loue on the western side of the Jura mountains. To consider the character of the countryside surrounding Ornans, his birthplace, is, I believe, one way of constructing a frame which may bring his work into focus.

The region has an exceptionally high rainfall: approximately 51 inches a year, whereas the average on the French plains varies from 31 inches in

the west to 16 inches in the centre. Most of this rain sinks through the limestone to form subterranean channels. The Loue, at its source, gushes out of the rocks as an already substantial river. It is a typical *karst* region, characterised by outcrops of limestone, deep valleys, caves and folds. On the horizontal strata of limestone there are often marl deposits which allow grass or trees to grow on top of the rock. One sees this formation – a very green landscape, divided near the sky by a horizontal bar of grey rock – in many of Courbet's paintings, including *The Burial at Ornans*. Yet I believe that the influence of this landscape and geology on Courbet was more than scenic.

Let us first try to visualise the mode of appearances in such a landscape in order to discover the perceptual habits it might encourage. Due to its folds, the landscape is *tall*: the sky is a long way off. The predominant colour is green: against this green the principal events are the rocks. The background to appearances in the valley is dark – as if something of the darkness of the caves and subterranean water has seeped into what is visible.

From this darkness whatever catches the light (the side of a rock, running water, the bough of a tree) emerges with a vivid, gratuitous but only partial (because much remains in shadow) clarity. It is a place where the visible is discontinuous. Or, to put it another way, where the visible cannot always be assumed and has to be grasped when it does make its appearance. Not only the abundant game, but the place's mode of appearances, created by its dense forests, steep slopes, waterfalls, twisting river, encourages one to develop the eyes of a hunter.

Many of these features are transposed into Courbet's art, even when the subjects are no longer his home landscape. An unusual number of his outdoor figure paintings have little or no sky in them (*The stonebreakers, Proudhon and his family, Girls on the banks of the Seine, The hammock*, most of the paintings of *Bathers*). The light is the lateral light of a forest, not unlike light underwater which plays tricks with perspective. What is disconcerting about the huge painting of the *Studio* is that the light of the painted wooded landscape on the easel is the light that suffuses the crowded Paris room. An exception to this general rule is the painting of *Bonjour Monsieur Courbet*, in which he depicts himself and his patron against the sky. This, however, was a painting consciously situated on the faraway plain of Montpelier.

I would guess that water occurs, in some form or another, in about two thirds of Courbet's paintings – often in the foreground. (The rural bourgeois house in which he was born juts out over the river. Running water must have been one of the first sights and sounds which he experienced). When water is absent from his paintings, the foreground forms are frequently reminiscent of the currents and swirls of running water (for example, *The woman with a parrot, The sleeping spinning girl*).

The lacquered vividness of objects, which catch the light in his paintings, often recalls the brilliance of pebbles or fishes seen through water. The tonality of his painting of a trout underwater is the same as the tonality of his other paintings. There are whole landscapes by Courbet which might be landscapes reflected in a pond, their colour glistening on the surface, defying atmospheric perspective (for example, *The rocks at Mouthier*).

He usually painted on a dark ground, on which he painted darker still. The depth of his paintings is always due to darkness – even if, far above, there is an intensely blue sky; in this his paintings are like wells. Wherever forms emerge from the darkness into the light, he defines them by applying a lighter colour, usually with a palette knife. Leaving aside for the moment the question of his painterly skill, this action of the knife reproduced, as nothing else could, the action of a stream of light passing over the broken surface of leaves, rock, grass, a stream of light which confers life and conviction but does not necessarily reveal structure.

Correspondences like these suggest an intimate relationship between Courbet's practice as a painter and the countryside in which he grew up. But they do not in themselves answer the question of what *meaning* he gave to appearances. We need to interrogate the landscape further. Rocks are the primary configuration of this landscape. They bestow identity, allow focus. It is the outcrops of rock which create the presence of the landscape. Allowing the term its full resonance, one can talk about *rock faces*. The rocks are the character, the spirit of the region. Proudhon, who came from the same area, wrote: 'I am pure Jurassic limestone.' Courbet, boastful as always, said that in his paintings, 'I even make stones think.'

A rockface is always there. (Think of the Louvre landscape which is called *The ten o'clock road*). It dominates and demands to be seen, yet its appearance, in both form and colour, changes according to light and weather. It continually offers different facets of itself to visibility. Compared to a tree, an animal, a person, its appearances are only very weakly normative. A rock can look like almost anything. It is undeniably itself, and yet its substance does not posit any particular form. It emphatically exists and yet its appearance (within a few very broad geological limitations) is arbitrary. It is only like it is, this time. Its appearance is, in fact, the limit of its meaning.

To grow up surrounded by such rocks is to grow up in a region in which the visible is both lawless and irreducibly real. There is visual fact but a minimum of visual order. Courbet, according to his friend Francis Wey, was able to paint an object convincingly – say a distant pile of cut wood – *without knowing what it was*. That is unusual amongst painters, and it is, I think, very significant.

In the early romantic *Self-portrait with a dog*, he painted himself, surrounded by the darkness of his cape and hat, against a large boulder.

And there his own face and hand are painted in exactly the same spirit as the stone behind. They were comparable visual phenomena, possessing the same visual reality. If visibility is lawless, there is no hierarchy of appearances. Courbet painted everything – snow, flesh, hair, fur, clothes, bark – as he would have painted it had it been a rock face. Nothing he painted has inferiority – not even, amazingly, his copy of a Rembrandt self-portrait – but everything is depicted with amazement: amazement because to see, where there are no laws, is to be constantly surprised.

It may now seem that I am treating Courbet as if he were 'timeless', as unhistorical as the Jura mountains which so influenced him. This is not my intention. The landscape of the Jura influenced his painting in the way that it did, given the historical situation in which he was working as a painter, and given his specific temperament. Even by the standards of Jurassic time, the Jura will have 'produced' only one Courbet. The 'geographical interpretation' does no more than ground, give material, visual substance to, the social-historical one.

It is hard to summarize Timothy Clark's percipient and subtle research on Courbet in a few sentences. He allows us to see the political period in all its complexity. He places the legends that surrounded the painter: the legend of the country buffoon with a gift for the paintbrush; the legend of the dangerous revolutionary; the legend of the coarse, drunken, thigh-slapping provocateur. (Probably the truest and most sympathetic portrait of Courbet is by Jules Valles in his *Cri du Peuple*.)

And then Clark shows how in fact in the great works of the early 1850s Courbet, with his inordinate ambition, with his genuine hatred of the bourgeoisie, with his rural experience, with his love of the theatrical, and with an extraordinary intuition, was engaged in nothing less than a double transformation of the art of painting. Double because it proposed a transformation of subject matter and audience. For a few years he was able to work, inspired by the ideal of both becoming popular for the first time.

The transformation involved 'capturing' painting as it was and altering its address. One can think of Courbet, I believe, as the last master. He learnt his prodigious skill in handling paint from the Venetians, from Rembrandt, from Velázquez, from Zurbarán and others. As a practitioner he remained traditionalist. Yet he acquired the skills he did without taking over the traditional values which those skills had been designed to serve. One might say he stole his professionalism.

For example: the practice of nude painting was closely associated with values of tact, luxury and wealth. The nude was an erotic ornament. Courbet stole the practice of the nude and used it to depict the 'vulgar' nakedness of a countrywoman with her clothes in a heap on a river bank. (Later, as disillusion set in, he too produced erotic ornaments like *The woman with a parrot*).

For example: the practice of 17th-century Spanish realism was closely connected with the religious principle of the moral value of simplicity and austerity and the dignity of charity. Courbet stole the practice and used it in *The stonebreakers* to present desperate unredeemed rural poverty.

For example: the Dutch 17th-century practice of painting group portraits was a way of celebrating a certain *esprit de corps*. Courbet stole the practice for the *Burial at Ornans* to reveal a mass solitude in face of the grave.

The hunter from the Jura, the rural democrat and the bandit painter came together in the same artist for a few years between 1848 and 1856 to produce some shocking and unique images. For all three personae, appearances were a direct experience, relatively unmediated by convention, and for that very reason astounding and unpredictable. The vision of all three was both matter-of-fact (termed by his opponents *vulgar*) and innocent (termed by his opponents *stupid*). After 1856, during the debauch of the Second Empire, it was only the hunter who sometimes produced landscapes which were still unlike those by any other painter, landscapes on which snow might settle.

In the *Burial* of 1849–50 we can glimpse something of the soul of Courbet, the single soul which, at different moments, was hunter, democrat and bandit painter. Despite his appetite for life, his bragging and proverbial laughter, Courbet's view of life was probably sombre if not tragic.

Along the middle of the canvas, for its whole length (nearly seven yards), runs a zone of darkness, of black. Nominally this black can be explained by the clothes of the massed mourners. But it is too pervasive and too deep – even allowing for the fact that over the years the whole painting has darkened – for its significance to stop there. It is the dark of the valley landscape, of the approaching night and of the earth into which the coffin will be placed. Yet I think this darkness also had a social and personal significance.

Emerging from the zone of darkness are the faces of Courbet's family, friends and acquaintances at Ornans, painted without idealisation and without rancour, painted without recourse to a pre-established norm. The painting was called cynical, sacrilegious, brutish. It was treated as if it were a plot. Yet what was involved in the plot? A cult of the ugly? Social subversion? An attack on the church? The critics searched the painting in vain to discover clues. Nobody discovered the source of its actual subversion.

Courbet had painted a group of men and women as they might appear when attending a village funeral, and he had refused to organise (harmonise) these appearances into some false – or even true – higher meaning. He had refused the function of art as the moderator of

appearances, as that which ennobles the visible. Instead, he had painted life-size, on 21 square metres of canvas, an assembly of figures at a graveside, which announced *nothing* except: This is how we appear. And precisely to the degree to which the art public in Paris received this announcement from the countryside, they denied its truth, calling it vicious exaggeration.

In his soul Courbet may have foreseen this; his grandiose hopes were perhaps a device for giving him the courage to continue. The insistence with which he painted – in the *Burial*, in *The stonebreakers*, in *The peasants of Flagey* – whatever emerged into the light, insisting on every apparent part as equally valuable, leads me to think that the ground of darkness signified entrenched ignorance. When he said that art 'is the most *complete* expression of an existing thing', he was opposing art to any hierarchical system or to any culture whose function is to diminish or deny the expression of a large part of what exists. He was the only great painter to challenge the chosen ignorance of the cultured.

1978

Turner and the Barber's Shop

There has never been another painter like Turner. And this is because he combined in his work so many different elements. There is a strong argument for claiming that it is Turner, not Dickens or Wordsworth or Walter Scott or Constable or Landseer, who, in his genius, represents most fully the character of the British 19th century. And it may be this which explains the fact that Turner is the only important artist who both before and after his death in 1851 had a certain popular appeal in Britain. Until recently a wide public felt that somehow, mysteriously, dumbly (in the sense that his vision dismisses or precludes words), Turner was expressing something of the bedrock of their own varied experience.

Turner was born in 1775, the son of a back-street barber in central London. His uncle was a butcher. The family lived a stone's throw from the Thames. During his life Turner travelled a great deal, but in most of his chosen themes water, coastlines, or river banks recur continually. During the last years of his life he lived – under the alias of Captain Booth, a retired sea captain – a little further down the river at Chelsea. During his middle years he lived at Hammersmith and Twickenham, both overlooking the Thames.

He was a child prodigy and by the age of nine he was already earning money by colouring engravings; at fourteen he entered the Royal Academy Schools. When he was eighteen he had his own studio, and shortly afterwards his father gave up his trade to become his son's studio assistant and factotum. The relation between father and son was obviously close. (The painter's mother died insane.)

It is impossible to know exactly what early visual experiences affected Turner's imagination. But there is a strong correspondence between some of the visual elements of a barber's shop and the elements of the painter's mature style, which should be noticed in passing without being

used as a comprehensive explanation. Consider some of his later paintings and imagine, in the backstreet shop, water, froth, steam, gleaming metal, clouded mirrors, white bowls or basins in which soapy liquid is agitated by the barber's brush and detritus deposited. Consider the equivalence between his father's razor and the palette knife which, despite criticisms and current usage, Turner insisted upon using so extensively. More profoundly – at the level of childish phantasmagoria – picture the always possible combination, suggested by a barber's shop, of blood and water, water and blood. At the age of twenty Turner planned to paint a subject from the Apocalypse entitled: *The Water Turned to Blood*. He never painted it. But visually, by way of sunsets and fires, it became the subject of thousands of his later works and studies.

Many of Turner's earlier landscapes were more or less classical, referring back to Claude Lorrain, but influenced also by the first Dutch landscapists. The spirit of these works is curious. On the face of it, they are calm, 'sublime', or gently nostalgic. Eventually, however, one realizes that these landscapes have far more to do with art than nature, and that as art they are a form of pastiche. And in pastiche there is always a kind of restlessness or desperation.

Nature entered Turner's work – or rather his imagination – as violence. As early as 1802 he painted a storm raging round the jetty at Calais. Soon afterwards he painted another storm in the Alps. Then an avalanche. Until the 1830s the two aspects of his work, the apparently calm and the turbulent, existed side by side, but gradually the turbulence became more and more dominant. In the end violence was implicit in Turner's vision itself; it no longer depended upon the subject. For example, the painting entitled *Peace: Burial at Sea* is, in its own way, as violent as the painting of *The Snowstorm*. The former is like an image of a wound being cauterized.

The violence in Turner's paintings appears to be elemental: it is expressed by water, by wind, by fire. Sometimes it appears to be a quality which belongs just to the light. Writing about a late painting called *The Angel Standing in the Sun*, Turner spoke of light *devouring* the whole visible world. Yet I believe that the violence he found in nature only acted as a confirmation of something intrinsic to his own imaginative vision. I have already suggested how this vision may have been partly born from childhood experience. Later it would have been confirmed, not only by nature, but by human enterprise. Turner lived through the first apocalyptic phase of the British Industrial Revolution. Steam meant more than what filled a barber's shop. Vermilion meant furnaces as well as blood. Wind whistled through valves as well as over the Alps. The light which he thought of as devouring the whole visible world was very similar to the new productive energy which was challenging and destroying all previous ideas about wealth, distance, human labour, the city, nature,

the will of God, children, time. It is a mistake to think of Turner as a virtuoso painter of natural effects – which was more or less how he was officially estimated until Ruskin interpreted his work more deeply.

The first half of the British 19th century was profoundly unreligious. This may have forced Turner to use nature symbolically. No other convincing or accessible system of symbolism made a deep moral appeal, but its moral sense could not be expressed directly. The *Burial at Sea* shows the burial of the painter, Sir David Wilkie, who was one of Turner's few friends. Its references are cosmic. But as a statement, is it essentially a protest or an acceptance? Do we take more account of the impossibly black sails or of the impossibly radiant city beyond? The questions raised by the painting are moral – hence, as in many of Turner's later works, its somewhat claustrophobic quality – but the answers given are all ambivalent. No wonder that what Turner admired in painting was the ability to cast doubt, to throw into mystery. Rembrandt, he said admiringly, 'threw a mysterious doubt over the meanest piece of common'.

From the outset of his career Turner was extremely ambitious in an undisguisedly competitive manner. He wanted to be recognized not only as the greatest painter of his country and time, but among the greatest of all time. He saw himself as the equal of Rembrandt and Watteau. He believed that he had outpainted Claude Lorrain. This competitiveness was accompanied by a marked tendency towards misanthropy and miserliness. He was excessively secretive about his working methods. He was a recluse in the sense that he lived apart from society by choice. His solitariness was not a by-product of neglect or lack of recognition. From an early age his career was a highly successful one. As his work became more original, it was criticized. Sometimes his solitary eccentricity was called madness; but he was never treated as being less than a great painter.

He wrote poetry on the themes of his paintings, he wrote and sometimes delivered lectures on art, in both cases using a grandiloquent but vapid language. In conversation he was taciturn and rough. If one says that he was a visionary, one must qualify it by emphasizing hardheaded empiricism. He preferred to live alone, but he saw to it that he succeeded in a highly competitive society. He had grandiose visions which achieved greatness when he painted them and were merely bombastic when he wrote about them, yet his most serious conscious attitude as an artist was pragmatic and almost artisanal: what drew him to a subject or a particular painting device was what he called its *practicability* – its capacity to yield a painting.

Turner's genius was of a new type which was called forth by the British 19th century, but more usually in the field of science or engineering or business. (Somewhat later the same type appeared as hero in the United States.) He had the ability to be highly successful, but success did not

satisfy him. (He left a fortune of £140,000.) He felt himself to be alone in history. He had global visions which words were inadequate to express and which could only be presented under the pretext of a *practical* production. He visualized man as being dwarfed by immense forces over which he had no control but which nevertheless he had discovered. He was close to despair, and yet he was sustained by an extraordinary productive energy. (In his studio after his death there were 19,000 drawings and watercolours and several hundred oil paintings.)

Ruskin wrote that Turner's underlying theme was Death. I believe rather that it was solitude and violence and the impossibility of redemption. Most of his paintings are as if about the aftermath of crime. And what is so disturbing about them – what actually allows them to be seen as beautiful – is not the guilt but the global indifference that they record.

On a few notable occasions during his life Turner was able to express his visions through actual incidents which he witnessed. In October, 1834, the Houses of Parliament caught fire. Turner rushed to the scene, made furious sketches and produced the finished painting for the Royal Academy the following year. Several years later, when he was sixty-six years old, he was on a steamboat in a snow storm and afterwards painted the experience. Whenever a painting was based on a real event he emphasized, in the title or in his catalogue notes, that the work was the result of first-hand experience. It was as though he wished to prove that life – however remorselessly – confirmed his vision. The full title of *The Snowstorm* was *Snowstorm. Steamboat off a Harbour's Mouth Making Signals in Shallow Water, and going by the Lead. The Author was in this storm on the night the Ariel left Harwich.*

When a friend informed Turner that his mother had liked the snowstorm painting, Turner remarked: 'I did not paint it to be understood, but I wished to show what such a scene was like: I got sailors to lash me to the mast to observe it; I was lashed for four hours, and I did not expect to escape, but I felt bound to record it if I did. But no one had any business to like the picture.'

'But my mother went through just such a scene, and it brought it all back to her.'

'Is your mother a painter?'

'No.'

'Then she ought to have been thinking of something else.'

The question remains what made these works, likeable or not, so new, so different. Turner transcended the principle of traditional landscape: the principle that a landscape is something which unfolds before you. In *The Burning of the Houses of Parliament* the scene begins to extend beyond its formal edges. It begins to work its way round the spectator in an effort to outflank and surround him. In *The Snowstorm* the tendency has become fact. If one really allows one's eye to be absorbed into the

forms and colours on the canvas, one begins to realize that, looking at it, one is in the centre of a maelstrom: there is no longer a near and a far. For example, the lurch into the distance is not, as one would expect, *into* the picture, but out of it towards the right-hand edge. It is a picture which precludes the outsider spectator.

Turner's physical courage must have been considerable. His courage as an artist before his own experience was perhaps even greater. His truthfulness to that experience was such that he destroyed the tradition to which he was so proud to belong. He stopped painting totalities. *The Snowstorm* is the total of everything which can be seen and grasped by the man tied to the mast of that ship. There is *nothing* outside it. This makes the idea of anyone liking it absurd.

Perhaps Turner did not think exactly in these terms. But he followed intuitively the logic of the situation. He was a man alone, surrounded by implacable and indifferent forces. It was no longer possible to believe that what he saw could ever be seen from the outside – even though this would have been a consolation. Parts could no longer be treated as wholes. There was either nothing or everything.

In a more practical sense he was aware of the importance of totality in his life's work. He became reluctant to sell his paintings. He wanted as many of his pictures as possible to be kept together, and he became obsessed by the idea of bequeathing them to the nation so that they could be exhibited as a whole. 'Keep them together,' he said. 'What is the use of them but together?' Why? Because only then might they conceivably bear obstinate witness to his experience for which, he believed, there was no precedent and no great hope of future understanding.

1972

Rouault and the Suburbs of Paris

'I have been so happy painting, a fool who paints, forgetting everything in the blackest gloom.' This is one of the many remarks which Georges Rouault made about himself. Like his art, it is apparently simple, in fact contradictory (how is one *happy* forgetting everything in the *blackest gloom?*) and authentically desperate.

He was a short man of 5 feet 6 inches. Versions of his own face are to be found in several of his clown paintings. Yet in reality Rouault's face was thinner skinned and both more receptive and more malicious than those of his painted clowns. It was a nocturnal, solitary face. One might have rashly concluded from his photograph that he was an aberrant entomologist obsessed by moths.

He was born in Paris in May, 1871, when the city was being shelled by government troops, just before they entered and began their massacres. His father was a cabinetmaker. The suburbs of Paris where he was brought up were to supply him with the setting and the atmosphere of many of his paintings and etchings. There are many different aspects of the suburbs of Paris and different ways of seeing them. Rouault's suburbs have little to do with those of the Impressionists or of Utrillo. His are the suburbs of the long road leading away, of dim street lamps at dusk, of lonely itinerants and of those who have failed in the city but are forced to stay on its fringes. There are no precise landmarks of these suburbs in Rouault's paintings. What they constitute is a spiritual climate – probably the climate of his own youth. He himself called one such work *The Suburb of Long Suffering.*

At the age of fourteen he became an apprentice to a stained-glass maker and attended art classes in the evening. Critics have made much of the influence of stained glass on his art, citing particularly his luminous colours and his heavy black outlines like the lead in stained-glass windows. The resemblance is indeed close, but in my

opinion it does not explain much. The essence of Rouault's art is psychological, not stylistic.

When he was nineteen he became the pupil of Gustave Moreau and began to paint dark mysterious landscapes and religious subjects in that nineteenth-century Romantic manner which it was believed followed in the footsteps of Rembrandt. They seem, these pictures, like images imagined in the folds of heavy hanging curtains. Pupil and master became deeply attached to each other. 'My poor Rouault,' Moreau said to him, 'I can read your future. With your absolute single-mindedness, your passion for work, your love of the unusual in paint structures – all your essential qualities, in fact – you will be more and more a figure on your own.'

In 1898, Moreau died. The shock and the ensuing solitude projected Rouault, frenzied, beside himself, into the great creative period of his life.

My feelings at Moreau's death were heartbreaking, but after being completely overwhelmed at first, I was not long in reacting, and it was an extremely profound inner change. I had just won a medal at the Salon and I could have built up a very comfortable position in official circles; I also had steady contacts with Moreau's admirers.

But you have to suffer and see for yourself, my master used to say, and it was no merit of mine to do so; there was nothing else I could do. Without deliberately wanting to forget all I had loved in the museums, I was gradually carried away by a more objective vision.

It was then that I passed through a most violent moral crisis. I experienced things that cannot be put into words. And I set about doing painting of an outrageous lyricism which disconcerted everybody.

For many years I wonder how I lived. Everybody dropped me, in spite of elegant, but vain, protests. People even wrote letters of abuse. That was the time to remember the words of my master: 'Thank heaven that you are not successful, at least until as late as possible. That way you can express yourself more completely, and without constraint.'

But when I looked at some of my pictures, I asked myself, was it really I who painted that? Can it be true? It is frightening what I have done.

What had he done? Death had made life real and at the same time hateful to him. He went out into the streets, the waste lots, the law courts, the cabarets, the public institutions of the city and painted those he saw there. He painted hucksters, judges, prostitutes, rent collectors, bons vivants, teachers, circus performers, wives, butchers, barristers, criminals, lecturers, tradesmen. Some he hated for themselves. The victims aroused

his hatred of those who had wronged them. He painted on scraps of paper with an eccentric mixture of materials: watercolour, gouache, pastel, oil paint, ink. This may at first have been due to his poverty – he had to use whatever was at hand; but his intemperate use of material on top of material corresponded also to the paroxysmal nature of his vision.

He had descended into what he thought was hell. Hell was established for him by the people he encountered there and their uses of each other, but it was established no less by his awareness of his own intransigence and the power of his own hatred. He was himself permeated by the outrages and sins among which he found himself. But unlike Baudelaire, whom he admired, he could never place himself in the position of another. Rouault remains at all times the one who records and condemns.

This is very clear in, for example, a painting of a prostitute sitting before the mirror. Describing such prostitutes who posed for him, Rouault wrote of their 'thick gelatinous masses of flesh, vacillating flesh, upon which no genuine kiss will ever again be pressed'. Today these paintings are said to illustrate the vanity of the flesh, the bitter truths of ageing, the bleakness of promiscuity. But if you look more carefully at the picture, it is evidence of something quite different. What degrades the woman sitting there are the black lines with which Rouault has outlined and interpreted her. The slash between the breasts. The burnt holes of the eyes. Remove these black marks in your imagination and you are left with a not unattractive woman whose nakedness is ambiguous. You are still seeing through Rouault's eyes: but what you see no longer corresponds to the disgust of his verbal description because you have removed the stigma of his misanthropy and you are seeing the woman as he would have perceived her if he had not already decided that 'no genuine' kiss would ever again be pressed upon her, and that, therefore, he was obliged to press on her nakedness his own judgment of the world.

A work like this is born of a vision which condemns the world *a priori*. The judgement does not arise out of what it shows; on the contrary, what it shows has been sought in order to confirm the judgement. Yet as an artist Rouault worked in good faith, for these images, if one looks at them with open eyes, reveal the truth about their own motivation. No other artist has ever produced such a volume of purely misanthropic work as Rouault during the period between 1905 and 1912. These pictures record the tragedy of their own vision. Confronted with the head of the scourged Christ, you see the lines and slashes and black marks of his paint confessing to their own cruelty.

In 1912, a second death deeply affected Rouault, this time that of his father.

We are all refugees in this life. Refugees from illness, from boredom, from nethermost poverty, from friendlessness, from the whisper of

scandal, from death above all. We hide ourselves under the sheets, pulling them up to our chins with a shaky hand, and even at the moment of going under we are still talking – talking of retirement, and of taking our ease among the Borromean Isles in Italy.

His painting gradually changed. Some of his subjects remained the same – clowns, dwarfs, judges. The new painting was no less sombre in spirit. But it was resonant in colour and it increasingly referred to another hieratic, introspective, sacred world where there was no place for hatred but only contrition. The black lines and stains of paint changed their function. Instead of condemning, they register static accepted suffering.

It is as though in his new work Rouault paints from within a church. His work is not conventional religious art, nor is it Catholic propaganda. The point I am making is only in terms of Rouault's own personal psychic development. From about 1914 onwards, most of his paintings are images conceived as altarpieces. They continually refer back to the period from 1905 to 1912, but they do so in something like a spirit of atonement. Is it to atone for his earlier work, one asks oneself, that he is now there alone in the church?

No life is as simple as the answer to a direct question like that. But the rest of Rouault's story does suggest a tortuous, guilt-ridden attitude to his own creative past.

In 1917, the art dealer Vollard bought up Rouault's entire output, which then consisted of nearly 800 paintings, many of them belonging to the period of 1905–1912. Rouault claimed that most of these paintings were unfinished, and he made Vollard agree that he would sell no work until the painter declared it finished. During the following thirty years of his working life, Rouault saw himself as the prisoner of his contract, bound to the impossible of finishing to his own satisfaction what was already completed. 'Atlas bearing the world on his shoulders,' he wrote, 'is a child compared to me . . . it is killing me . . . the whole of my effort, past, present and future, is at stake with Ambroise Vollard. That is why I exhaust myself with sleepless nights, why I pray in secret, it is perhaps why I shall succumb.'

Vollard was killed in an accident in 1939. The news of his death in no way came as a release to Rouault. Once again he was stricken. But after the war he brought a legal case against Vollard's heirs and demanded the return of his unfinished works. He won the case. His old paintings passed into his hands. On November 5, 1948, he publicly burned 315 of them because he believed that he could never finish them, never render them acceptable to his own conscience and the world.

1972

Magritte and the Impossible

Magritte accepts and uses a certain language of painting. This language is over 500 years old and its first master was Van Eyck. It assumes that the truth is to be found in appearances which are therefore worth preserving by being represented. It assumes continuity in time as also in space. It is a language which treats, most naturally, of *objects* – furniture, glass, fabrics, houses. It is capable of expressing spiritual experience but always within a concrete setting, always circumscribed by a certain static materiality – its human figures were like miraculous statues. This value of materiality was expressed through the illusion of tangibility. I cannot trace here the transformation which this language underwent during five centuries. But its essential assumptions remained unchanged and form part of what most Europeans still expect from the visual arts: likeness, the representation of appearances, the depiction of particular events and their settings.

Magritte never questioned the aptness of this language for expressing what he had to say. Thus there is no obscurity in his art. Everything is plainly readable. Even in his early work when he was far less skilful than he became during the last twenty years of his life. (I use the word *readable* metaphorically: his language is visual, not literary, though being a language, it signifies something other than itself.) Yet what he had to say destroyed the *raison-d'être* of the language he used; the point of most of his paintings depends on what is *not* shown, upon the event that is *not* taking place, upon what can *dis*appear.

Let us examine some early examples: *L'Assassin menacé.* The assassin stands listening to a record on a gramophone. Two plain-clothes policemen wait behind corners to arrest him. A woman lies dead. Through the window three men stare at the murderer's back. We are shown everything – and nothing. We see a particular event in its concrete setting, yet everything remains mysterious – the committed murder, the future arrest, the appearance of the three staring men in the window. What

fills the depicted moment is the sound of the record, and this, by the very nature of painting, we cannot hear. (Magritte frequently uses the idea of sound to comment upon the limitation of the visual.)

Another early painting: *La Femme Introuvable*. It shows a number of irregular stones embedded in cement. These stones frame a nude woman and four large hands searching for her. The painting stresses the quality of tangibility. Yet although the hands can feel their way over the stones, the woman eludes them.

A third early painting is called *Le Musée d'une nuit*. It depicts four cupboard shelves. An apple lies on one shelf, a severed hand on the second, and a piece of lead on the third. Over the fourth opening is stuck a piece of pink paper with scissor-cut holes in it. Through the holes we see nothing but darkness. Yet we assume that the significant, the all-revealing exhibit of the night lies behind the paper on the fourth shelf.

A year later Magritte painted a smoker's pipe, and on the canvas beneath the pipe he wrote: '*Ceci n'est pas une pipe.*' He made two languages (the visual and the verbal) cancel one another out.

What does this continual cancelling out mean? Despite Magritte's warnings to the contrary, critics have tended to interpret his work symbolically and to romanticise its mystery. He himself said that his pictures should be thought of 'as material signs of the freedom of thought'. And he defined what he meant by this freedom: 'Life, the Universe, the Void, have no value for thought when it is truly free. The only thing that has value for it is Meaning, that is the moral concept of the Impossible.'

To conceive of the impossible is difficult. Magritte knew this. 'In both the ordinary and extraordinary moments of life, our thought does not manifest its freedom to its fullest extent. It is unceasingly threatened or involved in what happens to us. It *coincides* with a thousand and one things which restrict it. This coincidence is almost permanent.' Almost, but the experience of escaping from it occurs spontaneously and briefly some time or another in most lives.

First, let us judge Magritte's work in the light of his own aims. This means that we should decide in each case how cleanly he has broken free of the contingent and coincidental. His links with the surrealist movement and that movement's rather vague appeals to the unconscious and the automatic have previously confused this issue.

There are paintings by Magritte which do not get beyond expressing a *sensation* of the impossible such as we experience in dreams or states of half-consciousness. Such sensations isolate us from the coincidental, but do not liberate us from it. I would cite as examples his paintings of the gigantic apple which fills an entire room (*La Chambre d'écoute*) or many of the paintings of the early 1950s in which figures or whole scenes have been turned to stone. By contrast, his fully successful paintings are those

in which the impossible has been grasped, measured and inserted as an *absence* in a statement made in a language originally and specially developed for depicting particular events in particular settings. Such paintings (*Le Modèle rouge, Le Voyageur, Au Seuil de la liberté*) are triumphs of Magritte's Meaning, triumphs of the moral concept of the Impossible.

If a painting by Magritte confirms one's lived experience to date, it has, by his standards, failed; if it temporarily destroys that experience, it has succeeded. (This destruction is the only fearful thing in his art.) The paradox of his art and of his insight was that to destroy familiar experience he needed to use the language of the familiar. Unlike most modern artists he despised the exotic. He hated the familiar and the ordinary too much to turn his back on them.

Were his aims valid? What is the value of his art for its public?

Max Raphael wrote that the aim of all art was 'the undoing of the world of things' and the establishment of a world of values. Marcuse refers to art as 'the great refusal' of the world as it is. I myself have written that art mediates between what is given and what is desired. Yet the great works of the past, in their opposition to what was, were able to believe in a language and to refer to established sets of values. The contradiction between what was and what could be thought was not yet insurmountable. Hence the unity achieved in their works. Indeed their critique of a disparate reality (whether one thinks of Piero, Rembrandt, Poussin or Cézanne) was always in the name of a greater and more profound unity. In this century – and more precisely since 1941 – the contradiction has become insurmountable, unity in a work of art inconceivable. Our idea of freedom extends, our experience of it diminishes. It is from this that the moral concept of the Impossible arises. Only through the occasional interstices of the interlocking oppressive systems can we glimpse the impossibility of it being otherwise: an impossibility which inspires us because we know that the optimum of what is considered possible within these systems is inadequate.

'I am not a determinist,' wrote Magritte, 'but I don't believe in chance either. It serves as still another "explanation" of the world. The problem lies precisely in not accepting any explanation of the world either through chance or determinism. I am not responsible for my belief. It is not even I who decides that I am not responsible – and so on to infinity: I am obliged not to believe. There is no point of departure.'

This statement – as always with Magritte – is remarkable for its clarity. But what it describes is part of the lived experience of millions. It is perhaps the conclusion of the majority in the industrialised countries. Who has not been forced at some time or another to the intransigent helplessness of this attitude? Magritte the artist, however, continues from where the statement ends. There is such a thing as a reduction, not to absurdity, but to freedom. Magritte's best, most eloquent, paintings are

about this reduction. *Le Modèle rouge* shows a pair of boots of which the toes have become human toes, placed on the ground in front of a wooden wall. I do not wish to impose a single meaning on any of Magritte's paintings, but I am sure that invention of the boots-half-turned-into-feet is not the point of this painting. This would be mystery for mystery's sake, which he hated. The point is what possibility/impossibility does such an invention propose? An ordinary pair of boots left on the ground would simply suggest that somebody had taken them off. A pair of severed feet would suggest violence. But the discarded feet-half-turned-into-boots propose the notion of a self that has left its own skin. The painting is about what is absent, about a freedom that *is* absence.

Les Promenades d'Euclide shows a window overlooking a town. In front of the window is an easel with a canvas on it. What is painted on the canvas coincides exactly with that part of the townscape which it covers. There is a second pun. The piece of landscape painted upon (or covered by?) the canvas includes a straight road going as far as the horizon and, beside it, a pointed tower.

The road in perspective and the tower are the same size, colour and pointed shape. The purpose of the puns is to demonstrate how easy it is to confuse the two-dimensional with the three-dimensional, surface with substance. And so we come to the proposition. The easel has a handle by turning which the canvas is lowered or raised. Magritte has painted this handle very tangibly and emphatically. What will happen if it is turned? Is it possible/impossible that when the canvas moves, we shall see that behind where it originally was *there is no landscape at all*: nothing, a free blank? Another painting, *La Lunette d'approche*, makes the same proposition. We see a double window with one of its frames not quite shut. On or through the glass of the windows is a conventional sunlit sea and sky. But through the gap behind the appearances of the sea and sky we glimpse a free dark impossible emptiness.

L'Evidence éternelle. This work consists of five separate framed canvases each depicting a close-up of a part of the same woman; her hand, her breasts, her stomach and sex, her knees, her feet. Together they offer visible evidence of her body and of her physical proximity. Yet how much is this evidence worth? Any one of the parts can be removed or they can be arranged in a different order. The work proposes that what appears to exist – the *res extensa* – may be seen as a series of discontinuous movable parts. *Behind* the parts and *through* their interstices we imagine an impossible freedom.

When the cannon fires, in his painting *On the Threshold of Liberty*, the panels of the apparent world will fall down.

Magritte's work derives from a profound social and cultural crisis which will probably continue to make any unified art impossible this side of several revolutions. His work might be said to be defeatist.

Nevertheless he refused to retreat from the present as it is lived, by way of a cult of either aesthetics or personality. What he had to make as an artist, he made of the present. This is why very many can recognise in Magritte a part of themselves which otherwise has no place in the present; the part which cannot concur with the rest of their lives, which cannot refute the moral concept of the impossible, which is the product of the violence done to the other parts.

1969

Romaine Lorquet

Romaine Lorquet was born in Lyons about fifty years ago. Soon after the war she was in Paris, where she knew Brancusi, Giacometti and Etienne-Martin, each of whom recognised and encouraged her as an artist. More than twenty years ago she left Paris to live and work in relative isolation in the country.

There she has made many carvings. I use the word carvings instead of sculptures because the first word fits a little less easily into the contemporary art world. Scarcely ever has she tried to place her work in any kind of contemporary artistic or cultural context. There is nothing, I think, evasive in this decision. She has simply chosen to remain outside.

And it is outside – in both a general and precise sense – that I have seen most of her carvings. They are on a hillside around a peasant's house, in which she lives; some lie on the earth beneath the trees, others are nearly lost in the undergrowth. A few are made of wood, most are made of stone. Their height varies between 30 and 90 centimetres. Sometimes grasses or roots have grown through them. They are not on display.

Most man-made objects refer back to the event of their own making. Their presence depends upon the use of the past tense. *This house was built of stone.* These carvings hardly refer back at all to their own making. They look neither finished nor unfinished. Like a tree or a river, they appear to exist in a continuous present. Their apparent lack of history makes them look inevitable.

Speculatively I have tried to imagine them in a different context. In a museum gallery, or a city street, or an apartment. Because they insist so little upon their own making, they would then look like something found in nature. If they were thought of as being hand-made, they would seem to belong to another period, in either the remote past or future.

Even on the earth, under the fruit trees, they challenge the demarca-

tion line to which we are accustomed between nature and art. They deceive us into thinking that they are on the far side of that frontier. Perhaps they occupy the area which art left empty when it relinquished its magical function over nature. Some of the carvings are fully carved only on three sides: on the fourth, the stone has been left blank. This could suggest that in the carver's mind they were to be placed against a wall. Yet I doubt it. I think it far more likely that the fourth side was left uncarved so that the carving could remain 'attached' to the nature from which it was only half-emerging.

Each of these carvings brings something forward towards the viewer. Yet they do not represent specific forms. They are not portraits of anything. Nor are they abstractions. The carver has not dug for forms in nature and cleaned and purified them in order to set them up as symbols. Lorquet's work has nothing in common with Classical decoration or with the modern sculptures of Arp, Miró, Max Bill, or Henry Moore.

What do these carvings bring forward?

Within nature space is not something accorded from the outside; it is a condition of existence born from within. It is what has been, or will be, *grown into*. Space in nature is what the seed contains. Symmetry is the spatial law of growth, the law of *spacing*. Again, its code is not imposed from the outside but works from within. What the carvings bring forward from nature is such space and symmetry. Their forms obey the same laws of assembly as the fruit or leaves on a tree. They are assembled in such a way that they promise continuity – not the continuity of a logical series, but of growth.

Each carving is a 'chain' of unions, of meetings, of events, 'giving to' and 'receiving' each other so that their sum total is a single event. This much is of course true of any successful sculpture. One could say the same of Michelangelo's *Moses*. But with these carvings the single event they add up to extends beyond themselves to include the whole landscape from grass below to mountains in the distance.

On those mountains are countless uncarved rocks and stones. I have studied some of them to see whether, by concentrating my attention on them, I can make them work in the same way as the carved ones. They remain inert, fixed in themselves. Far from their bringing anything forward, they withdraw deeper and deeper into the remote finished state of their own being. Their existence answers only its own question.

By contrast, the carvings invoke unity. They have something in common with Sumerian sculpture. In that very early art, the assemblage of parts also resembled the clustering of tangible forms in nature: berries, cones, fruit, organs of the body, animal or human, flowers, roots. Metaphor was still embedded in the physical unity of the world. For example, a mouth in a face was the variant of a hole in the earth, or a

leaf was the variant of a hand. Metamorphosis was considered a constant possibility, and sculpture was a celebration of the common material from which everything was made.

As the division of labour increased, art, like every other discipline, began to differentiate more and more sharply. Idealisation was one of its forms of differentiation. Sculptors competed with one another to carve the perfect mouth, the mouth which was perfectly and only itself. The more they succeeded, the greater the distinction became between the mouth and hole in the earth. Everything was divided into its type. Every distinction and distance became measurable. And empty space was born. For four centuries the drama of most European sculpture has been created out of defiance in face of this empty space. Yet for these carvings there is no such thing as empty space. There is only space *within* a system, including the space which surrounds them. François Jacob:

> The power of assembling, of producing increasingly complex structures, even of reproducing, belongs to the elements that constitute matter. From particles to man, there is a whole series of integrations, of levels, of discontinuities. But there is no breach either in the composition of objects or in the reactions that take place in them; no change in 'essence'.

The experience which informs these carvings is also the experience of our own bodies. They work like a mirror. Not a mirror which denies the interior by reflecting the surface, but the mirror of another's eyes. In their reflection of us, we find not an image of ourselves, but recognition of our physical being. Exceptionally, in moments of revelation, one can have a similar experience of being recognised in front of a tree, a corn field, a river. The carvings bring a little forward from nature the potential of this experience. Yet they can bring it so far and no further. They combine confidence with extreme restraint. Why must they be so reticent? Or, to ask the same question another way, why are they half abandoned on a hillside?

All art, which is based on a close observation of nature, eventually changes the way nature is seen. Either it confirms more strongly an already established way of seeing nature or it proposes a new way. Until recently a whole cultural process was involved; the artist observed nature: his work had a place in the culture of his time and that culture mediated between man and nature. In post-industrial societies this no longer happens. Their culture runs parallel to nature and is completely insulated from it. Anything which enters that culture has to sever its connections with nature. Even natural sights (views) have been reduced in consumption to commodities.

The sense of continuity once supplied by nature is now supplied by the

means of communication and exchange – publicity, TV, newspapers, records, radio, shop-windows, auto-routes, package holidays, currencies, etc. These, barring catastrophes – either personal or global – form a mindless stream in which any material can be transmitted and made homogeneous – including art.

The rejection implicit in these carvings of the present *institution of art* is therefore functional not cultural. The distinction is important. The cultural rejection of art – the anti-art movement, cultivated primitivism like Dubuffet's, auto-destructive art, etc. – are dependent on the art they reject and so lead back into the museum and the institution of art. Duchamp was not an iconoclast: he was a new type of curator.

The rejection of the carvings is functional because the culture within which they would have to operate is incapable of mediating between society and nature. And so they are forced to attempt to do this themselves. They begin from a very close observation of nature; and then, single-handed, they try to refer these observations, these insights, back to nature. Previously the referring-back would have been a gradual, indirect and socially mediated process. Here it becomes immediate, simple and physical, because the carvings have scarcely broken from nature. They refuse the *distinction* of art in our time.

Sometimes the vision of an individual imagination can outstrip the social forms of the existing culture – including the social form of art. When this happens the works produced by that imagination exist, not only in a personal but also in an historical solitude.

A butterfly alights on one of the carvings, closes its wings, becomes like the infinitely thin blade of an axe buried in the stone, opens and shuts its wings, flies off.

There is a paragraph by Marx which exists in the same solitude.

> The *human* essence of nature first exists only for *social* man; for only here does nature exist as the *foundation* of his own *human* existence. Only here has what is to him his *natural* existence become his *human* existence, and nature become man for him. Thus *society* is the unity of being of man with nature – the true resurrection of nature – the naturalism of man and the humanism of nature both brought to fulfillment. (Karl Marx: *Philosophical and Economic Manuscripts*)

1974

353

Field

'Life is not a walk across an open field' – Russian proverb

Shelf of a field, green, within easy reach, the grass on it not yet high, papered with blue sky through which yellow has grown to make pure green, the surface colour of what the basin of the world contains, attendant field, shelf between sky and sea, fronted with a curtain of printed trees, friable at its edges, the corners of it rounded, answering the sun with heat, shelf on a wall through which from time to time a cuckoo is audible, shelf on which she keeps the invisible and intangible jars of her pleasure, field that I have always known, I am lying raised up on one elbow wondering whether in any direction I can see beyond where you stop. The wire around you is the horizon.

Remember what it was like to be sung to sleep. If you are fortunate, the memory will be more recent than childhood. The repeated lines of words and music are like paths. These paths are circular and the rings they make are linked together like those of a chain. You walk along these paths and are led by them in circles which lead from one to the other, further and further away. The field upon which you walk and upon which the chain is laid is the song.

Into the silence, which was also at times a roar, of my thoughts and questions forever returning to myself to search there for an explanation of my life and its purpose, into this concentrated tiny hub of dense silent noise came the cackle of a hen from a nearby back garden, and at that moment that cackle, its distinct sharp-edged existence beneath a blue sky with white clouds, induced in me an intense awareness of freedom. The noise of the hen, which I could not even see, was an event (like a dog running or an artichoke flowering) in a field which until then had been awaiting a first event in order to become itself realisable. I knew that in that field I could listen to all sounds, all music.

From the city centre there are two ways back to the satellite city in which I live: the main road with a lot of traffic, and a side road which goes

over a level crossing. The second is quicker unless you have to wait for a train at the crossing. During the spring and early summer I invariably take the side road, and I find myself hoping that the level crossing will be shut. In the angle between the railway lines and the road there is field, surrounded on its other two sides by trees. The grass is tall in the field and in the evening when the sun is low, the green of the grass divides into light and dark grains of colour – as might happen to a bunch of parsley if lit up by the beam of a powerful lamp at night. Blackbirds hide in the grass and rise up from it. Their coming and going remains quite unaffected by the trains.

This field affords me considerable pleasure. Why then do I not sometimes walk there – it is quite near my flat – instead of relying on being stopped there by the closed level crossing? It is a question of contingencies overlapping. The events which take place in the field – two birds chasing one another, a cloud crossing the sun and changing the colour of the green – acquire a special significance because they occur during the minute or two during which I am obliged to wait. It is as though these minutes fill a certain area of time which exactly fits the spatial area of the field. Time and space conjoin.

The experience which I am attempting to describe by one tentative approach after another is very precise and is immediately recognizable. But it exists at a level of perception and feeling which is probably preverbal – hence, very much, the difficulty of writing about it.

Undoubtedly this experience must have a psychological history, beginning in infancy, which might be explained in psychoanalytic terms. But such explanations do not generalise the experience, they merely systematise it. The experience in one form or another is, I believe, a common one. It is seldom referred to only because it is nameless.

Let me now try to describe this experience diagrammatically in its ideal mode. What are the simplest things that can be said about it? The experience concerns a field. Not necessarily the same one. Any field, if perceived in a certain way, may offer it. But the *ideal* field, the field most likely to generate the experience, is:

1. A grass field. Why? It must be an area with boundaries which are visible – though not necessarily regular; it cannot be an unbounded segment of nature the limits to which are only set by the natural focus of your eyes. Yet within the area there should be a minimum of order, a minimum of planned events. Neither crops nor regularly planted lines of fruit trees are ideal.

2. A field on a hillside, seen either from above like a table top, or from below when the incline of the hill appears to tilt the field towards you – like music on a music stand. Again, why? Because then the effects of perspective are reduced to a minimum and the relation between what is distant and near is a more equal one.

3. Not a field in winter. Winter is a season of inaction when the range of what is likely to happen is reduced.

4. A field which is not hedged on all sides: ideally, therefore, a continental rather than an English field. A completely hedged field with only a couple of gates leading into it limits the number of possible exits or entrances (except for birds).

Two things might be suggested by the above prescriptions. The ideal field would apparently have certain qualities in common with (a) a painting – defined edges, an accessible distance, and so on; and (b) a theatre-in-the-round stage – an attendant openness to events, with a maximum possibility for exits and entrances.

I believe, however, that suggestions like this are misleading, because they invoke a cultural context which, if it has anything whatsoever to do with the experience in question, can only refer *back* to it rather than precede it.

Given the ideal field now suggested, what are the further constitutive elements of the experience? It is here that the difficulties begin. You are before the field, although it seldom happens that your attention is drawn to the field before you have noticed an event within it. Usually the event draws your attention to the field, and, almost instantaneously, your own awareness of the field then gives a special significance to the event.

The first event – since every event is part of a process – invariably leads to other, or, more precisely, invariably leads you to observe others in the field. The first event may be almost anything, provided that it is not in itself overdramatic.

If you saw a man cry out and fall down, the implications of the event would immediately break the self-sufficiency of the field. You would run into it from the outside. You would try to take him out of it. Even if no physical action is demanded, any over-dramatic event will have the same disadvantage.

If you saw a tree being struck by lightning, the dramatic force of the event would inevitably lead you to interpret it in terms which at that moment would seem larger than the field before you. So, the first event should not be over-dramatic but otherwise it can be almost anything:

Two horses grazing.

A dog running in narrowing circles.

An old woman looking for mushrooms.

A hawk hovering above.

Finches chasing each other from bush to bush.

Chickens pottering.

Two men talking.

A flock of sheep moving exceedingly slowly from one corner to the centre.

A voice calling.

A child walking.

The first event leads you to notice further events which may be consequences of the first, or which may be entirely unconnected with it except that they take place in the same field. Often the first event which fixes your attention is more obvious than the subsequent ones. Having noticed the dog, you notice a butterfly. Having noticed the horses, you hear a woodpecker and then see it fly across a corner of the field. You watch a child walking and when he has left the field deserted and eventless, you notice a cat jump down into it from the top of a wall.

By this time you are within the experience. Yet saying this implies narrative time and the essence of the experience is that it takes place outside such time. The experience does not enter into the narrative of your life – that narrative which, at one level or another of your consciousness, you are continually retelling and developing to yourself. On the contrary, this narrative is interrupted. The visible extension of the field in space displaces awareness of your own lived time. By what precise mechanism does it do this?

You relate the events which you have seen and are still seeing to the field. It is not only that the field frames them, it also *contains* them. The existence of the field is the precondition for their occurring in the way that they have done and for the way in which others are still occurring. All events exist as definable events by virtue of their relation to other events. You have defined the events you have seen primarily (but not necessarily exclusively) by relating them to the event of the field, which at the same time is literally and symbolically the *ground* of the events which are taking place within it.

You may complain that I have now suddenly changed my use of the word 'event'. At first I referred to the field as a space awaiting events; now I refer to it as an event in itself. But this inconsistency parallels exactly the apparently illogical nature of the experience. Suddenly an experience of disinterested observation opens in its centre and gives birth to a happiness which is instantly recognisable as your own.

The field that you are standing before appears to have the same proportions as your own life.

1971

From *The White Bird*

(US title *The Sense of Sight*)

The White Bird

From time to time I have been invited by institutions – mostly American – to speak about aesthetics. On one occasion I considered accepting and I thought of taking with me a bird made of white wood. But I didn't go. The problem is that you can't talk about aesthetics without talking about the principle of hope and the existence of evil. During the long winters the peasants in certain parts of the Haute Savoie used to make wooden birds to hang in their kitchens and perhaps also in their chapels. Friends who are travellers have told me that they have seen similar birds, made according to the same principle, in certain regions of Czechoslovakia, Russia and the Baltic countries. The tradition may be more widespread.

The principle of the construction of these birds is simple enough, although to make a fine bird demands considerable skill. You take two bars of pine wood, about six inches in length, a little less than one inch in height and the same in width. You soak them in water so that the wood has the maximum pliability, then you carve them. One piece will be the head and body with a fan tail, the second piece will represent the wings. The art principally concerns the making of the wing and tail feathers. The whole block of each wing is carved according to the silhouette of a single feather. Then the block is sliced into thirteen thin layers and these are gently opened out, one by one, to make a fan shape. Likewise for the second wing and for the tail feathers. The two pieces of wood are joined together to form a cross and the bird is complete. No glue is used and there is only one nail where the two pieces of wood cross. Very light, weighing only two or three ounces, the birds are usually hung on a thread from an overhanging mantelpiece or beam so that they move with the air currents.

It would be absurd to compare one of these birds to a Van Gogh self-portrait or a Rembrandt crucifixion. They are simple, home-made objects, worked according to a traditional pattern. Yet, by their very

simplicity, they allow one to categorize the qualities which make them pleasing and mysterious to everyone who sees them.

First there is a figurative representation – one is looking at a bird, more precisely a dove, apparently hanging in mid-air. Thus, there is a reference to the surrounding world of nature. Secondly, the choice of subject (a flying bird) and the context in which it is placed (indoors where live birds are unlikely) render the object symbolic. This primary symbolism then joins a more general, cultural one. Birds, and doves in particular, have been credited with symbolic meanings in a very wide variety of cultures.

Thirdly, there is a respect for the material used. The wood has been fashioned according to its own qualities of lightness, pliability and texture. Looking at it, one is surprised by how well wood becomes bird. Fourthly, there is a formal unity and economy. Despite the object's apparent complexity, the grammar of its making is simple, even austere. Its richness is the result of repetitions which are also variations. Fifthly, this man-made object provokes a kind of astonishment: how on earth was it made? I have given rough indications above, but anyone unfamiliar with the technique wants to take the dove in his hands and examine it closely to discover the secret which lies behind its making.

These five qualities, when undifferentiated and perceived as a whole, provoke at least a momentary sense of being before a mystery. One is looking at a piece of wood that has become a bird. One is looking at a bird that is somehow more than a bird. One is looking at something that has been worked with a mysterious skill and a kind of love.

Thus far I have tried to isolate the qualities of the white bird which provoke an aesthetic emotion. (The word 'emotion', although designating a motion of the heart and of the imagination, is somewhat confusing for we are considering an emotion that has little to do with the others we experience, notably because the self here is in a far greater degree of abeyance.) Yet my definitions beg the essential question. They reduce aesthetics to art. They say nothing about the relation between art and nature, art and the world.

Before a mountain, a desert just after the sun has gone down, or a fruit tree, one can also experience aesthetic emotion. Consequently we are forced to begin again – not this time with a man-made object but with the nature into which we are born.

Urban living has always tended to produce a sentimental view of nature. Nature is thought of as a garden, or a view framed by a window, or as an arena of freedom. Peasants, sailors, nomads have known better. Nature is energy and struggle. It is what exists without any promise. If it can be thought of by man as an arena, a setting, it has to be thought of as one which lends itself as much to evil as to good. Its energy is fearsomely indifferent. The first necessity of life is shelter. Shelter against nature.

362

The first prayer is for protection. The first sign of life is pain. If the Creation was purposeful, its purpose is a hidden one which can only be discovered intangibly within signs, never by the evidence of what happens.

It is within this bleak natural context that beauty is encountered, and the encounter is by its nature sudden and unpredictable. The gale blows itself out, the sea changes from the colour of grey shit to aquamarine. Under the fallen boulder of an avalanche a flower grows. Over the shanty town the moon rises. I offer dramatic examples so as to insist upon the bleakness of the context. Reflect upon more everyday examples. However it is encountered, beauty is always an exception, always *in despite of.* This is why it moves us.

It can be argued that the origin of the way we are moved by natural beauty was functional. Flowers are a promise of fertility, a sunset is a reminder of fire and warmth, moonlight makes the night less dark, the bright colours of a bird's plumage are (atavistically even for us) a sexual stimulus. Yet such an argument is too reductionist, I believe. Snow is useless. A butterfly offers us very little.

Of course the range of what a given community finds beautiful in nature will depend upon its means of survival, its economy, its geography. What Eskimos find beautiful is unlikely to be the same as what the Ashanti found beautiful. Within modern class societies there are complex ideological determinations: we know, for instance, that the British ruling class in the eighteenth century disliked the sight of the sea. Equally, the social use to which an aesthetic emotion may be put changes according to the historical moment: the silhouette of a mountain can represent the home of the dead or a challenge to the initiative of the living. Anthropology, comparative studies of religion, political economy and Marxism have made all this clear.

Yet there seem to be certain constants which all cultures have found 'beautiful': among them – certain flowers, trees, forms of rock, birds, animals, the moon, running water . . .

One is obliged to acknowledge a coincidence or perhaps a congruence. The evolution of natural forms and the evolution of human perception have coincided to produce the phenomenon of a potential recognition: what *is* and what we can see (and by seeing also feel) sometimes meet at a point of affirmation. This point, this coincidence, is two-faced: what has been seen is recognized and affirmed and, at the same time, the seer is affirmed by what he sees. For a brief moment one finds oneself – without the pretensions of a creator – in the position of God in the first chapter of Genesis . . . And he saw that *it was* good. The aesthetic emotion before nature derives, I believe, from this double affirmation.

Yet we do not live in the first chapter of Genesis. We live – if one

follows the biblical sequence of events – after the Fall. In any case, we live in a world of suffering in which evil is rampant, a world whose events do not confirm our Being, a world that has to be resisted. It is in this situation that the aesthetic moment offers hope. That we find a crystal or a poppy beautiful means that we are less alone, that we are more deeply inserted into existence than the course of a single life would lead us to believe. I try to describe as accurately as possible the experience in question; my starting point is phenomenological, not deductive; its form, perceived as such, becomes a message that one receives but cannot translate because, in it, all is instantaneous. For an instant, the energy of one's perception becomes inseparable from the energy of the creation.

The aesthetic emotion we feel before a man-made object – such as the white bird with which I started – is a derivative of the emotion we feel before nature. The white bird is an attempt to translate a message received from a real bird. All the languages of art have been developed as an attempt to transform the instantaneous into the permanent. Art supposes that beauty is not an exception – is not *in despite of* – but is the basis for an order.

Several years ago, when considering the historical face of art, I wrote that I judged a work according to whether or not it helped men in the modern world claim their social rights. I hold to that. Art's other, transcendental face raises the question of man's ontological right.

The notion that art is the mirror of nature is one that only appeals in periods of scepticism. Art does not imitate nature, it imitates a creation, sometimes to propose an alternative world, sometimes simply to amplify, to confirm, to make social the brief hope offered by nature. Art is an organized response to what nature allows us to glimpse occasionally. Art sets out to transform the potential recognition into an unceasing one. It proclaims man in the hope of receiving a surer reply . . . the transcendental face of art is always a form of prayer.

The white wooden bird is wafted by the warm air rising from the stove in the kitchen where the neighbours are drinking. Outside, in minus 25°C, the real birds are freezing to death!

1985

The Storyteller

Now that he has gone down, I can hear his voice in the silence. It carries from one side of the valley to the other. He produces it effortlessly, and, like a yodel, it travels like a lasso. It turns to come back after it has attached the hearer to the shouter. It places the shouter at the centre. His cows respond to it as well as his dog. One evening two cows were missing after we had chained them all in the stable. He went and called. The second time he called the two cows answered from deep in the forest, and a few minutes later they were at the stable door, just as night fell.

The day before he went down, he brought the whole herd back from the valley at about two in the afternoon – shouting at the cows, and at me to open the stable doors. Muguet was about to calve – the two forefeet were already out. The only way to bring her back was to bring the whole herd back. His hands were trembling as he tied the rope round the forefeet. Two minutes pulling and the calf was out. He gave it to Muguet to lick. She mooed, making a sound a cow never makes on other occasions – not even when in pain. A high, penetrating, mad sound. A sound stronger than complaint, and more urgent than greeting. A little like an elephant trumpeting. He fetched the straw to bed the calf on. For him these moments are moments of triumph: moments of true gain: moments which unite the foxy, ambitious, hard, indefatigable, seventy-year-old cattle-raiser with the universe which surrounds him.

After working each morning we used to drink coffee together and he would talk about the village. He remembered the date and the day of the week of every disaster. He remembered the month of every marriage of which he had a story to tell. He could trace the family relations of his protagonists to their second cousins by marriage. From time to time I caught an expression in his eyes, a certain look of complicity. About what? About something we share despite the obvious differences. Some-

thing that joins us together but is never directly referred to. Certainly not the little work I do for him. For a long time I puzzled over this. And suddenly I realized what it was. It was his recognition of our equal intelligence; we are both historians of our time. We both see how events fit together.

In that knowledge there is – for us – both pride and sadness. Which is why the expression I caught in his eyes was both bright and consoling. It was the look of one storyteller to another. I am writing on pages like these which he will not read. He sits in the corner of his kitchen, his dog fed, and sometimes he talks before he goes to bed. He goes to bed early after drinking his last cup of coffee for the day. I am seldom there and unless he were personally telling me the stories I wouldn't understand them because he speaks in patois. The complicity remains however.

I have never thought of writing as a profession. It is a solitary independent activity in which practice can never bestow seniority. Fortunately anyone can take up the activity. Whatever the motives, political or personal, which have led me to undertake to write something, the writing becomes, as soon as I begin, a struggle to give meaning to experience. Every profession has limits to its competence, but also its own territory. Writing, as I know it, has no territory of its own. The act of writing is nothing except the act of approaching the experience written about; just as, hopefully, the act of reading the written text is a comparable act of approach.

To approach experience, however, is not like approaching a house. Experience is indivisible and continuous, at least within a single lifetime and perhaps over many lifetimes. I never have the impression that my experience is entirely my own, and it often seems to me that it preceded me. In any case experience folds upon itself, refers backwards and forwards to itself through the referents of hope and fear; and, by the use of metaphor which is at the origin of language, it is continually comparing like with unlike, what is small with what is large, what is near with what is distant. And so the act of approaching a given moment of experience involves both scrutiny (closeness) and the capacity to connect (distance). The movement of writing resembles that of a shuttlecock: repeatedly it approaches and withdraws, closes in and takes its distance. Unlike a shuttlecock, however, it is not fixed to a static frame. As the movement of writing repeats itself, its nearness to, its intimacy with the experience increases. Finally, if one is fortunate, meaning is the fruit of this intimacy.

For the old man, who talks, the meaning of his stories is more certain but no less mysterious. Indeed the mystery is more openly acknowledged. I will try to explain what I mean by that.

All villages tell stories. Stories of the past, even of the distant past. As I was walking in the mountains with another friend of seventy by the foot

of a high cliff, he told me how a young girl had fallen to her death there, whilst hay-making on the alpage above. Was that before the war? I asked. In about 1800 (no misprint), he said. And stories of the very same day. Most of what happens during a day is recounted by somebody before the day ends. The stories are factual, based on observations or on an account given by somebody else. A combination of the sharpest observation of the daily recounting of the day's events and encounters, and of life-long mutual familiarities is what constitutes so-called village *gossip*. Sometimes there is a moral judgement implicit in the story, but this judgement – whether just or unjust – remains a detail: the story *as a whole* is told with some tolerance because it involves those with whom the storyteller and listener are going to go on living.

Very few stories are narrated either to idealize or condemn; rather they testify to the always slightly surprising range of the possible. Although concerned with everyday events, they are mystery stories. How is it that C, who is so punctilious in his work, overturned his haycart? How is it that L is able to fleece her lover J of everything, and how is it that J, who normally gives nothing away to anybody, allows himself to be fleeced?

The story invites comment. Indeed it creates it, for even total silence is taken as a comment. The comments may be spiteful or bigoted, but, if so, they themselves will become a story and thus, in turn, become subject to comment. How is it that F never lets a single chance go by of damning her brother? More usually the comments, which add to the story, are intended and taken as the commentator's personal response – in the light of that story – to the riddle of existence. Each story allows everyone to define himself.

The function of these stories, which are, in fact, close, oral, daily history, is to allow the whole village to define itself. The life of a village, as distinct from its physical and geographical attributes, is the sum of all the social and personal relationships existing within it, plus the social and economic relations – usually oppressive – which link the village to the rest of the world. But one could say something similar about the life of some large town. Even of some cities. What distinguishes the life of a village is that it is also *a living portrait of itself*: a communal portrait, in that everybody is portrayed and everybody portrays; and this is only possible if everybody knows everybody. As with the carvings on the capitals in a Romanesque church, there is an identity of spirit between what is shown and how it is shown – as if the portrayed were also the carvers. A village's portrait of itself is constructed, not out of stone, but out of words, spoken and remembered: out of opinions, stories, eyewitness reports, legends, comments and hearsay. And it is a continuous portrait; work on it never stops.

Until very recently the only material available to a village and its

peasants for defining themselves was their own spoken words. The village's portrait of itself was – apart from the physical achievements of their work – the only reflection of the meaning of their existence. Nothing and nobody else acknowledged such a meaning. Without such a portrait – and the 'gossip' which is its raw material – the village would have been forced to doubt its own existence. Every story and every comment on the story which is a proof that the story has been *witnessed* contributes to the portrait, and confirms the existence of the village.

This continuous portrait, unlike most, is highly realistic, informal and unposed. Like everybody else, and perhaps more so, given the insecurity of their lives, peasants have a need for formality and this formality is expressed in ceremony and ritual, but as makers of their own communal portrait they are informal because this informality corresponds closer to the truth: the truth which ceremony and ritual can only partially control. All weddings are similar but every marriage is different. Death comes to everyone but one mourns alone. That is the truth.

In a village, the difference between what is known about a person and what is unknown is slight. There may be a number of well-guarded secrets but, in general, deceit is rare because impossible. Thus there is little inquisitiveness – in the prying sense of the term – for there is no great need for it. Inquisitiveness is the trait of the city *concierge* who can gain a little power or recognition by telling X what he doesn't know about Y. In the village X already knows it. And thus too there is little performing: peasants do not *play roles* as urban characters do.

This is not because they are 'simple' or more honest or without guile, it is simply because the space between what is unknown about a person and what is generally known – and this is the space for all performance – is too small. When peasants play, they play practical jokes. As when four men, one Sunday morning when the village was at mass, fetched all the wheelbarrows used for cleaning out the stables and lined them up outside the church porch so that as each man came out he was obliged to find his barrow and wheel it, he in his Sunday clothes, through the village street! This is why the village's continual portrait of itself is mordant, frank, sometimes exaggerated but seldom idealized or hypocritical. And the significance of this is that hypocrisy and idealization close questions, whereas realism leaves them open.

There are two forms of realism. Professional and traditional. Professional realism, as a method chosen by an artist or a writer like myself, is always consciously political; it aims to shatter an opaque part of the ruling ideology, whereby, normally, some aspect of reality is consistently distorted or denied. Traditional realism, always popular in its origins, is in a sense more scientific than political. Assuming a fund of empirical knowledge and experience, it poses the riddle of the unknown. How is it

that . . .? Unlike science it can live without the answer. But its experience is too great to allow it to ignore the question.

Contrary to what is usually said, peasants are interested in the world beyond the village. Yet it is rare for a peasant to remain a peasant and be able to move. He has no choice of locality. His place was a given at the very moment of his conception. And so if he considers his village the centre of the world, it is not so much a question of parochialism as a phenomenological truth. His world has a centre (mine does not). He believes that what happens in the village is typical of human experience. This belief is only naïve if one interprets it in technological or organizational terms. He interprets it in terms of the species *man*. What fascinates him is the typology of human characters in all their variations, and the common destiny of birth and death, shared by all. Thus the foreground of the village's living portrait of itself is extremely specific whilst the background consists of the most open, general, and never entirely answerable questions. Therein is the acknowledged mystery.

The old man knows that I know this as sharply as he does.

1978

The Eaters and the Eaten

'The consumer society', so often and widely discussed as if it were a relatively new phenomenon, is the logical outcome of economic and technological processes which began at least a hundred years ago. Consumerism is intrinsic to nineteenth-century bourgeois culture. Consumption fulfils a cultural as well as an economic need. The nature of this need becomes clearer if we look at the most direct and simple form of consumption: eating.

How does the bourgeois approach his food? If we isolate and define this specific approach we will be able to recognize it when it is far more widely diffused.

The question could become complex because of national and historical differences. The French bourgeois attitude to food is not the same as the English. A German mayor sits down to his dinner with a somewhat different attitude from a Greek mayor. A fashionable banquet in Rome is not quite the same as one in Copenhagen. Many of the eating habits and attitudes described in Trollope and Balzac are no longer to be found anywhere.

Nevertheless an overall view, an outline, emerges if one compares the bourgeois manner of eating with the one, within the same geographical areas, from which it is most distinct: the peasant manner of eating. Working-class eating habits have less tradition than those of the other two classes because they are far more vulnerable to fluctuations of the economy.

On a world scale, the distinction between bourgeois and peasant is closely related to the brute contrast between plenty and scarcity. This contrast amounts to a war. But, for our limited purpose now, the distinction is not between the hungry and the overfed, but between two traditional views of the value of food, the significance of the meal and the act of eating.

At the outset it is worth noting a conflict in the bourgeois view. On the one hand, meals have a regular and symbolic importance in the life of the bourgeois. On the other hand, he considers that to discuss eating is frivolous. This article, for example, cannot by its nature be serious; and if it takes itself seriously, it is pretentious. Cookbooks are bestsellers and most newspapers have their food columns. But what they discuss is considered a mere embellishment and is (mostly) the domain of women. The bourgeois does not think of the act of eating as a fundamental one.

The principal regular meal. For the peasant this meal is usually at midday; for the bourgeois it is usually dinner in the evening. The practical reasons for this are so obvious that they need not be listed. What may be significant is that the peasant meal is in the middle of the day, surrounded by work. It is placed in the day's stomach. The bourgeois meal comes after the day's work and marks the transition between day and evening. It is closer to the day's head (if the day begins with getting to the feet) and to dreams.

At the peasant's table the relationship between implements, food and eaters is intimate, and a value is conferred on use and handling. Each person has his own knife which he may well take out of his pocket. The knife is worn, used for many purposes other than eating, and usefully sharp. Whenever possible the same plate is kept throughout the meal, and between dishes it is cleaned with bread which is eaten. Each eater takes his share of the food and drink which are placed before all. For example: he holds the bread to his body, cuts a piece of it towards himself, and puts the bread down for another. Likewise with cheese or sausage. Contiguity as between uses, users and foods is treated as natural. There is a minimum of division.

On the bourgeois table everything that can be is kept untouched and separate. Every dish has its own cutlery and plate. In general plates are not cleaned by eating – because eating and cleaning are distinct activities. Each eater (or a servant) holds the serving dish to allow another to serve himself. The meal is a series of discrete, untouched gifts.

To the peasant all food represents work accomplished. The work may or may not have been his own or that of his family, but if it isn't, the work represented is nevertheless directly exchangeable with his own work. Because food represents physical work, the eater's body already 'knows' the food it is going to eat. (The peasant's strong resistance to eating any 'foreign' food for the first time is partly because its origin in the work process is unknown.) He does not expect to be surprised by food – except, sometimes, by its quality. His food is familiar like his own body. Its action on his body is *continuous* with the previous action of the body (labour) on the food. He eats in the room in which the food is prepared and cooked.

To the bourgeois, food is not directly exchangeable with his own work

or activities. (The quality attributable to home-grown vegetables becomes exceptional.) Food is a commodity he buys. Meals, even when cooked at home, are purchased through a cash exchange. The purchase is delivered in a special room: the domestic dining-room, or restaurant. This room has no other purpose. It always has at least two doors or ways of entry. One door connects with his own daily life; through it he has entered in order to be served with food. The second door connects with the kitchen; through it the food is brought out and the waste is taken away. Thus, in the dining-room, food is abstracted from its own production and from the 'real' world of his daily activities. Behind the two doors lie secrets: secrets of recipes behind the kitchen door; professional or personal secrets, not to be discussed at table, behind the other.

Abstracted, framed, insulated, the eaters and what is eaten form an isolated moment. This moment has to create its own content out of the air. The content tends to be theatrical: the décor of the table with its silver, glass, linen, china, etc.; the lighting; the relative formality of dress; the careful seating arrangements whenever there are guests; the ritualistic etiquette of table manners; the formality of serving; the transformation of the table between each act (course); and, finally, the leaving of the theatre together for a more dispersed and informal setting.

To the peasant, food represents work done and therefore repose. The fruit of labour is not only the 'fruit' but also the time taken from work time, spent in eating the food. Feasts apart, he accepts at table the sedative effect of eating. The appetite, satisfied, is quietened.

To the bourgeois the drama of eating, far from being reposeful, is a stimulus. The theatrical invitation of the scene often provokes family dramas at meal times. The scene of the typical oedipal drama is not, as logically it might be, the bedroom, but the dinner table. The dining-room is the place of assembly where the bourgeois family appears to itself in public guise, and where its conflicting interests and power struggles are pursued in a highly formalized manner. The ideal bourgeois drama, however, is entertainment. The use of the word 'entertain' meaning to invite guests is significant here. Yet entertainment always proposes its opposite: boredom. Boredom haunts the insulated dining-room. Hence the conscious emphasis placed on dinner talk, wit and conversation. But the spectre of boredom also characterizes the way of eating.

The bourgeois overeats. Especially meat. A psychosomatic explanation may be that his highly developed sense of competition compels him to protect himself with a source of energy – proteins. (Just as his children protect themselves from the emotional cold with sweets.) The cultural explanation, however, is as important. If the scale of the meal is *spectacular*, all the eaters share in its achievement, and boredom is less likely. The shared achievement is not, fundamentally, culinary. The achievement is that of wealth. What wealth has obtained from nature

is an affidavit that overproduction and infinite increase are natural. The variety, the quantity, the waste of food prove the *naturalness* of wealth.

In the nineteenth century with partridge, mutton and porridge for breakfast (in England), and three meats and two fish for dinner, the quantities were net, the proof extracted from nature arithmetical. Today with modern means of transport and refrigeration, the accelerated pace of daily life and a different use of the 'servant' classes, the spectacular is achieved in another way. The most varied and exotic foods are acquired out of season, and the dishes come from all over the world. Canard à la Chinoise is placed beside Steak Tartare and Boeuf Bourguignon. The affidavit obtained is no longer just from nature concerning quantity. It is also from history to testify how wealth unites the world.

By using the vomitorium the Romans separated the palate from the stomach in the pursuit of 'pleasure'. The bourgeois separates the act of eating from the body so that it can become, first, a spectacular social claim. The significance of the act of eating asparagus is not: I am eating this with pleasure; but: we *can* eat this here and now. The typical bourgeois meal is for each eater a series of discrete gifts. Each gift should be a surprise. But the message in each gift is the same: *happy the world which feeds you.*

The distinction between the principal regular meal and the celebration or feast is very clear for the peasant, and often blurred for the bourgeois. (Which is why some of what I have written above borders, for the bourgeois, on the feast.) For the peasant what he eats and how he eats daily are continuous with the rest of his life. The rhythm of this life is cyclic. The repetition of meals is similar to, and connected with, the repetition of the seasons. His diet is local and seasonal. And so the foods available, the methods of cooking them, the variations in his diet, mark recurring moments throughout a lifetime. To become bored with eating is to be bored with life. This happens, but only to people whose unhappiness is very pronounced. The feast, small or large, is made to mark a special recurring moment or an unrepeatable occasion.

The bourgeois feast usually has more of a social than temporal significance. It is less a notch in time than the fulfilling of a social desideratum.

The feast for the peasant, when once the occasion has been given, begins with food and drink. It does so because food and drink have been reserved or put aside, on account of their rarity or special quality, for just such an occasion. Any feast, even if it is impromptu, has been partly prepared for for years. A feast is the consuming of the surplus saved and produced over and above daily needs. Expressing and using up some of this surplus, the feast is a double celebration – of the occasion which gives rise to it, and of the surplus itself. Hence its slow tempo, its generosity and the active high spirits which accompany it.

The feast for the bourgeois is an additional expense. What distinguishes its food from that of an ordinary meal is the amount of money spent. The true celebration of a surplus is beyond him, because he can never have a surplus of money.

The purpose of these comparisons is not to idealize the peasant. Peasant attitudes are mostly, in the strict sense of the word, *conservative*. At least until recently, the physical reality of the peasant's conservatism has hindered his understanding of the political realities of the modern world. These realities were originally a bourgeois creation. The bourgeois once had, and still to some degree retains, a mastery of the world of his own making.

I have tried to outline by using comparisons two modes of acquisition, of possessing, through the act of eating. If one examines each point of comparison, it becomes clear that the peasant way of eating is centred on the act of eating itself and on the food eaten: it is centripetal and physical. Whereas the bourgeois way of eating is centred on fantasy, ritual and spectacle: it is centrifugal and cultural. The first can complete itself in satisfaction; the second is never complete and gives rise to an appetite which, in essence, is insatiable.

1976

On the Bosphorus

For ten days I kept notes (after ten days we fast become ignorant habitués), with the idea of later being able to reconstruct my first impressions of Istanbul.

The reconstruction was not so simple as it might have been. Political violence, including a massacre at Maras, had forced Prime Minister Bülent Ecevit to declare a state of siege in thirteen of the provinces.

Why describe the tiles of Rustan Pasa mosque – their deep red and green lost in an even deeper blue – in a city where martial law has just been declared?

In Turkish, the Bosphorus is called the straits of the throat, the place of the stranglehold. It has featured for millennia in every global strategy. In 1947 Truman claimed an essential strategic interest in Turkey, just as, after the First World War, Britain and France had done. But whereas the Turks fought and won their war of independence (1918–23) against the first claim, they were powerless against the second.

American intervention in Turkish politics has been constant ever since. Nobody in Turkey doubts that the destabilizing programme of the right is backed by the CIA. The United States probably fears two things: the repercussions in Turkey of the fall of the Shah in Iran, unless there is a 'strong' government in Ankara; and Ecevit's reform programme which, though moderate, is not compliant with western interests, and revives some of the promise of Atatürk's independence movement. Among many other consequences, if Ecevit is ousted, the American-trained torturers will return to their prison posts.

When the ferry leaves Kadikoy on the Asian side of the Bosphorus, on your right you see the massive block of the Selemiye barracks, with its four towers, sentinels at each corner. In 1971 – the last time there was martial law in Istanbul – many political prisoners (nearly all of the left) were interrogated there. If you look the other way, you see the railway station of Hayderpasa and the buffers, only a few yards from the water, stopping the lines which

come from Baghdad, Calcutta and Goa. Nazim Hikmet, who spent thirteen years in Turkish prisons, wrote many lines about this railway station:

> A smell of fish in the sea
> bugs on every seat
> > spring has come to the station
> Baskets and bags
> > descend the station steps
> > go up the station steps
> > stop on the steps
> Beside a policeman a boy
> – of five, perhaps less –
> > goes down the steps.
> He has never had any papers
> but he is called Kemal.
> A bag
> a carpet bag climbs the steps.
> Kemal descending the steps
> > barefoot and shirtless
> > > is quite alone
> > > > in this beautiful world.
> He has no memories except of hunger
> > and then vaguely
> > > of a woman in a dark room.

Across the water, in the early morning sunlight, the mosques are the colour of ripe honeydew melons. The Blue Mosque with its six piercing minarets. Santa Sophia, taking advantage of its hill, immense, dominating its minarets so that they look no more than guardians of a breast. The so-called New Mosque, finished in 1660. On overcast days the same buildings across the straits look dull and grey, like the skin of cooked carp. I glance back now at the bleak towers of the Selemiye barracks.

Thousands of jellyfish of all sizes, as large as dishes, as small as eggcups, contract and distend in the current. They are milky and half-transparent. The local pollution has killed off the mackerel who used to eat the jellyfish. Hence their profusion in hundreds of thousands. Popularly they are called water cunts.

Hundreds of people crowd the boat. Most of them commute every day. A few, who stand out because of their clothes and the amazement to be read on their faces, are crossing into Europe for the first time, and have come from distant parts of Anatolia. A woman of thirty-five, wearing a scarf over her hair and baggy cotton trousers, sits on the uppermost deck in the sunshine which dazzles off the surface of the water.

The plain of central Anatolia, surrounded by mountains, with deep snow in the winter and the dust of rocks in the summer, was one of the

first sites of neolithic agriculture, and the communities were peace-loving and matriarchal. Today, eroded, it risks becoming a desert. The villages are dominated by the *aghas*, thieving officials who are also landowners. There has been no effective land reform, and the average annual income in 1977 was £10–£20.

Deliberately the woman holds her husband's hand. He is all that remains of the familiar. Together they look across at the famous skyline which is the breathtaking, incandescent, perfumed half-truth of the city. The hand which she holds is like many of the hands resting on laps on the deck. The idiom of the popular male Turkish hand: broad, heavy, plumper than you would guess (even when the body is emaciated), calloused, strong. Hands which do not look as if they have grown out of the earth like vines – the hands of old Spanish peasants, for example – but nomad hands which travel across the earth.

Speaking of his narrative poems, Hikmet once said he wanted to make poetry like a material for shirts, very fine, half silk, half cotton: silks which are also democratic because they absorb the sweat.

A beggar woman stands by the door to the saloon on the lower deck. In contrast to the heaviness of the male hands, the woman's hands are light. Hands which make cakes of dried cow dung for burning in central Anatolia, hands which plait the daughter's hair into strands. On her arm, the beggar woman carries a basket of sick cats: an emblem of pity, off which she scrapes a living. Most of those who pass place a coin in her outstretched hand.

Sometimes first impressions gather up some of the residue of centuries. The nomadic hand is not just an image; it has a history. Meanwhile, the torturers are capable, within a few days, of breaking entire nervous systems. The hell of politics – which is why politics compulsively seeks utopias – is that it has to straddle both times: millennia and a few days. I picture the face of a friend perhaps to be imprisoned again, his wife, his children. Since the foundation of the republic, this is the ninth time that martial law has been declared to deal with internal dissent. I see his clothes still hanging neatly in the wardrobe.

When the ferry passes the headland, eleven minarets become visible, and you can see clearly the camel chimneys of the kitchens of the Sultan's palace. This palace of Topkapi housed luxury and indulgence on such a scale that they percolated into the very dreams of the West; but in reality, as you can see today, it was no more than a labyrinthine monument to a dynastic paranoia.

Turning now against the current, black diesel smoke belches from the ship's funnel, obliterating Topkapi. Forty per cent of the population of Istanbul live in shanty towns which are invisible from the centre of the city. These shanty towns – each one with a population of at least 25,000 – are insanitary, overcrowded and desperate. They are also sites of super-exploitation (a shack may be sold for as much as £5,000).

Yet the decision to migrate to the city is not a stupid one. About a quarter of the men who live in the shanty towns are unemployed. The other three-quarters work for a future which may be illusory, but which was totally inconceivable in the village. The average wage in the city is between £20 and £30 a week.

The massacre at Maras was planned by fascists backed by the CIA. Yet to know this is to know little. Eric Hobsbawm wrote[1] recently that it has taken left-wing intellectuals a long time to condemn terrorism. Today left-wing terrorism in Turkey plays into the hands of those who want to re-establish a right-wing police state such as existed between 1950 and 1960 – to the enormous benefit of the *aghas*.

Yet however much one condemns terrorism, one must recognize that its popular (minority) appeal derives from experience which is bound to remain totally untouched by such tactical, or ethical, considerations. Popular violence is as arbitrary as the labour market, not more so. The violent outbreak, whether encouraged by the right or the left, is fed by the suppressed violence of countless initiatives *not* taken. Such outbreaks are the ferment of stagnation, kept at the right temperature by broken promises. For more than fifty years, since Atatürk's republic succeeded the sultanate, the peasants of central Anatolia, who fought for their independence, have been promised land and the means to cultivate it. But such changes as there have been have led to more suffering.

In the lower-deck saloon a salesman, who has bribed the stewards to let him sell, is holding up, high for all to see, a paper folder of needles. His patter is leisurely and soft-voiced. Those who sit or stand around him are mostly men. On the folder, which holds fifteen needles of different sizes, is printed in English HAPPY HOME NEEDLE BOOK, and around this title an illustration of three young white women wearing hats and ribbons in their hair. Both needles and folder were made in Japan.

The salesman is asking 20p. Slowly, one after another, the men buy. It is a bargain, a present and an injunction. Carefully they slip the folder into one of the pockets of their thin jackets. Tonight they will give them to their wives, as if the needles were seeds for a garden.

In Istanbul the domestic interior, in both the shanty towns and elsewhere, is a place of repose, in profound opposition to what lies outside the door. Cramped, badly roofed, crooked, cherished, these interiors are spaces like prayers, both because they oppose the traffic of the world as it is, and because they are a metaphor for the Garden of Eden or Paradise.

Interiors symbolically offer the same things as Paradise: repose, flowers, fruit, quiet, soft materials, sweetmeats, cleanliness, femininity. The offer can be as imposing (and vulgar) as one of the Sultan's rooms in the harem, or it can be as modest as the printed pattern on a square of cheap cotton, draped over a cushion on the floor of a shack.

It is clear that Ecevit will try to maintain control over the initiatives of the generals who are now responsible for the rule of each province. The politico-military tradition of imprisonment, assassination and execution is still a strong one in Turkey. When considering the power and decadence of the Ottoman empire, the West conveniently overlooks the fact that this empire is what protected Turkey from the first inroads of capitalism, western colonization and the supremacy of money over every other form of power. Capital assumes within itself all earlier forms of ruthlessness, and makes the old forms obsolete. This obsolescence permits the West a basis for its global hypocrisies, of which the latest is the 'human rights' issue.

A man stands by the ship's rail, staring down at the flashing water and the ghostly water cunts. The ship, seventeen years old, was built by the Fairfield Shipbuilding and Engineering Company, Govan, Glasgow. Until five years ago, he was a shoemaker in a village not far from Bolu. It took him two days to make a pair of shoes. Then factory-made shoes began to arrive in the village, and were sold cheaper than his. The cheaper, factory-made shoes meant that some children in some villages no longer went barefoot. No longer able to sell his shoes, he went to the state factory to ask for work. They told him he could hire a stamping machine for cutting out pieces of leather.

A pair of shoes consists of twenty-eight pieces. If he wanted to hire the machine, he must cut the necessary pieces of leather for 50,000 pairs a year. The machine was delivered to his shop. By working twelve hours every day, he fulfilled his quota. At the end of every week, the pieces, stacked in piles like dogs' tongues, filled the entire shop. There was only room for him to sit on his stool by the machine.

The next year he was told that, if he wanted to keep the machine, he must now cut enough pieces for 100,000 pairs of shoes. It was impossible, he said. Yet it proved possible. He worked twelve hours during the day, and his brother-in-law worked twelve hours during the night. In the room above, which was a metaphor for Paradise, the sound of the stamping machine never stopped day or night. In a year, the two men cut nearly three million pieces.

One evening he smashed his left hand, and the noise of the machine stopped. There was quiet beneath the carpet of the room above. The machine was loaded on to a lorry, and taken back to the factory. It was after that that he came to Istanbul to look for work. The expression in his eyes, as he tells his story, is familiar. You see it in the eyes of countless men in Istanbul. These men are no longer young; yet their look is not one of resignation, it is too intense for that. Each one is looking at his own life with the same knowingness, protectiveness and indulgence as he would look on a son. A calm Islamic irony.

The subjective opposites of Istanbul are not reason and unreason, nor virtue and sin, nor believer and infidel, nor wealth and poverty – colossal

as the objective contrasts are. They are, or so it seemed to me, purity and foulness.

This polarity covers that of interior/exterior, but is not confined to it. For example, as well as separating carpet from earth, it separates milk and cow, perfume and stench, pleasure and ache. The popular luxuries – honey-sweet to the tooth, shiny to the eye, silken to the touch, fresh to the nose – offer amends for the natural foulness of the world. Many Turkish popular expressions and insults play across this polarity. 'He thinks,' they say about someone who is conceited, 'that he's the parsley in everyone's shit.'

Applied to class distinction, this same polarity of purity/foulness becomes vicious. The faces of the rich bourgeois women of Istanbul, sick with idleness, fat with sweetmeats, are among the most pitiless I have seen.

When friends of mine were prisoners in the Selemiye barracks, their wives took them attar of roses and essence of lemons.

The ferry also carries lorries. On the tailboard of a lorry from Konya is written: 'The money I make I earn with my own hands, so may Allah bless me.' The driver, with grey hair, is leaning against the bonnet, drinking tea out of a small, gilt-rimmed glass. On every deck there are vendors of tea with such glasses and bowls of sugar on brilliant copper trays. The tea drinkers sip, relax, and look at the shining water of the Bosphorus. Despite the thousands of passengers carried daily, the ferry boats are almost as clean as interiors. There are no streets to compare with their decks.

On each side of the lorry from Konya, the driver has had a small landscape painted. Both show a lake surrounded by hills. Above is the all-seeing eye, almond-shaped with long lashes, like a bridegroom's. The painted water of the lakes suggests peace and stillness. As he sips his tea, the driver talks to three small, dark-skinned men with passionate eyes. The passion may be personal, but it is also the passion you can see all over the world in the eyes of proud and oppressed minorities. The three men are Kurds.

Both in the main streets of Istanbul, and in the back streets where there are chickens and sheep, you see porters carrying bales of cloth, sheets of metal, carpets, machine parts, sacks of grain, furniture, packing cases. Most of these porters are Kurds from eastern Anatolia, on the borders of Iraq and Iran. They carry everything where the lorries cannot. And because the industrial part of the city is full of small workshops in streets too narrow for lorries, there is a great deal to carry from workplace to workplace.

Fixed to their backs is a kind of saddle, on which the load is piled and corded high above their heads. This way of carrying, and the weight of the loads, obliges them to stoop. They walk, when loaded, like jack knives

half-shut. The three now listening to the lorry driver are sitting on their own saddles, sipping tea, gazing at the water and the approach to the Golden Horn. The cords with which they fasten their loads lie loose between their feet on the deck.

Altogether, the crossing takes twenty minutes (about the time needed to read this article). Beside the landing stage rowing boats rock in the choppy water. In some of them fires burn, the flames dancing to the rhythm of the slapping water. Over the fires, men are frying fish to sell to those on their way to work.

Beyond these pans – almost as wide as the boat – of frying fish lie all the energies and torpor of the city: the workshops, the markets, the mafia, the Galata Bridge on which the crowd walking across is invariably twenty abreast (the bridge is a floating one and incessantly, almost impercept-ibly, quivers like a horse's flank), the schools, the newspaper offices, the shanty towns, the abattoir, the headquarters of the political parties, the gunsmiths, the merchants, soldiers, beggars.

These are the last moments of peace before the driver starts up the engine of his lorry, and the porters hurry to the stern of the ship to be among the first to jump ashore. The tea vendors are collecting the empty glasses. It is as if, during the crossing, the Bosphorus induces the same mood as the painted lakes: as if the ferry boat, built in Glasgow in 1961, becomes an immense floating carpet, suspended in time above the shining water, between home and work, between effort and effort, between two continents. And this suspension, which I remember so vividly, corresponds now to the destiny of the country.

1979

381

The Theatre of Indifference

A story I want to write soon concerns a man from a remote village who settles in a city. A very old story. But the late-twentieth-century city has changed the old story's meaning. Such a city, in its extreme form, I see as white and northern. Climate helps a little to regulate the frontier between public and private. A Mediterranean city, or a city in the south in the United States, is of a slightly different character.

How does such a city, in its extreme form, first strike the villager? To do justice to his impression, one must understand *what* is impressing him. One cannot accept the city's version of itself. The city has at least as many illusions about itself as he, at first, has about it.

Most things look or sound unfamiliar to him: buildings, traffic, crowds, lights, goods, words, perspectives. This newness is both shocking and exciting. It underlines the incredibility of the sentence: *I am here.*

Quickly, however, he has to find his way among people. At first he assumes that they are a traditional element in the city: that they are more or less like men and women he and his father knew. What distinguishes them are their possessions – including their ideas: but relations with them will be more or less similar. Soon he sees this is not the case. Between their expressions, under their words, through accompanying gestures of hand and body, in their glances, a mysterious and constant exchange is taking place. He asks: what is happening?

If the storyteller places himself equidistant from city and village, he may be able to offer a descriptive answer. But it will not be immediately accessible to the questioner. Economic need has forced the villager to the city. Once there, his ideological transformation begins with his questions *not* being answered.

A young woman crosses the street, or the bar, using every part of her body, her mouth, her eyes to proclaim her nubility. (He calls her *shameless* to himself, but explains it in terms of what he assumes to be

her insatiable sexuality.) Two young men pretend to fight to attract the girl's attention. Circling one another like tom-cats, they never strike a blow. (He calls them *rivals*, armed with knives.) The girl watches them with a bored look. (He calls her *too frightened* to show emotion.) Police enter. The two immediately stop fighting. The faces of the police are without a trace of expression. Their eyes scan the public and they walk off. (He calls their impassiveness *impartiality*). The mythic quality and appeal of the early Chaplin lay in his spontaneous ability to act out so convincingly such 'innocent' misinterpretations of the city.

For the first time the villager is seeing caricatures, not drawn on paper, but alive.

Graphic caricature began in eighteenth-century England and then had a second lease of life in nineteenth-century France. Today it is dead because life has outstripped it. Or, more accurately, because satire is only possible when a moral reserve still exists, and those reserves have been used up. We are too used to being appalled by ourselves to be able to react to the idea of caricature. Originally the tradition of graphic caricature constituted a rural critique of the towns, and it flourished when large areas of the countryside were first being absorbed by the new cities but before the norms of the city were accepted as natural. Drawn caricature exaggerated to the point of absurdity when compared with the supposed 'even tenor' of life. Living caricatures imply a life of unprecedented fervour, danger and hope; and to the outsider it is his exclusion from this exaggerated 'super-life' which now appears absurd.

Graphic caricatures were of social types. Their typology took account of social class, temperament, character and physique. Their content invoked class interests and social justice. The living caricatures are simply creatures of immediate circumstance. They involve no continuity. They are behaviourist. They are not caricatures of character but of performance. The roles performed may be influenced by social class. (The girl crossing the street or bar in that particular way is likely to belong to the petit rather than grand bourgeoisie; the police are mostly working class; and so on.) But the contingencies of the immediate situation hide the essential class conditions. Likewise the judgement the living caricature demands has nothing to do with social justice, but with the success or failure of the individual performance. The sum total of these performances make a collectivity. But it is the collectivity of theatre. Not a theatre of the absurd as some dramatic critics once believed, but a theatre of indifference.

Most public life in the city belongs to this theatre. Two activities, however, are excluded. The first is productive labour. And the second is the exercise of real power. These have become hidden, non-public activities. The assembly line is as private – in this sense – as the President's telephone. Public life concerns inessentials upon which

the public have been persuaded to fix their hopes. Yet truth is not so easily ousted. It returns to transform public life into theatre. If a lie is accepted as truth, the real truth turns the false one into a merely theatrical truth.

The very cohesion of public life is now charged with this theatricality. Often it extends into domestic life – but here it is less evident to the newly arrived villager. In public nobody can escape it; everyone is forced to be either spectator or performer. Some performers perform their refusal to perform. They play insignificant 'little men', or, if they are many, they may play a cohort of 'the silent majority'. The change-over from performer to spectator is almost instantaneous. It is also possible to be both at the same time: to be a performer towards one's immediate entourage and the spectator of a larger more distant performance. For example: at a railway station or in a restaurant.

The indifference is between spectator and performer. Between audience and players. The experience of every performer – that's to say everyone – has led him to believe that, as soon as he begins, the audience will leave, the theatre will empty. Equally, the experience of every spectator has led him to expect that the performance of another will be irrelevant and indifferent to his own personal situation.

The aim of the performer is to prevent at least a few members of the audience from leaving. His fear is to find himself performing in an empty theatre. (This can happen even when he is physically surrounded by hundreds of people.) There is an inverse ratio of numbers. If a performer chooses an audience of a hundred, he is, in one sense, further from his fear of an empty theatre. But a hundred can leave in seconds. If he chooses an audience of three, he will be able to hold at least one of them back for a longer period – until this third person is forced to *perform* boredom or indifference.

Performing in the theatre of indifference inevitably leads to assuming and cultivating exaggerated expressions. Including expressions of un-interest, independence, nonchalance. It leads to the hamming of every-day life. The most usual final appeal to the departing audience is violence. This may be in words (swearing, threats, shouts), in grimaces, or in action. Some crimes which take place are the theatre's purest expression.

Exaggeration and violence become habitual. The violence is in the *address* of the exaggeration. In this sense the girl's performed nubility was as violent as a pointed gun. Gradually the habit of exaggeration informs the physical being of the performer. He becomes the living caricature of the expression towards which he is most generally forced, either by temperament or situation, in his performances.

The existence of the theatre makes itself felt when there is not even a second person present, when the minimum requirement for any per-

formance (two people) is lacking. Solitude is confused with the triumph of indifference and made entirely negative. The emptied theatre becomes the image of silence itself. To be alone in silence is to have failed to retain a single member of the audience. Hence the compulsive need to walk on again: to the corner shop to buy an evening paper; to the pub for half a pint. This helps to define the particular pathos of the old in the city.

Only one thing can defeat indifference: a star performance. The star is credited with all that has been suppressed in each spectator. The star is the only form of idol in the modern city. He fills the theatre. He promises that no indifference is final.

Following the example of the great stars, who occur in every spectacular activity from sport through crime to politics, everyone can aspire to be a small star of an occasion. If there are six customers in a shop, any one of them can be made a star, by the consensus of those present, elevated, for a brief instant, to that status by a remark, a reaction or a knack of physical presence. In a crowd on an escalator, in a line of traffic at the traffic lights, in a queue at the guichet, there is a chance, like that of winning a sweepstake, for anyone to briefly fill the theatre. During that instant a purely urban pleasure passes over the temporary star's face. An unexpectedly coy pleasure, comprising modesty and conceit. Like the pleasure of a child praised for something he has done by accident.

The theatre of indifference should not be subsumed under *the artificiality of city life*. It is a new phenomenon. The social life of a village is artificial in the sense that it is highly formalized. A village funeral, for example, is more, not less, formalized than any contemporary public event in a city. The antithesis of the theatre of indifference is not spontaneous simplicity, but drama in which both the principal protagonists and the audience have a common interest.

The historical precondition for the theatre of indifference is that everyone is consciously and helplessly dependent in most areas of their life on the opinions and decisions of others. To put it symbolically: the theatre is built on the ruins of the forum. Its precondition is the failure of democracy. The indifference is the result of the inevitable divergence of personal fantasies when isolated from any effective social action. The indifference is born of the equation between excessive mobility of private fantasy and social political stasis.

In the theatre of indifference, appearances hide failure, words hide facts, and symbols hide what they refer to.

A villager cannot conceive of the theatre of indifference. He has never seen people producing such a surplus of expression over and above what is necessary to express themselves. And so he assumes that their hidden lives are as rich and mysterious as their expressions are extreme. He demeans himself because he cannot yet see the invisible – that which,

according to his imagination, must lie behind their expressions and behaviour. He believes that what is happening in the city exceeds his imagination and his previous dreams. Tragically he is right.

1975

Modigliani's Alphabet of Love

The photographs show a man who fits his own laconic description of himself: born in Livorno, Jew, painter. Sad, vital, furious and tender, a man never quite filling his own appearance, a man searching behind appearances. A man who painted unseeing eyes – often closed, and even when open without iris or pupils, and yet eyes which in their very absence speak. A man whose intimacy had always to traverse great distances. A man maybe like music, present and yet detached from the visible. And nevertheless a painter.

With Van Gogh, Modigliani is probably one of the most regarded of modern artists. I mean that literally: the most looked-at by the most people. How many postcards of Modigliani at this moment on how many walls? He appeals particularly but not exclusively to the young. The young of succeeding generations.

This popular reputation has not been much encouraged by museums and art experts. In the art world during the last forty years Amadeo Modigliani, who died sixty years ago, has been acknowledged and, mostly, left aside. He may even be the only twentieth-century painter to have won, in this sense, an independent acknowledgement. Without cultural retailers. Beyond the reach of critics. Why should this be so?

In themselves his paintings demand little explanation. Indeed they impose a kind of silence, a listening. The whirrings of analysis become more than usually pretentious. Yet the answer to the question has to be found within the paintings. A sociology of popular taste will not help much. Nor can much weight be given to the 'Modigliani legend'. His life story, lending itself easily to film and sensational biographies, his apotheosis as the *peintre maudit* of Montparnasse in its heyday, the many women in his life, his poverty, his addictions, his early death, provoking the suicide of Jeanne Hebuterne, last companion, now buried near him

in the cemetery of Père Lachaise: all this has become well known, but it has little to do with why his paintings speak to so many people.

And in this, Modigliani's case is very different from Van Gogh's. The legend of Van Gogh's life enters the paintings, the two tumults mix. Whereas Modigliani's paintings, instantly recognizable as they are, remain at a profound level anonymous. In face of them, it is not the trace or the struggle of a painter that we confront, but a completed image, its very completeness imposing a kind of listening, during which the painter slips away, and gradually through the image, the subject comes closer.

In the history of art there are portraits which *announce* the men and women portrayed – Holbein, Velázquez, Manet . . . there are others which call them back – Fra Angelico, Goya, Modigliani, among others. The special appeal of Modigliani is surely related to his method as a painter. Not his technical procedure as such, but the method by which his vision transformed the visible. All painting, even hyper-realism, transforms.

Only by considering a painting's method, the practice of its transformation, can we be confident about the direction of its image, the direction of the image's passage towards us and past us. Every painting comes from far away (many fail to reach us), yet we only receive a painting fully if we are looking in the direction from which it has come. This is why seeing a painting is so different from seeing an object.

A single drawn curve on a flat surface – not a straight line – is already playing with the special power of drawn imagery. The curve stays on the surface like that of the letter *C* when written, and, at the same time, it can leave the surface and be filled out by an approaching volume which may be a pebble, an orange, a shoulder.

Modigliani began each painting with curves. The curve of an eyebrow, the shoulders, a head, a hip, a knee, the knuckles. And after hours of work, correction, refinement, searching, he hoped to re-find, preserve, the double function of the curve. He hoped to find curves that simultaneously would be both letter and flesh, would constitute something like a person's name to those who know the person. The name which is both word and physical presence. ANTONIA.

At the time of Cubism and its collages, it was not unusual for painters to introduce written words or even single letters into their paintings. And therefore one should not attach too much importance to Modigliani doing the same. And yet when he did do so, the letters always spelt out the name of the sitter: they did in their way what the paint was doing in its way – both recalling the person.

More profound and important, however, is that where there are no words, the curves in Modigliani's paintings, the curves with which he began, are still both two-dimensional like print, and three-dimensional

like the line of a cheek or breast. It is this which gives to almost every figure painted by Modigliani something of the quality of a silhouette – although in fact these figures glow, and are, in other ways, the opposite of silhouettes. But a silhouette is both substance and two-dimensional sign. A silhouette is both writing and existence.

Let us now consider the long, often violent process by which he proceeded from the initial curves to the finished vibrant static image. What did he intuitively seek through this process? He sought an invented letter, a monogram, a shape, which would *print as permanent* the transient living form he was looking at.

The achieving of such a shape was the result of numerous corrections and redrawn simplifications. Unlike many artists, Modigliani began with a simplification and drawing was the process of letting the living form complicate it. In his masterpieces like 'Nu Assis à la Chemise' (1917), 'Elvira Assise' (1918), 'La Belle Romaine' (1917) or 'Chaim Soutine' (1916), the dialectic between simplification and complexity becomes hypnotic: what our eyes see swings like a pendulum, ceaselessly, between the two.

And it is here that we find Modigliani's remarkable visual originality. He discovered new simplifications. Or, to put it, I think, more accurately, he allowed the model, in that life and in that pose, to offer him new simplifications. When this happened, a shape, that part of the simplified invented letter, which meant an arm resting on the table, an elbow resting on a hip, a pair of legs crossed, this shape, cut for the first and unique time during the drawing of those sessions, turned like a key in its lock, and a door swung open on the very life of the limbs in question.

An invented letter, a monogram, a name, the profile of a key – each of these comparisons stresses the stamped emblematic quality of the drawing in Modigliani's paintings. But what of their colour? His colours are as instantly recognizable as his use of lines and curves. And as amazing. Nobody for at least two centuries painted flesh as radiantly as he did. And then, if in one's mind one compares him with Titian or Rubens, what is specific to his use of colour becomes clearer. It is complementary to what we have already seen about his drawing.

His colour is sensuously, mysteriously (how did he achieve that glow and bloom?) articulated to the present, to the tangible and to what extends in space, *and* it is also emblematic. The radiance of the body becomes an emblematic field of intimacy. It is at one and the same time body, and the aura of that body as lovingly perceived by another. I put it like that because the other is not necessarily or exclusively a lover in the sexual sense. The bodies painted by Modigliani are more transcendent than those painted by Titian or Rubens. They have perhaps a certain affinity with some figures by Botticelli, but Botticelli's art was social, its symbolism and myths were public, whereas Modigliani's are solitary and private.

When critics discuss the influences behind Modigliani's art (he was thirty and had seven more years to live when he achieved his true independence), they speak of the Italian primitives, Byzantine art, Ingres, Toulouse-Lautrec, Cézanne, Brancusi, African sculpture. The latter had a very direct influence on his carving which, in my opinion, is unremarkable when compared to his painting. His sculpture remains a casing: the spirit of the subject is never freed. None of the visual dialectic we have examined can easily apply to sculpture.

Yet it has always seemed to me that if Modigliani's art has a close affinity with another, it is with the art of the Russian icon – although here there was probably no direct influence. The profound affinity is not stylistic. There may sometimes be a superficial resemblance in the 'silhouettes' of the figures, but in general the icon figures are more fluid, less taut; their grace was a given, and did not have to be rescued anew each time. The resemblance lies in the quality of the presence of the figures.

They are attendant. They have been called back, and they wait. They wait with such patience, such calm, that one can almost say that they wait with abandon, and what they have abandoned is time. They are still like a coastline is still before the endless movement of the sea. They are there for when all has been said and done. And this distance – which is not a question of superiority but of span, in the sense of a roof spanning what happens in a house – means that in their presence there is a quality of absence. All this is at the first degree. At the second, as soon as they enter the mind of the spectator – and it is this which they are awaiting – they become more present than the immediate.

Obviously this affinity cannot be pushed too far. On one hand, there are religious images of a traditional faith; on the other, secular images wrenched from a lonely and tempestuous modern life. Yet Modigliani's admiration for the mystical poetry of Max Jacob, much of his reading, and the titles he gave to some of his paintings, are a reminder that he at least might not have found the comparison surprising.

Let me now resume what we have so far noticed, before attempting an answer to the question with which I began. Modigliani wanted his paintings to *name* his subjects. He wanted them to have the constancy of a sign – like a monogram or an initial – and, equally, he wanted them to possess the variability, the temperamentality, the sentience of the flesh. He wanted his paintings to summon up the presence of the sitter and to diffuse it, but diffuse it as an aura within his and the spectator's imagination or memory.

He wanted his paintings to address both the flesh and the soul. And in his best works – through his method as a painter, not through simple nostalgia or yearning – this is what he achieved.

His paintings are so widely acknowledged because they speak of love.

Often explicitly sexual, sometimes not. Many painters have painted images of lovers, others – like Picasso – have painted images polarized by their own desire, but Modigliani painted images such as love invents to picture a loved one. (When no tenderness existed between him and his model, he failed and produced mere exercises.)

That he was usually able to achieve this without sentimentality was the consequence of his extraordinary rigour. He knew that the problem was to find and reveal the structural laws, the gestalt, of some of the ways by which love visualizes a loved one. He was concerned with romantic love, seduction; his images are about being in love. They are distinct from, for example, Rembrandt's images of love as familiarity and communion.

Nevertheless, despite his romanticism, Modigliani refused the obvious romantic short cuts of symbols, gestures, smiles or expressions. This is probably the reason why he often suppressed the look of the eyes. He was, at his strongest, not interested in the obvious signs of reciprocal love. But only in how love holds and transports its own image of a loved one. How the image concentrates, diffuses, distinguishes, and is both emblem and existence, like a name. ANTONIA.

Everything begins with the skin, the flesh, the surface of that body, the envelope of that soul. Whether the body is naked or clothed, whether the extent of that skin is finally bordered by a fringe of hair, by a neckline of a dress, or by a contour of a torso or a flank, makes little difference. Whether the body is male or female makes no difference. All that makes a difference is whether the painter had, or had not, crossed that frontier of imaginary intimacy on the far side of which a vertiginous tenderness begins. Everything begins with the skin and what outlines it. And everything is completed there too. Along that outline are assembled the stakes of Modigliani's art.

And what is at stake? The ancient – and how ancient! – meeting between the finite and the infinite. That meeting, that recurring rendezvous, only takes place, so far as we know, within the human mind and heart. And it is both very complex and very simple. A loved one is finite. The feelings provoked are felt as infinite. Against the law of entropy, there is only the faith of love. But if this were all, there would be no outline, only a blending, a merging of the two.

A loved one is also singular, distinct, separate. The more closely one defines, regardless of any given values, the more intimately one loves. The finite outline is a proof of its opposite, the infinity of emotion provoked by what the outline contains. This is the deepest reason for the frequent elongation of Modigliani's figures and faces. The elongation is the result of the closest possible definition, of wanting to be closer.

And the infinite? The infinite in Modigliani's painting, as in the icons, abandons space and enters the realm of time in order to try to overcome

it. The infinite seeks a sign, an emblem: it attaches itself to a name which belongs to a language that, unlike the body, endures. ANTONIA.

I would not suggest that the entire secret of Modigliani's art or of what his paintings say is identical to the secret of being in love. But the two do have something in common. And it may be this which has escaped the art theorists, but not those who pin up in their rooms postcards of Amadeo Modigliani's paintings.

1981

The Hals Mystery

Stories arrive in the head in order to be told. Sometimes paintings do the same. I will describe it as closely as I can. First, however, I will place it art-historically as the experts always do. The painting is by Franz Hals. My guess would be that it was painted some time between 1645 and 1650.

The year 1645 was a turning point in Hals's career as a portrait painter. He was in his sixties. Until then he had been much sought after and commissioned. From then onwards, until his death as a pauper twenty years later, his reputation steadily declined. This change of fortune corresponded with the emergence of a different kind of vanity.

Now I will try to describe the painting. The large canvas is a horizontal one – 1.85 by 1.30 metres. The reclining figure is a little less than life size. For a Hals – whose careless working methods often led to the pigment cracking – the painting is in good condition; should it ever find its way to a saleroom, it would fetch – given that its subject matter is unique in Hals's *oeuvre* – anything between two and six million dollars. One should bear in mind that, as from now, forgeries may be possible.

So far the identity of the model is understandably a mystery. She lies there naked on the bed, looking at the painter. Obviously there was some complicity between them. Fast as Hals worked, she is bound to have posed during several hours for him. Yet her look is appraising and sceptical.

Was she Hals's mistress? Was she the wife of a Haarlem burgher who commissioned the painting; and if so, where did such a patron intend to hang it? Was she a prostitute who begged Hals to do this painting of herself – perhaps to hang in her own room? Was she one of the painter's own daughters? (There is an opening here to a promising career for one of the more detective of our European art historians.)

What is happening in this room? The painting gave me the impression that neither painter nor model saw beyond their present acts, and

therefore it is these, undertaken for their own sake, which remain so mysterious. Her act of lying there on the dishevelled bed in front of the painter, and his act of scrutinizing and painting her in such a way that her appearances were likely to outlive them both.

Apart from the model, the bottom two-thirds of the canvas are filled with the bed, or rather with the tousled, creased white sheet. The top third is filled with a wall behind the bed. There is nothing to be seen on the wall, which is a pale brown, the colour of flax or cardboard, such as Hals often used as a background. The woman, with her head to the left, lies along and slightly across the bed. There is no pillow. Her head, turned so as to watch the painter, is pillowed on her own two hands.

Her torso is twisted, for whereas her bust is a little turned towards the artist, her hips face the ceiling and her legs trail away to the far side of the bed near the wall. Her skin is fair, in places pink. Her left elbow and foot break the line of the bed and are profiled against the brown wall. Her hair is black, crow black. And so strong are the art-historical conventions by which we are conditioned that, in this seventeenth-century painting, one is as surprised by the fact that she has pubic hair as one would be surprised in life by its absence.

How easily can you imagine a naked body painted by Hals? One has to discard all those black clothes which frame the experiencing faces and nervous hands, and then picture a whole body painted with the same degree of intense laconic observation. Not strictly an observation of forms as such – Hals was the most anti-Platonic of painters – but of all the traces of experience left on those forms.

He painted her breasts as if they were entire faces, the far one in profile, the near one in a three-quarter view, her flanks as if they were hands with the tips of their fingers disappearing into the black hair of her stomach. One of her knees is painted as if it revealed as much about her reactions as her chin. The result is disconcerting because we are unused to seeing the experience of a body painted in this way; most nudes are as innocent of experience as aims unachieved. And disconcerting, for another reason yet to be defined, because of the painter's total con-centration on painting her – her, nobody else and no fantasy of her.

It is perhaps the sheet which most immediately proposes that the painter was Hals. Nobody but he could have painted linen with such violence and panache – as though the innocence suggested by perfectly ironed white linen was intolerable to his view of experience. Every cuff he painted in his portraits informs on the habitual movements of the wrist it hides. And here nothing is hidden. The gathered, crumpled, slewed sheet, its folds like grey twigs woven together to make a nest, and its highlights like falling water, is unambiguously eloquent about what has happened on the bed.

What is more nuanced is the relation between the sheet, the bed and

the figure now lying so still upon it. There is a pathos in this relationship which has nothing to do with the egotism of the painter. (Indeed perhaps he never touched her and the eloquence of the sheet is that of a sexagenarian's memory.) The tonal relationship between the two is subtle, in places her body is scarcely darker than the sheet. I was reminded a little of Manet's 'Olympia' – Manet who so much admired Hals. But there, at this purely optical level, the resemblance ends, for whereas 'Olympia', so evidently a woman of leisure and pleasure, reclines on her bed attended by a black servant, one is persuaded that the woman now lying on the bed painted by Hals will later remake it and wash and iron the sheets. And the pathos lies precisely in the repetition of this cycle: woman as agent of total abandon, woman in her role as cleaner, folder, tidier. If her face mocks, it mocks, among other things, the surprise men feel at this contrast – men who vainly pride themselves on their homogeneity.

Her face is unexpected. As the body is undressed, the look, according to the convention of the nude, must simply invite or become masked. On no account should the look be as honest as the stripped body. And in this painting it is even worse, for the body too has been painted like a face open to its own experience.

Yet Hals was unaware of, or indifferent to, the achievement of honesty. The painting has a desperation within it which at first I did not understand. The energy of the brush strokes is sexual and, at the same time, the paroxysm of a terrible impatience. Impatience with what?

In my mind's eye I compared the painting with Rembrandt's 'Bathsheba' which (if I'm right about the dates) was painted at almost the same time, in 1654. The two paintings have one thing in common. Neither painter wished to idealize his model, and this meant that neither painter wished to make a distinction, in terms of looking, between the painted face and body. Otherwise the two paintings are not only different but opposed. By this opposition the Rembrandt helped me to understand the Hals.

Rembrandt's image of Bathsheba is that of a woman loved by the image maker. Her nakedness is, as it were, original. She is as she is, before putting her clothes on and meeting the world, before being judged by others. Her nakedness is a function of her being and it glows with the light of her being.

The model for Bathsheba was Hendrickye, Rembrandt's mistress. Yet the painter's refusal to idealize her cannot simply be explained by his passion. At least two other factors have to be taken into account.

First there is the realist tradition of seventeenth-century Dutch painting. This was inseparable from another 'realism' which was an essential ideological weapon in the rise to an independent, purely secular power by the Dutch trading and merchant bourgeoisie. And second, *contra-*

dicting this, Rembrandt's religious view of the world. It was this dialectical combination which allowed or prompted the older Rembrandt to apply a realist practice more radically than any other Dutch painter to the subject of individual experience. It is not his choice of biblical subjects which matters here, but the fact that his religious view offered him the principle of *redemption*, and this enabled him to look unflinchingly at the ravages of experience with a minimal, tenuous hope.

All the tragic figures painted by Rembrandt in the second half of his life – Hannan, Saul, Jacob, Homer, Julius Civilis, the self-portraits – are attendant. None of their tragedies is baulked and yet *being painted* allows them to wait; what they await is meaning, a final meaning to be conferred upon their entire experience.

The nakedness of the woman on the bed painted by Hals is very different from Bathsheba's. She is not in a natural state, prior to putting her clothes on. She has only recently taken them off, and it is her raw experience, just brought back from the world outside the room with the flax-coloured wall, that lies on the bed. She does not, like Bathsheba, glow from the light of her being. It is simply her flushed perspiring skin that glows. Hals did not believe in the principle of redemption. There was nothing to counteract the realist practice, there was only his rashness and courage in pursuing it. It is irrelevant to ask whether or not she was his mistress, loved or unloved. He painted her in the only way he could. Perhaps the famous speed with which he painted was partly the result of summoning the necessary courage for this, of wanting to be finished with such looking as quickly as possible.

Of course there is pleasure in the painting. The pleasure is not embedded in the act of painting – as with Veronese or Monet – but the painting refers to pleasure. Not only because of the history which the sheet tells (or pretends to tell like a storyteller) but also because of the pleasure to be found in the body lying on it.

The hair-thin cracks of the pigment, far from destroying, seem to enhance the luminosity and warmth of the woman's skin. In places it is only this warmth which distinguishes the body from the sheet: the sheet by contrast looks almost greenish like ice. Hals's genius was to render the full physical quality of such superficiality. It's as if in painting he gradually approached his subjects until he and they were cheek to cheek. And this time in this skin-to-skin proximity, there was already pleasure. Add to this that nakedness can reduce us all to two common denominators and that from this simplification comes a kind of assuagement.

I am aware of failing to describe properly the desperation of the painting. I will try again, beginning more abstractly. The era of fully fledged capitalism, which opened in seventeenth-century Holland, opened with both confidence and despair. The former – confidence

in individuality, navigation, free enterprise, trade, the *bourse* – is part of accepted history. The despair has tended to be overlooked or, like Pascal's, explained in other terms. Yet part of the striking evidence for this despair is portrait after portrait painted by Hals from the 1630s onwards. We see in these portraits of men (not of the women) a whole new typology of social types and, depending upon the individual case, a new kind of anxiety or despair. If we are to believe Hals – and he is nothing else if not credible – then today's world did not arrive with great rejoicing.

In face of the painting of the woman on the bed I understood for the first time to what degree, and how, Hals may have shared the despair he so often found in his sitters. A potential despair was intrinsic to his practice of painting. He painted appearances. Because the visible *appears* one can wrongly assume that all painting is about appearances. Until the seventeenth century most painting was about inventing a visible world; this invented world borrowed a great deal from the actual world but excluded contingency. It drew – in all senses of the word – conclusions. After the seventeenth century a lot of painting was concerned with disguising appearances; the task of the new academies was to teach the disguises. Hals began and ended with appearances. He was the only painter whose work was profoundly prophetic of the photograph, though none of his paintings is 'photographic'.

What did it mean for Hals as a painter to begin and end with appearances? His practice as a painter was not to reduce a bouquet of flowers to their appearance, nor a dead partridge, nor distant figures in the street; it was to reduce closely observed *experience* to appearance. The pitilessness of this exercise paralleled the pitilessness of every value being systematically reduced to the value of money.

Today, three centuries later, and after decades of publicity and consumerism, we can note how the thrust of capital finally emptied everything of its content and left only the shard of appearances. We see this now because a political alternative exists. For Hals there was no such alternative, any more than there was redemption.

When he was painting those portraits of men whose names we no longer know, the *equivalence* between his practice and their experiences of contemporary society may well have afforded him and them – if they were prescient enough – a certain satisfaction. Artists cannot change or make history. The most they can do is to strip it of pretences. And there are different ways of doing this, including that of demonstrating an existent heartlessness.

Yet when Hals came to paint the woman on the bed it was different. Part of the power of nakedness is that it seems to be unhistorical. Much of the century and much of the decade are taken off with the clothes. Nakedness seems to return us to nature. *Seems* because such a notion

ignores social relations, the forms of emotion and the bias of consciousness. Yet it is not entirely illusory, for the power of human sexuality – its capacity to become a passion – depends upon the promise of a new beginning. And this *new* is felt as not only referring to the individual destiny, but equally to the cosmic which, in some strange way, during such a moment, both fills and transcends history. The evidence for the fact that it happens like this is the repetition in love poetry everywhere, even during revolutions, of cosmic metaphors.

In this painting there could be no equivalence between Hals's practice as a painter and his subject, for his subject was charged, however prematurely, however nostalgically, with the potential promise of a new beginning. Hals painted the body on the bed with the consummate skill that he had acquired. He painted its experience as appearance. Yet his act of painting the woman with the crow black hair could not respond to the sight of her. He could invent nothing new and he stood there, desperate, at the very edge of appearances.

And then? I imagine Hals putting down his brushes and palette and sitting down on a chair. By now the woman had already gone out and the bed was stripped. Seated, Hals closed his eyes. He did not close them in order to doze. With his eyes shut, he might envisage, as a blind man envisages, other pictures painted at another time.

1979

In a Moscow Cemetery

The snow had thawed a week before, and the earth, just uncovered, was dishevelled like somebody woken up too early. In patches, new grass was growing, but mostly the grass was last year's: lank, lifeless and almost white. The earth, awoken too early, was stumbling towards a window. The immense sky was white, full of light and tactful. It told no stories, made no jokes. Earth and sky are always a couple.

Between them a wind blew. North-east veering to east. A routine unexceptional wind. It made people button their coats, the women adjust the kerchiefs on their heads, but across the plain it scarcely ruffled the surface of the million puddles. The earth had thrown a mud-coloured shawl over her shoulders.

Flying low over the waterlogged soil, jackdaws and crows let themselves be carried sideways by the wind. Now that the snow had gone, worms would become visible. Across the mud, lorries were transporting gravel. On one of the two building sites a crane was lifting concrete joists to an open fourth storey, which was as yet no more than a skeletal platform. Nothing there, between earth and sky, would ever be entirely finished.

Many people were arriving and leaving, a few in cars, most in lorries or old buses. There was no town to be seen. And yet you could sense the presence of a city not so far away: a question of sounds, the silence was still shallow, not yet deep like the ocean.

Twenty people got down from one of the buses, the last four carrying a coffin. Their faces – like those of other groups – were closed but not locked. Each face had pulled the door to – and, within, each one was conversing with an old certainty.

They carried the coffin over the pallid grass towards a wooden structure, rather like the stand on which generals take up their positions, so as to be better seen when reviewing their troops. A woman, who had been sheltering from the wind in a hut, stepped out, a camera slung

round her neck. She was the temporary specialist of last pictures. The coffin, its lid now removed, was placed on one of the lower steps of the wooden stand in such a way that it was inclined towards the photographer so that the woman inside the coffin should be visible. She must have been about seventy years old. The group of family and friends took up their position on the other steps of the stand.

Photography, because it stops the flow of life, is always flirting with death, but the temporary specialist of last pictures was only concerned that nobody in the group should be excluded by the frame. The photos were in black and white. The yellow daffodils surrounding the coffin would print out as pale grey, only the sky would be almost its real colour. She beckoned to the figures on the right to close in.

The image she saw through the viewfinder was not grief-stricken. Everyone knew that grief is private and long and has never spared anyone, and that the photograph they had ordered was a public record in which grief had no place. They looked hard at the camera, as if the old woman in the coffin was a newborn child, or a wild boar shot by hunters, or a trophy won by their team. This is how it appeared through the viewfinder.

The cemetery was very large but almost invisible because so low on the ground. For once, the equality of the dead was a perceptible fact. There were no outstanding monuments, no hopeless mausoleums. When the new grass came, it would grow between all. Around some of the graves there were low railings, no higher than hay, and inside the railings, small wooden tables and seats, which all winter long were buried under the snow, just as in ancient Egypt mirrors and jewels were buried in the sand with the royal dead, with the difference that, here, after the thaw the tables and seats could also serve the living.

The burial ground was divided up into plots of about an acre, each one numbered. The numbers were stencilled on wooden boards, nailed to posts, stuck into the earth. These numbers, too, were buried under the snow in the winter.

On some of the headstones there were sepia oval photos behind glass. It is strange how we distinguish one person from another. The visible outward differences are relatively so slight – as between two sparrows – yet by these differences we distinguish a being whose uniqueness seems to us to be as large as the sky.

The gravediggers, whose jokes are the same on every continent, had dug up many mounds of earth. The soil there was acid.

The cemetery was begun in the 1960s, the plots with the lowest numbers being the earliest. In each plot there were those who died young, and those who lived to an old age. But in the first plots those who had died in their forties or early fifties were far more numerous. These men and women had lived through the war and the purges. They had

survived to die early. All illnesses are clinical, and some are also historical.

Silver birches grow quickly and they were already growing between the graves. Soon their leaves would be in bud and then the blood-red catkins, now hanging from their branches like swabs of lint, would fall on to the acid earth. Of all trees, birches are perhaps the most like grass. They are small, pliant, slender; and if they promise a kind of permanence, it has nothing to do with solidity or longevity – as with an oak or a linden – but only with the fact that they seed and spread quickly. They are ephemeral and recurring – like words, like a form of conversation between earth and sky.

Between the trees you could glimpse figures, figures of the living. The family who had just been photographed were carrying wreaths of daffodils, whose yellow was strident as a keening.

> And perhaps, Jesus, holding your feet on
> my knees
> I am leaning to embrace
> The square shaft of the cross,
> Losing consciousness as I strain your
> body to me
> Preparing you for burial
>
> <div align="right">Pasternak</div>

The lid was placed on the coffin for the last time and nailed down.

Nearby, a middle-aged woman on her knees was cleaning an old grave as though it were her kitchen floor. The ground was water-logged, and when she stood up, her wide knees were black with rain water.

Far away the tractors were pulling their trailers of heaped gravel; the crane was delivering concrete slabs to the fifth storey; and the jackdaws, in that place where nothing would ever be entirely finished, were letting themselves be carried sideways by the wind.

A couple sat at one of the wooden tables. The woman brought out her string bag, wrapped in newspaper, a bottle and three glasses. Her husband filled the three glasses. They drank with the man beneath the earth, pouring his glass of vodka into the grass.

The specialist of last pictures had by now taken another dozen. A colleague had just phoned her, in her hut, to tell her that some raincoats had been delivered to the shop near the bridge over the canal. She would stop there on her way home tonight to see whether they had her son's size. The coffin she could see through the viewfinder was small, the child inside no more than ten years old.

Among the first plots a solitary man in a raincoat, leaning against a birch tree, was sobbing, his fists thrust deep into his pockets. In some

puddles, cloud was reflected; into others soil had crumbled, muddying them, so that there were no reflections. The man glanced up at the sky with a look of recognition. Had they, one evening when they were both drunk, reminisced together?

With questions and partial answers, mourners and visitors to the cemetery were trying to make sense of the deaths and their own lives, just as previously the dead had done. This work of the imagination, to which everybody and everything contributes, can never be entirely finished, either in the Khovanskoie cemetery, twenty miles south of Moscow, or anywhere else in the world.

1983

Ernst Fischer: A Philosopher and Death

It was the last day of his life. Of course we did not know it then – not until almost ten o'clock in the evening. Three of us spent the day with him: Lou (his wife), Anya and myself. I can write now only of my own experience of that day. If I tried to write about theirs – much as I was conscious of it at the time and later – I would nevertheless run the risk of writing fiction.

Ernst Fischer was in the habit of spending the summer in a small village in Styria. He and Lou stayed in the house of three sisters who were old friends and who had been Austrian Communists with Ernst and his two brothers in the 1930s. The youngest of the three sisters, who now runs the house, was imprisoned by the Nazis for hiding and aiding political refugees. The man with whom she was then in love was be-headed for a similar political offence.

It is necessary to describe this in order not to give a false impression of the garden which surrounds their house. The garden is full of flowers, large trees, grass banks and a lawn. A stream flows through it, conducted through a wooden pipe the diameter of an immense barrel. It runs the length of the garden, then across fields to a small dynamo which belongs to a neighbour. Everywhere in the garden there is the sound of water, gentle but persistent. There are two small fountains: tiny pin-like jets of water force their way hissing through holes in the wooden barrel-line; water flows into and empties continually from a nineteenth-century swimming pool (built by the grandfather of the three sisters): in this pool, now surrounded by tall grass, and itself green, trout swim and occasionally jump splashing to the surface.

It often rains in Styria, and if you are in this house you sometimes have the impression that it is still raining after it has stopped on account of the sound of water in the garden. Yet the garden is not damp and many colours of many flowers break up its greenness. The garden is a kind of

sanctuary. But to grasp its full meaning one must, as I said, remember that in its outhouses men and women were hiding for their lives thirty years ago and were protected by the three sisters who now arrange vases of flowers and let rooms to a few old friends in the summer in order to make ends meet.

When I arrived in the morning Ernst was walking in the garden. He was thin and upright. And he trod very lightly, as though his weight, such as it was, was never fully planted on the ground. He wore a wide-brimmed white and grey hat which Lou had recently bought for him. He wore the hat like he wore all his clothes, lightly, elegantly, but without concern. He was fastidious – not about details of dress, but about the nature of appearances.

The gate to the garden was difficult to open and shut, but he had mastered it and so, as usual, he fastened it behind me. The previous day Lou had felt somewhat unwell. I enquired how she was. 'She is better,' he said, 'you have only to look at her!' He said this with youthful, unrestricted pleasure. He was seventy-three years old and when he was dying the doctor, who did not know him, said he looked older, but he had none of the muted expressions of the old. He took present pleasures at their full face-value and his capacity to do this was in no way diminished by political disappointment or by the bad news which since 1968 had persistently arrived from so many places. He was a man without a trace, without a line on his face, of bitterness. Some, I suppose, might therefore call him an innocent. They would be wrong. He was a man who refused to jettison or diminish his very high quotient of belief. Instead he readjusted its objects and their relative order. Recently he *believed* in scepticism. He even believed in the necessity of apocalyptic visions in the hope that they would act as warnings.

It is the surety and strength of his convictions which now make it seem that he died so suddenly. His health had been frail since childhood. He was often ill. Recently his eyesight had begun to fail and he could read only with a powerful magnifying glass – more often Lou read to him. Yet despite this it was quite impossible for anyone who knew him to suppose that he was dying slowly, that every year he belonged a little less vehemently to life. He was fully alive because he was fully convinced.

What was he convinced of? His books, his political interventions, his speeches are there on record to answer the question. Or do they not answer it fully enough? He was convinced that capitalism would eventually destroy man – or be overthrown. He had no illusions about the ruthlessness of the ruling class everywhere. He recognized that we lacked a model for Socialism. He was impressed by and highly interested in what is happening in China, but he did not believe in a Chinese model. What is so hard, he said, is that we are forced back to offering visions.

We walked towards the end of the garden, where there is a small lawn

surrounded by bushes and a willow tree. He used to lie there talking with animated gestures, fingers plucking, hands turning out and drawing in – as though literally winding the wool from off his listeners' eyes. As he talked, his shoulders bent forward to follow his hands; as he listened, his head inclined forward to follow the speaker's words. (He knew the exact angle at which to adjust the back of his deckchair.)

Now the same lawn, the deckchairs piled in the outhouse, appears oppressively, flagrantly empty. It is far harder to walk across it without a shiver than it was to turn down the sheet and look again and again at his face. The Russian believers say that the spirits of the departed stay in their familiar surroundings for forty days. Perhaps this is based on a fairly accurate observation of the stages of mourning. At any rate it is hard for me to believe that if a total stranger wandered into the garden now, he would not notice that the end under the willow tree surrounded by bushes was flagrantly empty, like a deserted house on the point of becoming a ruin. Its emptiness is palpable. And yet it is not.

It had already begun to rain and so we went to sit in his room for a while before going out to lunch. We used to sit, the four of us, round a small round table, talking. Sometimes I faced the window and looked out at the trees and the forests on the hills. That morning I pointed out that when the frame with the mosquito net was fitted over the window, everything looked more or less two-dimensional and so composed itself. We give too much weight to space, I went on – there's perhaps more of nature in a Persian carpet than in most landscape paintings. 'We'll take the hills down, push the trees aside and hang up carpets for you,' said Ernst. 'Your other trousers,' remarked Lou, 'why don't you put them on as we're going out?' Whilst he changed we went on talking. 'There,' he said, smiling ironically at the task he had just performed, 'is that better now?' 'They are very elegant, but they are the same pair!' I said. He laughed, delighted at this remark. Delighted because it emphasized that he had changed his trousers only to satisfy Lou's whim, and that that was reason enough for him; delighted because an insignificant difference was treated as though it didn't exist; delighted because, encapsulated in a tiny joke, there was a tiny conspiracy against the existent.

The Etruscans buried their dead in chambers under the ground and on the walls they painted scenes of pleasure and everyday life such as the dead had known. To have the light to see what they were painting they made a small hole in the ground above and then used mirrors to reflect the sunlight onto the particular image on which they were working. With words I try to decorate, as though it were a tomb, the last day of his life.

We were going to have lunch in a *pension* high up in the forests and hills. The idea was to look and see whether it would be suitable for Ernst

to work there during September or October. Earlier in the year Lou had written to dozens of small hotels and boarding houses and this was the only one which was cheap and sounded promising. They wanted to take advantage of my having a car to go and have a look.

There are no scandals to make. But there is a contrast to draw. Two days after his death there was a long article about him in *Le Monde*. 'Little by little,' it wrote, 'Ernst Fischer has established himself as one of the most original and rewarding thinkers of "heretical" Marxism.' He had influenced an entire generation of the left in Austria. During the last four years he was continually denounced in Eastern Europe for the significant influence he had had on the thinking of the Czechs who had created the Prague Spring. His books were translated into most languages. But the conditions of his life during the last five years were cramped and harsh. The Fischers had little money, were always subject to financial worries, and lived in a small, noisy workers' flat in Vienna. Why not? I hear his opponents ask. Was he better than the workers? No, but he needed professional working conditions. In any case he himself did not complain. But with the unceasing noise of families and radios in the flats above and on each side he found it impossible to work as concentratedly in Vienna as he wished to do and was capable of doing. Hence the annual search for quiet, cheap places in the country – where three months might represent so many chapters completed. The three sisters' house was not available after August.

We drove up a steep dust road through the forest. Once I asked a child the way in my terrible German and the child did not understand and simply stuffed her fist into her mouth in amazement. The others laughed at me. It was raining lightly: the trees were absolutely still. And I remember thinking as I drove round the hairpin bends that if I could define or realize the nature of the submission of the trees, I would learn something about the human body too – at least about the human body when loved. The rain ran down the trees. A leaf is so easily moved. A breath of wind is sufficient. And yet not a leaf moved.

We found the *pension*. The young woman and her husband were expecting us and they showed us to a long table where some other guests were already eating. The room was large with a bare wooden floor and big windows from which you looked over the shoulders of some nearby steep fields across the forest to the plain below. It was not unlike a canteen in a youth hostel, except that there were cushions on the benches and flowers on the tables. The food was simple but good. After the meal we were to be shown the rooms. The husband came over with an architect's plan in his hands. 'By next year everything will be different,' he explained; 'the owners want to make more money and so they're going to convert the rooms and put bathrooms in and put up their prices. But this autumn you can still have the two rooms on the

top floor as they are, and there'll be nobody else up there, you'll be quiet.'

We climbed to the rooms. They were identical, side by side, with the lavatory on the same landing opposite them. Each room was narrow, with a bed against the wall, a wash-basin and an austere cupboard, and at the end of it a window with a view of miles and miles of landscape. 'You can put a table in front of the window and work here.' 'Yes, yes,' he said. 'You'll finish the book.' 'Perhaps not all of it, but I could get much done.' 'You must take it,' I said. I visualized him sitting at the table in front of the window, looking down at the still trees. The book was the second volume of his autobiography. It covered the period 1945–55 – when he had been very active in Austrian and international politics – and it was to deal principally with the development and consequences of the Cold War which he saw, I think, as the counter-revolutionary reaction, on both sides of what was to become the Iron Curtain, to the popular victories of 1945. I visualized his magnifying glass on the small table, his note-pad, the pile of current reference books, the chair pushed away when, stiffly but light on his feet, he had gone downstairs to take his regular walk before lunch. 'You must take it,' I said again.

We went for a walk together, the walk into the forest he would take each morning. I asked him why in the first volume of his memoirs he wrote in several distinctly different styles.

'Each style belongs to a different person.'

'To a different aspect of yourself?'

'No, rather it belongs to a different self.'

'Do these different selves coexist, or, when one is predominant, are the others absent?'

'They are present together at the same time. None can disappear. The two strongest are my violent, hot, extremist, romantic self and the other my distant, sceptical self.'

'Do they discourse together in your head?'

'No.' (He had a special way of saying No. As if he had long ago considered the question at length and after much patient investigation had arrived at the answer.)

'They watch each other,' he continued. 'The sculptor Hrdlicka has done a head of me in marble. It makes me look much younger than I am. But you can see these two predominant selves in me – each corresponding to a side of my face. One is perhaps a little like Danton, the other a little like Voltaire.'

As we walked along the forest path, I changed sides so as to examine his face, first from the right and then from the left. Each eye was different and was confirmed in its difference by the corner of the mouth on each side of his face. The right side was tender and wild. He had mentioned Danton. I thought rather of an animal: perhaps a kind of goat, light on its

feet, a chamois maybe. The left side was sceptical but harsher: it made judgements but kept them to itself, it appealed to reason with an unswerving certainty. The left side would have been inflexible had it not been compelled to live with the right. I changed sides again to check my observations.

'And have their relative strengths always been the same?' I asked.

'The sceptical self has become stronger,' he said. 'But there are other selves too.' He smiled at me and took my arm and added, as though to reassure me: 'Its hegemony is not complete!'

He said this a little breathlessly and in a slightly deeper voice than usual – in the voice in which he spoke when moved, for example when embracing a person he loved.

His walk was very characteristic. His hips moved stiffly, but otherwise he walked like a young man, quickly, lightly, to the rhythm of his own reflections. 'The present book,' he said, 'is written in a consistent style – detached, reasoning, cool.'

'Because it comes later?'

'No, because it is not really about myself. It is about an historical period. The first volume is also about myself and I could not have told the truth if I had written it all in the same voice. There was no self which was above the struggle of the others and could have told the story evenly. The categories we make between different aspects of experience – so that, for instance, some people say I should not have spoken about love *and* about the Comintern in the same book – these categories are mostly there for the convenience of liars.'

'Does one self hide its decisions from the others?'

Maybe he didn't hear the question. Maybe he wanted to say what he said whatever the question.

'My first decision,' he said, 'was not to die. I decided when I was a child, in a sick-bed, with death at hand, that I wanted to live.'

From the *pension* we drove down to Graz. Lou and Anya needed to do some shopping; Ernst and I installed ourselves in the lounge of an old hotel by the river. It was in this hotel that I had come to see Ernst on my way to Prague in the summer of '68. He had given me addresses, advice, information, and summarized for me the historical background to the new events taking place. Our interpretation of these events was not exactly the same, but it seems pointless now to try to define our small differences. Not because Ernst is dead, but because those events were buried alive and we see only their large contours heaped beneath the earth. Our specific points of difference no longer exist because the choices to which they applied no longer exist. Nor will they ever exist again in quite the same way. Opportunities can be irretrievably lost and then their loss is like a death.

When the Russian tanks entered Prague in August 1968 Ernst was absolutely lucid about that death.

In the lounge of the hotel I remembered the occasion of four years before. He had already been worried. Unlike many Czechs, he considered it quite likely that Brezhnev would order the Red Army to move in. But he still hoped. And this hope still carried within it all the other hopes which had been born in Prague that spring.

After 1968 Ernst began to concentrate his thoughts on the past. But he remained incorrigibly orientated towards the future. His view of the past was for the benefit of the future – for the benefit of the great or terrible transformations it held in store. But after '68 he recognized that the path towards any revolutionary transformation was bound to be long and tortuous and that Socialism in Europe would be deferred beyond his life-span. Hence the best use of his remaining time was to bear witness to the past.

We did not talk about this in the hotel, for there was nothing new to decide. The important thing was to finish the second volume of his memoirs and that very morning we had found a way of making this happen more quickly. Instead, we talked of love: or, more exactly, about the state of being in love. Our talk followed roughly these lines.

The capacity to fall in love is now thought of as natural and universal – and as a passive capacity. (Love strikes. Love-struck.) Yet there have been whole periods when the possibility of falling in love did not exist. Being in love in fact depends upon the possibility of free active choice – or anyway an apparent possibility. What does the lover choose? He chooses to stake the world (the whole of his life) against the beloved. The beloved concentrates all the possibilities of the world within her and thus offers the realization of all his own potentialities. The beloved for the lover empties the world of hope (the world that does not include her). Strictly speaking, being in love is a mood in so far as it is infinitely extensive – it reaches beyond the stars; but it cannot develop without changing its nature, and so it cannot endure.

The equivalence between the beloved and the world is confirmed by sex. To make love with the beloved is, subjectively, to possess and be possessed by the world. Ideally, what remains outside the experience is – nothing. Death of course is within it.

This provokes the imagination to its very depths. One wants to use the world in the act of love. One wants to make love with fish, with fruit, with hills, with forests, in the sea.

And those, said Ernst, 'are the metamorphoses! It is nearly always that way round in Ovid. The beloved becomes a tree, a stream, a hill. Ovid's *Metamorphoses* are not poetic conceits, they are really about the relation between the world and the poet in love.'

I looked into his eyes. They were pale. (Invariably they were moist with

the strain of seeing.) They were pale like some blue flower bleached to a whitish grey by the sun. Yet despite their moisture and their paleness, the light which had bleached them was still reflected in them.

'The passion of my life,' he said, 'was Lou. I had many love affairs. Some of them, when I was a student here in Graz, in this hotel. I was married. With all the other women I loved there was a debate, a discourse about our different interests. With Lou there is no discourse because our interests are the same. I don't mean we never argue. She argued for Trotsky when I was still a Stalinist. But our interest – below all our interests – is singular. When I first met her, I said No. I remember the evening very well. I knew immediately I saw her, and I said No to myself. I knew that if I had a love affair with her, everything would stop. I would never love another woman. I would live monogamously. I thought I would not be able to work. We would do nothing except make love over and over again. The world would never be the same. She knew too. Before going home to Berlin she asked me very calmly: "Do you want me to stay?" "No," I said.'

Lou came back from the shops with some cheeses and yoghurts she had bought.

'Today we have talked for hours about me,' said Ernst, 'you don't talk about yourself. Tomorrow we shall talk about you.'

On the way out of Graz I stopped at a bookshop to find Ernst a copy of some poems by the Serbian poet Miodrag Pavlovic. Ernst had said sometime during the afternoon that he no longer wrote poems and no longer saw the purpose of poetry. 'It may be,' he added, 'that my idea of poetry is outdated.' I wanted him to read Pavlovic's poems. I gave him the book in the car. 'I already have it,' he said. But he put his hand on my shoulders. For the last time without suffering.

We were going to have supper in the café in the village. On the stairs outside his room, Ernst, who was behind me, suddenly but softly cried out. I turned round immediately. He had both his hands pressed to the small of his back. 'Sit down,' I said, 'lie down.' He took no notice. He was looking past me into the distance. His attention was there, not here. At the time I thought this was because the pain was bad. But it seemed to pass quite quickly. He descended the stairs – no more slowly than usual. The three sisters were waiting at the front door to wish us good night. We stopped a moment to talk. Ernst explained that his rheumatism had jabbed him in the back.

There was a curious distance about him. Either he consciously suspected what had happened, or else the chamois in him, the animal that was so strong in him, had already left to look for a secluded place in which to die. I question whether I am now using hindsight. I am not. He was already distant.

We walked, chatting, through the garden past the sounds of water. Ernst opened the gate and fastened it because it was difficult, for the last time.

We sat at our usual table in the public bar of the café. Some people were having their evening drink. They went out. The landlord, a man only interested in stalking and shooting deer, switched off two of the lights and went out to fetch our soup. Lou was furious and shouted after him. He didn't hear. She got up, went behind the bar and switched on the two lights again. 'I would have done the same,' I said. Ernst smiled at Lou and then at Anya and me. 'If you and Lou lived together,' he said, 'it would be explosive.'

When the next course came Ernst was unable to eat it. The landlord came up to enquire whether it was not good. 'It is excellently prepared,' said Ernst, holding up the untouched plate of food in front of him, 'and excellently cooked, but I am afraid that I cannot eat it.'

He looked pale and he said he had pains in the lower part of his stomach.

'Let us go back,' I said. Again he appeared – in response to the suggestion – to look into the distance. 'Not yet,' he said, 'in a little while.'

We finished eating. He was unsteady on his feet but he insisted on standing alone. On the way to the door he placed his hand on my shoulder – as he had in the car. But it expressed something very different. And the touch of his hand was now even lighter.

After we had driven a few hundred metres he said: 'I think I may be going to faint.' I stopped and put my arm round him. His head fell on my shoulder. He was breathing in short gasps. With his left, sceptical eye he looked hard up into my face. A sceptical, questioning, unswerving look. Then his look became unseeing. The light which had bleached his eyes was no longer in them. He was breathing heavily.

Anya flagged down a passing car and went back to the village to fetch help. She came back in another car. When she opened the door of our car, Ernst tried to move his feet out. It was his last instinctive movement – to be ordered, willed, neat.

When we reached the house, the news had preceded us and the gates, which were difficult, were already open so that we could drive up to the front door. The young man who had brought Anya from the village carried Ernst indoors and upstairs over his shoulders. I walked behind to stop his head banging against the door-jambs. We laid him down on his bed. We did helpless things to occupy ourselves whilst waiting for the doctor. But even waiting for the doctor was a pretext. There was nothing to do. We massaged his feet, we fetched a hot-water bottle, we felt his pulse. I stroked his cold head. His brown hands on the white sheet, curled up but not grasping, looked quite separate from the rest of the body. They appeared cut off by his cuffs. Like the forefeet cut off from an animal found dead in the forest.

The doctor arrived. A man of fifty. Tired, pale-faced, sweating. He wore a peasant's suit without a tie. He was like a veterinary surgeon. 'Hold his arm,' he said, 'whilst I give this injection.' He inserted the needle finely in the vein so that the liquid should flow along it like the water along the barrel-pipe in the garden. At this moment we were alone in the room together. The doctor shook his head. 'How old is he?' 'Seventy-three.' 'He looks older,' he said.

'He looked younger when he was alive,' I said.

'Has he had an infarctus before?'

'Yes.'

'He has no chance this time,' he said.

Lou, Anya, the three sisters and I stood around his bed. He had gone.

Besides painting scenes from everyday life on the walls of their tombs, the Etruscans carved on the lids of their sarcophagi full-length figures representing the dead. Usually these figures are half-reclining, raised on one elbow, feet and legs relaxed as though on a couch, but head and neck alert as they gaze into the distance. Many thousands of such carvings were executed quickly and more or less according to a formula. But however stereotyped the rest of these figures, their alertness as they look into the distance is striking. Given the context, the distance is surely a temporal rather than a spatial one: the distance is the future the dead projected when alive. They look into that distance as though they could stretch out a hand and touch it.

I can make no sarcophagus carving. But there are pages written by Ernst Fischer where it seems to me that the writer wrote adopting an equivalent stance, achieving a similar quality of expectation.

1974

François, Georges and Amélie:

A Requiem in Three Parts

François

François was killed on a Saturday night. Just as it was getting dark. A car coming from behind knocked him over. The young driver of the car, who didn't stop, was fortunate because the autopsy showed that François was drunk. Even before the result of the autopsy, nobody in the village imagined anything different. If it was Saturday night and François wasn't at the farm, he was on one of his weekend walks and drunk. But usually, when very drunk, he was still attentive and careful about traffic.

He was seventy-six. He owned what he was wearing, a few clothes he had left in the stable, a mouth-organ and the money which the police found tied into a plastic bag that he carried on a cord round his neck.

Owning so little, what gave him pleasure? The mountains, women, music and red wine. This makes him sound like a bohemian – he who, even in his extravagant boasts and jokes, never left the valley of two adjacent rivers.

Why have I put off for so long trying to describe and remember your funeral? Because after it, you were not for once in the café telling a story about the late departed? Because I'm waiting for next summer when your absence will become more acute?

A knock on the door with your stick, and you walk in without waiting for an answer. Your creased face folded yet again into a smile. You give a long kiss to B. A smile of relish. Then through the door into the next room – as though it were beyond human ingenuity to invent a right that you wouldn't have in this mountain chalet where you once came to be congratulated on still being alive.

'There's a man with the same name as me who has just died over there!' You pointed across the valley to the second river far below. 'There were those who thought it was me, me who was dead! Me!'

You opened your mouth and spread out your arms like a jack-in-the-box and roared with laughter.

'To those who are alive!' And we clinked our glasses together. Do you remember?

There were only a few people at the funeral, because nobody thought of putting a notice in the local paper and François was buried, not in the village, but in the small town where he was killed.

Nobody knows what happened to the money he carried round his neck. It amounted to several hundred pounds. When he was at the farm, he hid it. You can leave your money around, he said to his boss, I won't touch it, I have my own. He worked in exchange for his keep, not for wages, and in this way he kept his independence. He worked when he liked, he left when he liked.

If there were any remaining members of his family left, none of them appeared. Small towns now have an exclusive deal with some undertaking firm. It's arranged by the mayor. In exchange for this exclusivity, the firm agrees to supply one free funeral a year. In the case of a pauper, this saves the community money. The firm in question gave a free funeral to François, which didn't include flowers.

He had looked after animals all his life, either in the valley or on the mountain. He was used to their company. Of the company of men – not women – he was more suspicious. They didn't all necessarily accept the authority he took upon himself.

'I've had enough of his cows eating *my* grass!' Every summer François re-started a wrangle about grazing.

'It's not even your grass!' said a young man standing at the counter.

'If I see *him*, I'll punch his face in!'

'You're too old to punch anything in!'

'And at your age, you know nothing. Nothing. I've been a shepherd for fifty years!'

The little group followed the coffin down the street towards the cemetery. As they passed the steamed-up windows of a café, six men came out to join the procession. They left their glasses half-full on the counter for they would soon be back.

When he was young he enjoyed dancing; later he liked to make people dance. And so whenever he heard of a celebration taking place and he was able to go, he took his mouth-organ. One Saturday night at a friend's birthday party he lost it.

I was there when his boss's wife gave him another to replace the one he had lost. The three of us were sitting outside the chalet. The water was flowing into the wooden trough. There were some geese by our feet. Some parachutists had just jumped off the mountain and were drifting down to the valley. He took the mouth-organ out of its box. He examined it on every side to ensure that it included no secret which he didn't already know. He tried holding it in his hands, as he would when playing, but without raising it to his lips. Then he put it back into its box

and slipped the box into his pocket. It was no longer a present, it was his.

The small group of us filed past the coffin. His, just as his completed life had now become his.

Georges

Georges was killed on a Monday when working by the bridge over the Foron. It was in the afternoon. Young Bernard came into the stable with the news at milking time the same evening. The vet was there looking at the calf who had had something wrong with its stomach since birth.

'He's dead!' cried out Claire in protest. Then she addressed each person in the stable as if hoping that one of them might contradict her. 'Jeanne, he's dead! Theophile, he's dead! Monsieur, he's dead!'

Jeanne said nothing but she clenched her jaw, and her eyes were filled with tears. The three men stood in silence without moving, the vet holding the syringe in his hand against his own arm.

He was carried down the river before anybody could reach him and drowned.

Bernard, who had never before been the bearer of such bad news, walked solemnly out of the stable. Then, a little later, after the vet had left, the words came.

'Where is the justice?'

'His arm was sticking out from the rocks, that's how they found him.'

'It takes away even your will to work.'

'There were three of them unblocking a drain, and then the water broke through without any warning.'

'Without any warning.'

Georges was twenty-eight. He had been married three years before. The couple didn't yet have any children. His body was wounded all over by the rocks against which the river had flung him. All over he was grazed and cut. But the bruises, which would have appeared, didn't come, because he was dead.

His body was taken home to his wife with a bandage round his head to hide the worst wounds. He was laid out on his large bed, and friends and relatives came to pay him their last respects. Each night Martine, his wife, lay beside him.

'He must have been outside the blankets,' she announced the first morning, 'for I could feel that he was a little cold.'

On the third day when it was time to place him in his coffin, she said: 'Now it is time to close it, his poor corpse is beginning to smell.'

During those three days, his death haunted the village too. It was an unnatural death which had come as brutally and unexpectedly as the

mass of water which engulfed him. All the rivers and streams around the village were swollen and white with froth. Everywhere there was the sound of the water which killed him. He was too young, he carried too many hopes away with him. A thousand people came to the funeral on Thursday.

When the coffin came out of the church, Martine was supported on either side by two of his brothers. They carried her, for her legs trailed behind her, and following the coffin, she wailed: 'Jo-Jo, no! Jo-Jo, no!' Georges, whom everyone knew as Jo-Jo, could not reply.

A thousand men and women stood in silence and witnessed the chief mourner's fight, her heaving fight, not for breath but to be able to stop breathing.

Above the cemetery the orchards were littered with broken branches torn from the apple trees by the snow which, melting now, swelled the rivers.

During the next two weeks Martine hoped against hope that she might have conceived just before Georges's death. And then again the blood came.

Amélie

Amélie never saw a doctor in her life until four days before. And unhappily it turned out to be too late. She was eighty-two; she had congestion on both lungs and her heart gave up.

She lived with her son who was already a widower. This son had been born when his mother was seventeen. She had not been able to marry the boy's father, because he, the father, was only thirteen.

Everyone knew the story of Amélie's life. She was a woman of great endurance. She worked every day on the farm with her son until she was taken ill for the first and last time. She was, it was often said, a force of nature.

Fifteen years after the birth of her son, she became pregnant again. Still unmarried, she was living with her mother. This was at the time of the Popular Front, Franco's victory in Spain, the approaching holocaust. Her mother was old and her eyes were failing. And so, on this second occasion, Amélie decided to spare her mother's feelings – or was it, too, in order to spare herself from her mother's nagging and execration? In any case, she kept her pregnancy a secret. She was already a large woman, and she bound her belly tightly so that its rising was not very pronounced.

On the evening when her labour began, she climbed up into the barn and there, during the night, delivered her own baby, alone. The baby was a girl, and this daughter, now a middle-aged woman, was standing against

the cemetery wall whilst neighbours and friends came and offered their condolences for her mother's death.

On Amélie's coffin, in the middle of the cemetery, there was a wreath, the size of a counterpane, of red and pink carnations. The colours of blood and youth.

Before dawn, fifty years ago, Amélie took the train to the nearest town and there left her newborn daughter at the house of a woman with whom she had already come to an arrangement. The same evening she was back home, working in the stable, as if nothing had happened to either her body or heart.

Amélie's mother never knew that she had a grand-daughter, but there were neighbours who had been aware of Amélie's condition and who now whispered that she had murdered her child.

The police from the town made an official investigation. They came to cross-question Amélie, who laughed in the inspector's face. What I've done is no crime, she said. You can accuse me of nothing, except – here she shut her eyes – of being too good-natured!

As soon as her mother died, Amélie brought her daughter back home. And when her village schooling was over, she sent her daughter to a secondary school, so that she would not be condemned to being a peasant, if, by chance, she had the opportunity of choosing.

This daughter did not take up the choice; she married locally and had two children. One of these children, now a young woman of seventeen, was at the funeral. Six months earlier she had given birth to a baby. The father had gone back to his own country – he was a pastrycook – and she had not pursued him to insist that he should marry her. She stood there now, her long hair loose on her shoulders, looking boldly and solemnly at those who had come to bury her grandmother.

At most funerals in the village there are at least 200 mourners. And Amélie's was no exception. They came because they respected her, because the last service they could offer her was to pray for her, because their absence might be noticed, because when, for each of them, their turn came to join the population of the village dead beneath the ground, a population which, counted over the centuries, was now that of a small city, each hoped to benefit from the same gesture of solidarity.

Yet this afternoon the funeral was ending differently. The priest was as usual blessing the family grave into which later the coffin would be lowered. But in the cypress tree a bird was singing. Nobody knew what kind of bird it was. Its song was so loud and shrill that the priest's prayers and the amens of the two choirboys were quite inaudible. The entire cemetery was filled with the thrills and warbling of this song.

And there was scarcely a woman or man standing in the February sunlight, their arms folded, or their large hands clasped behind the back, who did not think: throughout the years, across the generations, a force

drives on, like the sap now rising, and it is implacable and destructive and reproductive; it makes mouths open, eyes burn, hands join. (They were gazing as much at the grand-daughter as at the coffin with its red and pink flowers.) And this force condemns to work and to sacrifice, also it kills, and it sings, even at this moment is singing, and will never stop.

1980

Drawn to That Moment

When my father died recently, I did several drawings of him in his coffin. Drawings of his face and head.

There is a story about Kokoschka teaching a life class. The students were uninspired. So he spoke to the model and instructed him to pretend to collapse. When he had fallen over, Kokoschka rushed over to him, listened to his heart and announced to the shocked students that he was dead. A little afterwards the model got to his feet and resumed the pose. 'Now draw him,' said Kokoschka, 'as though you were aware that he was alive and not dead!'

One can imagine that the students, after this theatrical experience, drew with more verve. Yet to draw the truly dead involves an ever greater sense of urgency. What you are drawing will never be seen again, by you or by anybody else. In the whole course of time past and time to come, this moment is unique: the last opportunity to draw what will never again be visible, which has occurred once and which will never reoccur.

Because the faculty of sight is continuous, because visual categories (red, yellow, dark, thick, thin) remain constant, and because so many things appear to remain in place, one tends to forget that the visual is always the result of an unrepeatable, momentary encounter. Appearances, at any given moment, are a construction emerging from the debris of everything which has previously appeared. It is something like this that I understand in those words of Cézanne which so often come back to me: 'One minute in the life of the world is going by. Paint it as it is.'

Beside my father's coffin I summoned such skill as I have as a draughtsman, to apply it *directly* to the task in hand. I say *directly* because often skill in drawing expresses itself as a manner, and then its application to what is being drawn is indirect. Mannerism – in the general rather than art-historical sense – comes from the need to invent urgency, to

produce an 'urgent' drawing, instead of submitting to the urgency of what is. Here I was using my small skill to save a likeness, as a lifesaver uses his much greater skill as a swimmer to save a life. People talk of freshness of vision, of the intensity of seeing for the first time, but the intensity of seeing for the last time is, I believe, greater. Of all that I could see only the drawing would remain. I was the last ever to look on the face I was drawing. I wept whilst I strove to draw with complete objectivity.

As I drew his mouth, his brows, his eyelids, as their specific forms emerged with lines from the whiteness of the paper, I felt the history and the experience which had made them as they were. His life was now as finite as the rectangle of paper on which I was drawing, but within it, in a way infinitely more mysterious than any drawing, his character and destiny had emerged. I was making a record and his face was already only a record of his life. Each drawing then was nothing but the site of a departure.

They remained. I looked at them and found that they resembled my father. Or, more strictly, that they resembled him as he was when dead. Nobody could ever mistake these drawings as ones of an old man sleeping. Why not? I ask myself. And the answer, I think, is in the way they are drawn. Nobody would draw a sleeping man with such objectivity. About this quality there is finality. Objectivity is what is left when something is finished.

I chose one drawing to frame and hang on the wall in front of the table at which I work. Gradually and consistently the relationship of this drawing to my father changed – or changed for me.

There are several ways of describing the change. The content of the drawing increased. The drawing, instead of marking the site of a departure, began to mark the site of an arrival. The forms, drawn, filled out. The drawing became the immediate locus of my memories of my father. The drawing was no longer deserted but inhabited. For each form, between the pencil marks and the white paper they marked, there was now a door through which moments of a life could enter: the drawing, instead of being simply an object of perception, with one face, had moved forward to become double-faced, and worked like a filter: from behind, it drew out my memories of the past whilst, forwards, it projected an image which, unchanging, was becoming increasingly familiar. My father came back to give the image of his death mask a kind of life.

If I look at the drawing now I scarcely see the face of a dead man; instead I see aspects of my father's life. Yet if somebody from the village came in, he would see only a drawing of a death mask. It is still unmistakably that. The change which has taken place is subjective. Yet, in a more general sense, if such a subjective process did not exist, neither would drawings.

The advent of the cinema and television means that we now define drawings (or paintings) as *static* images. What we often overlook is that their virtue, their very function, depended upon this. The need to discover the camera, and the instantaneous or moving image, arose for many different reasons but it was not in order to *improve* on the static image, or, if it was presented in those terms, it was only because the meaning of the static image had been lost. In the nineteenth century when social time became unilinear, vectorial and regularly exchangeable, the instant became the maximum which could be grasped or preserved. The plate camera and the pocket watch, the reflex camera and the wrist-watch, are twin inventions. A drawing or painting presupposes another view of time.

Any image – like the image read from the retina – records an appearance which will disappear. The faculty of sight developed as an active response to continually changing contingencies. The more it developed, the more complex the set of appearances it could construct from events. (An event in itself has no appearances.) Recognition is an essential part of this construction. And recognition depends upon the phenomenon of reappearance sometimes occurring in the ceaseless flux of disappearance. Thus, if appearances, at any given moment, are a construction emerging from the debris of all that has previously appeared, it is understandable that this very construction may give birth to the idea that everything will one day be recognizable, and the flux of disappearance cease. Such an idea is more than a personal dream; it has supplied the energy for a large part of human culture. For example: the story triumphs over oblivion; music offers a centre; the drawing challenges disappearance.

What is the nature of this challenge? A fossil also 'challenges' disappearance but the challenge is meaningless. A photograph challenges disappearance but its challenge is different from that of the fossil or the drawing.

The fossil is the result of random chance. The photographed image has been selected for preservation. The drawn image contains the experience of looking. A photograph is evidence of an encounter between event and photographer. A drawing slowly questions an event's appearance and in doing so reminds us that appearances are always a construction with a history. (Our aspiration towards objectivity can only proceed from the admission of subjectivity.) We use photographs by taking them with us, in our lives, our arguments, our memories; it is we who *move* them. Whereas a drawing or painting forces us to *stop* and enter its time. A photograph is static because it has stopped time. A drawing or painting is static because it encompasses time.

I should perhaps explain here why I make a certain distinction between drawings and paintings. Drawings reveal the process of their

own making, their own looking, more clearly. The imitative facility of a painting often acts as a disguise – i.e. what it refers to becomes more impressive than the reason for referring to it. Great paintings are not disguised in this way. But even a third-rate drawing reveals the process of its own creation.

How does a drawing or painting encompass time? What does it hold in its stillness? A drawing is more than a memento – a device for bringing back memories of time past. The 'space' that my drawing offers for my father's return into it is quite distinct from that offered by a letter from him, an object owned by him or, as I have tried to explain, a photograph of him. And here it is incidental that I am looking at a drawing which I drew myself. An equivalent drawing by anybody else would offer the same 'space'.

To draw is to look, examining the structure of appearances. A drawing of a tree shows, not a tree, but a tree-being-looked-at. Whereas the sight of a tree is registered almost instantaneously, the examination of the sight of a tree (a tree-being-looked-at) not only takes minutes or hours instead of a fraction of a second, it also involves, derives from, and refers back to, much previous experience of looking. Within the instant of the sight of a tree is established a life-experience. This is how the act of drawing refuses the process of disappearances and proposes the simultaneity of a multitude of moments.

From each glance a drawing assembles a little evidence, but it consists of the evidence of many glances which can be seen together. On one hand, there is no sight in nature as unchanging as that of a drawing or painting. On the other hand, what is unchanging in a drawing consists of so many assembled moments that they constitute a totality rather than a fragment. The static image of a drawing or painting is the result of the opposition of two dynamic processes. Disappearances opposed by assemblage. If, for diagrammatic convenience, one accepts the metaphor of time as a flow, a river, then the act of drawing, by driving upstream, achieves the stationary.

Vermeer's view of Delft across the canal displays this as no theoretical explanation ever can. The painted moment has remained (almost) unchanged for three centuries. The reflections in the water have not moved. Yet this painted moment, as we look at it, has a plenitude and actuality that we experience only rarely in life. We experience everything we see in the painting as *absolutely* momentary. At the same time the experience is repeatable the next day or in ten years. It would be naïve to suppose that this has to do with accuracy: Delft at any given moment never looked like this painting. It has to do with the density per square millimetre of Vermeer's looking, with the density per square millimetre of assembled moments.

As a drawing, the drawing above my table is unremarkable. But it works

in accord with the same hopes and principles which have led men to draw for thousands of years. It works because from being a site of departure, it has become a site of arrival.

Every day more of my father's life returns to the drawing in front of me.

1976

The Eyes of Claude Monet

Too much has been made of Cézanne's famous remark that, if Monet was only an eye, what an eye! More important now, perhaps, to acknowledge and question the sadness in Monet's eyes, a sadness which emerges from photograph after photograph.

Little attention has been paid to this sadness because there is no place for it in the usual art-historical version of the meaning of Impressionism. Monet was the leader of the Impressionists – the most consistent and the most intransigent – and Impressionism was the beginning of Modernism, a kind of triumphal arch through which European art passed to enter the twentieth century.

There is some truth in this version. Impressionism *did* mark a break with the previous history of European painting and a great deal of what followed – Post-Impressionism, Expressionism, Abstraction – can be thought of as being partly engendered by this first modern movement. It is equally true that today, after half a century, Monet's later works – and particularly the water lilies – appear now to have prefigured the work of artists such as Pollock, Tobey, Sam Francis, Rothko.

It is possible to argue, as Malevich did, that the twenty paintings which Monet made in the early 1890s of the façade of Rouen Cathedral, as seen at different times of day and under different weather conditions, were the final systematic proof that the history of painting would never be the same again. This history had henceforward to admit that every appearance could be thought of as a mutation and that visibility itself should be considered flux.

Furthermore, if one thinks of the claustrophobia of mid-nineteenth-century bourgeois culture, it is impossible not to see how Impressionism appeared as a liberation. To paint out of doors in front of the motif; to observe directly, to accord to light its proper hegemony in the domain of the visible; to relativize all colours (so that everything sparkles); to

abandon the painting of dusty legends and all direct ideology; to speak of everyday appearances within the experience of a wide urban public (a day off, a trip to the country, boats, smiling women in sunlight, flags, trees in flower – the Impressionist vocabulary of images is that of a popular dream, the awaited, beloved, secular Sunday); the innocence of Impressionism – innocence in the sense that it did away with the secrets of painting, everything was there in the full light of day, there was nothing more to hide, and amateur painting followed easily – how could all this not be thought of as a liberation?

Why can't we forget the sadness in Monet's eyes, or simply acknowledge it as something personal to him, the result of his early poverty, the death of his first wife when so young, his failing eyesight when old? And in any case, are we not running the risk of explaining the history of Egypt as the consequence of Cleopatra's smile? Let us run the risk.

Twenty years before painting the façade of Rouen Cathedral, Monet painted (he was thirty-two years old) 'Impression Soleil Levant', and from this the critic Castagnary coined the term *Impressionist*. The painting is a view of the port of Le Havre where Monet was brought up as a child. In the foreground is the tiny silhouette of a man standing and rowing with another figure in a dinghy. Across the water, masts and derricks are dimly visible in the morning twilight. Above, but low in the sky, is a small orange sun and, below, its inflamed reflection in the water. It is not an image of dawn (Aurora), but of a day slipping in, as yesterday slipped out. The mood is reminiscent of Baudelaire's 'Le Crépuscule de Matin', in which the coming day is compared to the sobbing of somebody who has just been woken.

Yet what is it that exactly constitutes the melancholy of this painting? Why, for example, don't comparable scenes, as painted by Turner, evoke a similar mood? The answer is the painting method, precisely that practice which was to be called Impressionist. The transparency of the thin pigment representing the water – the thread of the canvas showing through it, the swift broken-straw-like brush strokes suggesting ripples of spars, the scrubbed-in areas of shadow, the reflections staining the water, the optical truthfulness and the *objective* vagueness, all this renders the scene makeshift, threadbare, decrepit. It is an image of homelessness. Its very insubstantiality makes shelter in it impossible. Looking at it, the idea occurs to you of a man trying to find his road home through a theatre décor. Baudelaire's lines in 'La Cygne', published in 1860, belong to the slow intake of breath before the accuracy and the refusal of this scene.

> . . . La forme d'une ville
> Change plus vite, hélas, que le coeur d'un
> mortel.

If Impressionism was about 'impressions', what change did this imply in the relation between seen and seer? (Seer here meaning both painter and viewer.) You do not have an *impression* of a scene with which you feel yourself to be longstandingly familiar. An impression is more or less fleeting; it is what is *left behind* because the scene has disappeared or changed. Knowledge can coexist with the known; and impression, by contrast, survives alone. However intensely and empirically observed at the moment, an impression later becomes, like a memory, impossible to verify. (Throughout his life Monet complained, in letter after letter, about not being able to complete a painting already begun, because the weather and therefore the subject, the motif, had irredeemably changed.) The new relation between scene and seer was such that now the scene was more fugitive, more chimerical than the seer. And there we find ourselves returned to the same lines by Baudelaire: 'La forme d'une ville . . .'

Suppose we examine the experience offered by a more typical Impressionist painting. In the spring of the same year as 'Le Soleil Levant' (1872) Monet painted two pictures of a lilac tree in his garden at Argenteuil. One shows the tree on a cloudy day and the other on a sunny day. Lying on the lawn beneath the tree in both pictures are three barely distinguishable figures. (They are thought to be Camille, Monet's first wife, Sisley and Sisley's wife.)

In the overcast picture these figures resemble moths in the lilac shade; in the second, dappled with sunlight, they become almost as invisible as lizards. (What betrays their presence is in fact the viewer's past experience; somehow the viewer distinguishes the mark of a profile with a tiny ear from the other almost identical marks which are only leaves.)

In the overcast picture the flowers of the lilac glow like mauve copper; in the second picture the whole scene is alight, like a newly lit fire: both are animated by a different kind of light energy, there is apparently no longer a trace of decrepitude, everything radiates. Purely optically? Monet would have nodded his head. He was a man of few words. Yet it goes much further.

Before the painted lilac tree you experience something unlike anything felt in front of any earlier painting. The difference is not a question of new optical elements, but of a new relation between what you are seeing and what you have seen. Every spectator can recognize this after a moment's introspection; all that may differ is the personal choice of which paintings reveal the new relation most vividly. There are hundreds of Impressionist paintings, painted during the 1870s, to choose from.

The painted lilac tree is both more precise and more vague than any painting you have seen before. Everything has been more or less sacrificed to the optical precision of its colours and tones. Space, measurement, action (history), identity, all are submerged within the

play of light. One must remember here that *painted* light, unlike the real thing, is *not* transparent. The painted light covers, buries, the painted objects, a little like snow covering a landscape. (And the attraction of snow to Monet, the attraction of things being lost without a loss of first-degree reality, probably corresponded to a deep psychological need.) So the new energy *is* optical? Monet was right to nod his head? The painted light dominates everything? No, because all this ignores how the painting actually works on the viewer.

Given the precision and the vagueness, you are forced to re-see the lilacs of your own experience. The precision triggers your visual memory, while the vagueness welcomes and accommodates your memory when it comes. More than that, the uncovered memory of your sense of sight is so acutely evoked, that other appropriate memories of other senses – scent, warmth, dampness, the texture of a dress, the length of an afternoon – are also extracted from the past. (One cannot help but think again of Baudelaire's *Correspondances.*) You fall through a kind of whirlpool of sense memories towards an ever receding moment of pleasure, which is a moment of total re-cognition.

The intensity of this experience can be hallucinating. The fall into and towards the past with its mounting excitement, which, at the same time, is the mirror-opposite of expectation for it is a return, a withdrawal, has something about it which is comparable with an orgasm. Finally every-thing is simultaneous with and indivisible from the mauve fire of the lilac.

And all this follows – surprisingly – from Monet's affirmation, with slightly different words on several occasions, that 'the motif is for me altogether secondary; what I want to represent is what exists between the motif and me' (1895). What *he* had in mind were colours; what is bound to come into the viewer's mind are memories. If, in a generalized way, Impressionism lends itself to nostalgia (obviously in particular cases the intensity of the memories precludes nostalgia) it is not because we are living a century later, but simply because of the way the paintings always demanded to be read.

What then has changed? Previously the viewer entered into a painting. The frame or its edges were a threshold. A painting created its own time and space which were like an alcove to the world, and their experience, made clearer than it usually is in life, endured changeless and could be visited. This had little to do with the use of any systematic perspective. It is equally true, say, of a Sung Chinese landscape. It is more a question of permanence than space. Even when the scene depicted was momentary – for example, Caravaggio's 'Crucifixion of St Peter' – the momentari-ness is held within a continuity: the arduous pulling up of the cross constitutes part of the permanent assembly point of the painting. Viewers passed one another in Pierro della Francesca's 'Tent of Solo-

mon' or on Grünewald's 'Golgotha' or in the bedroom of Rembrandt. But not in Monet's 'Gare de St Lazare'.

Impressionism closed that time and that space. What an Impressionist painting shows is painted in such a way that *you are compelled to recognize that it is no longer there.* It is here and here only that Impressionism is close to photography. You cannot enter an Impressionist painting; instead it extracts your memories. In a sense it is more active than you – the passive viewer is being born; what you receive is taken from what happens *between* you and it. No more within it. The memories extracted are often pleasurable – sunlight, river banks, poppy fields – yet they are also anguished, because each viewer remains alone. The viewers are as separate as the brush strokes. There is no longer a common meeting place.

Let us now return to the sadness in Monet's eyes. Monet believed that his art was forward-looking and based on a scientific study of nature. Or at least this is what he began by believing and never renounced. The degree of sublimation involved in such a belief is poignantly demonstrated by the story of the painting he made of Camille on her death bed. She died in 1879, aged thirty-two. Many years later Monet confessed to his friend Clemenceau that his need to analyse colours was both the joy and torment of his life. To the point where, he went on to say, I one day found myself looking at my beloved wife's dead face and just systematically noting the colours, according to an automatic reflex!

Without doubt the confession was sincere, yet the evidence of the painting is quite otherwise. A blizzard of white, grey, purplish paint blows across the pillows of the bed, a terrible blizzard of loss which will for ever efface her features. In fact there can be very few death-bed paintings which have been so intensely felt or subjectively expressive.

And yet to this – the consequence of his own act of painting – Monet was apparently blind. The positivistic and scientific claims he made for his art never accorded with its true nature. The same was equally true of his friend Zola. Zola believed that his novels were as objective as laboratory reports. Their real power (as is so evident in *Germinal*) comes from deep – and dark – unconscious feeling. At this period the mantle of progressive positivist enquiry sometimes hid the very same premonition of loss, the same fears, of which, earlier, Baudelaire had been the prophet.

And this explains why *memory* is the unacknowledged axis of all Monet's work. His famous love of the sea (in which he wanted to be buried when he died), of rivers, of water, was perhaps a symbolic way of speaking of tides, sources, recurrence.

In 1896 he returned to paint again one of the cliffs near Dieppe which he had painted on several occasions fourteen years earlier. ('Falaise à Vavengeville', 'Gorge du Petit-Ailly'.) The painting, like many of his

works of the same period, is heavily worked, encrusted, and with the minimum of tonal contrast. It reminds you of thick honey. Its concern is no longer the instantaneous scene, as revealed in the light, but rather the slower dissolution of the scene by the light, a development which led towards a more decorative art. Or at least this is the usual 'explanation' based on Monet's own premises.

It seems to me that this painting is about something quite different. Monet worked on it, day after day, believing that he was interpreting the effect of sunlight as it dissolved every detail of grass and shrub into a cloth of honey hung by the sea. But he wasn't, and the painting has really very little to do with sunlight. What he himself was dissolving into the honey cloth were all his previous memories of that cliff, so that it should absorb and contain them all. It is this almost desperate wish to save *all* which makes it such an amorphous, flat (and yet, if one recognizes it for what it is, touching) image.

And something very similar is happening in Monet's paintings of the water lilies in his garden during the last period of his life (1900–26) at Giverny. In these paintings, endlessly reworked in face of the optically impossible task of combining flowers, reflections, sunlight, underwater reeds, refractions, ripples, surface, depths, the real aim was neither decorative nor optical; it was to preserve everything essential about the garden, which he had made, and which now as an old man he loved more than anything else in the world. The painted lily pond was to be a pond that remembered all.

And here is the crux of the contradiction which Monet as a painter lived. Impressionism closed the time and space in which previously painting had been able to preserve experience. And, as a result of this closure, which of course paralleled and was finally determined by other developments in late-nineteenth-century society, both painter and viewer found themselves more alone than ever before, more ridden by the anxiety that their own experience was ephemeral and meaningless. Not even all the charm and beauty of the Ile de France, a Sunday dream of paradise, was a consolation for this.

Only Cézanne understood what was happening. Single-handed, impatient, but sustained by a faith that none of the other Impressionists had, he set himself the monumental task of creating a new form of time and space within the painting, so that finally experience might again be shared.

1980

The *Work* of Art

It has taken me a long time to come to terms with my reactions to Nicos Hadjinicolaou's book *Art History and Class Consciousness*.[1] These reactions are complex for both theoretical reasons and personal ones. Nicos Hadjinicolaou sets out to define the possible practice of a scientific Marxist art history. How necessary it is to produce this initiative, first proposed by Max Raphael nearly fifty years ago!

The exemplary figure of the book, one could almost say its chosen father, is the late Frederick Antal. To see at last this great art historian's work being recognized is a heartening experience; the more so for me personally because I was once an unofficial student of Antal's. He was my teacher, he encouraged me, and a great deal of what I understand by art history I owe to him. Two pupils of the same exemplary master might be likely to make common cause.

Yet I am obliged to argue against this book as a matter of principle. Hadjinicolaou's scholarship is impressive and well used; his arguments are courageously clear. In France, where he lives, he has helped to form with other Marxist colleagues the Association Histoire et Critiques des Arts, which has held several notable and important conferences. My argument will, I hope, be fierce but not dismissive.

Let me first try to summarize the book as fairly as I can. 'The history of all hitherto existing society is the history of class struggles.' Opening with this quotation from the Communist Manifesto, Hadjinicolaou asks: how should this apply to the discipline of art history? He dismisses as over-simple the answers of 'vulgar' Marxism which seek direct evidence of the class struggle in the class origins and political opinions of the painter or, alternatively, in the story the painting tells. He recognizes the relative autonomy of the production-of-pictures (a term which he prefers to *art* because implicit in the latter is a value judgment deriving from bourgeois aesthetics). He argues that pictures have their own ideology – a visual

one, which must not be confused with political, economic, colonial and other ideologies.

For him an ideology is the systematic way in which a class or a section of a class projects, disguises and justifies its relations to the world. Ideology is a social/historical element – encompassing like water – from which it is impossible to emerge until classes have been abolished. The most one can do is identify an ideology and relate it to its precise class function.

By *visual ideology* he means the way that a picture makes you see the scene it represents. In some ways it is similar to the category of *style*, yet it is more comprehensive. He regrets totally the ordinary connotations of style. There is no such thing as the style of an artist. Rembrandt has no style, everything depends upon which picture Rembrandt was producing under what circumstances. The way each picture renders experience visible constitutes its visual ideology.

Yet in considering the visible – and this is my gloss, not his – one must remember that according to such a theory of ideology (which owes a lot to Althusser and Poulantzas) we are, in some ways, like blind men who have to learn to allow for and overcome our blindness, but to whom sight itself, whilst class societies continue, cannot be accorded. The negative implication of this becomes crucial as I shall try to show later.

The task of a scientific art history is to examine any picture, to identify its visual ideology and to relate it to the class history of its time, a complex history because classes are never homogeneous and consist of many conflicting groups and interests.

The traditional schools of art history are unscientific. He examines each in turn. The first treats art history as if it were no more than a history of great painters and then explains them in psychological, psychoanalytical or environmental terms. To treat art history as if it were a relay race of geniuses is an individualist illusion, whose origins in the Renaissance corresponded with the phase of the primitive accumulation of private capital. I argue something similar in *Ways of Seeing*. The immense theoretical weakness of my own book is that I do not make clear what relation exists between what I call 'the exception' (the genius) and the normative tradition. It is at this point that work needs to be done. It could well be the theme of a conference.

A second school sees art history as part of the history of ideas (Jacob Burckhardt, Aby Warburg, Panofsky, Saxl). The weakness of this school is to avoid the specificity of the language of painting and to treat it as if it were a hieroglyphic text of ideas. As for the ideas themselves, they tend to be thought of as emanating from a *Zeitgeist* who, in class terms, is immaculate and virgin. I find the criticisms valid.

The third school is that of formalism (Wölfflin, Riegl) which sees art as a history of formal structures. Art, independent of both artists and

society, has its own life coiled in its forms. This life develops through stages of youthfulness, maturity, decadence. A painter inherits a style at a certain stage of its spiral development. Like all organic theories applied to highly socialized activities – mistaking *history* for *nature* – the formalist school leads to reactionary conclusions.

Against each of these schools Hadjinicolaou fights as valiantly as David, armed with his sling of *visual ideology*. The proper subject matter of 'art history as an autonomous science' is 'the analysis and explanation of the visual ideologies which have appeared in history'. Only such ideologies can explain art. 'Aesthetic effect' – the enhancement that a work of art offers – 'is none other than the pleasure felt by the observer when he recognizes himself in a picture's visual ideology.' The 'disinterested' emotion of classical aesthetics turns out to be a precise class interest.

Now, within the logic of Althusserian Marxism and its field of ideological formulations, this is an elegant if abstract formula. And it has the advantage of cutting the interminable knotting of the obsolete discourse of bourgeois aesthetics. It may also go some way to explaining the dramatic fluctuations which have occurred in the history of taste: for example, the neglect during centuries after their original fame of painters as different as Franz Hals and El Greco.

The formula would seem to cover retrospectively Antal's practice as an art historian. In his formidable study on Florentine painting – as well as in other works – Antal set out to show in detail how sensitive painting was to economic and ideological developments. Single-handed he disclosed, with all the rigour of a European scholar, a new seam of content in pictures, and through this seam ran the class struggle. But I do not think that he believed that this explained the phenomenon of art. His respect for art was such that he could not forgive, as Marx could not forgive, the history he studied.

And Marx himself posed the question which the formula of visual ideology cannot answer. If art is bound up with certain phases of social historical development, how is it that we still find, for example, classical Greek sculpture beautiful? Hadjinicolaou replies by arguing that what is seen as 'art' changes all the while, that the sculptures seen by the nineteenth century were no longer the same *art* as seen by the third century BC. Yet the question remains: what then is it about certain works which allows them to 'receive' different interpretations and continue to offer a mystery? (Hadjinicolaou would consider the last word unscientific, but I do not.)

Max Raphael, in his two essays, *The Struggle to Understand Art* and *Towards an Empirical Theory of Art* (1941), began with the same question posed by Marx and proceeded in exactly the opposite direction. Whereas Hadjinicolaou begins with the work as an object and looks for explanations prior to its production and following its production, Raphael

believed that the explanation had to be sought in the process of production itself: the power of paintings lay in their *painting*. 'Art and the study of art lead from the work to the process of creation.'

For Raphael, 'The work of art holds man's creative powers in a crystalline suspension from which they can again be transformed into living energies.' Everything therefore depends upon this crystalline suspension, which occurs in history, subject to its conditions, and yet at another level defies those conditions. Raphael shared Marx's doubt; he recognized that historical materialism and its categories as so far developed could only explain certain aspects of art. They could not explain why art is capable of defying the flow of historical process and time. Yet Raphael proposed an empirical – not an idealist – answer.

'Art is an interplay, an equation of three factors – the artist, the world and the means of figuration.' A work of art cannot be considered as either a simple object or simple ideology. 'It is always a synthesis between nature (or history) and the mind, and as such it acquires a certain autonomy vis-à-vis both these elements. This independence seems to be created by man and hence to possess a psychic reality; but in point of fact the process of creation can become an existent only because it is embedded in some concrete material.' Wood, pigment, canvas and so on. When this material has been worked by the artist it becomes like no other existing material: what the image represents (a head and shoulders, say) is pressed, embedded into this material, whilst the material by being worked into a representational image acquires a certain immaterial character. And it is this which gives works of art their incomparable energy. They exist in the same sense that a current exists: it cannot exist without substances and yet it is not in itself a simple substance.

None of this precludes 'visual ideologies'. But Raphael's theory is bound to situate them as one factor amongst others within the act of painting; they cannot form the simple grid through which the artist sees and the spectator looks. Hadjinicolaou wants to avoid the reductionism of vulgar Marxism, yet he replaces it with another because he has no theory about *the act* of painting or *the act* of looking at pictures.

The lack becomes obvious as soon as he considers the visual ideology of particular pictures. There is nothing in common, he says, between a Louis David portrait painted in 1781, the David painting of 'The Death of Marat' of 1793, and his painting of 'Madame Récamier' of 1800. He has to say this because, if a painting consists of nothing but visual ideology, and these three paintings clearly have different visual ideologies reflecting the history of the Revolution, they cannot have anything in common. David's experience as a painter is irrelevant, and our experience as spectators of David's experience is also irrelevant. And there's the rub. The real experience of looking at paintings has been eliminated.

When Hadjinicolaou goes further and equates the visual ideology of 'Madame Récamier' with that of a portrait by Girodet, one realizes that the visual content to which he is referring goes no deeper than the *mise-en-scène*. The correspondence is at the level of clothes, furniture, hairstyle, gesture, pose: at the level, if you wish, of manners and appearances!

Of course, there are paintings which do only function at this level, and his theory may help to fit some of these paintings into history. But no painting of value is about appearances: it is about a totality of which the visible is no more than a code. And in face of such paintings the theory of visual ideology is helpless.

To this Hadjinicolaou would reply that the term 'painting of value' is meaningless. And in a sense I cannot answer his objection because my own theory is weak about the relation existing between the exceptional work and the average. Nevertheless I would beg Hadjinicolaou and his colleagues to consider the possibility that their approach is self-defeating and retrograde, leading back to a reductionism not dissimilar in degree to Zhdanov's and Stalin's.

The refusal of comparative judgements about art ultimately derives from a lack of belief in the purpose of art. One can only qualify X as better than Y if one believes that X achieves more, and this achievement has to be measured in relation to a goal. If paintings have no purpose, have no value other than their promotion of a visual ideology, there is little reason for looking at old pictures except as specialist historians. They become no more than a text for experts to decipher.

The culture of capitalism has reduced paintings, as it reduces everything which is alive, to market commodities, and to an advertisement for other commodities. The new reductionism of revolutionary theory, which we are considering, is in danger of doing something similar. What the one uses as an advertisement (for a prestige, a way of life and the commodities that go with it), the other sees as only a visual ideology of a class. Both eliminate art as a potential model of freedom, which is how artists and the masses have always treated art when it spoke to their needs.

When a painter is working he is aware of the means which are available to him – these include his materials, the style he inherits, the conventions he must obey, his prescribed or freely chosen subject matter – as constituting both an opportunity and a restraint. By working and using the opportunity he becomes conscious of some of its limits. These limits challenge him, at either an artisanal, a magical or an imaginative level. He pushes against one or several of them. According to his character and historical situation, the result of his pushing varies from a barely discernible variation of a convention – changing no more than the individual voice of a singer changes a melody – to a fully original discovery, a breakthrough. Except in the case of the pure hack, who,

needless to say, is a modern invention of the market, every painter from palaeolithic times onwards has experienced this will to push. It is intrinsic to the activity of rendering the absent present, of cheating the visible, of making images.

Ideology partly determines the finished result, but it does not determine the energy flowing through the current. And it is with this energy that the spectator identifies. Every image used by a spectator is a *going further* than he could have achieved alone, towards a prey, a Madonna, a sexual pleasure, a landscape, a face, a different world.

'On the margin of what man can do,' wrote Max Raphael, 'there appears that which he cannot or cannot yet do – but which lies at the root of all creativeness.' A revolutionary scientific history of art has to come to terms with such creativeness.

1978

Mayakovsky: His Language

and His Death [*with Anya Bostock*]

> Jackals used to creep right up to the house. They moved in large packs and howled terribly. Their howling was most unpleasant and frightening. It was there that I first heard those wild piercing howls. The children could not sleep at night and I used to reassure them, 'Don't be afraid, we have good dogs, they won't let them come near.'

Thus Mayakovsky's mother described the forest in Georgia, Russia, where Vladimir and his sisters were brought up. The description is a reminder at the start that the world into which Mayakovsky was born was very different from our own.

When a man in good health commits suicide it is, finally, because there is no one who understands him. After his death the incomprehension often continues because the living insist on interpreting and using his story to suit their own purposes. In this way the ultimate protest against incomprehension goes unheard after all.

If we wish to understand the meaning of Mayakovsky's example – and it is an example central to any thinking about the relation between revolutionary politics and poetry – we have to work on that meaning. A meaning embodied both in his poetry and in the destiny of his life, and death.

Let us begin simply. Outside Russia, Mayakovsky is known as a romantic political legend rather than as a poet. This is because his poetry has so far proved very hard to translate. This difficulty has encouraged readers to return to the old half-truth that great poetry is untranslatable. And so the story of Mayakovsky's life – his avant-garde Futurist youth, his commitment to the Revolution in 1917, his complete self-identification as poet with the Soviet state, his role during ten years as poetic orator and proselytizer, his apparently sudden despair and suicide at the age of 36 – all this becomes

abstract because the stuff of his poetry, which, in Mayakovsky's case, *was* the stuff of his life, is missing. Everything began for Mayakovsky with the language he used, and we need to appreciate this even if we cannot read Russian. Mayakovsky's story and tragedy concern the special historical relation which existed between him and the Russian language. To say this is not to depoliticize his example but to recognize its specificity.

Three factors about the Russian language.

1. During the nineteenth century the distinction between spoken and written Russian was far less marked than in any Western European country. Although the majority were illiterate, the written Russian language had not yet been expropriated and transformed to express the exclusive interests and tastes of the ruling class. But by the end of the century a differentiation between the language of the people and the new urban middle class was beginning to become apparent. Mayakovsky was opposed to this 'emasculation of the language'. Nevertheless it was still possible and even natural for a Russian poet to believe that he could be the inheritor of a living popular language. It was not mere personal arrogance which made Mayakovsky believe that he could speak with the voice of Russia, and when he compared himself with Pushkin it was not to bracket two isolated geniuses but two poets of a language which might still belong to an entire nation.

2. Because Russian is an inflected and highly accented language, it is especially rich in rhymes and especially rhythmical. This helps to explain why Russian poetry is so widely known by heart. Russian poetry when read out loud, and particularly Mayakovsky's, is nearer to rock than to Milton. Listen to Mayakovsky himself:

> Where this basic dull roar of a rhythm comes from is a mystery. In my case it's all kinds of repetitions in my mind of noises, rocking motions, or in fact of any phenomenon with which I can associate a sound. The sound of the sea, endlessly repeated, can provide my rhythm, or a servant who slams the door every morning, recurring and intertwining with itself, trailing through my consciousness; or even the rotation of the earth, which in my case, as in a shop full of visual aids, gives way to, and inextricably connects with the whistle of a high wind.[1]

These rhythmic and mnemonic qualities of Mayakovsky's Russian are not, however, at the expense of content. The rhythmic sounds combine whilst their sense separates with extraordinary precision. The regularity of the sound reassures whilst the sharp, unexpected sense shocks. Russian is also a language which lends itself easily, through the addition of prefixes and suffixes, to the invention of new words whose meaning is nevertheless quite clear. All this offers opportunities to the poet as virtuoso: the poet as musician, or the poet as acrobat or juggler. A trapeze artist can bring tears to the eyes more directly than a tragedian.

3. After the Revolution, as a result of the extensive government literacy campaign, every Soviet writer was more or less aware that a vast new reading public was being created. Industrialization was to enlarge the proletariat and the new proletarians would be 'virgin' readers, in the sense that they had not previously been corrupted by purely commercial reading matter. It was possible to think, without unnecessary rhetoric, of the revolutionary class claiming and using the written word as a revolutionary right. Thus the advent of a literate proletariat might enrich and extend written language in the USSR instead of impoverishing it as had happened under capitalism in the West. For Mayakovsky after 1917 this was a fundamental article of faith. Consequently he could believe that the formal innovations of his poetry were a form of political action. When he worked inventing slogans for the government's propaganda agency, ROSTA, when he toured the Soviet Union giving unprecedented public poetry readings to large audiences of workers, he believed that by way of his words he would actually introduce new turns of phrase, and thus new concepts, into the workers' language. These public readings (although as the years went by he found them more and more exhausting) were probably among the few occasions when life really appeared to confirm the justice of his own self-appointed role. His words were understood by his audiences. Perhaps the underlying sense sometimes escaped them, but there in the context of his reading and their listening this did not seem to matter as it seemed to matter in the interminable arguments he was forced to have with editors and literary officials: there the audience, or a large part of it, seemed to sense that his originality belonged to the originality of the Revolution itself. Most Russians read poetry like a litany; Mayakovsky read like a sailor shouting through a megaphone to another ship in a heavy sea.

Thus the Russian language at that moment in history. If we call it a language *demanding poetry* it is not an exaggerated figure of speech, but an attempt to synthesize in a few words a precise historical situation. But what of the other term of the relation, Mayakovsky the poet? What kind of poet was he? He remains too original to be easily defined by comparison with other poets, but perhaps, however crudely, we can begin to define him as a poet by examining his own view of poetry, always remembering that such a definition is made without the pressures to which he was subject throughout his life: pressures in which subjective and historical elements were inseparable.

This is how, in his autobiographical notes, he describes becoming a poet:

Today I wrote a poem. Or to be exact: fragments of one. Not good. Unprintable. 'Night'. Stretensky Boulevard. I read the poem to Bur-lyuk. I added: written by a friend. David stopped and looked at me. 'You wrote it yourself!' he exclaimed. 'You're a genius!' I was happy at

this marvellous and undeserved praise. And so I steeped myself in poetry. That evening, quite unexpectedly, I became a poet.

The tone is laconic. Nevertheless he is saying that he became a poet because he was called upon to become one. Obviously the potential of his genius already existed. And would probably have been released in any case. But his temperament insisted that the release should come *through a demand*.

Later, he continually refers to poetry as something which must meet 'a social command'. The poem is a direct response to that command. One of the things which his early, marvellously flamboyant Futurist poetry has in common with his later political poetry is its form of address. By which we mean the poet's stance towards the *you* being addressed. The *you* may be a woman, God, a party official, but the way of presenting the poet's life to the power being addressed remains similar. The *you* is not to be found in the life of the *I*. Poetry is the making of poetic sense of the poet's life for the use of another. One might say that this is more or less true of all poetry. But in Mayakovsky's case the notion that poetry is a kind of exchange *acting between* the poet's life and the demands of other lives is specially developed. In this idea is implanted the principle that the poetry will be justified or not by its reception. And here we touch upon one of the important conflicts in Mayakovsky's life as a poet. Its starting point is the existence of language as the primary fact; its finishing point is the judgement of others towards his use of that language in a set of particular circumstances. He took language upon himself as though it were his own body, but he depended upon others to decide whether or not that body had the right to exist.

One of Mayakovsky's favourite comparisons is between the production of poetry and industrial factory production. To explain this metaphor just in terms of a Futurist admiration for modern technology would be to miss the point. Poetry for Mayakovsky was a question of processing or transforming experience. He speaks of the poet's experience as the *raw material* for poetry, the finished product being the poem which will answer the social command.

> Only the presence of rigorously thought-out preliminary work gives me the time to finish anything, since my normal output of work in progress is eight to ten lines a day.
>
> A poet regards every meeting, every signpost, every event in whatever circumstances simply as material to be shaped into words.

What he means there by preliminary work is the inventing and storing of rhymes, images, lines which will later be useful. The 'manufacture' of the poem, as he explains with unique frankness in *How Are Verses Made?*, goes through several stages. First there is the preliminary work: the casting into words of experience and the storing of these relatively short word-units.

In about 1913, when I was returning from Saratov to Moscow, so as to prove my devotion to a certain female companion, I told her that I was 'not a man, but a cloud in trousers'. When I'd said it, I immediately thought it could be used in a poem ... Two years later I needed 'a cloud in trousers' for the title of a whole long poem.

Then comes the realization that there is 'a social command' for a poem on a particular theme. The need behind the command must be fully understood by the poet. Finally comes the composition of the poem in accordance with the need. Some of what has been cast into words can now be used to its ideal maximum. But this requires trial and retrial. When it is at last right, it acquires explosive power.

> Comrade tax inspector,
> > on my honour,
> A rhyme
> > costs the poet
> > > a sou or two.
> If you'll allow the metaphor,
> > a rhyme is
> > > a barrel.
> A barrel of dynamite.
> > The line is the fuse.
> When the fuse burns up
> > the barrel explodes.
> And the city blows into the air:
> > that's the stanza.
> What is the price tariff
> > for rhymes
> Which aim straight
> > and kill outright?
> It could be that
> > only five undiscovered rhymes
> > > are left
> In all the world
> > and those perhaps in Venezuela.
> The trail leads me
> > into cold and hot climates.
> I plunge,
> > entangled in advances and loans.
> Citizen,
> > make allowance for the cost of the
> > fare!

 Poetry – all of it! –
 is a voyage into the unknown.
 Poetry
 is like mining for radium.
 The output an ounce
 the labour a year.
 For the sake of a single word
 you must process
 Thousands of tons
 of verbal ore.
 Compare the flash-to-ashes
 of such a word
 With the slow combustion
 of the ones left in their natural
 state!
 Such a word
 sets in motion
 Thousands of years
 and the hearts of millions.[2]

When the poem is written, it needs to be read. By readers themselves, but
also by the poet out loud. At his public readings Mayakovsky was a man
showing what the things he had made could do: he was like a driver or
test pilot – except that his performance with the poems took place, not
on the ground or in the air, but in the minds of his listeners.

 We should not, however, be deceived, by Mayakovsky's desire to
rationalize the making of verses, into believing that there was no mystery
in the process for him. His poetic vision was passionate, and continually
rocked by his own astonishment.

 The universe sleeps
 And its gigantic ear
 Full of ticks
 That are stars
 Is now laid on its paw.

Yet he saw poetry as an act of exchange, an act of translation whose purpose
was to make the poet's experience usable by others. He believed in an
alchemy of language; in the act of writing the miraculous transformation
occurred. When he wrote about Yessenin's suicide in 1925 he was unable to
give any convincing reason why Yessenin should have gone on living –
although he judged that this was what the social command required. It is
early in the poem that he makes his real point: if only there had been ink in
the hotel bedroom where Yessenin cut his wrists and hanged himself, if

only he had been able to *write*, he could have gone on living. To write was simultaneously to come into one's own and to join others.

In the same poem Mayakovsky speaks of the Russian people 'in whom our language lives and breathes', and he castigates all timid, academic usage of this language. (Yessenin, he says, would have told the conformist orators at his funeral to stuff their funeral orations up their arse.) He admits that it is a difficult time for writers. But what time hasn't been? he asks. And then he writes:

> Words are
> > the commanders
> > > of mankind's forces.
> March!
> > and behind us
> > > time
> > > > explodes like a landmine.
> To the past
> > we offer
> > > only the streaming tresses
> Of our hair
> > tangled
> > > by the wind.[3]

To clarify what we are saying, it may be helpful to compare Mayakovsky with another writer. Yannis Ritsos, the contemporary Greek poet, is like Mayakovsky an essentially political poet: he is also a Communist. Yet despite their common political commitment, Ritsos is precisely the opposite kind of poet to Mayakovsky. It is not from the act of writing or processing words that Ritsos's poetry is born. His poetry appears as the *consequence* of a fundamental decision which in itself has nothing to do with poetry. Far from being the finished product of a complicated production process, Ritsos's poetry seems like a by-product. One has the impression that his poems exist for him *before* their accumulation of words: they are the precipitate of an attitude, a decision already taken. It is not by his poems that he proves his political solidarity, but the other way round: on account of his political attitude, certain events offer their poetic face.

> *Saturday 11 a.m.*
> The women gather the clothes from
> > the clothes line.
> The landlady stands in the doorway
> > of the yard.
> One holds a suitcase.

The other has a black hat on.
The dead pay no rent.
They have disconnected Helen's
 telephone.
The doughnut man shouts on
 purpose: 'Doughnuts,
 warm doughnuts.' The young
 violinist at the window –
 'warm zero-round doughnuts,'
 he says.
He throws his violin down on the
 sidewalk.
The parrot looks over the baker's
 shoulder.
The landlady tinkles her keys.
The three women go in, shut the
 door.[4]

There can be no question of quoting Ritsos against Mayakovsky, or vice versa. They are different kinds of poets writing in different circumstances. Ritsos's choice, of which his poetry (given his poetic genius) is the by-product, is a choice of opposition and resistance. Mayakovsky considered that it was his political duty to celebrate and affirm. One form of poetry is public, the other clandestine. Contrary, however, to what one may expect, the former may be the more solitary.

To return now to Mayakovsky. Before the Revolution and during its first years, one can say that the Russian language was *demanding* poetry on a mass scale; it was seeking its own national poets. It is impossible to know whether Mayakovsky's genius was actually formed by this demand or only developed by it. But the coincidence between his genius and the state of the language at that moment is crucial to his life's work, and perhaps to his death. It was a coincidence which lasted only for a certain time.

From the period of NEP onwards, the language of the Revolution began to change. At first the change must have been almost imperceptible – except to a poet-performer like Mayakovsky. Gradually words were ceasing to mean exactly what they said. (Lenin's will-to-truthfulness was exceptional and his death, in this respect as in others, now appears as a turning point.) Words began to hide as much as they signified. They became double-faced: one face referring to theory, the other to practice. For example the word *Soviet* became a designation of citizenship and a source of patriotic pride: only in theory did it still refer to a particular form of proletarian democracy. The 'virgin' reading public became, to a large degree, a reading public that was deceived.

Mayakovsky was dead before the devaluation of the Russian language had extended very far, but already in the last years of his life, in works like *Good, The Bedbug, The Bath-house* – all of which were badly received – his vision became increasingly satirical. Words were loaded with a meaning that was no longer just or true. Listen to the Producer in the third act of *The Bath-house*:

> All right now, all the men on stage. Kneel down on one knee and hunch your shoulders, you've got to look enslaved, right? Hack away there with your imaginary picks at the imaginary coal. Gloomier there, gloomier, you're being oppressed by dark forces.
>
> You there, you're Capital. Stand over here, Comrade Capital. You're going to do us a little dance impersonating Class Rule . . .
>
> The women on stage now. You'll be Liberty, you've got the right manners for it. You can be Equality, doesn't matter who acts that does it? And you're Fraternity, dear, you're not likely to arouse any other feeling anyway. Ready? Go! Infect the imaginary masses with your imaginary enthusiasm! That's it! That's it!

Meanwhile, what was happening to Mayakovsky himself? A woman he was in love with had abandoned him. His work was being subjected to more and more severe criticism, on the grounds that its spirit was far from the working class. The doctors had told him that he had damaged his vocal cords irrevocably by straining his voice when reading. He had dissolved his own avant-garde group (LEF, renamed REF) and had joined the most official, 'majority' association of writers, which had always been highly critical of him (RAPP): as a result, he was snubbed by them and treated as a renegade by his former friends. A retrospective exhibition of his life's work – poems, plays, posters, films – failed to make the impact he had hoped. He was thirty-six, next year he would be the same age as Pushkin when he met his death. Pushkin had incontestably been the founder of the language of modern Russian poetry. Yet what was happening to the language of revolutionary poetry which Mayakovsky had once believed in?

If a writer sees his life as raw material waiting to enter language, if he is continually involved in processing his own experience, if he sees poetry primarily as a form of exchange, there is a danger that, when he is deprived of an immediate audience, he will conclude that his life *has been used up*. He will see only its fragments strewn across the years – as if, after all, he had been torn to pieces by the jackals. 'Don't be afraid, we have good dogs, they won't let them come near.' The promise was broken. They came.

1975

The Hour of Poetry

> We all know the number of steps,
> compañero, from the cell
> to that room.
>
> If it's twenty
> they're not taking you to the bathroom.
> If it's forty-five
> they can't be taking you out
> for exercise.
>
> If you get past eighty
> and begin
> to stumble blindly
> up a staircase
> oh if you get past eighty
> there's only one place
> they can take you
> there's only one place
> there's only one place
> now there's only one place left
> they can take you.

There is a hotel by a lake, near where I live. During the last war it was the local headquarters of the Gestapo. Many people were interrogated and tortured there. Today it is a hotel again. From the bar you look out across the water to the mountains on the far side; you look out on a scene that would have appealed to hundreds of romantic painters in the nineteenth century as sublime. And it was on to this scene that, before and after their interrogations, the tortured looked out. It was before this scene that loved ones and friends of the tortured stopped, powerless, to stare at the

445

building, in which their own was being subjected to unspeakable pain or a lingering and agonizing death. Between the sublime and their present reality, what did they see in those mountains and that lake?

Of all experiences, systematic human torture is probably the most indescribable. Not simply because of the intensity of the suffering involved, but also because the initiative of such torture is opposed to the assumption on which all languages are based: the assumption of mutual understanding across what differentiates. Torture smashes language: its purpose is to tear language from the voice and words from the truth. The one being tortured knows: they are breaking me. His or her resistance consists in trying to limit the *me* being broken. Torture tears apart.

> Don't believe them when they show you
> the photo of my body,
> don't believe them.
> Don't believe them when they tell you
> the moon is the moon,
> if they tell you the moon is the moon,
> that this is my voice on tape,
> that this is my signature on a confession,
> if they say a tree is a tree
> don't believe them,
> don't believe
> anything they tell you
> anything they swear to
> anything they show you,
> don't believe them.

Torture has a very long and widespread history. If people today are surprised by the scale of its reappearance (did it ever disappear?), it is perhaps because they have ceased believing in evil. Torture is not shocking because it is rare or because it belongs to the past: it is shocking because of what it does. The opposite of torture is not *progress* but *charity*. (The subject is so close to the New Testament that its terms are usable.)

The majority of torturers are neither sadists – in the clinical sense of the word – nor incarnations of pure evil. They are men and women who have been conditioned to accept and then use a certain practice. There are formal and informal schools for torturers, mostly state-financed. But the first conditioning begins, before the school, with ideological propositions that a certain category of people are fundamentally different and that their difference constitutes a supreme threat. The tearing apart of the third person, *them*, from *us* and *you*. The next lesson, now in the schools for torture, is that *their* bodies are lies because, as bodies, they claim *not* to be so different: torture is a punishment for this lie. When

and if the torturers begin to question what they have learnt, they still continue, out of fear of what they have already done; they torture now to save their own untortured skins.

The fascist regimes of Latin America – Pinochet's Chile, for example – have recently and systematically extended the logic of torture. Not only do they tear apart the bodies of their victims, but they also try to tear up – so that they cannot be read – their very names. It would be wrong to suppose that these regimes do this out of shame or embarrassment: they do it in the hope of eliminating martyrs and heroes, and in order to produce the maximum intimidation among the population.

A woman or man is openly arrested, taken away in a car from his home at night, or from his workplace during the day. The arresters, the abductors, wear plain clothes. After this it is impossible to have any news of the one who has disappeared. Police, ministers, courts, deny all knowledge of the missing person. Yet the missing persons are in the hands of the military intelligence services. Months, years, pass. To believe that the missing are dead is to betray those who have thus been torn away; yet to believe that they are alive is to dream of them being tortured and then, often later, to be forced to admit their death. No letter, no sign, no whereabouts, no one responsible, no one to appeal to, no imaginable end to the sentence, because no sentence. Normally silence means a lack of sound. Here silence is active and has been turned, once again systematically, into an instrument, this time for torturing the heart. Occasionally carcasses are washed up on the beaches and identified as belonging to the list of the missing. Occasionally one or two return with some news of the others who are still missing: released intentionally perhaps, so as to sow again hopes which will torture thousands of hearts.

> My son has been
> missing
> since May 8
> of last year.
>
> They took him
> just for a few hours
> they said
> just for some routine
> questioning.
>
> After the car left,
> the car with no licence plate,
> we couldn't
>
> find out

anything else
about him.

But now things have changed.
We heard from a compañero
who just got out
that five months later
they were torturing him
in Villa Grimaldi,
at the end of September
they were questioning him
in the red house
that belonged to the Grimaldis.

They say they recognized
his voice his screams
they say.

Somebody tell me frankly
what times are these
what kind of world
what country?
What I'm asking is
how can it be
that a father's
joy
a mother's
joy
is knowing
that they
that they are still
torturing
their son?
Which means
that he was alive
five months later
and our greatest
hope
will be to find out
next year
 that they're still torturing him
eight months later

and he may might could
still be alive.

Physical torture often concentrates upon the genitalia because of their sensitivity, because of the humiliation involved, and because thus the victim is threatened with sterility. In the emotional torture of the women and men who love those who have been made to disappear, their hopes are chosen as the point of application for pain, so as to produce – at another level – a comparable threat of sterility.

> If he were dead
> I'd know it.
> Don't ask me how.
> I'd know.
>
> I have no proof,
> no clues, no answer,
> nothing that proves
> or disproves.
>
> There's the sky,
> the same blue
> it always was.
>
> But that's no proof.
> Atrocities go on
> and the sky never changes.
>
> There are the children.
> They've finished playing.
> Now they'll start to drink
> like a herd of wild
> horses.
> Tonight they'll be asleep
> as soon as their heads
> touch the pillow.
>
> But who would accept that
> as proof
> that their father
> is not dead?

In the face of such practices and their increasing frequency and the involvement of US agencies in their preparation, if not their daily routine,

every sort of active protest and resistance needs to be mounted. (Amnesty International is coordinating some of them.) In addition, poets – such as the Chilean Ariel Dorfman – will write poems (all the above quotations are from Dorfman's *Missing*, published by Amnesty International). In face of the monstrous machinery of modern totalitarian power, so often now compared to that of the Inferno, poems will increasingly be written.

During the eighteenth and nineteenth centuries many protests against social injustice were written in prose. They were reasoned arguments written in the belief that, given time, people would come to see reason; and that, finally, history was on the side of reason. Today this is by no means so clear. The outcome is by no means guaranteed. The suffering of the present and the past is unlikely to be redeemed by a future era of universal happiness. And evil is a constantly ineradicable reality. All this means that the resolution – the coming to terms with the sense to be given to life – cannot be deferred. The future cannot be trusted. The moment of truth is now. And more and more it will be poetry, rather than prose, that receives this truth. Prose is far more trusting than poetry: poetry speaks to the immediate wound.

The boon of language is not tenderness. All that it holds, it holds with exactitude and without pity. Even a term of endearment: the term is impartial; the context is all. The boon of language is that *potentially* it is complete, it has the potentiality of holding with words the totality of human experience. Everything that has occurred and everything that may occur. It even allows space for the unspeakable. In this sense one can say of language that it is potentially the only human home, the only dwelling place that cannot be hostile to man. For prose this home is a vast territory, a country which it crosses through a network of tracks, paths, highways; for poetry this home is concentrated on a single centre, a single voice.

One can say anything to language. This is why it is a listener, closer to us than any silence or any god. Yet its very openness often signifies indifference. (The indifference of language is continually solicited and employed in bulletins, legal records, communiqués, files.) Poetry addresses language in such a way as to close this indifference and to incite a caring. How does poetry incite this caring? What is the labour of poetry?

By this I do not mean the work involved in writing a poem, but the work of the written poem itself. Every authentic poem contributes to the labour of poetry. And the task of this unceasing labour is to bring together what life has separated or violence has torn apart. Physical pain can usually be lessened or stopped by action. All other human pain, however, is caused by one form or another of separation. And here the act of assuagement is less direct. Poetry can repair no loss, but it defies the space which separates. And it does this by its continual labour of reassembling what has been scattered.

O my beloved
how sweet it is
to go down
and bathe in the pool
before your eyes
letting you see how
my drenched linen dress
marries
the beauty of my body.
Come, look at me

Poem inscribed on an Egyptian statue, 1500 BC

Poetry's impulse to use metaphor, to discover resemblance, is not for the sake of making comparisons (all comparisons as such are hierarchical), nor is it to diminish the particularity of any event; it is to discover those correspondences of which the sum total would be proof of the indivisible totality of existence. To this totality poetry appeals, and its appeal is the opposite of a sentimental one; sentimentality always pleads for an exemption, for something which *is* divisible.

Apart from reassembling by metaphor, poetry reunites by its *reach*. It equates the reach of a feeling with the reach of the universe; after a certain point the type of extremity involved becomes unimportant and all that matters is its degree; by their degree alone extremities are joined.

I bear equally with you
the black permanent separation.
Why are you crying? Rather give me
 your hand,
promise to come again in a dream.
You and I are a mountain of grief.
You and I will never meet on this earth.
If only you could send me at midnight
a greeting through the stars

Anna Akhmatova

To argue here that the subjective and objective are confused is to return to an empirical view which the extent of present suffering challenges; strangely enough it is to claim an unjustified privilege.

Poetry makes language care because it renders everything intimate. This intimacy is the result of the poem's labour, the result of the bringing-together-into-intimacy of every act and noun and event and perspective to which the poem refers. There is often nothing more substantial to place against the cruelty and indifference of the world than this caring.

> From where does Pain come to us?
> From where does he come?
> He has been the brother of our visions
> from time immemorial
> And the guide of our rhymes

writes the Iraqi poet Nazik al-Mil'-ika.

To break the silence of events, to speak of experience however bitter or lacerating, to put into words, is to discover the hope that these words may be heard, and that when heard, the events will be judged. This hope is, of course, at the origin of prayer, and prayer – as well as labour – was probably at the origin of speech itself. Of all uses of language, it is poetry that preserves most purely the memory of this origin.

Every poem that works as a poem is original. And *original* has two meanings: it means a return to the origin, the first which engendered everything that followed; and it means that which has never occurred before. In poetry, and in poetry alone, the two senses are united in such a way that they are no longer contradictory.

Nevertheless poems are not simple prayers. Even a religious poem is not exclusively and uniquely addressed to God. Poetry is addressed to language itself. If that sounds obscure, think of a lamentation – there words lament loss to their language. Poetry is addressed to language in a comparable but wider way.

To put into words is to find the hope that the words will be heard and the events they describe judged. Judged by God or judged by history. Either way the judgement is distant. Yet the language – which is immediate, and which is sometimes wrongly thought of as being only a means – offers, obstinately and mysteriously, its own judgment when it is addressed by poetry. This judgement is distinct from that of any moral code, yet it promises, within its acknowledgment of what it has heard, a distinction between good and evil – as though language itself had been created to preserve just that distinction!

This is why poetry opposes more *absolutely* than any other force in the world the monstrous cruelties by which the rich today defend their ill-gotten riches. This is why the hour of the furnaces is also the hour of poetry.

1982

Leopardi

> What was that acid spot in time
> That went by the name of life?
>
> Leopardi

I will begin with two stories.

Recently I was in Moscow. At the airport, when I was entering the country, the customs officer found in my bag some poems typed in Russian. They were my poems, translated by a friend in London. He handed them to a colleague to read. I explained what they were, but the colleague went on with his attentive reading. Finally, along with everything else that they had examined, he gave me back the poems, with a smile that was half-official and half-jocular. 'Perhaps your poetry is a little too pessimistic,' he said.

The other day I was speaking to my friend the Swiss film director Alain Tanner. I had just seen a television programme about the German actor Bruno Ganz. Ganz plays – very well – in Tanner's latest film. The programme I found infuriating because Ganz talked only about himself and his moods. 'What do you expect him to talk about?' replied Alain. 'Do you still expect people to talk about the world? Today the self is the only thing left to talk about.' I could not agree.

Enter Giacomo Leopardi (1798–1837). No poet, no thinker, has been more lucidly pessimistic than Leopardi. Lucidly because unlike, say, Kafka, without self-pity. Nor is there any obscurity in his writings. They clarify terribly – like the electric light bulb in Picasso's 'Guernica'.

Leopardi was born in the Marches of Rome into a small-time aristocratic family. Perhaps his only positive inheritance was his father's extensive library. By the age of ten he had taught himself Hebrew, Greek, German and English. For the rest, he inherited solitude, ill-health, an ever-failing eyesight and humiliating financial dependence. He said that he would prefer his writings to be burnt rather than that the reader should believe his conclusions about the human condition were drawn from his personal and wretched experience. I believe he was right to say this.

In an extraordinary way, Leopardi made, out of the pit of his own unhappiness, a tower from which to study the stars and the lives of others, past, present and future. It is difficult for somebody who is not Italian or an Italian scholar to talk with authority about the full quality of his poetry. Many believe him to be the greatest Italian poet since Dante. In every poem he wrote, there is a sustained thought, contributing to, and taking its place in, a global view of life. In this he is classical, like Virgil. But in his attitude to both language and the *immediate* subject (a village, a wedding, a carpenter) there is simultaneously a gentleness and a galactic distance – the downy breast feathers of a fledgling beside the mineral harshness of a meteorite – which produce a lyricism that is like no other.

He also wrote prose, notably a kind of philosophical journal called *Zibaldone*, which he kept between 1817 and 1832 and which was only published sixty years after his death, and a collection of *Moral Tales* mostly published during his lifetime.

Nietzsche, reading these *Tales*, qualified Leopardi as the greatest prose writer of the century. In fact today we can see how deeply he belongs to our century. The irony, the lack of rhetoric, the conversational lightness, and the acute gravity without self-importance of his prose, prophesy much in writers as different from one another as Pasolini, Brecht or Bulgakov.

The *Moral Tales* in their entirety are now available in English for the first time for seventy years, marvellously translated, annotated and prefaced by Patrick Creagh.[1] Unfortunately it is rare in academic life that, as here, the work of a master finds a scholar who is ready to learn so much, that even the tone of the commentary owes the master a debt. It is surely important that Creagh is a poet in his own right. This new book deserves to be read far beyond the academic readership for which it was principally designed. Anybody, from fourteen to eighty years old, interested in the primary questions posed by the human condition, will find pages to mark, distract and frighten him.

FASHION. Madame Death!

DEATH. Go to the devil. I'll come when you don't want me.

FASHION. As if I weren't immortal!

DEATH. Immortal? Already now the thousandth year hath passed since the times of the immortals.

FASHION. So even Madame can quote Petrarch like an Italian poet of the sixteenth or the nineteenth century.

DEATH. I like Petrarch's poems, because among them I find my Triumph, and because nearly all of them talk about me. But anyway, be off with you.

FASHION. Come on, by the love you bear the Seven Deadly Sins, stand still for once and look at me.

DEATH. Well? I'm looking.

FASHION. Don't you recognize me?

DEATH. You must know I'm short-sighted, and that I can't use spectacles because the English don't make any that suit me, and even if they did, I haven't got a nose to stick them on.

FASHION. I am Fashion, your sister.

DEATH. My sister?

FASHION. Yes: don't you remember that both of us are daughters of Decay?

DEATH. What do you expect me to remember, I who am the mortal foe of memory?

FASHION. But I remember it well; and I know that both of us equally aim continually to destroy and change all things here below, although you achieve this by one road and I by another.

In the *Moral Tales* wit often takes the place of the lyricism to be found in Leopardi's poetry, but the same approach to life, the same way of thinking, is present in both. Leopardi was a prodigy of the Enlightenment. He saw the world through the eyes of its materialism. He accepted the place that its philosophers gave to Pleasure. He was in agreement with their dismantling of religion and their exposure of the reactionary power of the Church. In his own way he was a populist. But he rejected absolutely the Enlightenment's belief in Progress. The basis of human equality, as he saw it, could never be a promise of happiness, but always a present suffering.

Writing as he was during the aftermath of Napoleon, his prognosis for the coming century, in which he foresaw money and the new means of communication and demagogy finally distorting everything, was catastrophic. Every historical period, he said, was a period of transition and every transition involved unhappiness. Once, however, there had been consolations – faith, a belief in destiny or redemption; such consolations had now been shown to be illusory, and the modern truth was starker and more hopeless than ever before.

Man was constructed in such a way that, above all, he loved his own life. This love made him believe that his life promised him happiness. This belief was incorrigible, and therefore most of the time he suffered. All this was the work of nature, in whose scheme of things man was an insignificant, marginal detail. (The *Tales* abound in ideas related to current science fiction.) The only possible deliverance from the human condition was the eternal sleep of death. He wrote often about the 'logic' of suicide, but he always refused it out of a curious but very deep solidarity with the living.

There is a paradox buried in Leopardi's work: a paradox which he himself was aware of. In the following quotation he was not so much

claiming genius for himself, as describing what he felt to be the potentiality of the written word:

> Works of genius have this intrinsic property, that even when they give a perfect likeness of the nullity of things, even when they clearly demonstrate and make us feel the inevitable unhappiness of life, even when they express the most terrible despair; nevertheless to a great soul, that may even find itself in a state of utter prostration, disillusionment, futility, boredom and discouragement with life, or in the harshest and most death-dealing adversities (whether these appertain to the strong and lofty emotions, or to any other thing), they always serve as a consolation, rekindling enthusiasm, and though speaking of and portraying nothing but death, restore to it, at least for a while, the life that it had lost.
>
> *Zibaldone*, 259–60

A Marxist interpretation of Leopardi would place him historically and remind us of all that he leaves out of account: the class struggle, the suffering directly caused by the economic law of capitalism, the historical destiny of man. At the limit, Leopardi, as a thinker, might even be dismissed as representing the despair of the aristocracy whose days were being numbered. Anyone attempting this would nevertheless have to contend with the Italian Marxist Sebastiano Timpanaro, who has written brilliantly on his behalf.

A year or two ago, at a meeting of the Transnational Institute in Amsterdam, I was asked to speak about Hopes for the Future. Somewhat mischievously, I played a recording of Beethoven's Thirty-first Piano Sonata (*Opus* 110) and then made the following proposal: political disillusion is born of political impatience and we have all been conditioned to live this impatience because of the overall promises repeatedly made in the name of Progress.

Suppose, I said, that we change the scenario, suppose we say that we are not living in a world in which it is possible to construct something approaching heaven-on-earth, but, on the contrary, are living in a world whose nature is far closer to that of hell; what difference would this make to any single one of our political or moral choices? We would be obliged to accept the same obligations and participate in the same struggle as we are already engaged in; perhaps even our sense of solidarity with the exploited and suffering would be more singleminded. All that would have changed would be the enormity of our hopes and finally the bitterness of our disappointments. My argument was, if you like, a Leopardian one, and it seems to me to be unanswerable.

And yet we cannot stop there. By force of circumstance, or (and how he would have appreciated the irony of the word!) by privilege, Leopardi was essentially a passive observer. And the unrelieved consistency of his

pessimism was connected with this fact. The connection is named Ennui, boredom.

As soon as one is engaged in a productive process, however circumscribed, total pessimism becomes improbable. This has nothing to do with the dignity of labour or any other such crap; it has to do with the nature of physical and psychic human energy. Expenditure of this energy creates a need for food, sleep and brief moments of respite. This need is so acute that, when it is satisfied or partly satisfied, the satisfaction, however fleeting, produces a hope for the next break. It is thus that the fatigued survive; fatigue plus total pessimism condemns to extinction.

Something similar happens at the level of imagination. The act of participating in the production of the world, even if the particular act in itself seems absurd, creates the imaginative perspective of a potential, more desired production. When in the old (halcyon?) days, a worker on an assembly line, tied to meaningless repetition, dreamt of a colour television or a new fishing-rod, it was wrong to explain this only in terms of consumerism or misplaced hopes. Inexorably, work, because it is productive, produces in man a productive hope. Hence one of the reasons why unemployment is so inhuman.

Leopardi, solitary, childless, incapable of physical work, was condemned to be a spectator of production. His personal condition cannot be used to explain his philosophical position. Yet, because of this condition, there was one thing which he, who knew so much and had such a respect for knowledge, did not know. He did not know how the body, with its terrible mortality, nevertheless comes to the rescue.

'Those whom the gods love, die young,' he used to quote as a confirmation of the sombre wisdom of the past. Probably that is still true. Yet what it excludes is the love of one or of both parents, and the hope that the infant – perhaps one of those whom the gods were to love – sometimes inspired in them.

Leopardi would, of course, have dismissed these hopes and the small rescue operations of the body as illusory. And indeed they do not, in themselves, undermine his argument. They coexist with it. Just as affirmation coexists with anguish in Beethoven's Thirty-first Sonata.

I want now to return to the paradox: how is it that Leopardi's black pages still encourage? When I said that Leopardi's life was that of a passive spectator, I was deliberately leaving aside one outstanding fact: the heroic, solitary production of his writings. If, for all their bleakness, these writings inspire, it is because, in their own way, they participate in the production of the world. And by now it should be clear that this term needs to cover, not only production in the classical economic sense of the word, but also the never-completed, always-being-produced state of

existence: the production of the world as reality. It is highly significant that in the *Moral Tales* Leopardi continually refers to, and speculates about, the creation of the universe and the forces, never entirely omnipotent, which lay behind it.

Which lay or which lie? His preoccupations were not retrospective but actual. The production of reality has never been finished, its outcome has never been made decisive. Something is always in the balance. *Reality is always in need.* Even of us, damned and marginal as we may be. This is why what Leopardi called Intensity and Schopenhauer called The Will – as man experiences them – are part of the continuous act of creation, part of the interminable production of meaning in face of 'the nullity of things'. And this is why his pessimism transcends itself.

1983

The Production of the World

I no longer know how many times I have arrived at the Central Station in Amsterdam, nor how many times I have been to the Rijksmuseum to look at Vermeer or Fabritius or Van Gogh. The first time must have been nearly thirty years ago, and during the last seven years I have been to Amsterdam systematically every six months to attend meetings of the Transnational Institute, of which I am a fellow.

I come away from each meeting where twenty or so fellows from the Third World, the United States, Latin America, Britain and the Continent discuss aspects of the world situation within a socialist perspective – I come away each time a little less ignorant and more determined. By now we all know each other well and when we reassemble it is like a team coming together; sometimes we win, sometimes we are beaten. Each time we find ourselves battling against false representations of the world – either those of ruling-class propaganda or those we carry within ourselves.

I owe this Institute a great deal, yet the last time I was due to go to Amsterdam I almost decided not to go. I felt too exhausted. My exhaustion, if I may so put it, was as much metaphysical as physical. I could no longer hold meanings together. The mere thought of making connections filled me with anguish. The only hope was to stay put. Nevertheless at the last minute I went.

It was a mistake. I could scarcely follow anything. The connection between words and what they signified had been broken. It seemed to me that I was lost; the first human power – the power to name – was failing, or had always been an illusion. All was dissolution. I tried joking, lying down, taking a cold shower, drinking coffee, not drinking coffee, talking to myself, imagining faraway places – none of it helped.

I left the building, crossed the street and entered the Van Gogh museum, not in order to look at the paintings but because I thought that

the one person who could take me home might be there; she was, but before I found her I had to run the gauntlet of the paintings. At this moment, I told myself, you need Van Gogh like you need a hole in the head.

'It seems to me not impossible that cholera, gravel, consumption may be celestial means of transport just as steamships, buses, railways, are means of transport on this earth. To die quietly of old age would be like going on foot . . .' Van Gogh wrote in a letter to his brother, Theo.

Still I found myself glancing at the paintings and then looking at them. 'The Potato Eaters'. 'The Cornfield with a Lark'. 'The Ploughed Field at Auvers'. 'The Pear Tree'. Within two minutes – and for the first time in three weeks – I was calm, reassured. Reality had been confirmed. The transformation was as quick and thorough-going as one of those sensational changes that can sometimes come about after an intravenous injection. And yet these paintings, already very familiar to me, had never before manifested anything like this therapeutic power.

What, if anything, does such a subjective experience reveal? What is the connection, if any, between my experience in the Van Gogh museum and the life work of Van Gogh the painter? I would have been tempted to reply: none or very little, were it not for a strange correspondence. Sometime after my return from Amsterdam I happened to take up a book of stories and essays by Hugo von Hoffmannsthal. Among them is a story entitled 'Letters of a Traveller Come Home'. The 'letters' are dated 1901. The supposed letter-writer is a German businessman who has lived most of his life outside Europe; now that he has returned to his homeland, he increasingly suffers from a sense of unreality; Europeans are not as he remembered them, their lives mean nothing because they systematically compromise.

'As I told you, I cannot grasp them, not by their faces, not by their gestures, not by their words; for their Being is no longer anywhere, indeed they *are* no longer anywhere.'

His disappointment leads him on to question his own memories and finally the credibility of anything. In many respects these thirty pages are a kind of prophecy of Sartre's *Nausea*, written thirty years later. This is from the last letter:

> Or again – some trees, those scraggy but well-kept trees which, here and there, have been left in the squares, emerging from the asphalt, protected by railings. I would look at them and I would know that they reminded me of trees – and yet were not trees – and then a shudder, seizing me, would break my breast in two, as though it were the breath, the indescribable breath of everlasting nothingness, of the everlasting nowhere, something which comes, not from death, from non-being.

The final letter also relates how he had to attend a business meeting in Amsterdam. He was feeling spineless, lost, indecisive. On his way there he passed a small art gallery, paused, and decided to go inside.

> How am I to tell you half of what these paintings said to me? They were a total justification of my strange and yet profound feelings. Here suddenly I was in front of something, a mere glimpse of which had previously, in my state of torpor, been too much for me. I had been haunted by that glimpse. Now a total stranger was offering me – with incredible authority – a reply – an entire world in the form of a reply.

The ending of the story is unexpected. Rehabilitated, confirmed, he went on to his meeting and pulled off the best business coup of his entire career.

A PS to the final letter gives the name of the artist in question as being a certain Vincent Van Gogh.

What is the nature of this 'entire world' which Van Gogh offers 'in the form of a reply' to a particular kind of anguish?

For an animal its natural environment and habitat are a given; for a man – despite the faith of the empiricists – reality is not a given: it has to be continually sought out, held – I am tempted to say *salvaged*. We are taught to oppose the real to the imaginary, as though one were always at hand and the other distant, far away. And this opposition is false. Events are always to hand. But the coherence of these events – which is what we mean by reality – is an imaginative construction. Reality always *lies beyond*, and this is as true for materialists as for idealists, for Plato and for Marx. Reality, however one interprets it, lies beyond a screen of clichés. Every culture produces such a screen, partly to facilitate its own practices (to establish habits) and partly to consolidate its own power. Reality is inimical to those with power.

All modern artists have thought of their innovations as offering a closer approach to reality, as a way of making reality more evident. It is here, and only here, that the modern artist and the revolutionary have sometimes found themselves side by side, both inspired by the idea of pulling down the screen of clichés, clichés which in the modern period have become unprecedentedly trivial and egotistical.

Yet many such artists have reduced what they found beyond the screen, to suit their own talent and social position as artists. When this has happened they have justified themselves with one of the dozen variants of the theory of art for art's sake. They say: reality is art. They hope to extract an artistic profit from reality. Of no one is this less true than Van Gogh.

We know from his letters how intensely he was aware of the screen. His whole life story is one of an endless yearning for reality. Colours, the

Mediterranean climate, the sun, were for him vehicles going towards this reality; they were never objects of longing in themselves. This yearning was intensified by the crises he suffered when he felt that he was failing to salvage any reality at all. Whether these crises are today diagnosed as being schizophrenic or epileptic changes nothing; their content, as distinct from their pathology, was a vision of reality consuming itself like a phoenix.

We also know from his letters that nothing appeared more sacred to him than work. He saw the physical reality of labour as being, simultaneously, a necessity, an injustice and the essence of humanity to date. The artist's creative act was for him only one among many. He believed that reality could best be approached through work, precisely because reality itself was a form of production.

The paintings speak of this more clearly than words. Their so-called clumsiness, the gestures with which he drew with pigment upon the canvas, the gestures (invisible to us but imaginable) with which he chose and mixed his colours on the palette, all the gestures with which he handled and manufactured the stuff of the painted image, are analogous to the *activity* of the existence of what he is painting. His paintings imitate the active existence – the labour of being – of what they depict.

Take a chair, a bed, a pair of boots. His act of painting them was far nearer than that of any other painter to the carpenter's or the shoemaker's act of making them. He brings together the elements of the product – legs, cross bars, back, seat; sole, uppers tongue, heel – as though he too were fitting them together, *joining* them, and as if this *being joined* constituted their reality.

Before a landscape the process required was far more complicated and mysterious, yet it followed the same principle. If one imagines God creating the world from earth and water, from clay, his way of handling it to make a tree or a cornfield might well resemble the way that Van Gogh handled paint when he painted that tree or cornfield. I am not suggesting that there was something quasi-divine about Van Gogh: this would be to fall into the worst kind of hagiography. If, however, we think of the creation of the world, we can imagine the act only through the visual evidence, before our eyes here and now, of the energy of the forces in play. And to these energies, Van Gogh was terribly – and I choose the adverb carefully – attuned.

When he painted a small pear tree in flower, the act of the sap rising, of the bud forming, the bud breaking, the flower forming, the styles thrusting out, the stigmas becoming sticky, these acts were present for him in the act of painting. When he painted a road, the roadmakers were there in his imagination. When he painted the turned earth of a ploughed field, the gesture of the blade turning the earth was included in his own act. Wherever he looked he saw the

labour of existence; and this labour, recognized as such, for him constituted reality.

If he painted his own face, he painted the construction of his destiny, past and future, rather as palmists believe they can read this construction in the hand. His contemporaries who considered him abnormal were not all as stupid as is now assumed. He painted compulsively – no other painter was ever compelled in a comparable way.

His compulsion? It was to bring the two acts of production, that of the canvas and that of the reality depicted, ever closer and closer. This compulsion derived not from an idea about art – this is why it never occurred to him to profit from reality – but from an overwhelming feeling of empathy.

'I admire the bull, the eagle, and man with such an intense adoration, that it will certainly prevent me from ever becoming an ambitious person.'

He was compelled to go ever closer, to approach and approach and approach. *In extremis* he approaches so close that the stars in the night sky became maelstroms of light, the cypress trees ganglions of living wood responding to the energy of wind and sun. There are canvases where reality dissolves him, the painter. But in hundreds of others he takes us as close as any man can, while remaining intact, to that permanent process by which reality is being produced.

Once, long ago, paintings were compared with mirrors. Van Gogh's might be compared with lasers. They do not wait to receive, they go out to meet, and what they traverse is, not so much empty space, as the act of production. The 'entire world' that Van Gogh offers as a reply to the vertigo of nothingness is the production of the world. Painting after painting is a way of saying, with awe but little comfort: it works.

1983

Ulysses

The First and Last Recipe: *Ulysses*

I first sailed into James Joyce's *Ulysses* when I was fourteen years old. I use the words *sailed into* instead of *read* because, as its title reminds us, the book is like an ocean; you do not read it, you navigate it.

Like many people whose childhoods are lonely, I had by the age of fourteen an imagination that was already grown-up, ready to put to sea; what it lacked was experience. I had already read *Portrait of the Artist as a Young Man* and its title was the honorary title I gave to myself in my daydreams. A kind of alibi or a kind of seaman's card – to show, when challenged, to the middle-aged, or one of their agents.

It was the winter of 1940–41. Joyce was in fact dying of a duodenal ulcer in Zurich. But I did not know that then. I did not think of him as mortal. I knew what he looked like and even that he suffered from bad eyesight, I did not picture him as a god, but I felt him through his words, through his endless perambulations, as ever-present. And so not prone to die.

The book had been given to me by a friend who was a subversive schoolmaster. Arthur Stowe his name. Stowbird I called him. I owe him everything. It was he who extended his arm and offered me a hand to grasp so that I could climb out of the basement in which I had been brought up, a basement of conventions, taboos, rules, *idées reçues*, prohibitions, fears, where nobody dared to question anything and where everybody used their courage – for courage they had – to submit to no matter what, without complaining.

It was the French edition in English published by Shakespeare and Company. Stowbird had bought it in Paris on his last trip before the war broke out in 1939. He used to wear a long raincoat and a black beret acquired at the same moment.

When he gave the book to me, I believed it was illegal in Britain to own a copy. In fact this was no longer the case (it had been) and I was

mistaken. Yet the 'illegality' of the book was for me, the fourteen-year-old, a telling literary quality. And there, perhaps, I was not mistaken. I was convinced that legality was an arbitrary pretence. Necessary for the social contract, indispensable for society's survival, but turning its back on most lived experience. I knew this by instinct and when I read the book for the first time, I came to appreciate with mounting excitement that its supposed illegality as an object was more than matched by the illegitimacy of the lives and souls in its epic.

Whilst I read the book, the Battle of Britain was being fought in the sky above the south coast of England and London. The country was expecting invasion. No future was certain. Between my legs I was becoming a man, but it was quite possible that I would not live long enough to discover what life was about. And of course I didn't know. And of course I didn't believe what I was told – either in history classes, on the radio or in the basement.

All their accounts were too small to add up to the immensity of what I did not know, and of what I might never have. Not, however, *Ulysses*. This book had that immensity. It didn't pretend to it; it was impregnated by it, it flowed through it. To compare the book with an ocean again makes sense, for isn't it the most *liquid* book ever written?

Now I was about to write: there were many parts, during this first reading, which I didn't understand. Yet this would be false. There were no parts that I understood. And there was no part that did not make the same promise to me: the promise that deep down, beneath the words, beneath the pretences, beneath the claims and the everlasting moralistic judgement, beneath the opinions and lessons and boasts and cant of everyday life, the lives of adult women and men were made up of such stuff as this book was made of: offal with flecks in it of the divine. The first and last recipe!

Even at my young age, I recognised Joyce's prodigious erudition. He was, in one sense, Learning incarnate. But Learning without solemnity that threw away its cap and gown to become joker and juggler. (As I write about him, something of the rhythm of his words still animates my pen.) Perhaps even more significant for me at that time was the company his learning kept: the company of the unimportant, those for ever off stage, the company of publicans and sinners as the Bible puts it, low company. *Ulysses* is full of the disdain of the represented for those who claim (falsely) to represent them, and packed with the tender ironies of those who are said (falsely) to be lost!

And he did not stop there – this man who was telling me about the life I might never know, this man who never spoke down to anybody, and who remains for me to this day an example of the true adult, which is to say of a being who, because he has accepted life, is intimate with it – this man did not stop there, for his *penchant* for the lowly led him to keep the

same kind of company *within* his single characters: he listened to their stomachs, their pains, their tumescences: he heard their first impressions, their uncensored thoughts, their ramblings, their prayers without words, their insolent grunts and heaving fantasies. And the more carefully he listened to what scarcely anybody had listened to before, the richer became life's offering.

One day in the autumn of 1941 my father, who must have been anxiously surveying me for some time, decided to check out the books on the shelf by my bed. Having done so, he confiscated five – including *Ulysses*. He told me the same evening what he had done and added that he had locked all five in the safe in his office! At this time he was doing important war work for the government on the question of how to increase factory production. I had a vision of my *Ulysses* locked away under folders of government secrets, labelled *Highly Confidential.*

I was furious as only a fourteen-year-old can be. I refused to compare my father's pain – as he had asked me to – with my own. I painted a portrait of him – the largest canvas I'd done to date – where I made him look diabolic, with the colours of Mephistopheles. Yet my fury notwithstanding, I couldn't help finally acknowledging something else: the story of the confiscated books and the father in fear for the son's soul and the Chubb safe and the government files might have come straight out of the confiscated book in question, and it would have been narrated with equanimity and without hate.

Today, fifty years later, I continue to live the life for which Joyce did so much to prepare me, and I have become a writer. It was he who showed me, before I knew anything, that literature is inimicable to all hierarchies and that to separate fact and imagination, event and feeling, protagonist and narrator, is to stay on dry land and never put to sea.

Under the upswelling tide he saw the writhing weeds lift languidly and sway reluctant arms, hising up their petticoats, in whispering water swaying and upturning coy silver fronds. Day by day: night by night: lifted, flooded and let fall. Lord, they are weary; and, whispered to, they sigh. Saint Ambroso heard it, sigh of leaves and waves, waiting, awaiting the fullness of their times, *diebus ac noctibus injurias patiens ingemiscit.* To no end gathered; vainly then released, forthflowing, wending back: loom of the moon. Weary too in sight of lovers, lascivious men, a naked woman shining in her courts, she draws a toil of waters.

1991

From *Keeping a Rendezvous*

Note to the Reader

I travel to places. I live the years. This is a book about keeping
rendezvous. (The ones I failed to keep are another story.) Each account
begins with an image which conjures up something of where the meeting
took place. Some would not be easy to find on a map, others would be.
All of them, of course, have been visited by other travellers. I hope
readers too will find themselves saying: I've been here . . .

1992

Ev'ry Time We Say Goodbye

For Tamara and Tilda and Derek J.

Film was invented a hundred years ago. During this time people all over the world have travelled on a scale that is unprecedented since the establishment of the first towns, when the nomads became sedentary. One might immediately think of tourism: business trips too, for the world market depends upon a continual exchange of products and labour. But, mostly, the travelling has been done under coercion. Displacements of whole populations. Refugees from famine or war. Wave after wave of emigrants, emigrating for either political or economic reasons but emigrating for survival. Ours is the century of enforced travel. I would go further and say that ours is the century of disappearances. The century of people helplessly seeing others, who were close to them, disappear over the horizon. 'Ev'ry Time We Say Goodbye' – as immortalized by John Coltrane. Perhaps it is not so surprising that this century's own narrative art is the cinema.

In Padua there is a chapel that was built in the year 1300 on the site of a Roman arena. The chapel adjoined a palace that has now disappeared without a trace, as palaces often do. When the chapel was finished, Giotto and his assistants began painting frescoes all over the interior walls and ceiling. These have survived. They tell the story of the life of Christ and the Last Judgement. They show heaven, earth and hell. When you are inside the chapel, you are surrounded by the events depicted. The story-line is very strong. The scenes are dramatic. (The one where Judas kisses Christ, for example, offers an unforgettable rendering of treachery.) Everywhere the expressions and gestures are charged with intense meaning – like those in silent films. Giotto was a realist and a great *metteur en scène*. The scenes, which follow one after another, are full of stark material details, taken from life. This chapel, built and conceived seven hundred years ago, is, I think, more like a cinema than anything else that has come down to us from before the twentieth century.

Somebody one day should name a cinema the Scrovegni – which is how the chapel is called, after the family who had the palace built.

Nevertheless, there is a very obvious difference between cinema and painting. The cinema image moves and the painted image is static. And this difference changes our relationship to the *place* where we are looking at the images. In the Scrovegni you have the feeling that everything which has happened in history has been brought there and belongs to an eternal present in the chapel in Padua. The frescoes – even those that have clearly deteriorated – inspire a sense of transcendental permanence.

The painted image makes what is absent – in that it happened far away or long ago – present. The painted image delivers what it depicts to the here and now. It collects the world and brings it home. A seascape by Turner may appear to contradict what I've just said. But even before a Turner the spectator remains aware of the pigment that has been scraped on to the canvas – and indeed this awareness is part of his excitement. Turner comes out of the gale with a painting. Turner crosses the Alps and brings *back* an image of nature's awesomeness. Infinity and the surface of the canvas play hide-and-seek in a room where a painting is hung. This is what I meant when I said painting collects the world and brings it home. And it can do this because its images are static and changeless.

Imagine a cinema screen being installed in the Scrovegni Chapel and a film being projected on to it. Let's say the scene where the angel appears to the shepherds to announce Christ's birth at Bethlehem. (The legend has it that Giotto, when he was a boy, was a shepherd.) Watching this film, we would be transported *out* of the chapel to a field somewhere at night, where shepherds are lying in the grass. The cinema, because its images are moving, takes us *away* from where we are to the *scene of action*. (Action! murmurs or shouts the director to set the scene in motion.) Painting brings home. The cinema transports elsewhere.

Compare now the cinema with theatre. Both are dramatic arts. Theatre brings actors before a public and every night during the season they re-enact the same drama. Deep in the nature of theatre is a sense of ritual return.

The cinema, by contrast, transports its audience individually, singly, *out* of the theatre towards the unknown. Twenty takes of the same scene may be shot, but the one that is used will be selected because it has the most convincing look and sound of a First Time.

Where, then, do these First Times take place? Not, of course, on the set. *On* the screen? The screen, as soon as the lights go out, is no longer a surface but a space. Not a wall, as the walls of the Scrovegni Chapel, but more like a sky. A sky filled with events and people. From where else would film stars come if not from a film sky?

The scale and grain of the cinema screen enhance the sky effect. This is why cinema films shown on small TV screens lose so much of their sense of destiny. The meetings are no longer in a sky but in a kind of cupboard.

At the end of a play, the actors, abandoning the characters they have been playing, come to the footlights to take their bow. The applause they receive is a sign of recognition for their having brought the drama into the theatre tonight. At the end of a film, those protagonists who are still alive have to move on. We have been following them, stalking them, and, finally, out there, they have to elude us. Cinema is perpetually about leaving.

'If there is an aesthetics of the cinema,' said René Clair, 'it can be summarised in one word: movement.' One word: movies.

Maybe this is why so many couples, when they go to the cinema, hold hands, as they don't in the theatre. A response to the dark, people say. Perhaps a response to the travelling too. Cinema seats are like those in a jet plane.

When we read a story, we inhabit it. The covers of a book are like a roof and four walls. What is to happen next will take place within the four walls of the story. And this is possible because the story's voice makes everything its own. *Film is too close to the real* to be able to do this. And so it has no home ground. It is always coming and going. In a story which is read, suspense simply involves waiting. In a film it involves displacement.

To show that it is in the very nature of film to shuttle us between a here and a there, let us think of Bresson's first masterpiece – *Un Condamné à Mort s'Est Echappé*. Watching it, we scarcely ever leave the prisoner, Fontaine, who is either in his cell or in the exercise yard. Meticulously, step by step, we follow him preparing for his escape. The story is told in a very linear way, like one of the ropes Fontaine is making to escape with. It must be one of the most unilinear films ever made. Yet all the while, on the soundtrack we hear the guards in the prison corridors and on the staircases, and, beyond, the sound of trains passing. (How much the cinema was in love with locomotives!) We remain *here* with Fontaine in his cell; but our imagination is being pulled to *there*, where the guards are doing their rounds, or to *there*, where men at liberty can still take trains. Continually, we are made aware of an elsewhere. This is part of the inevitable method of film narration.

The only way around it would be to shoot a whole story in one take and with a camera that didn't move. And the result would be a photocopy of theatre – without the all-important presence of the actors. Movies, not because we see things moving, but because a film is a shuttle service between different places and times.

In early westerns there are those classic chase scenes in which we see a train and men on horses galloping beside it. Sometimes a rider succeeds

in leaving his horse and pulling himself aboard the train. This action, so beloved by directors, is the emblematic action of cinema. All film stories use cross-overs. Usually they occur not on the screen as an event but as the consequence of editing. And it is through these cross-overs that we are made to feel the destiny of the lives we are watching.

When we read, it is the story's voice which conveys a sense of destiny. Films are much nearer to the accidents of life, and in them destiny is revealed in the split second of a cut or the few seconds of a dissolve. These cuts, of course, are not accidental: we know that they are *intended* by the film – they reveal how the film is hand in glove with the destiny working in the story. The rest of the time this destiny is lurking elsewhere, in the sky behind.

It may seem that, eighty years after Griffith and Eisenstein, I'm simply saying that the secret of the Seventh Art is editing! My argument, however, concerns not the making of films, but how they work, when made, on the spectator's imagination.

Walt Whitman, who was born at the end of the Napoleonic age and died two years before the first reels were shot, foresaw our cinematographic vision. His intensely democratic sense of human destiny made him the poet of the cinema before the cameras were made. Listen:

> The little one sleeps in its cradle,
> I lift the gauze and look a long time, and silently
> brush away flies with my hand.
>
> The youngster and the red-faced girl turn aside up
> the bushy hill,
> I peeringly view them from the top.
>
> The suicide sprawls on the bloody floor of the
> bedroom,
> I witness the corpse with its dabbled hair, I note
> where the pistol has fallen.
>
> (*Song of Myself*, section 8)

Film narration has another unique quality. The French critic Lucien Sève once said that a film shot offers scarcely more explanations than reality itself, and from this arises its enigmatic power to 'cling to the surface of things'. André Bazin wrote, 'Cinema is committed to communicate only by way of what is real.' Even as we wait to be transported elsewhere, we are held fascinated by the *presence* of what has come towards us out of the sky. The most familiar sights – a child sleeping, a man climbing a staircase – become mysterious when filmed. The mystery derives from our closeness to the event and from the fact that the filmed

event still retains a multiplicity of possible meanings. What we are being shown has, at one and the same time, something of the focus, the intentionality, of art, and the unpredictability of reality.

Directors like Satyajit Ray, Rossellini, Bresson, Buñuel, Forman, Scorsese, and Spike Lee have used non-professional actors precisely in order that the people we see on the screen may be scarcely more *explained* than reality itself. Professionals, except for the greatest, usually play not just the necessary role, but an explanation of the role.

Films which are null and void are so not because of their trivial stories but because there is nothing else but story. All the events they show have been tailor-made for the story and have no recalcitrant body to them. There are no real surfaces to cling to.

Paradoxically, the more familiar the event, the more it can surprise us. The surprise is that of rediscovering the world (a child asleep, a man, a staircase) after an absence elsewhere. The absence may have been very brief, but in the sky we lose our sense of time. Nobody has used this surprise in his films more crucially than Tarkovsky. With him we come back to the world with the love and caring of ghosts who left it.

No other narrative art can get as close as the cinema to the variety, the texture, the skin of daily life. But its unfolding, its coming into being, its marriage with the Elsewhere, reminds us of a longing, or a prayer.

Fellini asks:

> What is an artist? A provincial who finds himself somewhere between a physical reality and a metaphysical one. Before this metaphysical reality we are all of us provincial. Who are the true citizens of transcendence? The Saints. But it's this in-between that I'm calling a province, this frontier-country between the tangible world and the intangible one – which is really the realm of the artist.

Ingmar Bergman says:

> Film as dream, film as music. No art passes our conscience in the way film does, and goes directly to our feelings, deep down into the dark rooms of the soul.

From the beginning the cinema's talent for inventing dreams was seized upon. This faculty of the medium is why cinema industries have often become *dream factories*, in the most pejorative sense of the term, producing soporifics.

Yet there is no film that does not partake of dream. And the great films are dreams which reveal. No two moments of revelation are the same. *The Gold Rush* is very different from *Pather Panchali*. Nevertheless, I want

to ask the question: What is the longing that film expresses and, at its best, satisfies? Or, what is the nature of this filmic revelation?

Film stories, as we have seen, inevitably place us in an Elsewhere, where we cannot be at home. Once again the contrast with television is revealing. TV focuses on its audience being at home. Its serials and soap operas are all based on the idea of *a home from home.* In the cinema, by contrast, we are travellers. The protagonists are strangers to us. It may be hard to believe this, since we often see these strangers at their most intimate moments, and since we may be profoundly moved by their story. Yet no individual character in a film do we *know* – as we know, say, Julien Sorel, or Macbeth, Natasha Rostova, or Tristram Shandy. We cannot get to know them, for the cinema's narrative method means that we can only encounter them, not live with them. We meet in a sky where nobody can stay.

How then does the cinema overcome this limitation to attain its special power? It does so by celebrating what we have in common, what we share. The cinema longs to go beyond individuality.

Think of Citizen Kane, an arch individualist. At the beginning of the story he dies, and the film tries to put together the puzzle of who he really was. It turns out that he was multiple. If we are eventually moved by him, it is because the film reveals that somewhere Kane might have been a man like any other. As the film develops, it dissolves his individuality. Citizen Kane becomes a co-citizen with us.

The same is not true of the Master Builder in Ibsen's play or Prince Myshkin in Dostoevsky's novel *The Idiot.* In *Death in Venice* Thomas Mann's Aschenbach dies discreetly, privately; Visconti's Aschenbach dies publicly and theatrically, and the difference is not merely the result of Visconti's choices but of the medium's narrative need. In the written version we *follow* Aschenbach, who retires like an animal to die in hiding. In the film version Bogarde comes towards us and dies in close-up. In his death he approaches us.

When reading a novel, we often identify ourselves with a given character. In poetry we identify ourselves with the language itself. Cinema works in yet another way. Its alchemy is such that the characters come to identify themselves with us! The only art in which this can happen.

Take the old-age pensioner, Umberto D., in De Sica's masterpiece. He has been made anonymous by age, indifference, poverty, homelessness. He has nothing to live for and he wants to kill himself. At the end of the story, only the thought of what will happen to his dog prevents him from doing so. But by now this nameless man has, for us, come to represent life. Consequently, his dog becomes an obscure hope for the world. As the film unfolds, Umberto D. begins to *abide* in us. The biblical term defines with surprising precision how De Sica's film – and any successful

narrative film – has to work. Heroes and heroines, defeated or triumphant, come out of the sky to abide in us. At this moment Elsewhere becomes everywhere.

Umberto D. comes to abide in us because the film reminds us of all the reality that we potentially share with him, and because it discards the reality which distinguishes him from us, which has made him separate and alone. The film shows what happened to the old man in life and, in the showing, opposes it. This is why film – when it achieves art – becomes like a human prayer. Simultaneously a plea and an attempt to redeem.

The star system too, in a paradoxical way, is dependent upon sharing. We know very well that a star is not just the actress or actor. The latter merely serve the star – often tragically. The star always has a different and mythic name. The star is a figure accepted by the public as an archetype. This is why the public enjoy and recognize a star playing, relatively undisguised, many different roles in different films. The overlapping is an advantage, not a hindrance. Each time, the star pulls the role, pulls the character in the film story, towards her or his archetype.

The difficulty of labelling the archetypes should not encourage us to underestimate their importance.

Take Laurel and Hardy. They form a couple. Because they do so, women are marginal in the stories of their films. Laurel quite often dresses up as a woman. Both of them – in their sublime comic moments – have certain habitual gestures which are distinctly 'effeminate'. So why is it that they do not register in the public imagination as homosexual? It is because, archetypally, Laurel and Hardy are kids – somewhere between the ages of seven and eleven. The public imagination perceives them as kid wreckers of an adult world order. And therefore, given their archetype age, they are not yet sexual beings! It is thanks to their archetype that they are not sexually labelled.

Finally, let's return to the fact that film pulls us into the visible world: the one into which we are thrown at birth and which we all share. Painting does not do this; it interrogates the visible. Nor does still photography – for all still photographs are about the past. Only movies pull us into the present and the visible, the visible which surrounds us all.

Film doesn't have to say 'tree': it can show a tree. It doesn't have to describe a crowd: it can be in one. It doesn't have to find an adjective for mud; it can be up to the wheels in it. It doesn't have to analyse a face, it can approach one. It doesn't have to lament, it can show tears.

Here is Whitman, prophetically imagining the screen image as it addresses the public:

Translucent mould of me it shall be you!
Shaded ledges and rests it shall be you!
Firm masculine colter it shall be you!
Whatever goes to the tilth of me it shall be you!
You my rich blood! your milky stream pale strippings
 of my life!
Breast that presses against other breasts it shall be
 you!
My brain it shall be your occult convolutions!
Root of wash'd sweet-flag! timorous pond-snipe! nest
 of guarded duplicate eggs! it shall be you!
Mix'd tussled hay of head, beard, brawn, it shall be
 you!
Trickling sap of maple, fibre of manly wheat, it shall
 be you!
Sun so generous it shall be you!
Vapors lighting and shading my face it shall be you!

(*Song of Myself*, section 24)

Most films, of course, do not achieve universality. Nor can the universal be consciously pursued – for such an ambition leads only to pretension or rhetoric. I have been trying to understand the modality of how cinema occasionally bestows universality upon a film-maker's work. Usually it is in response to love or compassion. At such moments cinema does something very complicated in a simpler way than any other art can. Here are two examples.

In Jean Vigo's *L'Atalante* a sailor marries a peasant girl. We see the couple come out of church at the end of a joyless, almost sinister, ceremony, with all the men dressed in black, intimidated by the priest, and with old women whispering scandal. Then the sailor takes his wife home to his barge on a river. She is swung aboard on a yardarm by the crew, who consist of a kid and an old man. The *Atalante* casts off and sails away on its long journey to Paris. Perhaps it is dusk. The bride, still in white, slowly walks along the length of the barge towards the prow. Alone, she is being borne away and she walks solemnly, as if to another altar that is no longer a sinister one. On the bank a woman with a child sees her passing down the river, and she crosses herself as if she has just seen a vision. And she has. She has seen at that moment a vision of every bride in the world.

In the *Mean Streets* of Martin Scorsese, a gang of neighbourhood friends put up daily, makeshift shelters against the flames. They do this separately and together. The flames are those of hell. The shelters are: wisecracks, shoot-outs, whiskeys, memories of innocence, a windfall of a hundred bucks, a new shirt. New York Italian Catholics, they know about

Jesus, but here, on the Lower East Side, there is no redemption; everyone is on the back of everyone, trying not to sink down into the pit. Charlie is the only one capable of bullshit pity, though he can save nobody. Driving away from yet another fight, he says out loud: 'I know things haven't gone well tonight, Lord, but I'm trying.' And, in that instant, which is buried in the shit of Manhattan, he becomes the repentant child in all of us and a soul in Dante's Hell – Dante, whose vision of the Inferno was modelled after the cities he knew in his time.

What is saved in the cinema when it achieves art is a spontaneous continuity with all of mankind. It is not an art of the princes or of the bourgeoisie. It is popular and vagrant. In the sky of the cinema people learn what they might have been and discover what belongs to them apart from their single lives. Its essential subject – in our century of disappearances – is the soul to which it offers a global refuge. This, I believe, is the key to its longing and its appeal.

1990

That Which Is Held

I am thinking in front of Giorgione's *Tempest* and I want to begin with a quotation from Osip Mandelstam: 'For Dante time is the content of history felt as a single synchronic act. And inversely the purpose of history is to keep time together so that all are brothers and companions in the same quest and conquest of time.'

Of all that we have inherited from the nineteenth century, only certain axioms about time have passed largely unquestioned. The left and right, evolutionists, physicists, and most revolutionaries, all accept – at least on a historical scale – the nineteenth-century view of a unilinear and uniform 'flow' of time.

Yet the notion of a uniform time within which *all* events can be temporally related depends upon the synthesizing capacity of a mind. Galaxies and particles in themselves propose nothing. We face at the start a phenomenological problem. We are obliged to begin with a conscious experience.

Everybody has noticed that, despite clocks and the regular turning of the earth, time is experienced as passing at different rates. This 'impression' is generally dismissed as subjective, because time, according to the nineteenth-century view, is objective, incontestable and indifferent; to its indifference there are no limits.

Yet perhaps our experience should not be dismissed so quickly. Supposing we accept the clocks: time does not slow down or accelerate. But time appears to pass at different rates because our experience of its passing involves not a single but *two* dynamic processes which are opposed to each other: as accumulation and dissipation.

The deeper the experience of a moment, the greater the accumulation of experience. This is why the moment is lived as longer. The dissipation of the time-flow is checked. The lived *durée* is not a question of length but of depth or density. Proust is the master who gave this truth a literary form.

Yet it is not only a cultural truth. A natural equivalent of the periodic increase of the density of lived time may be found in those days of alternating sun and rain, in the spring or early summer, when plants grow, almost visibly, several millimetres or centimetres a day. These hours of spectacular growth and accumulation are *incommensurate* with the winter hours when the seed lies inert in the earth.

The content of time, which is to say that which time carries, seems to entail another dimension. Whether one calls this dimension the fourth, the fifth, or even (in relation to time) the third is unimportant, and only depends upon the space-time model that one is using. What matters and is important is that this dimension is intractable to the regular, uniform flow of time. There may be a sense in which time does not sweep *all* before it; to assert that it did was a specifically nineteenth-century article of faith.

Earlier this intractable dimension was allowed for. It is present in all cyclic views of time. According to such views, time passes, time goes on, and it does so by turning on itself like a wheel. Yet for a wheel to turn, there needs to be a surface like the ground which resists, which offers friction. It is against this resistance that the wheel turns. Cyclic views of time are based on a model whereby two forces are in play: a force (time) moving in one direction and a force resisting that movement.

Today the intractable dimension lives a ghostly life within the cyclic measurements – seconds, minutes, days, years – which we still use to measure time. The term light-year is eloquent of this persistent ghost. To measure astronomic distances one takes as a unit that distance which light travels in a year. The magnitude of such distances, the degree of *separation* they imply, seems boundless. Yet hidden within the conceptual system for measuring such boundlessness is the indispensable, local, cyclic unit of the year, a unit which is recognized by its *returning*.

The body ages. The body is preparing to die. No theory of time offers a reprieve here. Yet we condemn ourselves as no other culture has done.

The spectre of death has always haunted man. Death and Time were always in alliance. Time took away more or less slowly, and Death more or less suddenly.

Yet Death was also thought of as the companion of life, as the precondition for that which came into Being from Non-being: one was not possible without the other. As a result, Death was qualified by that which it could not destroy, or by that which would return.

That life is brief was continually lamented. Time was Death's agent, and one of life's constituents. But the timeless – that which Death could not destroy – was another. All cyclic views of time held these two constituents together: the wheel turning and the ground on which it turned.

Modern thought has removed time from this unity and transformed it

into a single, all-powerful and active force. Modern thought has transferred the spectral character of Death to the notion of time itself. Time has become Death triumphant over all.

The concept of entropy is the figure of Death translated into scientific principle. Yet, whereas Death used to be thought of as being the condition of life, entropy, it is maintained, will eventually exhaust and extinguish not only lives but life itself. And entropy, as Eddington termed it, 'is time's arrow'. Here is the finality of modern despair, against which no plea is possible. Our totalitarianism begins with our teleology.

The modern transformation of time from a condition into a force began with Hegel. For Hegel, however, the force of history was positive; there has rarely been a more optimistic philosopher. Later Marx set out to prove that this force – the force of history – was subject to man's actions and choices. The always-present drama in Marx's thinking, the original opposition of his dialectics, stems from the fact that he both accepted the modern transformation of time into the supreme force *and* wished to return this supremacy into the hands of man. This is why his thought was – in every sense of the word – gigantic. The size of man – his potential, his coming power – would replace the timeless.

Today, as the culture of capitalism abandons its claim to be a culture and becomes nothing more than an instant practice, the force of time, still retaining its absolute supremacy, is felt to be inhuman and annihilating. The planet of the earth and the universe are running down. Disorder increases with every time-unit that passes. The envisaged final state of maximum entropy, where there will be no activity at all, is termed heat death.

To question the finality of the principle of entropy is not to dispute the second law of thermodynamics. Within a given system this and the other laws of thermodynamics can apply to what unfolds within time. They are laws of time's processes. It is their finality which needs to be disputed.

The process of increasing entropy ends with heat death. It began with a state of total order (perfection?), which in astrophysical terms is thought of as an explosion. The theory necessitates a beginning and an end; both these face on to what is beyond time. The theory of entropy ultimately treats time as a parenthesis, and yet has nothing to say, and has eliminated everything that might be said, about what precedes or follows the parenthesis. Therein lies its innocence.

Many previous cosmological explanations of the world proposed, as does the theory of entropy, an ideal original state and afterwards, for man, a continually deteriorating situation. The Golden Age, the Garden of Eden, the Time of the Gods – all were far away from the misery of the present.

That life may be seen as a fall is intrinsic to the human faculty of imagination. To imagine is to conceive of that height from which the Fall takes place.

In most earlier cosmogonies, however, time was cyclic and this meant that the 'ideal' original state would one day return or was *retrievable*. Not usually in a lifetime – this was only the occasional revolutionary hope – but in the lifetime of existence. Recognition of the Fall coexisted with hope. Accumulation and dissipation increased concurrently. With entropy and the nineteenth-century view of time, we face only the irretrievable and only dissipation.

The facing of this may be considered an act of intellectual courage. Yet it is also an act of inhibition.

The sexual thrust to reproduce and to fill the future is a thrust against the current of time flowing towards the past. The genetic information which assures reproduction works against dissipation. The sexual animal – like a grain of corn – is a conduit of the past into the future. The scale of that span over millennia and the distance covered by that temporal short circuit which is fertilization are such that sexuality opposes the impersonal passing of time and is antithetical to it.

Every life is both created by and *held* in the encounter of these two opposing forces. The paired relationship of Eros and Thanatos is an expression of this holding. To speak of such a 'holding' is another way of defining Being. What is so baffling and mysterious about the state of Being is that it represents both stillness and movement. The stillness of an equilibrium created by the movement of two opposing forces.

The nineteenth-century inhibition was not towards the function of sexuality in nature; it was towards the intimacy of the relation between sexuality and love. The two had to be kept as far apart as possible. Partly because in capitalist practice – and capitalism was now annexing the entire world – all love had to be reduced to the narrowly private; and partly because the century's view of time left no place (except in poetry) for the energy of love. It was Blake who saw this so clearly and so early.

Love, in the history of human development, was born, and still is, from sexuality. Without the initial force of the sexual impulse *across, towards* another body, the transmigration of the self which constitutes love would never have been possible. The distinction between love, in any of its sexual forms, and simple sexuality, can be seen in their different relations to time.

Sexuality is a source of continual renewal – renewal of the species and renewal of itself. The sexual is forever unfinished, is never complete. It finishes only to rebegin, *as if for the first time.*

By contrast, the utopia of love is completion to the point of stillness. The ideal act of love is to contain all. The love poetry of every continent and century testifies to this. 'Here I understand,' wrote Camus, 'what they call glory: the right to love without limits.' But this ideal act is not a passive one, for the totality which love has to continually reclaim is precisely the totality which time so convincingly appears to fragment and

hide. Love is a reconstitution – in the heart as much as in the mind – of that 'holding', of that Being, which occurs in the momentary equilibrium created by the opposing forces of sexuality and time.

Sublimated forms of love – political, social, religious, cultural – reclaim a totality on a historical as well as a personal scale. But in every form of love a past and a future are grasped as if present. The momentary 'holding', seized by the imagination through the energy of love, realizes a whole, which is outside time.

Such realizations are intrinsic to the human experience and occur, more or less intensely, all the while. To ask whether love has or has not an objective existence is to ask a somewhat mechanical question, for it ignores that what we feel can be a response to what *approaches* us from our surroundings; surroundings in both time and space. Heidegger suggests the nature of this approach: 'It might be that that which distinguishes man as man, is determined precisely by what we must think about here: man, who is concerned with, approached by presence, who, through being thus approached, is himself present in his own way for all present and absent things.'

This 'approaching' has always been recognized by artists and in the modern era has been termed inspiration.

Much has to be thought through. Particularly the question of how each art finds its own specific means for giving form to a whole, realized by love. Poetry would seem to be the simplest art to approach in this sense because it so often speaks of love, sexual or otherwise. Yet for this very reason poetry could confuse the inquiry.

For it is not a question of saying that every painter (Goya?) has loved what he has painted, that every story-teller (Stendhal?) has loved all his characters, that all music is lyrical. Rather it is a question of seeing that the artist's will to preserve and complete, to create an equilibrium, to hold – and in that 'holding' to hope for an ultimate assurance – that this derives from a lived or imagined experience of love.

This may seem close to Freud's theory of sublimation. Except for the important difference that Freud, given his nineteenth-century view of time, could not distinguish between sexuality and love in terms of what is intractable to time. I am arguing that sexuality is the antithesis of art, but that love is the human model for both.

Does this mean that historical analysis is therefore irrelevant? No. The means used by each art at different periods for giving form to 'what is held' are often historically determined. To analyse these determinants helps us to understand better the conditions under which people were living or were trying to live, and this is to understand better the form of their hopes.

What is *ahistorical* is the need to hope. And the act of hoping is inseparable from the energy of love, from that which 'holds', from that which is art's constant example.

There is a question which finally has to be answered, one way or the other. Is art consolation or revelation? Modern aesthetics have mostly avoided this question by reducing art to the personal and private; most superficially by reducing it to a question of taste; more subtly, by isolating the artistic experience by refusing to place what poetry says *beside* the findings of science – for example, what poetry says, often explicitly, about that which is intractable to time. 'More permanent than anything on earth is sadness,' wrote Akhmatova, 'and more long-lived is the regal word.'

Art is either a social practice to maintain illusions (a conclusion not so different from that of many Althusserians), or it is a glimpse of what lies beyond other practices, beyond them because it is not subject to the tyranny of the modern view of time.

I began with a quotation from Mandelstam. The sentence which follows reads: 'Dante is anti-modernist. His topicality is inexhaustible, incalculable, perennial.'

There is no question of looking away from the modern world and its practices. There is no question of a Pre-Raphaelite flight back to the Middle Ages. It is rather that Dante advances towards us. And in the specific purgatory of the modern world, created and maintained by corporate capitalism, every injustice is grounded in that modern uni-linear view of time, for which the only relation conceivable is that between cause and effect. In contrast to this, in defiance of this, the 'single synchronic act' is that of loving.

1982

A Load of Shit

In one of his books, Milan Kundera dismisses the idea of God because, according to him, no God would have designed a life in which shitting was necessary. The way Kundera asserts this makes one believe it's more than a joke. He is expressing a deep affront. And such an affront is typically elitist. It transforms a natural repugnance into a moral shock. Elites have a habit of doing this. Courage, for instance, is a quality that all admire. But only elites condemn cowardice as vile. The dispossessed know very well that under certain circumstances everyone is capable of being a coward.

A week ago I cleared out and buried the year's shit. The shit of my family and of friends who visit us. It has to be done once a year and May is the moment. Earlier it risks to be frozen and later the flies come. There are a lot of flies in the summer because of the cattle. A man, telling me about his solitude not long ago, said, 'Last winter I got to the point of missing the flies.'

First I dig a hole in the earth – about the size of a grave but not so deep. The edges need to be well cut so the barrow doesn't slip when I tip it to unload. Whilst I'm standing in the hole, Mick, the neighbour's dog, comes by. I've known him since he was a pup, but he has never before seen me there before him, less tall than a dwarf. His sense of scale is disturbed and he begins to bark.

However calmly I start the operation of removing the shit from the outhouse, transporting it in the barrow, and emptying it into the hole, there always comes a moment when I feel a kind of anger rising in me. Against what or whom? This anger, I think, is atavistic. In all languages 'Shit!' is a swear word of exasperation. It is something one wants to be rid of. Cats cover their own by scraping earth over it with one of their paws. Men swear by theirs. Naming the stuff I'm shovelling finally provokes an irrational anger. Shit!

* * *

Cow dung and horse dung, as muck goes, are relatively agreeable. You can even become nostalgic about them. They smell of fermented grain, and on the far side of their smell there is hay and grass. Chicken shit is disagreeable and rasps the throat because of the quantity of ammonia. When you are cleaning out the hen house, you're glad to go to the door and take a deep breath of fresh air. Pig and human excrement, however, smell the worst, because men and pigs are carnivorous and their appetites are indiscriminate. The smell includes the sickeningly sweet one of decay. And on the far side of it there is death.

Whilst shovelling, images of Paradise come into my mind. Not the angels and heavenly trumpets, but the walled garden, the fountain of pure water, the fresh colours of flowers, the spotless white cloth spread on the grass, ambrosia. The dream of purity and freshness was born from the omnipresence of muck and dust. This polarity is surely one of the deepest in the human imagination, intimately connected with the idea of home as a shelter – shelter against many things, including dirt.

In the world of modern hygiene, purity has become a purely metaphoric or moralistic term. It has lost all sensuous reality. By contrast, in poor homes in Turkey the first act of hospitality is the offer of lemon eau-de-Cologne to apply to the visitors' hands, arms, neck, face. Which reminds me of a Turkish proverb about elitists: 'He thinks he is a sprig of parsley in the shit of the world.'

The shit slides out of the barrow when it's upturned with a slurping dead weight. And the foul sweet stench goads, nags teleologically. The smell of decay, and from this the smell of putrefaction, of corruption. The smell of mortality for sure. But it has nothing to do – as puritanism with its loathing for the body has consistently taught – with shame or sin or evil. Its colours are burnished gold, dark brown, black: the colours of Rembrandt's painting of Alexander the Great in his helmet.

A story from the village school that Yves my son tells me:

It's autumn in the orchard. A rosy apple falls to the grass near a cow pat. Friendly and polite, the cow shit says to the apple: 'Good morning, Madame la Pomme, how are you feeling?'

She ignores the remark, for she considers such a conversation beneath her dignity.

'It's fine weather, don't you think, Madame la Pomme?'

Silence.

'You'll find the grass here very sweet, Madame la Pomme.'

Again, silence.

At this moment a man walks through the orchard, sees the rosy apple, and stoops to pick it up. As he bites into the apple, the cow shit, still irrepressible, says: 'See you in a little while, Madame la Pomme!'

What makes shit such a universal joke is that it's an unmistakable

reminder of our duality, of our soiled nature and of our will to glory. It is the ultimate *lèse-majesté*.

As I empty the third barrow of shit, a chaffinch is singing in one of the plum trees. Nobody knows exactly why birds sing as much as they do. What is certain is that they don't sing to deceive themselves or others. They sing to announce themselves as they are. Compared to the transparency of birdsong, our talk is opaque because we are obliged to search for the truth instead of being it.

I think of the people whose shit I'm transporting. So many different people. Shit is what is left behind undifferentiated: the waste from energy received and burnt up. This energy has myriad forms, but for us humans, with our human shit, all energy is partly verbal. I'm talking to myself as I lift the shovel, prudently, so that too much doesn't fall off on to the floor. Evil begins not with decomposing matter but with the human capacity *to talk oneself into.*

The eighteenth-century picture of the noble savage was short-sighted. It confused a distant ancestor with the animals he hunted. All animals live with the law of their species. They know no pity (though they know bereavement) but they are never perverse. This is why hunters dreamt of certain animals as being naturally noble – of having a spiritual grace which matched their physical grace. It was never the case with man.

Nothing in the nature around us is evil. This needs to be repeated since one of the human ways of *talking oneself into* inhuman acts is to cite the supposed cruelty of nature. The just-hatched cuckoo, still blind and featherless, has a special hollow like a dimple on its back, so that it can hump out of the nest, one by one, its companion fledglings. Cruelty is the result of *talking oneself into* the infliction of pain or into the conscious ignoring of pain already inflicted. The cuckoo doesn't talk itself into anything. Nor does the wolf.

The story of the Temptation with the other apple (not Madame la Pomme) is well told. '. . . the serpent said unto the woman, Ye shall surely not die.' She hasn't eaten yet. Yet these words of the serpent are either the first lie or the first play with empty words. (Shit! Half a shovelful has fallen off.) Evil's mask of innocence.

'A certain phraseology is obligatory,' said George Orwell, 'if one wants to name things without calling up mental images of them.'

Perhaps the insouciance with which cows shit is part of their peace-fulness, part of the patience which allows them to be thought of in many cultures as sacred.

Evil hates everything that has been physically created. The first act of this hatred is to separate the order of words from the order of what they denote. O Hansard!

Mick the dog follows me as I trundle the barrow to the hole. 'No more sheep!' I tell him. Last spring, palled up with another dog, he killed three. His tail goes down. After killing he was chained up for three months. The tone of my half-joking voice, the word 'sheep', and the memory of the chain make him cringe a little. But in his head he doesn't call spilt blood something else, and he stares into my eyes.

Not far from where I dug the hole, a lilac tree is coming into flower. The wind must have changed to the south, for this time I can smell the lilac through the shit. It smells of mint mixed with a lot of honey.

This perfume takes me back to my very early childhood, to the first garden I ever knew, and suddenly from that time long ago I remember both smells, from long before either lilac or shit had a name.

1989

Mother

For Katya

From the age of five or six I was worried about the death of my parents. The inevitability of death was one of the first things I learnt about the world on my own. Nobody else spoke of it, yet the signs were so clear.

Every time I went to bed – and in this I am sure I was like millions of other children – the fear that one or both of my parents might die in the night touched the nape of my neck with its finger. Such a fear has, I believe, little to do with a particular psychological climate and a great deal to do with nightfall. Yet since it was impossible to say 'You won't die in the night, will you?' (when Grandmother died, I was told she had gone to have a rest, or – this was from my uncle who was more outspoken – that she had passed over), since I couldn't ask the real question and I sought a reassurance, I invented – like millions before me – the euphemism See you in the morning! To which either my father or mother who had come to turn out the light in my bedroom would reply, See you in the morning, John.

After their footsteps had died away, I would try for as long as possible not to lift my head from the pillow so that the last words spoken remained, trapped like fish in a rock-pool at low tide, between my pillow and my ear. The implicit promise of the words was also a protection against the dark. The words promised that I would not (yet) be alone.

Now I'm no longer usually frightened by the dark and my father died ten years ago and my mother a month ago at the age of ninety-three. It would be a natural moment to write an autobiography. My version of my life can no longer hurt either of them. And the book, when finished, would be there, a little like a parent. Autobiography begins with a sense of being alone. It is an orphan form. Yet I have no wish to do so. All that interests me about my past life are the common moments. The moments – which if I relate them well enough – will join countless others lived by people I do not personally know.

Six weeks ago my mother asked me to come and see her; it would be the last time, she said. A few days later, on the morning of my birthday, she believed she was dying. Open the curtains, she said to my brother, so I can see the trees. In fact, she died the following week.

On my birthdays as a child, it was my father rather than she who gave me memorable presents. She was too thrifty. Her moments of generosity were at the table, offering what she had bought and prepared and cooked and served to whoever came into the house. Otherwise she was thrifty. Nor did she ever explain. She was secretive, she kept things to herself. Not for her own pleasure, but because the world would not forgive spontaneity, the world was mean. I must make that clearer. She didn't believe life was mean – it was generous – but she had learnt from her own childhood that survival was hard. She was the opposite of quixotic – for she was not born a knight and her father was a warehouse foreman in Lambeth. She pursed her lips together, knitted her brows as she calculated and thought things out and carried on with an unspoken determination. She never asked favours of anyone. Nothing shocked her. From whatever she saw, she just drew the necessary conclusions so as to survive and to be dependent on nobody. If I were Aesop, I would say that in her prudence and persistence my mother resembled the agouti. (I once wrote about an agouti in the London zoo but I did not then realize why the animal so touched me.) In my adult life, the only occasions on which we shouted at each other were when she estimated I was being quixotic.

When I was in my thirties, she told me for the first time that ever since I was born she had hoped I would be a writer. The writers she admired when young were Bernard Shaw, J. M. Barrie, Compton Mackenzie, Warwick Deeping, E. M. Dell. The only painter she really admired was Turner – perhaps because of her childhood on the banks of the Thames.

Most of my books she didn't read. Either because they dealt with subjects which were alien to her or because – under the protective influence of my father – she believed they might upset her. Why suffer surprise from something which, left unopened, gives you pleasure? My being a writer was unqualified for her by what I wrote. To be a writer was to be able to see to the horizon where, anyway, nothing is ever very distinct and all questions are open. Literature had little to do with the writer's vocation as she saw it. It was only a by-product. A writer was a person familiar with the secrets. Perhaps in the end she didn't read my books so that they should remain more secret.

If her hopes of my becoming a writer – and she said they began on the night after I was delivered – were eventually realized, it was not because there were many books in our house (there were few) but because there was so much that was unsaid, so much that I had to discover the existence of on my own at an early age: death, poverty, pain (in others), sexuality . . .

These things were there to be discovered within the house or from its windows – until I left for good, more or less prepared for the outside world, at the age of eight. My mother never spoke of these things. She didn't hide the fact that she was aware of them. For her, however, they were wrapped secrets, to be lived with but never to be mentioned or opened. Superficially, this was a question of gentility, but profoundly, of a respect, a secret loyalty to the enigmatic. My rough-and-ready pre-paration for the world did not include a single explanation – it simply consisted of the principle that events carried more weight than the self.

Thus, she taught me very little – at least in the usual sense of the term: she a teacher about life, I a learner. By imitating her gestures I learnt how to roast meat in the oven, how to clean celery, how to cook rice, how to choose vegetables in a market. As a young woman she had been a vegetarian. Then she gave it up because she did not want to influence us children. Why were you a vegetarian? I once asked her, eating my Sunday roast, much later when I was first working as a journalist. Because I'm against killing. She would say no more. Either I understood or I didn't. There was nothing more to be said.

In time – and I understand this only now writing these pages – I chose to visit abattoirs in different cities of the world and to become something of an expert concerning the subject. The unspoken, the unfaceable beckoned me. I followed. Into the abattoirs and, differently, into many other places and situations.

The last, the largest and the most personally prepared wrapped secret was her own death. Of course I was not the only witness. Of those close to her, I was maybe the most removed, the most remote. But she knew, I think, with confidence that I would pursue the matter. She knew that if anybody can be at home with what is kept a secret, it was me, because I was her son who she hoped would become a writer.

The clinical history of her illness is a different story about which she herself was totally uncurious. Sufficient to say that with the help of drugs she was not in pain, and that, thanks to my brother and sister-in-law who arranged everything for her, she was not subjected to all the mechanical ingenuity of aids for the artificial prolongation of life.

Of how many deaths – though never till now of my own mother's – have I written? Truly we writers are the secretaries of death.

She lay in bed, propped up by pillows, her head fallen forward, as if asleep.

I shut my eyes, she said, I like to shut my eyes and think. I don't sleep though. If I slept now, I wouldn't sleep at night.

What do you think about?

She screwed up her eyes which were gimlet sharp and looked at me, twinkling, as if I'd never, not even as a small child, asked such a stupid question.

Are you working hard? What are you writing?

A play, I answered.

The last time I went to the theatre I didn't understand a thing, she said. It's not my hearing that's bad though.

Perhaps the play was obscure, I suggested.

She opened her eyes again. The body has closed shop, she announced. Nothing, nothing at all from here down. She placed a hand on her neck. It's a good thing, make no mistake about it, John, it makes the waiting easier.

On her bedside table was a tin of hand cream. I started to massage her left hand.

Do you remember a photograph I once took of your hands? Working hands, you said.

No, I don't.

Would you like some more photos on your table? Katya, her grand-daughter, asked her.

She smiled at Katya and shook her head, her voice very slightly broken by a laugh. It would be *so* difficult, so difficult, wouldn't it, to choose.

She turned towards me. What exactly are you doing?

I'm massaging your hand. It's meant to be pleasurable.

To tell you the truth, dear, it doesn't make much difference. What plane are you taking back?

I mumbled, took her other hand.

You are all worried, she said, especially when there are several of you. I'm not. Maureen asked me the other day whether I wanted to be cremated or buried. Doesn't make one iota of difference to me. How could it? She shut her eyes to think.

For the first time in her life and in mine, she could openly place the wrapped enigma between us. She didn't watch me watching it, for we had the habits of a lifetime. Openly, she knew that at that moment her faith in a secret was bound to be stronger than any faith of mine in facts. With her eyes still shut, she fingered the Arab necklace I'd attached round her neck with a charm against the evil eye. I'd given her the necklace a few hours before. Perhaps for the first time I had offered her a secret and now her hand kept looking for it.

She opened her eyes. What time is it?

Quarter to four.

It's not very interesting talking to me, you know. I don't have any ideas any more. I've had a good life. Why don't you take a walk?

Katya stayed with her.

When you are very old, she told Katya confidentially, there's one thing that's very, very difficult – it's very difficult to persuade other people that you're happy.

She let her head go back on to the pillow. As I came back in, she smiled.

In her right hand she held a crumpled paper handkerchief. With it she dabbed from time to time the corner of her mouth when she felt there was the slightest excess of spittle there. The gesture was reminiscent of one with which, many years before, she used to wipe her mouth after drinking Earl Grey tea and eating watercress sandwiches. Meanwhile, with her left hand she fingered the necklace, cushioned on her forgotten bosom.

Love, my mother had the habit of saying, is the only thing that counts in this world. Real love, she would add, to avoid any factitious misunderstanding. But apart from that simple adjective, she never added anything more.

1986

A Story for Aesop

The image impressed me when I set eyes upon it for the first time. It was as if it was already familiar, as if, as a child, I had already seen the same man framed in a doorway. The picture was painted by Velázquez around 1640. It is an imaginary, half-life-size portrait of Aesop.

He stands there, keeping a rendezvous. With whom? A bench of judges? A gang of bandits? A dying woman? Travellers asking for another story?

Where are we? Some say that the wooden bucket and the chammy leather indicate a tannery, and these same commentators remember Aesop's fable about the man who learnt gradually to ignore the stench of tanning hides. I'm not entirely convinced. Perhaps we are at an inn, amongst travellers on the road. His boots are as used as nags with sway backs. Yet at this moment he is surprisingly dust-free and clean. He has washed and douched his hair, which is still a little damp.

His itinerant pilgrim's robe has long since taken on the shape of his body, and his dress has exactly the same expression as his face. It has reacted as cloth to life, in the same way as his face has reacted as skin and bone. Robe and face appear to share the same experience.

His gaze now makes me hesitate. He is intimidating, he has a kind of arrogance. A pause for thought. No, he is not arrogant. But he does not suffer fools gladly.

Who was the painter's model for this historical portrait of a man who lived two thousand years earlier? In my opinion it would be rash to assume that the model was a writer, or even a regular friend of Velázquez. Aesop is said to have been a freed slave – born perhaps in Sardinia. One might believe the same of the man standing before us. The power of his presence is of the kind which belongs exclusively to those without power. A convict in a Sicilian prison said to Danilo Dolci: 'With all this experience reading the stars all over Italy, I've plumbed the

depths of the universe. All of humanity under Christendom, the poor, the rich, princes, barons, counts, have revealed to me their hidden desires and secret practices.'[1]

Legend has it that at the end of his life Aesop too was condemned for theft. Perhaps the model was an ex-convict, a one-time galley slave, whom Velázquez, like Don Quixote, met on the road. In any case he knows 'their hidden desires and their secret practices'.

Like the court dwarfs painted by Velázquez, he watches the spectacle of worldly power. As in the eyes of the dwarfs, there is an irony in his regard, an irony that pierces any conventional rhetoric. There, however, the resemblance ends, for the dwarfs were handicapped at birth. Each dwarf has his own expression, yet all of them register a form of resignation which declares: This time round, normal life was bound to exclude me. Aesop has no such exemption. He is normal.

The robe clothes him and at the same time reminds us of the naked body underneath. This effect is heightened by his left hand, inside the robe against his stomach. And his face demonstrates something similar concerning his mind. He observes, watches, recognizes, listens to what surrounds him and is exterior to him, and at the same time he ponders within, ceaselessly arranging what he has perceived, trying to find a sense which goes beyond the five senses with which he was born. The sense found in what he sees, however precarious and ambiguous it may be, is his only possession. For food or shelter he is obliged to tell one of his stories.

How old is he? Between fifty and sixty-five? Younger than Rembrandt's Homer, older than Ribera's Aesop. Some say the original story-teller lived to the age of seventy-five. Velázquez died at sixty-one. The bodies of the young are gifts – both to themselves and others. The goddesses of ancient Greece were carriers of this gift. The bodies of the powerful, when old, become unfeeling and mute – already resembling the statues which they believe will be their due after their death.

Aesop is no statue. His physique embodies his experience. His presence refers to nothing except what he has felt and seen. Refers to no possessions, to no institution, to no authority or protection. If you weep on his shoulder, you'll weep on the shoulder of his life. If you caress his body, it will still recall the tenderness it knew in childhood.

Ortega y Gasset describes something of what I feel in this man's presence:

> At another time we shall see that, while astronomy for example is not a part of the stellar bodies it researches and discovers, the peculiar vital wisdom we call 'life experience' is an essential part of life itself, constituting one of its principal components or factors. It is this wisdom that makes a second love necessarily different from a first one, because

the first love is already there and one carries it rolled up within. So if we resort to the image, universal and ancient as you will see, that portrays life as a road to be travelled and travelled again – hence the expressions 'the course of life, *curriculum vitae*, decide on a career' – we could say that in walking along the road of life we keep it with us, know it; that is the road already travelled curls up behind us, rolls up like a film. So that when he comes to the end, man discovers that he carries, stuck there on his back, the entire roll of the life he led.[2]

He carries the roll of his life with him. His virility has little to do with mastery or heroism, but a lot to do with ingenuity, cunning, a certain mockery and a refusal to compromise. This last refusal is not a question of obstinacy but of having seen enough to know one has nothing to lose. Women often fall in love with energy and disillusion, and in this they are wise for they are doubly protected. This man, elderly, ragged, carrying nothing but his tattered life's work, has been, I believe, memorable to many women. I know old peasant women with faces like his.

He has now lost his male vanity. In the stories he tells he is not the hero. He is the witness become historian, and in the countryside this is the role which old women fill far better than men. Their reputations are behind them and count for nothing. They become almost as large as nature. (There is an art-historical theory that Velázquez, when painting this portrait, was influenced by an engraving by Giovanni Battista Porta which made a physiognomical comparison between the traits of a man and an ox. Who knows? I prefer my recollection of old peasant women.)

His eyes are odd, for they are painted less emphatically than anything else in the picture. You almost have the impression that everything else has been painted *except* his eyes, that they are all that remains of the ground of the canvas.

Yet everything in the picture, apart from the folio and his hand holding it, points to them. Their expression is given by the way the head is held and by the other features: mouth, nose, brow. The eyes perform – that is to say they look, they observe and little escapes them, yet they do not react with a judgement. This man is neither protagonist nor judge nor satirist. It is interesting to compare Aesop with Velázquez's companion painting (same size and formula) of Menippus. Menippus, one of the early cynics and a satirist, looks out at the world, as at something he has left behind, and his leaving affords him a certain amusement. In his stance and expression there is not a trace of Aesop's compassion.

Indirectly, Aesop's eyes tell a lot about story-telling. Their expression is reflective. Everything he has seen contributes to his sense of the enigma of life: for this enigma he finds partial answers – each story he tells is one – yet each answer, each story, uncovers another question, and so he is

continually failing and this failure maintains his curiosity. Without mystery, without curiosity and without the form imposed by a partial answer, there can be no stories – only confessions, communiqués, memories and fragments of autobiographical fantasy which for the moment pass as novels.

I once referred to story-tellers as Death's Secretaries. This was because all stories, before they are narrated, begin with the end. Walter Benjamin said: 'Death is the sanction of everything that the story-teller can tell. He has borrowed his authority from death.' Yet my phrase was too romantic, not contradictory enough. No man has less to do with death than this one. He watches life as life might watch itself.

A story for Aesop. It was the sixth of January, Twelfth Night. I was invited into the kitchen of a house I'd never been into before. Inside were some children and a large, bobtail sheep-dog with a coarse grey coat and matted hair over her eyes. My arrival frightened the dog, and she started to bark. Not savagely but persistently. I tried talking to her. Then I squatted on the floor so as to be the same size as her. Nothing availed. Ill at ease, she went on barking. We sat round the table, eight or nine of us, drank coffee and ate biscuits. I offered her a biscuit at arm's length. Finally, she took it. When I offered her another, close to my knee, she refused. She never bites, said the owner. And this remark prompted me to tell a story.

Twenty-five years ago I lived in a suburb on the edge of a European city. Near the flat were fields and woods where I walked every morning before breakfast. At a certain point, by a makeshift shed where some Spaniards were living, I always passed the same dog. Old, grey, blind in one eye, the size of a boxer, and a mongrel if ever there was one. Each morning, rain or sunny, I would stop, speak to her, pat her head and then continue on my way. We had this ritual. Then one winter's day she was no longer there. To be honest I didn't give it a second thought. On the third day, however, when I approached the shed, I heard a dog's bark and then a whine. I stopped, looked around. Not a trace. Perhaps I had imagined it. Yet no sooner had I taken a few steps than the whining started again, turning into a howl. There was snow on the ground. I couldn't even see the tracks of a dog. I stopped and walked towards the shed. And there, at my feet, was a narrow trench for drain pipes, dug, presumably, before the ground was frozen. Five feet deep with sheer sides. The dog had fallen into the trench and couldn't get out. I hesitated. Should I try to find its owner? Should I jump down and lift it out?

As I walked away, my demon's voice hissed: Coward!

Listen, I replied, she's blind, she's been there for a day or two.

You don't know, hissed the demon.

At least all night, I said. She doesn't know me and I don't even know her name!

Coward!

So I jumped down into the trench. I calmed her. I sat with her till the moment came to lift her up to the level of my shoulders and put her on the ground. She must have weighed a good thirty kilos. As soon as I lifted – as was to be expected – she bit me. Deep into the pad of my thumb and my wrist. I scrambled out and hurried off to the doctor. Later I found the dog's owner, an Italian, and he gave me his card and wrote on the back of it the name and address of his insurance company. When I recounted what had happened to the insurance agent, he raised his eyebrows.

The most improbable story I've ever heard! he said.

I pointed at my bandaged right arm in its sling.

Then you're mad! he said.

The owner of the dog asked me to report to you.

Of course! You're in it together. How much do you earn?

At that moment I was inspired. Ten thousand a month, I lied.

Please take a seat, sir.

The people listening around the table laughed. Somebody else told a story and then we got to our feet, for it was time to go. I walked over to the door, buttoning up my coat. The dog came across the room in a straight line towards me. She took my hand in her mouth, gently, and backed away, tugging.

She wants to show you the stable where she sleeps, said one of the children.

But no, it was not to the stable door the dog was taking me, it was to the chair where I had been sitting. I sat down again and the dog lay down by my feet, undisturbed by the laughter of everyone else in the room and watchful for the smallest sign that I intended to leave.

A small story for Aesop. You can make what you like of it. How much can dogs understand? The story becomes a story because we are not quite sure; because we remain sceptical either way. Life's experience of itself (and what else are stories if not that?) is always sceptical.

Legend has it that Pyrrho, the founder of scepticism, was at first a painter. Later he accompanied Alexander the Great on his voyage through Asia, gave up painting and became a philosopher, declaring that appearances and all perceptions were illusory. (One day somebody should write a play about Pyrrho's journey.) Since the fourth century BC, and more precisely during the last two centuries, the sense of the term 'scepticism' has radically changed. The original sceptics rejected any total explanation (or solution) concerning life because they gave priority to their experience that a life really lived was an enigma. They thought of their philosophical opponents as privileged, protected academicians.

They spoke for common experience against elitism. They believed that if God existed, he was invisible, unanswerable and certainly didn't belong to those with the longest noses.

Today scepticism has come to imply aloofness, a refusal to be engaged, and very often – as in the case of logical positivism – privileged pedantry. There was a certain historical continuity from the early sceptics through the heretics of the Middle Ages to modern revolutionaries. By contrast, modern scepticism challenges nobody and dismantles only theories of change. This said, the man before us is a sceptic in the original sense.

If I did not know the painting was by Velázquez, I think I would still say it came from Spain. Its intransigence, its austerity and its scepticism are very Spanish. Historically, Spain is thought of as a country of religious fervour, even fanaticism. How to reconcile this with the scepticism I am insisting upon? Let us begin with geography.

Cities have always been dependent on the countryside for their food; is it possible that they are similarly dependent on the countryside for much of their ontology, for some of the terms in which they explain man's place in the universe?

It is outside the cities that nature, geography, climate, have their maximum impact. They determine the horizons. Within a city, unless one climbs a tower, there is no horizon.

The rate of technological and political change during our century has made everyone aware of history on a world scale. We feel ourselves to be creatures not only of history but of a universal history. And we are. Yet the supremacy given to the historical has perhaps led us to under-estimate the geographical.

In the Sahara one enters the Koran. Islam was born of, and is continually reborn from, a nomadic desert life whose needs it answers, whose anguish it assuages. Already I am writing too abstractly so that one forgets the weight of the sky on the sand or on the rock which has not yet become sand. It is under this weight that a prophetic religion becomes essential. As Edmond Jabes has written:

In the mountain the sense of infinitude is disciplined by heights and depths and by the sheer density of what you confront; thus you yourself are limited, defined as an object among other objects. At sea there is always more than just water and sky; there is the boat to define your difference from both, giving you a human place to stand. But in the desert the sense of the infinite is unconditional and therefore truest. In the desert you're left utterly to yourself. And in that unbroken sameness of sky and sand, you're nothing, absolutely nothing.

The blade (the knife, the sword, the dagger, the sickle) occupies a special place in Arabic poetry. This is not unrelated to its usefulness as a weapon and as a tool. Yet the knife-edge has another meaning too. Why is the knife so true to this land? Long before the slanders and half-truths of European Orientalism ('the cruelty of the scimitar'), the blade was a reminder of the thinness of life. And this thinness comes, very materially, from the closeness in the desert between sky and land. Between the two there is just the height for a horseman to ride or a palm to grow. No more. Existence is reduced to the narrowest seam, and if you inhabit that seam, you become aware of life as an astonishing *outside* choice, of which you are both witness and victim.

Within this awareness there is both fatalism and intense emotion. Never fatalism and indifference.

'Islam,' writes Hasam Saab, 'is, in a sense, a passionate protest against naming anything sacred except God.'

In the thin stratum of the living laid on the sand like a nomad's carpet, no compromise is possible because there are no hiding places; the directness of the confrontation produces the emotion, the helplessness, the fatalism.

The interior tableland of Spain is, in a certain sense, more negative than the desert. The desert promises nothing and in its negation there are miracles to be found. The Will of God, the oasis, the alpha, the *ruppe vulgaire* – for example. The Spanish steppe is a landscape of *broken* promises. Even the backs of its mountains are broken. The typical form of the *meseta* is that of a man cut down, a man who has lost his head and shoulders, truncated by one terrible horizontal blow. And the geographical repetition of these horizontal cuts interminably underlines how the steppe has been lifted up towards the sky to bake in the summer (it is the horizontals which continually suggest the oven) and to freeze in the winter, coated with ice.

In certain areas the Spanish steppe produces wheat, maize, sunflowers, and vines. But these crops, less tough than briars, thistles or the *jara*, risk being burnt or frozen out. Little lends itself to their survival. They have to labour, like the men who cultivate them, in the face of an inherent hostility. In this land even the rivers are mostly enemies rather than allies. For nine months of the year they are dried-out ravines – obstacles; for two months they are wild, destructive torrents.

The broken promises, like the fallen stones and the salt gravel, appear to guarantee that everything will be burnt to dust, turning first black and then white. And history? Here one learns that history is no more than the dust raised by a flock of sheep. All architecture on the tableland is defensive, all monuments are like forts. To explain this entirely by national military history – the Arab occupation, the Wars of Reconquest – is, I think, too simple. The Arabs introduced light into Spanish

architecture. The essential Spanish building, with its massive doors, its defensive walls, its four-facedness and its solitude, is a response to the landscape as representation, a response to what its signs have revealed about the origins of life.

Those who live there and work on this land live in a world visibly without promise. What promises is the invisible and lies behind the apparent. Nature, instead of being compliant, is indifferent. To the question 'Why is man here?' it is deaf, and even its silence cannot be counted as a reply. Nature is ultimately dust (the Spanish term for ejaculation is 'throwing dust') – in face of which nothing remains except the individual's ferocious faith or pride.

What I am saying here should not be confused with the character of the Spanish men and women. Spaniards are often more hospitable, truer to their promises, more generous, more tender than many other people. I am not talking about their lives but about the stage on which they live.

In a poem called *Across the Land of Spain* Antonio Machado wrote:

> You will see battle plains and hermit steppes
> – in these fields there is nothing of the garden in
> the Bible –
> here is a land for the eagle, a bit of planet
> crossed by the wandering shadow of Cain.

Another way of defining the Spanish landscape of the interior would be to say that it is unpaintable. And there are virtually no paintings of it. There are of course many more unpaintable landscapes in the world than paintable ones. If we tend to forget this (with our portable easels and colour slides!) it is the result of a kind of Eurocentrism. Where nature on a large scale lends itself to being painted is the exception rather than the rule. (Perhaps I should add that I would be the last to forget about the specific social-historical conjuncture necessary for the production of pure landscape painting, but that is another story.) A landscape is never unpaintable for purely descriptive reasons; it is always because its sense, its meaning, is not *visible*, or else lies elsewhere. For example, a jungle is paintable as a habitation of spirits but not as a tropical forest. For example, all attempts to paint the desert end up as mere paintings of sand. The desert is elsewhere – in the sand drawings of the Australian Aborigines, for instance.

Paintable landscapes are those in which what is visible enhances man – in which natural appearances make *sense*. We see such landscapes around every city in Italian Renaissance painting. In such a context there is no distinction between appearance and essence – such is the classic ideal.

Those brought up in the unpaintable *meseta* of the Spanish hinterland

are convinced that essence can never be visible. The essence is in the darkness behind closed lids. In another poem, called *The Iberian God,* Machado asks:

> Who has ever seen the face of the God of Spain?
> My heart is waiting
> for that Spaniard with rough hands
> who will know how to carve from the ilex of Castile
> the austere God of that brown earth.

The unpaintability of a landscape is not a question of mood. A mood changes according to the time of day and season. The Castilian steppe at noon in summer – desiccated as a dried fish – is different in mood from the same steppe in the evening when the broken mountains on the horizon are as violet as living sea anemones. In Goya's Aragon the summer dust of endless extension becomes, in the winter when the north-east *cierzo* is blowing, a frost that blindfolds. The mood changes. What does not change is the scale, and what I want to call the *address* of the landscape.

The scale of the Spanish interior is of a kind which offers no possibility of any focal centre. This means that it does not lend itself to being looked at. Or, to put it differently, *there is no place to look at it from.* It surrounds you but it never faces you. A focal point is like a remark being made to you. A landscape that has no focal point is like a silence. It constitutes simply a solitude that has turned its back on you. Not even God is a visual witness there – for God does not bother to look there, the visible is nothing there. This surrounding solitude of the landscape which has turned its back is reflected in Spanish music. It is the music of a voice surrounded by emptiness. It is the very opposite of choral music. Profoundly human, it carries like the cry of an animal. Not because the Spaniards are animal-like, but because the territory has the character of an unchartable vastness.

By 'address' I mean what a given landscape addresses to the indigenous imagination: the background of meaning which a landscape suggests to those familiar with it. It begins with what the eye sees every dawn, with the degree to which it is blinded at noon, with how it feels assuaged at sunset. All this has a geographical or topographical basis. Yet here we need to understand by geography something larger than what is usually thought. We have to return to an earlier geographical experience, before geography was defined purely as a natural science. The geographical experience of peasants, nomads, hunters – but perhaps also of cosmonauts.

We have to see the geographic as a representation of an invisible origin: a representation which is constant yet always ambiguous and

unclear because what it represents is about the beginning and end of everything. What we actually see (mountains, coastlines, hills, clouds, vegetation) are the temporal consequences of a nameless, unimaginable event. We are still living that event, and geography – in the sense I'm using it – offers us signs to read concerning its nature.

Many different things can fill the foreground with meaning: personal memories; practical worries about survival – the fate of a crop, the state of a water supply; the hopes, fears, prides, hatreds, engendered by property rights; the traces of recent events and crimes (in the countryside all over the world crime is one of the favourite subjects of conversation). All these, however, occur against a common constant background which I call the landscape's *address*, consisting of the way a landscape's 'character' determines the imagination of those born there.

The address of many jungles is fertile, polytheistic, mortal. The address of deserts is unilinear and severe. The address of western Ireland or Scotland is tidal, recurring, ghost-filled. (This is why it makes sense to talk of a Celtic landscape.) The address of the Spanish interior is timeless, indifferent and galactic.

The scale and the address do not change with mood. Every life remains open to its own accidents and its own purpose. I am suggesting, however, that geography, apart from its obvious effects on the biological, may exercise a cultural influence on how people envisage nature. This influence is a visual one, and since until very recently nature constituted the largest part of what men saw, one can further propose that a certain geography encourages a certain relation to the visible.

Spanish geography encourages a scepticism towards the visible. No sense can be found there. The essence lies elsewhere. The visible is a form of desolation, appearances are a form of debris. What is essential is the invisible self, and what may lie behind appearances. The self and the essential come together in darkness or blinding light.

The language of Spanish painting came from the other side of the Pyrenees. This is to say it was a language originally born of the scientific visual curiosity of the Italian Renaissance and the mercantile realism of the Low Countries. Later this language becomes baroque, then neo-classicist and romantic. But throughout its evolution it remains – even during its mannerist fantasy phase – a visual language constructed around the credibility of natural appearances and around a three-dimensional materialism. One has only to think of Chinese or Persian or Russian ikonic art to appreciate more clearly the *substantiality* of the main European tradition. In the history of world art, European painting, from the Renaissance until the end of the nineteenth century, is the most corporeal. This does not necessarily mean the most sensuous, but

the most corporeally addressed to the living-within-their-bodies, rather than to the soul, to God, or to the dead.

We can call this corporeality humanist if we strip the word of its moral and ideological connotations. Humanist insofar as it places the living human body at the centre. Such a humanism can only occur, I believe, in a temperate climate within landscapes that lend themselves, when the technological means are available and the social relations permit, to relatively rich harvests. The humanism of the visual language of European painting presumes a benign, kind nature. Perhaps I should emphasise here that I'm talking about the language as such, and not about what can be said with it. Poussin in *Arcadia* and Callot in his *Horrors of War* were using the same language, just as were Bellini with his Madonnas and Grünewald with his victims of the plague.

Spain at the beginning of the sixteenth century was the richest and most powerful country in Europe: the first European power of the Counter-Reformation. During the following centuries of rapid decline and increasing poverty, it nevertheless continued as a nation to play a European role, above all as a defender of the Catholic faith. That its art should be European, that its painters practised in a European language (often working in Italy) is therefore not surprising. Yet just as Spanish Catholicism was unlike that in any other European country, so was its art. The great painters of Spain took European painting and turned it against itself. It was not their aim to do so. Simply, their vision, formed by Spanish experience, could not stomach that painting's humanism. A language of plenty for a land of scarcity. The contrast was flagrant, and even the obscene wealth of the Spanish church couldn't bridge it. Once again Machado, the greatest poet of Spanish landscape, points a way to an answer:

> O land of Alvorgonzalez,
> In the heart of Spain,
> Sad land, poor land,
> So sad that it has a soul!

There is a canvas by El Greco of St Luke, the patron saint of painters. In one hand he is holding a paintbrush and, in his other, an open book against his torso. We see the page in the book on which there is an image of the Madonna and Child.

Zurbarán painted at least four versions of the face of Christ, printed miraculously on St Veronica's head-cloth. This was a favourite subject of the Counter-Reformation. The name Veronica, given to the woman who is said to have wiped Christ's face with her scarf as he carried the cross to Golgotha, is doubtless derived from the words *vera icona*, true image.

In the El Greco and the Zurbarán we are reminded of how *thin* even a true image is. As thin as paper or silk.

508

In bullfighting the famous pass with the cape is called a St Veronica. The bullfighter holds his cape up before the bull, who believes the cape is the matador. As the bull advances with his head down, the matador slowly withdraws the cape and flaunts it so that it becomes no more than a scrap of material. He repeats this pass again and again, and each time the bull believes in the solidity and corporeality of what has been put before his eyes, and is deceived.

Ribera painted at least five versions of a philosopher holding a looking-glass, gazing at his own reflection and pondering the enigma of appearances. The philosopher's back is turned to us, so that we see his face properly only in the mirror which offers, once again, an image as thin as its coat of quicksilver.

Another painting by Ribera shows us the blind Isaac blessing his youngest son, Jacob, whom he believes to be Esau. With the connivance of Rebecca, his mother, Jacob is tricking his father with the kidskin he has wrapped around his wrist and arm. The old man, feeling the hairy arm, believes he is blessing Esau his eldest son, the hirsute shepherd. I cannot remember ever seeing another painting of this subject. It is an image devoted to demonstrating graphically how surfaces, like appearances, deceive. Not simply because the surface is superficial, but because it is false. The truth is not only deeper, it is elsewhere.

The iconographic examples I have given prepare the way for a generalization I want to make about *how* the Spanish masters painted – regardless of subject or iconography. If this *how* can be seized, we will come nearer to understanding something intrinsic to the Spanish experience of the momentous and of the everyday. *The Spanish masters painted all appearances as though they were a superficial covering.*

A covering like a veil? Veils are too light, too feminine, too transparent. The covering the painters imagined was opaque. It had to be, for otherwise the darkness it dressed would seep through, and the image would become as black as night.

Like a curtain? A curtain is too heavy, too thick, and it obliterates every texture save its own. According to the Spanish masters, appearances were a kind of skin. I am always haunted by Goya's two paintings *The Maja Dressed* and *The Maja Undressed*. It is significant that this dressed-undressed painting game occurred to a Spaniard, and remains unique in the history of art – the white skin of the naked maja is as much a covering as was her costume. What she *is* remains undisclosed, invisible.

The appearance of everything – even of rock or of armour – is equally a skin, a membrane. Warm, cold, wrinkled, fresh, dry, humid, soft, hard, jagged, the membrane of the visible covers everything we see with our eyes open, and it deceives us as the cape deceives the bull.

*　　*　　*

In Spanish painting there are very few painted eyes that are openly *looking*. Eyes are there to suggest the inner and invisible spirit of the painted person.

In El Greco they are raised to heaven. In Velázquez – think again of his portraits of the court dwarfs – their eyes are masked from vision as if by a terrible cataract; the eyes of his royal portraits are marvellously painted orbs, jellies, but they do not scrutinize like those painted by Hals, who was his contemporary a thousand miles to the north.

In Ribera and Zurbarán eyes look inward, lost to the world. In Murillo the windows of the soul are decorated with tinsel. Only Goya might seem to be the exception – particularly in the portraits of his friends. But if you place these portraits side by side, a curious thing becomes evident: their eyes have the same expression: an unflinching, lucid resignation – as if they had already seen the unspeakable, as if the existent could no longer surprise them and was scarcely worth observing any more.

Spanish art is often designated as realist. In a sense, it is. The surfaces of the objects painted are studied and rendered with great intensity and directness. The existent is stated, never simply evoked. There is no point in seeing through appearances, because behind them there is nothing to see. Let the visible be visible without illusion. The truth is elsewhere.

In *The Burial of Count Orgaz,* El Greco paints the armour of the dead count and, reflected on its metal, the image of St Stephen, who is lifting up the corpse by its legs. In *The Spoliation* he uses the same virtuoso device. On the armour of the knight standing beside Christ is reflected, in gladiola-like flames, the red of the Saviour's robe. In El Greco's 'transcendental' world, the sense of touch, and therefore of the tangible reality of surfaces, is everywhere. He had a magnificent wardrobe for dressing up his saints. There's not another garment-painter like him.

In the more austere work of Ribera and Zurbarán, the cloak covers the body, the flesh covers the bones, the skull contains the mind. And the mind is what? Darkness and invisible faith. *Behind* the last surface is the unpaintable. Behind the pigment on the canvas is what counts, and it corresponds to what lies behind the lids of closed eyes.

The wound in Spanish painting is so important because it penetrates appearances, reaches behind them. Likewise the tatters and rags of poverty – of course they reflect both the reality and the cult of poverty, but visually what they do is to tear apart, to reveal the next surface, and so take us nearer to the last, behind which the truth begins.

The Spanish painters, with all their mastery, set out to show that the visible is an illusion, only useful as a reminder of the terror and hope within the invisible. Think, by contrast, of a Piero della Francesca, a Raphael, a Vermeer, in whose work all is visibility and God, above all, is the all-seeing.

Goya – when he was past the age of fifty and deaf – broke the mirror, stripped off the clothes and saw the bodies mutilated. In the face of the first modern war, he found himself in the darkness, on the far side of the visible, and from there he looked back on the debris of appearances (if that sounds like a metaphor, look at the late brush drawings), picked up the pieces and rearranged them together. Black humour, black painting, flares in the night of *The Disasters of War* and the *Disparates.* (In Spanish *disparate* means 'folly', but its Latin root means 'divide, separate'.) Goya worked with the scattered, disfigured, hacked, fragments of the visible. Because they are broken fragments, we see what lies behind: the same darkness that Zurbarán, Ribalta, Maino, Murillo and Ribera had always presumed.

Maybe one of the *Disparates* comments on this reversal, by which the presumed dark behind appearances becomes the evident dark between their mutilated pieces. It shows a horse that turns its head to seize between its teeth the rider, who is a woman in a white dress. That which once you rode annihilates you.

Yet the reality of what Goya experienced and expressed is not finally to be found in any symbol, but simply in the way he drew. He puts parts together without considering the whole. Anatomy for him is a vain, rationalist exercise that has nothing to do with the savagery and suffering of bodies. In front of a drawing by Goya our eyes move from part to part, from a hand to a foot, from a knee to a shoulder, as though we were watching an action in a film, as though the parts, the limbs, were separated not by centimetres but by seconds.

In 1819, when he was seventy-three, Goya painted *The Last Communion of St Joseph de Calasanz,* the founder of a religious order, who educated the poor for nothing and in one of whose schools Goya had been educated as a child in Saragossa. In the same year Goya also painted a small picture of the Agony in the Garden.

In the first painting the old grey-faced, open-mouthed man kneels before the priest, who is placing the Host on his tongue. Beyond the two foreground figures is the congregation in the dark church: children, several men of different ages, and perhaps, on the extreme left, a self-portrait of the painter. Everything in the painting diminishes before the four pairs of praying hands we can see: the saint's, another old man's, the painter's and a younger man's. They are painted with furious concentra-tion – by the painter who, when he was young, was notorious for the cunning with which he avoided hands in his portraits to save himself time. The fingertips of each pair of hands interlace loosely, and the hands cup with a tenderness that only young mothers and the very old possess, cup – as if protecting the most precious thing in the world – nothing, *nada.*

St Luke tells the story of Christ on the Mount of Olives in the following words:

And he came out, and went, as he was wont, to the Mount of Olives; and his disciples followed him. And when he was at the place, he said unto them, Pray that ye enter not into temptation. And he was withdrawn from them about a stone's cast, and kneeled down, and prayed, saying Father, if thou be willing, remove this cup from me; nevertheless not my will, but thine, be done. And there appeared an angel unto him from heaven, strengthening him. And being in an agony he prayed more earnestly; and his sweat was as it were great drops of blood falling down to the ground.

Christ is on his knees, arms outstretched, like the prisoner awaiting, for another second, his execution on the Third of May 1808.

It is said that in 1808, when Goya began drawing *The Disasters of War*, his manservant asked him why he depicted the barbarism of the French. 'To tell men eternally,' he replied, 'not to be barbarians.'

The solitary figure of Christ is painted on a ground of black with scrubbed brush marks in pale whites and greys. It has no substance at all. It is like a tattered white rag whose silhouette against the darkness makes the most humanly expressive gesture imaginable. Behind the rag is the invisible.

What makes Spanish painting Spanish is that in it is to be discovered the same anguish as the landscapes of the great *mesa* of the interior often provoked on those who lived and worked among them. In the Spanish galleries of the Prado, in the centre of modern Madrid, a Spanish earth, measured not by metres but by 'a stone's cast', on to which sweat falls like drops of blood, is present everywhere, insistent and implicit. The Spanish philosopher Miguel de Unamuno has defined it very exactly: 'Suffering is, in effect, the barrier which unconsciousness, matter, sets up against consciousness, spirit; it is the resistance to will, the limit which the visible universe imposes upon God.'

Velázquez was as calm as Goya was haunted. Nor are there any signs of religious fervour or passion in his work. His art is the most unprejudiced imaginable – everything he sees receives its due; there is no hierarchy of values. Before his canvases we are not aware of the thinness of surfaces, for his brush is too suave to separate surface from space. His paintings seem to come to our eyes like nature itself, effortlessly. Yet we are disturbed even as we admire. The images, so masterly, so assured, so tactful, have been conceived on a basis of total scepticism.

Unprejudiced, effortless, sceptical – I repeat the epithets I have used and they yield a sense: an image in a mirror. Velázquez's deliberate use of mirrors in his work has been the subject of several art-historical treatises. What I'm suggesting here, however, is more sweeping. He treated all appearances as being the equivalent of reflections in a mirror.

That is the spirit in which he quizzed appearances, and this is why he discovered, long before anyone else, a miraculous, purely optical (as distinct from conceptual) verisimilitude.

But if all appearances are the equivalent of reflections, what lies behind the mirror? Velázquez's scepticism was founded upon his faith in a dualism which declared: Render unto the visible what is seen, and to God what is God's. This is why he could paint so sceptically with such certitude.

Consider Velázquez's canvas which was once called *The Tapestry Makers* and is now entitled *The Fable of Arachne*. It was always thought to be one of the painter's last works, but recently certain art historians (for reasons which to me are not very convincing) have dated it ten years earlier. In any case everyone is agreed that it is the nearest thing we have to a testament from Velázquez. Here he reflects upon the practice of image-making.

The story of Arachne, as related by Ovid, tells how a Lydian girl (we see her on the right, winding a skein of wool into a ball) made such famous and beautiful tapestries that she challenged the goddess of the arts and crafts, Pallas, to a contest. Each had to weave six tapestries. Pallas inevitably won and, as a punishment, turned Arachne into a spider. (The story is already contained in her name.) In the painting by Velázquez both are at work (the woman on the left at the spinning wheel is Pallas) and in the background in the lighted alcove there is a tapestry by Arachne which vaguely refers to Titian's painting *The Rape of Europa*. Titian was the painter whom Velázquez most admired.

Velázquez's canvas was originally somewhat smaller. Strips were added to the top and the left and the right in the eighteenth century. The overall significance of the scene, however, has not been changed. Everything we see happening is related to what we can call the cloth or the garment of appearances. We see the visible being created from spun thread. The rest is darkness.

Let us move across the foreground from left to right. A woman holds back a heavy red curtain as if to remind the spectator that what she or he is seeing is only a temporary revelation. Cry 'Curtain!' and everything disappears as off a stage.

Behind this woman is a pile of unused coloured cloths (a stock of appearances not yet displayed) and, behind that, a ladder up which one climbs into darkness.

Pallas at the spinning wheel spins a thread out of the debris of sheared wool. Such threads, when woven, can become a kerchief like the one she is wearing on her head. Equally, the golden threads, when woven, can become flesh. Look at the thread between her finger and thumb and consider its relation to her bare, outstretched leg.

To the right, seated on the floor, another woman is carding the wool,

preparing it for the life it will assume. With Arachne, winding a skein of spun wool into a ball with her back to us, we have an ever-clearer allusion as to how the thread can become either cloth or flesh. The skein, her outstretched arm, the shirt on her back, her shoulders, are all made of the same golden stuff, partaking of the same life: whilst hanging on the wall behind we see the dead, inert material of the sheep's wool before it has acquired life or form. Finally, on the extreme right, the fifth woman carries a basket from which flows a golden, diaphanous drapery, like a kind of surplus.

To underline even further the equivalence of flesh and cloth, appearance and image, Velázquez has made it impossible for us to be sure which figures in the alcove are woven into the tapestry and which are free-standing and 'real'. Is the helmeted figure of Pallas part of the tapestry or is she standing in front of it? We are not sure.

The ambiguity with which Velázquez plays here is of course a very old one. In Islamic and Greek and Indian theology the weaver's loom stands for the universe and the thread for the thread of life. Yet what is specific and original about this painting in the Prado is that everything in it is revealed against a background of darkness, thus making us acutely aware of the *thinness* of the tapestry and therefore of the *thinness* of the visible. We come back, despite all the signs of wealth, to the rag.

Before this painting by Velázquez we are reminded of Shakespeare's recurring comparison of life with a play.

> . . . These our actors,
> As I foretold you, were all spirits and
> Are melted into air, into thin air:
> And, like the baseless fabric of this vision,
> The cloud-capped towers, the gorgeous palaces,
> The solemn temples, the great globe itself,
> Yea, all which it inherit, shall dissolve
> And, like this insubstantial pageant faded,
> Leave not a rack behind . . .

This famous quotation (Shakespeare died at the age of fifty-two, when Velázquez was seventeen) leads us back to the scepticism of which I have already spoken. Spanish painting is unique in both its faithfulness and its scepticism towards the visible. Such scepticism is embodied in the story-teller standing before us.

Looking at him, I am reminded that I am not the first to pose unanswerable questions to myself, and I begin to share something of his composure: a curious composure for it coexists with hurt, with pain and with compassion. The last, essential for story-telling, is the complement of the original scepticism: a tenderness for experience, because it is

human. Moralists, politicians, merchants ignore experience, being exclusively concerned with actions and products. Most literature has been made by the disinherited or the exiled. Both states fix the attention upon experience and thus on the need to redeem it from oblivion, to hold it tight in the dark.

He is no longer a stranger. I begin, immodestly, to identify with him. Is he what I have wanted to be? Was the doorway he appeared in during my childhood simply my wished-for future? Where exactly is he?

One might have expected it from Velázquez! I think he's in front of a mirror. I think the entire painting is a reflection. Aesop is looking at himself. Sardonically, for his imagination is already elsewhere. In a minute he will turn and join his public. In a minute the mirror will reflect an empty room, through whose wall the sound of occasional laughter will be heard.

1986

The Ideal Palace

Very few peasants become artists – occasionally perhaps the son or daughter of peasants has done so. This is not a question of talent, but of opportunity and free time. There are some songs and, recently, a few autobiographies about peasant experience. There is the marvellous philosophical work of Gaston Bachelard. Otherwise there is very little. This lack means that the peasant's soul is as unfamiliar or unknown to most urban people as is his physical endurance and the material conditions of his labour.

It is true that in medieval Europe peasants sometimes became artisans, masons, even sculptors. But they were then employed to express the ideology of the Church, not, directly, their own view of the world.

There is, however, one colossal work, which resembles no other and which is a direct expression of peasant experience. It is about this work – which includes poetry, sculpture, architecture – that I want now to talk.

A country postman, as my 27,000 comrades, I walked each day from Hauterives to Tersanne – in the region where there are still traces of the time when the sea was here – sometimes going through snow and ice, sometimes through flowers. What can a man do when walking everlastingly through the same setting, except to dream? I built in my dreams a palace passing all imagination, everything that the genius of a simple man can conceive – with gardens, grottoes, towers, castles, museums and statues: all so beautiful and graphic that the picture of it was to live in my mind for at least ten years . . .

When I had almost forgotten my dream, and it was the last thing I was thinking about, it was my foot which brought it all back to me. My foot caught on something which almost made me fall: I wanted to know what it was: it was a stone of such strange shape that I put it in my pocket to admire at leisure. The next day, passing through the same

place, I found some more, which were even more beautiful. I arranged them together there and then on the spot and was amazed . . . I searched the ravines, the hillside, the most barren and desolate places . . . I found tufa which had been petrified by water and which is also wonderful . . .

This is where my trials and tribulations began. I then brought along some baskets. Apart from the 30 km a day as postman, I covered dozens with my basket on my back, full of stones. Each commune has its own particular type of very hard stone. As I crossed the countryside I used to make small piles of these stones: in the evenings, I returned with my wheelbarrow to fetch them. The nearest were four to five km away, sometimes ten. I sometimes set out at two or three in the morning.

The writer is Ferdinand Cheval, who was born in 1836 and died in 1924, and who spent thirty-three years building his 'palace passing all imagination'. It is still to be found in Hauterives, the village where he was born, in the Department of the Drôme, France.

> In the evening when night has fallen,
> And other men are resting.
> I work at my palace.
> No one will know my suffering.
> In the minutes of leisure
> Which my duty allows me
> I have built this palace of a thousand and one
> nights –
> I have carved my own monument

Today the Palace is crumbling, its sculptures disintegrating, and its texts, inscribed on or cut into the walls, are being slowly effaced. It is less than eighty years old. Most buildings and sculptures fare better, because they belong to a mainstream tradition which lays down principles for whom they should be made, and, afterwards, for how they should be preserved. This work is naked and without tradition because it is the work of a single 'mad' peasant.

There are now a number of books of photographs about the Palace but the trouble with photographs – and even in film – is that the viewer stays in his chair. And the Palace is about the experience of being inside itself. You do not *look* at it any more than you look at a forest. You either enter it or you pass it by.

As Cheval has explained, the origin of its imagery was stones: stones which, shaped during geological times, appeared to him as caricatures. 'Strange sculptures of all kinds of animals and caricatures. Impossible for

man to imitate. I said to myself: since nature wants to make sculpture, I will make the masonry and architecture for it.' As you look *into* these stones, they become creatures, mostly birds or animals. Some look at you. Some you only glimpse as they disappear back into the stones from which they emerged briefly as profiles. The Palace is full of a life that is never entirely visible.

Except for a few exceptions which I will discuss later, there are no definitively exterior surfaces. Every surface refers, for its reality, inwards. The animals return to within the stones; when you are not looking, they re-emerge. Every appearance changes. Yet it would be wrong to think of the Palace as dream-like. This was the mistake of the Surrealists, who were the first to 'discover' it in the thirties. To psychologize it, to question Cheval's unconscious is to think in terms which never explain its uniqueness.

Despite its title, its model is not a palace but a forest. Within it are contained many smaller palaces, châteaux, temples, houses, lairs, earths, nests, holes, etc. The full content or population of the Palace is impossible to establish. Each time you enter it, you see something more or different. Cheval ended up by doing far more than just making the masonry and architecture for the sculptures of nature. He began to make his own. But nature remained his model: not as a depository of fixed appearances, not as the source of all taxonomy, but as an example of continual metamorphosis. If I look immediately in front of me now, I see:

> a pine tree
> a calf, large enough for the pine tree to be its horn
> a snake
> a Roman vase
> two washerwomen, the size of moles
> an otter
> a lighthouse
> a snail
> three friends nestling in coral
> a leopard, larger than the lighthouse
> a crow

Such a list would have to be multiplied several thousand times in order to make even a first approximate census. And as soon as you realize that, you realize how foreign to the spirit of the work such an exercise would be. Its function is not to present but to surround.

Whether you climb up its towers, walk through its crypts or look up at a façade from the ground, you are aware of having *entered* something. You

find yourself in a system which includes the space you occupy. The system may change its own image, suggesting different metaphors at different times. I have already compared it with a forest. In parts it is like a stomach. In other parts it is like a brain – the physical organ in the skull, not the abstract *mind*.

What surrounds you has a physical reality. It is constructed of sandstone, tufa, quicklime, sand, shells and fossils. At the same time, all this diverse material is unified and made mysteriously figurative. I do not now speak of the population of its images. I speak of the mineral material as a whole being arranged to represent a living organic system.

A kind of tissue connects everything. You can think of it as consisting of leaves, folds, follicles, or cells. All Cheval's sustained energy, all his faith, went into creating this. It is in this tissue that you feel the actual rhythm of his movements as he moulded the cement or placed his stones. It was in seeing this tissue grow beneath his hands that he was confirmed. It is this tissue which surrounds you like a womb.

I said the basic unit of this tissue suggested a kind of leaf or fold. Perhaps the closest I can get to defining it, or fully imagining it – inside the Palace or far away – is to think of the ideal leaf which Goethe writes about in his essay 'On the Metamorphosis of Plants'. From this archetypal leaf all plant forms derived.

In the Palace this basic unit implies a process of reproduction: not the reproduction of appearances: the reproduction of itself in growth.

Cheval left the Drôme once in his life: as a young man to work for a few months in Algeria. He gained his knowledge of the world via the new popular encyclopaedic magazines which came on the market during the second quarter of the nineteenth century. This knowledge enabled him to aspire to a world, as distinct from a local and partial, view. (Today modern means of communication are having, in different parts of the world, a comparable political effect. Peasants will eventually visualize themselves in global terms.)

Without a global aspiration, Cheval could never have sustained the necessary confidence to work alone for thirty-three years. In the Middle Ages the Church had offered a universal view, but its craftsmen mostly worked within the constraint of a prescribed iconography in which the peasant view had a place but was not formative. Cheval emerged, alone, to confront the modern world with his peasant vision intact. And according to this vision he built his Palace.

It was an incredibly improbable event, depending on so many contingencies. Of temperament. Of geography. Of social circumstance. The fact, for instance, that he was a postman and so had a small pension. If he had been a peasant working his own land, he could never have afforded

the 93,000 hours spent on the Palace. Yet he remained organically and consciously a member of the class into which he was born. 'Son of a peasant, it is as a peasant that I wish to live and die in order to prove that in my class too there are men of energy and genius.'

The character of the Palace is determined by two essential qualities: physicality (it contains no abstract sentimental appeals, and Cheval's statements all emphasize the enormous physical labour of its construction) and innerness (its total emphasis on what is within and being within). Such a combination does not exist in modern urban experience but is profoundly typical of peasant experience.

The notion of the *visceral* may perhaps be used here as an example. A word of warning, however, is necessary. To think of peasant attitudes as being more 'gutsy' than urban ones is to miss the point and to resort to an ignorant cliché.

A stable door. Hanging from a nail, a young goat being skinned and eviscerated by a grandfather deploying the point of his pocket-knife with the greatest delicacy, as if it were a needle. Beside him the grandmother holding the intestines in her arms to make it easier for her husband to detach the stomach without perforating it. One yard in front, sitting on the ground, oblivious for a moment of his grandparents, a four-year-old grandson, playing with a cat and rubbing its nose against his own. The visceral is an everyday, familiar category from an early age to peasants.

By contrast, the urban horror of the visceral is encouraged by unfamiliarity, and is linked with urban attitudes to death and birth. Both have become secret, removed moments. In both it is impossible to deny the primacy of inner, invisible processes.

The ideal urban surface is a brilliant one (e.g., chrome) which reflects what is in front of it, and seems to deny that there is anything visible behind it. Its antithesis is the flank of a body rising and falling as it breathes. Urban experience concentrates on recognizing what is outside for what it is, measuring it, testing it and treating it. When what is inside has to be explained (I am not talking now in terms of molecular biology but in terms of everyday life), it is explained as a mechanism, yet the measures of the mechanics used always belong to the outside. The outside, the exterior, is celebrated by continuous visual reproduction (duplication) and justified by empiricism.

To the peasant the empirical is naïve. He works with the never entirely predictable, the emergent. What is visible is usually a sign for him of the state of the invisible. He touches surfaces to form in his mind a better picture of what lies behind them. Above all, he is aware of following and modifying processes which are beyond him, or anybody, to start or stop: he is always aware of being within a process himself.

A factory line produces a series of identical products. But no two fields, no two sheep, no two trees are alike. (The catastrophes of the green

revolution, when agricultural production is planned from above by city experts, are usually the result of ignoring specific local conditions, of defying the laws of natural heterogeneity.) The computer has become the storehouse, the 'memory' of modern urban information: in peasant cultures the equivalent storehouse is an oral tradition handed down through generations; yet the real difference between them is this: the computer supplies, very swiftly, the exact answer to a complex question; the oral tradition supplies an ambiguous answer – sometimes even in the form of a riddle – to a common practical question. Truth as a certainty. Truth as an uncertainty.

Peasants are thought of as being traditionalists when placed in historical time: but they are far more accustomed to living with change in cyclical time.

A closeness to what is unpredictable, invisible, uncontrollable and cyclic predisposes the mind to a religious interpretation of the world. The peasant does not believe that Progress is pushing back the frontiers of the unknown, because he does not accept the strategic diagram implied by such a statement. In his experience the unknown is constant and central: knowledge surrounds it but will never eliminate it. It is not possible to generalize about the role of religion among peasants but one can say that it articulates another profound experience: their experience of production through work.

I have said that a few surfaces in Cheval's Palace do not refer inwards for their reality. These include the surfaces of some of the buildings he reproduces, like the White House in Washington, DC, the Maison-Carrée in Algiers. The others are the surfaces of human faces. All of them are enigmatic. The human faces hide their secrets, and it is possible, as with nothing else in the Palace, that their secrets are unnatural. He has sculpted them with respect and suspicion.

Cheval himself called his Palace a temple to nature. Not a temple to the nature of travellers, landscapists, or even Jean-Jacques Rousseau, but to nature as dreamt by a genius expressing the vision of a class of cunning, hardened survivors.

In the centre of the Palace is a crypt, surrounded by sculpted animals – only towards his animals did Cheval show his capacity for tenderness. Between the animals are shells, stones with eyes hidden in them, and, linking everything, the tissue of the first leaf. On the ceiling of this crypt, in the form of a circle, Cheval wrote, 'Here I wanted to sleep.'

1992

Imagine Paris

In the Place du Tertre, behind the Sacré-Coeur, which dominates the northern skyline of Paris, dozens of painters display their canvases of the Seine, the Notre Dame, the Boulevards. Cheap, kitsch and in real oil paint. Not entirely insincere, however. The intentions of poor art are simply kinder than those of great art. One or two tourists occasionally buy a canvas, but the more interesting trade is in portraits.

Strolling between the café tables of the little *place*, other painters politely accost the foreign and provincial visitors. A drawing while you wait in charcoal or Conté. The price may be as high as a hundred dollars. A surprising number of tourists agree, stand on the street corner for a quarter of an hour to be drawn, pay up, and go away happy. Why?

The answer has to lead us to another question. Why do people visit art galleries all over the word? Art appreciation? I don't believe it. People really go to the great museums to look at those who once lived, to look at the dead. By the same token, the tourists who pose, standing still for a long quarter of an hour on a sidewalk in the Place du Tertre, believe that their likeness, if 'caught', is already being preserved for the future, their old age, their grandchildren. A hundred dollars to be there when the angels come marching in is not so expensive.

What of course is derisory in this commerce is the carefully encouraged hint that the portraits being made in the Place du Tertre have somehow been 'authenticated' by Renoir, Van Gogh, Utrillo, Picasso and all the other great painters who, half a century or more ago, worked and drank and went hungry in the same quarter, within shouting distance of the little *place*. This, however, is an art-critical point, and has little to do with the ontological wager that a likeness, once caught, carries the mystery of a Being.

The mystery of Paris. How can I draw a likeness of the city? Not the official one, stamped on the coins of history. Something more intimate.

The date of my birth shows that I was conceived in a hotel somewhere between the Madeleine and the Opéra.

The Madeleine was much admired when it was built in the nineteenth century because it resembled a bank more than a church. It was a monument to worldliness, keeping a proper distance from the original Madeleine's washing of a preacher's dusty feet. Today, inside, it is like a half-empty warehouse for every sort of broken public promise.

I prefer to think that the hotel in 1926 was nearer to the Opéra. Perhaps where, today, two storeys down in a basement, there's a tea-dance every afternoon. The strobing coloured lights gyrate in a circle; the mirror wall along the side of the dance floor reflects the turning dancers. The music is retro – waltzes, tangos, foxtrots. It's an old-fashioned Aladdin's cave of glitter, where time, dates, age, are put aside (not forgotten) between 4 and 7 p.m.

Men of a certain age in well-cut suits come to relax and dance with women they've never met before. The women, younger, genteel and a little disappointed with life, come in the hope of meeting a kind widower. They are not tarts. They dream of becoming wives or understanding mistresses. There's a bar, but scarcely anyone drinks. The first pleasure is dancing, and everyone dances exceptionally well.

Both the women and the men pride themselves on being experts in life without illusion. In this expertise there is a typical Parisian fastidious-ness. A chic. What is touching is that, entwined with the music, between 4 and 7 p.m., an unreasonable hope still intermittently flickers and persists there.

In 1926 when I was conceived, I was a hope without any expertise, embalmed in sweet illusions, for my parents were not Parisians. To them the city was a simple honeymoon. To me it's the capital of the country in which I've lived for twenty-five years. Yet what distinguishes Paris from any other city has perhaps not changed so much. How to draw its likeness?

Take the first metro from a suburb early on a summer morning. The first swallows flying. The dustbins under the trees not yet emptied. An incongruous small cornfield between apartment blocks. The suburbs of Paris demand a portrait to themselves. Among them you find the only remaining details from the world as painted by the Impressionists. They are anachronistic, makeshift and look as if they've been constructed out of contraband. They were marginal long before the word became fashionable. A man sleepily clipping the hedge of his tiny front garden, still in his pyjamas. Beehives. A take-away hamburger counter, not yet open, but with the smell of yesterday's oil. Rich Parisians don't live in the suburbs: they live in the centre. Take the train.

There's little traffic there yet. The cars parked along the streets are like silent toy ones. On a corner the smell of fresh croissants wafts from a

patisserie. Time to get dressed. In a greengrocer's shop two men are arranging fruit and vegetables as if they were millinery. An uncle in a café is looking through a magnifying glass at the stock prices in the morning paper. He doesn't have to ask for the cup of coffee which is brought to him. The last street is being washed. Where's the towel, Maman?

This strange question floats into the mind because the heart of Paris is like nothing so much as the unending interior of a house. Buildings become furniture, courtyards become carpets and arrases, the streets are like galleries, the boulevards conservatories. It is a house, one or two centuries old, rich, bourgeois, distinguished. The only way of going out, or shutting the door behind you, is to leave the centre.

The vast number of little shops, artisans, boutiques, constitute the staff of the house, its servants, there day and night for its hourly upkeep. Their skills are curiously interrelated: hairdressing and carving, needlework and carpentry, tailoring and masonry, lace-making and wrought-iron work, dress-making and painting. Paris is a mansion. Its dreams are the most urban and the most furnished in the world.

Sufficient to look at Balzac's study. (Now a museum in the Rue Raynouard, 16ème.) The room is not extravagant. Far from it. But it is furnished, enclosed, papered, polished, and inlaid to a degree that would make anybody but a Parisian very claustrophobic. Yet this is highly appropriate to the city's imagination: Balzac's novels are about property, the human heart, destiny, and the natural meeting place for all these forces in Paris is the *salon*. The battlefields are beds, carpets, counters. Everything made in Paris is for indoor use. Even the marvellous silvery light of the typical Paris sky is like a framed skylight.

Who lives in this mansion which is Paris? Every city has a sex and an age which have nothing to do with demography. Rome is feminine. So is Odessa. London is a teenager, an urchin, and, in this, hasn't changed since the time of Dickens.

Paris, I believe, is a man in his twenties in love with an older woman. Somewhat spoilt by his mother, not so much with kisses as with purchases: well-cooked food, fine shoes, after-shave lotion, leather-bound books, chic envelopes. He discusses everything, he is handsome – perhaps, for once, the word 'debonair' is the right one, and he has a special courage: life is enacted on a stage and he wishes to be exemplary, whatever the risk. His father was his first example of an Expert. Now he has become one himself. There's a complicity between the two men, but also a slight anxiety, for they risk having the same mistress. She also is Paris, and if every city has its own unique smile, in Paris it is hers.

I try to think of a well-known painting containing such a smile but cannot find one. Walking in the city, you see it often. The Boulevard de Charonne is working-class, hot in summer, without shade. A large

woman in a floral dress with hefty arms is drinking a beer on the sidewalk at a café table. Under the table is a black mongrel dog with pointed ears to whom she feeds the peanuts she has bought from a machine. A neighbour passes, stops at the table. The woman goes to the counter to buy her friend a lemonade. 'She's pretty, your Maman!' says the neighbour to the dog. When the woman comes back with the lemonade, her friend, laughing, says to her: 'I'd be happy to be guided by you – so long as the lead wasn't too short!' And the woman in the floral dress, who must be in her seventies, smiles that inimitable smile of indulgent but lucid experience.

Often cemeteries are unexpectedly revealing about the life of the living. And this is true of the Père Lachaise. One needs a map, for it is large. Sections are built like towns – with streets, crossroads, pavements: each house is a tomb or a mausoleum. The dead rest there in furnished property, still protected from the vast exterior. Each tomb has a licence and a number: Concession Perpétuelle Numéro . . . It is the most urban and the most secular cemetery.

Where, for example, would you find a father's grave with an inscription ordered by the family declaring: 'President of the Society of High Class Masculine Hairdressing. World Champion. 1950–80'?

A shrine of property this cemetery, certainly. But also one of popular heroes: the last 147 Communards summarily shot against a wall here in 1871; Sarah Bernhardt; Edith Piaf; Chopin. Every day people come to visit them and to listen to their silence.

There is also another, more mysterious shrine, which is our reason for coming: the grave of Victor Noir. In 1870, Prince Pierre Bonaparte, cousin of Emperor Napoleon III, wrote an article in a reactionary Corsican journal attacking the good faith of the radical Paris paper called *La Revanche*. The editor sent Victor Noir and another journalist to ask the prince for an apology. Instead, Pierre Bonaparte seized his pistol and shot Victor Noir dead. The popular outrage provoked by this murder of political pique transformed a relatively unknown young man into a national hero, and the sculptor Jules Dalou made an effigy for his tombstone. Life-size, cast in bronze, it shows Victor Noir – twenty-two years old – dead on the ground, an instant after the pistol shot has been fired. Division ninety-two, Père Lachaise.

Dalou was a realist, making in sculpture works whose vision has something in common with Courbet's paintings: the same kind of fullness in the bodies and limbs depicted, the same close attention to realistic details of costume, a similar corporeal weight. The two artists were friends and both had to go into exile after the fall of the Commune, which they had actively supported.

Victor Noir lies there with the abandon of the two girls in Courbet's *Demoiselles au Bord de la Seine*. The only difference being that the man has

died at that very instant – his blood still hot – whereas the girls are overcome by drowsiness and the langour of their day-dreams.

An elegant tall hat lies on the ground beside him. His handsome face is still proud of his own courage, believing it will be rewarded by the love of women. (Each generation of young men knows that, from time to time, the mansion is transformed into an improvised theatre, on whose stage history is played out – often to the death.) His coat is open, the top button of his tight trousers is undone. His soft-skinned, well-manicured hands lie unclenched, expecting to touch or be touched only by what is fine.

The effigy is moving and strange in its integrity, for it gives the impression that the death it shows has somewhere been selected with the same fastidiousness as the shirt or boots.

Beneath the sky of the cemetery the bronze has turned a dull green. In three places, however, the metal is shiny and gold-coloured where it has been polished by innumerable caresses and kisses. For certain sections of the populace, Victor Noir has become a talisman, a fetish, promising fertility, potency, success, continuity. People come all the while to seek his aid, to touch his example.

The three places where the bronze metal shines are his mouth, the pointed toes of his superbly elegant boots and, most brilliantly of all, the protuberance which his sex makes against his tight trousers.

Perhaps a likeness of the city of Paris begins there in the south-east corner of the Père Lachaise cemetery . . .

1987

A Kind of Sharing

The suicide of an art is a strange idea. Yet I am bound to start with it, if I'm to talk about the story of Jackson Pollock and his wife, the painter Lee Krasner. Krasner outlived her husband by nearly thirty years and went on working as a considerable painter in her own right until 1984. Now, however, I want to concentrate on the fifteen years during which the two of them lived and worked together and Pollock made a bid to change the course of what was then thought of as modern art.

Pollock died thirty-five years ago in a car accident near his house in Springs on Long Island, New York. This wasn't the suicide. He was forty-four years old and he had already been acclaimed the first great American painter. The tragedy of his death, even if foreseeable, obscured for most the suicide of the art.

Born in 1912, Pollock was the youngest of five children of a poorish Irish-Scots Presbyterian family, living mostly in Arizona. He revealed a clumsy but passionate talent early on. Talent doesn't necessarily mean facility. It's a kind of motor activity within a temperament – a form of energy. Pollock's talent was immediately recognized by his teacher, Thomas Hart Benton, the country folk painter.

Pollock was slim, handsome, aggressive, brooding: deeply ambitious to prove he was not a failure and perhaps to earn, at last, his stern mother's approval. In everything he did there was a touch of charisma, and, following everything he did, a nagging doubt. He was more or less an alcoholic before he was twenty.

As a teenager he dropped his first name, Paul, and used only his second name, Jackson. The change says a lot about the persona he was already being driven into. Jackson Pollock was a name for fighting in the ring. A champ's name.

His later fame as a painter produced the legend that at heart Pollock was a cowboy. Compared to his first collector, Peggy Guggenheim, or to

his first apologist, Clement Greenberg, or to the art critic Harold Rosenberg, who invented the term 'action painter' for him, he was indeed a goy and a redneck. He hated verbal theories, he didn't read much, he'd never travelled outside the States, he punched people up, and when he was drunk at parties, he pissed into the fireplace. But whatever miracles cowboys may achieve with lassos, no cowboy could dream of controlling paint as Pollock did. This needs repeating several times because with his notorious drip paintings he came to be thought of by some as a dripster, a drooler, a mere pourer. Nothing could be further from the truth. The suicide was committed with mastery, and the desperation was very precise.

Pollock found himself as a painter during the 1940s. At that time most avant-garde painters in the United States were interested in Picasso, surrealism, the Jungian unconscious, the inner self, abstraction. Direct painted references to the objective visible world were usually dismissed as 'illustrative'. The trip was inwards, an uneasy quest for the soul.

In 1943 the well-known painter Hans Hofmann asked the young Pollock how important nature was for his art. 'I am nature,' replied Pollock. The older painter was shocked by the arrogance of the reply and Pollock, sensing this, rubbed salt into the wound by adding: 'Your theories don't interest me! Put up or shut up! Let's see your work!' The reply may or may not have been arrogant, but, more significantly, it carried within itself the fatality to come.

Six years later Harold Rosenberg, thinking of Pollock and praising him, wrote: 'The modern painter begins with nothingness. That is the only thing he copies. The rest he invents.'

At this moment, what was happening in the outside world? For a cultural climate is never separate from events. The United States had emerged from the war as the most powerful nation in the world. The first atom bomb had been dropped. The apocalypse of the Cold War had been placed on the agenda. McCarthy was inventing his traitors. The mood in the country that had suffered least from the war was defiant, violent, haunted. The play most apt to the period would have been *Macbeth*, and the ghosts were from Hiroshima.

The word 'freedom' was being bandied about a lot at the time and meant many different things. It's worth considering three different kinds of freedom, for, put together, they may conjure up something of the stridency of the period. Time was short in the US. There was very little patience. The stakes were down. There was an inarticulate sense of loss, often expressed with anger or violence. Vietnam was one of the historical tragedies which would eventually follow from this insecurity.

Freedom of the market. The New York artists were working, more crudely than ever before, for an expanding free market. They painted

exactly what they wanted, the size they wanted, with the materials they wanted. Their finished works, scarcely dry, were then put up for sale, promoted, sometimes bought. Bought by collectors – and for the first time whilst, as it were, still wet – by museums. The competition, however, was ruthless and aggressive. The latest was always at a premium. Gallery fashions changed quickly. Recognition (being featured in *Life*) was dramatic but short-lived. The risks were high and the casualties many. Gorky and Rothko killed themselves. Kline, Reinhardt and Newman died young. Nearly all the painters drank heavily to protect their nerves, for finally their works, transformed into extraordinary property investments, benefited from far more security measures than their working lives. They lived on success and despair.

Next, the freedom the artists were seeking within themselves. As a mixed show catalogue statement put it: 'The past decade in America has been a period of great creative activity in painting. Only now has there been a concerted effort to abandon the tyranny of the object and the sickness of naturalism to enter within consciousness.' Entering into consciousness – an obscure phrase – meant trying to be oneself on the canvas, without the props of a single familiar reference, and thus to be free of rhetoric, history, convention, other people, safety, the past. Perhaps in a foul world these men were seeking purity.

Then there was the freedom of the Voice of America, the freedom of the Free World. By 1948 the United States needed an international cultural prestige to offset its military and political power: it needed a sophisticated reply to the slogans of 'Yankee Go Home!' This is why the CIA during the fifties and sixties covertly supported a multitude of initiatives whose aim was to present the new American art across the world as a promise for the future. Since the works (de Kooning apart) were abstract, they lent themselves to diverse interpretations.

In this way a mostly desperate body of art, which had at first shocked the American public, was transformed by speeches, articles and the context in which it was displayed, into an ideological weapon for the defence of individualism and the right to express oneself. Pollock, I'm sure, was unaware of this programme – he died too soon; nevertheless, the propaganda apparatus helped to create the confusion surrounding his art after his death. A cry of despair was turned into a declaration for democracy.

In 1950 Hans Namuth made a film of Pollock painting. Pollock puts on his paint-spattered boots – which appear as a kind of homage to Van Gogh – and then he starts to walk around the unprimed canvas laid out on the earth. With a stick he flicks paint on to it from a can. Threads of paint. Different colours. Making a net. Making knots. His gestures are slow but follow one another swiftly. Next he uses the same technique but

this time on to a sheet of transparent glass placed on trestles, which allows the photographer to film the act through the glass, so that we see the paint falling around the pebbles and wires already placed on the glass. We look towards the painter from the painting's point of view. We look out from behind to the front where everything is happening. The way he moves his arms and shoulders suggests something between a marksman and a beekeeper putting a swarm into a hive. It is a star performance.

It was probably this film which prompted the phrase 'action painting'. The canvas, according to this definition, becomes an arena for the artist's free actions, which the spectator relives through the traces they leave. Art is no longer mediation but act. No longer pursuit but arrival.

What we are slowly making our way towards are the pictorial consequences of Rosenberg's *nothingness* and the fatality.

Photos of Lee Krasner and Jackson Pollock together somehow indicate how much theirs was a marriage of two painters. It's on their clothes. You can smell the paint. Lee Krasner's first love was a Russian painter called Igor Pantuhoff. She lived with him for eleven years. When she first met Pollock, she was thirty-four and better known as an artist than he was. 'I had a comet by the tail,' she said afterwards. What called out to her was, surely, what she felt to be Pollock's destiny as an artist. He was inspired, probably more inspired than anybody she had ever met. And for Jackson Pollock the champion, always fearful of losing. Lee was at last the judge he could trust. If she told him that something he had painted worked, he believed it – at least at the beginning of their marriage. Between them the ultimate in praise was 'It works.' A phrase between professionals.

From 1943 till 1952 – the period when Pollock produced all his most surprising work – the two of them were, in part, painting for each other: to see each other's surprise. It was a way of communicating, of touching or being touched. (Maybe there were not many ways of communicating with Pollock.) During these years Lee Krasner painted less than she did before or afterwards. Pollock took the studio on the property they bought in Springs, and she worked in a bedroom. Yet the argument that she sacrificed her art for his is as stupid as the argument about who influenced whom. (In 1953 Pollock produced a canvas called *Easter and the Totem* which anybody might mistake for a Krasner.) The truth is that as painters and as a man and a woman, they were engaged, during these years, in the same adventure which turned out to be more fatal than either of them realized at the time. And today their canvases speak of it.

Lee Krasner's paintings were, by nature, sensuous and ordered. Their colours and gestures frequently suggested flesh, the body; their order, a garden. Abstract as they are, one enters them to find, behind the colours or collage, a kind of welcome.

By contrast, Pollock's paintings were metaphysical in aim and violent. The body, the flesh, had been rejected and they were the consequence of this rejection. One can feel the painter, at first with gestures that are almost childish, and later like a strong, fully grown man, emptying his body of energy and liquids so as to leave traces to prove that he had physically existed. On one occasion he put his hand prints on the painting as if beseeching the canvas to acknowledge the exiled body. There is an order in these works, but it is like that at the centre of an explosion, and all over their surfaces there is a terrible indifference to everything that is sentient.

When their paintings are hung together, the dialogue between them is very clear. He paints an explosion; she, using almost identical pictorial elements, constructs a kind of consolation. (Perhaps their paintings said things to one another during these years that they could never say in person.) Yet it would be wrong to give the impression that Krasner's paintings were primarily consolatory. Between the two of them there was a fundamental issue at stake. Time and again her paintings demonstrated an alternative to the brink which they sensed his were heading for. Time and again her paintings protested against the art's threat of suicide. And I think they did this as paintings whilst Lee Krasner as a person was being dazzled by the brilliance of his recklessness.

An obvious example would be a painting called *Bald Eagle*, made in 1955, one year before the car accident. Here Lee Krasner took a canvas Jackson Pollock had abandoned – a bare hessian canvas with flicked black lines across it – and incorporated pieces of this canvas into a large colourful collage, a little suggestive of autumn and a bird soaring. Thus her picture saved the lost gestures of his. The example, however, is not typical, for it occurred after the suicide.

Before, he would splatter, and she would take the same pigment, the same colours, and assemble. He would thrash; and she would make the same wound and stitch it. He would paint flames; and she would paint fire in a brazier. He would throw paint imitating a comet; and she would paint a part of the Milky Way. Every time the pictorial elements – as distinct from the purpose – were similar, if not almost identical. He would lend himself to a deluge; she would imagine water gushing into a basin.

But the messages of her paintings to his paintings were not about domestication. They were about continuity, they were about the desire of painting to go on living.

Unfortunately, it was already too late.

Pollock had stood the art of painting on its head, reversed it, negated it.

The negation had nothing to do with technique or abstraction. It was inherent in his purpose – in the *will* which his canvases expressed.

On these canvases the visible is no longer an opening but something which has been abandoned and left behind. The drama depicted is something that once happened *in front of* the canvas – where the painter claimed to be nature! Within or beyond them there is nothing. Only the visual equivalent of total silence.

Painting throughout its history has served many different purposes, has been flat and has used perspective, has been framed and has been left borderless, has been explicit and has been mysterious. But one act of faith has remained a constant from palaeolithic times to cubism, from Tintoretto (who also loved comets) to Rothko. The act of faith consisted of believing that the visible contained hidden secrets, that to study the visible was to learn something more than could be seen in a glance. Thus paintings were there to reveal a presence *behind* an appearance – be it that of a Madonna, a tree or, simply, the light that soaks through a red.

Jackson Pollock was driven by a despair which was partly his and partly that of the times which nourished him, to refuse this act of faith: to insist, with all his brilliance as a painter, that there was nothing behind, that there was only *that which was done to the canvas on the side facing us.* This simple, terrible reversal, born of an individualism which was frenetic, constituted the suicide.

1989

Christ of the Peasants

I try to imagine how to describe the pilgrim photographs of Marketa Luskacova to somebody who could not see them. An obviously vain exercise in one sense, because appearances and words speak so differently; the visual never allows itself to be translated intact into the verbal. Nothing I could say would enable the reader to imagine a single one of these pictures. Yet what of those who, finding themselves before the photographs, still have difficulty in seeing them? There are good reasons why this might happen. The pictures are of peasants whose experience over the centuries has been very rarely understood by other classes. Worse than that, the pictures are about the experience of religious faith when today most city-dwellers – at least in our continent – have become accustomed to living without any religious belief. Finally, even for the religious minority the pictures may well suggest fanaticism or heresy, because priests and the Church have for so long oppressed peasants, and this oppression has encouraged on both sides the recurring suspicion that principles are being betrayed. The Christ of the peasants has never been the Christ of the papacy. How, then, would I describe the photographs to somebody who could not see them?

I'm inclined to believe that Marketa Luskacova had a secret assignment, such as no photographer had had before. She was summoned by the Dead. How she joined them I don't know. The Dead live, of course, beyond time and are ageless; yet, thanks to the constant arrival of newcomers, they are aware of what happens in history, and sometimes this general, vast awareness of theirs provokes a kind of curiosity so that they want to know more. This curiosity led them to summon a photographer. They told her how they had the impression – and it had been growing for a century or more – that they, the Dead, were being forgotten by the Living to an unprecedented degree. Let her understand clearly what they were talking about: the individual Dead had always

been quickly or slowly forgotten – it was not this which was new. But now it appeared that the huge, in fact countless, collective of the Dead was being forgotten, as if the living had become – was it ashamed? or was it simply negligent? – of their own mortality, of the very consanguinity which joined them to the Dead. Of this, they said they needed no proof, there was ample evidence. What they would like to see – supposing that somewhere in the heart of the continent in which she lived they still existed – were people who still remembered the Dead. Neither the bereaved (for bereavement is temporary) nor the morbid (for they are obsessed by death, not by the Dead), but people living their everyday lives whilst looking further, beyond, aware of the Dead as neighbours.

'We would like you,' they told her, 'to do a reportage on *us*, in the eyes of the living: can you do that?' She did not reply, for she already knew, although she was only in her early twenties, that the only possible reply could be in the images developed in a dark-room.

Soon after, Luskacova found herself in the village of Sumiac. Before beginning her assignment proper, she took some pictures to remind the long-departed of the earth on which everything happens. A woman and a horse, with the grass cropped and the footpaths going as far back as living memory. A man sowing, striding slowly through the field he has ploughed, the gesture of his arm like that of a cellist. Three children asleep in a bed.

Then she moved on to the unprecedented challenge of her commission. The people she was photographing trusted her; more than that, they allowed her to become intimate. This was a precondition for her assignment, for she could not photograph the presence of the Dead in the lives of the living from afar: a telescopic lens in this case would have been useless. Nor could she be in a hurry. Intimacy implies having time on one's hands, even a kind of boredom. And further, she could not be in a hurry because the project demanded isolating an instant filled with the timeless, and isolating a set of appearances containing the invisible. These were not impossible demands, since the human eye and the human face are windows on to the soul.

In some pictures she failed – failed for a simple and understandable reason. Sometimes the people being photographed were aware of her being there with her camera, they trusted her completely and so they appealed for recognition. In a flash they imagined how: *Take Us Now = We'll See How We Were at This Moment.*

In other pictures she succeeded; she carried out the assignment and she produced photos such as nobody had ever taken before. We see the photographed in all their intimacy and they are not *there*; they are *elsewhere* with their neighbours: the dead, the unborn, the absent. For instance, her extraordinary photo of the Sleeping Man might be a companion piece to a poem by Rilke:

> . . . You, neighbour God, if sometimes in the night
> I rouse you with loud knocking, I do so
> only because I seldom hear you breathe
> and know: you are alone.
> And should you need a drink, no one is there
> to reach it to you, groping in the dark.
> Always I hearken. Give but a small sign.
> I am quite near.
> Between us there is but a narrow wall,
> and by sheer chance; for it would take
> merely a call from your lips or from mine
> to break it down,
> and that without a sound.
>
> The wall is builded of your images . . .

To stop there would be too resolved, too 'transcendental' for the peasant experience which Marketa Luskacova interprets so faithfully. The peasant, within the secrecy of his own mind, is independent, and he projects this independence on to those he worships. *Nothing is ever quite arranged.*

Italo Calvino has recorded a story from the countryside near Verona; and I think of it when, for instance, I look at the picture of the builders at Sumiac eating a meal:

Once there was a farmer who was devout, but who prayed only to St Joseph. When he died, St Peter refused to let him into heaven. 'No question,' said St Peter, 'you forgot about Christ, God the Father and the Virgin.' 'Since I'm here,' replied the man, 'could I have a word with Joseph?' Joseph appeared, recognized the farmer and said: 'Come in, make yourself at home.' 'I can't,' complained the man, 'Peter here has forbidden me to enter heaven.' Joseph turned to Peter and angrily remonstrated: 'You let him in here, or I'll take my son and my wife and we'll go somewhere else to build paradise!'

1985

A Professional Secret

'When somebody is dead, you can see it from two hundred yards away,' says Goya in a play we wrote, 'his silhouette goes cold.'

I wanted to see Holbein's painting of the dead Christ. He painted it in 1552 when he was twenty-five. It is long and thin – like a slab in a morgue, or like the predella of an altarpiece – although it seems that this painting never joined an altarpiece. There is a legend that Holbein painted it from the corpse of a Jew drowned in the Rhine.

I'd heard and read about the picture. Not least from Prince Myshkin in *The Idiot.* 'That painting!' he exclaimed. 'That painting! Do you realize what it could do? It could make a believer lose his faith.'

Dostoevsky must have been as impressed as Prince Myshkin, for he makes Hypolyte, another character in *The Idiot*, say: 'Supposing on the day before his agony the Lord had seen this picture, would he have been able to go to his crucifixion and death as he did?'

Holbein painted an image of death, without any sign of redemption. Yet what exactly is its effect?

Mutilation is a recurrent theme in Christian iconography. The lives of the martyrs, St Catherine, St Sebastian, John the Baptist, the Crucifixion, the Last Judgement. Murder and rape are common subjects in painted classical mythology.

Before Pollaiuolo's *St Sebastian*, instead of being horrified (or convinced) by his wounds, one is seduced by the naked limbs of both executioners and executed. Before Rubens's *Rape of the Daughters of Leucippus*, one thinks of nights of exchanged love. Yet this sleight-of-hand by which one set of appearances replaces another (the martyrdom becomes an Olympics: the rape becomes a seduction) is nevertheless an acknowledgement of an original dilemma: how can the brutal be made visibly acceptable?

The question begins with the Renaissance. In medieval art the suffer-

ing of the body was subservient to the life of the soul. And this was an article of faith which the spectator brought with him to the image; the life of the soul did not have to be demonstrated in the image itself. A lot of medieval art is grotesque – that is to say a reminder of the worthlessness of everything physical. Renaissance art idealizes the body and reduces brutality to gesture. (A similar reduction occurs in Westerns: see John Wayne or Gary Cooper.) Images of consequential *brutality* (Breughel, Grünewald, etc.) were marginal to the Renaissance tradition of harmonizing dragons, executions, cruelty, massacres.

At the beginning of the nineteenth century Goya, because of his unflinching approach to horror and brutality, was the first modern artist. Yet those who choose to look at his etchings would never choose to look at the mutilated corpses they depict with such fidelity. So we are forced back to the same question, which one might formulate differently: how does catharsis work in visual art, if it does?

Painting is distinct from the other arts. Music by its nature transcends the particular and the material. In the theatre words redeem acts. Poetry speaks to the wound but not to the torturers. Yet the silent transaction of painting is with appearances and it is rare that the dead, the hurt, the defeated, or the tortured *look* either beautiful or noble.

A painting can be pitiful?

How is pity made visible?

Perhaps it's born in the spectator in face of the picture?

Why does one work produce pity when another does not? I don't believe pity comes into it. A lamb chop painted by Goya touches more pity than a massacre by Delacroix.

So, how does catharsis work?

It doesn't. Paintings don't offer catharsis. They offer something else, similar but different.

What?

I don't know. That's why I want to see the Holbein.

We thought the Holbein was in Berne. The evening we arrived we discovered it was in Basel. Because we had just crossed the Alps on a motorbike, the extra hundred kilometres seemed too far. The following morning we visited instead the museum in Berne.

It is a quiet, well-lit gallery rather like a space vessel in a film by Kubrick or Tarkovsky. Visitors are asked to pin their entrance tickets on to their lapels. We wandered from room to room. A Courbet of three trout, 1873. A Monet of ice breaking up on a river, 1882. An early cubist Braque of houses in L'Estaque, 1908. A love song with a new moon by Paul Klee, 1939. A Rothko, 1963.

How much courage and energy were necessary to struggle for the right to paint in different ways! And today these canvases, outcome of that

struggle, hang peacefully beside the most conservative pictures: all united within the agreeable aroma of coffee, wafted from the cafeteria next to the book shop.

The battles were fought over what? At its simplest – over the language of painting. No painting is possible without a pictorial language, yet with the birth of modernism after the French Revolution, the use of any language was always controversial. The battles were between custodians and innovators. The custodians belonged to institutions that had behind them a ruling class or an élite who needed appearances to be rendered in a way which sustained the ideological basis of their power.

The innovators were rebels. Two axioms to bear in mind here: sedition is, by definition, ungrammatical; the artist is the first to recognize when a language is lying. I was drinking my second cup of coffee and still wondering about the Holbein, a hundred kilometres away.

Hypolyte in *The Idiot* goes on to say: 'When you look at this painting, you picture nature as a monster, dumb and implacable. Or rather – and however unexpected the comparison may be it is closer to the truth, much closer – you picture nature as an enormous modern machine, unfeeling, dumb, which snatched, crushed and swallowed up a great Being, a Being beyond price, who, alone, is worth the whole of nature . . .'

Did the Holbein so shock Dostoevsky because it was the opposite of an ikon? The ikon redeems by the prayers it encourages with closed eyes. Is it possible that the courage not to shut one's eyes can offer another kind of redemption?

I found myself before a landscape painted at the beginning of the century by an artist called Caroline Müller – *Alpine Chalets at Sulward near Isenflushul.* The problem about painting mountains is always the same. The technique is dwarfed (like we all are) by the mountain, so the mountain doesn't live; it's just there, like the tombstone of a distant grey or white ancestor. The only European exceptions I know are Turner, David Bomberg and the contemporary Berlin painter Werner Schmidt.

In Caroline Müller's rather dull canvas three small apple trees made me take in my breath. *They* had been seen. Their having-been-seen could be felt across eighty years. In that little bit of the picture the pictorial language the painter was using ceased to be just accomplished and became urgent.

Any language as taught always has a tendency to close, to lose its original signifying power. When this happens it can go straight to the cultivated mind, but it bypasses the thereness of things and events.

'Words, words, mere words, no matter from the heart.'

Without a pictorial language, nobody can render what they see. With one, they may stop seeing. Such is the odd dialectic of the practice of painting or drawing appearances since art began.

We came to an immense room with fifty canvases by Ferdinand Hodler. A gigantic life's work. Yet in only one of the paintings had he forgotten his accomplishment and could we forget that we were looking at virtuoso pigment. It was a relatively small picture and it showed the painter's friend, Augustine Dupin, dying in her bed. Augustine was seen. The language, in being used, had opened.

Was the Jew who drowned in the Rhine seen in this sense by the twenty-five-year-old Holbein? And what might this being-seen mean?

I returned to look at the paintings I'd studied earlier. In the Courbet of the three fish, hanging gaffed from a branch, a strange light permeates their plumpness and their wet skins. It has nothing to do with glistening. It is not on the surface but comes through it. A similar but not identical light (it's more granular) is also transmitted through the pebbles on the river's edge. This light-energy is the true subject of the painting.

In the Monet the ice on the river is beginning to break up. Between the jagged opaque pieces of ice there is water. In this water (but not of course on the ice) Monet could see the still reflections of the poplars on the far bank. And these reflections, glimpsed *behind* the ice, are the heart of the painting.

In the Braque of L'Estaque, the cubes and triangles of the houses and the V forms of the trees are not imposed upon what his eye saw (as happens later with the mannerists of cubism), but somehow drawn from it, brought forward from behind, salvaged from where the appearances had begun to come into being and had not yet achieved their full particularity.

In the Rothko the same movement is even clearer. His life's ambition was to reduce the substance of the apparent to a pellicle thinness, aglow with what lay behind. Behind the grey rectangle lies mother-of-pearl, behind the narrow brown one, the iodine of the sea. Both oceanic.

Rothko was a consciously religious painter. Yet Courbet was not. If one thinks of appearances as a frontier, one might say that painters search for messages which cross the frontier: messages which come from the back of the visible. And this, not because all painters are Platonists, but because they look so hard.

Image-making begins with interrogating appearances and making marks. Every artist discovers that drawing – when it is an urgent activity – is a two-way process. To draw is not only to measure and put down, it is also to receive. When the intensity of looking reaches a certain degree, one becomes aware of an equally intense energy coming towards one, through the appearance of whatever it is one is scrutinizing. Giacometti's life's work is a demonstration of this.

The encounter of these two energies, their dialogue, does not have the

form of question and answer. It is a ferocious and inarticulated dialogue. To sustain it requires faith. It is like a burrowing in the dark, a burrowing under the apparent. The great images occur when the two tunnels meet and join perfectly. Sometimes when the dialogue is swift, almost instantaneous, it is like something thrown and caught.

I offer no explanation for this experience. I simply believe very few artists will deny it. It's a professional secret.

The act of painting – when its language opens – is a response to an energy which is experienced as coming from behind the given set of appearances. What is this energy? Might one call it the will of the visible that sight should exist? Meister Eckardt talked about the same reciprocity when he wrote: 'The eye with which I see God is the same eye with which he sees me.' It is the symmetry of the energies which offers us a clue here, not the theology.

Every real act of painting is the result of submitting to that will, so that in the painted version the visible is not just interpreted but allowed to take its place actively in the community of the painted. Every event which has been really painted – so that the pictorial language opens – joins the community of everything else that has been painted. Potatoes on a plate join the community of a loved woman, a mountain, or a man on a cross. This – and this only – is the redemption which painting offers. This mystery is the nearest painting can offer to catharsis.

1987

Ape Theatre

In memory of Peter Fuller and our many
conversations about the chain of being and Neo-Darwinism

In Basel the zoo is almost next to the railway station. Most of the larger birds in the zoo are free-flying, and so it can happen that you see a stork or a cormorant flying home over the marshalling yards. Equally un-expected is the ape house. It is constructed like a circular theatre with three stages: one for the gorillas, another for the orang-utans and a third for the chimpanzees.

You take your place on one of the tiers – as in a Greek theatre – or you can go to the very front of the pit, and press your forehead against the soundproof plate glass. The lack of sound makes the spectacle on the other side, in a certain way, sharper, like mime. It also allows the apes to be less bothered by the public. We are mute to them too.

All my life I've visited zoos, perhaps because going to the zoo is one of my few happy childhood memories. My father used to take me. We didn't talk much, but we shared each other's pleasure, and I was well aware that his was largely based on mine. We used to watch the apes together, losing all sense of time, each of us, in his fashion, pondering the mystery of progeniture. My mother, on the rare occasions she came with us, refused the higher primates. She preferred the newly found pandas.

I tried to persuade her, but she would reply, following her own logic: 'I'm a vegetarian and I only gave it up, the practice not the principle, for the sake of you boys and for Daddy.' Bears were another animal she liked. Apes, I can see now, reminded her of the passions which lead to the spilling of blood.

The audience in Basel is of all ages. From toddlers to pensioners. No other spectacle in the world can attract such a wide spectrum of the public. Some sit, like my father and I once did, lost to the passing of time. Others drop in for a few moments. There are habitués who come every

day and whom the actors recognize. But on nobody – not even the youngest toddler – is the dramatic evolutionary riddle lost: how is it that they are so like us and yet not us?

This is the question which dominates the dramas on each of the three stages. Today the gorillas' play is a social one about coming to terms with imprisonment. Life sentences. The chimpanzees' is cabaret, for each performer has her or his own number. The orang-utans' is *Werther* without words – soulful and dreamy. I am exaggerating? Of course, because I do not yet know how to define the real drama of the theatre in Basel.

Is theatre possible without an awareness of re-enactment, which is related to a sense of death? Probably not. But perhaps both, almost, exist here.

Each stage has at least one private recess where an animal can go if she or he wishes to leave the public. From time to time they do so. Sometimes for quite long periods. When they come out to face the audience again, they are perhaps not so far from a practice of re-enactment. In the London zoo chimps pretended to eat and drink off invisible plates with nonexistent glasses. A pantomime.

As for a sense of death, chimpanzees are as familiar as we are with fear, and the Dutch zoologist Dr Kortlaudt believes they have intimations of mortality.

In the first half of the century there were attempts to teach chimpanzees to talk – until it was discovered that the form of their vocal tract was unsuitable for the production of the necessary range of sounds. Later they were taught a deaf and dumb language, and a chimp called Washoe in Ellensburg, Washington, called a duck a water bird. Did this mean that Washoe had broken through a language barrier, or had she just learnt by rote? A heated debate followed (the distinction of man was at stake!) about what does or does not constitute a language for animals.

It was already known – thanks to the extraordinary work of Jane Goodall, who lived with her chimpanzees in the wild in Tanzania – that these animals used tools, and that, language or no language, their ability to communicate with one another was both wide-ranging and subtle.

Another chimpanzee in the United States named Sarah underwent a series of tests, conducted by Douglas Gillan, which were designed to show whether or not she could reason. Contrary to what Descartes believed, a verbal language may not be indispensable for the process of reasoning. Sarah was shown a video of her trainer playing the part of being locked in a cage and desperately trying to get out! After the film she was offered a series of pictures of varying objects to choose from. One, for instance, showed a lighted match. The picture she chose was of

a key – the only object which would have been useful for the situation she had seen enacted on the video screen.

In Basel we are watching a strange theatre in which, on both sides of the glass, the performers may believe they are an audience. On both sides the drama begins with resemblance and the uneasy relationship that exists between resemblance and closeness.

The idea of evolution is very old. Hunters believed that animals – and especially the ones they hunted – were in some mysterious way their brothers. Aristotle argued that all the forms of nature constituted a series, a chain of being, which began with the simple and became more and more complex, striving towards the perfect. In Latin *evolution* means unfolding.

A group of handicapped patients from a local institution come into the theatre. Some have to be helped up the tiers, others manage by themselves, one or two are in wheelchairs. They form a different kind of audience – or rather, an audience with different reactions. They are less puzzled, less astounded, but more amused. Like children? Not at all. They are less puzzled because they are more familiar with what is out of the ordinary. Or, to put it another way, their sense of the norm is far wider.

What was new and outrageous in *The Origin of Species* when it was first published in 1859 was Darwin's argument that all animal species had evolved from the same prototype, and that this immensely slow evolution had taken place through certain accidental mutations being favoured by natural selection, which had worked according to the principle of the survival of the fittest. A series of accidents. Without design or purpose and without experience counting. (Darwin rejected Lamarck's thesis that acquired characteristics could be inherited.) The pre-condition for Darwin's theory being plausible was something even more shocking: the wastes of empty time required: about 500 million years!

Until the nineteenth century it was generally, if not universally, believed that the world was a few thousand years old – something that could be measured by the time scale of human generations. (As in Genesis, chapter 5.) But in 1830 Charles Lyell published *The Principles of Geology* and proposed that the earth, with 'no vestige of a beginning – no prospect of an end', was millions, perhaps hundreds of millions of years old.

Darwin's thinking was a creative response to the terrifying immensity of what had just been opened up. And the sadness of Darwinism – for no other scientific revolution, when it was made, broadcast so little hope – derived, I think, from the desolation of the distances involved.

The sadness, the desolation, is there in the last sentence of *The Descent of Man*, published in 1871: 'We must, however, acknowledge, as it seems

to me, that man with all his noble qualities, still bears in his bodily frame the indelible stamp of his lowly origin.'

'The indelible stamp' speaks volumes. 'Indelible' in the sense that (unfortunately) it cannot be washed out. 'Stamp' meaning 'brand, mark, stain'. And in the word 'lowly' during the nineteenth century, as in Thatcher's Britain, there is shame.

The liberty of the newly opened-up space-time of the universe brought with it a feeling of insignificance and *pudeur*, from which the best that could be redeemed was the virtue of intellectual courage, the virtue of being unflinching. And courageous the thinkers of that time were!

Whenever an actor who is not a baby wants to piss or shit, he or she gets up and goes to the edge of a balcony or deck, and there defecates or urinates below, so as to remain clean. An habitual act which we seldom see enacted on the stage. And the effect is surprising. The public watch with a kind of pride. An altogether legitimate one. Don't shit yourself. Soon we'll be entering another century.

Mostly, the thinkers of the nineteenth century thought mechanically, for theirs was the century of machines. They thought in terms of chains, branches, lines, comparative anatomies, clockworks, grids. They knew about power, resistance, speed, competition. Consequently, they discovered a great deal about the material world, about tools and production. What they knew less about is what we still don't know much about: the way brains work. I can't get this out of my mind: it's somewhere at the centre of the theatre we're watching.

Apes don't live entirely within the needs and impulses of their own bodies – like the cats do. (It may be different in the wild, but this is true on the stage.) They have a gratuitous curiosity. All animals play, but the others play at being themselves, whereas the apes experiment. They suffer from a surplus of curiosity. They can momentarily forget their needs, or any single unchanging role. A young female will pretend to be a mother cuddling a baby lent by its real mother. 'Baby-sitting,' the zoologists call it.

Their surplus of curiosity, their research (every animal searches, only apes research) make them suffer in two evident ways – and probably also in others, invisibly. Their bodies, forgotten, suddenly nag, twinge, and irritate. They become impatient with their own skin – like Marat suffering from eczema.

And then too, starved of events, they suffer boredom. Baudelaire's *l'ennui*. Not at the same level of self-doubt, but nevertheless with pain, apathy. The signs of boredom may resemble those of simple drowsiness. But *l'ennui* has its unmistakable lassitude. The body, instead of relaxing, huddles, the eyes stare painfully without focus, the hands, finding

nothing new to touch or do, become like gloves worn by a creature drowning.

'If it could be demonstrated,' Darwin wrote, 'that any complex organ existed which could not possibly have been formed by numerous, successive slight modifications, my theory would absolutely break down.'

If the apes are partly victims of their own bodies – the price they pay, like man, for not being confined to their immediate needs – they have found a consolation, which Europe has forgotten. My mother used to say the chimps were looking for fleas, and that when they found one, they put it between their teeth and bit it. But it goes further than Mother thought – as I guessed even then. The chimpanzees touch and caress and scratch each other for hours on end (and according to the etiquette rules of a strict group hierarchy) not only hygienically, to catch parasites, but to give pleasure. 'Grooming', as it is called, is one of their principal ways of appeasing the troublesome body.

This one is scratching inside her ear with her little finger. Now she has stopped scratching to examine minutely her small nail. Her gestures are intimately familiar and strikingly remote. (The same is true for most actions on any theatre stage.) An orang-utan is preparing a bed for herself. Suddenly, she hesitates before placing her armful of straw on the floor, as if she has heard a siren. Not only are the apes' functional gestures familiar, but also their expressive ones. Gestures which denote surprise, amusement, tenderness, irritation, pleasure, indifference, desire, fear.

But they move differently. A male gorilla is sitting at ease with his arm held straight and high above his head; and for him this position is as relaxed as sitting with legs crossed is for women and men. Everything which derives from the apes' skill in swinging from branches – *brachiation*, as the zoologists call it – sets them apart. Tarzan only swung from vines – he never used his hanging arms like legs, walking sideways.

In evolutionary history, however, this difference is in fact a link. Monkeys walk on all fours along the tops of branches and use their tails for hanging. The common ancestors of man and apes began, instead, to use their arms – began to become *brachiators*. This, the theory goes, gave them the advantage of being able to reach fruit at the ends of branches!

I must have been two years old when I had my first cuddly toy. It was a monkey. A chimpanzee, in fact. I think I called him Jackie. To be certain, I'd have to ask my mother. She would remember. But my mother is dead. There is just a chance – one in a hundred million (about the same as a chance mutation being favoured by natural selection) – that a reader may be able to tell me, for we had visitors to our home in Higham's Park, in East London, sixty years ago, and I presented my chimp to everyone who came through the front door. I think his name was Jackie.

Slowly, the hanging position, favoured by natural selection, changed the anatomy of the brachiators' torsos so that finally they became half-upright animals – although not yet as upright as humans. It is thanks to hanging from trees that we have long collarbones which keep our arms away from our chests, wrists which allow our hands to bend backwards and sideways, and shoulder sockets that let our arms rotate.

It is thanks to hanging from trees that one of the actors can throw himself into the arms of a mother and cry. Brachiation gave us breasts to beat and to be held against. No other animal can do these things.

When Darwin thought about the eyes of mammals, he admitted that he broke out in a cold sweat. The complexity of the eye was hard to explain within the logic of his theory, for it implied the co-ordination of so many evolutionary 'accidents'. If the eye is to work at all, all the elements have to be there: tear glands, eyelid, cornea, pupil, retina, millions of light-sensitive rods and cones which transmit to the brain millions of electrical impulses per second. Before they constituted an eye, these intricate parts would have been useless, so why should they have been favoured by natural selection? The existence of the eye perfidiously suggests an evolutionary aim, an intention.

Darwin finally got over the problem by going back to the existence of light-sensitive spots on one-celled organisms. These, he claimed, could have been 'the first eye' from which the evolution of our complex eyes first began.

I have the impression that the oldest gorilla may be blind. Like Beckett's Pozzo. I ask his keeper, a young woman with fair hair. Yes, she says, he's almost blind. How old is he? I ask. She looks at me hard. About your age, she replies, in his early sixties.

Recently, molecular biologists have shown that we share with apes 99 per cent of their DNA. Only 1 per cent of his genetic code separates man from the chimpanzee or the gorilla. The orang-utan, which means in the language of the people of Borneo 'man of the forest', is fractionally further removed. If we take another animal family, in order to emphasize how small the 1 per cent is, a dog differs from a raccoon by 12 per cent. The genetic closeness between man and ape – apart from making our theatre possible – strongly suggests that their common ancestor existed not 20 million years ago as the Neo-Darwinist palaeontologists believed, but maybe only 4 million years ago. This molecular evidence has been contested because there are no fossil proofs to support it. But in evolutionary theory fossils, it seems to me, have usually been notable by their absence!

In the Anglo-Saxon world today the Creationists, who take the Genesis story of the Creation as the literal truth, are increasingly vocal and insist that their version be taught in schools alongside the Neo-Darwinist one.

The orang-utan is like he is, say the Creationists, because that's the way God made him, once and for all, five thousand years ago! He is like he is, reply the Neo-Darwinists, because he has been efficient in the ceaseless struggle for survival!

Her orang-utan eyes operate exactly like mine – each retina with its 130 million rods and cones. But her expression is the oldest I've ever seen. Approach it at your peril, for you can fall into a kind of maelstrom of ageing. The plunge is still there in Jean Mohr's photo.

Not far up the Rhine from Basel, Angelus Silesius, the seventeenth-century German doctor of medicine, studied in Strasbourg, and he once wrote:

Anybody who passes more than a day in eternity is as old as God could ever be.

I look at her with her eyelids which are so pale that when she closes them they're like eyecups, and I wonder.

Certain Neo-Darwinist ideas are intriguing: Bolk's theory of neoteny, for instance. According to Bolk, 'man in his bodily development is a primate foetus that has become sexually mature', and consequently can reproduce. His theory proposes that a genetic code can stop one kind of growth and encourage another. Man is a neonate ape to whom this happened. Unfinished, he is able to learn more.

It has even been argued that today's apes may be descendants of a hominid, and that in them the neoteny brake was taken off so that they stopped stopping at the foetus stage, grew body hair again and were born with tough skulls! This would make them more modern than we are.

Yet in general, the conceptual framework in which the Neo-Darwinists and the Creationists debate is of such limited imagination that the contrast with the immensity of the process whose origin they are searching is flagrant. They are like two bands of seven-year-olds who, having discovered a packet of love letters in an attic, try to piece together the story behind the correspondence. Both bands are ingenious and argue ferociously with one another, but the passion of the letters is beyond their competence.

Perhaps it is objectively true that only poetry can talk of birth and origin. Because true poetry invokes the whole of language (it breathes with everything it has not said), just as the origin invokes the whole of life, the whole of Being.

The mother orang-utan has come back, this time with her baby. She is sitting right up against the glass. The children in the audience have come close to watch her. Suddenly, I think of a Madonna and Child by Cosimo Tura. I'm not indulging in a sentimental confusion. I haven't forgotten

I'm talking about apes any more than I've forgotten I'm watching a theatre. The more one emphasizes the millions of years, the more extraordinary the expressive gestures become. Arms, fingers, eyes, always eyes . . . A certain way of being protective, a certain gentleness – if one could feel the fingers on one's neck, one would say a certain *tenderness* – which has endured for five million years.

A species that did not protect its young would not survive, comes the answer. Indisputably. But the answer does not explain the theatre.

I ask myself about the theatre – about its mystery and its essence. It's to do with time. The theatre, more tangibly than any other art, presents us with the past. Paintings may show what the past looked like, but they are like traces or footprints, they no longer move. With each theatre performance, what once happened is re-enacted. Each time we keep the same rendezvous: with Macbeth who can't wake up from his down-fall; with Antigone who must do her duty. And each night in the theatre Antigone, who died three millennia ago, says: 'We have only a short time to please the living, all eternity to please the dead.'

Theatre depends upon two times physically co-existing. The hour of the performance and the moment of the drama. If you read a novel, you leave the present; in the theatre you never leave the present. The past becomes the present in the only way that it is possible for this to happen. And this unique possibility is theatre.

The Creationists, like all bigots, derive their fervour from rejection – the more they can reject, the more righteous they themselves feel. The Neo-Darwinists are trapped within the machine of their theory, in which there can be no place for creation as an act of love. (Their theory was born of the nineteenth century, the most orphaned of centuries.)

The ape theatre in Basel, with its two times, suggests an alternative view. The evolutionary process unfolded, more or less as the evolutionists suppose, within time. The fabric of its duration has been stretched to breaking point by billions of years. Outside time, God is still (present tense) creating the universe.

Silesius, after he left Strasbourg to return to Cracow, wrote: 'God is still creating the world. Does that seem strange to you? You must suppose that in him there is no before nor after, as there is here.'

How can the timeless enter the temporal? the gorilla now asks me.

Can we think of time as a field magnetized by eternity? I'm no scientist. (As I say that, I can see the real ones smiling!)

Which are they?

The ones up there on a ladder, looking for something. Now they're coming down to take a bow . . .

As I say, I'm no scientist, but I have the impression that scientists today, when dealing with phenomena whose time or spatial scale is either immense or very small (a full set of human genes contains about 6 billion

bases: bases being the units – the signs – of the genetic language), are on the point of breaking through space-time to discover another axis on which events may be strung, and that, in face of the hidden scales of nature, they resort increasingly to the model of a brain or mind to explain the universe.

'Can't God find what he is looking for?' To this question Silesius replied, 'From eternity he is searching for what is lost, far from him, in time.'

The orang-utan mother presses the baby's head against her chest.

Birth begins the process of learning to be separate. The separation is hard to believe or accept. Yet, as we accept it, our imagination grows – imagination which is the capacity to reconnect, to bring together, that which is separate. Metaphor finds the traces which indicate that all is one. Acts of solidarity, compassion, self-sacrifice, generosity are attempts to re-establish – or at least a refusal to forget – a once-known unity. Death is the hardest test of accepting the separation which life has incurred.

You're playing with words!

Who said that?

Jackie!

The act of creation implies a separation. Something that remains attached to the creator is only half-created. To create is to let take over something which did not exist before, and is therefore new. And the new is inseparable from pain, for it is alone.

One of the male chimps is suddenly angry. Histrionically. Everything he can pick up he throws. He tries to pull down the stage trees. He is like Samson at the temple. But unlike Samson, he is not high up in the group hierarchy of the cage. The other actors are nonetheless impressed by his fury.

Alone, we are forced to recognize that we have been created, like everything else. Only our souls, when encouraged, remember the origin, wordlessly.

Silesius's master was Eckardt, who, further down the Rhine beyond Strasbourg, in Cologne, wrote during the thirteenth century, 'God becomes God when the animals say: God.'

Are these the words which the play behind the soundproof plate glass is about?

In any case I can't find better.

1990

The Opposite of Naked

Among the French Impressionists, Renoir is still the most popular. All over the world his name is associated with a particular vision of sunlight, leisure and women. This would have pleased him. It was for his paintings of women – and particularly for his nudes – that he believed he would be admired and remembered.

I believe he will remain a widely popular painter, because his work is about pleasure. But pleasure in what exactly? Or, to put it another way, what does Renoir's way of painting – which is so instantly recognizable – really reveal to us?

A male dream of goddesses? An eternal summer of full-fleshed happy women? Daily domesticity treated as recurring honeymoon? Some of this. But what has been *replaced*? What is crying out because it is not there, has not been included?

All the photographs of Renoir – from the first in 1861 when he was twenty to the last when, nearly eighty, he could only paint by having the brushes strapped to his arthritic hand – show a nervous, lean, vulnerable man. About halfway through his life the expression in his eyes changes: from being shy and dreamy, it becomes a little fixed and fanatical. This change, occurring around 1890, corresponds more or less with three other developments: his settling down into marriage, his achieving financial security, and the first signs of the rheumatoid arthritis which was to cripple him, yet in face of which his obstinacy and courage were very impressive.

These photographs remind us that what is banished from Renoir's paintings is any sign of anguish, any possibility of choice. He often said that he painted for his own pleasure and to give pleasure. Yet for him the pre-condition of pleasure was the fantasy of a world without edges, without sharpness or conflict, a world that enveloped like a mother's open blouse and breast. Pleasure for him was not for the *taking*: it had to

be ubiquitous and omnipresent. You have to embellish, he said; paintings should be friendly, pleasurable and pretty. And about this, as he grew older, he became fanatical: 'The best exercise for a woman is to kneel down and scrub the floor, light fires or do the washing – their bellies need movement of that sort.' By this he meant that such work produced the kind of belly he found friendly and pleasurable.

His son, the film director Jean Renoir, has written a remarkable book about his childhood memories. In it there is this conversation with his father:

'Whose music is that?'

'Mozart's.'

'What a relief. I was afraid for a minute it was that imbecile Beethoven . . . Beethoven is positively indecent the way he tells about himself. He doesn't spare us either the pain in his heart or in his stomach. I have often wished I could say to him: what's it to me if you are deaf?'

Nothing is simpler than to ridicule a past age, and nothing is more ridiculous. It is not by our own virtue today that we are closer to Beethoven. Feminist reasoning applied retrospectively to Renoir is too easy. I use these quotations only to indicate how threatened Renoir often felt. He was, for instance, obsessional about the safety of his children: all sharp edges had to be sawn off the furniture, no razor-blades were allowed inside the house. Only if we appreciate Renoir's fears can we better understand *how* he painted.

Now I want to add one more element to the riddle of the meaning of Renoir's oeuvre. He was born in 1841. His father was a tailor who worked at home. His mother was a dress-maker. Very soon the father's trade began to diminish, as more and more factory-made clothes came on to the market in the second half of the nineteenth century. The immensity of any childhood begs description. Yet we can suppose that in this childhood home there was already a certain nostalgia for the security of the past and that this nostalgia was intimately associated with cottons, silks, organdies, tulles, taffetas – clothes.

The exact nature of Renoir's anxiety – which became more acute as he settled down into a successful, secure life – we can never know. Some aspect of reality frightened him – as may happen to any of us. Yet Renoir was a painter working directly from the real. And so his imagination and his senses led him to develop a way of painting which transformed the real, which banished fears and consoled him. You have to embellish, he said. How?

By muffling, by covering, by draping, by dressing. He studied the surface or the skin of everything he saw before his eyes, and he turned

this skin into a veil which hid what lay behind the surface – the real that frightened him.

This process which generated all the energy of his vision (painting as an act not of disclosing but of covering) had two obvious consequences. When he painted coverings, when he painted cloth, there was a complicity between the *stuff* and his vision of it which is unique for its freedom in the history of art. He painted the dreams of dressing as no other artist except Watteau has ever done. Sometimes I imagine him before his easel, having almost stopped breathing, his eyes screwed up, with pins in his mouth like his mother.

Think of *La Danse à Bougival* and you'll see a warm dress dancing with a sweating suit and two hats breathing each other's perfumes. What about the hands? you ask. But look again, the hands are like gloves. What about her pretty face? It's as if painted with face-powder and it's a pretty mask.

Think of *Le Déjeuner des Canotiers*, where you have, at the end of a summer lunch, a rumpled pearly table-cloth with discarded napkins which are like a concert of singing angels. And the bottles and the dog's coat and the man's vest and the hats and scarves, all the *confection*, as the French say, is singing: only the figures are mute because lacking substance.

Renoir did not paint many landscapes, but when he did, his vision transformed them into something like chintz cushion covers. Landscapes are frightening because they imply exits and entrances. Renoir's are not, because there is no gravity, no resistance, no edges, no horizon. You simply lay your cheek on them. It is interesting to speculate what Renoir, in another age, might have designed for tapestries – the medium would have curiously touched his genius.

The second consequence of Renoir's relation to reality and the salvation which painting offered him is to be found in the way he painted women and their bodies. And here, if one really looks, one discovers something which, given his reputation, is a little surprising. The women he depicts are never naked; they and everything around them are clothed, covered, by the act of painting. He made hundreds of nudes and they are the least present, the most chaste in European art.

He paints their flesh, their skin, the light playing on it. He observes this with the sweet obsessiveness of love. (I reject the word fetishism because it is too patronizing.) Nobody before had watched this play of light with such single-minded concentration – not even Titian. It is the light of the early Mediterranean afternoon, when work has stopped and only the bees maintain their energy. Looking at these paintings, we enter a kind of paradise, an Eden of the sense of touch. (He forbade his children to cut their nails, for they protected the sensibility of their fingertips.) Yet what is within these dappled skins and what is without?

Within, there is nobody – the living flesh, so alive, is the equivalent of a dress that nobody is wearing. Without – beyond the body's limits – there are trees or rocks or hills or the sea, but all these prolong and extend the same paradise. Every conflict, every edge of difference and distinction has been eliminated. Everything – from the silicate rocks to the hair falling on a woman's shoulders – is homogeneous, and as a consequence, there is no identity, because there are no dualities. We are faced with a cloth of delight that covers all. This is why the paintings are so chaste.

Passion begins with a sense of the uniqueness, the solitude, the vulnerability of the loved one in a harshly indifferent world. Or, to put this in an active rather than a passive mood, it begins with the loved one's impudence, defiance or promise of an alternative. In an unfeeling world such a promise becomes like a well in a desert. None of this exits in Renoir's world because there are no contrasts and no edges. Everything has been dressed by the act of painting. The paradox is strange. We gaze at shoulders, breasts, thighs, feet, mounds, dimples, and we marvel at their softness and warmth. Yet everything has been veiled. Everything, however apparently intimate, is in purdah – for the person has been eternally hidden.

They are sweet paintings of a terrible loss. They speak to the dreams of frightened men, their obsession with the surface of femininity, and their lack of women. Perhaps they also speak to some women's dreams: those dreams in which the guise of femininity alone can arrange everything.

'Me,' Renoir once said, 'I like paintings which make me want to take a stroll in them if they're landscapes, and if they're figures of women, to touch their breasts ['tits' is closer to the word he used] or their backs.' The wish, the fantasy, is timeless. Passion and the erotic, as John Donne knew so well, are not:

> For I had rather owner be
> of thee one hour, than all else ever.

1985

A Household

It was seven years ago, in the National Gallery in Stockholm, that I first became really interested in Zurbarán. Zurbarán, renowned during his lifetime in the seventeenth century, has again become eloquent at the end of ours, the twentieth. I want to try to discover why this might be so.

The painting in Stockholm which stopped me in my tracks was of Veronica's Veil. (He painted several versions.) The white kerchief is pinned to a dark wall. Its realism is such that it borders on trompe l'oeil. Rubbed on to the white linen (or is it cotton?) are the traces of Christ's face, haggard and drawn as he carried the cross to Golgotha. The imprint of the face is ochre-coloured and monochrome, as befits an image whose medium was sweat.

The canvas in Stockholm made me realize something which applies, I think, to any visual work of art that has the power to move us. Painting first has to convince us – within the particular use of the pictorial language it is using – of what is *there*, of the reality of what it depicts. In the case of Zurbarán, of the kerchief pinned to the wall. Any painting which is powerful first offers this certitude. And then it will propose a doubt. The doubt is not about *what* is there, but about *where* it is.

Where is the face so faintly printed on the kerchief? At what point in space and time are we looking? It is there, it touches and even impregnates the reality of the cloth, but its precise whereabouts is an enigma.

Before any impressive painting one discovers the same enigma. The continuity of space (the logic of the whereabouts) will somewhere on the canvas be broken and replaced by a haunting discontinuity. This is as true of a Caravaggio or a Rubens as of a Juan Gris or a Beckmann. The painted images are always held within a broken space. Each historical period has its particular system of breaking. Tintoretto typically breaks between foreground and background. Cézanne miraculously exchanges the far for the near. Yet always one is forced to ask: what I'm being shown,

what I'm being made to believe in, is exactly where? Perspective cannot answer this question.

The question is both material and symbolic, for every painted image of something is also about the absence of the real thing. All painting is about the presence of absence. This is why man paints. The broken pictorial space confesses the art's wishfulness.

Let us now return to what is specific to Zurbarán. One of his early paintings shows St Pierre Nolasque kneeling before the apparition of St Peter, crucified upside down on his cross. Nolasque kneels on solid, solid ground. The crucified saint, who is the same size as the living figure, is a vision from beyond time and space. And on the ground where the two spaces (one solid, the other visionary) are hinged, Zurbarán has placed his signature. He was the master of such hinges. They were his life's obsession.

What sort of man was he? Apart from his paintings and the commissions he received, we know little about him. A supposed self-portrait – he is standing with his painter's palette at the foot of the Cross – shows us a rather indecisive man who is both devout and sensuous. A contemporary of Velázquez, he worked not for the sophisticated royal court but almost exclusively for the Spanish Church at the height of its fanatical Counter-Reformation. A large number of his canvases were painted especially for monasteries.

I should perhaps say that I have a visceral antipathy for the kind of religious institution for which Zurbarán worked. Cults of martyrdom, flagellation, saints' relics, damnation and inquisitorial power are for me detestable. All my spiritual sisters and brothers were its victims. Yet for years this man's art has – not fascinated me, for one can be fascinated by horror – but touched me, made me dream. It took me a long time to guess why.

Zurbarán was married three times and was the father of nine children – most of whom in the age of the plague died before he did. He worked for the monasteries, yet his inspiration was domesticity – an inspiration which became more and more obvious during the course of his life. Not the domesticity of a paterfamilias or a bourgeois male moralist (sufficient here to compare his paintings with Dutch contemporaries like Jan Steen), but a domesticity which accrues through labour: childbirth, ironed linen, prepared food, fresh clothes, arranged flowers, embroidery, clean children, washed floors. His art is infused, as that of no other painter of his time, by the experience, pride and pain of women – and, in this sense, is very feminine. Perhaps it was this 'contraband', carried in by his paintings, which created such a demand for them among the religious orders?

In qualifying Zurbarán's vision as domestic, I am not only thinking of certain favourite subjects he painted, or of the turn he gave to certain

subjects (his Immaculate Conceptions are perfumed like layettes), but, more profoundly, of the way he envisaged almost any scene he was ordered to paint. For example, in an early painting of the monstrously tortured St Serapion, what we actually see in his picture are the hands and head of a peasant husband asleep, and the robes hanging from his body, like precious linen tousled by the wind on a clothes-line. It isn't that the subject has been secularized; it is rather that the life of the soul has been thought of, has been tended, and finally, has been saved, like the life of a household.

Art historians point out that Zurbarán remained in some ways a provincial painter. He was never at ease in the grand architecture of ambitious compositions. This is true. His genius lay in making a shelter, a home of *corners*.

Let us go to *The Holy House of Nazareth* (in Cleveland). On the right, Mary imagining the future; on the middle finger of her right hand a thimble, by the flank of her nose a tear. On the left, her son Jesus, who is making a crown of thorns, one of which has pricked his finger. Between them a kitchen table. Every object in the picture has its symbolic tag: the two turtle doves are for the Purification of the Virgin after the birth of her child; the fruit on the table for Redemption; the lilies for Purity, and so on. In the seventeenth century, such scenes from the childhood of Christ, and also from the childhood of the Virgin (another subject which Zurbarán loved), were widely popular and were controlled and distributed by the Church as models of devotion and patience. None of this, however, explains the image's emotional charge. The French painter Laneuville, who was a pupil of David, wrote in 1821 about 'the magic' of this canvas.

The magic begins, as I've said, with a doubt following a certitude. It begins with a spatial break, a discontinuity. The foreground of the floor is continuous right across the canvas. The hinge of the discontinuity is the nearest leg of the table.

From his knees upwards, the child is placed in a space that is indefinable, and opens on to angels. To the right of the table leg, in the territory of the mother, the space remains that of a room in a house – even the window, or picture, on the wall takes up its everyday position.

The table-top, impossibly upturned towards us, mediates between the two spaces. The pages of the open book on the left flicker in the light of the angels. The two books on the right are unmistakably placed on the kitchen table.

The two different spaces correspond with two different times: on the right everyday time, every nighttime: on the left the time of prophecy, pierced time – like the boy's finger pierced by the thorn.

We come now to the psychic spatial discontinuity – to the narrative jolt which, given the rest, increases further the picture's extraordinary

charge. It is the sight of her boy which is making the mother so pensive. The sight reminds her of his future. She foresees their destiny. *And yet she is not looking at him.* Spatially, she is simply not looking in his direction. It is we who are looking at two spaces. She, confined to one, *knows.*

Mothers in Nazareth today, foreseeing the tragic destiny of their sons, are Palestinians. I say this to recall us to the century in which we are living. What does Zurbarán mean in our contemporary world?

Let us first be clear. It is no longer a single historical world – as it has been from the beginning of the nineteenth century onwards. Nor is it any longer ours. We, in our culture of commodities, are living our crisis; the rest of the world are living theirs. Our crisis is that we no longer believe in a future. Their crisis is us. The most we want is to hang on to what we've got. They want the means to live.

This is why our principal preoccupations have become private and our public discourse is compounded of spite. The historical and cultural space for public speech, for public hopes and action, has been dismantled. We live and have our being today in private coverts.

The fact that Zurbarán's art is domestic means it is an art to which we are not necessarily closed. By contrast, public art – whether it be that of Piero della Francesca, Rubens, Poussin, David or the cubists – leaves us cold. (The debate of post-modernism is simply about the loss of public nerve.) Zurbarán's art of the interior suits our fear of the outside.

Once we are inside with him, we are intrigued, troubled, and obliged to dream about the colossal difference between the life he paints and ours. Everything he paints looks as if it is eternal. (His eternity has a lot to do with childhood.) Everything with which we surround ourselves feels as if it's disposable. Return to the marvellous house in Nazareth.

Her sewing, the cushion on her lap, her dress the colour of pomegranates, the chiffon scarf round her neck, her cuffs, the hand holding her head, her lips, are as present as a Manet or Degas might have wished, painted with a tactile intensity which reminds one yet again that only the eye can do justice to the phenomenon of existence. And yet, present as she is, the expression of her eyes shows she is also elsewhere. The hinge of the two spaces within the picture is a visible one. A similar but invisible hinge exists within the being of this woman.

Zurbarán painted a few still lifes of jars, cups, fruit. The objects are invariably placed on the edge of a table (or shelf) against a dark background. Under them, beneath the table, or, above and behind them, there is a darkness which may be nothingness. What is visible has been placed on the very edge of this darkness, as if somehow the visible has come through the darkness like a message. Everything and everybody in the house at Nazareth has a similar quality of being or receiving a message. And so, quite apart from the fact that the subject is a prophecy concerning the Holy Family – everything in the painting is perceived as being sacred.

What do I mean by sacred? 'Set apart because holy', as the dictionary suggests? Why holy? On account of the angels? No – curiously enough, angels in the sky are the least holy thing in Zurbarán's repertoire. (They are simply a fond parent's baby fantasies.) His sense of the sacred comes not from symbolism but from a way of painting and of placing. In everything he paints, he sees not only a form but a task accomplished or being accomplished. The tasks are everyday household ones such as I have already mentioned. They imply care, order, regularity: these qualities being honoured not as moral categories but as evidence of meaning, as a message. Any peasant not entirely dispossessed of his land would recognize what I'm talking about here. It is where, against the chaos of nature, a sense of achievement includes aesthetics. It is why, if possible, the wood is stacked and not just thrown into a corner. Against the myriad natural risks, daily acts of maintenance acquire a ritual meaning.

In Zurbarán's art we don't find the chaos of nature, but we do find a background – as in all Spanish art – which is blackness: the blackness represents the world into which we have been thrown like salt into water.

It is not Zurbarán's saints or martyrs or angels that emanate a sense of the sacred for us, but the intensity of his looking at what has been worked upon against this background, and his knowledge that human space is always broken and twofold. Such knowledge comes through compassion, for which there is no space in our culture of greed. As for ritual acts – such as making a cup of coffee or tea – they are still performed every day, and within a family or between an old couple, they may still preserve a meaning, but publicly there are no everyday ritual acts, for a ritual requires a permanent sense of past and future and in our culture of commodities and novelties there is neither.

Zurbarán has become eloquent at the end of our century because he paints stuff – stuff one might find in a flea market – with a concentration and care that reminds us how once it may have been sacred.

1985

Drawing on Paper

I still sometimes have a dream in which I am my present age with grown-up children and newspaper editors on the telephone, and in which nevertheless I have to leave and pass nine months of the year in the school to which I was sent as a boy. As an adult, I think of these months as an early form of exile, but it never occurs to me in the dream to refuse to go. In life I left that school when I was sixteen. The war was on and I went to London. Amongst the debris of bomb sites and between the sirens of the air-raid warnings, I had a single idea: I wanted to draw naked women. All day long.

I was accepted in an art school – there was not a lot of competition, for nearly everyone over eighteen was in the services – and I drew in the daytime and I drew in the evenings. There was an exceptional teacher in the art school at that time – an elderly painter, a refugee from fascism named Bernard Meninsky. He said very little and his breath smelt of dill pickles. On the same imperial-sized sheet of paper (paper was rationed; we had two sheets a day), beside my clumsy, unstudied, impetuous drawing, Bernard Meninsky would boldly draw a part of the model's body in such a way as to make its endlessly subtle structure and movement clearer. After he had stood up and gone, I would spend the next ten minutes, dumbfounded, continuously looking from his drawing to the model and vice versa.

Thus I learnt to question with my eyes a little more probingly the mystery of anatomy and of love, whilst outside in the night sky, audibly, RAF fighters were crossing the city to intercept the approaching German bombers before they reached the coast. The ankle of the foot on which her weight was posed was vertically under the dimple of her throat – directly vertical.

Recently I was in Istanbul. There I asked my friends if they could arrange for me to meet the writer Latife Tekin. I had read a few translated

extracts from two novels she had written about life in the shanty towns on the edge of the city. And the little I had read had deeply impressed me by its imagination and authenticity. She must herself have been brought up in a shanty town. My friends arranged a dinner and Latife came. I do not speak Turkish and so naturally they offered to interpret. She was sitting beside me. Something made me say to my friends, 'No, don't bother, we'll manage somehow.'

The two of us looked at each other with some suspicion. In another life I might have been an elderly police superintendent interrogating a pretty, shifty, fierce woman of thirty repeatedly picked up for larceny. In fact, in this our only life we were both story-tellers without a word in common. All we had were our powers of observation, our habits of narration, our Aesopian sadness. The suspicion between us gave way to shyness.

I took out a notebook and did a drawing of myself as one of her readers. She drew a boat upside down to show she couldn't draw. I turned the paper around so it was the right way up. She made a drawing to show that her drawn boats always sank. I said there were birds at the bottom of the sea. She said there was an anchor in the sky. (Like everybody else, we were drinking raki.) Then she told me a story about the municipal bulldozers destroying the houses built in the night. I told her about an old woman who lived in a van. The more we drew, the quicker we understood. In the end, we were laughing at our own speed – even when the stories were monstrous or sad. She took a walnut and, dividing it in two, held it up to say, Halves of the same brain! Then somebody put on some Bektasi music and the company began to dance.

In the summer of 1916, Picasso drew on a page of a middle-sized sketchbook the torso of a nude woman. It is neither one of his invented figures – it hasn't enough bravura – nor a figure drawn from life – it hasn't enough of the idiosyncracy of the immediate.

The face of the woman is unrecognizable, for the head is scarcely indicated. Yet the torso is also like a face. It has a familiar expression. A face of love become hesitant or sad. The drawing is quite distinct in feeling from the others in the same sketchbook. The other drawings play rough games with cubist or neo-classical devices, some looking back on the previous still-life period, others preparing the way for the Harlequin themes he would take up the following year when he did the decor for the ballet *Parade*. The torso of the woman is very fragile.

Usually, Picasso drew with such verve and such directness that every scribble reminds you of the act of drawing and of the pleasure of that act. It is this which makes his drawings insolent. Even the weeping faces of the *Guernica* period or the skulls he drew during the German occupation possess an insolence. They know no servitude. The act of their drawing is triumphant.

The drawing in question is an exception. Half-drawn – for Picasso didn't continue on it for long – half woman, half vase; half seen as by Ingres, half seen as by a child; the apparition of the figure counts for far more than the act of drawing. It is she, not the draughtsman, who insists, insists by her very tentativeness.

My hunch is that in Picasso's imagination this drawing belonged somehow to Eva Gouel. She had died only six months before of tuberculosis. They had lived together – Eva and Picasso – for four years. Into his now-famous cubist still lifes he had inserted and painted her name, transforming austere canvases into love letters. JOLIE EVA. Now she was dead and he was living alone. The image lies on the paper as in a memory.

This hesitant torso – re-become more child than woman – has come from another floor of experience, has come in the middle of a sleepless night and still has the key to the door of the room where he sleeps.

Perhaps these three stories suggest the three distinct ways in which drawings can function. There are those which study and question the visible, those which put down and communicate ideas, and those done from memory. Even in front of drawings by the old masters, the distinction between the three is important, for each type survives in a different way. Each type of drawing speaks in a different tense. To each we respond with a different capacity of imagination.

In the first kind of drawing (at one time such drawings were appropriately called *studies*) the lines on the paper are traces left behind by the artist's gaze, which is ceaselessly leaving, going out, interrogating the strangeness, the enigma, of what is before his eyes, however ordinary and everyday this may be. The sum total of the lines on the paper narrate a sort of optical emigration by which the artist, following his own gaze, settles on the person or tree or animal or mountain being drawn. And if the drawing succeeds, he stays there for ever.

In a study entitled *Abdomen and Left Leg of a Nude Man Standing in Profile,* Leonardo is still there: there in the groin of the man, drawn with red chalk on a salmon-pink prepared paper, there in the hollow behind the knee where the femoral biceps and the semimembranous muscle separate to allow for the insertion of the twin calf muscles. Jacques de Gheyn (who married the rich heiress Eva Stalpaert van der Wiele and so could give up engraving) is still there in the astounding diaphanous wings of the dragonflies he drew with black chalk and brown ink for his friends in the University of Leyden in 1600.

If one forgets circumstantial details, technical means, kinds of paper, etc., such drawings do not date, for the act of concentrated looking, of questioning the appearance of an object before one's eyes, has changed very little throughout the millennia. The ancient Egyptians stared at fish

in a comparable way to the Byzantines on the Bosphorus or to Matisse in the Mediterranean. What changed, according to history and ideology, was the visual rendering of what artists dared not question: God, Power, Justice, Good, Evil. Trivia on the side could always be visually questioned. This is why exceptional drawings of trivia carry with them their own 'here and now', putting their humanity into relief.

Between 1603 and 1609 the Flemish draughtsman and painter Roelandt Savery travelled in Central Europe. Eighty drawings of people in the street – marked with the title *Taken from Life* – have survived. Until recently, they were wrongly thought to be by the great Pieter Breughel. One of them, drawn in Prague, depicts a beggar seated on the ground.

He wears a black cap; wrapped round one of his feet is a white rag, over his shoulders a black cloak. He is staring ahead, very straight; his dark sullen eyes are at the same level as a dog's would be. His hat, upturned for money, is on the ground beside his bandaged foot. No comment, no other figure, no placing. A tramp of nearly four hundred years ago.

We encounter him today. Before this scrap of paper, only six inches square, we *come across* him as we might come across him on the way to the airport, or on a grass bank of the highway above Latife's shanty town. One moment faces another and they are as close as two facing pages in today's unopened newspaper. A moment of 1607 and a moment of 1987. Time is obliterated by an eternal present. Present Indicative.

In the second category of drawings the traffic, the transport, goes in the opposite direction. It is now a question of bringing to the paper what is already in the mind's eye. Delivery rather than emigration. Often such drawings were sketches or working drawings for paintings. They bring together, they arrange, they set a scene. Since there is no direct interrogation of the visible, they are far more dependent upon the dominant visual language of their period and so are usually more datable in their essence: more narrowly qualifiable as Renaissance, Baroque, Mannerist, Eighteenth-century, Academic, or whatever.

There are no confrontations, no encounters to be found in this category. Rather we look through a window on to a man's capacity to dream up, to construct an alternative world in his imagination. And everything depends upon the space created within this alternative. Usually, it is meagre – the direct consequence of imitation, false virtuosity, mannerism. Such meagre drawings still possess an artisanal interest (through them we see how pictures were made and joined – like cabinets or clocks), but they do not speak directly to us. For this to happen the space created within the drawing has to seem as large as the earth's or the sky's space. Then we can feel the breath of life.

Poussin could create such a space; so could Rembrandt. That the achievement is rare in European drawing (less so in Chinese) may be

because such space only opens up when extraordinary mastery is combined with extraordinary modesty. To create such immense space with ink marks on a sheet of paper one has to know oneself to be very small.

Such drawings are visions of 'What would be if . . .' The majority of them record visions of the past which are now closed to us, like private gardens. When there is enough space, the vision remains open and we enter. Tense Conditional.

Thirdly, there are the drawings done from memory. Many are notes jotted down for later use – a way of collecting and of keeping impressions and information. We look at them with curiosity if we are interested in the artist or the historical subject. (In the fifteenth century the wooden rakes used for raking up hay were exactly the same as those still used in the mountains where I live.)

The most important drawings in this category, however, are made in order to exorcise a memory which is haunting, in order to take an image once and for all out of the mind and put it on paper. The unbearable image may be sweet, sad, frightening, attractive, cruel. Each has its own way of being unbearable.

The artist in whose work this mode of drawing is most obvious is Goya. He made drawing after drawing in a spirit of exorcism. Sometimes the subject was a prisoner being tortured by the Inquisition to exorcise his or her sins: a double, terrible exorcism.

I see a red-wash and sanguine drawing by Goya of a woman in prison. She is chained by her ankles to the wall. Her shoes have holes in them. She lies on her side. Her skirt is pulled up above her knees. She bends her arm over her face and eyes so she need not see where she is. The drawn page is like a stain on the stone floor on which she is lying. And it is indelible.

There is no bringing together here, no setting of a scene. Nor is there any questioning of the visible. The drawing simply declares: I saw this. Historic Past Tense.

A drawing from any of the three categories, when it is sufficiently inspired, when it becomes miraculous, acquires another temporal dimension. The miracle begins with the basic fact that drawings, unlike paintings, are usually monochrome. (If they are coloured, they are only partially coloured.)

Paintings with their colours, their tonalities, their extensive light and shade, compete with nature. They try to seduce the visible, to *solicit* the scene painted. Drawings cannot do this. The virtue of drawings derives from the fact that they are diagrammatic. Drawings are only notes on paper. (The sheets rationed during the war! The paper napkin, folded

into the form of a boat and put into a raki glass where it sank.) The secret is the paper.

The paper becomes what we see through the lines, and *yet* remains itself. Let me give an example. A drawing made in 1553 by Pieter Brueghel (in reproduction its quality would be fatally lost: better to describe it). In the catalogues it is identified as a *Mountain Landscape with a River, Village and Castle*. It was drawn with brown inks and wash. The gradations of the pale wash are very slight. The paper lends itself between the lines to becoming tree, stone, grass, water, masonry, limestone mountain, cloud. Yet it can never for an instant be confused with the substance of any of these things, for evidently and emphatically it remains a sheet of paper with fine lines drawn upon it.

This is both so obvious and – if one reflects upon it – so strange that it is hard to grasp. There are certain paintings which animals could read. No animal could ever read a drawing.

In a few great drawings, like the Brueghel landscape, everything appears to exist in space, the complexity of everything vibrates – yet what one is looking at is only a project on paper. Reality and project become inseparable. One finds oneself on the threshold before the creation of the world. Such drawings, using the Future Tense, *foresee*, forever.

1987

Erogenous Zone

The very last period of Picasso's life as a painter was dominated by the theme of sexuality. Looking at these late works, I yet again think of W. B. Yeats, writing in his old age:

> You think it horrible that lust and rage
> Should dance attention upon my old age;
> They were not such a plague when I was young;
> What else have I to spur me into song?

Yet, why does such an obsession so suit the medium of painting? Why does painting make it so eloquent?

Before attempting an answer, let us clear the ground a little. Freudian analysis, whatever else it may offer in other circumstances, is of no great help here, because it is concerned primarily with symbolism and the unconscious. Whereas the question I'm asking addresses the immediately physical and the evidently conscious.

Nor, I think, do philosophers of the obscene – like the eminent Bataille – help a great deal because, again but in a different way, they tend to be too literary and psychological for the question. We have to think quite simply about pigment and the look of bodies.

The first images ever painted displayed the bodies of animals. Since then, most paintings in the world have showed bodies of one kind or another. This is not to belittle landscape or other later genres, nor is it to establish a hierarchy. Yet if one remembers that the first, the basic, purpose of painting is to conjure up the presence of something which is not there, it is not surprising that what is usually conjured up are bodies. It is their presence which we need in our collective or individual solitude to console, strengthen, encourage or inspire us. Paintings keep our eyes company. And company usually involves bodies.

Let us now – at the risk of colossal simplification – consider the other arts. Narrative stories involve action: they have a beginning and an end in time. Poetry addresses the heart, the wound, the dead – everything which has its being within the realm of our inter-subjectivities. Music is about what is behind the given: the wordless, the invisible, the unconstrained. Theatre re-enacts the past. Painting is about the physical, the palpable and the immediate. (The insurmountable problem facing abstract art was to overcome this.) The art closest to painting is dance. Both derive from the body, both evoke the body, both in the first sense of the word are physical. The important difference is that dance, like narration and theatre, has a beginning and an end and so exists in time; whereas painting is instantaneous. (Sculpture, because it is more obviously static than painting, often lacks colour and is usually without a frame and therefore less intimate, is in a category by itself, which demands another essay.)

Painting, then, offers palpable, instantaneous, unswerving, continuous, physical presence. It is the most immediately sensuous of the arts. Body to body. One of them being the spectator's. This is not to say that the aim of every painting is sensuous; the aim of many paintings has been ascetic. Messages deriving from the sensuous change from century to century, according to ideology. Equally, the role of gender changes. For example, paintings can present women as a passive sex object, an active sexual partner, as somebody to be feared, as a goddess, as a loved human being. Yet, however the art of painting is used, its use begins with a deep sensuous charge which is then transmitted in one direction or another. Think of a painted skull, a painted lily, a carpet, a red curtain, a corpse – and in every case, whatever the conclusion may be, the beginning (if the painting is alive) is a sensuous shock.

He who says 'sensuous' – where the human body and the human imagination are concerned – is also saying 'sexual'. And it is here that the practice of painting begins to become more mysterious.

The visual plays an important part in the sexual life of many animals and insects. Colour, shape and visual gesture alert and attract the opposite sex. For human beings the visual role is even more important, because the signals address not only reflexes but also the imagination. (The visual may play a more important role in the sexuality of men than women, but this is difficult to assess because of the extent of sexist traditions in modern image-making.)

The breast, the nipple, the pubis, and the belly are natural optical focii of desire, and their natural pigmentation enhances their attractive power. If this is often not said simply enough – if it is left to the domain of spontaneous graffiti on public walls – it is due to the weight of puritan moralizing. The truth is, we are all made like that. Other cultures in other times have underlined the magnetism and centrality of these parts

with the use of cosmetics. Cosmetics which add more colour to the natural pigmentation of the body.

Given that painting is the appropriate art of the body, and given that the body, to perform its basic function of reproduction, uses visual signals and stimuli of sexual attraction, we begin to see why painting is never very far from the erogenous.

Tintoretto painted a canvas, *Woman with Bare Breasts*, which is now in the Prado. This image of a woman uncovering her breast so that it can be seen is equally a representation of the gift, the talent, of painting itself. At the simplest level, the painting (with all its art) is imitating nature (with all its cunning) in drawing attention to a nipple and its aureole. Two very different kinds of 'pigmentation' used for the same purpose.

Yet just as the nipple is only part of the body, so its disclosure is only part of the painting. The painting is also the woman's distant expression, the far-from-distant gesture of her hands, her diaphanous clothes, her pearls, her coiffure, her hair undone on the nape of her neck, the flesh-coloured wall or curtain behind her, and, everywhere, the play between greens and pinks so beloved of the Venetians. With all these elements, the *painted* woman seduces us with the visible means of the living one. The two are accomplices in the same visual coquetry.

Tintoretto was so called because his father was a dyer of cloth. The son, although at one degree removed and hence within the realm of art, was, like every painter, a 'colourer' of bodies, of skin, of limbs.

Let us imagine this Tintoretto beside a Giorgione painting of *An Old Woman*, painted about half a century earlier. The two paintings together show that the intimate and unique relation existing between pigment and flesh does not necessarily mean sexual provocation. On the contrary, the theme of the Giorgione is the loss of the power to provoke.

Perhaps no words could ever register like this painting does the sadness of the flesh of an old woman, whose right hand makes a gesture which is so similar and yet so different from that of the woman painted by Tintoretto. Why? Because the pigment has become that flesh? This is almost true but not quite. Rather, because the pigment has become the communication of that flesh, its lament.

Finally, I think of Titian's *Vanity of the World*, which is in Munich. There a woman has abandoned all her jewellery (except a wedding ring) and all adornment. The 'fripperies', which she has discarded as vanity, are reflected in the dark mirror she holds up. Yet, even here, in this least suitable of contexts, her painted head and shoulders cry out with desirability. And the pigment is the cry.

Such is the ancient mysterious contract between pigment and flesh. This contract permits the great paintings of the Madonna and Child to offer profound sensuous security and delight, just as it confers upon the great Pietàs the full weight of their mourning – the terrible weight of the

hopeless desire that the flesh should live again. Paint belongs to the body.

The stuff of colours possesses a sexual charge. When Manet paints *Le Déjeuner sur l'Herbe* (a picture which Picasso copied many times during his last period), the flagrant paleness of the paint does not just imitate, but becomes the flagrant nakedness of the women on the grass. What the painting *shows* is the body *shown*.

The intimate relation (the interface) between painting and physical desire, which one has to extricate from the churches and the museums, the academies and the lawcourts, has little to do with the special mimetic texture of oil paint, as I discuss it in my book *Ways of Seeing*. The relation begins with the act of painting, not with the medium. The interface can be there too in fresco painting or water-colour. It is not the illusionist tangibility of the painted bodies which counts, but their visual signals, which have such an astounding complicity with those of real bodies.

Perhaps now we can understand a little better what Picasso did during the last twenty years of his life, what he was driven to do, and what – as one might expect of him – nobody had quite done before.

He was becoming an old man, he was as proud as ever, he loved women as much as he ever had and he faced the absurdity of his own relative impotence. One of the oldest jokes in the world became his pain and his obsession – as well as a challenge to his great pride.

At the same time, he was living in an uncommon isolation from the world – an isolation, as I point out in my book, which he had not altogether chosen himself, but which was the consequence of his monstrous fame. The solitude of this isolation gave him no relief from his obsession; on the contrary, it pushed him further and further away from any alternative interest or concern. He was condemned to a single-mindedness without escape, to a kind of mania, which took the form of a monologue. A monologue addressed to the practice of painting, and to all the dead painters of the past whom he admired or loved or was jealous of. The monologue was about sex. Its mood changed from work to work but not its subject.

The last paintings of Rembrandt – and particularly the self-portraits – are proverbial for their questioning of everything the artist had done or painted before. Everything is seen in another light. Titian, who lived almost as long as Picasso, painted towards the end of his life *The Flaying of Marsyas* and *The Pietà* in Venice: two extraordinary last paintings in which the paint as flesh turns cold. For both Rembrandt and Titian the contrast between their late works and their earlier work is very marked. Yet also there is a continuity, whose basis it is difficult to define briefly. A continuity of pictorial language, of cultural reference, of religion, and of the role of art in social life. This continuity qualified and reconciled –

to some degree – the despair of the old painters; the desolation they felt became a sad wisdom or an entreaty.

With Picasso this did not happen, perhaps because, for many reasons, there was no such continuity. In art he himself had done much to destroy it. Not because he was an iconoclast, nor because he was impatient with the past, but because he hated the inherited half-truths of the cultured classes. He broke in the name of truth. But what he broke did not have the time before his death to be reintegrated into tradition. His copying, during the last period, of old masters like Velázquez, Poussin or Delacroix, was an attempt to find company, to re-establish a broken continuity. And they allowed him to join them. But they could not join him.

And so he was alone – like the old always are. But he was unmitigatedly alone because he was cut off from the contemporary world as a historical person, and from a continuing pictorial tradition as a painter. Nothing spoke back to him, nothing constrained him, and so his obsession became a frenzy: the opposite of wisdom.

An old man's frenzy about the beauty of what he can no longer do. A farce. A fury. And how does the frenzy express itself? (If he had not been able to draw or paint every day, he would have gone mad or died – he needed the painter's gesture to prove to himself he was still a living man.) The frenzy expresses itself by going directly back to the mysterious link between pigment and flesh and the signs they share. It is the frenzy of paint as a boundless erogenous zone. Yet the shared signs, instead of indicating mutual desire, now display the sexual mechanism. Crudely. With anger. With blasphemy. This is painting swearing at its own power and at its own mother. Painting insulting what it had once celebrated as sacred. Nobody before imagined how painting could be obscene about its own origin, as distinct from illustrating obscenities. Picasso discovered how it could be.

How to judge these late works? Those who pretend that they are the summit of Picasso's art are as absurd as the hagiographers around him have always been. Those who dismiss them as the repetitive rantings of an old man understand nothing about either love or the human plight.

Spaniards are proverbially proud of the way they can swear. They admire the ingenuity of their oaths and they know that swearing can be an attribute, even a proof, of dignity.

Nobody had ever sworn in paint before Picasso painted these canvases.

1988

The Soul and the Operator

The photos come from Warsaw, Leipzig, Budapest, Bratislava, Riga, Sofia. Every nation has a slightly different way of physically standing shoulder to shoulder during mass demonstrations. But what interests me in all the photos is something that is invisible.

Like most moments of great happiness, the events of 1989 in Eastern Europe were unforeseeable. Yet is happiness the right word to describe the emotion shared by millions that winter? Was not something graver than happiness involved?

Just as the events were unforeseeable, so still is the future. Would it not be more apt to talk of concern, confusion, relief? Why insist upon happiness? The faces in the photos are tense, drawn, pensive. Yet smiles are not obligatory for happiness. Happiness occurs when people can give the whole of themselves to the moment being lived, when Being and Becoming are the same thing.

As I write, I remember leaving Prague in a train more than twenty years ago. It was as if we were leaving a city in which every stone of every building was black. I hear again the words of a student leader, who stayed behind, as he addressed the last meeting: 'What are the plans of my generation for this year of 1969? To pursue a current of political thought opposed to all forms of Stalinism, and yet not to indulge in dreams. To reject the utopia of the New Left, for with such dreams we could be buried. To maintain somehow our links with the trade unions, to continue to work for and prepare an alternative model of socialism. It may take us one year, it may take us ten . . .'

Now the student leader is middle-aged. And Dubček is the prime minister of his country.

Many refer to what is happening as a revolution. Power has changed hands as a result of political pressure from below. States are being transformed – economically, politically, juridically. Governing élites are

being chased from office. What more is needed to make a revolution? Nothing. Yet it is unlike any other one in modern times.

First because the ruling élite (except in the case of Romania) did not fight back, but abdicated or reneged, although the revolutionaries were unarmed. And secondly, because it is being made without utopian illusions. Made step by step, with an awareness that speed is necessary, yet without the dreaded classic exhortation of *Forward!*

Rather, the hope of a return. To the past, to the time before all the previous revolutions? Impossible. And it is only small minorities who demand the impossible. These are spontaneous mass demonstrations. People of every generation, muffled up against the cold, their faces grave, happy, keeping a rendezvous. With whom?

Before answering, we have to ask what is it that has just ended? The Berlin Wall, the one-party system, in many countries the Communist Party, the Red Army occupation, the Cold War? Something else which was older than these and less easy to name has also ended. Voices are not lacking to tell us what it is. History! Ideology! Socialism! Such answers are unconvincing, for they are made by wishful thinkers. Nevertheless, something vast has ended.

Occasionally, history seems to be oddly mathematical. Last year – as we were often reminded – was the two hundredth anniversary of the French Revolution, which, although not the first, became the classic model for all other modern revolutions. 1789–1989. Sufficient to write down these dates to ask whether they do not constitute a period. Is it this that has ended? If so, what made this a period? What was its distinguishing historical feature?

During these two centuries the world was 'opened up', 'unified', modernized, created, destroyed and transformed on a scale such as had never occurred before. The energy for these transformations was generated by capitalism. It was the period when self-interest, instead of being seen as a daily human temptation, was made heroic. Many opposed the new Promethean energy in the name of the General Good, of Reason and of Justice. But the Prometheans and their opponents had certain beliefs in common. Both believed in Progress, Science, and a new future for Man. Everyone had their particular personal set of beliefs (one reason why so many novels could be written) but in their *practice*, their traffic with the world, their exchanges, all were subject to systems based exclusively on a materialist interpretation of life.

Capitalism, following the doctrines of its philosophers – Adam Smith, Ricardo and Spencer – installed a practice in which only materialist considerations and values counted. Thus the spiritual was marginalized; its prohibitions and pleas were ruled out of court by the priority given to economic laws, laws given the authority (as they still have today) of natural laws.

571

Official religion became an evasive theatre, turning its back on real consequences and blessing principally the powerful. And in face of the 'creative destruction' of capitalism – as Joseph Schumpeter, one of its own eminent theorists, defined it – the modern rhetoric of bourgeois politics developed, so as to hide the pitiless logic of the underlying practice.

The socialist opposition, undeceived by the rhetoric and hypocrisy, insisted upon the practice. This insistence was Marx's genius. Nothing diverted him. He unveiled the practice layer by layer until it stood exposed once and for all. The shocking vastness of the revelation gave prophetic authority to historical materialism. Here was the secret of history and all its sufferings! Everything in the universe could now be explained (and resolved!) on a material basis, open to human reason. Egoism itself would eventually become outdated.

The human imagination, however, has great difficulty in living strictly within the confines of a materialist practice or philosophy. It dreams, like a dog in its basket, of hares in the open. And so, during these two centuries, the spiritual persisted, but in new, marginalized forms.

Take Giacomo Leopardi, who was born in exactly the year our period opens. He was to become Italy's greatest modern lyric poet. As a child of his time, he was a rationalist of the existent and studied the universe as a materialist. Nevertheless, his sadness and the stoicism with which he bore it, became, within his poetry, even larger than the universe. The more he insisted on the materialist reality surrounding him, the more transcendent became his melancholy.

Likewise, people who were not poets tried to make exceptions to the materialism which dominated their epoch. They created enclaves of the *beyond*, of what did not fit into materialist explanations. These enclaves resembled hiding places; they were often kept private. Visited at night. Thought of with bated breath. Sometimes transformed into theatres of madness. Sometimes walled in like gardens.

What they contained, the forms of the *beyond* stored away in these enclaves, varied enormously according to period, social class, personal choice, and fashion. Romanticism, the Gothic revival, vegetarianism, Rudolf Steiner, art for art's sake, theosophy, sport, nudism . . . Each movement saved for its adepts fragments of the spiritual which had been banished.

The question of fascism, of course, cannot be avoided here. It did the same thing. Nobody should presume that evil has no spiritual power. Indeed, one of the principal errors of the two centuries concerned evil. For the philosophical materialists the category was banished, and for the rhetoricians of the establishment evil became Marxist materialism! This left the field wide open for what Kierkegaard correctly called the prattle

of the Devil, the prattle that erects a terrible screen between name and thing, act and consequence.

Yet the most original marginalized spiritual form of the period was the transcendent yet secular faith of those struggling for social justice against the greed of the rich. This struggle extended from the Club des Cordeliers of the French Revolution to the sailors in Kronstadt to my student friends in the University of Prague. It included members of all classes – illiterate peasants and professors of etymology. Their faith was mute in the sense that it lacked ritual declaration. Its spirituality was implicit, not explicit. It probably produced more acts of willing self-sacrifice, of nobility (a word from which some might have shrunk) than any other historical movement of the period. The explanations and strategies of the men and women concerned were materialist; yet their hopes and the unexpected tranquillity they sometimes found in their hearts were those of transcendent visionaries.

To say, as is often said, that communism was a religion is to understand nothing. What counted was that the material forces in the world carried for millions – in a way such as had never happened before – a promise of *universal* salvation. If Nietzsche had announced that God was dead, these millions felt that he was hiding in history and that, if together they could carry the full weight of the material world, souls would again be given wings. Their faith marked a road for mankind across the usual darkness of the planet.

Yet in their socio-political analyses there was no space for such faith, so they treated their own as an illegitimate but loved child who was never given a name. And here the tragedy began. Since their faith was unnamed, it could easily be usurped. It was in the name of their determination and their solidarity that the party-machines justified the first crimes, and, later, the crimes to cover up further crimes, till finally there was no faith left anywhere.

Sometimes, because of its immediacy, television produces a kind of electronic parable. Berlin, for instance, on the day the Wall was opened. Rostropovich was playing his cello by the Wall that no longer cast a shadow, and a million East Berliners were thronging to the West to shop with an allowance given them by West German banks! At that moment the whole world saw how materialism had lost its awesome historic power and become a shopping list!

A shopping list implies consumers. And this is why capitalism believes it has won the world. Chunks of the Berlin Wall are now being sold across the world. Forty marks for a large piece from the Western side, ten marks for a piece from the Eastern side. Last month the first McDonald's opened in Moscow; last year the first Kentucky Fried Chicken in Tiananmen Square. The multinationals have become global in the sense that

they are more powerful than any single nation state. The free market is to be installed everywhere.

Yet if the materialist philosophy of the last two centuries has run out, what is to happen to the *materialist fantasy* on which consumerism and therefore global capitalism is now utterly dependent?

Marketing punctuates our lives as regularly and systematically as any prayer cycle in a seminary. It transfigures the product or package being sold so that it gains an aura, wins a radiance, which promises a kind of temporary immunity from suffering, a sort of provisional salvation, the salutary act always being the same one of buying. Thus any commodity becomes a way of dreaming, but, more importantly, the imagination itself becomes acquisitive, accepting the credo of Ivan Boesky addressing graduates at Berkeley business school: 'I think greed is healthy. You can be greedy and still feel good about yourself.'

The poverty of our century is unlike that of any other. It is not, as poverty was before, the result of natural scarcity, but of a set of priorities imposed upon the rest of the world by the rich. Consequently, the modern poor are not pitied – except by individuals – but written off as trash. The twentieth-century consumer economy has produced the first culture for which a beggar is a reminder of nothing.

Most commentators on the events in Eastern Europe emphasize the return to religion and nationalism. This is part of a world-wide tendency, yet the word 'return' may be misleading. For the religious organizations in question are not the same as they previously were, and the people who make up this 'return' are living with transistors at the end of the *twentieth* century, not the eighteenth.

For example, in Latin America it is a branch of the Catholic Church (much to the Pope's embarrassment) which today leads the revolutionary struggle for social justice and offers means of survival to those being treated as historical trash. In many parts of the Middle East the growing appeal of Islam is inseparable from the social conscience it promises on behalf of the poor, or (as with the Palestinians) the landless and the exiled, up against the remorseless economic and military machinery of the West.

The resurgent nationalisms reflect a similar tendency. Independence movements all make economic and territorial demands, but their first claim is of a spiritual order. The Irish, the Basques, the Corsicans, the Kurds, the Kosovans, the Azerbaijanis, the Puerto Ricans and the Latvians have little in common culturally or historically, but all of them want to be free of distant, foreign centres which, through long, bitter experience, they have come to know as soulless.

All nationalisms are at heart deeply concerned with names: with the most immaterial and original human invention. Those who dismiss names as a detail have never been displaced; but the peoples on the

peripheries are always being displaced. This is why they insist upon their identity being recognized, insist upon their continuity – their links with their dead and the unborn.

If the 'return' to religion is in part a protest against the heartlessness of the materialist systems, the resurgence of nationalism is in part a protest against the anonymity of those systems, their reduction of everything and everybody to statistics and ephemerality.

Democracy is a political demand. But it is something more. It is a moral demand for the individual right to decide by what criteria an action is called right or wrong. Democracy was born of the principle of conscience. Not, as the free market would today have us believe, from the principle of choice which – if it is a principle at all – is a relatively trivial one.

The spiritual, marginalized, driven into the corners, is beginning to reclaim its lost terrain. Above all, this is happening in people's minds. The old reasoning, the old common sense, even old forms of courage have been abandoned, and unfamiliar recognitions and hopes, long banished to the peripheries, are returning to claim their own. This is where the happiness behind the faces in the photos starts. But it does not end there.

A reunion has occurred. The separated are meeting – those separated by frontiers and by centuries. Throughout the period which is ending, daily life, with all its harshness, was continually justified by promises of a radiant future. The promise of the new Communist man for whom the living were ceaselessly sacrificed. The promise of science forever rolling back the frontiers of ignorance and prejudice. More recently, the promise of credit cards buying the next instant happiness.

This excessive need of a radiant future separated the present from all past epochs and past experience. Those who had lived before were further away than they had ever been in history. Their lives became remote from the unique exception of the present. Thus for two centuries the future 'promise' of history assured an unprecedented solitude for the living.

Today the living are remeeting the dead, even the dead of long ago, sharing their pain and their hope. And, curiously, this too is part of the happiness behind the faces in the photos.

How long can this moment last? All the imaginable dangers of history are waiting in the wings – bigotry, fanaticism, racism. The colossal economic difficulties of ongoing everyday survival are, in theory, going to be solved by the free market. With such a market comes the risk of new ravenous appetites for money, and with their voraciousness jungle law. But nothing is finally determined. The soul and the operator have come out of hiding together.

1990

The Third Week of August, 1991

In 1958 when Nazim Hikmet, after being imprisoned for many years as a communist in Turkey, was living as an exile in Moscow, he wrote a poem for my friend, the Turkish painter and poet, Abidine Dino.

> These men Dino
> grasping rags of torn light in their hands
> where are they going Dino
> these men in the depth of the darkness?
> You and I also Dino
> we are among them
> we too Dino we too have seen
> a sky which was blue.

The poem was inspired by a painting of Dino's which I have never seen but can imagine a little. Abidine is a visionary painter, inspired in his turn by traditions which come from the wandering Sufis.

Nazim Hikmet's poem comes to me tonight after watching the news on TV. Like everybody else I have been watching for a week. Tonight in Moscow the crowds in the Lubyanka Square were living a moment which not a single one of them will ever forget. The gigantic statue of Felix Dzerjinski outside the notorious KGB building was being dismantled. Known as Iron Felix, he was the founder in 1918 of the Cheka, the political police who were the precursors of the KGB. A crane lifted the bronze figure off its pedestal. What the word Lubyanka meant until tonight – but, in another sense, forever – Anna Akhmatova has conveyed. The statue, in mid-air and horizontal, was slowly manoeuvred away. It will join others.

Castings and carvings, Marx, Engels, Kalinin, Sverdlov are falling everywhere. Overturned, they all look like wrecks, like write-offs. Yet

they weren't involved in a road or air accident: they were idols which justified or demanded, over the years, sacrifice after sacrifice. That they now look, when horizontal and suspended from a cable, like write-offs is the result of their aesthetic style and iconography.

Among monumental sculptures only certain Crucifixions would remain meaningful when suspended horizontally in mid-air. The Crucifixion happened on a tree that had already been felled and the figure on the cross, if carved truthfully, was a man humiliated and suffering. By contrast idols, when set up as sculptures, have to remain vertical.

Despite the Eastern European example of 1989, the speed of events took everyone by surprise. After the putsch – which apparently the CIA did not foresee – the newly acquired will-power of Russian civil society must have surprised even those it was motivating. The pace in the third week of August was no longer that of an historical process but of a sudden resurgence of nature. It resembled fire, wind, or desire. Not only statues fell, but also institutions, citadels, networks, files, arsenals. 'All fall down,' as the English nursery rhyme says.

The organic nature of the energy involved was confirmed by the unforeseeable yet crucial participation of the young. What happened in Parliament Square on Wednesday, August 21 was the birth of a generation. And Gorbachev aged overnight.

The triumph and drama of Gorbachev is astounding. We can see now that he, with his advisers, calculated many years ago – well before he acquired power – that there was no real chance of bringing about any changes in the Soviet state apparatus until a potential civil society had been created at home and the Soviet satellites had been dismantled abroad. Hence, first glasnost. And then, later, the road to the Red Square in Moscow, which had to begin in Berlin. The irony of it having to be like this – after the heroic advance of the Red Army in the opposite direction in 1944 – must have struck him many times.

His calculations were proved correct, and consequently something happened on a scale which has no parallel in history. Never before has such a massive power system been dismantled in such a short time with so little loss of life. The face of Europe utterly transformed, and almost everybody sleeping in his usual bed every night. This is why I quoted from a nursery rhyme.

Hans Magnus Enzensberger has named Gorbachev a genius of withdrawal, the great master of retreat. He is right. But the conception, the carrying out, and the success of the great withdrawal depended on one thing, which is the axis of the man's drama.

Gorbachev believed in the possibility and the desirability of reforming the Communist Party. If he hadn't believed this, he could never have

gained the necessary power, convinced his comrades, intimidated his opponents, or moved with the visionary power that he did.

He might have written a book of political theory, but the immense transformations we have lived through during the past five years would not have taken place in the way they have. Probably the economic collapse of the USSR would eventually have provoked very violent and desperate confrontations.

Gorbachev is a man, formed within the Communist Party, who undertook to change his party and its role in the world. He failed to imagine only one thing: that, due to all the other changes he'd brought about or stage-managed, the CPSU would overnight be declared illegal.

At the end of the third week of August, he turns to the audience, which is a world set free, and at the same instant he finds himself empty-handed.

I thought of Hikmet's poem because it refers to another but similar paradox and drama. It is small, a postcard of a poem, suffused with sadness and, differently – as with so many of Hikmet's poems – with pity. Applied to a poem, the word pity presents no problems. In life, during modern times, the notion of pity became suspect. Unfortunately there was thought to be an insult in it.

Its opposite, pitilessness, remained terrible and simple. The idols are being torn down because they embodied pitilessness. The party is being banned for the same reason. No appeal can be made to the pitiless. And the iconoclasm of this moment is the revenge of those who learned that it was hopeless to appeal.

Yet, in the beginning, communists became communists because moved by pity, Marx included. He wrote into what he saw as the laws of history the salvation of the pitiful. Nothing less. Gradually these laws were used to make ever wider and dogmatic generalisations so that they finally became lies, as all generalisations which become dogma are bound to do. The reality of the living was obscured by the writing of these laws, and whenever this happens evil reigns.

The communism, today certified as dead, represented at one and the same time an ardent hope born of pity and a pitiless practice.

These men . . . 'grasping rags of torn light in their hands'.

What then is pity? Simone Weil defined it better than anyone else I know. It 'consists in seeing that no harm is done to men. Whenever a man cries inwardly, "why am I being hurt?" harm is being done to him. He is often mistaken when he tries to define the harm, and why and by whom it is being inflicted on him. But the cry itself is infallible.'

I don't believe other statues in bronze will take the place of the write-offs in Russian cities. The nightmare of the merciless fallen idols there has

already been replaced by a dream. The free market carries with it the right to dream. We are here, as the French magazine *Marie Claire* so succinctly put it, we are here to offer names to your longings. Russian longings, after so much hardship, are intense. The world network of media exchanges seems to answer, more consistently at this moment than any other proposal, many of their longings. The statues are being replaced by far more volatile images, which are working like a screen on to which is being projected a preview of the future. What lies behind the screen is contradictory.

On one hand, the Gulf war showed how politicians have reason to fear the media; or, rather, have reason to fear public reaction to what the media may show. Satellite transmission has given the world a new meaning for the term 'moment of truth'. (Like the moment in Parliament Square when a soldier in a Red Army tank threw in his lot with the unarmoured crowd.)

On the other hand, the Gulf war showed – as did events in Romania last year – that a scenario of lies can be written for the media which will then transmit it, with excitement, commentary, analysis, etc., as if it was the truth.

Perhaps, as was the case with the statues, the essential nature of the media network is most clearly revealed by its aesthetic and iconography. These are not stamped on everything which passes – sometimes dispatches come from life itself – but they are dominant and they fashion a style not only of presentation but also of perception.

It is a style of winners and would-be winners, not of conquerors, not really of supermen, but simply of those who do well and succeed because they have come to believe that success is natural. (Sport is a significant field for this style, since it allows for winners who can temporarily lose whilst remaining winners.)

Like all aesthetics, this one entails an anaesthetic: a numbed area without feeling. The winning aesthetic excludes experience of loss, defeat, affliction, except insofar as those suffering these ills may be presented as exceptions requiring the aid of winners. The anaesthetic protects from any assertion or evidence or cry which shows life as a site of hopes forever deferred. And it does this despite the fact that such a vision of life remains the experience of the majority of people in the world today.

The media network has its idols, but its principal idol is its own style which generates an aura of winning and leaves the rest in darkness. It recognises neither pity nor pitilessness.

1991

Appendices

Notes

The Moment of Cubism

1. See John Golding, *Cubism* (London: Faber & Faber, 1959; New York: Harper & Row, 1971).

2. D. H. Kahnweiler, *Cubism* (Paris: Editions Braun, 1950).

3. In the Penguin translation of Apollinaire a misreading of these lines unfortunately reverses the meaning of the poem.

4. *El Lissitzky* (Dresden: Verlag der Kunst, 1967), p. 325 (trans. Anya Bostock).

5. E. M. Remarque, *All Quiet on the Western Front,* trans. A. W. Wheen (London: Putnam & Co., 1929; New York: Mayflower/Dell Paperbacks, 1963).

6. Quoted in Anthony Blunt, *Artistic Theory in Italy 1450–1600* (London and New York: Oxford University Press, 1956; OUP paperback edn, 1962).

7. See Arnold Hauser, *Mannerism* (London: Routledge, 1965; New York: Knopf, 1965); an essential book for anybody concerned with the problematic nature of contemporary art, and its historical roots.

8. Quoted in Anthony Blunt, *op. cit.*

9. *Artists on Art,* ed. R. J. Goldwate and M. Treves (New York: Pantheon Books, 1945; London: John Murray, 1976).

10. *Ibid.*

11. *Ibid.*

12. Werner Heisenberg, *Physics and Philosophy* (London: Allen & Unwin, 1959), p. 75 (New York: Harper & Row/Torch, 1959).

13. For a similar analysis of Cubism, written thirty years earlier but unknown to the author at the time of writing, see Max Raphael's great work *The Demands of Art* (London: Routledge, 1969), p. 162 (Princeton, New Jersey: Princeton University Press, 1968).

14. Eddie Wolfram, in *Art and Artists,* London, September 1966.

15. Werner Heisenberg, *op. cit.,* p. 172.

16. W. Grey Walter, *The Living Brain* (London: Duckworth, 1953; Harmondsworth, Penguin, 1961), p. 69 (New York: Norton, 1963).

17. Marshall McLuhan, *Understanding Media* (London: Routledge, 1964; New York: McGraw-Hill, 1964), pp. 4, 5.

18. Quoted in Hans Richter, *Dada* (London: Thames & Hudson, 1966), p. 55 (New York: Oxford University Press, 1978).

Art and Property Now

1. *Notes pour un Manifeste* (Paris: Galerie Denise René, 1955).

Image of Imperialism

1. 'Vietnam must not stand alone', *New Left Review*, London, no. 43, 1967.

2. Saint-Just, *Discours et Rapports* (Paris: Editions Sociales, 1957), p. 66 (trans. by the author).

3. *Ibid.*, p. 90.

4. *Ibid.*

5. *Ibid.*

6. *Ibid.*

7. Quoted in Albert Camus, *The Rebel* (London: Peregrine, 1962), p. 140.

8. E. 'Che' Guevara, *Le Socialisme et l'homme* (Paris: Maspero, 1967), p. 113 (trans. by the author).

Nude in a Fur Coat

1. *The Success and Failure of Picasso* (Harmondsworth: Penguin, 1965).

The Painter in His Studio

1. Lawrence Gowing, *Vermeer* (London: Faber & Faber, 1952).

2. Pascal, *Pensées* (trans. by the author).

L. S. Lowry

1. This quotation is from Mervyn Levy's *L. S. Lowry* (London: Studio Vista, 1961). Levy establishes the character of the artist very well, but his interpretations of the works are vulgar.

2. Kenneth Clark, *A Tribute to L. S. Lowry* (Eccles: Monks Hall Museum, 1964).

3. *L. S. Lowry* (London: Arts Council catalogue, 1966).

4. Mervyn Levy, *L. S. Lowry, op. cit.*

5. George Orwell, *The Road to Wigan Pier* (London: Gollancz, 1937).

Pierre Bonnard

1. *Collected Poems of W. B. Yeats* (London: Macmillan, 1958), p. 168.
2. Stendhal, *De l'Amour* (Paris: Editions de Cluny, 1938), p. 43 (trans. by the author).
3. Quoted in *Pierre Bonnard* (London: Royal Academy catalogue, 1966).

Auguste Rodin

1. Isadora Duncan, *My Life* (London: Gollancz, 1966), pp. 99, 100.
2. *Ibid.*
3. Ovid, *Metamorphoses*, Book X, trans. Mary M. Innes (Harmondsworth: Penguin, 1955).
4. Quoted by Denys Sutton, *Triumphant Satyr* (London: Country Life, 1966).

Peter Peri

1. John Berger, *A Painter of Our Time* (London: Secker & Warburg, 1958; Harmondsworth: Penguin, 1965).

Victor Serge

1. Victor Serge, *Memoirs of a Revolutionary 1901–1941*, ed. and trans. Peter Sedgwick (Oxford: Oxford University Press, 1963).
2. Victor Serge, *Birth of Our Power*, trans. Richard Greeman (London: Gollancz, 1968).

Fernand Léger

1. John Berger, *Corker's Freedom* (London: Methuen, 1964).

The Sight of a Man

1. Maurice Merleau-Ponty, *Sense and Non-Sense*, trans. Hubert L. Dreyfus (Evanston, Illinois: Northwestern University Press, 1964).
2. Merleau-Ponty, *op. cit.*
3. Merleau-Ponty, *The Primacy of Perception*, ed. James M. Edie, trans. William Cogg *et al.* (Evanston, Illinois: Northwestern University Press, 1964).

Revolutionary Undoing

1. Max Raphael, *The Demands of Art*, trans. Norbert Guterman (London: Routledge, 1968).

On the Bosphorus

1. 'The new dissent: intellectuals, society and the left', *New Society*, 23 November 1978.

The *Work* of Art

1. Nicos Hadjinicolaou, *Art History and Class Consciousness* (London: Pluto Press, 1978; Atlantic Highlands, New Jersey: Humanities Press, 1978).

Mayakovsky

1. V. V. Mayakovsky, *How Are Verses Made?* (London: Cape, 1970; New York: Grossman, 1970).
2. This is a literal translation by the authors.
3. Mayakovsky, *op. cit.*
4. Yannis Ritsos, *Gestures*, trans. Nikos Stangos (London: Cape Goliard, 1971; New York: Grossman, 1970).

Leopardi

1. Giacomo Leopardi, *Moral Tales*, trans. Patrick Creagh (Manchester: Carcanet, 1983; New York: Columbia University Press, 1983).

A Story for Aesop

1. Danilo Dolci, *Sicilian Lives* (New York: Pantheon, 1981), p. 171.
2. José Ortega y Gasset, *Historical Reason* (New York: W. W. Norton, 1984), p. 187.

Sources

Where no prior source is indicated, a piece is assumed to have been first published in book form. Otherwise the pieces were first published – sometimes with different titles, in different versions – as follows.

Permanent Red

All pieces first published in the *New Statesman*

The Moment of Cubism

The Moment of Cubism: *New Left Review*
The Historical Function of the Museum, The Changing View of Man in the Portrait, Art and Property Now, Image of Imperialism, *Nude in a Fur Coat*, Mathias Grünewald, L. S. Lowry, Alberto Giacometti, Pierre Bonnard, Auguste Rodin: *New Society*
The Painter in His Studio: Vermeer: *Punch*
Et in Arcadia Ego: Poussin: *New Statesman*
The Maja Dressed and *The Maja Undressed*: Goya: *Sunday Times Magazine*
Toulouse-Lautrec: *Observer*
Frans Hals: *Sunday Times Magazine*

The Look of Things

Peter Peri, Zadkine, Victor Serge, Walter Benjamin, Painting a Landscape, Understanding a Photograph, The Political Uses of Photo-Montage, The Sight of a Man, Revolutionary Undoing, Past Seen from a Possible Future, The Nature of Mass Demonstrations: *New Society*

Le Corbusier, Drawings by Watteau, Thicker than Water: *New Statesman*
Fernand Léger: *Marxism Today*

The Booker Prize Speech: *Guardian* (24 November 1972)

About Looking

All previously published in *New Society* except:
Between Two Colmars, Romaine Lorquet: *Guardian*
Turner and the Barber's Shop, Rouault and the Suburbs of Paris: *Réalités*

The White Bird

The Storyteller, On the Bosphorus, The Theatre of Indifference, The Hals Mystery, In a Moscow Cemetery, François, Georges and Amélie: A Requiem in Three Parts, Drawn to That Moment, The Eyes of Claude Monet, The *Work* of Art, The Hour of Poetry, Leopardi, The Production of the World: *New Society*
The Eaters and the Eaten: *Guardian*
Modigliani's Alphabet of Love: *Village Voice*
Ernst Fischer: A Philosopher and Death: Introduction to his autobiography, *An Opposing Man*: The Autobiography of a Romantic Revolutionary (New York: Liverlight, 1974)
Mayakovsky: His Language and His Death: *7 Days*

The First and Last Recipe: *Ulysses*: *Guardian*

Keeping a Rendezous

Ev'ry Time We Say Goodbye, The Soul and the Operator: *Expressen*
That Which Is Held: *Village Voice*
A Load of Shit, Imagine Paris, The Opposite of Naked, Drawing on Paper: *Harper's Magazine*
Mother: *Threepenny Review*
A Story for Aesop: partly in *Granta*, partly in *Village Voice Literary Supplement*
A Kind of Sharing, The Third Week of August, 1991: *Guardian*
Christ of the Peasants: exhibition catalogue published by the Arts Council of Great Britain
A Professional Secret: *New Society*
Ape Theatre: *Granta*
A Household: *New Statesman & Society*
Erogenous Zone: *El Pais*

A Note on the Author

John Berger was born in London in 1926. His many books, innovative in form and far-reaching in their historical and political insight, include the Booker Prize-winning novel *G.* His new collection of essays *The Shape of a Pocket* has been published in 2001. John Berger now lives and works in a small village in the French Alps.

A Note on the Editor

Geoff Dyer's first book, *Ways of Telling*, was a critical study of John Berger; since then he has published seven works of fiction and non-fiction, including *But Beautiful, Out of Sheer Rage,* (a finalist, in America, for a National Book Critics Circle Award), *Paris Trance* and, most recently, *Anglo-English Attitudes*, a collection of essays.

A Note on the Type

The text of this book is set in New Baskerville, which is based on the original Baskerville font designed by John Baskerville of Birmingham (1706–75). The original punches he cut for Baskerville still exist. His widow sold them to Beaumarchais, from where they passed through several French foundries to Deberney & Peignot in Paris, before finding their way to Cambridge University Press.

Baskerville was the first of the 'transitional romans' between the softer and rounder calligraphic Old Face and the 'Modern' sharp-tooled Bodoni. It does not look very different from the Old Faces, but there is a crisper differentiation between thick and thin strokes, and the serifs on lower-case letters are closer to the horizontal, with the stress nearer the vertical. The R in some sizes has the eighteenth-century curled tail, the lower-case w has no middle serif, and the lower-case g has an open tail and a curled ear.